PHOTOGRAPHIC CREDITS

The author and publisher wish to thank the museums, galleries, and private collectors for permitting the reproduction of works in their collections. Photographs have been supplied by the owners or custodians of the works of art except for the following plates:

Alberts' Studio & Camera Shop, Visalia, Calif.: 489; George Arents Research Library (James Earle and Laura Gardin Fraser Collection), Syracuse University, Syracuse, N.Y.: 181, 186; B & T Studios, Tucson, Ariz.: 475; Peter Balestrero, Phoenix, Ariz.: 235, 374, 375, 454; E. Irving Blomstrann, New Britain, Conn.: 75; Peter L. Bloomer, Flagstaff, Ariz.: 415, 416, 417, 418, 420; Brenwasser Photographer, New York, N.Y.: 42, 43, 226, 276, 307, 363, 367, 368, 444, 479; Camera Arts Studio, Phoenix, Ariz.: 484, 485; George Carlson, Franktown, Colo.: 373; Vernon Castleton, Springville, Utah: 440; Chamber of Commerce of Greater Kansas City, Kansas City, Mo.: 502; Lawrence X. Champeau, New York, N.Y.: 202, 203; Chapellier Galleries, New York, N.Y.: 204; Geoffrey Clements, Staten Island, N.Y.: frontispiece, 2, 10, 11, 15, 23, 46, 55, 95, 124, 125, 126, 127, 128, 131, 140, 175, 176, 177, 340; Cornelius Photography, Tulsa, Okla.: 253; Dr. Wayne Craven, University of Delaware, Newark, Dela.: 16, 17; Mr. and Mrs. A. Mervyn (Monica Borglum) Davies, Wilton, Conn.: 65, 70 (courtesy Jack Richard, Cody, Wyo.), 73; George Farquhar, Eugene, Ore.: 501; Rell G. Francis, Springville, Utah: 441, 499; Hampton, Jackson, Wyo.: 431; Helga Photo Studio, Inc., New York, N.Y.: 313; Ted Hill, Scottsdale, Ariz.: 156, 298, 299, 300, 301, 302, 303, 304, 392, 393, 453, 460, 467, 468, 469, 470, 471, 472, 473, 474; Hopkins Photography Co., Tulsa, Okla.: 252; Ed Hunt, Salt Lake City, Utah: 316, 317, 318, 500, 503, 504, 505, 506, 507, 509; Peter A. Juley & Son, New York, N.Y.: 91; Richard Kehrwald, Sheridan, Wyo.: 174; Kemoha, Bartlesville, Okla.: 326; Dick Kent, Albuquerque, N.M.: 423, 424, 425, 455; Koppes, Phoenix, Ariz.: 376, 384, 477; Don Lindsey, Muskogee, Okla.: 386; Vernon MacNeil, Muskogee, Okla.: 86; John Manship, New York, N.Y.: 341, 342, 343, 344 (courtesy Walter J. Russell, New York, N.Y.), 345 (courtesy Walter J. Russell, New York, N.Y.); Markow Photography, Phoenix, Ariz.: 348, 349, 350, 351, 352, 353, 354, 355, 356, 357; Roger Meyers, Oklahoma City, Okla.: 271; Charles Mills, Philadelphia, Pa.: 28, 44, 45, 90, 493; Gabriel Moulin Studios, San Francisco, Calif.: 227; Ed Muno, Oklahoma City, Okla.: 118, 168, 208, 291, 292, 293, 294, 325, 327, 328, 329, 330, 331, 332, 333, 334, 335, 336, 337, 387, 388, 394, 421, 433, 487; Museum of New Mexico, Santa Fe, N.M.: 239; Nebraska State Historical Society, Lincoln, Neb.: 508; The New York Public Library, New York, N.Y.: 130; Oregon Historical Society, Portland, Ore.: 83, 110, 111; T. Harmon Parkhurst, Santa Fe, N.M.: 240, 241, 242, 243, 244; Mike Piper, Eugene, Ore.: 84; Hester Proctor, Stockton, Calif.: 229; Jack Richard, Cody, Wyo.: 3, 51, 68, 69, 76, 96, 213, 314, 315, 430; Glenn Rider, Kansas City, Mo.: 94; Robbins Library, Arlington, Mass. (courtesy Duette Photographers, Arlington, Mass.): 93; Rhonda Ronan, Chicago, Ill.: 27, 88, 218, 219; Walter Rosenblum, Long Island City, N.Y.: 400; John D. Schiff, New York, N.Y.: 312, 404; Seattle Historical Society, Seattle, Wash.: 254; Lewis Sharp, New York, N.Y.: 19, 20; Avnet Shaw Art Foundry, Plainview, N.Y.: 478; Skelton Photography, San Francisco, Calif.: 289; Sotheby-Parke-Bernet Galleries, New York, N.Y.: 217; Willard Starks, Princeton, N.J.: 319, 320; Hal Swiggett, San Antonio, Tex.: 60, 61, 491, 492; Myron Tannenbaum, King's Photography, Denver, Colo.: 4, 108, 112, 279, 369, 490, 494, 495, 496, 497, 498; Taylor & Dull, Inc., New York, N.Y.: 347; University of Oklahoma Press, Norman, Okla.: 113, 114; The Urbana Citizen, Urbana, Ohio: 21; Belton Wall, Jacksonville, Fla.: 130; Frances Wallace, San Francisco, Calif.: 232 (courtesy De Witt Ward Studio, New York, N.Y.); Tony Webber, Lubbock, Tex.: 432; Roy Wieghorst, El Cajon, Calif.: 411, 414; Kay V. Wiest, Santa Fe, N.M.: 380, 382, 383.

BRONZES OF THE AMERICAN WEST

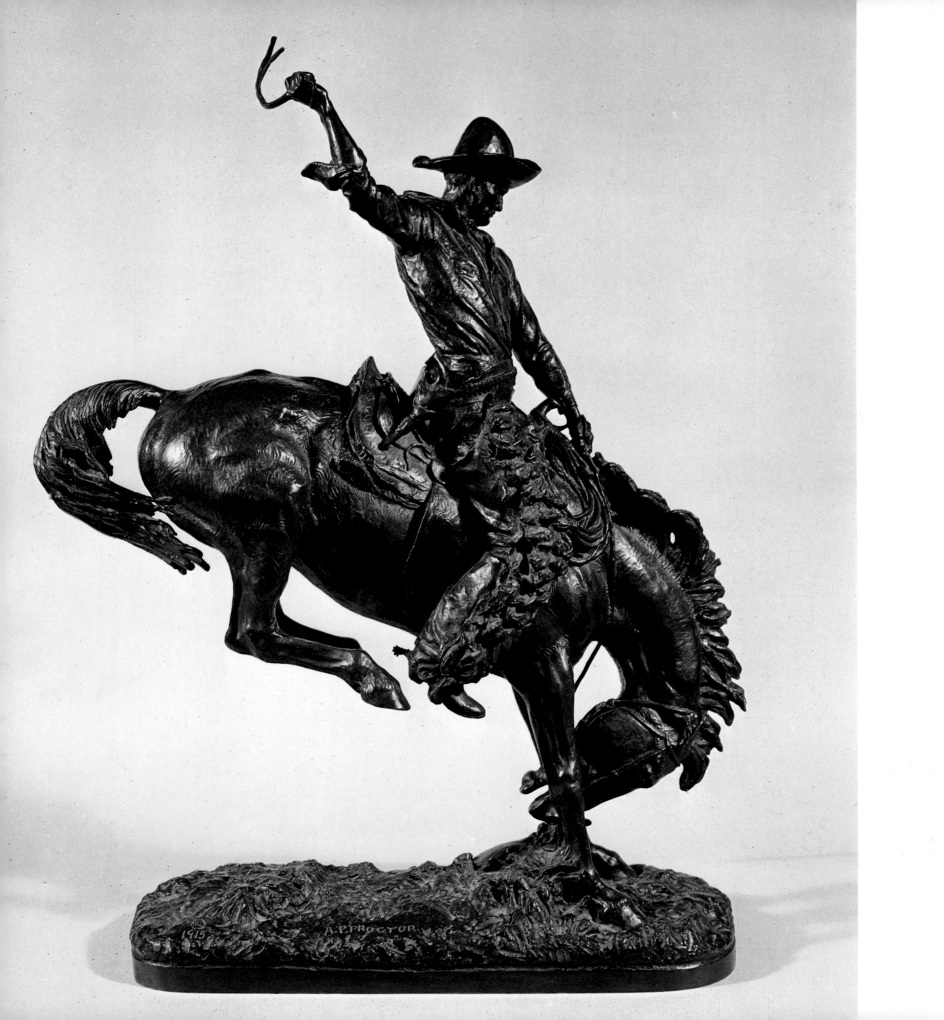

BRONZES OF THE AMERICAN WEST

PATRICIA JANIS BRODER

Introduction by Dr. Harold McCracken
DIRECTOR EMERITUS, WHITNEY GALLERY OF WESTERN ART

Harry N. Abrams, Inc., Publishers, New York

In Memory of My Father, MILTON W. JANIS

Frontispiece: A. Phimister Proctor. *The Buckaroo*. 1915. Roman Bronze Works, N.Y. H. 28 ½″. The Metropolitan Museum of Art, New York City. Bequest of George Dupont Pratt, 1935.

*Library of Congress Cataloging
in Publication Data*

Broder, Patricia Janis.
Bronzes of the American West.

Bibliography: p.
1. Bronzes—The West. 2. Sculptors, American.
I. Title.
NK7912.B76 739′.512′0978 73–8848
ISBN 0-8109-0133-1 Regular Edition
ISBN 0-8109-4743-9 Leather bound Edition

*Library of Congress Catalogue
Card Number: 73–8848*

ACKNOWLEDGMENTS

I wish to thank the many individuals and institutions without whose help and cooperation my work would not have been possible:

Dr. Harold McCracken, Director Emeritus, Whitney Gallery of Western Art, Cody, Wyoming, for his interest in my research from its earliest stages and for his advice during the preparation of my manuscript.

Dr. Wayne Craven, H. F. du Pont Winterthur Professor of Art, University of Delaware; James Graham, New York, New York; Dean Krakel, Director, National Cowboy Hall of Fame and Western Heritage Center, Oklahoma City, Oklahoma; Beatrice Gilman Proske, Curator of Sculpture Emerita, Hispanic Society of America, New York, New York; Frederic Renner, Washington, D.C.; Paul Rossi, Tucson, Arizona; and Mitchell Wilder, Director, Amon Carter Museum of Western Art, Fort Worth, Texas, for their helpful suggestions, enthusiasm, and cooperation in making available research materials otherwise unattainable.

The many specialists in the field of Western art for their advice and the use of their reference libraries: James Baker, Lubbock, Texas; J.N. Bartfield, New York, New York; Don Blair, Santa Fe, New Mexico; Eugene Coulon, New York, New York; Ralph Du Bois, Tulsa, Oklahoma; Richard Flood, Phoenix, Arizona; Richard Flood III, Phoenix, Arizona; Rell G. Francis, Springville, Utah; Victor Hammer, New York, New York; Warren Howell, San Francisco, California; David C. Hunt, Orange, Texas; Thomas Lewis, Taos, New Mexico; Leo Lombardo, New York, New York; Elaine May, Phoenix, Arizona; James Parson, Denver, Colorado; Peregrine Pollen, London, England; Fred Rosenstock, Denver, Colorado; Ginger K. Schimmel, Palm Desert, California; Jean Seth, Santa Fe, New Mexico; Ralph West, Pittsburgh, Pennsylvania; Nettie Wheeler, Muskogee, Oklahoma; Rudolph Wunderlich, New York, New York.

The directors and staffs of the many museums, historical societies, universities, and libraries throughout the United States for biographical, historical, and statistical information and photographs of sculptures in their collections: Addison Gallery of American Art, Phillips Academy, Andover, Massachusetts; Akron Art Institute, Akron, Ohio; Albrecht Gallery, St. Joseph, Missouri; Albright-Knox Art Gallery, Buffalo, New York; American Academy of Arts and Letters, New York, New York; American Museum of Natural History, New York, New York; Amherst College Art Museum, Mead Art Building, Amherst, Massachusetts; Amon Carter Museum of Western Art, Fort Worth, Texas; George Arents Research Library, Syracuse University, Syracuse, New York; Arizona Pioneers' Historical Society, Tucson, Arizona; Art Institute of Chicago, Chicago, Illinois; Bacone College Indian Museum, Muskogee, Oklahoma; Baltimore Museum of Art, Baltimore, Maryland; Birmingham Mu-

seum of Art, Birmingham, Alabama; Bradford Brinton Memorial Museum, Big Horn, Wyoming; Brookgreen Gardens, Murrells Inlet, South Carolina; Brooklyn Museum, Brooklyn, New York; Bureau of Indian Affairs, U.S. Department of the Interior, Washington, D.C.; Burke Memorial, Washington State Museum, University of Washington, Seattle, Washington; Butler Institute of American Art, Youngstown, Ohio; California Palace of the Legion of Honor, San Francisco, California; Carnegie Institute Museum of Art, Pittsburgh, Pennsylvania; Carpenter Art Gallery, Dartmouth College, Hanover, New Hampshire; Chamber of Commerce of Greater Kansas City, Kansas City, Missouri; Chamber of Commerce, Visalia, California; Chicago Historical Society Museum and Library, Chicago, Illinois; Chrysler Museum, Norfolk, Virginia; Cincinnati Art Museum, Cincinnati, Ohio; City Art Museum of St. Louis, St. Louis, Missouri; Colorado Springs Fine Arts Center, Colorado Springs, Colorado; Columbia Museum of Art, Columbia, South Carolina; Corcoran Gallery of Art, Washington, D.C.; Cranbrook Academy of Art Galleries, Bloomfield Hills, Michigan; Currier Gallery of Art, Manchester, New Hampshire; Dallas Museum of Fine Arts, Dallas, Texas; Delaware Art Center, Wilmington, Delaware; Denver Art Museum, Denver, Colorado; Denver Museum of Natural History, Denver, Colorado; Denver Public Library, Denver, Colorado; Detroit Institute of Arts, Detroit, Michigan; M. H. De Young Memorial Museum, San Francisco, California; Eastern Washington State Historical Society, Spokane, Washington; Eisenhower Memorial Library, Eisenhower Center, Abilene, Kansas; El Paso Museum of Art, El Paso, Texas; Explorers Club, New York, New York; Fairmount Park Commission, Philadelphia, Pennsylvania; Field Museum of Natural History, Chicago, Illinois; Fine Arts Gallery of San Diego, San Diego, California; First National Bank, Lubbock, Texas; Five Civilized Tribes Museum, Muskogee, Oklahoma; Fogg Art Museum, Harvard University, Cambridge, Massachusetts; Fort Pitt Museum, Pittsburgh, Pennsylvania; Homer Garrison Texas Ranger Museum, Fort Fisher, Waco, Texas; Gibbes Art Gallery, Charleston, South Carolina; Thomas Gilcrease Institute of American History and Art, Tulsa, Oklahoma; Glenbow-Alberta Institute, Calgary, Alberta, Canada; George Gund Collection of Western Art, Princeton, New Jersey; George F. Harding Museum, Chicago, Illinois; William S. Hart County Park and Museum, Los Angeles, California; Harwood Foundation of the University of New Mexico, Taos, New Mexico; Heard Museum of Anthropology and Primitive Art, Indian Collection, Phoenix, Arizona; Historical Society of Pennsylvania Museum, Philadelphia, Pennsylvania; Henry E. Huntington Library and Art Gallery, San Marino, California; Indiana Historical Society Collection, Indianapolis, Indiana; Indiana State Library, Indianapolis, Indiana; Indianapolis Museum of Art, Indianapolis, Indiana; Institute of American Indian Art, Santa Fe, New Mexico; International Silver Company Historical Library, Meriden, Connecticut; Lyndon Baines Johnson Library, Austin, Texas; Joslyn Art Museum, Omaha, Nebraska; Kansas State Historical Society Museums, Topeka, Kansas; Lakeview Center for the Arts and Sciences, Peoria, Illinois; B. F. Larsen Gallery, Brigham Young University, Provo, Utah; Los Angeles County Museum of Art, Los Angeles, California; Lovelace Foundation for Medical Education and Research, Albert K. Mitchell Collection, Albuquerque, New Mexico; General Douglas MacArthur Memorial, Norfolk, Virginia; Massachusetts Historical Society Collections, Boston, Massachusetts; Metropolitan Museum of Art, New York, New York; Michigan Historical Commission Museum, Lansing, Michigan; Milwaukee Art Center, Milwaukee, Wisconsin; Minneapolis Institute of Arts, Minneapolis, Minnesota; Missouri Historical Society, St. Louis, Missouri; Montana Historical Society, State Museum and Galleries, Helena, Montana; Montclair Art Museum, Montclair, New Jersey; Mormon History Association, Provo, Utah; Musée Luxembourg, Paris, France; Museum of Fine Arts, Boston, Massachusetts; Museum of Fine Arts, Houston, Texas; Museum of Fine Arts, Springfield, Massachusetts; Museum of New Mexico, Santa Fe, New Mexico; Museum of Northern Arizona, Flagstaff, Arizona; Museum of the Southwest, Midland, Texas; Museum of Texas Technical University, Lubbock, Texas; National Art Museum of Sport, Inc., New York, New York; National Collection of Fine Arts, Washington, D.C.; National Cowboy Hall of Fame and Western Heritage Center, Oklahoma City, Oklahoma; National Gallery of Art, Washington, D.C.; National Hall of Fame for Famous American Indians, Anadarko, Oklahoma; Nebraska State Historical Society, Lincoln, Nebraska; William Rockhill Nelson Gallery of Art, Kansas City, Missouri; Nevada Historical Society Museum, Reno, Nevada; New Britain Museum of American Art, New Britain, Connecticut; New-York Historical Society, New York, New York; Newark Museum, Newark, New Jersey; Newark Public Library, Newark, New Jersey; Norfolk Museum of Arts and Sciences, Norfolk, Virginia; R.W. Norton Art Gallery, Shreveport, Louisiana; Oakland Museum, Oakland, California; Ohio Historical Society, Columbus, Ohio; Oklahoma Art Center, Oklahoma City, Oklahoma; Oklahoma Historical Society, Oklahoma City, Oklahoma; Oregon Historical Society, Portland, Oregon; Pacific Northwest Indian Center, Spokane, Washington; Paine Art Center and Arboretum, Oshkosh, Wisconsin; Parke-Bernet-Sotheby Auction Galleries, New York, New York; Pennsylvania Academy of the Fine Arts, Philadelphia, Pennsylvania; Philadelphia Museum of Art, Philadelphia, Pennsylvania; Philbrook Art Center, Tulsa, Oklahoma; Phoenix Art Museum,

Phoenix, Arizona; Portland Art Museum, Portland, Oregon; Princeton University Art Museum, Princeton, New Jersey; Princeton University Library, Phillip Ashton Rollins Collection of Western Americana, Princeton, New Jersey; Reading Public Museum and Art Gallery, Reading, Pennsylvania; Remington Art Memorial, Ogdensburg, New York; Rhode Island Historical Society, Providence, Rhode Island; Robbins Library, Arlington, Massachusetts; Rockwell Foundation, Corning, New York; Lauren Rogers Library and Museum of Art, Laurel, Mississippi; C. M. Russell Gallery, Great Falls, Montana; St. Louis County Historical Society, St. Louis, Missouri; St. Paul Art Center, St. Paul, Minnesota; Salt Lake Art Center, Salt Lake City, Utah; Santa Barbara Museum of Art, Santa Barbara, California; Scriver Museum of Montana Wildlife, Browning, Montana; Seattle Art Museum, Seattle, Washington; Seattle Historical Society, Seattle, Washington; Seattle Public Library, Seattle, Washington; Sheldon Memorial Art Gallery, Lincoln, Nebraska; Smith College Museum of Art, Northampton, Massachusetts; Smithsonian Institution, Washington, D.C.; South Dakota State Historical Society, Pierre, South Dakota; Southern Plains Indian Museum and Crafts Center, U.S. Department of the Interior, Anadarko, Oklahoma; Springville Museum of Art, Springville, Utah; State Historical Society of Colorado, Denver, Colorado; State Historical Society Museum, Bismarck, North Dakota; Sterling and Francine Clark Art Institute, Williamstown, Massachusetts; Latter-Day Saints Museum, Salt Lake City, Utah; Texas Memorial Museum, Austin, Texas; Toledo Museum of Art, Toledo, Ohio; University of Delaware Art Gallery, Newark, Delaware; University of Michigan Museum of Art, Ann Arbor, Michigan; University of New Mexico Art Museum, Albuqerque, New Mexico; University of Texas Museum of Art, Austin, Texas; University of Utah Museum of Fine Arts, Salt Lake City, Utah; Wadsworth Atheneum, Hartford, Connecticut; Walters Art Gallery, Baltimore, Maryland; Washington County Museum of Fine Arts, Hagerstown, Maryland; Washington State Historical Society Museum, Tacoma, Washington; White House, Washington, D.C.; Whitney Gallery of Western Art, Buffalo Bill Historical Center, Cody, Wyoming; Will Rogers Memorial, Claremore, Oklahoma; Witte Memorial Museum, San Antonio, Texas; Woodmere Art Gallery, Philadelphia, Pennsylvania; Woolaroc Museum, Bartlesville, Oklahoma; Wyoming Historical Society, Cheyenne, Wyoming; Wyoming State Archives and History Department, Cheyenne, Wyoming; Yale University Art Gallery, New Haven, Connecticut.

I especially appreciate the extensive work of the following individuals: James B. Allen, Professor of History, Brigham Young University; Dale Archibald, Chief Curator, Oregon Historical Society; Jerry M. Bloomer, Secretary-Registrar, R. W. Norton Art Gallery; Alfred Bush, Curator of Western Americana, Princeton University Library; Vera Costello, Curator, Valley National Bank Art Collection, Phoenix, Arizona; James H. Davis, Research Assistant, Western History Department, Denver Public Library; Mildred Dillenbeck, Curator, Remington Art Memorial; Rosemary Ellis, Curator, Southern Plains Indian Museum and Crafts Center; James T. Forest, Director, Bradford Brinton Memorial Museum; Alys Freeze, Head, Western History Department, Denver Public Library; Kathryn Gamble, Director, Montclair Art Museum; Sam Gilluly, Director, Montana Historical Society; Mary Elizabeth Good, Public Relations, Thomas Gilcrease Institute of American History and Art; Mildred Goosman, Curator of Western Collections, Joslyn Art Museum; Peter Hassrick, Curator of Collections, Amon Carter Museum of Western Art; James Heslin, Director, New-York Historical Society; Edmond P. Hogan, Historian, International Silver Company; Robert Lansdown, Director, Frank Phillips Foundation; Douglas Lewis, Curator of Sculpture, National Gallery of Art; Esther Long, Education Director, National Cowboy Hall of Fame and Western Heritage Center; James Marone, Assistant Vice President, Parke-Bernet-Sotheby Auction Galleries; Marjorie A. Morey, Photo Archivist, Amon Carter Museum of Western Art; Milo Naeve, Director, Colorado Springs Fine Arts Center; Alice W. Nichols, Director, Ball State University Art Gallery; Dick Nickolai, Information Officer, Fairmount Park Commission, Philadelphia, Pennsylvania; Martin E. Petersen, Curator of Western Art, Fine Arts Gallery of San Diego; Michael Richman, Samuel H. Kress Fellow, Smithsonian Institution; Edna Robertson, Curator of Fine Arts Collection, Museum of New Mexico; Marie Roy, Public Relations, Explorers Club, New York; Martha Royce, Chief Curator, Oklahoma Historical Society; Lewis Sharp, Assistant Curator of American Paintings and Sculpture, Metropolitan Museum of Art; Gary E. Smith, Director, B. F. Larsen Gallery, Brigham Young University; Claire Stein, Executive Director, National Sculpture Society, New York; Gordon L. Tarbox, Jr., Director, Brookgreen Gardens; Patricia Trenton, Curator of American Art, Denver Art Museum; Martha Utterback, Curator of Art, Witte Memorial Museum; Edward F. Weeks, Curator, Birmingham Museum of Art; Muriel Wright, Director, Oklahoma Historical Society; Gary A. Yarrington, Curator, Lyndon Baines Johnson Library.

Ed Muno for his cooperation and extensive travel in order to photograph bronze sculpture throughout Oklahoma.

The galleries specializing in Western art for providing biographical and statistical data on contemporary Western sculptors and photographs of their work: Baker Gallery, Lubbock, Texas; J. N. Bartfield, New York, New York; Biltmore Gallery, Los Angeles, Cali-

fornia; Blair Galleries, Ltd., Santa Fe, New Mexico; Chapellier Galleries, New York, New York; Cross Gallery, Fort Worth, Texas; Desert Southwest Gallery, Palm Desert, California; Gallery West, Denver, Colorado; Graham Gallery, New York, New York; Hammer Gallery, New York, New York; John Howell Books, San Francisco, California; Hunting World, New York, New York; Kennedy Galleries, New York, New York; Main Trail Galleries, Scottsdale, Arizona; Maxwell Galleries, San Francisco, California; May Gallery, Jackson, Wyoming; Owens Gallery of Western Art, Oklahoma City, Oklahoma; Parke-Bernet-Sotheby Auction Galleries, New York, New York; Fred Rosenstock Books, Denver, Colorado; Jean Seth's Canyon Road Gallery, Santa Fe, New Mexico; Sporting Gallery, Middleburg, Virginia; Taos Art Gallery, Santa Fe, New Mexico; Thunderbird Shop, Muskogee, Oklahoma; Trailside Galleries, Jackson, Wyoming; Troys Art Gallery, Scottsdale, Arizona.

The Honorable Florence A. Dwyer, member of the House of Representatives, U.S. Congress, for furnishing information on Western bronze statuary in Washington, D.C.

The mayors and municipal officials throughout the United States for furnishing information on Western bronze sculpture in their cities: Hon. Tom Allen, Mayor, Olympia, Washington; Hon. William Bennett, Mayor, St. Joseph, Missouri; Steve Carter, Administrative Assistant, Phoenix, Arizona; Hon. A. J. Cervantes, Mayor, St. Louis, Missouri; Hon. Paul J. Cooley, Mayor, Muncie, Indiana; Hon. Jim Corbett, Mayor, Tucson, Arizona; Hon. Verl G. Dixon, Mayor, Provo, Utah; Douglas B. Evans, Chief, Division of Environmental Interpretation and Research, Boulder City, Nevada; George I. Franklin, Director, Public Relations, Conventions and Tourist Council, Kansas City, Missouri; Hon. Walter Gerrells, Mayor, Carlsbad, New Mexico; Hon. Sylvan L. Harenberg, Mayor, Flagstaff, Arizona; Hon. Taylor T. Hicks, Mayor, Prescott, Arizona; Hon. Floyd Holland, Mayor, Cheyenne, Wyoming; L. B. Houston, Director, Parks and Recreation Department, Dallas, Texas; Hon. Gordon Johnston, Mayor, Tacoma, Washington; Hon. Erik Jonsson, Mayor, Dallas, Texas; Virginia Kazor, Curator, Department of Municipal Arts, Los Angeles, California; Hon. James M. King, Mayor, Bloomington, Minnesota; Hon. John M. Larson, Mayor, Yakima, Washington; Ivan A. Lebamoff, Mayor, Fort Wayne, Indiana; Hon. J. Bracken Lee, Mayor, Salt Lake City, Utah; Hon. Edwin H. Magruder, Mayor, Midland, Texas; Hon. W. McNichols, Jr., Mayor, Denver, Colorado; Hon. Vern W. Miller, Mayor, Salem, Oregon; Hon. Norman Mineta, Mayor, San Jose, California; Hon. Lorn D. Proctor, Mayor, Walla Walla, Washington; Hon. Chester Reiten, Mayor, Minot, North Dakota; Hon. Terry D. Schrunk, Mayor, Portland, Oregon; Alva Stem, Director, Parks and Recreation Department, Waco, Texas; Hon. Charles Stenvig, Mayor, Minneapolis, Minnesota; Paul J. Strawhecker, Special Assistant to Mayor, Omaha, Nebraska; Hon. Lloyd W. Stromgren, Mayor, Vancouver, Washington; Hon. Sam Swartzkopf, Mayor, Lincoln, Nebraska; Hon. B. L. Tims, Mayor, Scottsdale, Arizona; Hon. Wes Uhlman, Mayor, Seattle, Washington; Hon. Thomas Urban, Mayor, Des Moines, Iowa; Hon. Ted C. Wills, Mayor, Fresno, California; Hon. Bart Wolthuis, Mayor, Ogden, Utah; Hon. Sam Yorty, Mayor, Los Angeles, California.

The families and friends of artists for providing biographical information and photographs otherwise unattainable: Mr. and Mrs. A. Mervyn Davies (Monica Borglum Davies), Wilton, Connecticut; Jonathan Fairbanks, Boston, Massachusetts; Mrs. Emry Kopta, Sun City, Arizona; Vernon MacNeil, Muskogee, Oklahoma; John Manship, New York, New York; Louise Phippen, Skull Valley, Arizona; Hester Proctor, Stockton, California; Peter Reiss, Seattle, Washington; Peggy Tiger, Muskogee, Oklahoma; Gerna Saville Walker, Boston, Massachusetts; Mahonri Sharp Young, Columbus, Ohio.

The collectors of Western art for providing statistical data and photographs of their collections: Walter R. Bimson, Phoenix, Arizona; James Brubaker, Kalispell, Montana; Dr. John M. Christlieb, Bellevue, Nebraska; Mr. and Mrs. George Cobb, Oklahoma City, Oklahoma; Jack T. Conn, Oklahoma City, Oklahoma; Peter H. Davidson, New York, New York; Harrison Eiteljorg, Indianapolis, Indiana; Michael Harrison, Fair Oaks, California; Peter Krindler, New York, New York; Richard W. Norton, Shreveport, Louisiana; Kenneth L. Reese, Elwood, Colorado; Robert Rockwell, Corning, New York; Mr. and Mrs. Ed Trumble, Boulder, Colorado; Frances Wallace, San Francisco, California.

The many artists who welcomed me into their studios and homes and furnished biographical and statistical information on their work.

My personal friends for their special help: Mr. and Mrs. H. W. Dugdale, Whittier, California; Ernest Hickok, Summit, New Jersey; Frank J. Hills, Bernardsville, New Jersey; Rita Jacobs, West Orange, New Jersey; Janet Lax, South Orange, New Jersey; Amanda Piper, Summit, New Jersey; Paul Wesley, Millington, New Jersey.

My husband Stanley and my sons Clifford and Peter for their cooperation and assistance during the past years of research and writing.

This is only a partial list of credits, for it is not possible formally to acknowledge all the people who have contributed valuable suggestions and information to this book.

Patricia Janis Broder

Short Hills, New Jersey
July 1974

CONTENTS

INTRODUCTION

A comprehensive book on sculptors and their work in the field of Western art has been greatly needed for a long time. During the past twenty-five years there have been a great many books published on Western artists, although little has been done on the sculptors, in spite of the close relationship of the two.

Sculpture is the creation of three-dimensional forms generally fashioned from some form of nature, human or otherwise. Instead of using globs of colored paint on canvas or paper, the sculptor uses amorphous lumps of plastic or solid material to create images in-the-round. Michelangelo described it as "revealing a form imprisoned in a mass of stone, wood or other hard material." This definition can also apply to those who work in clay, wax, plaster, or other pliable materials and have their creations cast in bronze. But all forms of pictorial art have the common basis of finding their inspiration in nature. Even the foremost of the teachers of abstract art frequently use live nude human models in their classrooms, although the results may show no resemblance to the inspiration; and the most successful of the realistic painters use live models to approach a closer simulation of the three-dimensional appearance in their work on-the-flat. Many accomplished painters become proficient in sculpture, although they are generally better in one form or the other. But the hall-mark of a really fine artist is the ability to excel in all mediums.

Popular interest in sculpture, both early as well as contemporary, has increased extremely in the past few years. Even advanced collectors, however, will find this book not only of special interest as an important reference, but in a good many respects a revelation in unfamiliar names of artists whose work might well be sought. It does not necessarily mean that just because the name is unfamiliar that the artist's work is of inferior quality. The story of early Western art is spotted with accomplished individuals whose work is extremely obscure. This is particularly true in the field of sculpture.

The compilation which has been assembled by Patricia Janis Broder covers the field of Western sculpture from the earliest times to the contemporaries, the latter of which have become almost too numerous to catalog. Also included are the most representative of Europeans who depicted the American West and whose work had a strong influence on our native American sculptors. Ironically, some of these never visited America and the closest they ever came to a wild Indian or buffalo was from seeing a Buffalo Bill Wild West Show. The works of most of these have a distinctly romanticized "European" appearance, such as that of the Austrian Carl Kauba (1865–1922), whose work has recently become quite popular in this country.

Among the earliest of the American sculptors is Henry Kirke

Brown (1814–1886), whose first Western bronze was cast in 1859; his work was of sufficient quality to gain him election to the National Academy in 1851. Among others of the early artisans are such names as Edward Kemeys (1843–1907), one of the first to gain recognition for his sculptures of the animals of the Western Plains and mountains. These are only two of many. Also presented in some depth of work and biography are such later and better-knowns as Dallin, MacNeil, Proctor, and the Borglums. The relatively few women sculptors are also included.

This book should add appreciably to the already flourishing interest in sculpture of the American West.

Harold McCracken, Director Emeritus
Whitney Gallery of Western Art
Cody, Wyoming

I

AMERICA'S HERITAGE IN BRONZE

Bronzes of the West are America's most unique form of sculpture. As no other land shares the same frontier heritage, no other land could produce a sculpture which breathes the spirit and tells the story of the American West. This art is not a naive art, and these bronzes are not primitive efforts which charm or delight with their childlike simplicity. They are neither academic copies of the heroic statuary of ancient Greece or Rome, nor are they imitations of the flamboyant works of the Renaissance or the Baroque. These bronzes are dramatic representations of the Western migration and settlement, creative expressions of America's natural, cultural, and spiritual heritage.

The primary focus of interest in Western bronzes is historical. The art of the Western bronze is essentially a narrative art. Here are tangible pages in the story of America, three-dimensional documents of the past. The Western sculptor has preserved this heritage in the most permanent form possible. He is the finest narrator of the colorful story of the frontier.

The Western sculptor has always been a historian, a storyteller conscious of his role in preserving his national heritage. He had an awareness of that which is essentially American and felt that he was witness to a side of American life that would soon belong only to memory or to history.

Western bronzes illustrate the story of the movement westward and the life on each new frontier. They tell of the hardships of the journey and the struggle for settlement. They record days of peace and days of war. Through these sculptures, the trapper and the explorer, the farmer and the soldier, the hero and the outlaw all live again. Most of all Western bronzes glorify the cowboy and the Indian. Bronze sculptures also document local as well as national history through countless monuments and memorials to men and events that are part of the collective past of various sections of the country.

The tremendous interest in ecology today lends added dimension to Western bronzes, for Americans wish to preserve what is left of the scenic beauty and natural resources of their country and protect the

wildlife which constitutes the remains of their natural heritage. Much of the forest, plains, and prairies, which gave the feeling of endless freedom to the early settlers, has been ravaged by an industrialized civilization. The frontier has vanished, man's natural resources are indeed limited, and the great herds of buffalo and of Longhorn steer have been reduced to remnants of memory. Those who struggle with the polluted air of industrialized cities long for the exhilaration of life in the open air as celebrated in bronze. They delight in those sculptures which portray the men and animals of an earlier wilderness.

As man learns to value and to care for his natural environment, there is a new appreciation of the bronze naturalists and a re-evaluation of their sculptures of grizzly, elk, moose, deer, or any re-creation of woodland wildlife.

To the white man and Indian alike, the horse has always been the symbol of the West. The Western artist is continually examining the relationship between man and horse and nature and is fascinated with the horse in both its wild and its domesticated state. Whether mustang, cowboy's range horse, farm horse, or bronco, the spirit of the horse is best captured in bronze.

Today too there is a widespread interest in the spiritual heritage of the American West. In a society that questions all institutions and moral codes, there is undeniable appeal in a bygone world where there is an absolute definition of basic values. Here the traditional values of America prevail: industriousness and honor, courage and fortitude. The world of the Western bronze is a world of opportunity and of confidence in progress. It is a world where individual fortitude and ingenuity are honored. Here is represented the simple life, life in a society unfettered by the problems of an industrialized world. In the Western ideal, man deals directly with Nature. Charles Russell in one of his letters shows his distaste for and disillusionment with the complexities of industrialized civilization and his nostalgia for the life of the past:

Invention has made it easy for man kind but it has made him no better. Michinary has no branes A lady with manicured fingers can drive an automobile with out maring her polished nailes But to sit behind six range bred horses with both hands full of ribbons these are God made animals and have branes. To drive these over a mountain rode takes both hands feet and head an its no ladys job. . . .
And men who went in small partys or alone in to a wild country that swarmed with painted hair hunters with a horse under tham and a

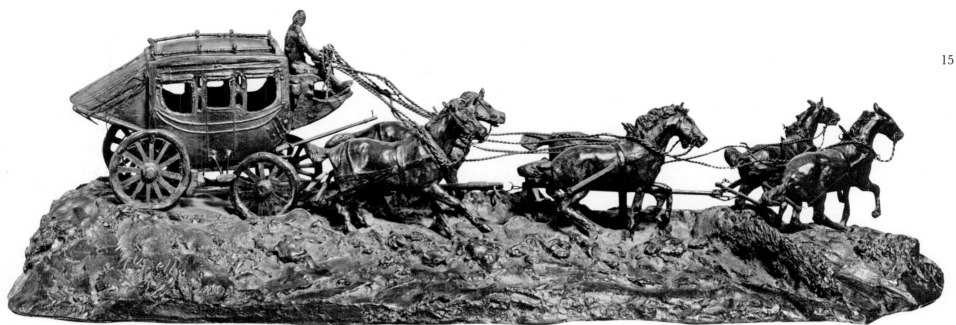

1. Charles M. Russell. *It Ain't No Lady's Job*. Modeled 1926, cast 1962. Roman Bronze Works, N.Y. H. 8″. Hammer Gallery, New York City. The model of this bronze was Russell's last sculpture, which he presented to his wife on their final wedding anniversary

rifel as thair pasporte These were the kind of men that brought the spotted cattel to the west before the humped backed cows were gon Most of these people live now only in the pages of history.[1] *(plate 1)*

The spirit and values of the principal characters in Western sculpture are a delight to those who live in this age of anxiety *(plates 4, 5)*. In a world of urban and corporate tensions, the life of the Western settler personifies a relevant and meaningful existence. The pioneer is a man or woman of strength, courage, and optimism. The cowboy is at one with his environment, filled with the joy of living and a spirit of contentment. The traders and trappers deal directly with nature and live by their wits. Even the outlaw confirms the very code he violates, for there is no question as to the validity of his crime. Whether it is committed in the name of revenge or even of honor, there is never any doubt about its outcome or his punishment. Both lawman and outlaw defend or violate the same legal and moral code. Indeed, many Western figures, for example Wyatt Earp or Doc Holliday, were at different stages of their lives on different sides of the law. The solidarity of frontier law, however, is at no time in question.

Today in America there is a new pride in race, a vital interest in the roots of the land and the people. There is a new appreciation of the Indian as the "original American" and an examination of the spirit and beliefs of the Indian with new understanding. After three centuries of looking upon the Indian as a "noble savage," an "aborigine," or a "child of nature," Americans have slowly realized that the Indian had a highly developed civilization, enriched by an

16

2. Charles M. Russell. *In the White Man's World*. Cast 1947. Roman Bronze Works, N.Y. H. 15¼". Hammer Gallery, New York City

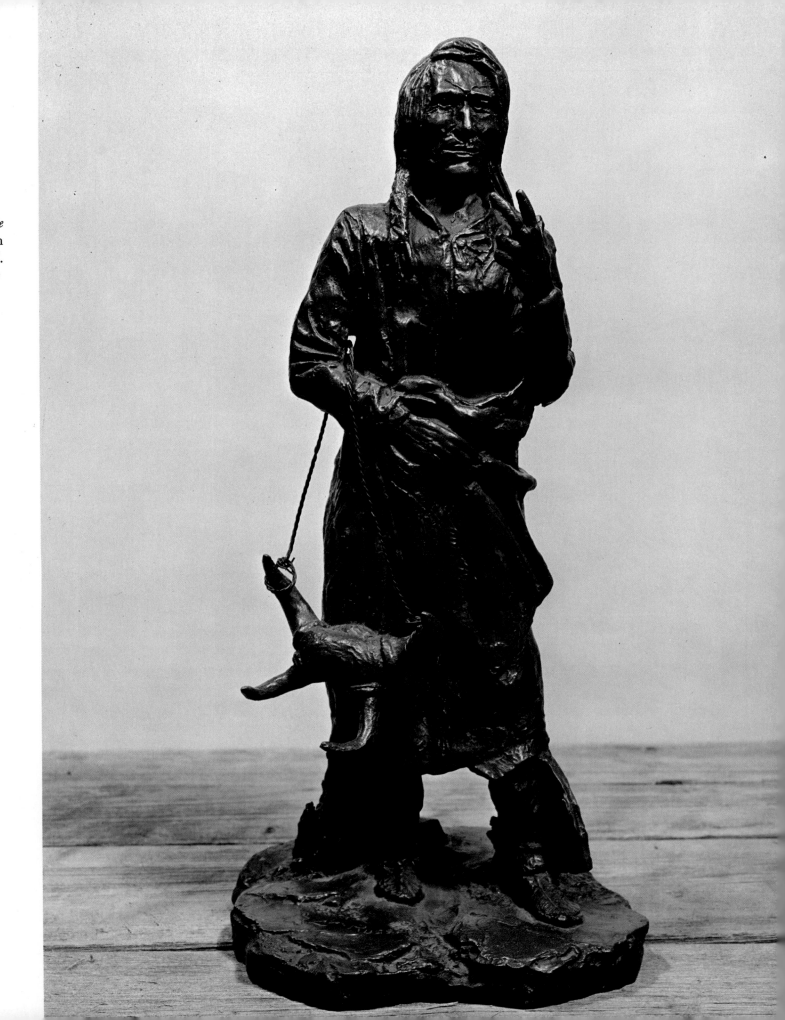

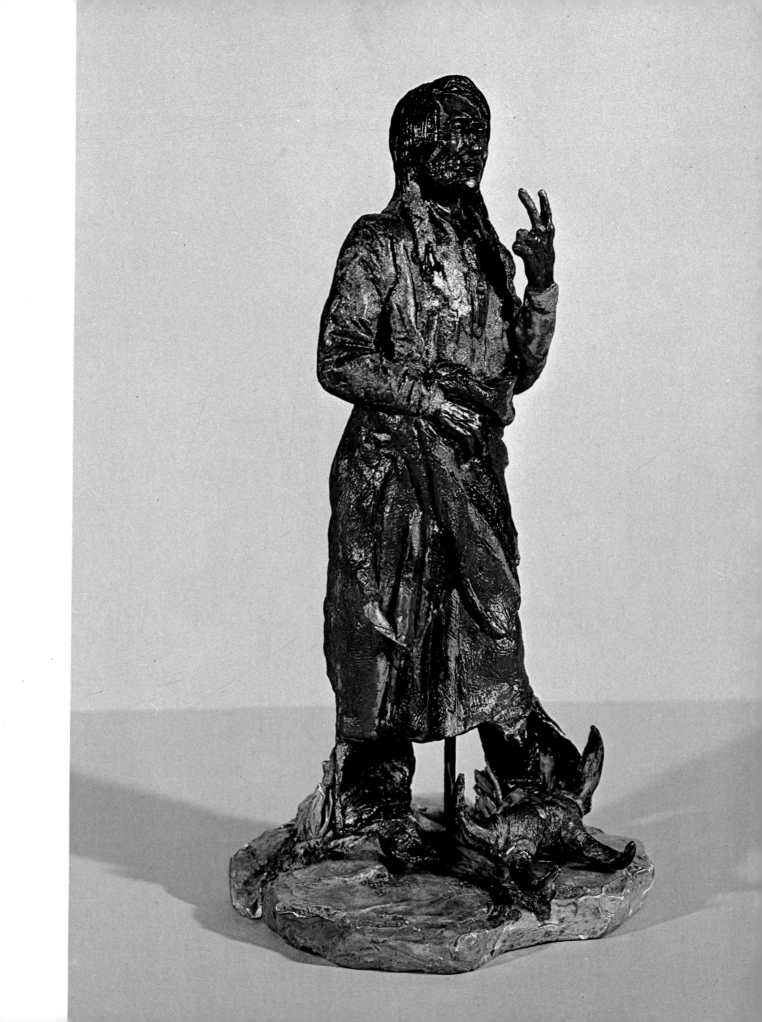

3. Charles M. Russell. *In the White Man's World*. Original wax model. H. 15½″. Whitney Gallery of Western Art, Cody, Wyo. Russell portrayed his friend Chief Young Boy, a Cree Indian, selling buffalo-horn hatracks to survive in the white man's world

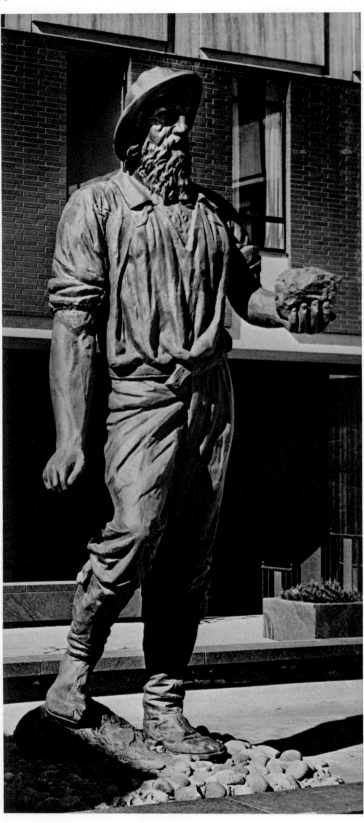

equanimity of spirit, a just moral code, and a respect for his natural environment.

Long before the awakening of the general public, many of the Western sculptors realized the value of Indian civilization and the injustices of our treatment of the Indian *(plates 2, 3)*. Russell wrote:

The Red man was the true American They have almost gon. but
will never be forgotten The history of how they faught for their
country is written in blood a stain that time cannot grinde out their
God was the sun their Church all out doors their only book was
nature and they knew all its pages[2]

Through the study of Western bronzes we can follow the evolution of the artistic attitude toward the Indian: the early interest in him as a romantic primitive man, then a perception of his feelings of defeat and disillusionment, the sense of pathos and helplessness, and now the awakening of racial pride. Today Indian sculptors honor their past and extol in bronze the history and nature of their race.

Today too there is a growing consciousness of that which is intrinsically American. On every level—historical, environmental, spiritual, and ethnic—the bronze sculptures of the West are the most permanent expression of America's national heritage.

Before beginning a history of bronze sculpture of the American West, it is necessary first to explain that the term *American West* refers to both a geographical and historical concept.

The geographical definition of the West has changed many times throughout its history. To the very first white settlers, it meant any

4. Alphonse Pelzer. *The Prospector*. 1891. H. 12′. Entrance to Brooks Tower, Denver, Colo. For many years this statue stood atop the Colorado Mining Stock Exchange, a trading center, where the prices of precious metals were set. The nugget which the miner holds originally was silver, but in 1935 was replaced by gold plate

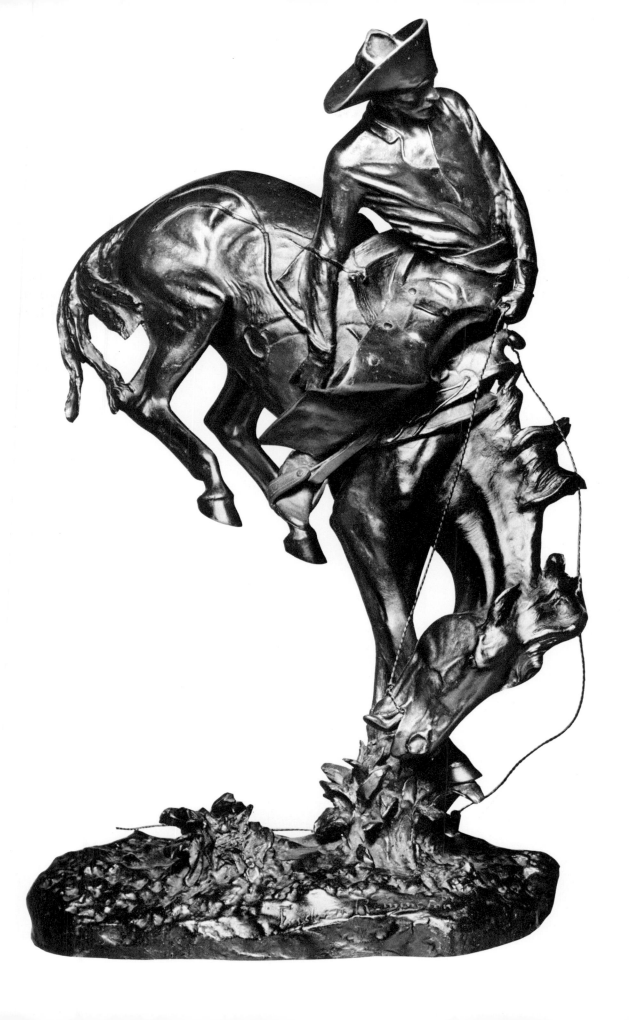

5. Frederic Remington. *The Outlaw.* 1906. Roman Bronze Works, N.Y. H. 22½″. The St. Louis Art Museum, St. Louis, Mo.

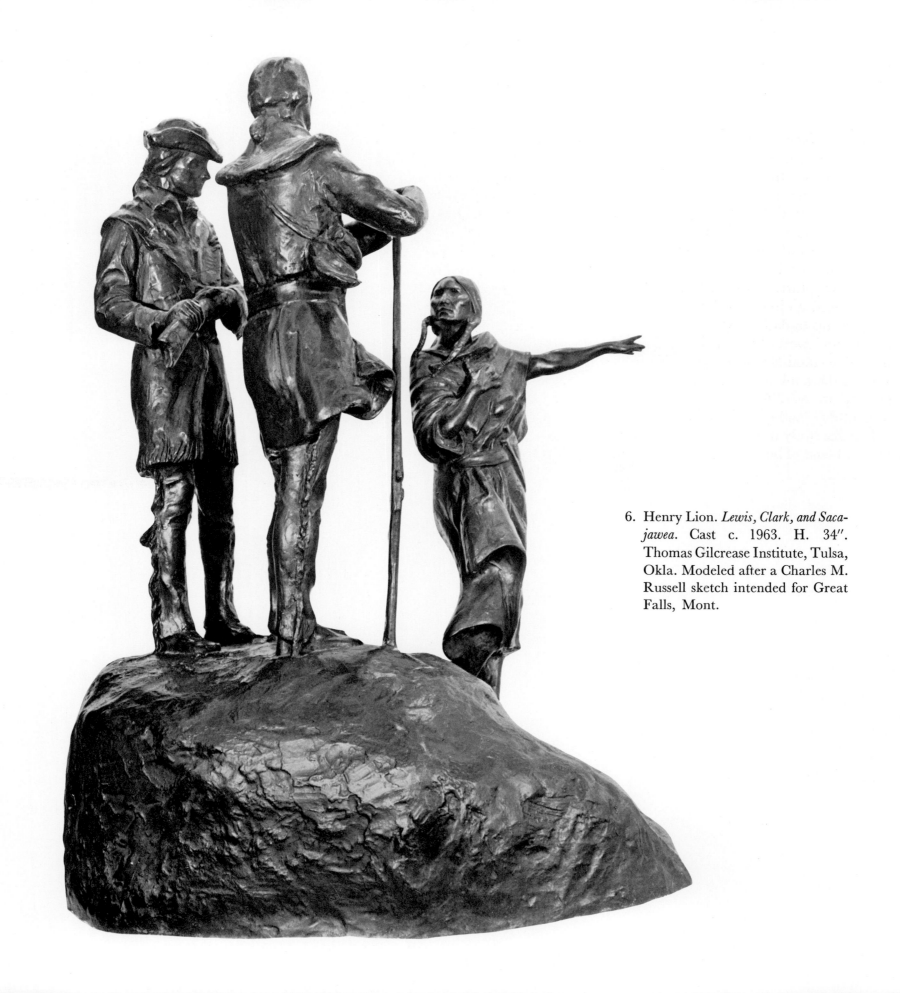

6. Henry Lion. *Lewis, Clark, and Saca-jawea*. Cast c. 1963. H. 34″. Thomas Gilcrease Institute, Tulsa, Okla. Modeled after a Charles M. Russell sketch intended for Great Falls, Mont.

part of the New World. After Daniel Boone opened the Appalachian Pass, those who crossed these mountains settled the new Western frontier. Later, those who crossed the Mississippi to settle the plains and the prairies were the pioneers of their West *(plate 6)*. Finally, the men who crossed the Rocky Mountains reached the ultimate American West, the Pacific Coast.

In a historical sense, the West refers to land that once was either a frontier or the land of the American Indian. *Western bronzes* are bronze sculptures illustrating life in this land, whether the artist has experienced it directly or learned of it through historical research.

In an up-to-date geographical sense, the West refers to the non-urban land west of the Mississippi. Here men live close to nature, their lives reminiscent of that of their ancestors. The geographical West is the land of the plains, prairie, forest, and mountains. It is a land where wildlife is still abundant. The geographical West is the present-day land of the hunter, the cowboy, and the Indian.

For this study it seems most suitable and expedient to consider the West a blend of both the historical and the geographical concepts.

II
ROME, ROMANTICS, AND ROUGH RIDERS

To understand the history of the American Western bronze, it is necessary first to have a general background of the development of American sculpture. Sculpture as an independent art form gained acceptance very slowly in America. Since the prevailing religion in the colonies, Protestantism, frowned upon sculpture as "image making," followers of the Puritan tradition believed art was the invention of the devil and a temptation to be resisted. To those unprejudiced by religious fears, the creation or collection of art was looked upon as a frivolity. In the eyes of America's industrious pioneer builders, the artist was not gainfully occupied; therefore, art was not accorded the status of a profession.

America's sculptural heritage was indeed poor. Its parent country, England, had no great tradition of sculpture, and the masterpieces of the Dutch were pictorial rather than plastic. The early sculptors thus turned to Greece and Rome for inspiration and example, producing an art which was best described by Lorado Taft, the great sculpture critic of the early twentieth century, as "alien and impersonal, expressing in no way the spirit of the people nor even the emotions of its authors."[1]

During early colonial years, there was little desire to own decorative art objects. The state of Virginia was the only exception. Here the moneyed class collected primarily European drawing-room art. As the colonies grew prosperous, however, and as individuals established private fortunes, a demand for sculpture gradually developed. This early demand was primarily for status-enhancing decoration. The colonists, yearning for the adornments of European culture, purchased imported works and settled for an American copy only if necessary. The early efforts of American sculptors were of necessity awkward imitations of European masters.

Until the nineteenth century, there were no schools or academies in America where prospective students could develop technical skills. The Pennsylvania Academy of the Fine Arts, the first art school in the United States, was founded in 1805. The only available sources of

inspiration and instruction were a few examples of classical art belonging to the wealthy, engravings in books, and some English ceramic figures and busts. In addition, there were a few royal statues sent to America by the English and torn down by the colonists in patriotic fervor *(plate 7)*.

Most art critics of Taft's generation cited the 1876 Centennial Exposition in Philadelphia as the turning point in American sculpture. The great exposure of American sculptors to the masterpieces of Europe led most of them away from classical antiquity and toward Paris and the Romantic Naturalism of the French. Many followed the example of Augustus Saint-Gaudens *(plate 8)*, the leading sculptor of this time, who had sailed for Europe in 1867 to study in Paris. These newly inspired artists entered the Parisian academies, studied with the French masters of their day, and then entered European competitions. They returned to the United States, sophisticated in technique and inspired to produce "meaningful" sculpture.

The art most valued by the American public during the late nineteenth century was high in symbolic content. They delighted in such abstract sculptures as *Evening, Dawn,* or *The Struggle of the Two Natures of Man.* They also enjoyed mythological subjects. The first truly

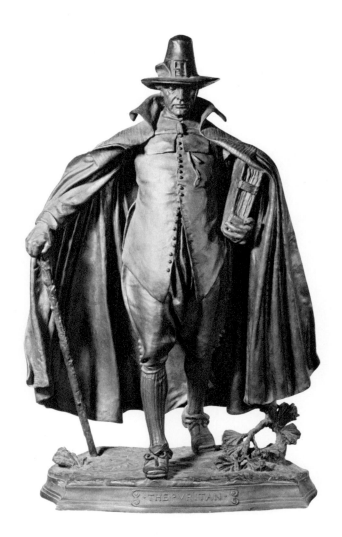

8. Augustus Saint-Gaudens. *The Puritan.* 1889. H. 30½″. The New-York Historical Society, New York City

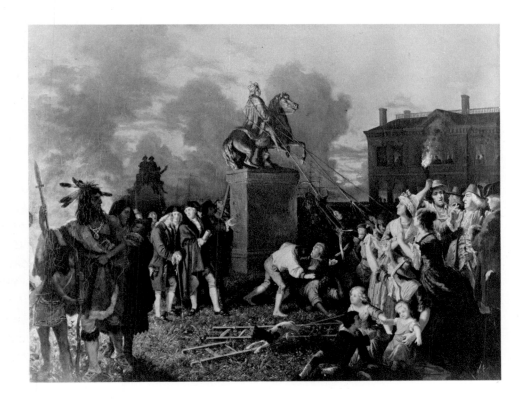

7. Johanes Dertel. *Pulling Down George III.* Oil on canvas. 32 × 41¼″. The New-York Historical Society, New York City

natural American sculptures were the strong realistic portraits glorifying the great men of the time. During the late nineteenth century in America, the nobility of a sculpture's theme determined its value. Sculpture was expected to express ideals that were noble, beautiful, and inspirational. *A Primitive Chant (plate 9)*, a bronze sculpture of an Indian by Hermon Atkins MacNeil, received this criticism from Taft:

Why so much labor and so much time expended upon a thing unbeautiful in idea? With all its masterful workmanship, and even its sculptural pose, it remains but an illustration of an incident, a custom; curious it may be, and even to some persons moderately interesting, but possessing for none a deep significance. Where does the emotion come in—the poetic thrill which we are told is fundamental in the genesis of every great work of art, and which in turn a truly great work must convey in some fashion and some degree to men and women of taste?[2]

As late as 1923, the Western bronzes of such giants as Frederic Remington *(plates 10, 11)* were considered tangible illustrations, not works of art. Taft wrote:

Mr. Frederic Remington has also been tempted to carry certain of his illustrations over into another medium, and it must be confessed that, while they remain illustrations, this clever artist seems as much at home in one form of expression as in the other. Mr. Remington is not an interpreter, nor is he likely ever to conceive a theme sculpturally; but his dashing compositions not only picture with much skill the machinery and paraphernalia of four-footed locomotion, but occasionally suggest somewhat of the spirit of the centaur life of the West.[3]

The American public of the late nineteenth century, with its newly sophisticated appreciation of sculpture, paid homage primarily to the products of the Beaux-Arts academies in Paris. Many of the sculptors of Western subjects in their later years surrendered to the taste of the

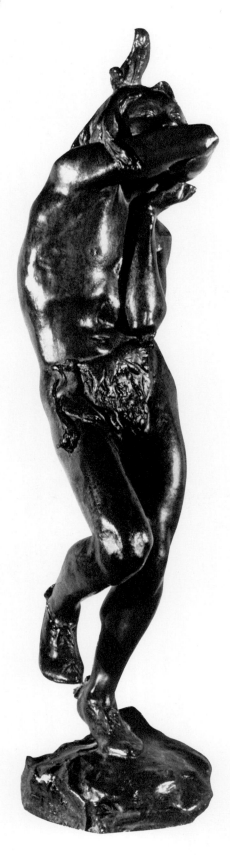

9. Hermon A. MacNeil. *A Primitive Chant*. 1909. Roman Bronze Works, N.Y. H. 25″. Thomas Gilcrease Institute, Tulsa, Okla.

10. Frederic Remington. *The Bronco Buster*. 1905. Roman Bronze Works, N.Y. H. 32½″. Hammer Gallery, New York City. This is a larger version of the work copyright in 1895 (plates 122, 148)

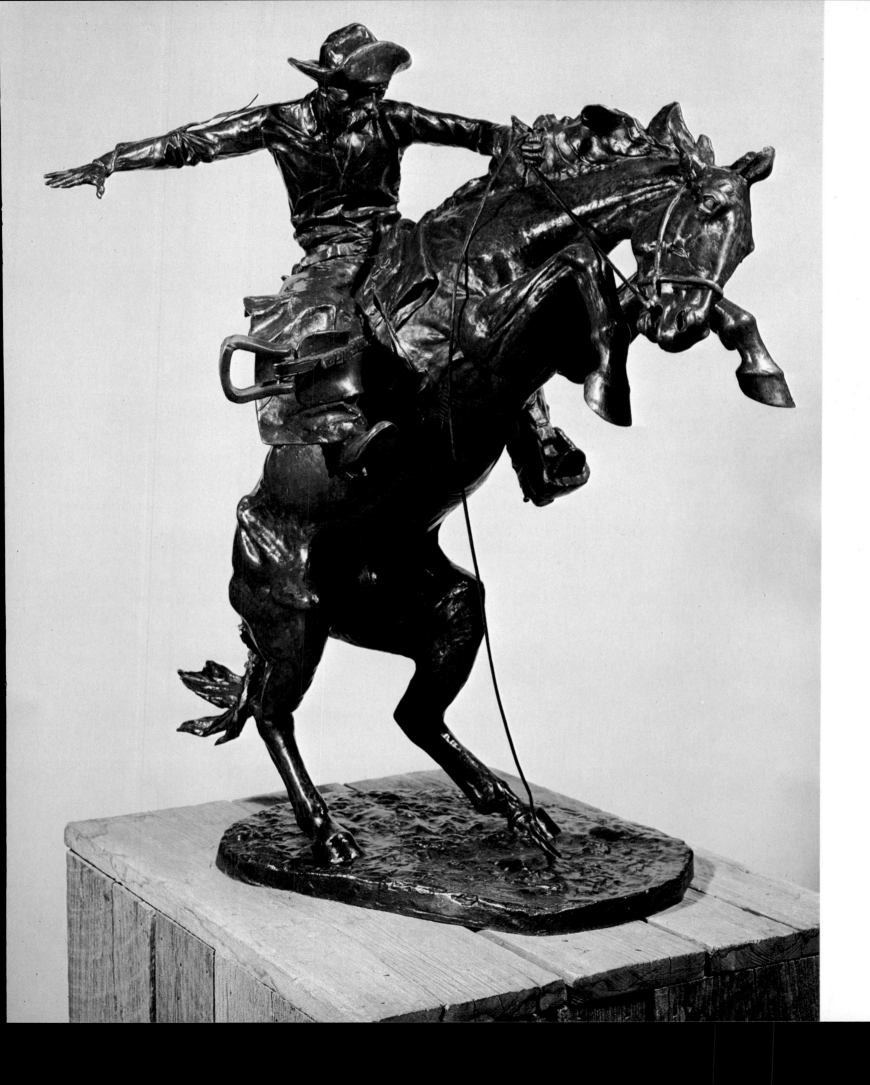

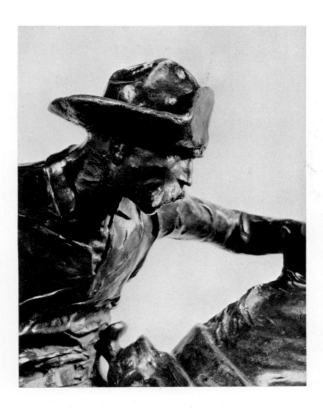

11. Frederic Remington. *The Bronco Buster* (detail of plate 10)

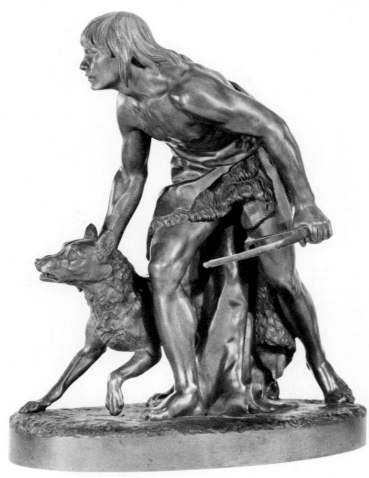

12. John Quincy Adams Ward. *The Indian Hunter.* 1860. H. 16″. The New-York Historical Society, New York City. This is a small model of the bronze sculpture in Manhattan's Central Park (plate 23)

general public and produced glorious heroic monuments. Americans at this time resented the European stereotype of the United States as the "Land of the Wild West" and they longed to forget their frontier heritage. They feared being considered provincial, or, worst of all, being reminded that theirs was a land of "savages." An example of their attitude toward Indian subjects may be found in Lorado Taft's reaction to seeing John Quincy Adams Ward's *The Indian Hunter (plate 23)* in Central Park rather than in a museum:

. . . the "Indian Hunter" in Central Park is one of our few public statues which are suitably placed. The same group in a museum would be quite another thing. There one might wonder whether this is a real Indian, and of what tribe, and if Indians wore their clothes in that way; might compare his tense muscles with the suaver works of men of Parisian schooling. Such refinements of curiosity do not occur to one when he looks upon the original in its fortunate setting of trees and shrubs.[4]

Despite the preoccupation of nineteenth-century American artists with mythological subjects and philosophical abstractions, a native tradition of sculpture slowly began to develop. A growing number of sculptors and critics acknowledged that Americans should make their own country the inspiration for their art. The founding of the National Sculpture Society in 1893 gave a new dignity to American sculptors and helped set higher standards for their work.

In 1847, Robert Ball Hughes, an Englishman living in Boston, was the first to cast a bronze statue in America—his portrait of General Bowditch. Nevertheless, until almost 1900, the majority of bronze sculpture was cast in Munich or in Paris.

As American taste for public statuary developed, many sculptors turned to bronze, which was lighter than marble or any other stone

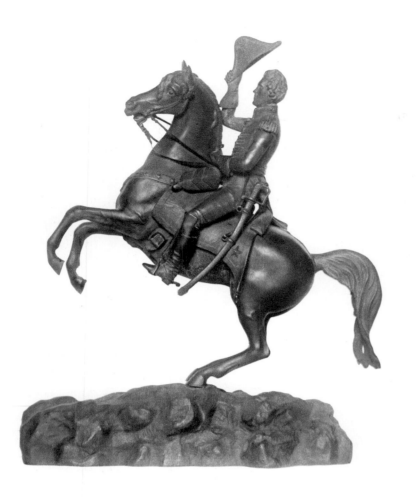

and far more flexible. In 1853, Clark Mills, a self-taught artist, cast in his own studio the first American equestrian bronze. This was a statue of General Andrew Jackson at Washington *(plate 13)*. The rider is on a rearing horse, whose hind legs are centered directly under the mass of its body. A rearing horse, a subject so often seen in Western sculpture, is most difficult to represent in stone, because the legs must support the great weight of the body.

The early Western artist, whose primary concern was narrative, found great appeal in the permanence of bronze. Bronze better withstood the destructive forces of the weather. Both realism and exactitude were fundamental to Western American art and bronze was the perfect medium to express realistic details. The lost-wax process of casting enabled the artist to change and perfect the details of his model between castings.

Although the Centennial Exposition of 1876 marks the beginning of technical excellence for the American bronze, the World's Colum-

13. Clark Mills. *Equestrian Statuette of Andrew Jackson.* Published 1855 by Cornelius and Baker, Philadelphia. The New-York Historical Society, New York City. This is a small model of the heroic statue in Lafayette Square, Washington, D.C., completed in 1853. It is the first American bronze of a rearing horse

14. Solon H. Borglum. *On the Border of the White Man's Land* (front view). Modeled 1899, cast 1906. Roman Bronze Works, N.Y. H.19″. Brookgreen Gardens, Murrells Inlet, S.C.

bian Exposition in Chicago in 1893 heralded the beginning of an era of national consciousness. Those artists who stood at the crossroads of the nineteenth and twentieth centuries wished to document the history and to capture the spirit of a world that would soon belong to the past. For the first time, there was an awareness on a broad level that the sculptors must "extol the pageant of their country."[5] The era of settlement was over. The Chicago Exposition celebrated the new century which the United States would enter as a wholly civilized country. Wayne Craven expressed the mood of national introspection pervading the Exposition:

From that time on, the West was thought of as a part of civilized America, and the country began to reminisce nostalgically about the exciting era just ended—and to suffer the first pangs of national conscience for its deplorable treatment of the Indian. By 1893 an acceptable solution had been found to the "Indian question," at least as far as the white man was concerned, who no longer living in fear of bloody reprisals for his misdeeds could well afford to take a more dispassionate view of the red man.[6]

It was to take more than half a century before the American public would question the morality of that "acceptable solution" and begin to develop a national conscience toward the Indian.

Buffalo Bill's Wild West Show, which had intrigued and delighted viewers throughout Europe, visited the Chicago Exposition and here fascinated the American public.

Many sculptors, including Europeans, were inspired to travel westward and bear final witness to this quickly closing pageant. Others who had settled in the East were content to re-create in bronze the people and the land of their youth. During the mid-nineteenth century only a few sculptors had chosen to portray the life of the West. By the 1890s the mission of the Western sculptor was clear—to preserve the heritage of the West. Both those who had the gift of memory and those who had the opportunity to travel reflected upon and documented the vanishing civilization they had seen.

The expositions of the late nineteenth and early twentieth centuries gave sculptors the opportunity to create and to display to the world life in the West. Sculptors of cowboys, Indians, and animals won many medals and honors at the expositions (plates 14, 15) and these awards gave a new dignity to Western sculpture. To a growing number of artists, the world of the American West was at last considered a respectable and inspirational subject, worthy of bronze permanence.

15. Solon H. Borglum. *On the Border of the White Man's Land*. Modeled 1899, cast 1906. Roman Bronze Works, N.Y. H. 19". The Metropolitan Museum of Art, New York City. Purchase, Rogers Fund, 1907. Borglum won a Silver Medal at the 1900 Paris Exposition for this sculpture

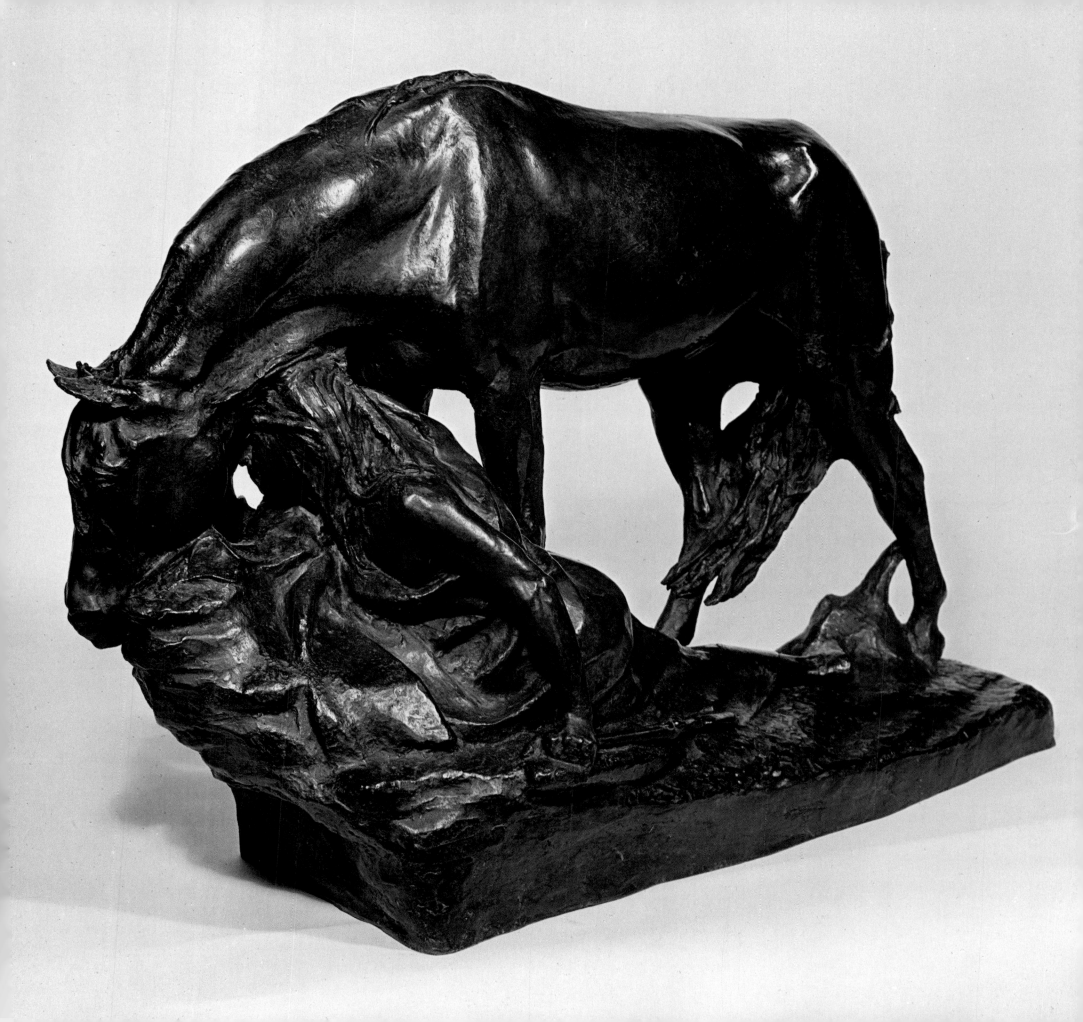

III

NATURE'S NOBLEMEN: THE FIRST BRONZE INDIANS

The first Western subject to inspire the bronze sculptors of the nineteenth century was the American Indian. During this period, for a subject to be considered worthy of sculpture, it had to be poetic in feeling, lofty in ideals, and dramatic in content. The Indian or the "aboriginal" was perfect in every way. To the romantic nineteenth-century mind, he was the "child of nature," a "noble savage" who lived in an Eden-like state, in perfect harmony both with his environment and with the animal kingdom. The Indian was "nature's nobleman." To those who prior to this time had given little thought or study to the Indian, his way of life and tribal rituals held great mystic appeal. As the Indian had not yet been completely subdued by the United States government, periodically there appeared terrifying reports of massacres, such as that of Custer's defeat in 1876. Contemplation of the Indian recalled these "thrilling tales of horror." The "noble savage," therefore, was the object of fear as well as of idealization, an excellent choice for a dramatic subject.

The Indian always appeared romanticized and dramatized in these early efforts. Nevertheless, he was a purely American subject. These bronzes of the Indian are indeed based on historical reality and are representations taken from nature, not heroic abstractions or allegorical myths. Their basis was American history, not classical antiquity or ancient mythology.

Many inspired artists traveled West and studied the Indians and tribal life so that their sculptures would be more accurate. By living among the Indians, they developed an understanding of their way of life and of their dedication to their tribes and families. Some sculptors saw that the Indian way of life on the American continent was soon to end and thus portrayed the red man as a tragic subject.

In tracing the history of American bronzes, we note that the first Western bronze was *The Choosing of the Arrow* by Henry Kirke Brown, cast in 1849. Brown was hailed by Lorado Taft as "the first American sculptor. . . the first strongly native factor in the development of our sculpture."[1]

Henry Kirke Brown (1814–1886) was born in Leyden, Massachusetts. He showed an early aptitude for portraiture and, upon reaching the age of eighteen, traveled to Boston to study with Chester Harding, a leading portrait artist of the period. One day Brown chanced to experiment with clay and modeled the head of a friend. He was delighted with the results and fascinated with this new medium. This small experiment in sculpture changed the entire direction of his career.

Brown's dream, like that of all aspiring artists of his era, was to travel to Italy. Since this trip required funds far beyond his financial means, he took a job as a civil engineer working on the first railroad to be built in Illinois. He held many odd jobs but always studied and worked independently at improving his art. When he failed to earn sufficient funds, friends—impressed by his talent and dismayed by his poverty and ill-health—financed his trip to Italy.

After reaching Florence, the city of his dreams, Brown became deeply disillusioned with the value of European training for American artists. He rebelled against the expatriation of the American sculptor and grew firm in his conviction that the American artist should study at home and concern himself primarily with American subjects.

While in Italy, Brown began one of his major studies, an Indian boy with a bow and arrow. He hired a thirteen-year-old Italian boy as a model. He then wrote to George Catlin, the renowned painter of American Indians, to learn about the ethnological details of the Indian head and face, so that his subject would look authentically Indian rather than Italian. In Europe as at home, Brown was always preoccupied by subjects taken from American history. His wife, Lydia, wrote that to Brown the *Indian Boy* represented a subject that "to an American, at least . . . possesses as much historical interest and poetry as an Apollo or Bacchus . . ."[2]

Upon returning to New York five years later, Brown's first efforts once again centered on the theme of the American Indian. He traveled to several Indian settlements in Michigan and made many sketches that became the basis for his revised models of his *Indian Boy,* now known as *The Choosing of the Arrow*. From these sketches *(plate 16)*, he completed his model and cast the sculpture in his own studio. The American Art Union commissioned the bronze and awarded twenty castings as premiums in 1849. (They possibly awarded a twenty-first casting in 1850.)

Brown also experimented with a *Dying Tecumseh* and completed a monumental seven-foot statue, *Indian and Panther (plate 17)*. He described it as

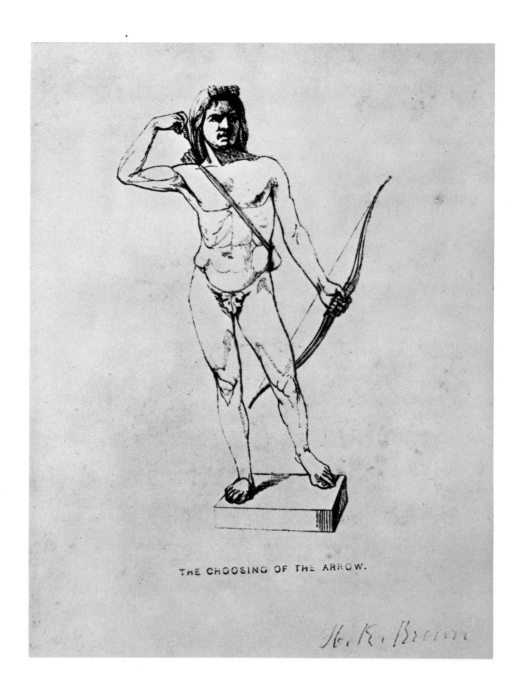

THE CHOOSING OF THE ARROW.

16. Henry Kirke Brown. *The Choosing of the Arrow*. 1849. Ink drawing on paper. Whereabouts unknown. Photo courtesy of Dr. Wayne Craven, University of Delaware, Newark, Del.

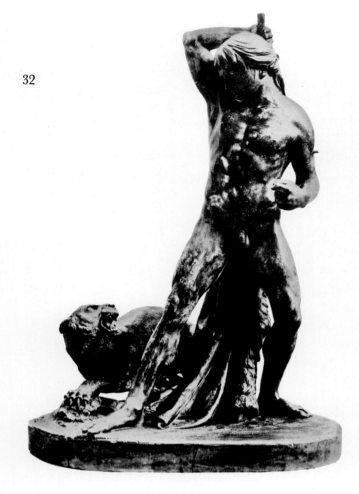

17. Henry Kirke Brown. *Indian and Panther*. 1849–50. H. 7'. Whereabouts unknown. Photo courtesy of Dr. Wayne Craven, University of Delaware, Newark, Del.

. . . a fine old Indian defending his child against the attack of a panther. He has already struck one blow and is in the act of dealing another. . . . These three figures—the strong man, the panther, his natural energy, and the child—admit of a very sculpturesque treatment; and . . . it seems to me to present a striking idea of the Indians' mode of life, before they were disturbed by the presence of the whites.[3]

Although Brown's Indians were romanticized and idealized as "noble savages," they were purely American heroes and won many honors during Brown's lifetime. As he grew in prosperity, Brown yielded to the taste of the day and produced more conventional portraits. Four of his figures stand in the National Statuary Hall in the Capitol in Washington, D.C. Brown was elected to the National Academy of Design in 1851.

Although Brown attained great heights as a sculptor, his strongest influence was as a teacher. He rejected the late nineteenth century's total dependence on the classics for both subject matter and technique, protesting the strong Italian influence on American art. He felt that Americans should dedicate themselves to native American subjects *(plate 18)*, using nature as their mode instead of the classics or the examples of others. Brown wrote: "I am, daily, more and more convinced of the folly of studying the works of others; in no work of art is there anything beautiful but what nature fully justifies . . ."[4]

The greatest exponent of Brown's nineteenth-century patriotic naturalism was his pupil John Quincy Adams Ward (1830–1910), who has been called the "Dean of American sculptors."[5] Ward, like his teacher, enjoyed great success in sculpting the "noble red man" and was highly acclaimed by early twentieth-century critics. Adeline Adams wrote that Brown "represents not only the pioneer in American sculpture, but in no small measure and sometimes in a singular way, the prophet."[6]

The Ward family had deep roots in America. The sculptor's ancestors landed in Virginia, moved to Kentucky, and then settled in Urbana, Ohio, where "Quincy" was born. Ward enjoyed a happy childhood on his father's farm. He delighted in the pleasures of outdoor life, especially riding, hunting, and fishing. He attended school only irregularly and was permitted great freedom to wander over the farm.

One day he discovered potter's clay on the farm. He experimented with the clay and tried modeling the head of an old Negro who lived nearby. In the eyes of his neighbors, the result was a phenomenal success. This praise inspired young Quincy to new efforts. He continued

his experiments with modeling clay, both independently and in the studio of a local potter named Chatfield.

Ward rejected his father's plan for him to become either a farmer in the family tradition or a physician. Young Ward's dream was to become a great sculptor. Ward was encouraged in this ambition by his sister, who lived in New York. When he was nineteen, she invited him to visit her and introduced him to Henry Kirke Brown. Ward, totally fascinated with both Brown and his studio, persuaded the master to accept him as a pupil. Before long he was promoted to being Brown's assistant. Under his tutelage, Ward studied every facet of sculpture and grew to be a major exponent of Brown's naturalism.

Unlike many of his contemporaries, Ward had little desire to study in Europe. Like Brown, he believed that the American artist should express American ideas. An American sculptor should develop his craft and achieve artistic success by remaining home, working diligently, and experimenting freely. Indeed, Ward was the first academically sophisticated American sculptor never to have studied in Europe. Ward remained in Brown's studio for seven years. After leaving Brown, Ward modeled and cast the busts of many prominent men of his day and supplemented his income by designing small decorative objects for the Ames Company in New York.

During this period, Ward was determined to complete his first serious sculpture. He chose to enlarge and improve *The Indian Hunter*, a statuette which he had begun in 1857 as a study in Brown's studio *(plate 12)*. In order to study the movements, habits, and dress of the Indians, Ward traveled to the West and Northwest. He lived among the tribes there and drew many sketches of Indian life. Throughout his career, Indian studies and themes of nature and freedom *(plates 19, 20)* held special appeal for Ward.

Ward returned to his New York studio and in 1860 cast *The Indian Hunter*. His work had simplicity, naturalness, and dignity. He had both a keen eye for exactitude of detail and the ability to select the most significant of these details. William Clark, Jr., discloses the contemporary reaction to *The Indian Hunter*:

The great thing is that the sculptor has undertaken to represent a man engaged in a certain act in which he calls all of his faculties into intense and characteristic play, and that he has succeeded in doing so. Both the dog—which fairly quivers with excitement, and which is barely stayed by the cautionary hand of his master from rushing on his prey—and the Indian who advances with stealthy step, his eye intently fixed upon the object against which he is advancing and his whole being absorbed in the eagerness of his pursuit, are instinct with

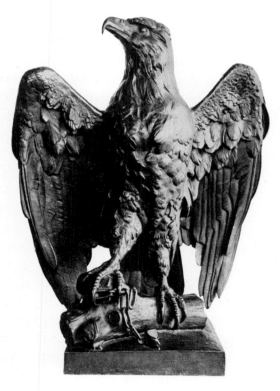

18. Henry Kirke Brown. *The Eagle.* 1867. H. 32″. Thomas Gilcrease Institute, Tulsa, Okla.

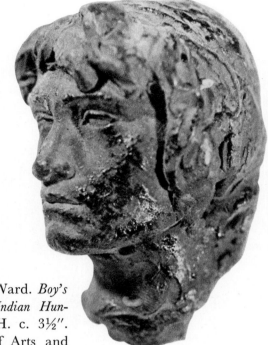

19. John Quincy Adams Ward. *Boy's Head* (study for *The Indian Hunter*). c. 1857. Wax. H. c. 3½″. American Academy of Arts and Letters, New York City. Photo courtesy of Lewis Sharp. This study was created following Ward's trip through the Dakotas and exhibited at the Broadway Gallery in 1865

20. John Quincy Adams Ward. *Dog's Head* (study for *The Indian Hunter*). c. 1857. Wax. H. c. 3″. American Academy of Arts and Letters, New York City. Photo courtesy of Lewis Sharp. This study was created following Ward's trip through the Dakotas and exhibited at the Broadway Gallery in 1965

an intense vitality which suggests not merely nature, but nature in one of her most interesting, because most unsophisticated, moods.[7]

The Indian Hunter was purchased by a group of prominent New York City citizens and placed in Central Park, where it may be seen today *(plate 23)*.

Throughout his career, Ward was attracted to many facets of American life and created numerous well-known portraits *(plates 21, 22)* and monuments. Ward won many honors in his lifetime. He was elected to the National Academy of Design in 1863 and was elected President of the Academy in 1874. He helped to organize the National Sculpture Society and served as its first president from 1893 until 1905. Ward was truly the most popular sculptor of his day.

After Ward, the influence of Italian study was still to be seen in several American bronzes of the "noble red man." Randolph Rogers (1825–1892) was one of the last important sculptors to be inspired by Rome. He created a bronze statue of an Indian, called *The Last Arrow (plate 24)*, which shows an Indian on a rearing horse. The Indian has just fired his last shot at an unseen enemy and on the ground beneath his horse lies a second Indian who has been wounded. Rogers' Indian sculpture was relatively unacclaimed thanks to the saccharine aesthetic taste of nineteenth-century America. Rogers won renown for a figure of the blind girl Nydia wandering through the ruins of Pompeii.

In the years following Ward's *The Indian Hunter*, most "noble savages" were executed with a skill and aesthetic sensibility developed at the École des Beaux-Arts in Paris. Paul Wayland Bartlett (1865–1925), the son of Truman A. Bartlett, a sculptor and Boston art critic, was one of the most competent exponents of this art. Young Bartlett entered the École des Beaux-Arts at the age of fifteen. Fascinated by the French *animaliers* of this era, he studied with one of the most popular masters, Emmanuel Frémiet. In 1887, while in Paris, Bartlett created *The Bohemian Bear Tamer (plates 25, 26)*. This bronze, which shows a young Indian boy training a small bear cub, was first exhibited at the Paris Salon and in 1893 was sent to the World's Columbian Exposition in Chicago.

Bartlett did a second Indian piece, *The Ghost Dancer,* which was also exhibited at the World's Columbian Exposition. Lorado Taft described this statue as

. . . a vicious-looking savage, quite unclothed, excepting for an imaginary coat of paint. He hops in the loose-jointed way characteristic of the Indian dancer, though quite without the ceremonial solemnity which always marks this most significant of aboriginal dances. The

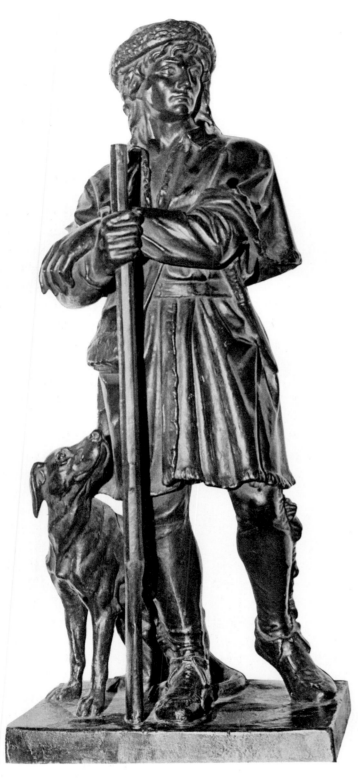

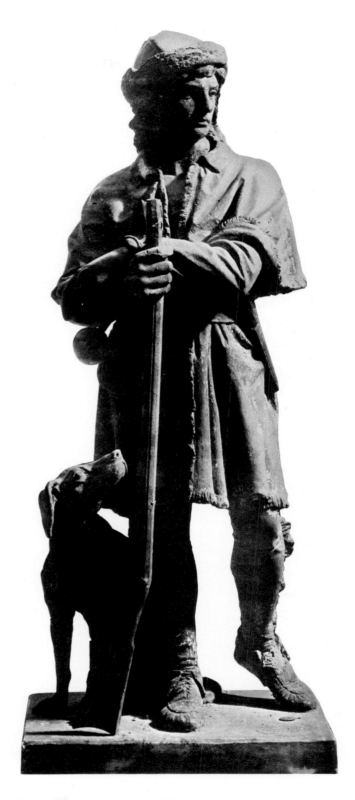

21. John Quincy Adams Ward. *Simon Kenton, the Indian Fighter*. c. 1860. H. 26½". Public Library, Urbana, Ohio. Photo courtesy of Lewis Sharp. This sculpture is derived from the *Apollo Belvedere*

22. John Quincy Adams Ward. *Simon Kenton, the Indian Fighter*. Before 1860. Original plaster. H.27½". Cincinnati Art Museum, Cincinnati, Ohio

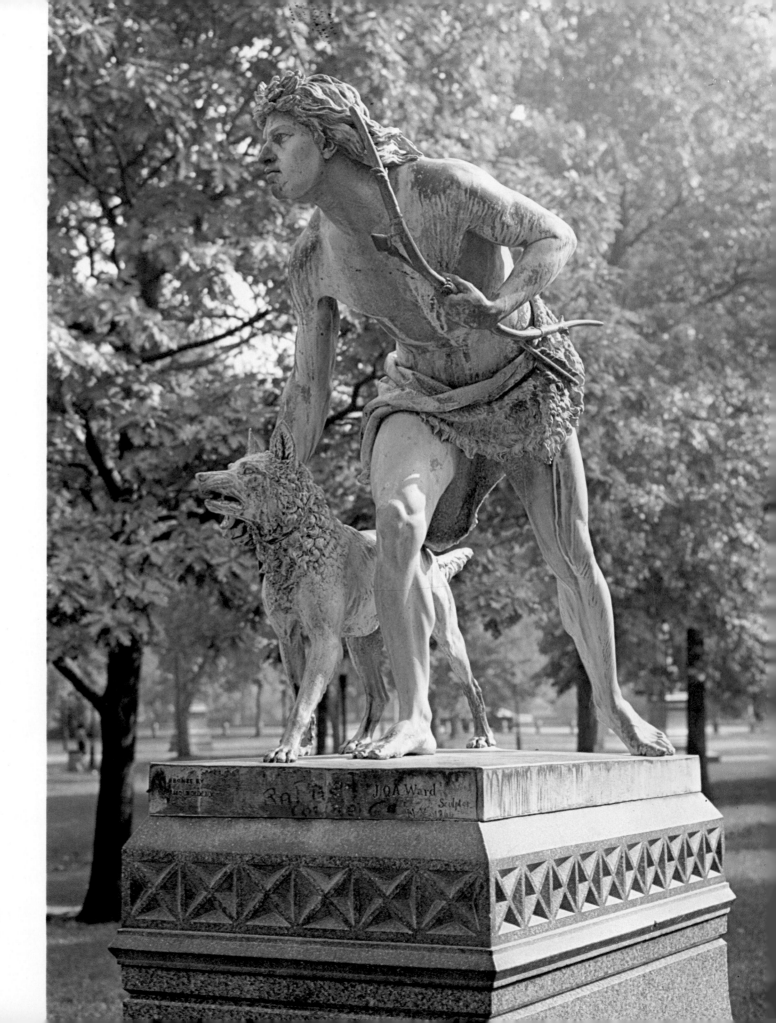

23. John Quincy Adams Ward. *The Indian Hunter*. 1860. H. 10′. Central Park, New York City

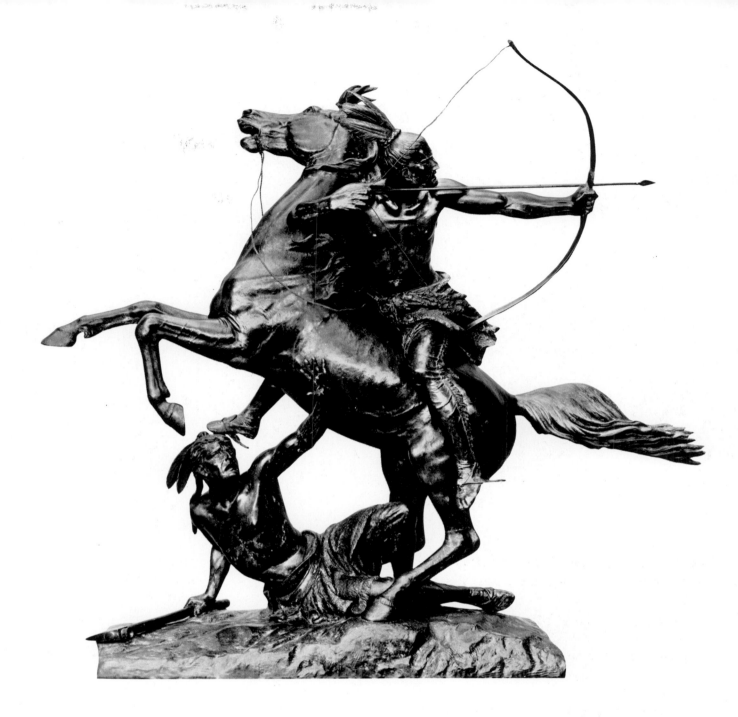

24. Randolph Rogers. *The Last Arrow*. 1880. Fonderia Nelli, Rome. H. 45″. Cincinnati Art Museum, Cincinnati, Ohio. Gift of O. J. Wilson

brutal head is shaved and decorated with a feather, the mouth wide open, the hands hanging like a prairie dog's paws on the outstretched arms.[8]

Another Beaux-Arts sculptor of imaginary bronze Indians was John Boyle (1852–1917). The son of an Irish stonecutter, Boyle first worked in his father's trade in order to support his widowed mother. During this period, he also studied art with Thomas Eakins at the Pennsylvania Academy of the Fine Arts. Having earned sufficient funds to further his artistic education, Boyle traveled to Paris, where he attended the Ecole des Beaux-Arts for three years.

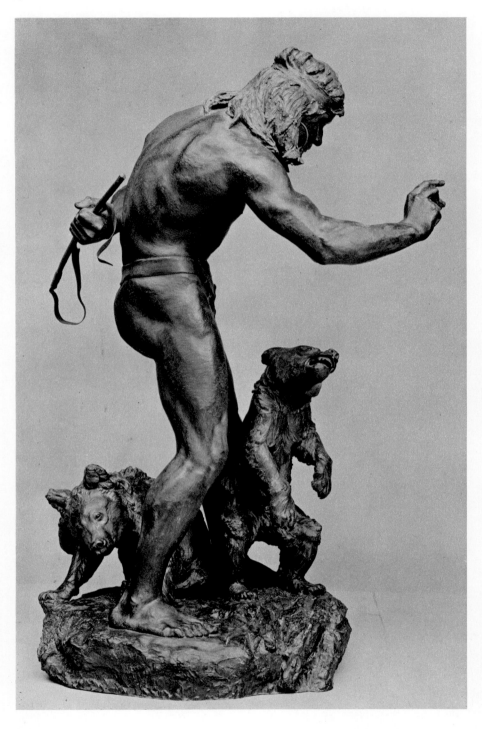

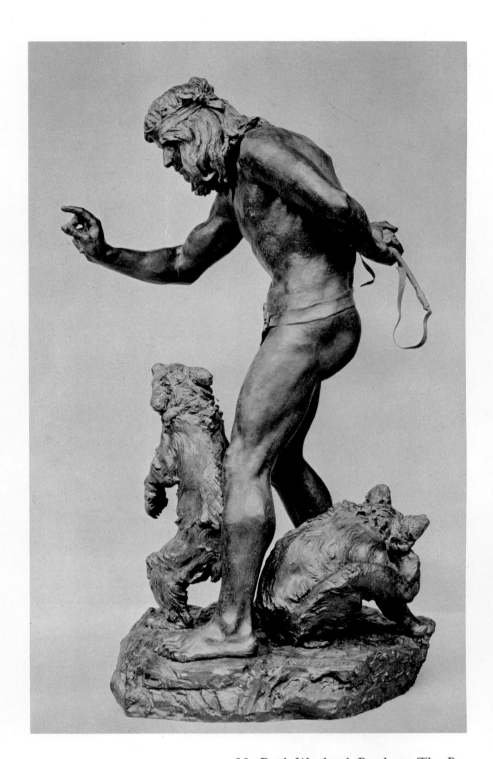

25. Paul Wayland Bartlett. *The Bo-
hemian Bear Tamer* (right view).
1887. Gruet Fondeur, Paris.
H. 68½". The Metropolitan Mu-
seum of Art, New York City. Gift
of an Association of Gentlemen

26. Paul Wayland Bartlett. *The Bo-
hemian Bear Tamer* (left view)

Upon his return to Philadelphia, Boyle received a commission for a sculptural group to commemorate the Ottawa Indians. The donor, Martin Ryerson, a prominent Chicago citizen, had enjoyed a friendly relationship with this tribe and wished to give Chicago a monument to honor them.

Boyle traveled to the West to observe the Ottawas. He studied their customs and clothing as well as their ceremonies and rituals, and was particularly interested in the ethnological features of the tribesmen. In 1884 he created his monument *The Alarm,* or *The Indian Family (plate 27).* An Indian brave stands protectively over his family. The squaw sits quietly at her husband's feet, a papoose cradled in her lap, and nearby is their alert watchdog. In deference to nineteenth-century tradition, the whole sculptural group is placed on a Neo-classical pedestal of polished granite, complete with Grecian ornamentation.

This group was so acclaimed and admired that the city of Philadelphia commissioned a second group, *The Stone Age in America (plate 28).* Boyle modeled this sculpture in Paris and exhibited it in the Salon of 1886. In 1888, it was placed in Fairmount Park, Philadelphia. The group portrays a strong Indian woman defending her children against a bear cub. The origin of the bear cub as the potential enemy was the result of the interference of the Fairmount Association with Boyle's original model, in which a huge eagle had been the menacing danger. Lorado Taft describes the original sculpture and its alterations at the hands of the Philadelphia patriots:

He had sketched a fine thing, an Indian woman of mighty physique defending her children from a powerful eagle,—a western Rizpah, as it were. The children were living ones, however, and clung to their mother's skirts, as far as possible from the vanquished bird, which lay upon its back clawing the air and apparently shrieking defiance in impotent rage. The great outspread wings offered beautiful lines, and their shadowy concaves set off the figures most effectively. The sculptor was pleased with his work, and when he had the full-sized model well advanced, he called in a photographer, so that the committee at home might note his progress.

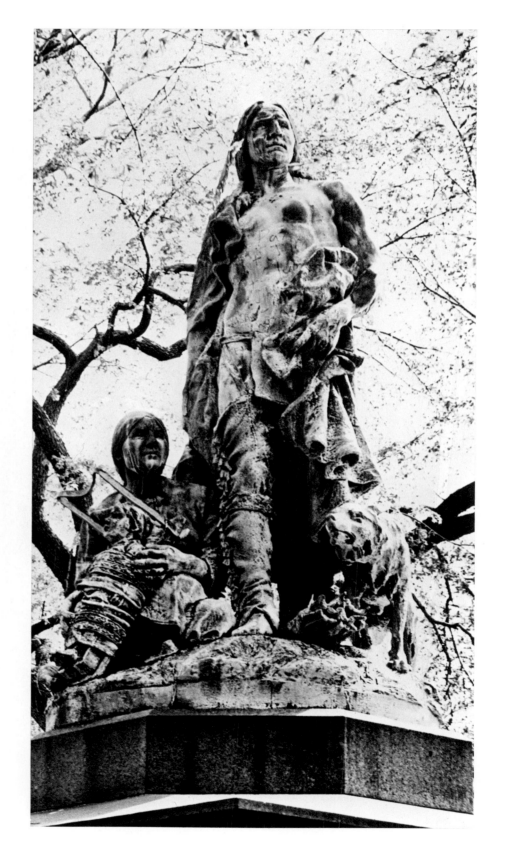

27. John Boyle. *The Alarm (The Indian Family).* Erected 1884. Life-size. Lincoln Park, Chicago

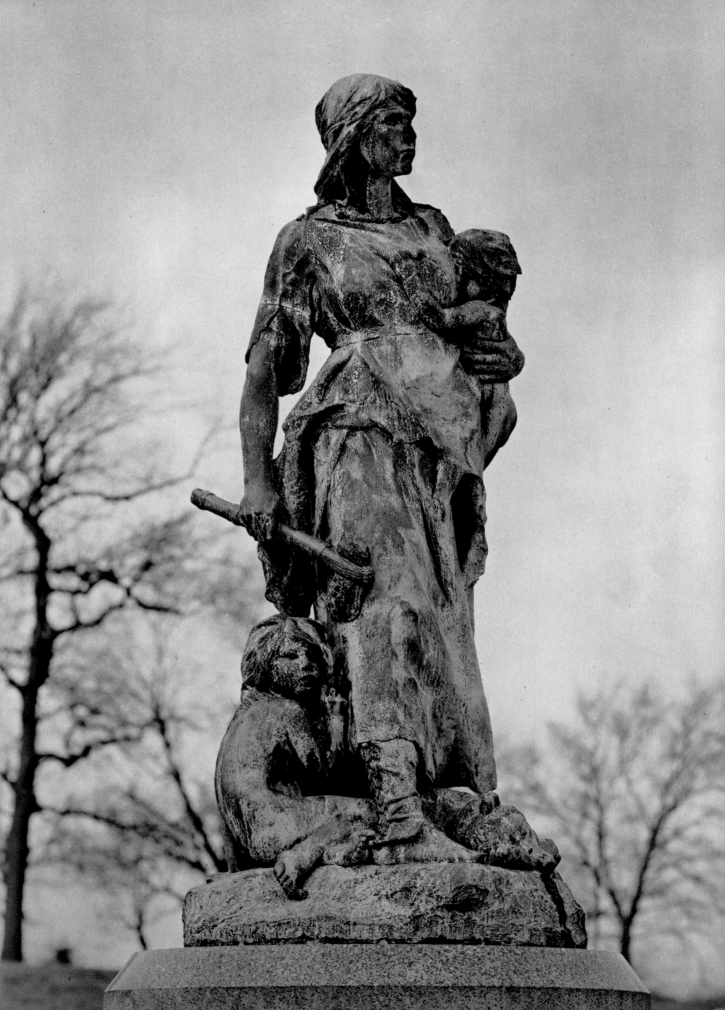

The answer came, and all too soon, for it urged with sufficient emphasis that it would never do to treat the national bird so ignominiously, and would the sculptor not kindly substitute some other creature? He did so. It is perhaps as well that there is no record of his half-murmured observations as he cut off those magnificent wings and painfully converted the Bird of Freedom into a bear cub! It lies there to this day—very dead. The squaw still clasps her baby to her breast and clutches her stone hatchet, looking out from under disheveled locks, scanning the horizon for signs of a more formidable foe. . .[9]

The Fairmount Association was nevertheless delighted with the results and proclaimed Boyle "the first sculptor who has adequately presented the Indian's case in American art."[10]

Boyle's work is distinguished by great vigor and a fine balance of sculptural masses. His use of detail is imaginative without being excessive. Boyle completed several Indian works within his lifetime. He made two heroic groups, *The Savage Age in the East* and *The Savage Age in the West*, which were mechanically enlarged in plaster for the Pan-American Exposition in Buffalo in 1901. The groups proclaimed the superiority of the American system of government to that of the "savage ages" of the past. They were never cast in bronze or in any other permanent form.

Olin Levi Warner (1844–1896) was one of the artists most influential in transplanting the Beaux-Arts style to the United States. Warner, the son of a New England Methodist minister, was born in Suffield, Connecticut. During his childhood he showed a talent for carving heads and statuettes in chalk. One day he attempted a plaster bust of his father and showed it at a state fair. This exhibit was a turning point in Warner's life, for here he recognized his calling as a sculptor.

Using money he had earned as a railroad telegrapher, Warner traveled to Paris and enrolled in the École des Beaux-Arts, where he studied with Jouffroy and with Carpeaux. In 1872 he returned to the United States and found the artistic atmosphere of his homeland to be "an arid and howling wilderness."[11]

In 1880 he took a trip, lasting over two years, to the Northwest Territory and did a series of relief portraits of Indians *(plates 29–36)*. These Indian reliefs are landmarks in the history of Western bronzes. For the first time, specific tribal chiefs and members of their families are represented as individuals rather than as the usual naked savages. Royal Cortissoz, one of the most influential art critics of the early

28. John Boyle. *The Stone Age in America*. Erected 1888. Life-size. Fairmount Park, Philadelphia

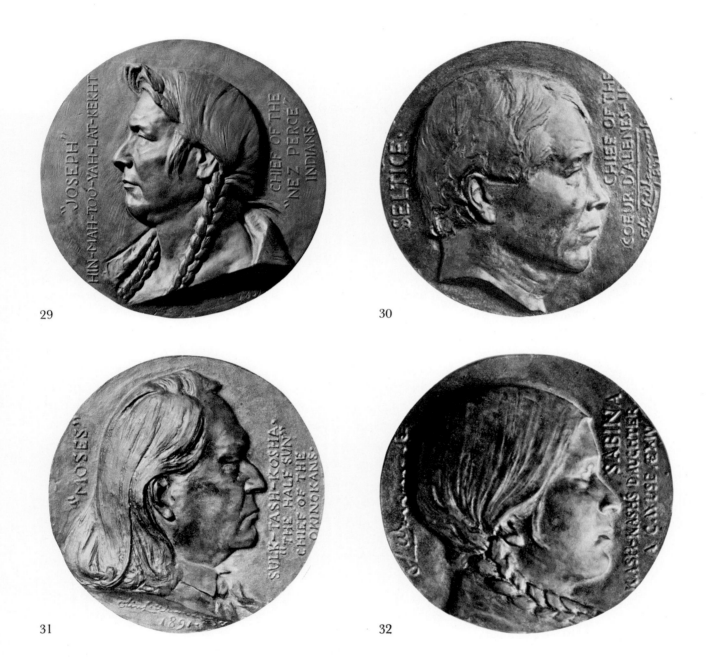

29

30

31

32

29. Olin Levi Warner. *Joseph, the Noble and Heroic Chief of the Nez-Percé Indians*. 1889. Jno Williams Founder, N.Y. Diam. 17½″. The Metropolitan Museum of Art, New York City. Gift of Mr. and Mrs. Frederick S. Wait, 1906

30. Olin Levi Warner. *Seltice, Chief of the Coeur D'Alene Indians*. 1891. Diam. 7½″. The Metropolitan Museum of Art, New York City. Gift of Mr. and Mrs. Frederick S. Wait, 1906

31. Olin Levi Warner. *Moses, Chief of the Okinokan Indians*. 1891. Diam. 8¼″. The Metropolitan Museum of Art, New York City. Gift of Mr. and Mrs. Frederick S. Wait, 1906

32. Olin Levi Warner. *Sabina, Daughter of Kash-Kash, a Cayuse Indian*. 1891. Diam. 5¾″. The Metropolitan Museum of Art, New York City. Gift of Mr. and Mrs. Frederick S. Wait, 1906.

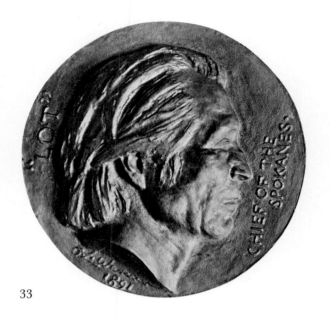

33

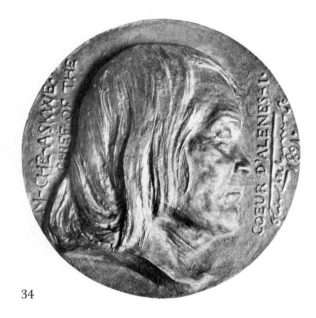

34

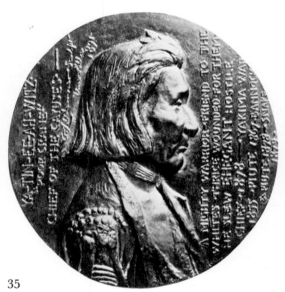

35

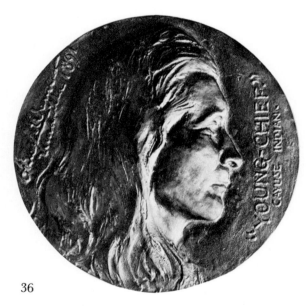

36

33. Olin Levi Warner. *Lot, Chief of the Spokane Indians*. 1891. Diam. 8″. The Metropolitan Museum of Art, New York City. Gift of Mr. and Mrs. Frederick S. Wait, 1906

34. Olin Levi Warner. *N-Che-Askwe, Chief of the Coeur D'Alene Indians*. 1891. Diam. 7¼″. The Metropolitan Museum of Art, New York City. Gift of Mr. and Mrs. Frederick S. Wait, 1906

35. Olin Levi Warner. *Ya-Tin-Ee-Ah-Witz, Chief of the Cayuse Indians*. 1891. Diam. 10¾″. The Metropolitan Museum of Art, New York City. Gift of Mr. and Mrs. Frederick S. Wait, 1906

36. Olin Levi Warner. *Young Chief, Chief of the Cayuse Indians*. 1891. Diam. 8″. The Metropolitan Museum of Art, New York City. Gift of Mr. and Mrs. Frederick S. Wait, 1906

37. Henry Kirke Bush-Brown. *Indian Mother and Child*. Gorham and Co., N.Y. H. 19″. Thomas Gilcrease Institute, Tulsa, Okla.

twentieth century, felt that these plaques were highly significant in the development of the naturalistic tradition of Indian sculpture. They were reproduced in *The Century Magazine* in 1893.

Warner was appointed an Associate of the National Academy of Design in 1884. He did not enjoy extensive public recognition, however, until very late in his career. Warner's life ended suddenly in 1896 when a carriage struck his bicycle in Central Park, causing him to have a fatal fall.

Warner's work reflected his classical training in both its feelings for rhythmic and harmonious forms and its emphasis on the monumental rather than the picturesque. The classical serenity in his work also reflected his personal spiritual calm. Warner was felt by his contemporaries to be a man of great stability and moral balance.

By the end of the nineteenth century, many artists were portraying the original Americans, whom they had heretofore ignored and feared. Carl Rohl-Smith (1848–1900) created the bronze sculpture entitled *Indian Massacre* as an ornament for the Pullman Building in Chicago. Henry Kirke Bush-Brown (1857–1935), nephew of Henry Kirke Brown, was the creator of several sculptural groups on Indian themes *(plate 37)*. In 1893, he exhibited *Indian Hunting Buffalo,* also known as *The Buffalo Hunt,* at the World's Columbian Exposition.

William de la Montagne Cary (1840–1922) traveled up the Missouri River in 1860 and viewed the Missouri frontier in the last days before it was settled. Traveling with two companions, he visited Fort Union and Fort Benton, crossed the mountains to Oregon, then traveled to San Francisco and returned by boat via Panama.

The young men had been inspired by reading the accounts of the Lewis and Clark expedition and the tales of James Fenimore Cooper. They enjoyed hunting the plentiful game and visited trading posts along the way. Cary made many paintings of the trappers, traders, and riverboatmen he saw in the course of his trip. During this expedition, his party was captured by the Crow Indians.

Cary made two later trips beyond the frontier. In 1867, he traveled to Fort Riley, Kansas, and in 1874 he made a second, less eventful journey up the Missouri River.

During Cary's first trip, he was privileged to have a unique view of the world beyond the frontier—the West before the days of the settlers. In his later trips he was witness to the great changes that had begun to sweep the continent and change the Indian world forever. In addition to technical achievements, the white man brought the Indian his vanities and vices. Cary created both sculptural and painted versions of *Going the White Man's Way (plates 38, 39),* which shows the Indians, one in a high silk hat, playing cards. Both the dress

38. William de la Montagne Cary.
Going the White Man's Way. 1909.
Roman Bronze Works, N.Y. H.
12½". Thomas Gilcrease Institute,
Tulsa, Okla.

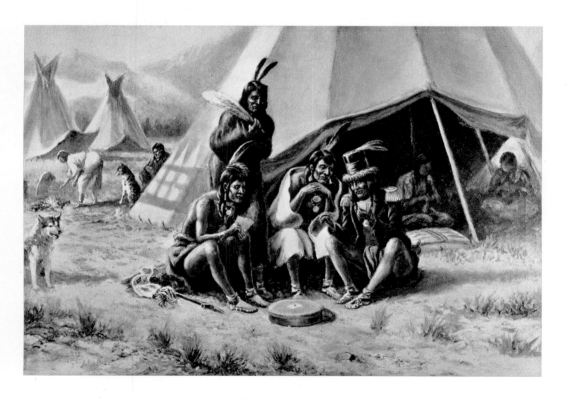

39. William de la Montagne Cary.
Going the White Man's Way. 1909.
Oil on canvas. 20 × 30". Thomas
Gilcrease Institute, Tulsa, Okla.

and the pastime were the contributions of the white man to Indian civilization.

Cary also made several sculptures of everyday Indian life, of which the bronze *Pets of the Teepee (plate 40)* is an excellent example. While his bronzes are not elaborate artistic creations, they are a significant part of our permanent documentary record of life in the Old West.

These early artists, whether disciples of Rome and Paris or exponents of American naturalism, were pioneers in the development of a purely national art. Through their representations of the Indians, they laid the foundations for the most uniquely American form of sculpture, the Western bronze.

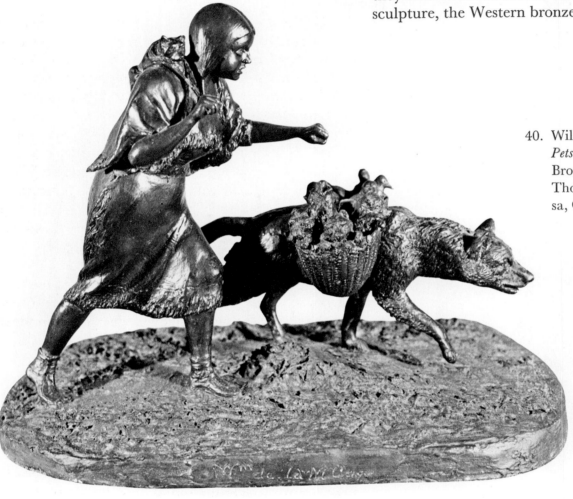

40. William de la Montagne Cary. *Pets of the Teepee.* c. 1910. Roman Bronze Works, N.Y. H. 11½″. Thomas Gilcrease Institute, Tulsa, Okla.

IV

PIONEER *ANIMALIERS:* "IN THE FOREST PRIMEVAL"

Among the most important subjects for Western bronze sculpture are the animals of the frontier world. Each successive wave of pioneers faced many frightening kinds of wild animals. Bears, mountain lions, and wildcats were but a few of the known terrors to those who ventured into the wilderness. Even after the pioneers had established permanent settlements, the dark of the forests or the upper regions of the mountains sheltered many dangerous predators. Animal life also helped to sustain the new Westerners. Elk, moose, deer, and many small animals provided both food and clothing. Trappers and traders depended upon the skins of these animals for their livelihood. For those who settled the Great Plains and the Southwest, the gray wolf and the coyote or prairie wolf were their menacing companions in the new land.

The buffalo is truly a central figure in the history of the settlement of the West. At the time of the arrival of the white man in the Great Plains, the Indians there based their entire culture on the buffalo. It was the skin of the buffalo which, when dried in the sun, often provided the Indians' shelter and the flesh of the buffalo which provided one of the principal staples of their diet. The bones of the buffalo were sharpened and shaped to form tools and weapons.

The mass slaughter of the buffalo in the mid-nineteenth century dealt the final blow to the Indian in his struggle for independence and survival against the encroaching white civilization. It has been estimated that more than four million buffalo were killed in the three years from 1872 to 1874. This extermination took place because each hide was worth about a dollar. The horror of that slaughter can best be pictured through the description of a Santa Fe Railway conductor, J. H. Helton, who said that he could have walked for a hundred miles along the right of way without stepping off the carcasses.[1]

The horse is today the foremost symbol of the West. During the eighteenth and nineteenth centuries, thousands of mustangs ran free over the plains and prairies. Descendants of the noble horses brought to the New World by the Spanish explorers, they were the product of

41. Antoine Louis Barye. *Walking Tiger*. Modeled before 1847, executed after 1848. H. 9¼". The Metropolitan Museum of Art, New York City. Rogers Fund, 1910

many adaptations to conditions of nomadic life in America. To many, the mustangs symbolize the freedom and exhilaration of Western life. In addition to the mustangs, there were the horses captured and domesticated by the Indians. Often called cayuses, these small sturdy horses were named after the Cayuse Indians, who made great use of them. Today, the term cayuse often refers to the Western horse in general.

To the mountain men or trappers, the horse was not only a means of transportation but also their solitary companion on their long expeditions into the wilderness. As they journeyed westward, the pioneers often traveled on horseback or brought horses with them which would later be used for farm work. The settlers also brought many domesticated animals with them.

Although by the middle of the nineteenth century the American West was populated by an inspirational variety of wild and domesticated animals, it is an amazing fact in the history of American sculpture that, prior to the 1870s, there were only two works in which native animals appeared. One was the panther in Henry Kirke Brown's early work, *Indian and Panther (plate 17)*, and the other was the dog in John Quincy Adams Ward's *The Indian Hunter (plate 12)*.

How can this artistic oversight be explained? Up to this time the choice of an animal as a subject was considered unworthy of execu-

tion. How could the representation of mere animals inspire the spirit or enrich the mind? The classical tradition demanded the study and idealization of the human, not the animal, form. It is the Romantic who looks to nature for a subject and chooses an animal, preferably wild or exotic, as worthy of artistic representation and idealization. In both Europe and America, by the late nineteenth century, wild animals had captured the imagination of sportsmen and artists alike. Hunting expeditions to Africa or to the American Rocky Mountains offered a chance for either big-game sport or scientific study and many Europeans and Americans journeyed westward on these expeditions.

During this time, many zoos were founded in large cities throughout the United States. Their directors commissioned hunters to return with living examples of wild beasts both from the American West and from Africa. Simultaneously, many museums of natural history were founded and filled with stuffed examples of wildlife. As this new interest in animals grew, the zoos and museums offered Easterners an opportunity to see, study, and be inspired by animals previously unknown to them. Often captivated by this glimpse of wildlife, the artists and scientists traveled to the West for firsthand experience and nature study.

The earliest and most famous sculpture to result from this new fascination with animal life appeared in France. Antoine Louis Barye (1795–1875), a Parisian, was the first artist to receive acclaim for his sculpture of wild animals *(plate 41)*. His works, which were exhibited at the Paris Salon of 1831, delighted Frenchmen and Americans alike. Although academicians condemned his subject matter as trivial and his execution as overly realistic, collectors and museums competed for examples of his sculpture. In 1873, the Corcoran Gallery in Washington, D.C., ordered a complete collection of every sculpture that Barye had ever created.

Barye was indeed a Romantic, as he sculpted wild, fierce beasts. He idealized his animals and endowed them with heroic proportions. His art, nevertheless, shows a solid background of anatomical study. His animals are heroic and passionate beasts, but in truth Barye used only animals which he observed in the zoos of Paris. The Romantic spirit demanded that all animals be represented as free, at liberty, and these animals were to many people, especially the French, the symbol of liberty, so important at this time.

A second influential *animalier* was Christophe Fratin (1800–1864). The subjects of his sculptures, although still Romantic representations, are less exotic and melodramatic than those of Barye. Fratin chose to portray tamer animals—for example, horses, cattle, and deer

42. Pierre Jules Mène. *Roebuck*. c. 1860s. H. 10¾″. Collection Mr. and Mrs. Stanley H. Broder

—in highly imaginative motion-filled poses. The manes and tails of his animals are usually flying in a fantastic wind storm.

Whereas the wild animals of Barye are often represented in violent and bloody scenes of combat, it is the bronze portraits of woodland life by Pierre Jules Mène (1810–1879) which are closest in spirit and execution to the more realistic representations of the American animal sculptors. Mène, like Fratin, was less exotic than Barye in his choice of animal subjects. He was the master sculptor of stags and deer, horses and dogs. Interested in the anatomy and movements of these animals, Mène in his wildlife sculptures recaptured the beauty of a suspended moment in the forest *(plates 42, 43)*. He also did many sculptures of dogs and horses, but these were usually portraits of specific animals.

Emmanuel Frémiet (1824–1910), one of the most popular sculptors of the late nineteenth century, had a particularly strong influence on American animal sculpture. Frémiet, a member of the École des Beaux-Arts, was a professor of drawing at the Jardin des Plantes, the natural history museum in Paris. He taught many of the American sculptors who went to Paris for both inspiration and instruction.

After these early masters of animal sculpture, there followed a great succession of French *animaliers* whose works were tremendously popular on both sides of the Atlantic. Auguste Nicolas Cain (1821–1894), Mène's son-in-law, was foremost among the younger sculptors.

Barye, Fratin, Mène, Frémiet, these great French *animaliers* each had an enormous influence on the successive waves of American sculptors who came to study in France. Many American sculptors studied under these and other French masters in the great art schools and studios of Paris. Other American artists were inspired by the many examples of French animal sculpture which were on display throughout Europe and America.

As the new America pushed westward, farsighted artists realized that many animals which were still common would soon become scarce or perhaps extinct. It was the mission of the Western sculptor to give permanent form to these animals.

As the pioneers cleared their farmlands, cutting timber and draining marshes, they slowly transformed a land of wilderness into one of civilization. As part of the struggle for survival, the frontiersmen killed millions of animals. They depended on animal meat for food. They hunted wild animals to protect the inhabitants of new settlements from attack. Trappers killed fur-bearing animals for their valuable skins. It became increasingly evident that the advance of white civilization would soon cause many species of American wildlife to become extinct.

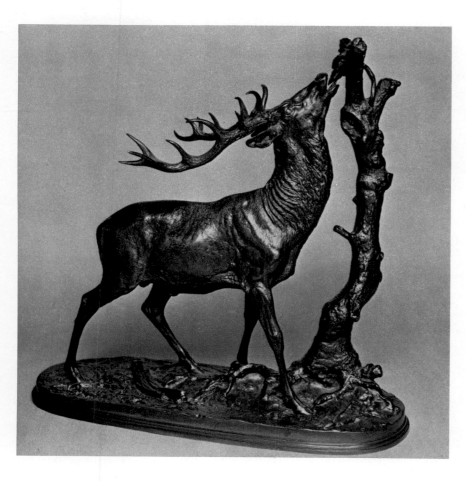

43. Pierre Jules Mène. *Stag Browsing*.
c. 1843. H. 14¼". Collection Mr.
and Mrs. Stanley H. Broder

Edward Kemeys (1843–1907) was the first American sculptor to recognize as his artistic mission the recording and preserving of the animal life of the plains and the mountains. He was also the first American to win recognition as a sculptor of animals *(plates 48–50)*.

Kemeys was born in Savannah, Georgia. His parents, originally Northerners, moved to New York shortly after Kemeys' birth. Here young Edward received a good public school education, but no artistic training. After leaving school, he went first into the iron business, which he abandoned at the outbreak of the Civil War. He saw much active duty with the Federal Army and ultimately attained the rank of Captain of Artillery. Following the war, Kemeys traveled to Illinois to run a small farm. He loved the frontier atmosphere which Illinois still retained in the mid-nineteenth century and was especially interested in the varied animal life of the farm. Since he had spent a joyful summer on a farm there when he was thirteen, he was determined to return when grown. His only attempt at farming, however, was doomed to failure.

Kemeys returned to New York and took a job with the civil engineering corps. His job was felling trees in Central Park, which at this time was still in its formative stages. Always fascinated with animals, Kemeys was a frequent visitor to the Central Park Zoo. One day, seeing a man modeling the head of a wolf, he was seized with the desire to try a sculpture of his own. He took as his subject two wolves fighting over the carcass of their victim. He entitled this initial composition *Hudson Bay Wolves (plates 44, 45)*. Kemeys was an immediate success as a sculptor. The Fairmount Park Commission in Philadelphia purchased the work and erected it there in 1872.

Kemeys, delighted with his new career, dedicated his life to animal sculpture. With the proceeds of his first sale, he chose to travel to the American West, thus spurning the opportunity to first travel to Europe to study with the French masters. Kemeys adored living in the West and throughout his life returned whenever possible. There in the wilderness, he explored and hunted, studied and sketched. Finally, his funds exhausted, Kemeys returned to New York, where he opened a small studio. Here he produced some of his finest sculptures —*Panther and Deer, Raven and Coyote,* and *Playing Possum*—which he exhibited in the Philadelphia Centennial Exposition.

In 1877 Kemeys traveled to Paris in the hope of studying with the French *animaliers*. After his travels in the West, where he had studied animals in their natural environment, he found formal study both confining and pedantic. He detested sculpting caged animals in a zoo and felt the results to be lifeless. In 1878 Kemeys exhibited *Bison and Wolves* at the Salon in Paris, where it received high critical acclaim.

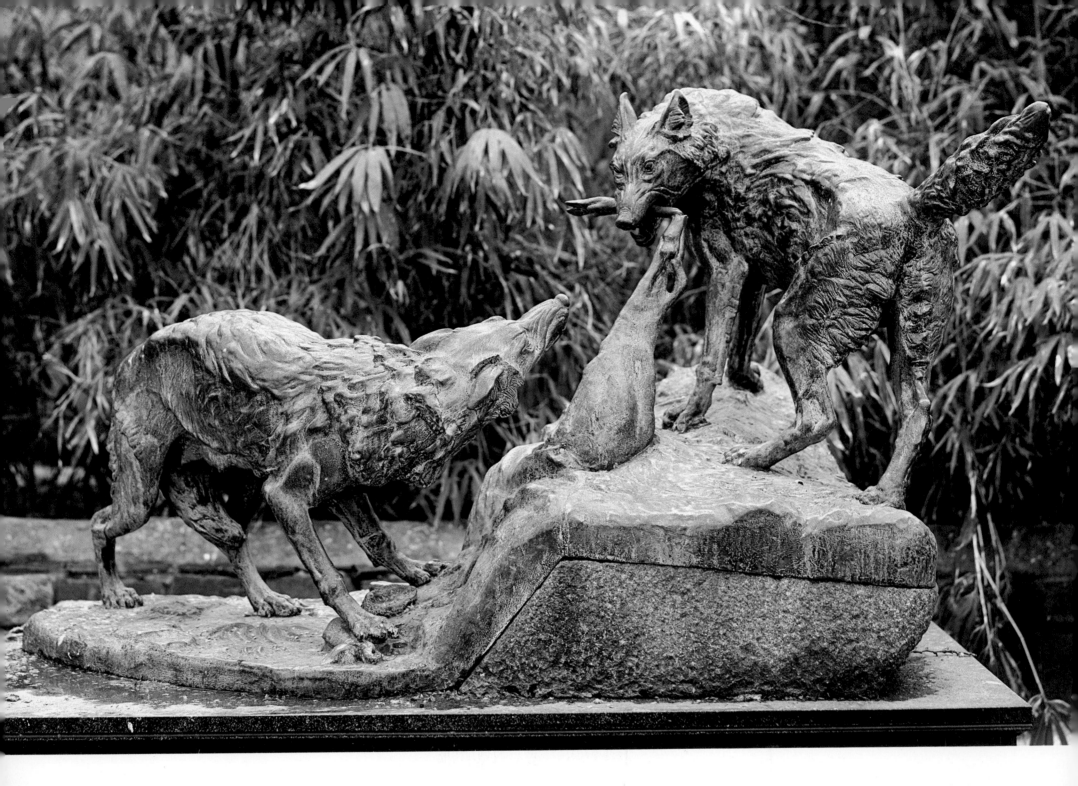

44. Edward Kemeys. *Hudson Bay Wolves*. Erected 1872. Life-size. The Philadelphia Zoo, Fairmount Park

He soon grew bored and restless in Paris and longed for the excitement of the frontier.

In 1879 Kemeys returned to the United States. Delighted to be in his native land, he devoted his full energy to the study and sculpture of its wild animals. He studied animals, both living and dead, making countless dissections to add to his anatomical knowledge. Kemeys considered himself a self-taught artist: "I never studied under any master here; no man can ever say that he gave me a lesson."[2]

In 1881–83 Kemeys created *Still Hunt (plate 46)*, a sculpture of a fierce mountain lion about to seize its prey. This bronze was purchased by New York City and placed in Central Park. Kemeys had a special ability to capture the spirit of the members of the cat family. His work is more impressionistic than that of the French animal sculptors. He sacrifices finely modeled detail for the force and dramatic impact of rough surfaces. This technique is very close to that employed by many modern animal sculptors.

In 1892 Kemeys moved to Chicago and remained there for eight years, working in his studio, Wolfden. Every summer he traveled to his beloved Western wilderness for inspiration and study.

Kemeys' career reached its height at two of the great expositions of his era, the World's Columbian Exposition in Chicago (1893), where he displayed twelve sculptures, and the Louisiana Purchase Exposition in St. Louis (1904), where he exhibited fifteen. At the Chicago Fair, his two huge standing bronze lions guarded the main entrance to the Art Institute, while at the end of two of the bridges stood *Wild Cats*. Charles H. Caffin describes these feline masterpieces: "Their stealthy supple movement, as, bellies low to the ground, they advanced with that slow clinging step which precedes the spring, represented the closest study of the naturalist, while the treatment of the lines and masses was altogether a sculptor's, monumental in a high degree."[3]

Kemeys' work was vastly popular with visitors to the fairs and he was awarded medals at both expositions. These awards were of critical importance to him. In summarizing his career, he wrote: "Of honors I have only two, World's Fair Medals. I could have had plenty of others had I cared to mix with men, but you know, and all artists know I have always been a hermit."[4]

Kemeys' last work was a great outdoor fountain which stands in Champagne, Illinois. In it he combines a panther and a deer with an Indian praying for rain. This is one of Kemeys' rare representations of the human form.

In addition to Kemeys' tremendous knowledge of the anatomy of wild animals and his familiarity with their habits, one of the most

45. Edward Kemeys. *Hudson Bay Wolves* (detail of plate 44)

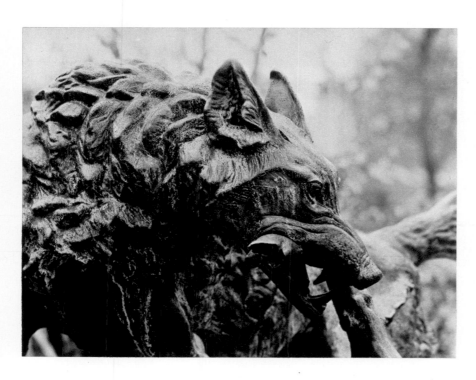

46. Edward Kemeys. *Still Hunt*. Modeled 1881–83, erected 1885. H. 31″. Central Park, New York City

47. Edward Kemeys. *Chief Sitting Bull*. c. 1884. Bas relief, brass. Collection J. N. Bartfield, New York City

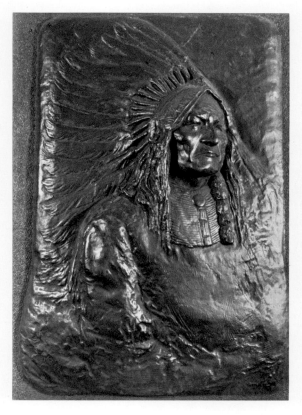

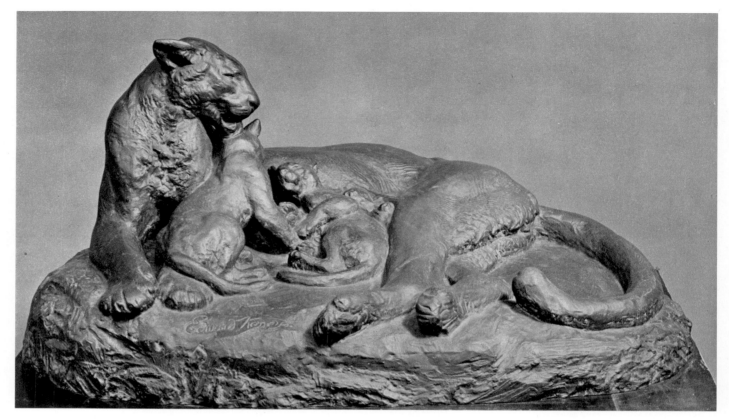

48. Edward Kemeys. *Panther and Cubs.* 1907. Jno Williams Founder, N.Y. H. 26½″. The Metropolitan Museum of Art, New York City. Rogers Fund, 1907

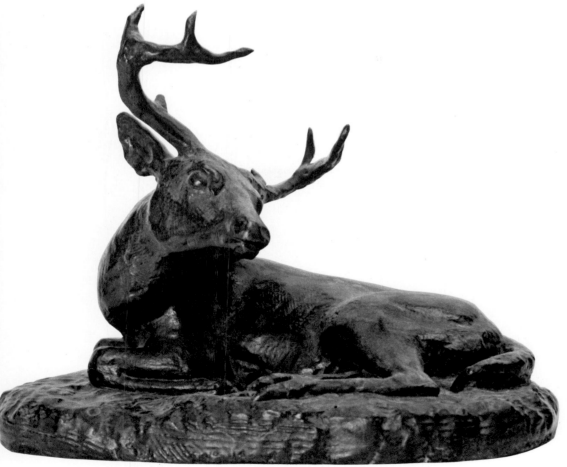

49. Edward Kemeys. *Stag.* H. 8⅝″. University of Michigan Museum of Art, Ann Arbor. Bequest of Margaret Watson Parker

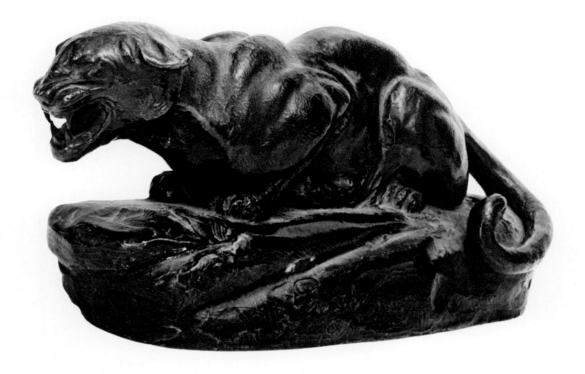

50. Edward Kemeys. *Crouching Snarling Panther*. c. 1876. H. 5¼″. University of Michigan Museum of Art, Ann Arbor. Bequest of Margaret Watson Parker

important factors in his huge success was his empathy with and psychological insight into his animal subjects. Julian Hawthorne, in an article of 1884, celebrated Kemeys' ability to create "not merely, nor chiefly, the accurate representation of the animals' external aspect, but what is vastly more difficult to seize and portray—the essential animal character or temperament which controls and actuates the animals' movements and behavior. Each one of Mr. Kemeys's figures gives not only the form and proportions of the animal according to the nicest anatomical studies and measurements, but is the speaking embodiment of profound insight into that animal's nature and knowledge of its habits."[5]

Lorado Taft hailed Kemeys as "one of the first to see and appreciate the immediate world about him, to recognize the artistic possibilities of our own land and time."[6] Kemeys was indeed the first sculptor to open his eyes to the natural world around him. He was the first to re-create in bronze the beauty and drama of the wild animals of the American West. Naturalists, historians, and artists—all owe him a great debt.

Eli Harvey (1860–1957) succeeded Kemeys as the most popular *animalier* in America. Although many of Harvey's bronzes portray animals of the Western woodlands, they are creatures of the zoo, rather than of the forest. Harvey was born in Ogden, Ohio. He first

studied drawing and painting but later enrolled in the Art Academy of Cincinnati in order to study both painting and sculpture. He then traveled to Paris, where he studied sculpture with Frémiet at the Jardin des Plantes at the Paris Zoo.

Upon his return to the United States, Harvey worked in a New York studio. He based his creations on studies which he had made at the zoo. He exhibited his sculptures in both Europe and the United States and won awards at the Paris Salon as well as at American expositions. He did the elk bronze for the Order of Elks and the bear mascot for Brown University. Harvey's bronzes are closer in spirit and execution to Paris than to the American West, for they are exact in naturalistic detail and have the polished surface modeling of the French school *(plates 51–53)*.

Edwin W. Deming (1860–1942) is better known as a painter than as a sculptor. His animal bronzes, however, are truly Western and are close in feeling to those of Kemeys. Born in Ashland, Ohio, young Deming grew up on the prairie frontier. In 1815 his grandfather had traveled westward from Massachusetts to Ohio in a covered wagon. When Edwin was six months old, the family moved to Genesco, Illinois, to a tract of land that previously belonged to the Fox and Sac Indians. In his youth, Deming played with boys from these tribes as well as those from the Winnebago tribe. With his Indian friends, he often dug clay from the banks of the Mississippi River. Deming would then delight his companions by modeling the different animals they saw daily. When he was a young man, Deming traveled West by railroad and stagecoach to Indian Territory, where he studied and sketched the Ponca, Osage, Oto, and Pawnee Indians.

In order to please his father, Deming attempted to study business law. He realized very quickly, however, that his only ambition was to become an artist. He spent one winter studying at the Art Students League in New York and one year in Paris with Gustave Rodolphe Boulanger and Jules Lefebvre. Deming, however, was primarily self-taught, and the greatest part of his artistic knowledge came from his close observations.

In 1887 Deming lived for a year among the Apache, the Yuma, and the Pueblo Indians of the Southwest and the Umatillas of Oregon. On a later trip, he visited the Crows on Montana's Little Big Horn, and the Sioux reservations in the Dakotas. In 1892 he married Theresa Osterheld, a native of New York State, and he chose for his honeymoon a trip to New Mexico and Arizona. The couple camped among the Navaho, Zuni, and Hopi tribes. Theresa became deeply interested in Indian life and lore and subsequently wrote eleven books on the subject.

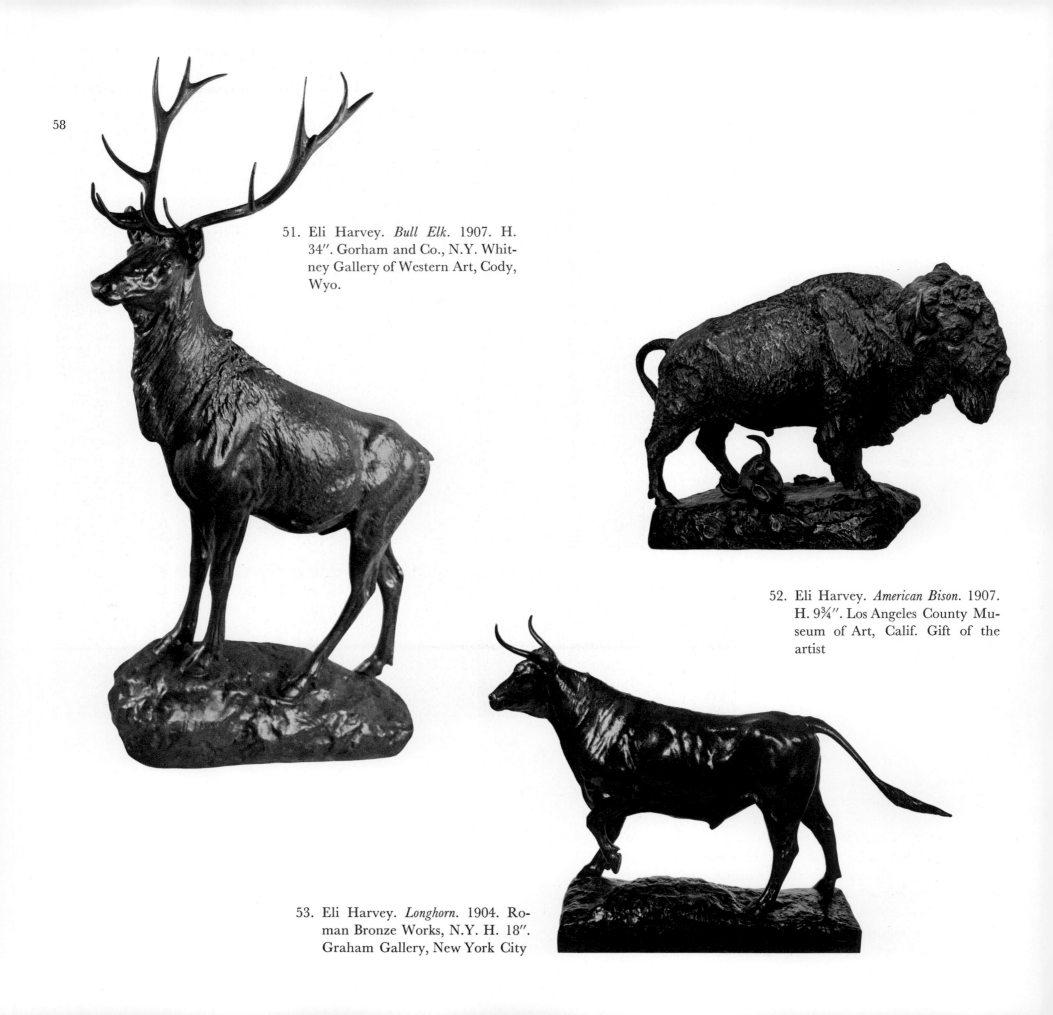

58

51. Eli Harvey. *Bull Elk*. 1907. H. 34″. Gorham and Co., N.Y. Whitney Gallery of Western Art, Cody, Wyo.

52. Eli Harvey. *American Bison*. 1907. H. 9¾″. Los Angeles County Museum of Art, Calif. Gift of the artist

53. Eli Harvey. *Longhorn*. 1904. Roman Bronze Works, N.Y. H. 18″. Graham Gallery, New York City

54. Edwin W. Deming. *The Fight*. c.
1906. Roman Bronze Works,
N.Y. H. 7¾". The Metropolitan
Museum of Art, New York City.
Rogers Fund, 1907

Deming was determined to use his artistic ability to record the
beliefs and customs of the Indian. He wrote:

The Indian of the old time has passed away. . . and we have
certainly very little to be proud of in the record of our dealing with
him. . . . The white man owes the red man a debt greater than he
can ever repay and is in honor bound to record as true a history of the
oldtime Indian as possible, that future generations may know and
appreciate this stone-age people surviving until today. There has never
been in literature or art a more splendid subject to treat.[7]

55. Edwin W. Deming. *Mutual Surprise*. 1907. Roman Bronze Works, N.Y. H. 9½″. The Metropolitan Museum of Art, New York City. Rogers Fund, 1908

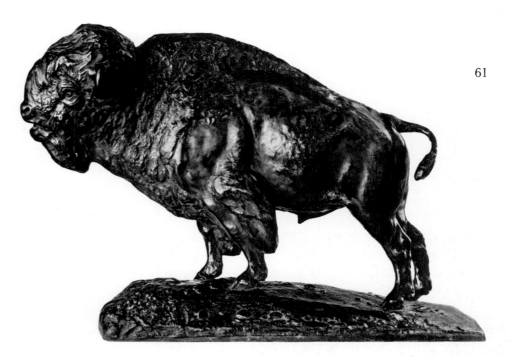

56. Edwin W. Deming. *Buffalo*. H. 14½″. Brooklyn Museum, N.Y. Carl H. DeSilver Fund

Deming was particularly fascinated by the mysteries of Indian folk-lore and won recognition for his paintings of Indian life. Some of his most celebrated murals are in the Museum of Natural History in New York.

Although Deming lived in New York City until his death at the age of eighty-two, whenever possible he and his family traveled among the Indians of Mexico, the United States, and Canada. He and his six children were adopted by the Blackfoot tribe.

Bears held a special fascination for Deming. He named his studio-home in New York's McDougal Alley Lodge of the Eight Bears. He chose this name after his Blackfoot friends had decided that Eight Bears would be his Indian name. Bears were the subject of some of his finest sculptures. These bronzes, modeled primarily between 1905 and 1910, show the keenness of his powers of observation.

In *The Fight (plate 54)*, Deming re-created a struggle which was described to him by one of his Indian friends: "He was watching a deer trail when he saw a grizzly coming down the trail and coming towards him from the opposite direction was a mountain lion. When they met the lion jumped on the grizzly's back and began to bite and claw the grizzly. The grizzly stood on his hind leg, growling, and reached back and nearly pulled the lion's legs off. When they parted their skins were so torn that the Indian did not skin them."[8] Deming chose to portray the moment when the mountain lion has leaped on the back of the bear to tear at his flesh. The bear rises in self-defense but is bowed by the great weight of the mountain lion.

In *Mutual Surprise (plate 55)*, Deming portrayed the meeting of a bear cub and a turtle. Here is a gentler mood filled with Deming's affection for wildlife and his appreciation of the humorous subtleties of nature. During his career Deming modeled several sculptures of coyote, sheep, buffalo *(plate 56)*, and wolves. In addition to these, he made several bronzes of Indian subjects.

These early bronzes of wildlife were only the beginning of what has today become a tradition of Western animal sculpture. Adeline Adams described these sculptures as an integral part of our pioneer heritage, stating: "A genius for [sculpting] animals is found rather often among us, as befits the people whose fathers so lately subdued the forest born."[9]

V

GUTZON BORGLUM: A MAN OF MONUMENTAL AMBITION

In the mid-nineteenth century, the land west of the Mississippi was still an untamed frontier. In the 1830s the Mormons followed their leaders to what would be their promised land. They settled first in Nauvoo, Illinois. Expelled from Nauvoo, they again turned westward, and ultimately reached what is now Utah. Here on the shores of the Great Salt Lake they built their permanent settlement. In 1849 prospectors discovered gold in Sutter's Fort in California, and a decade later they found both gold and silver in Colorado. Men scrambled greedily over the mountains in search of a new and golden life. To "go West" was to travel to a new world of opportunity, religious freedom, and perhaps even great fortune.

The Far West was a world of raw natural beauty. It offered a rough life of endless promise. This was a time "when the Indians were beginning their last desperate fight, when men's blood ran as red as a prairie sunset and their muscles were like the rocks they grappled with and when impulse was often law . . . "[1]

In 1860 a young Danish woodcarver, Jens Møller Haugaard Borglum, and his wife, Christina Michelsen Borglum, left Denmark to start a new life in America. They became the parents of two of America's greatest Western sculptors, Gutzon and Solon Borglum. Jens and Christina traveled westward across the continent. After crossing the Mississippi, they joined a wagon train which they followed over the Oregon Trail. They stopped in Idaho along the shores of Bear Lake. Idaho was then a Territory which comprised an area which is now divided into several states. There were only about twelve thousand white settlers. There was neither city nor town nearby, only a small army post. Bear Lake has been described as "a beautiful spot where nature, with reckless abandon, has heaped high great piles of earth and stone, studded them with trees, and where in winter great strips of white down the sides of the mountains reveal the snow valleys."[2]

There they built a small primitive house and in 1867 the first of nine children, Gutzon de la Mothe Borglum, was born. The name Gutzon is Danish for "good son." The Borglums traveled onward from Idaho and settled next in Ogden, Utah, where Jens's fourth child,

Solon Hanibal Borglum, was born in 1868. (Gutzon and Solon were the only children of Christina. The Borglums were a Mormon family and Ida, a second wife, was the mother of Jens's other seven children.)

Jens Borglum was unhappy in the woodcarving trade and so, with his family, he went eastward to Nebraska City and St. Louis to study medicine. A few years later, proud of his new medical degree, Borglum and his family turned westward again.

This time they settled in Fremont, Nebraska. Gutzon, in an interview in *American Magazine,* described life there in the 1870s:

Fremont was then a frontier town of perhaps a thousand people, all of them sturdy pioneers. My father's practice took him great distances into the plains, and I often rode with him as he visited his patients.

Caravans of people, moving westward, passed through Fremont, driving oxen, horses, and mules. I loved to look at these hearty folk, pushing on to new adventures. Many of them became sick, and died in Fremont; others died along the trails; some were killed by Indians; and many were caught in blizzards and perished of cold.

Indians used to come to town to sell meat and to exchange their baskets and pottery for trinkets. We children were afraid of them, for the pale-face hadn't entirely subdued the wild red men of the plains in those days. Sometimes we would scurry to the attic and hide when we saw them approaching; at other times they would come upon us unawares, and stare curiously through the cabin windows, sending shivers up and down our backs.[3]

Gutzon was educated in the public school in Fremont. He preferred the colorful world around him to that of his schoolbooks and was constantly in trouble for drawing pictures of Indians and horses on his books and etching them on his slates.

Gutzon was fascinated by horses. Throughout his life he drew and sculptured every type of horse in every possible phase of motion. He bought his first horse, an Indian pony, for $2.75. As a boy he knew General Frémont, a pioneer hero. The General's wife predicted of Gutzon: "That boy will surely ride to fame on horseback!"[4]

Gutzon rode his pony over the colorful frontier towns and dreamed of a heroic and fantastic world of Western glory. "I had my heroes, and they were a strange lot: Savonarola, the medieval evangelist; Wild Bill, the Indian fighter; Socrates, the philosopher; and Sitting Bull, the fierce Indian chief. I had a pony and used to ride him all about the place, letting my imagination run riot. I gloried in imaginary fights, migrations, hunting, and all sorts of adventure."[5]

This phenomenal combination of the classic philosopher, Renais-

sance intellectual, pioneer hero, and Indian chief fused together in Gutzon's mind to produce a unique set of beliefs. He developed an artistic creed bordering on a religion that determined his entire artistic career.

In 1914, Gutzon Borglum explained how these wildly diverse influences molded his artistic goals:

I was born in the Golden West, reared in the arms of the Church, deluged with "saints to draw from," and suckled on Italian art: my slates were covered from end to end with portraits of Savonarola, Fra Angelico, and Wild Bill and Sitting Bull; I knew all equally well and admired them about alike; Dante, Angelo and Petrarch were my intimate friends, with Crow and Sioux raiding all about. Into this was injected the legends of the Danes, poured into my ears by a Danish mother, while a father talked Socrates till the candles went out. I grew into manhood with this variety of ideals and of life from all the corners of the Old and New Worlds. Over it all, goodness and beauty and the emotions seem to hover. And I remember very distinctly that beauty and form and the making of things all seemed to be a very idle kind of pastime until I myself formed some definite ideals for my own life, quite apart from my own work, and then the work shaped itself to fulfill that life.[6]

His parents encouraged him in his efforts to become an artist. After the family moved to Omaha, Gutzon studied at Saint Mary's, a Jesuit boarding school near Topeka, where he far preferred drawing cowboys and Indians to copying Italian religious art. Finally, tired of this forced confinement, he ran away from school and returned to his family. On the way home he bought his first set of paints. Happily enrolled in the Omaha public school, Gutzon continued his efforts in drawing. "I never had received any instruction in the technique of art," he was later to say, "except from an occasional itinerant teacher who was no good."[7]

In the 1880s, his father moved the family again, this time to Los Angeles, where Gutzon became apprenticed first to a lithographer and then to a fresco painter. He had a small studio of his own in which he continued to paint horses, Indians, and scenes of frontier life. He managed to sell enough of these paintings to earn sufficient money to go to San Francisco where, for the first time, he entered an art school, the Mark Hopkins Art Institute. He studied there for two years and began to experiment with making small sculptures.

In San Francisco, Gutzon married Mrs. Elizabeth Putnam and moved to Sierra Madre. He lived near a ranch which he visited

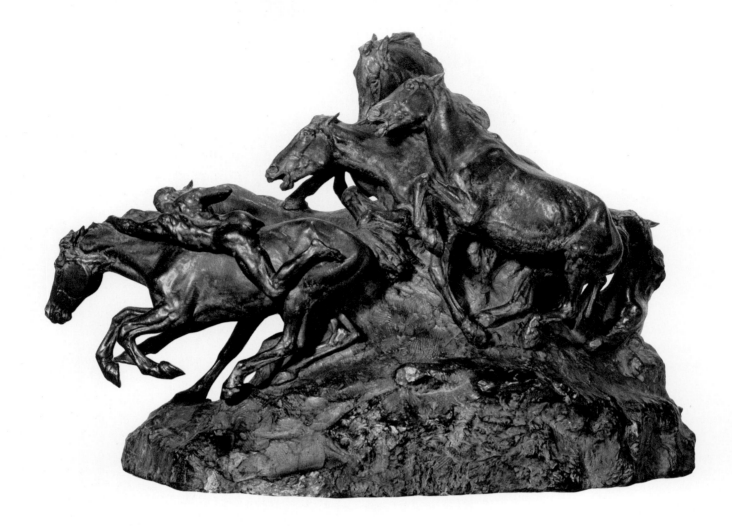

57. Gutzon Borglum. *Mares of Diomedes* (left view). Modeled 1903. Gorham and Co., N.Y. H. 62″. The Metropolitan Museum of Art, New York City. Gift of James Stillman, 1906

frequently in order to draw and model the horses. Gutzon then decided to go East, with Paris his goal, but his money lasted only as far as Omaha, Nebraska. He had brought with him, however, his entire collection of paintings and bronzes, which he sold to a collector for $2,000.

With these funds Borglum traveled to Paris and enrolled at the École des Beaux-Arts and the Académie Julian. He exhibited at the Paris Salon in 1891 and 1892. Gutzon was especially interested in the sculptures of wild animals that were extremely popular in Paris at this time. He particularly enjoyed the wild beauty of the sculpture of Barye and Frémiet.

Gutzon was greatly influenced by the art of Rodin. From his study of Rodin's sculpture, he developed a feeling for sculptural mass and texture. The roughness of surface gave viewers an understanding of the spontaneity of creation. The impressionistic technique produced a harmony between the power of the raw material and the artistic skill of the sculptor's hand. However thoroughly he made his preparatory studies of a subject, Gutzon worked rapidly with great energy and thus retained the original vitality and freshness of expression (*plates 60, 61*).

In 1891 Borglum won his first honor as a sculptor, membership in France's Société Nationale des Beaux-Arts. This award was for a sculpture entitled *The Fallen Warrior* or *The Death of the Chief (plate 59)* which portrayed a horse standing mournfully over a rider laying lifeless on the ground.

Gutzon remained in Europe for three years and traveled through Holland, Belgium, and Spain. Most of his paintings and sculptures were scenes of American Western life. He returned to the United States in 1893 and exhibited *Indian Scout* at the Chicago Exposition.

England at the time was known to be most receptive to American Western art, and so after the Chicago Exposition, Borglum traveled to London. According to one story, it was here that he was first "discovered" by the Duchess of York, later Queen Mary, wife of George VI, and by the Duchess of Manchester. They were delighted by his Indian statues and watercolors which they found in a small shop on Bond Street. In London, Borglum had his first successful public exhibition. He received many orders for portraits and two commissions for a series of mural decorations.

In 1902 Borglum returned to the United States to complete these

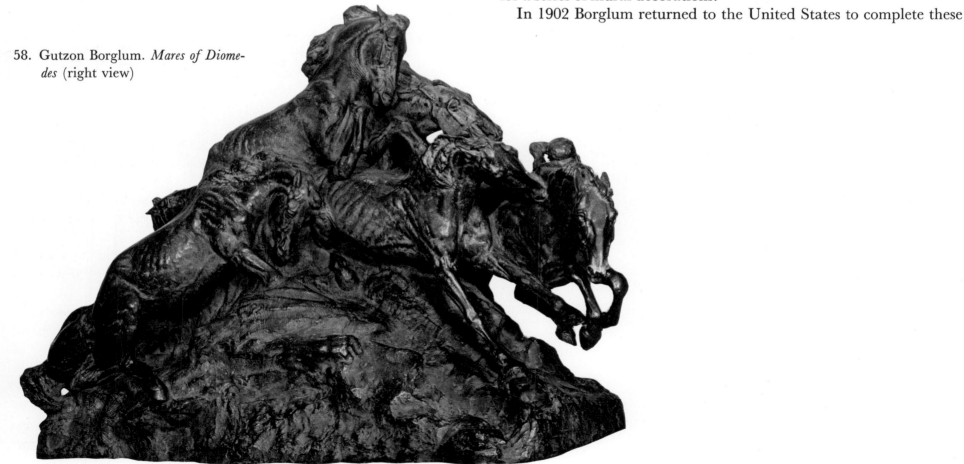

58. Gutzon Borglum. *Mares of Diomedes* (right view)

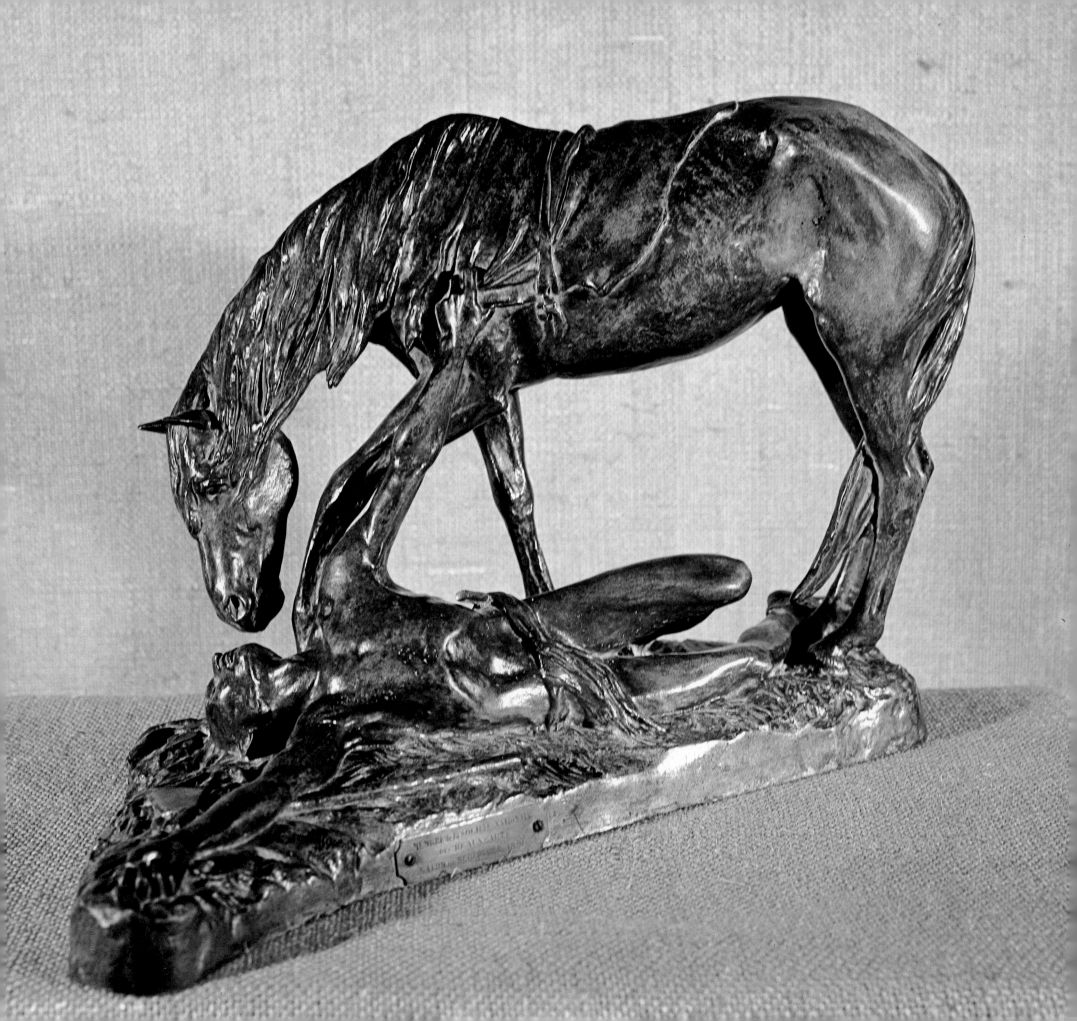

commissions. He set to work on East 38th Street in a studio which had been remodeled from a stable. Here, in the following year, he created his first great sculptural success, the *Mares of Diomedes (plates 57, 58)*. Borglum exhibited this group of four thundering horses at the St. Louis Exposition in 1904 and won the Gold Medal. The Metropolitan Museum of Art in New York subsequently purchased the work for its permanent collection.

This work is a blend of a clearly Western subject with classical and philosophical overtones and explanations. This approach, so important to both the artist and his public at this time, is today unnecessary for our appreciation and enjoyment of a sculpture of a group of stampeding horses, all at a full gallop. We have little need for the explanation that it "symbolized the power of the human mind over brute force."[8] The title *Mares of Diomedes* was added long after Borglum created the model, when a viewer was reminded of one of the Labors of Hercules in which the mythical hero was forced to tame the man-eating mares of Diomedes.

Borglum admitted to the frankly Western theme of his sculpture: "I have utilized a subject from the West—the stealing of horses. The method is, mounting a tractable horse, entering the band, and riding about quietly until the band follows—then leading them away. I stripped the horseman of garments, both to delocalize him and also to show the play of a fine nude figure on a nude horse. The name is a convenience—the motive of the group, mainly intense controlled action."[9]

Borglum was hailed as a success and he was deluged by commissions for statues and monuments. As Borglum became famous as a sculptor, he grew adamant in his artistic beliefs. He hated both imitations of antiquity and art which depended on European example. He demanded that "art in America should be American, draw from American sources, memorializing American achievement."[10] He grew fanatical in his belief about the inadequacy of our national art: "We see our city buildings, our state and national buildings, marked and counterfeited by the symbols of peoples two thousand years dead, and splendid structures built into heroic lines to meet the volume of trade, fretted, ruined by the trinkets and gewgaws plagiarized from the Middle Ages."[11] Borglum declared that most public monuments should be dynamited, particularly the Lincoln Memorial and the National Academy of Design.

When Borglum had exhibited at the Louisiana Purchase Exposition, he had been appalled by what he felt was an abundance of saccharine, academic, European-oriented art. He strove unsuccessfully to become director of the San Francisco Exposition which was to be

59. Gutzon Borglum. *The Fallen Warrior (The Death of the Chief)*. c. 1891. H. 11″. Thomas Gilcrease Institute, Tulsa, Okla.

held in 1915, in the hope of enlightening audiences in the Far West with truly inspired examples of American art: ". . . those mountains ought to screen out this cheap and stolen stuff that was made for a day for St. Louis and Buffalo and Chicago. . . ."[12] As Borglum grew more successful, the subjects of his sculpture became nationalistic rather than Western. He did many portraits of such American heroes as Lincoln and General Sheridan.

Borglum settled in Stamford, Connecticut, where he was always an outspoken and militant social critic, continuously involved in local and national causes. He even became an impassioned sympathizer in the struggle of the newly formed Czechoslovakian Republic and offered his land as a training center for the volunteers.

Borglum's ambitions as a sculptor became truly monumental in scope:

So our land grew, yet Art seemed to be silent about it all, and I have asked and complained not a little of this lack and said we have a great story of our own and we should think and build these great moments into our monuments.

Monumental art must rank as world work. It must see, form, and in no mistakeable terms express the flood of power that surges in the race when it rises to great heights. American artists should be seers and should give, serve, and complete the spirit and concept of Columbus—of Washington—of Lincoln.[13]

One such monumental project, *The South's Lost Cause,* was to show the figures of Robert E. Lee and other leaders carved into a sixteen-

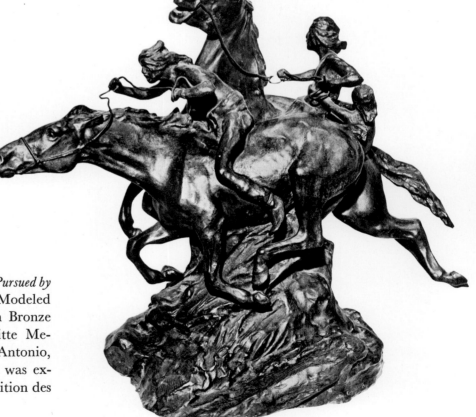

60. Gutzon Borglum. *Apaches Pursued by U.S. Troops* (left view). Modeled 1901, cast 1946. Roman Bronze Works, N.Y. H. 14″. Witte Memorial Museum, San Antonio, Tex. The original model was exhibited at the 1901 Exposition des Beaux-Arts in Paris

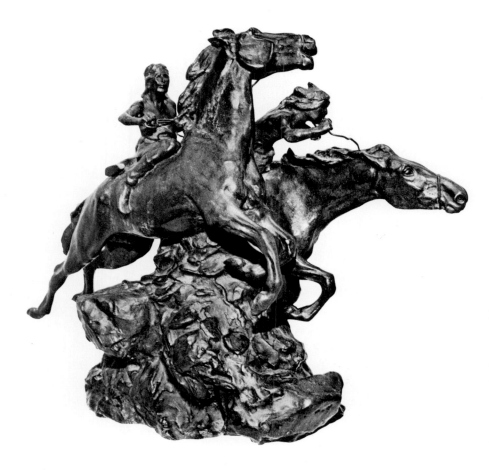

61. Gutzon Borglum. *Apaches Pursued by U.S. Troops* (right view)

story-high relief around Stone Mountain, a giant monolith near Atlanta, Georgia. This carving was to be the Eighth Wonder of the World, but was never completed due to a violent disagreement between Borglum and the Stone Mountain Confederate Memorial Association. One of the points of disagreement was Borglum's refusal to include the figure of a Ku Klux Klansman in his work. Borglum consequently stopped all work on the project and destroyed his models.

Borglum's greatest fame was as the sculptor of Mount Rushmore in the Black Hills of South Dakota. Here, with his son Lincoln, he began *The Shrine of Democracy,* carving into the side of the mountain the heads of four United States Presidents: Washington, Jefferson, Lincoln, and Theodore Roosevelt. The work was still unfinished when he died in 1941, but was completed by his son. By the end of his career, only entire mountains offered surfaces sufficiently monumental in scale to inspire him.

In the 1920s Borglum was commissioned by the Trail Drivers Association to design a monument commemorating a cattle drive along the Chisholm Trail from San Antonio, Texas, to the railroad centers of Kansas. He created a gigantic statue, *Texas Cowboys (plates 491, 492),* thirty-two feet high and forty feet long, which is reputed to have cost $100,000. Borglum's group portrays two cowboys on horseback, driving a thundering herd of Longhorn steers. It has stood in San Antonio, Texas, since its dedication in 1942. Borglum also did a group entitled *A Nation Moving Westward,* erected in Marietta, Ohio.

Borglum lived twenty years longer than his brother Solon. Although during his lifetime he was considered by many critics to be of lesser artistic stature than Solon, he nevertheless made an extremely important contribution to the bronze sculpture of the American West.

Gutzon Borglum was one of the earliest sculptors to celebrate the American West. He was one of the first to be inspired by the pioneers and cowboys, horses and cattle of the West and to glorify them in bronze. Monumental large groups like *Texas Cowboys* and smaller bronzes like *The Fallen Warrior (plate 59)* show his imaginative power and artistic ability.

VI

SOLON H. BORGLUM: THE FIRST COWBOY SCULPTOR

To all the world, the American West is best known as the land of the cowboy. Solon Borglum was the first sculptor to re-create in bronze the beauty, vitality, and isolation of the life of the American cowboy. He was the first to create sculptures which expressed the spontaneity, vigor, and simple harmony of the world of the prairie and frontier.

The bronzes of Solon Borglum express the excitement and exuberance of life in the open and untamed land of the West. This was a life close to the wild beauty of nature, a life of freedom for both man and beast. Yet Borglum knew that the settling of the West would bring an end to this very freedom.

Solon Borglum was born in 1868 in Ogden, Utah, during his family's brief settlement there. He spent the greater part of his childhood in the frontier towns of Nebraska, where he grew to love the life of the prairie.

Like his elder brother Gutzon, Solon joined his father on his medical visits to settlers living in isolated cabins far from the security of towns and to Indians living beyond the border of the white settlements. Frequently, during Dr. Borglum's long round of medical calls, he left his sons at the camp of friendly Indians, where the boys played with the young braves and listened to tales that they would always remember. It was here that Solon developed an empathy with the Indian and an appreciation for Indian civilization which lasted throughout his life. In Nebraska, young Solon learned the skills necessary for the rough life of the prairie. He became a competent horseman and learned to hurl the lasso. He grew to understand the pioneer values of self-reliance, fortitude, and courage.

The colorful tales told by both the old settlers and the Indians kindled Solon's youthful imagination. Once he and his brother ran off in the boxcar of a freight train, fired with the boyish desire to fight hostile Indians. Their only encounter, however, was with the brakeman, who sent the young scouts home.

Solon hated the conformity and regulations imposed by school. He disliked book learning and consequently did very poorly in his

70

studies. When he was fifteen, his parents, realizing that Solon was a total scholastic failure, sent him, along with Gutzon, to work on a ranch in California. On the ranch, Solon perfected the skills and learned the routine of cowboy life. This was the life he truly enjoyed, filled with the freedom he loved.

When the brothers returned from California, Gutzon embarked upon a business venture. Solon, knowing well his necessity for freedom, rejected Gutzon's offer of a partnership and chose the life of a cowboy.

His father owned a six-thousand-acre stretch of desolate prairie land bordering on the Loop River in Nebraska. This land offered Solon a chance to live the wild frontier life he had dreamed of so often. He built a small cabin, stocked the ranch with cattle, and hired some boys to tend the herd. Arthur Goodrich described life on Borglum's ranch:

Through the long, cold winter months, facing the cutting wind and snow of the blizzards on the plains, around the crackling fire inside the cabin, while Joe Andrews, his right-hand man, or one of the other "boys" told stirring stories of other storms and narrow escapes from death, then on through the spring work, the delight of the true cow-puncher, and the long baking summer and finally the alert, straining days of the fall round-up, these men and their horses lived together daily comrades. The plains and their isolation knitted their lives into a single piece. Many a time a pony was unruly in the yard about the cabin, and was caught and controlled only by the most subtle cowboy strategy and brute force, but once out on the open plain with the long reach of prairie in every direction the man and the horse became one in their loneliness, and each toiled in sympathy with the other. It was so with the men as well.[1]

Solon's ranch was an isolated and harmonious world. He delighted in the free open-air existence and grew increasingly perceptive regarding the natural world around him. He developed a sympathy and tenderness for men and animals alike:

Many a time he would urge or lead his pony up some undiscovered ridge of country and, reaching the top, he would sprawl on the sand hill and watch the wind mow paths in the bunch grass below or, looking over the stretch of silent plain and hill to the illimitable blue beyond, he would unwittingly know himself a part of a great inexplicable Something that he could not understand or express. Or after a stampede, as he sat in the saddle or stood beside his horse at night alone, with the sweating flank of the herd before him, and the hills and his cabin back of him somewhere in the blackness, the fierce epic of the plains wrote itself into his heart while he knew it not. Across the black ground, where the blizzard swept snow and sleet into his face, he guided the herd past the dry runs and gullies in which the treacherous snow lay like a quicksand, and when a cow would falter, half frozen and exhausted, with the weird cry of a coyote in his ears he kept courage in the beast because he disliked to leave her to die.[2]

It was this sensitivity to the excitement and the joys, the hardships and the dangers to both men and animals which would later endow Solon's work with a quality previously unknown in American sculpture. In 1922, Louise Eberle wrote: "One might indeed say that he carried into art the spirit of the plainsman, to whom his own brand on his cattle, and none other, is man's inviolable right."[3]

Solon was very happy as a rancher. He was competent in his work, popular with his men and respected by townsfolk who looked upon him as the local peacemaker. He often made sketches, sometimes on brown wrapping paper, of the colorful world around him, but gave no thought to becoming a professional artist. Occasionally he also modeled in clay. It was during these years that he made the half-figure model of his foreman, Joe Andrews. Andrews worked for him until 1890, when Solon's brother Miller came to work on the ranch. The model of Andrews, created before 1890, was first cast in plaster and later in bronze. It is the first "cowboy sculpture."

Solon might have lived his entire life as a rancher, had not his brother Gutzon, already a promising young artist, visited him in 1890. Seeing his sketches, especially those of horses, Gutzon encouraged him and suggested that Solon also had the talent to become an artist. Solon was greatly drawn to this idea. Fascinated with perfecting his drawing and sketching techniques, he spent more and more of his day trying to recapture on paper the world of the ranch and its animals. Finally Solon decided to abandon his life as a rancher and study art. Having made this decision, he sold his ranch to the first bidder and joined Gutzon in the Sierra Madre Mountains in California. With Gutzon he studied the fundamentals of painting and drawing. Soon, however, Solon felt bored and confined studying with his older brother. He decided to strike out on his own and traveled south, taking with him only a blanket and an oil stove.

While traveling through Santa Ana, Solon met a rancher who wished to have his portrait painted. Delighted with the chance to live on a ranch once again, Solon spent four happy months working on the portrait. When the commission was completed, he decided to

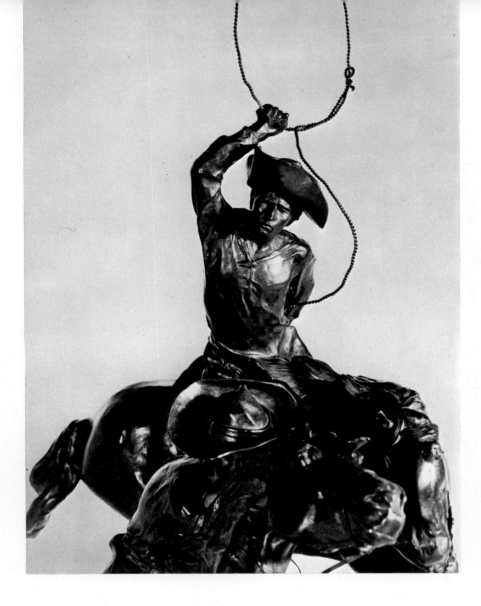

62. Solon H. Borglum. *Lassoing Wild
Horses* (detail of plate 64)

remain in Santa Ana. He rented a small room costing two dollars a month, which served as both home and studio. A hole in the roof was the only source of light for Solon's first studio. Solon lived as simply as possible, sleeping on the floor on his blanket and eating mostly oatmeal and crackers. Even these few expenses were excessive at this time, for Solon had no income.

Life in this small room soon became unbearable. One day Solon nailed a sign to the door, "In studio Saturdays only," and set off into the wilderness of the Saddleback Mountains. He wandered deeper and deeper into the mountains until he came upon a settlement of old Spanish Indians. Each week, Solon stayed in the mountains with the Indians and the migrant workers. Far from urban life, Solon once again was happy, sketching and drawing the people and animals around him. He returned to Santa Ana just before dawn on Saturday to devote the entire day to earning his livelihood.

One Saturday a young school teacher ventured into Solon's studio and requested to have his portrait painted. This first patron of Solon's Santa Ana studio returned the next Saturday, bringing with him two ladies who wished to learn to paint. Their payment each Saturday of one dollar per lesson supported Solon for a year, enabling him to travel weekly into the mountains.

Up to this time, Solon's knowledge of painting came almost entirely from studying articles in old art journals. Wishing for an opportunity to study at an art school, he gathered together his sketches of mountain life and whatever oil paintings he had completed and held an art sale. The sale was a tremendous success and Solon sold his entire output, earning the then fabulous sum of sixty-five dollars. As this was still insufficient to finance his planned journey to Cincinnati, Gutzon paid the difference. Thus Solon once again gathered together his art supplies, his oil stove, and his blanket and traveled to Ohio.

He enrolled in both day and night classes at the Cincinnati Art School. Solon was lonely in Cincinnati and homesick for prairie life. Only when visiting the U.S. Mail stables near his small room did he feel at home. Each morning before classes, Solon walked to the stables and, with special permission, sketched his new equine friends from four until seven o'clock.

For a short time Solon also attended veterinary school. He learned to dissect dead horses and thus developed a superior knowledge of their anatomical structure. To further this knowledge, he decided to try a clay model. His first attempt at sculpture was a subject from Western life, a horse pawing a dead horse on the prairie.

Solon, wishing to know whether he had been successful in this new

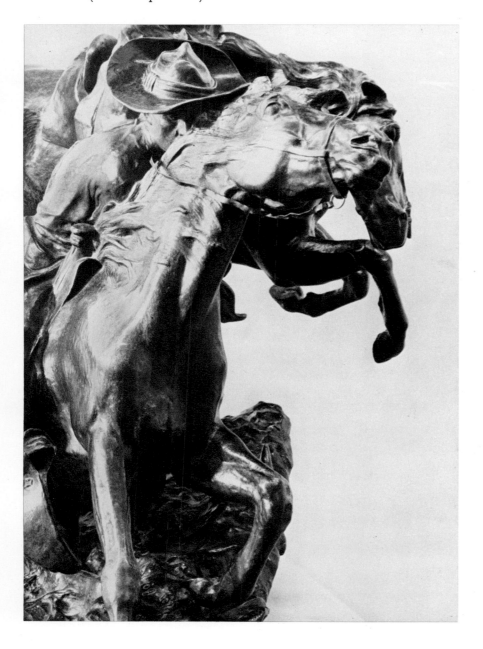

63. Solon H. Borglum. *Lassoing Wild Horses* (detail of plate 64)

medium, wrote to Louis Rebisso, an instructor at the Cincinnati Art School. Rebisso was greatly impressed by Solon's first effort and asked the young artist to enter the sculpture in a school exhibition. Solon won a fifty-dollar prize and a scholarship to the School of Sculpture. Rebisso bought some furniture for Solon's room and offered the young man the use of his own studio. Solon continued to study in the mail stables, and by the end of his first year had completed seventeen sculptures of horses which he placed in the school exhibition. He won the grand prize of one hundred dollars and a second scholarship.

Solon endowed his work with the spirit and inner life of the horse. These sculptures had an emotional quality that transcended physical reality, for his early life on the prairie and his continuous close contact with horses had given him a special insight and understanding of his subject. Louise Eberle described Solon's artistic gift:

And it is this union of complete habitude toward, yet conscious and delighted perception of, his West that gives his Western work its great authority, its depths of human sympathy, and that makes clear the fact that his years there were, actually, a definite preparation for his work as a sculptor. For he saw the human form in action each day of his life, all those years, as the veiled, chained thing is not seen in cities. He saw and lived in such close touch with horses that his relation to them was almost that of a centaur to his horse body. Plastic form, motion, action—those were the things he was feeding on even while he seemed only to be learning ranching.[4]

Solon now aspired to visit Paris. He was eager to see the masterpieces of sculpture created through the centuries, and to live for a few months in the artistic atmosphere of Paris of the 1890s. Rebisso helped him to finance the trip by arranging for a sale of the plasters modeled in art school. The proceeds of this sale, plus his prize money, enabled Solon to journey to Paris.

Solon arrived in Paris in July, 1897, intending to stay only a month or two. He was completely without friends and unable to speak or understand French. To cure his homesickness, he acquired some letters of introduction to one of the largest stables in Paris. He began to visit the stable regularly to work on a Western group he called *Lassoing Wild Horses (plates 62–64)*. He worked and lived in a small room costing four dollars a month. Once again he slept on his blanket and cooked on his oil stove.

Solon attended the Académie Julian but remained only six months, since he disliked both the academic discipline and the use of plaster casts as models. He enjoyed the great examples of sculpture in the

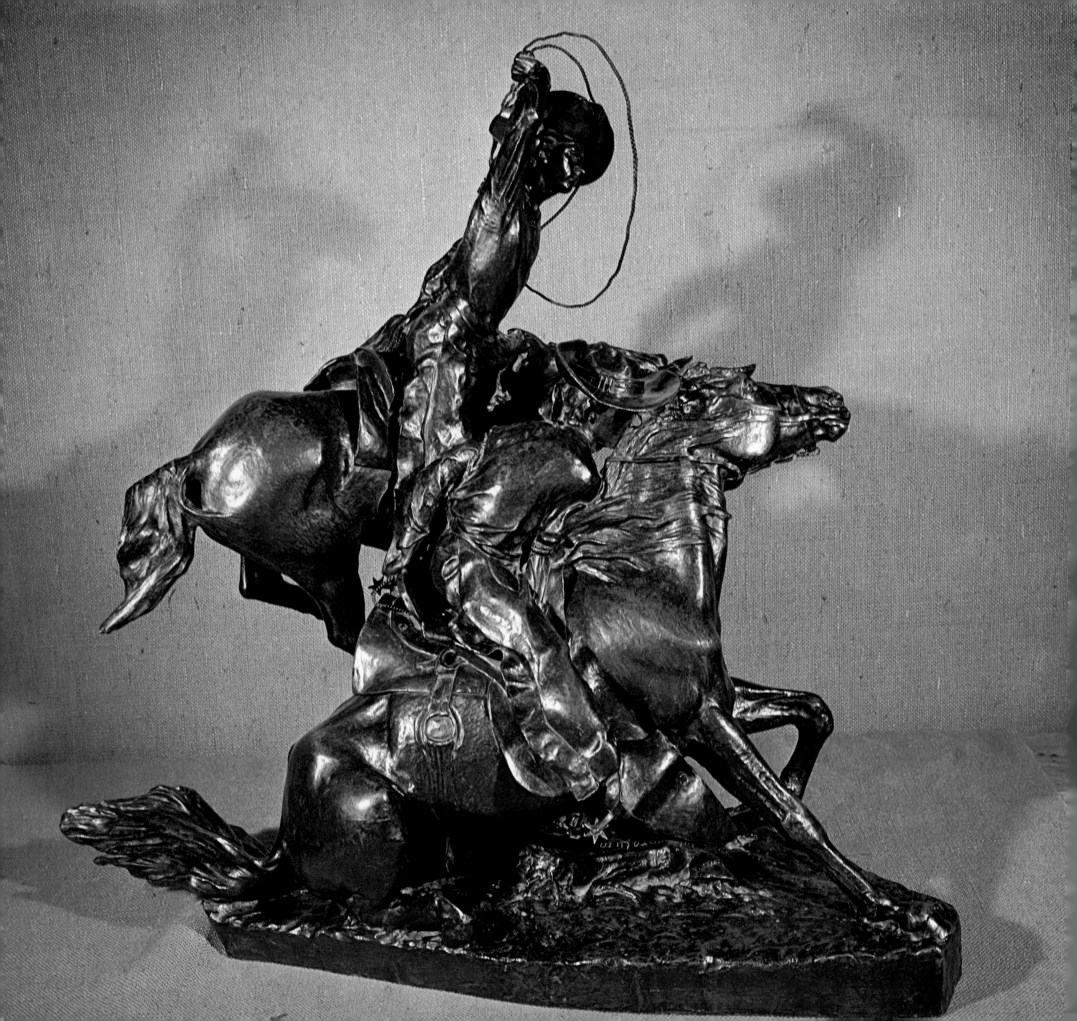

Louvre and the Luxembourg Gardens, but was discouraged with his formal art education. Encouraged in his efforts by Saint-Gaudens and Frémiet, however, Borglum decided to remain in Paris and complete *Lassoing Wild Horses*. He requested and was granted permission from the Cincinnati Art School to do a year's work in Paris. In 1898 he submitted *Lassoing Wild Horses* and a sculpture entitled *In the Wind* to the Paris Salon. Both were accepted for exhibition. He was astounded when the Cincinnati Museum purchased the former for its permanent collection. Subsequently, a life-size model of it was placed inside the U.S. Pavilion at the Paris Exposition.

Encouraged by this fantastic early success, Borglum set to work on several Western groups, *The Bucking Bronco (plate 67)*, *The Rough Rider*, *Night Hawking (plate 68)*, and the large *Stampede of Wild Horses (plate 65)*. Frémiet is reported to have told Borglum, "You are lucky, sir. Many young men go to art school, and come out polished with nothing to say. You lived, you had something to say, then you studied art."[5] When the horse Borglum had used for the model in *Lassoing Wild Horses* became lame, he created *The Lame Horse*.

As Borglum won many honors in Paris, his reputation spread to the United States. A New York dealer purchased several examples of his work for his gallery. It is indeed interesting that the Parisian art public in 1900 was more appreciative of representations of the American West than Borglum's countrymen. Buffalo Bill had made two successful visits to Paris with his Wild West Show. The Parisians were delighted with cowboy and Indian art which, thanks to the enterprising Buffalo Bill, they could now understand and appreciate.

Borglum remained in Paris for four years. He left only once for a short honeymoon following his marriage to Emma Vignal, the daughter of a French clergyman. The Borglums spent their honeymoon on the Crow Creek Reservation in South Dakota. Solon was more than ever drawn to Indian and Western life as the principal subject for his sculpture. Throughout his life, he retained his great friendship for and sympathy with the Indians.

With his improved technical ability and a more mature understanding of the people he visited, Solon began *On the Border of the White Man's Land (plates 14, 15)*, *Burial on the Plains*, and *Our Slave*. *On the Border of the White Man's Land* is one of Borglum's finest sculptures. It portrays an Indian, protected by his horse, scanning the horizon for a potential enemy. There is total harmony between horse and rider as both appear to move with a single rhythm.

Borglum owed the opportunity to work with Indian models to the Reverend Hachaliah Burt, an Episcopal clergyman who was the spiritual leader of the district. Reverend Burt persuaded the Indians to

64. Solon H. Borglum. *Lassoing Wild Horses*. 1898. Susse Foundry, Paris. H. 33″. Thomas Gilcrease Institute, Tulsa, Okla.

65. Solon H. Borglum. *The Stampede of Wild Horses*. 1899. Plaster. Life-size. Original model destroyed. Photo courtesy of Mr. and Mrs. A. Mervyn Davies, Wilton, Conn.

pose for the sculptor and acted as their interpreter so that they could communicate with the young artist. The Western trip delighted the young French bride: "They gave me the oat-bag for a pillow," said Mrs. Borglum, "and it is not such a bad pillow. But when the horse eat the oat then at last there is no more pillow."[6] This trip, the last time Borglum was able to live in the West, was the source of great inspiration in his work for many years thereafter.

In 1901 Borglum left Paris and he returned to the United States, an established figure in the art world. During that year, Augustus Saint-Gaudens sponsored his successful election to the National Sculpture Society. In 1903, Lorado Taft wrote: "Mr. Borglum's work is only begun, but it gives promise of a new and virile interpretation of the magnificent 'epic of the West'; of an art of national flavor, yet distinctly individual, which will be enjoyed long after the cowboys have followed the wild red men over the 'long trail' into the dim land of legend and song."[7]

At the St. Louis Exposition in 1904, Borglum exhibited nine small Western bronzes: *On the Trail (plate 71)*, *In the Wind*, *The Lame Horse*, *The Bull Fight*, *New Born (plate 66)*, *Blizzard (plate 72)*, *Deer Killing a Snake*, *Dancing Horse*, and *Our Slave*. Borglum won the Gold Medal for sculpture at the fair. Four large groups stood in the fair's main concourse: *Peril of the Plain*, in which a cowboy huddles against his horse for protection against an oncoming storm; *Cowboy at Rest*; *The Sioux Indian Buffalo Dance (plates 74, 75)*; and *Steps Toward Civilization (plate 73)*, showing an Indian advising his son. Wayne Craven

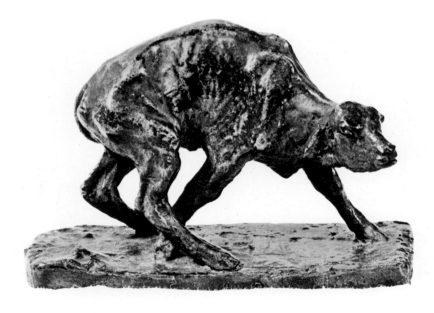

66. Solon H. Borglum. *New Born*. 1900. Roman Bronze Works, N.Y. H. 4″. Joslyn Art Museum, Omaha, Neb.

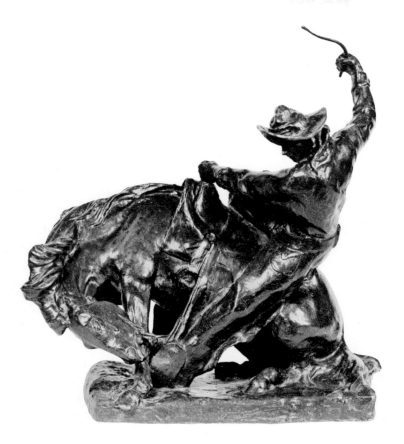

67. Solon H. Borglum. *The Bucking Bronco*. 1898. Roman Bronze Works, N.Y. H. 15". R.W. Norton Art Gallery, Shreveport, La.

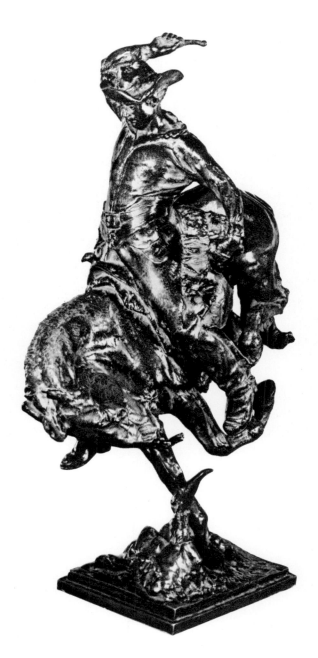

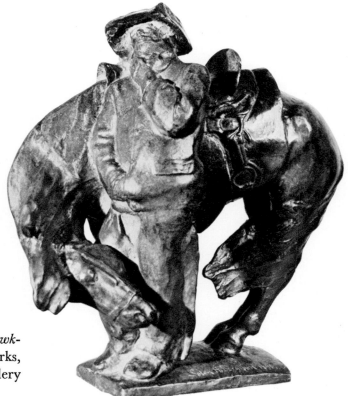

69. Solon H. Borglum. *The Bronco Buster (One in a Thousand)*. 1901. H. 43½". Whitney Gallery of Western Art, Cody, Wyo.

68. Solon H. Borglum. *Night Hawking*. 1898. Roman Bronze Works, N.Y. H. 12½". Whitney Gallery of Western Art, Cody, Wyo.

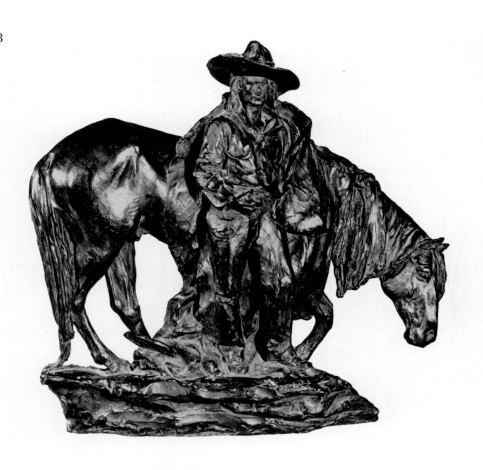

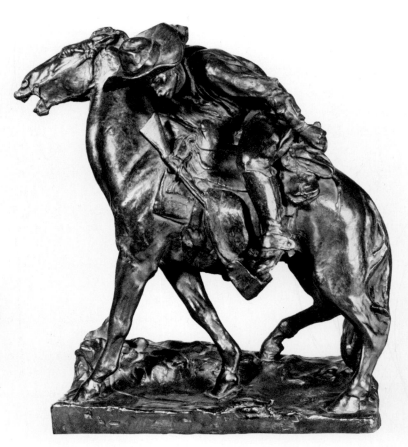

71. Solon H. Borglum. *On the Trail.*
1900. Roman Bronze Works, N.Y.
H. 14½″. Joslyn Art Museum,
Omaha, Neb.

70. Solon H. Borglum. *Evening.* c.
1905. Roman Bronze Works, N.Y.
H. 22″. Collection Deborah B.
Chastain, Saratoga, Wyo.

72. Solon H. Borglum. *Blizzard.*
1900. Sklaber and Co., N.Y. H.
5¾″. Detroit Institute of Arts,
Mich.

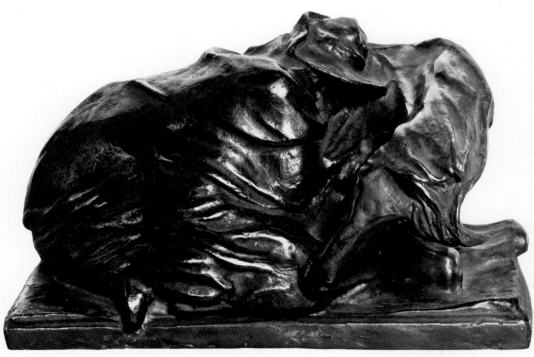

described the highly complex *The Sioux Indian Buffalo Dance,* which was later cast in a small version, as "a dance in which those powers of the red man's universe were emplored to send the life-sustaining buffalo to his people once more. Hooded and cloaked in a buffalo hide, a wiry medicine man, clad only in breechcloth and moccasins, crouches to make a mighty leap, his body tight as a coiled spring; an old man chanting beats a drum at the rear of the group, and a stalwart chief stands on the other side."[8]

Borglum worked for a short time in New York City, then moved to Rocky Ranch in Silvermine, Connecticut. He worked in his barn, which he had converted into a studio.

In 1906 Borglum was commissioned to create a monument *(plate 76)* in honor of William Owen ("Bucky") O'Neill of Prescott, Arizona. O'Neill, who resigned as Mayor of Prescott to become one of the Rough Riders under Colonel Theodore Roosevelt, was fatally wounded in the Battle of San Juan Hill (1898) and was buried in Arlington National Cemetery. Borglum's monument of Captain O'Neill astride a bucking horse was dedicated in Prescott in 1907.

Two years later in San Francisco, Borglum created a second equestrian monument, *The Pioneer,* which stood in the Court of Flowers, opposite James Earl Fraser's *The End of the Trail.* Borglum's statue shows a courageous man of the plains, similar to many frontiersmen he had known in his youth, riding forward with rifle in hand to meet the countless challenges of the frontier.

Although Borglum was nearly fifty years old when World War I began, he went to France and was twice gassed while aiding the troops. His official title while in military service was Director of the Sculpture Department of the American Expeditionary Force's Educational System. On his return to the United States, he helped establish an art school to rehabilitate soldiers and was awarded the Croix de Guerre by the French government.

Borglum became increasingly interested in art education and in 1919 established the School of American Sculpture, whose methods were based on three principles: "belief in sheer hard labor in a given direction, belief that every individual should start for himself at bedrock, and belief in a true art heritage for America."[9] Borglum's greatest desire was for his own art to be truly American.

In the last years of his life, Borglum worked on two bronzes of Indian chiefs to which he gave the abstract philosophical titles *Aspiration* and *Inspiration.* They are in the church of St. Mark's-in-the-Bowery in New York. In 1922, at the age of fifty-three, Borglum died suddenly of acute appendicitis.

Borglum's work is distinguished by great originality in both tech-

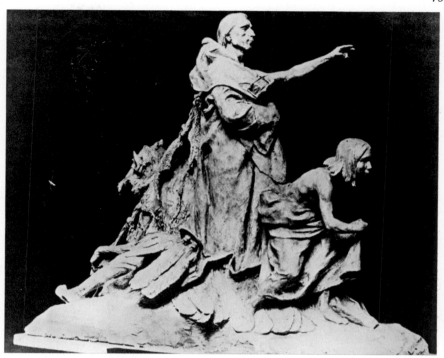

73. Solon H. Borglum. *Steps Toward Civilization.* 1904. Plaster. Heroic size. Collection the Borglum Family. Photo courtesy of Mr. and Mrs. A. Mervyn Davies, Wilton, Conn. The Indian has thrown down his war bonnet and taken up a book, the symbol of the white man's civilization

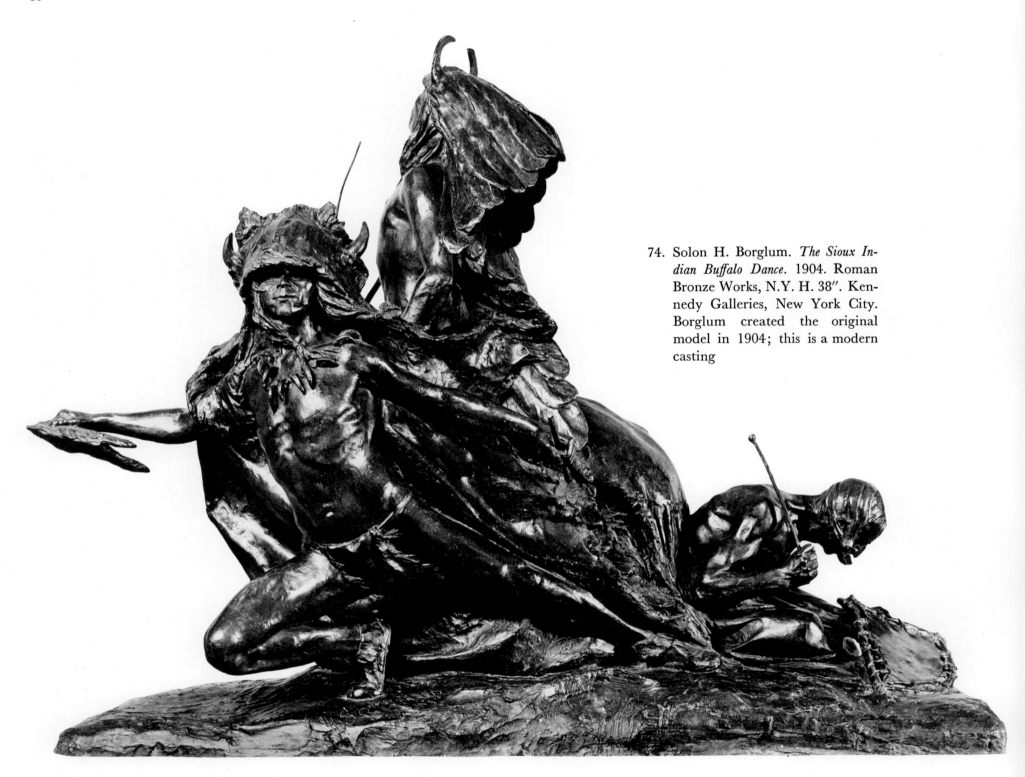

74. Solon H. Borglum. *The Sioux Indian Buffalo Dance.* 1904. Roman Bronze Works, N.Y. H. 38″. Kennedy Galleries, New York City. Borglum created the original model in 1904; this is a modern casting

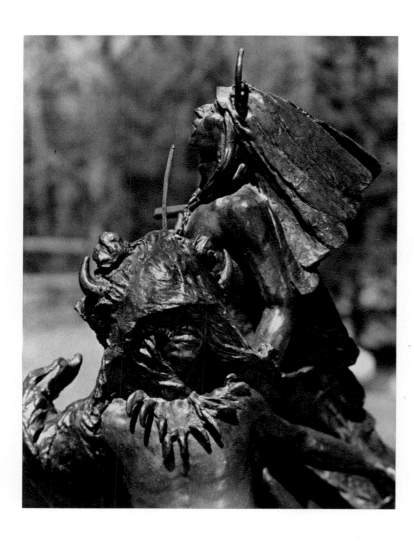

75. Solon H. Borglum. *The Sioux Indian Buffalo Dance* (detail). Collection Mr. and Mrs. A. Mervyn Davies, Wilton, Conn.

nique and subject matter. His sculpture is realistic and natural in detail, and shows a total disregard for symmetry. Borglum strongly believed in the importance of technical proficiency. He designed a book entitled *Sound Construction*, published in 1923, which was filled with illustrations of comparative plant and animal forms.

Borglum's sculptures are often impressionistic, showing the strong influence of Rodin. This is especially evident in sculptures which portray great blizzards or high winds. The blur of outline, due to a lack of detailed modeling, creates the true feeling of a storm, during which it is impossible to distinguish exact detail. The viewer is able to sense the strength and turbulence of the moment.

Several of Borglum's sculptures have the feeling that they are still in the process of creation. Their roughness of surface suggests a vitality and spontaneity unattainable in an overly polished and symmetrical work. Lorado Taft wrote that Borglum's groups have the "accidental look of fragments of rock or of twisted ingots of melted metal, but they are sure to reveal somewhere the caressing touches of a trained and intelligent hand."[10]

Borglum's greatest strength was in his knowledge and understanding of the men and animals of the prairie. He knew firsthand the feelings of the cowboys and could identify with their problems of isolation, their sense of purpose, and their feeling of being at one with nature. Borglum understood the intimate relationship between the cowboy and his horse *(plates 67, 69, 70–72)*. Indeed, Borglum's sculpture, thanks to the many years he lived with horses as practically his only companions, shows that he understood the emotions of the horse equally well as those of the rider. Borglum is proficient in re-creating every phase of the life cycle of the frontier horse: the tender relationship of the colt with its mother, the terrible and fearful necessity of learning to accept saddle and rider, the peaceful days of camaraderie while working on the range, and the fierce winter when the horse is his master's sole protection against the raging storms *(plates 72, 79)*.

Solon Borglum was America's first cowboy sculptor. Lorado Taft described Borglum as "a genuine product of the West, who unites in his creations the untamed freedom of the frontier with the tenderness of the true artist."[11]

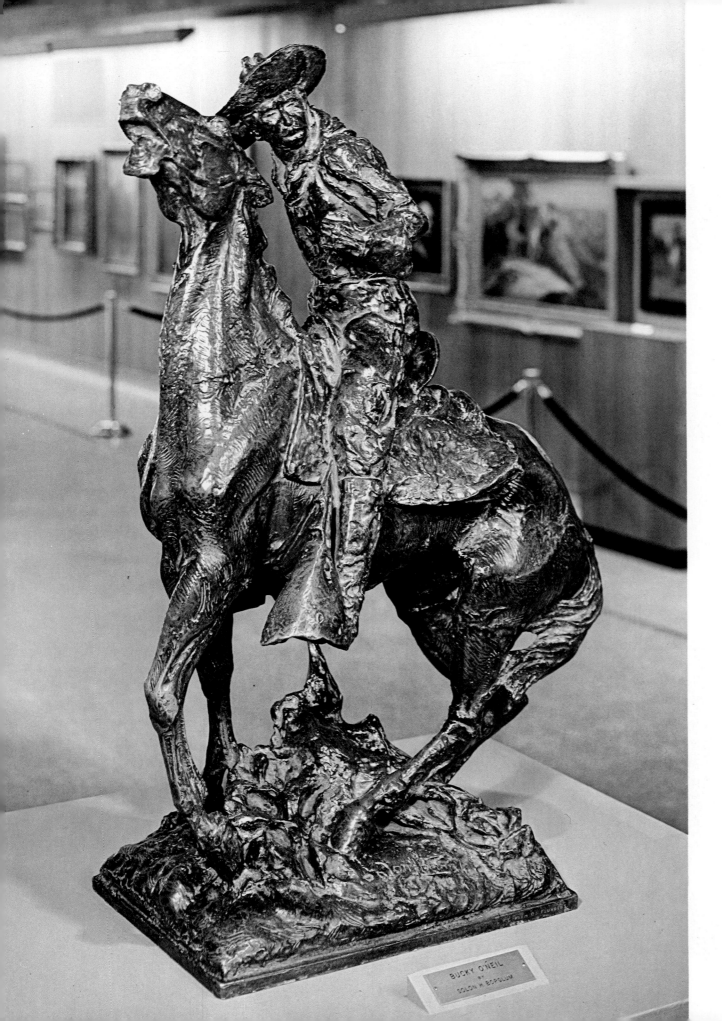

76. Solon H. Borglum. *Bucky O'Neill*. 1907. Roman Bronze Works, N.Y. H. 44″. Whitney Gallery of Western Art, Cody, Wyo. This is a reduced model of the bronze statue in Prescott, Ariz.

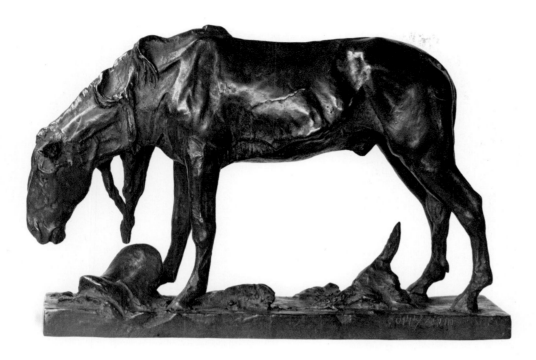

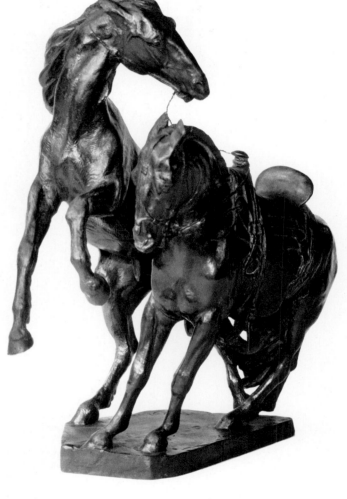

77. Solon H. Borglum. *Horse Tamed.* Roman Bronze Works, N.Y. H. 7¾". Detroit Institute of Arts, Mich.

78. Solon H. Borglum. *Intelligent Bronco.* Roman Bronze Works, N.Y. H. 20¾". Detroit Institute of Arts, Mich.

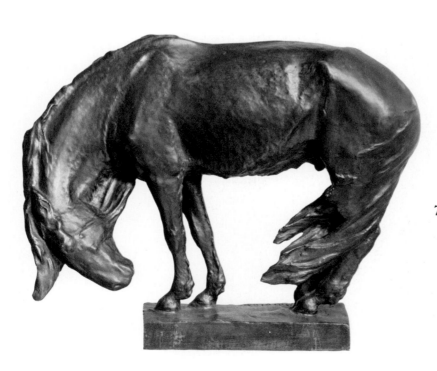

79. Solon H. Borglum. *Winter.* 1898. H. 10½". Cincinnati Art Museum, Cincinnati, Ohio. Gift of W. W. Taylor, M. E. Ingalls, D. H. Holmes, Alexander McDonald, L. B. Harrison, J. G. Schmidlapp. The model was purchased from the artist. A.T. Goshorn had the figure cast into bronze

VII

HERMON A. MACNEIL: IMMORTAL INDIANS

Hermon Atkins MacNeil was one of the sculptors most influential in winning worldwide recognition of the American Indian as a valid artistic theme. His early statues helped viewers in both the United States and Europe learn to accept and appreciate these truly American representations.

While earlier artists like Paul Wayland Bartlett, John Boyle, and Randolph Rogers executed an occasional "exotic" sculpture, MacNeil dedicated the early years of his career to portraying the beauty and dignity of the Indian race.

Although MacNeil envisioned the Indian as a "noble savage," he added a new dimension to Indian sculpture by portraying the majesty and pride of the primitive people. He saw the Indians as participants in long-established traditions and rituals. Early in his career, MacNeil traveled throughout Arizona, New Mexico, and Colorado in order to study the customs and ceremonies of the tribes and to learn the histories of their leaders. Rejecting the view of the Indians as childlike and simplistic in behavior, MacNeil saw them as idealistic exponents of an untarnished culture.

MacNeil was born in 1866 in Chelsea, Massachusetts. He enjoyed childhood on his father's farm and was educated in a local public school. He received his training in art at the State Normal School in Boston and, after his graduation, taught modeling at Cornell University for three years. In 1888, following the tradition of artists of his generation, MacNeil traveled to Paris to study at the Académie Julian with Chapu and at the École des Beaux-Arts with Falguière.

Upon returning to the United States in 1891, MacNeil went to

80. Hermon A. MacNeil. *Return of the Snakes.* c. 1896. H. 23″. Thomas Gilcrease Institute, Tulsa, Okla. This bronze is frequently called *Moqui Snake Dance*

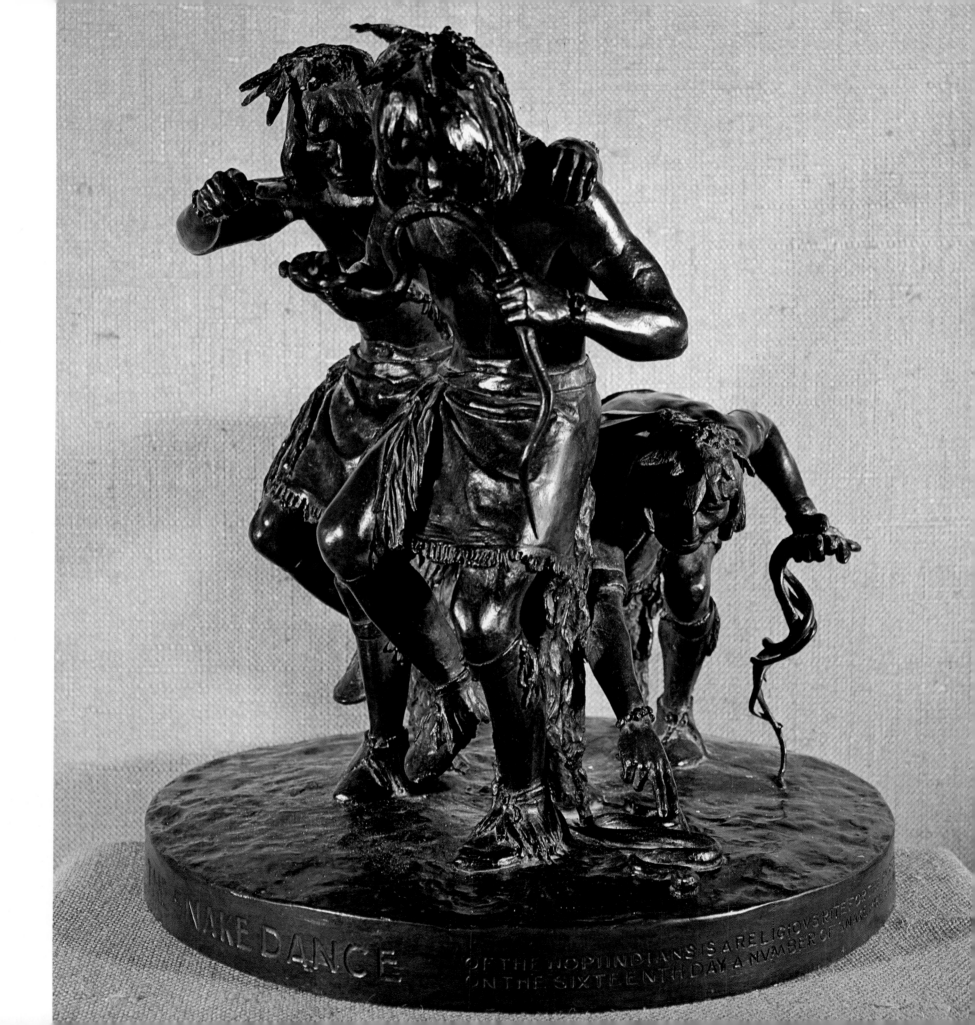

THE SNAKE DANCE ... OF THE HOPI INDIANS IS A RELIGIOVS RITE FOR ... ON THE SIXTEENTH DAY A NVMBER OF SNAKE ...

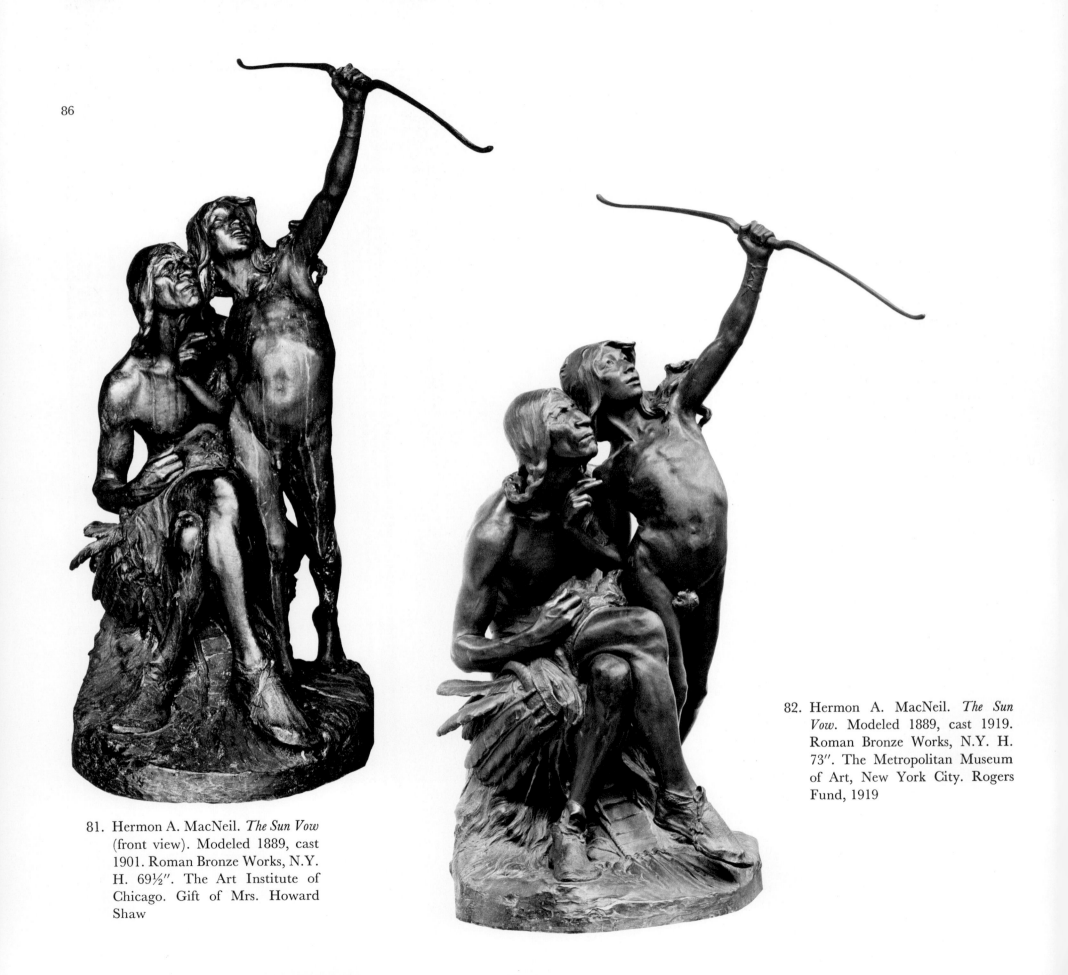

86

81. Hermon A. MacNeil. *The Sun Vow* (front view). Modeled 1889, cast 1901. Roman Bronze Works, N.Y. H. 69½″. The Art Institute of Chicago. Gift of Mrs. Howard Shaw

82. Hermon A. MacNeil. *The Sun Vow*. Modeled 1889, cast 1919. Roman Bronze Works, N.Y. H. 73″. The Metropolitan Museum of Art, New York City. Rogers Fund, 1919

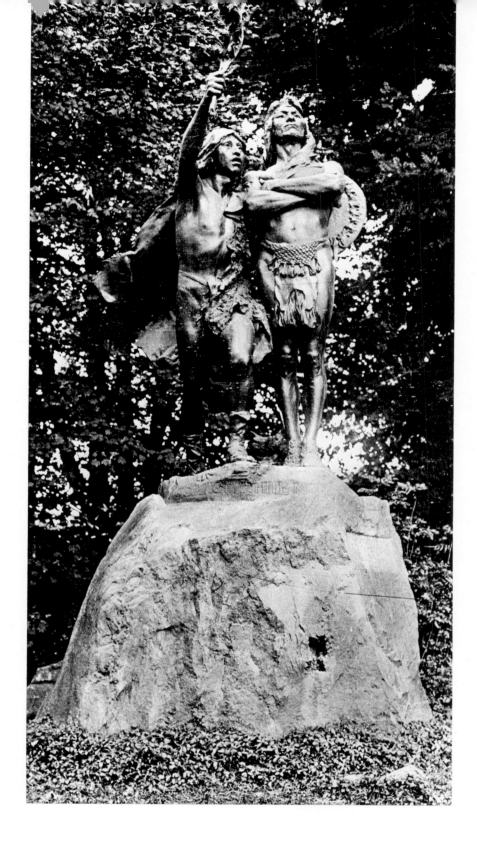

83. Hermon A. MacNeil. *The Coming of the White Man.* Modeled 1902–3, dedicated 1907. Washington Park, Portland, Ore. Photo courtesy The Oregon Historical Society

Chicago to assist Philip Martiny with sculpture for the forthcoming World's Columbian Exposition. After four years of studying Parisian sculpture, MacNeil thought American architectural design and sculpture was lacking in inspiration and national character. He wished to see American sculpture more expressive of the background and traditions of its own land.

In Chicago, MacNeil developed his first interest in the American Indian. Buffalo Bill's Wild West Show was a highlight of the fair. This show was a source of artistic inspiration to many young artists both in Paris and in the United States. MacNeil was fascinated by the Indians in the show, and he visited the fair at every opportunity, making as many sketches as possible. These served as reference for many of his later works. MacNeil felt that by sculpting the ceremonies and rituals of Indian life, he could create a truly national art form. He believed that the Indian was comparable to the Greek warrior in beauty and dignity, and thus was worthy of artistic immortality.

One day, MacNeil met a Sioux Indian, Black Pipe, who had remained in Chicago after the fair had closed. Black Pipe became the model for MacNeil's first Indian sculpture, a portrait in high relief. He also served as model for the sculpture which brought MacNeil his first public acclaim, *A Primitive Chant (plate 9),* which depicts the uninhibited dance of an Indian flutist.

MacNeil settled in Chicago and opened a small studio. He made several trips to the Southwest to determine what sculptural motifs best expressed "original" American traditions. He visited the reservations of the Moqui and Zuni tribes, and studied the rituals and costumes of their daily life as well as their special ceremonies and crafts.

MacNeil returned to Chicago to decorate the Marquette Building. His reliefs over the entrance doors illustrated the life of the adventurous Jesuit priest Père Jacques Marquette, who was one of the early explorers of the Mississippi River and worked with the Indians in the years when Chicago was still wilderness territory. Simultaneously, MacNeil also taught at the Chicago Art Institute.

In 1895, MacNeil was awarded the Rinehart Scholarship to study

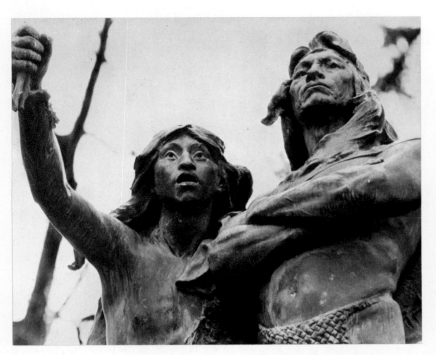

84. Hermon A. MacNeil. *The Coming of the White Man* (detail of plate 83)

sculpture in Rome. Before sailing for Europe, he married a former pupil, Carol Brooks, who shared his dream of Rome as the mecca of artistic achievement. The conditions of the scholarship were ideal: for four years the sculptor lived in the Villa dell'Auro, all expenses paid, and was free to work on the subjects of his choice. To show "satisfying evidences of industry," the only productions required were "a life-size figure at the end of the second year, a relief containing two life-size figures before the close of the third year, and during the fourth year, a life-size group of two or more figures in the round."[1]

What effect did the wonders of the ancient and Renaissance worlds have on young MacNeil's art? His first creation was *Return of the Snakes*, also known as *The Moqui Snake Dance* or *The Moqui Runner (plate 80)*, depicting a nude Indian racing through the cactus carrying a mass of rattlesnakes. An Indian priest, having used the snakes in a tribal ceremony to pray for rain to save the crops, is running down the Mesa to set the snakes free so that they may carry the prayers for rain to heaven. The snakes represent lightning. Mac-Neil had watched a snake dance on his visits to Hopi country. In 1939, he used the theme for a second time for a commemorative medal.

MacNeil's next sculpture was *A Primitive Chant*. In his second version of this subject, he portrayed a majestic Indian, on his knees, chanting through the crook of his raised arm. This was MacNeil's first Indian sculpture to have a sense of monumentality and power. In 1907, a critic wrote in praise of MacNeil's Indians: "They are genuine savages—not cigar store Indians nor 'Wild West Show' specimens. . . . But while the types are genuine, caught 'in the open,' they are not the shiftless, saloon types. His Indians do not shoot deer out of season, nor tap other men's maples."[2]

To satisfy the requirement for a two-figure relief, MacNeil created the complex and abstract *From Chaos Came Light*, a far less effective work than his Indian sculptures. His final sculpture for the Rinehart Scholarship was *The Sun Vow (plates 81, 82)*, which won the Silver Medal at the 1900 Paris Exposition and became one of his most famous works. A boy has just shot an arrow toward the sun while an old Indian seated next to him watches its flight. This was a re-creation of a Sioux ceremony, testing the qualifications of a young boy to become a warrior. To attain success, the boy must shoot the arrow straight at the sun, far enough to make it disappear from sight. This statue is also interpreted as an old Indian teaching a young boy to always have the highest aspirations in life.

MacNeil's sculpture has precise and authentic details which are

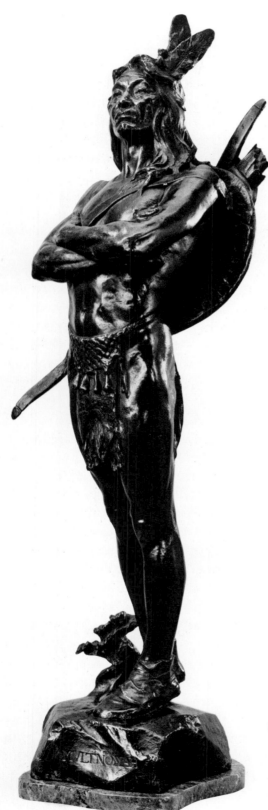

simplified in order to have the greatest dramatic impact. MacNeil employed a variety of surface textures and modeled Indians beautifully in the finest Parisian tradition; however, neither the surface texture nor the details detract from the harmony of the whole. The harmony of composition reinforces his themes of the continuity in Indian life from one generation to the next, and of the harmony between the generations.

MacNeil's cousin, Vernon MacNeil, a professor of art history at Bacone College in Oklahoma, described an incident which illustrates MacNeil's insistence on authenticity: "When the sculptor, George Blodgett, who was familiar only with the Pueblo Indians of the Southwest, criticized *The Sun Vow* for not being *Indian*, Hermon asserted that it was more *Indian* than any piece of sculpture he would ever see. For the model, he had used a plaster cast taken from one of the Indians Columbus had taken back with him and was presently in the Louvre."[3]

Rome and the creations of classical antiquity and the Renaissance made little impression on MacNeil. The American Indian remained his primary source of inspiration. Rome had equally little influence on his style. Following the tenets of Romantic Naturalism taught in Paris at this time, MacNeil favored strong impressionistic modeling and realistic details in his sculptures.

On leaving Rome in 1899, MacNeil returned to Paris for a year's work and study. The following year he returned to the United States, a famous sculptor. He devoted the next fifteen years to commissions for the many expositions celebrated throughout the United States: the Pan-American Exposition in Buffalo (1901); the Charleston Exposition in South Carolina (1902); the Louisiana Purchase Exposition in St. Louis (1904); the Lewis and Clark Exposition in Portland, Oregon (1905); and the Pan-Pacific Exposition in San Francisco (1915).

As most of the sculptures for these exhibitions were made of staff, a combination of plaster and straw, only a few have survived through the years. One of MacNeil's best-known Indian figures was *The*

85. Hermon A. MacNeil. *A Chief of the Multinomah Tribe.* 1905. Roman Bronze Works, N.Y. H. 33⅜″. The Metropolitan Museum of Art, New York City. Bequest of Jacob Ruppert, 1939

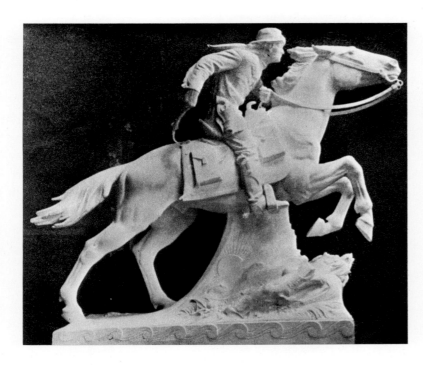

86. Hermon A. MacNeil. *Pony Express*. Dedicated 1940. Plaster model. Civic Center Park, St. Joseph, Mo. This photo was sent by MacNeil to his nephew Vernon to illustrate his progress with the model

Adventurous Bowman, a giant figure atop a column at the Pan-Pacific Exposition.

During this period, MacNeil also made many small bronze figures. The Pratt Institute in New York held an exhibit of twenty-two of MacNeil's sculptures, seventeen of which depicted Indian subjects. *Early Toil*, a small bronze of an Indian maiden carrying a water jar, is a successful example of his work at this time.

Perhaps the most famous of MacNeil's Indian sculptures is *The Coming of the White Man (plates 83, 84)*, designed for Washington Park in Portland, Oregon. This group is composed of two Indians, the Chief and the Medicine Man of the Multinomah tribe of Oregon. The Chief stands firm, his arms folded, the symbol of dignity and racial pride. The Medicine Man, the prophet of his people, points out to his leader the approach of the white settlers. Perhaps it is due to the Medicine Man's ability to foretell the future that he alone shows excitement and apprehension. There have been many interpretations of the majestic reception of the newcomers. These contrasting figures compose one of the most dramatically effective representations of the Indian's reactions to white civilization. When the Chief of this group is cast separately, the statue is called *A Chief of the Multinomah Tribe (plate 85)*.

After 1910, MacNeil, then a highly successful artist, abandoned Indian sculpture. He yielded to popular taste and fed the public's appetite for abstract personifications, heroic monuments, and portraits. Only a few of these—for example, the statue of Père Marquette for Chicago's West Park and a statue of General George Rogers Clark for Vincennes, Indiana—may be considered Western in subject matter. In 1916, MacNeil designed the silver twenty-five-cent piece for the U.S. Mint, depicting an American eagle on one side and the personification of Liberty on the other.

When questioned in 1937 about his early success with Indian sculptures, MacNeil said that he wished he could go back and revisit the Indian country, travel the old trails, and smell the Western air once more. He remembered particularly an Indian statue he had made of the Navaho chief Manuelito in Gallup, New Mexico. He said he had made it one summer around the turn of the century when he was "doing the West" for the Santa Fe Railroad:

. . . old man Cotton, an Indian trader, came in and wanted to talk to the sculptor. He showed Hermon a photograph of Manuelito (who had just died) and asked if he could work from it. Hermon said, "of course,". . . He called Mr. Cotton in when he had finished asking if it was OK. He said he would see. He let a Navajo woman into the

room and closed the door. When she came out a few minutes later crying, he said it was OK. She was Manuelito's widow.[4]

MacNeil's last major work was his *Pony Express* monument for St. Joseph, Missouri, dedicated in 1940 *(plate 86)*. He had won the commission for the monument in a competition sponsored by the W.P.A. and worked with the same enthusiasm for his model as during his student days. Greatly pleased with his progress, MacNeil wrote to his nephew:

I wish you could see my studio now with this huge equestrian filling it quite completely and the whole place given over to it. Research I have made in all directions so I think I have forestalled criticism from every point of view and have had a very warm O.K. from a man who is said to be the best authority on horses in the country. His remark was that he had seen a great many equestrian statues, mostly bad, but that I had made an outstanding one. There was some discussion previous to my interpretation as to what kind of horse was used on these Pony Express rides and this authority says I have exactly the horse that fits the bill and have designed it with the rider reaching forward at a full clip with flying scarf, etc. that it looks as if it was going. For support of the horse I have used a scheme I have never yet seen in this form.[5]

MacNeil died in 1947, in his home at College Point on Long Island Sound, where he had lived and worked for forty-seven years. Here, in 1966, the twenty-eight-acre Hermon Atkins MacNeil Park was named in his honor.

VIII

CYRUS DALLIN: PROTEST IN BRONZE

Cyrus Dallin was one of the first sculptors to recognize the plight of the American Indian and to devote his life and art to making dramatic and heroic monuments which proclaimed the Indian point of view.

Dallin's sculptures were a protest against the deceitful and inhumane treatment of the Indians by the United States government. Dallin mourned and protested the banishment of the Indians from their original home. Deprived of both their hunting grounds and of their traditional game, the buffalo, the Indians were moved to poorer and poorer lands. Often they were confined to reservations, doomed to a life made wretched by poverty and disease.

By the late nineteenth century, the Indian appeared to be a dying race. He was being swallowed by a society totally alien to his culture and values. The Bureau of Indian Affairs had with equanimity broken treaty after treaty in the name of progress. To the nineteenth-century mind, it was "manifest destiny" that the white man should settle the American continent from coast to coast. If the Indian vanished as a race, it was part of the march of civilization.

Indian civilization was a familiar artistic theme long before Dallin's creations. By the 1830s, George Catlin had begun his massive documenting of the beliefs and customs of various Indian tribes. In the 1830s and 1840s, Karl Bodmer, Seth Eastman, and Alfred Jacob Miller were masters of painting who delighted in the beauty and pageantry of Indian life. They were but a few of the many painters who found Indian life a constant source of artistic inspiration. Some were idealists, some were realists, but all saw Indian civilization as inspirational and worthy of preservation. By contrast, it was the American sculptors who clung so dearly to the themes and stereotypes of classical and Renaissance art.

Early sculptures of the Indians had been primarily idealizations, for most artists who glorified the aboriginal heroes were Easterners, totally removed from contact with the Indians in their everyday life. To them, the Indian was either a romantic figure of the past or a

"noble savage," belonging to a world of uncivilized wilderness. They had little interest in the philosophical beliefs of the Indians. The Indian was purely a decorative and exotic member of a mysterious race, not a human being whose world was being destroyed.

Most American sculptors lived in the sophisticated world of the northeastern United States and in Paris, a world of studios, art academies, and galleries. The most zealous of them traveled West so that their sculptures might have a physiognomical authenticity and that the costumes and weapons might be ethnologically correct. Olin Levi Warner was the first to create sculptural portraits of Indians and thus to recognize their dignity as individuals. Hermon Atkins MacNeil through his sculpture expressed the beauty and majesty of the Indian and his rituals. Edwin W. Deming was sensitive to the unjust treatment of the Indian, although he chose to re-create their history and culture through mural painting rather than through sculpture.

Most of the early Western settlers were totally involved in the struggle to survive on the frontier and establish their families in their new homes. There were neither art schools nor artists to inspire the young. To many pioneers, the Indians were a terror. Many tribes retaliated against those who came to take over their land and greeted the newcomers with overt hostility. Tales of Indian massacres and horrors were an everyday part of frontier life. The pioneers made little effort to analyze the problems of the Indian or the causes of his actions.

Who then was to act as spokesman for the American Indian? To the Westerner, the Indian was a fearful man of terror and mystery; to the Easterner, he was an exotic and noble "child of nature." Cyrus Dallin recognized the unjust treatment of the American Indians and devoted most of his life to immortalizing their tragic story. He endowed his Indian statues with a dignity and humanity heretofore unknown.

Through tracing the early life of Dallin, it is easy to understand the origin of his feelings of admiration and respect for the Indians and his indignation at the injustices dealt to his friends. Cyrus Dallin was born in 1861 in a log cabin in the newly founded settlement of Springville, Utah. Eleven years before, his English-born parents, Jane and Thomas Dallin, had helped to found this Mormon village. They had joined a wagon train for the long and dangerous journey across the plains and mountains to the Territory of Utah. In the isolation of the Wasatch Mountains, these Mormons hoped their new religion might flourish, free from religious persecution. Three years earlier, Brigham Young and his followers had founded the center of the Mormon world, known today as Salt Lake City.

In the Utah wilderness, the Dallins and other pioneers built their cabins. Then, heeding the warnings of their prophets, they surrounded their village with an adobe wall ten feet high, which they hoped would protect them from the impending fierce attack of neighboring Indians. These hostile red men, however, proved to exist only in their vivid imaginations. In reality, Springville was settled near a tribe of friendly Ute Indians who came each spring and fall to trade with the white settlers.

Young Cyrus marveled at the colorful teepees which the Utes pitched each season. He made friends with the Indian boys and learned to play their games. His favorite, the "warrior game," was played on a clay bank between the Ute encampment and the white settlement. The boys would flatten a handful of clay in their hands, then press it around the end of a willow shoot. Next they would chose one of their "enemy" as target, sling the stick, and hope the clay bullet would find its mark.

In an interview in 1927, Dallin told how the "warrior game" was the beginning of his lifetime dedication to sculpture: "When we got tired, we used to sit down at the clay bank and make models of the animals that roamed the prairie in those days—antelope, wolves, buffalo, and horses. That was where I got my liking for modeling—there at the clay bank beside the village of Ute teepees."[1]

Cyrus grew to admire the Indians and have a tremendous respect for their culture:

Those Indians whom I knew were not reservation Indians, by the way. They were a free people, proud of their heritage and their race, at liberty to come and go as they chose. . . .

They had a culture and refinement that was lacking in our settlement inside the adobe wall—as a matter of fact, the cowboys with their bluster and horseplay frightened me as a child; it was always a treat to visit my little Indian companions in the homes of their parents. They had a civilization which was in many ways superior to ours. For instance, I never saw an Indian child given corporal punishment. I never heard an Indian child shrill and impudent to its parents. Respect for their elders was inbred in the young Indians; and when a rebuke was administered, it was done in a quiet, instructive way.[2]

The beauty of the Indian villages delighted the young artist:

Our settlement, like other frontier settlements, was in the making. Consequently, everything existed for utility alone. There was neither

94

the time nor the thought to develop beauty. The Indian encampments, on the other hand, were always places of beauty. There I saw beautiful colors and combinations of colors which white people are today finally adopting. But in those days—and in fact until recent years—the same color schemes were laughed at and termed "savage."[3]

Young Dallin was deeply impressed with the Indian sense of honor and was appalled by the injustices inflicted upon them as the reward for their credulity:

They were a very trusting people—almost childlike in their trustfulness. That was due partly to their code of honor. To lie was an unthinkable crime. A liar was simply an outcast. It never occurred to the Indian in the beginning that the white men—fine looking people —would stoop to lying. That was simply inconceivable to them. Consequently, it was a simple matter to trick the Indians with falsehoods and empty promises and to cheat them by misrepresenting the value of things to be traded.

When the Indians had it forced upon them that the white men did lie, they spoke of them as "men with forked tongues"; and it became the habit of the Indian to refer in sign language to the white men by holding up two fingers outstretched from the lips—the symbol of the forked tongue.[4]

As he grew older, Dallin began to realize that the heart of the irreconcilable struggle between the white man and Indian lay in their opposing concepts of land ownership:

The Indians were communistic. That is, as individuals they did not own land. They held land as a tribe and allotted sections of it to individuals for their use. The whole country had been theirs, placed there for them by the Great Spirit. They could not conceive of anybody claiming the right to bar them from it. When they made treaties with the whites for the land, they believed they were assigning to the whites the right to use land; and the whites believed that they were buying it outright. Neither understood the point of view of the other. That was one reason for the misunderstandings which led to so much bloodshed.[5]

Young Dallin, totally impressed by Indian culture and civilization, grew to disdain the rough frontier values of his town. Like many of the pioneers, his father worked in a silver mine in the Tintic district. When Cyrus was eighteen, he joined his father in the mine. He first worked as "chief cook and bottle washer" and later as a sorter of ore.

Work in the mines was merely temporary employment for Cyrus. Inspired by the Indians' sense of beauty and love of creativity, Dallin was determined to "make things"—ideally, to become a sculptor. He rejected the idea of a life dedicated to mechanical labor in the mine. He worked industriously, nevertheless, to try to earn sufficient money to attend the art school in nearby Provo.

One day, however, the miners unearthed what to Dallin proved to be the mine's greatest hidden treasure—a layer of white talc clay. Cyrus used this clay to model two heads, which immediately won the admiration of the miners and his neighbors in the village. A wealthy mine investor, C. H. Blanchard, was so impressed by Dallin's talent that he offered him a chance for a formal art education by paying Cyrus's fare to Boston, "the seat of culture." Once there, Dallin was to be on his own.

On his journey to Boston, Dallin traveled from Ogden to Omaha with a deputation of Crow Indians en route from Idaho to Washington to air their grievances to the "Great White Father," the United States government. Dallin made friends with these Indians, who had been frightened when the train passed under a railway tunnel. When, twenty years later, Dallin once again met their leader, Chief Plentycoose ("Many Honors"), both men enjoyed reminiscing over this episode of their youth.

Dallin arrived in Boston with only fifteen dollars in his pocket. He sought out Truman Bartlett, a prominent sculptor, and arranged for lessons in exchange for caring for Bartlett's studio. Dallin paid for his living expenses by working at a nearby terra-cotta works, and later by working as a "pot boiler," making wax figures for display windows of department stores. His skill as a sculptor improved rapidly, and after two years he opened his own studio, where he specialized in portrait busts and statuettes. He made his first sculpture of an Indian in 1884, which he entitled *Indian Chief (plate 87)*.

In 1888, Dallin traveled to Paris and enrolled in the Académie Julian to study with Chapu. The next summer, when Buffalo Bill and his Wild West Show visited Paris, Dallin rejoiced to see American Indians once again. He visited Buffalo Bill's camp at Neuilly almost daily to make clay studies of the show Indians, who were delighted to pose for him. He completed his first clay model, *The Signal of Peace*, and many preliminary studies for his later equestrian statues.

The Signal of Peace (plate 88) is the first of his four great equestrian statues which depict the cycle of the Indian's relations with the white man. *The Medicine Man, The Protest*, and *Appeal to the Great Spirit* complete the series.

The Signal of Peace shows a Sioux chief, clad in a war bonnet and

buckskin, mounted on his horse, which stands motionless, all four feet planted firmly on the ground. The chief is totally trusting and ready to offer his friendship and good will to the newcomers. He does not dream that the white man will challenge his right to live peacefully on his own native soil. He raises his feathered spear in a well-known gesture of peace. Dallin treats his subject with simplicity and reserve and employs a strong, naturalistic modeling rather than picturesque surface detail.

Dallin described his inspiration for *The Signal of Peace* in this way:

The origin of that statue goes back to my boyhood, to a day when I witnessed a peace pow-wow between the Indian chiefs and the United States Army officers. I shall never forget those splendid looking Indians arrayed in their gorgeous head-dress riding up on their ponies to the army camp where the pow-wow was to be held. The Indians dismounted, gravely saluted the officers, and followed them into one of the tents. . . .

The pipe of peace was passed; and before it was smoked, it was pointed to the north, south, east, and west, the boundaries of the firmament, then to Mother Earth, the source of all life, then to the Great Spirit above, whither all life goes. This was done with a dignity and grace that it is impossible to describe. The chiefs spoke then, rising from their places and accompanying their words with impressive, easy gestures . . .

In making my model of "The Signal of Peace," I used, to a certain extent, one of the Buffalo Bill Indians; in putting into it that dignity typical of the Indian, I had in my memory the chiefs who rode up to the peace pow-wow many years before.[6]

The Signal of Peace was exhibited in 1890 at the Paris Salon and in 1893 at the Chicago Exposition. Judge Lambert Tree of Chicago was so impressed by the work that he purchased it and donated it to the city of Chicago. The statue was dedicated in Lincoln Park in 1894 and may be seen there today.

On donating the statue, Judge Tree wrote to the commissioners of Lincoln Park:

I fear the time is not far distant when our descendants will only know through the chisel and brush of the artist these simple, untutored children of nature who were, little more than a century ago, the sole human occupants and proprietors of the vast northwestern empire of which Chicago is now the proud metropolis. Pilfered by the advance-guards of the whites, oppressed and robbed by government

87. Cyrus Dallin. *Indian Chief.* Cast 1907. H. 26″. The New-York Historical Society, New York City

agents, deprived of their land by the government itself, with only scant compensation, shot down by soldiery in wars fomented for the purpose of plundering and destroying their race, and finally drowned by the ever westward tide of population, it is evident there is no future for them except as they may exist as a memory in the sculptor's bronze or stone and the painter's canvas.[7]

After his return to the United States in 1891, Dallin once again opened a studio in Boston. The purchase of *The Signal of Peace* assured him of recognition in the art world, and in 1893 he was elected to the National Sculpture Society.

Dallin longed to return once again to the Utah Territory of his childhood and so with his wife, the former Vittoria Colonna Murray of Boston, he journeyed to Salt Lake City. There, he honored his Mormon state by creating the *Brigham Young Pioneer Monument (plates 503, 506)*, which is in Temple Square. This monument pays tribute to the tremendous hardships endured by those first Mormons who founded Salt Lake City. Dallin also sculpted the angel who appeared to Joseph Smith, founder of the Mormon Church. *The Angel* is on the dome of the Mormon Temple.

On returning to Philadelphia, Dallin became an instructor at the Drexel Institute of Technology. Although his success as a sculptor was assured, he was still determined to perfect his art and so in 1897 he returned to Paris for three years of additional study. During this second visit to Paris, his primary interest remained the American Indian. In 1898, he began work on the second of his Indian cycle statues, *The Medicine Man (plates 89, 90)*. The statue won a Gold Medal at the Paris Exposition of 1900 and was purchased for Fairmount Park in Philadelphia. Dallin exhibited models of *The Medicine Man* at the Pan-American Exposition and at the Louisiana Purchase Exposition.

The Medicine Man is the prophet of his tribe, the guardian of the well-being of his people. Dallin's Medicine Man sits astride his horse, his arm raised in a gesture of warning. For many years, he has watched

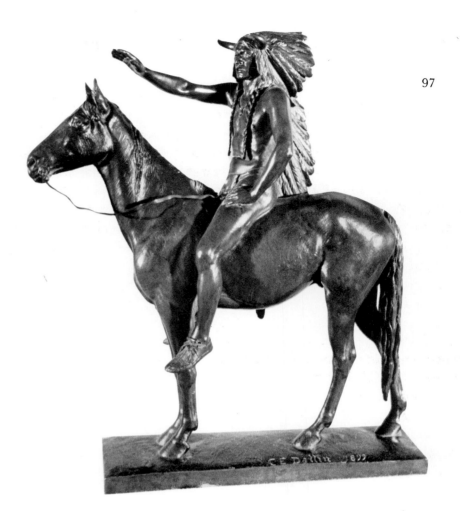

89. Cyrus Dallin. *The Medicine Man.* 1899. Gruet Fondeur, Paris. H. 17″. Thomas Gilcrease Institute, Tulsa, Okla. This bronze is a small model of the statue in Fairmount Park (plate 90)

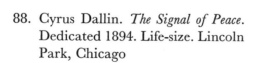

88. Cyrus Dallin. *The Signal of Peace.* Dedicated 1894. Life-size. Lincoln Park, Chicago

98

the growing mass of pioneers traveling further across the continent. He senses the imminent danger to his people and cautions them to be careful of their dealings with the white man. His horse stands, four feet planted on the ground as before, but seems alert to an unknown danger. The statue has tremendous dramatic power. Dallin eliminated all ornamental detail. The simple strong modeling and careful selection of only the most fundamental realistic forms elevate this statue to the highest level thus far attained for statuary depicting an Indian scene.

In 1904, Dallin also exhibited the third statue of the Indian cycle, *The Protest*, at the St. Louis Exposition. The Indian portrayed in this work knows that his entire civilization is in danger of annihilation. In an article of 1915, this statue is described as "The War Stage." "His peaceful advances have been of no avail. He must accept the prophecy of the seer of his tribe. He now arrays himself against the enemy, and, with clinched fist, his steed rearing on its haunches, he hurls defiance at his foe."[8]

It is interesting to see Dallin's selection of the clenched fist as the ultimate dramatic symbol of protest and revolt, over sixty years before it became today's accepted gesture of minority protest. Although it had great dramatic power, this statue was never cast in bronze as a permanent monument. However, it has been cast in a small version *(plates 91, 92)*.

The fourth and final statue in Dallin's Indian cycle is *Appeal to the Great Spirit (plate 96)*. The Indian cause is lost. The red man has been totally defeated by the white man, both through negotiations and in combat. In his despair, he can only turn and pray to heaven for help and deliverance. The Indian sits on his horse, his arms outstretched and his head thrown backward, searching the heavens for a signal of deliverance. His horse stands motionless. Both man and horse exhibit a sense of stoicism and dignity. Here again, the simplicity of Dallin's approach adds to the dramatic strength of the work.

Dallin's cycle of the American Indian was one of the most important contributions to Western bronze sculpture. Wayne Craven wrote that these statues "carried the imagery of the red man to its finest expression in sculptural form. Dallin in these works achieved a true monumentality, bestowing upon his subjects those innate qualities that had been almost wholly obscured to the eyes of the white man during the decades of hatred and conflict."[9]

On his return from Paris, Dallin once again settled in Boston. He taught at the Massachusetts State Normal Art School and created both monumental portraits and Indian statues for public display. Among those celebrating a pioneer or Indian theme were *The Caval-*

90. Cyrus Dallin. *The Medicine Man.* Erected 1903. Life-size. Fairmount Park, Philadelphia

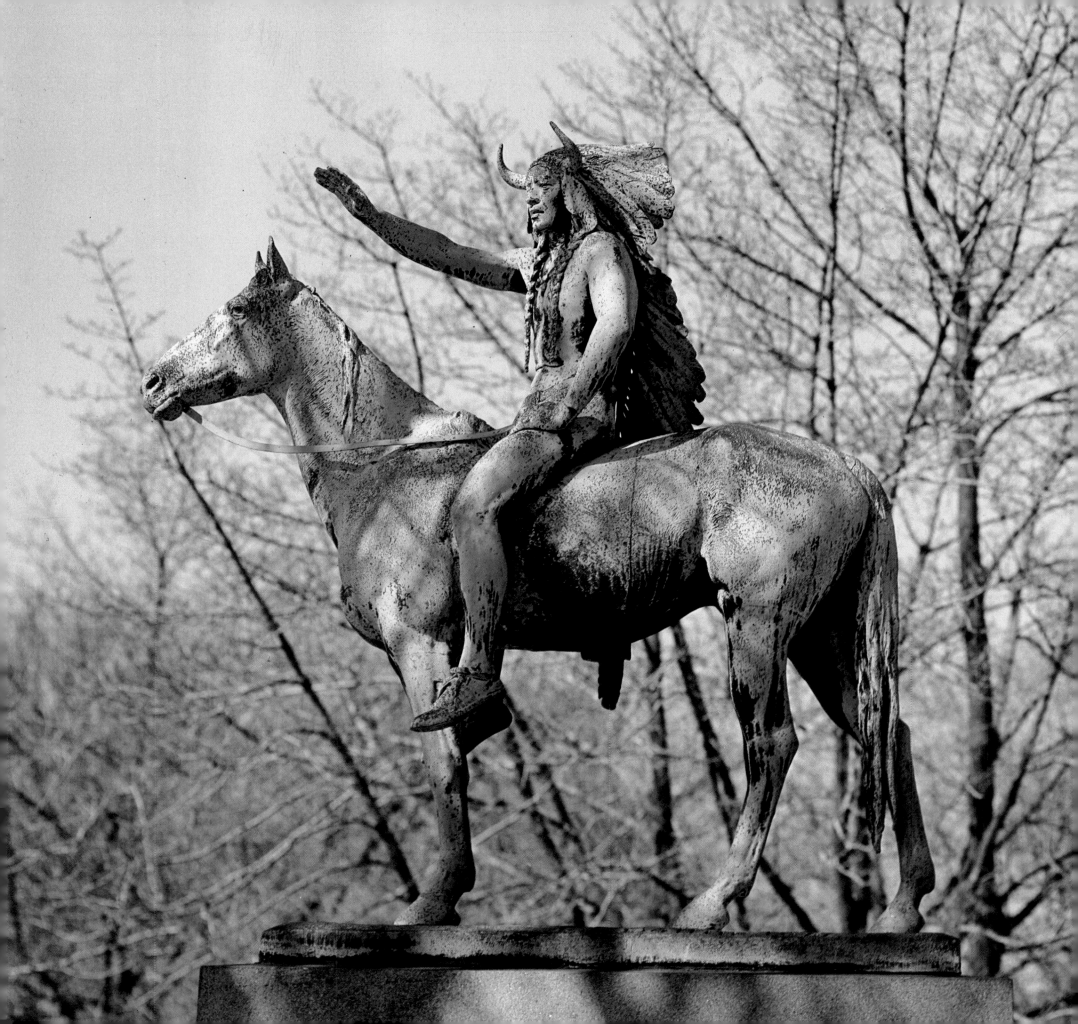

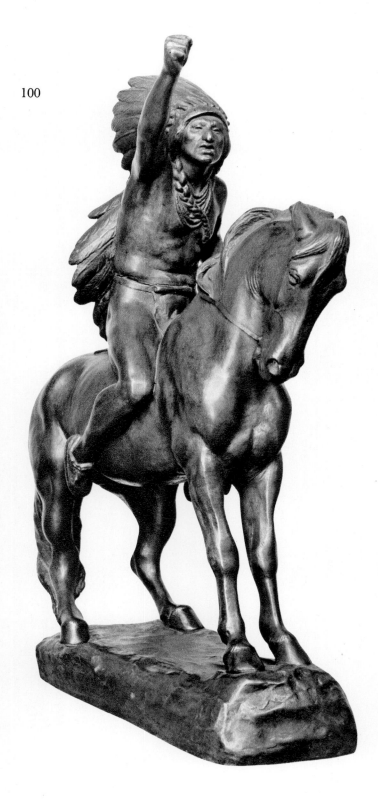

92. Cyrus Dallin. *The Protest*. 1904. Roman Bronze Works, N.Y. H. 18½″. Kennedy Galleries, New York City

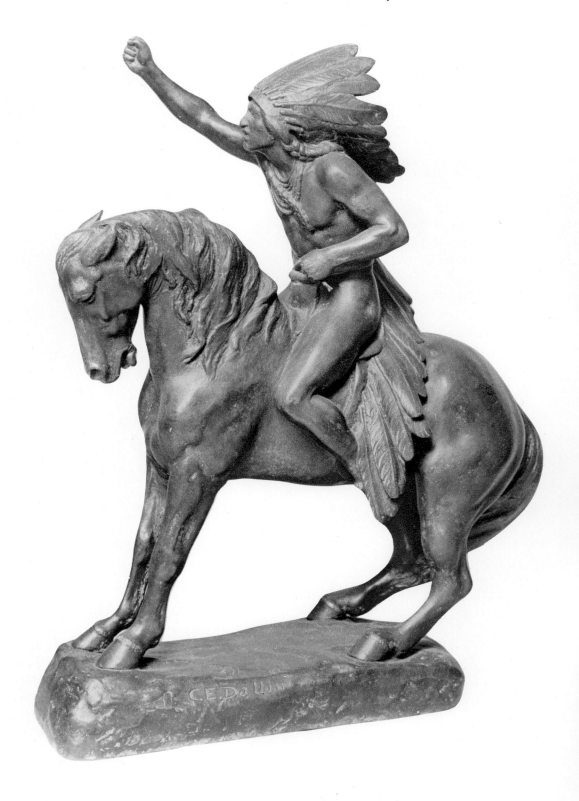

91. Cyrus Dallin. *The Protest* (front view). 1904. Roman Bronze Works, N.Y. H. 18½″. Graham Gallery, New York City. The heroic version of this sculpture was exhibited in staff at the Louisiana Purchase Exposition in St. Louis in 1904

93. Cyrus Dallin. *Indian Hunter at the Spring*. Dedicated 1913. Life-size. Robbins Memorial Park, Arlington, Mass. Photo courtesy of the Robbins Library, Arlington, Mass.

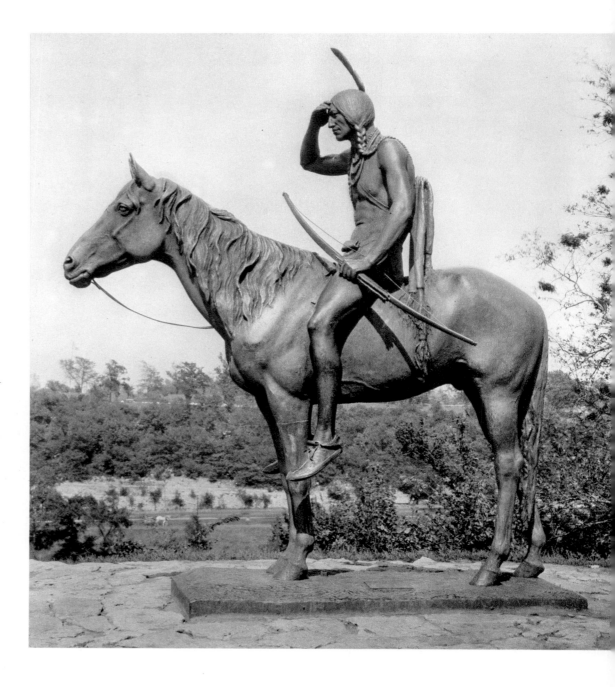

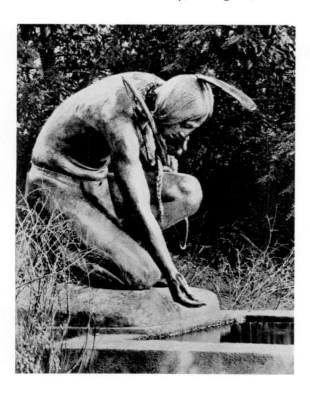

94. Cyrus Dallin. *The Scout*. Modeled 1914–15, dedicated 1922. Heroic size. Penn Valley Park, Kansas City, Mo. Dallin picked the site for its location and supervised its placement in 1916

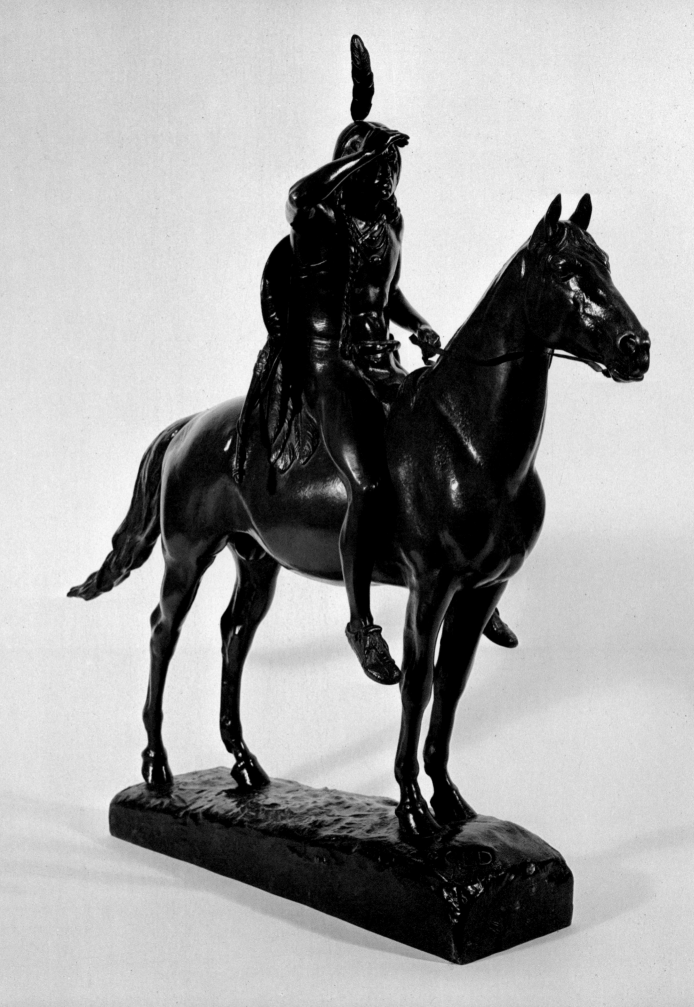

95. Cyrus Dallin. *The Scout*. 1902. Cast by the artist. H. 39″. Graham Gallery, New York City. This is the earliest small bronze of the heroic bronze statue in Kansas City, Mo. (plate 94). *The Scout* won the Gold Medal at the 1915 Pan-Pacific Exposition in San Francisco

96. Cyrus Dallin. *Appeal to the Great Spirit*. 1909. Gorham and Co., N.Y. H. 22″. Whitney Gallery of Western Art, Cody, Wyo. This bronze is a small model of the statue in front of the Museum of Fine Arts in Boston, Mass.

APPEAL TO THE GREAT SPIRIT
BY C. E. DALLIN
GIFT OF MISS CLARA PECK

97. Cyrus Dallin. *Archery Lesson*. 1907. Roman Bronze Works, N.Y. H. 17″. Kennedy Galleries, New York City

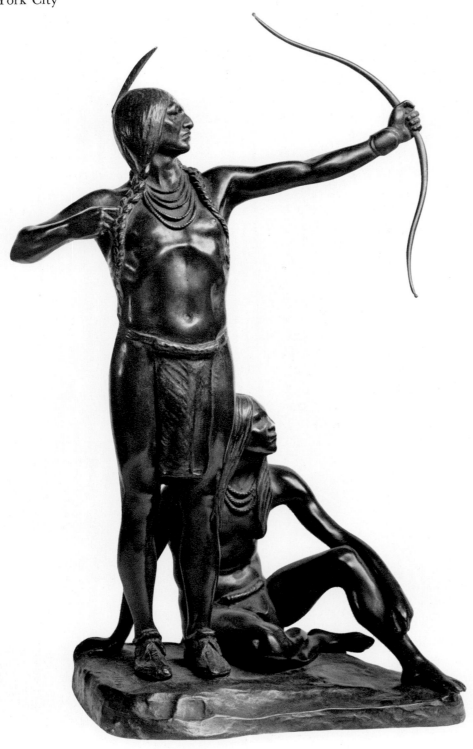

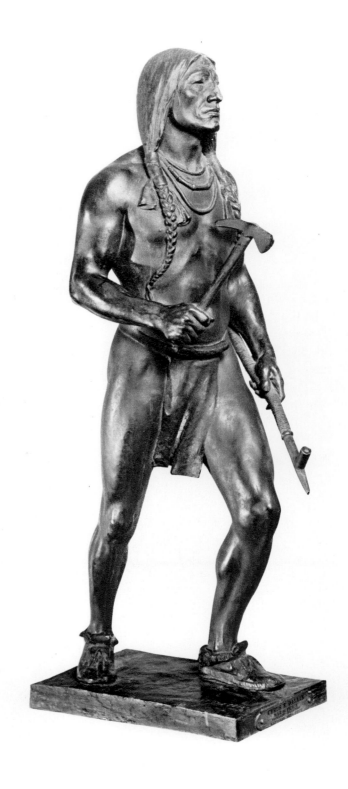

98. Cyrus Dallin. *War or Peace*. c. 1905. Roman Bronze Works, N.Y. H. 33″. Kennedy Galleries, New York City

ry Man, dedicated in Hanover, Pennsylvania, in 1905; *Indian Hunter at the Spring (plate 93)*, a fountain dedicated in Robbins Memorial Park at Arlington, Massachusetts, in 1913; and *The Scout (plate 94)*, which was exhibited in 1914 at the San Francisco Exposition and later placed in Penn Valley Park in Kansas City, Missouri. *The Scout* was cast in a smaller version *(plate 95)* as well. Dallin also created a character study of an Indian rifleman, *The Marksman*, and a mounted brave, *On the Warpath (plate 99)*. The statue of Massasoit, atop Coles Hill in Plymouth, Massachusetts, was the finest of his later Indian sculptures. This statue commemorated the three hundredth anniversary of the peace negotiations between the Pilgrims and the Indians. It was Massasoit and his tribesmen who shared the first Thanksgiving with the Pilgrims. The peace they negotiated lasted forty years. In 1931, at age seventy, Dallin completed his *Pioneer Mother (A Memorial to the Pioneer Mothers of Springville, Utah) (plate 499)*. His aged mother served as the model. Dallin died in 1944.

99. Cyrus Dallin. *On the Warpath*. 1915. Gorham and Co., N.Y. H. 23″. Brookgreen Gardens, Murrells Inlet, S.C. This statue was exhibited at the Pennsylvania Academy of the Fine Arts in 1915

100. Cyrus Dallin. *Two-Gun Cowboy (Cowboy Shooting 'Em Up)*. 1920. Gorham and Co., N.Y. H. 24″. Graham Gallery, New York City. This sculpture is perhaps Dallin's only bronze of a cowboy

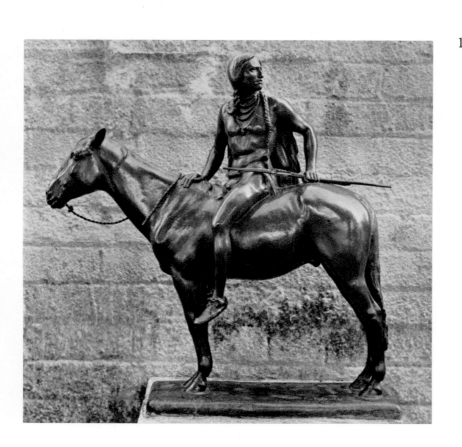

Throughout his life, Cyrus Dallin was the eloquent defender of the Indian in both his speech and his art:

I have heard people speak of the Indians as cruel. I never found evidence of any more cruelty among them than among white men. I don't believe that we can point to an Indian outrage that has not had its counterpart in the white men's record. When we say that the Indians were treacherous, we are simply closing our eyes to facts. Very few treaties made between white men and red were ever broken by the red men. I think you will find that every Indian war was started by the whites and that every Indian outrage was committed by way of retaliation for some outrage perpetrated by the white men.[10]

His intimate knowledge of the Indians gave Dallin's work an authenticity and a reality heretofore unknown. His personal involvement with their cause gave his statues a dramatic impact which has retained its strength through the years. The simplicity of his sculptural style with its emphasis on the essentials rather than the decorative gives Dallin's statues a special appeal to the aesthetic taste of the modern world.

IX

A. PHIMISTER PROCTOR: THE JOYS OF SPORT AND SCULPTURE

Alexander Phimister Proctor, through his sculptures, expressed the joy and beauty of all aspects of Western life. He loved every form of wildlife. A hunter from boyhood, he delighted in giving permanent form to the wild fauna of the West. During his lifetime, he was honored in Europe and the United States as the foremost American *animalier*.

Sheriffs, preachers, cowboys, and frontiersmen—these were the colorful characters of Proctor's early life in the West. From them, Proctor learned firsthand the courage and determination of the pioneers. Later in his life, he gave a new vitality to monumental sculpture through his interpretations of these courageous men and women. His statues immortalized the spirit of the settlers. His interest was not that of a sociologist or anthropologist, but rather that of a naturalist, observing the glorious figures of the West. Animals and hunters, pioneers and Indians, these were the inhabitants of Proctor's West. Throughout his life, Proctor's art proclaimed his delight with the West.

Proctor was the perfect blend of the poet and the scientist. His dream was that of the poet, the ideal world of exuberant freedom and beauty, inhabited by the animals of the mountains and plains: elk, moose, mountain lions, bison, and mustangs. He glorified the fierce Indian warriors and hunters and idealized the endurance and courage of the pioneers.

Proctor's poetic inspiration was transformed into tangible creations by the most detailed scientific processes. He studied every aspect of animal anatomy, even stripping away the skins to learn the details of the skeletal structures. When hunting, he studied the movements of the animals and then returned home with trophies which would be the basis of endless examination and study.

In choosing a horse for an equestrian statue, only the most perfect specimen of the proper type of animal would suit Proctor. In modeling Indians, he would exhaust even his most patient model. If a model refused to continue, Proctor's long search for the right brave

would begin again. The length of study necessary would often outlast the season of the year.

Proctor was a man of the outdoors, a sportsman and an adventurer. He was inspired by scaling a mountain peak considered unattainable. During many hunting expeditions, he faced extreme danger. In the tradition of America's frontiersmen, this danger intensified his very existence.

Proctor was also a scholar. In his desire to improve and perfect his art, he left his beloved West for many years to study and work in New York and Paris. Only through the best instruction could he hope to achieve that perfection of expression so important to his art. Throughout his life, his vacations were the fuel, the inspiration for the technically perfect statues that he would spend years in creating. Artist and craftsman were united in the production of his finest sculptures.

Proctor was born in 1862 in Bozanquit, Ontario. His father, Alexander Proctor, was a native of the wilds of Ontario. His mother, Tirzah Smith, was of English birth and before her marriage taught school in Ontario. Phimister was the fourth of eleven children. Proctor's father, a Sunday school superintendent, instilled firm religious principles in his children, which lasted throughout their lives.

From childhood, Proctor was fascinated by the Indians. Just before his fourth birthday, the Proctor family traveled by covered wagon to Clinton, Michigan. They remained only a year, then traveled further westward, first to Newton, Iowa, and then to Des Moines. In *Sculptor in Buckskin*, his autobiography, which was published posthumously, Proctor recalled the highlights of his nomadic childhood and of his successful career. It was in Newton that he saw his first Indians:

I was standing on a pile of lumber when a band of Indians on horseback emerged from the woods and passed within a few yards of me. I can still see the chief riding solemnly along, followed by some fifteen or twenty braves. Behind them came the women with their papooses. I started to pull a silent sneak-away, but my first step made a board fall with a crash. All the Indians turned to look at me. Abandoning caution, I scrambled off the lumber and, to the great delight of the savages, fled, yelling at every step, just as fast as my legs would carry me.[1]

As a child he often amused himself by staging a make-believe hunt using metal deer borrowed from a Noah's Ark toy set and a toy hunter.

In 1869, Proctor heard Horace Greeley at the Iowa State Fair advise, "Go West, young man, go West." Proctor never forgot this advice. In 1871, hard times fell upon the Proctor family. Alexander Proctor, having lost everything following a mortgage foreclosure, decided to make a fresh start and moved his family to Denver.

Young Proctor was excited by the prospect of going West. His imagination had been fired by tales of fortunes made through gold mining and by stories of unequaled fishing and hunting. He dreamed secret dreams of Indian terrors.

Denver in 1871 was a frontier mountain town. Proctor described the booming town in his autobiography:

Trappers, cowboys, and dirty-clothed prospectors were familiar sights on the few sagging wooden sidewalks. Huge charcoal wagons with many yokes of oxen filled the streets. Covered wagons were to be seen at any time of day or night. Saloons and gambling halls flourished. Frequently herds of longhorns were driven through town. My brother George and I were on our way to school one morning when several men dashed around the corner of Fifteenth Street, shouting, "Run, you damn fools, run!" All of us flew for the alley fence and scrambled to the top just as a herd of longhorns stampeded past in a cloud of dust.[2]

Proctor also remembered Utes riding into Denver with fresh scalps hanging from their belts.

To young Phimister, the greatest pleasures in life were traveling across the Rocky Mountains and hunting for wild game. The family vacationed yearly in Grand Lake, which not long before had been an Indian camping ground. The lengthy voyages to Grand Lake by covered wagon were high adventures Proctor would always treasure. He became good friends with the rough trappers, miners, and hunters of the region. Proctor was only sixteen when, in a single day of glory, he killed both his first grizzly and an elk.

Throughout his youth, Proctor had a double ambition: to achieve greatness as a hunter and to succeed as an artist. His earliest art lessons, at fifty cents each, were from a Dutch painter, newly settled in Colorado. These were unsuccessful, however, for they interfered with baseball and rabbit hunting.

Proctor, knowing he would need a trade to finance his art studies, next learned wood engraving from J. Harrison Mills. Mills was interested in both wild animals and landscapes. Proctor was greatly impressed with Mills's belief that the artist should live the life he intended to depict and he remained faithful to Mills's teachings throughout his life.

Through Mills, Proctor met many hunters, prospectors, and other Western characters. It was at this time that he met Frederick Delenbaugh, a Munich-trained artist, who had accompanied John Wesley Powell on his trip through the Grand Canyon. Delenbaugh sensed artistic promise in young Proctor and advised him to go to Europe to study. Proctor's poor finances prevented his considering this advice, but he was greatly flattered. Proctor's first art commission was for a series of woodcuts to illustrate a book, *Hands Up*, by Sheriff Dave Cook.

As a young man, Proctor bought some land in Grand Lake. He enjoyed the rough, sometimes dangerous life in Grand County at a time when the gun was the chief arbiter of land disputes. In 1883, he went to Yosemite, California, and with a companion spent two days scaling the perilous Half Dome. This experience was critical in crystallizing his dedication to become a sculptor and symbolized the division between carefree youth and serious manhood: "I had decided long before to be an artist; there was no other profession for me. Those hours of anxiety and danger crystallized in my mind the goals toward which I would direct my life."[3]

Proctor was determined to study in New York. He worked unsuccessfully for a short time as a miner, hoping to strike it rich, but at last he had to sell his beloved Grand Lake homestead in order to finance the trip.

On arriving in New York, Proctor enrolled at the National Academy of Design. A year later, he studied at the Art Students League. Proctor gained in self-confidence as he acquired more advanced academic skills. In 1887, he met John Rogers, famous for the small plaster Rogers Groups of Civil War subjects. Rogers encouraged Proctor and helped him acquire increased facility both in modeling and in constructing armatures. The inspiration for Proctor's first bronze, *Mule Deer* or *Fate (plate 101)*, was a newborn fawn at the deer house of the New York Zoo. Proctor attributed this first sculptural success to Rogers' interest and support. A photograph of Proctor's fawn appeared in *Harper's Weekly* and, through Delenbaugh's influence, Proctor exhibited his fawn at the Century Club in New York.

During his early years in New York, Proctor was very poor. Conditions were hard for a young sculptor:

Having begun modeling, I started group after group of both animals and Indians, but many were never finished, and most were later destroyed or lost. Wax, or American plasteline, as it was called, cost about fifty cents a pound. I seldom could afford enough to model all the subjects I wanted to do. Often I had to destroy one model to use the wax for some other figure. Many times I dug wax out of the inside of a figure and filled the space with blocks of wood, leaving only the outside surface. I was also handicapped by not having a regular studio where I could work and store my materials.[4]

At the same time as the sculpture of the fawn, Proctor began his first statue of a panther, *Prowling Panther (plate 102)*. Proctor traveled almost daily to the zoo to study the panther in motion. By opening and closing his eyes quickly, he was able to isolate the basic elements of the panther's movements. One experiment was not nearly so successful:

One day as I was sketching close to the bars of the panthers' cage, I carelessly turned my back on my models to get better light on the drawing. Suddenly I felt needle-sharp pains in my shoulder. Leaping away from the cage, I turned to see the big male cat's foreleg—at least six feet long, it looked to be—stretched through the cage, *my* blood dripping from his claws. Then and there I learned an important lesson for an artist: never turn your back on a wild four-legged model![5]

Proctor continued to study and work in New York, and whenever possible traveled to Colorado for adventure, inspiration, and refreshment. His rifle and his sketchbook were the mainstays of these expeditions. In New York, Proctor often visited the Metropolitan Museum of Art. While studying the Egyptian carvings, Proctor decided that his tools were crude and inadequate compared to those of the ancients. He then remodeled and reshaped them, and thus achieved a finer control that was reflected by considerable improvement in his work.

In the summer of 1891, Proctor received his greatest opportunity, a commission for work on the World's Columbian Exposition, which was to open in Chicago in 1893. Proctor won international recognition and financial success for his sculptures at the fair. He created thirty-five animal models depicting all forms of Western wildlife.

Proctor also made two huge equestrian statues—a mounted cowboy and an Indian scout—for the exposition, which were among the earliest monuments to publicly honor the Western frontier. Wayne Craven wrote:

There can be no doubt that Proctor added a new ingredient to American sculpture, for while others in his profession were creating robed maidens and assorted neoclassical personifications, Proctor brought to the attention of the world the strength and beauty of the

wild animals of America. Moreover, his cowboy on his pony and his Indian scout scanning the horizon were among the first monumental equestrian statues to give dignity to those subjects from the American West.[6]

When he first received the commission for the giant statues, Proctor knew very little about modeling monumental figures; therefore, he passionately studied both human and animal anatomy. His sincerity and industriousness won the approval of several older sculptors working in Chicago. Olin Levi Warner, Edward Kemeys, and Augustus Saint-Gaudens offered him their advice whenever possible. While working on his models for the fair, Proctor met his future wife, Margaret Gerow, at Lorado Taft's studio.

101. A. Phimister Proctor. *Mule Deer (Fate)*. 1893. Gorham and Co., N.Y. H. 7″. Mead Art Building, Amherst College, Amherst, Mass.

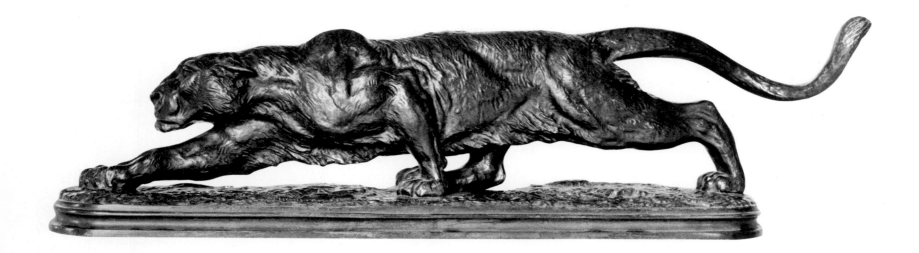

102. A. Phimister Proctor. *Prowling Panther.* c. 1894. Jno Williams Founder, N.Y. H. 6½". The Corcoran Gallery of Art, Washington, D.C.

William ("Buffalo Bill") Cody's Wild West Show was a highlight of the Chicago fair. Buffalo Bill gave Proctor passes to the show and granted him permission to use the cowboys and Indians as models. It was easier, however, to work with the cowboys than with the Indians. Proctor explained:

Some of the Indians were too superstitious to pose for me. There was one fellow, named Kills-Him-Twice, whom I wanted for a model above all others. . . .

I went to the tipi early and arranged a box to work on and another for a seat. Pretty soon in marched Kills-Him-Twice, his stone war club in his hand, accompanied by six or seven braves. All the Indians sat down opposite me in a row, with Kills-Him-Twice in the middle. The model was still in the box before me, and the Indians had not yet seen it. They scowled at me as though I were about to throw down on them.

I then took out the portrait model and placed it on the box facing the Indians. Amazement showed on every face. There in front of them was the head of Kills-Him-Twice, true to life. Hot words broke from the Indians. They had thought that I was merely going to take a photograph, which was bad enough, but to make a "real" head was going too far. Kills-Him-Twice glared furiously at me and jumped to his feet, making a move as though to demolish the model with his club.

All the Indians spoke furiously, if incomprehensibly. Then the interpreter, who really spoke very little English, said something, whereupon one of the braves dashed out of the tipi. Presently another interpreter came in, and the Indians told him what had happened. He turned to me and said that I had offended them. It was very bad medicine for me to sit there for a couple of minutes looking at Kills-Him-Twice and then take a likeness of him out of a box.

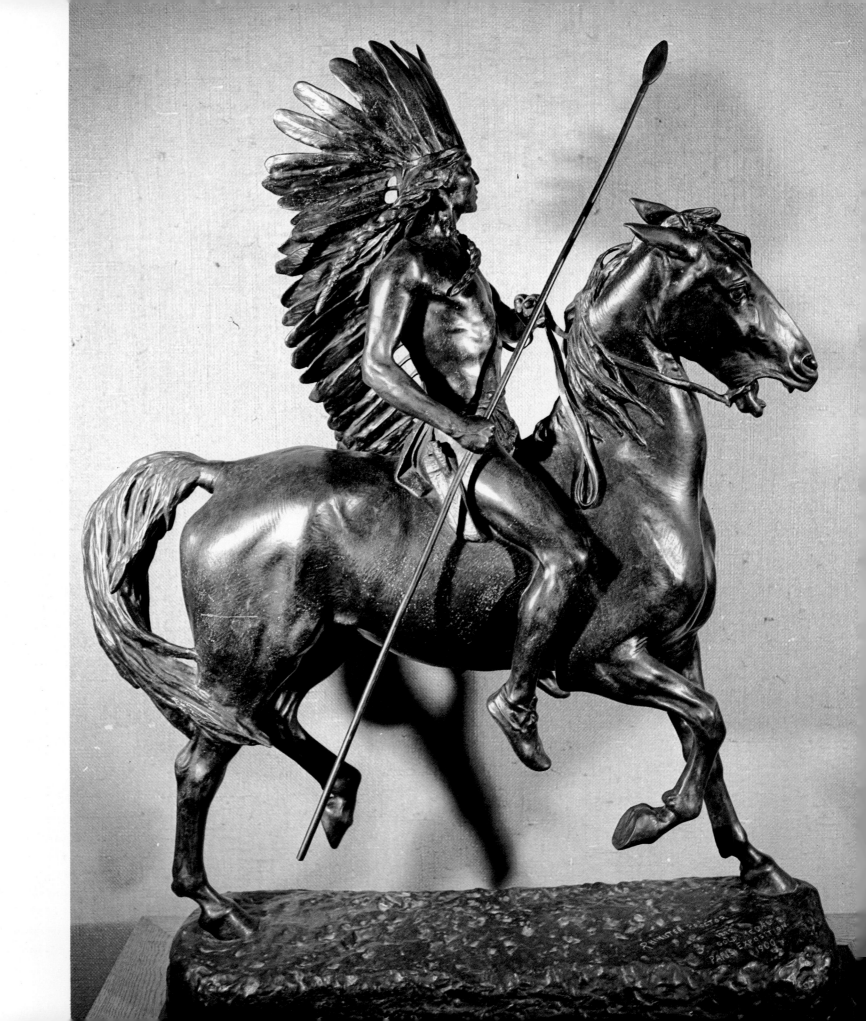

According to the Indians, I had removed a part of his soul, and if I carried it away, evil spirits would harm him when he wasn't there to defend himself. It was indeed a serious matter to the Indians.

The interpreter talked to them for a while and then suggested that I pay Kills-Him-Twice two dollars. I did so, and that settled it, but he would pose no more and avoided me from then on. I had to use Jack Red Cloud, a Sioux, for my mounted Indian instead of the fierce, majestic Kills-Him-Twice.[7]

Although Proctor won fame and admiration at the fair, he felt he needed further art education. After his success at the fair, he could well afford European study and so he sailed for Paris with his bride. He enrolled at the Académie Julian to study with Denys Puech. In 1894 he created a small sculpture, a hound gnawing a bone, which received high praise from Parisian art critics. Proctor's Parisian training lasted only a year, for he returned to the United States in order to model the horses for Augustus Saint-Gaudens' equestrian statues of General Logan and General Sherman.

Even when employed on other commissions, Proctor always continued to work on his sculptures of the West. While modeling the horses for Saint-Gaudens, he began his statue, *The Indian Warrior (plate 103)*. This study followed a trip to Montana, where he had the opportunity to live on the Blackfoot Indian Reservation. The horse used as a model belonged to a friend of Saint-Gaudens.

In 1896, Proctor received the Rinehart Scholarship for three years of study in Paris. Because of his special interest in Indians, animals, and Western subjects, the scholarship committee waived the usual classical requirements. Proctor had earlier refused the Rinehart committee's Prix de Rome, since it would have necessitated the execution of classical subjects. Proctor was very happy in Paris. He studied at the Académie Julian once more and at the Académie Colarossi. At the zoo, he devoted extensive study to the pumas. In Paris, Proctor completed *The Indian Warrior*, the *Prowling Panther*, and some small animal bronzes to fulfill the scholarship requirements. His exhibit of these models at the Paris Exposition of 1900 won a Gold Medal.

Following Proctor's success in Paris, he returned to the United States, where he received as many commissions as it was possible for him to execute. After working on the expositions in Buffalo and St. Louis, Proctor settled in the East. He lived in Westchester and Connecticut, and maintained a studio in New York. Although Proctor accepted such commissions as the lion statues for the Lions' House at New York's Bronx Zoo, the marble lions for the McKinley Monument in Buffalo, and the tigers at Princeton University, his dedi-

103. A. Phimister Proctor. *The Indian Warrior*. 1898. Gorham and Co., N.Y. H. 39″. Thomas Gilcrease Institute, Tulsa, Okla. This bronze won the Gold Medal for sculpture at the 1900 Paris Exposition

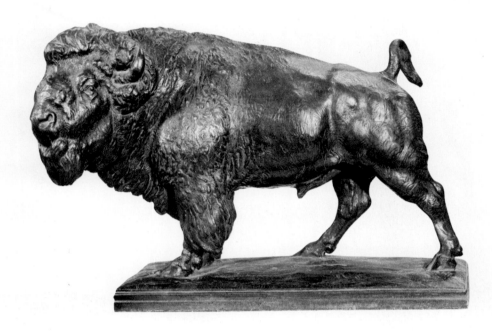

104. A. Phimister Proctor. *The "Q" Street Buffalo*. 1912–14. Tiffany and Co., N.Y. H. 13″. Indianapolis Museum of Art, Ind. General Fund

cation to Western themes never weakened. He always devoted as much time as possible to sculpting the wild animals of the American West.

The Proctor family spent the summer of 1914 on the Cheyenne Reservation in Crow, Montana. Chief Little Wolf adopted both Proctor and his wife, and honored the sculptor by giving him the name Okomahkahchitah ("Large Coyote"). Proctor had often considered the sculptural theme of an Indian pursued by an unseen enemy. Little Wolf was exactly the Indian that he had envisioned for his work. With little persuasion, Little Wolf agreed to pose for *Pursued (plates 106, 107)*. Proctor's method of work was as follows:

My idea was to depict the Indian riding downhill and at the same time making a wheeling motion. To capture the motion and the realism, I had Wolf ride uphill on the walk, turn, and then gallop down, sometimes on one side of me, sometimes on the other.[8]

Following this summer, Proctor traveled to Oregon. He loved the lively Western atmosphere of Pendleton, and was excited by the wealth of Western subjects awaiting execution. He telegraphed his wife, Margaret, and within two weeks she and their seven children had settled in their new home there.

105. A. Phimister Proctor. *Buffalo*. 1897. Verbeyst Founders. H. 12½″. The Walters Art Gallery, Baltimore, Md.

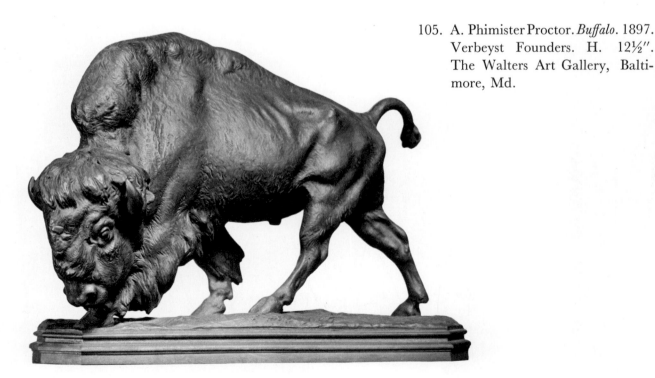

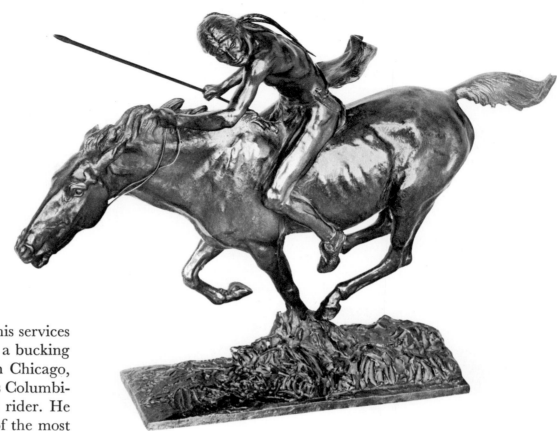

106. A. Phimister Proctor. *Pursued.* Copyright 1915 and 1928. Roman Bronze Works, N.Y. H. 16½". Thomas Gilcrease Institute, Tulsa, Okla.

Proctor especially enjoyed the rodeo and often offered his services as a judge. He decided to create a bronze of a cowboy on a bucking horse, *The Buckaroo (frontispiece)*. Twenty years before, in Chicago, Proctor had executed that theme in plaster for the World's Columbian Exposition. Proctor carefully selected both horse and rider. He chose a six-foot-three cowboy named Red who was one of the most colorful characters around Pendleton: "If anyone gave him five dollars and a drink of whiskey, he would ride one of the buffaloes. The Cayuse . . . was a wall-eyed brute, a direct offspring of the devil."[9] Proctor had to bail Red out of jail when the cowboy was

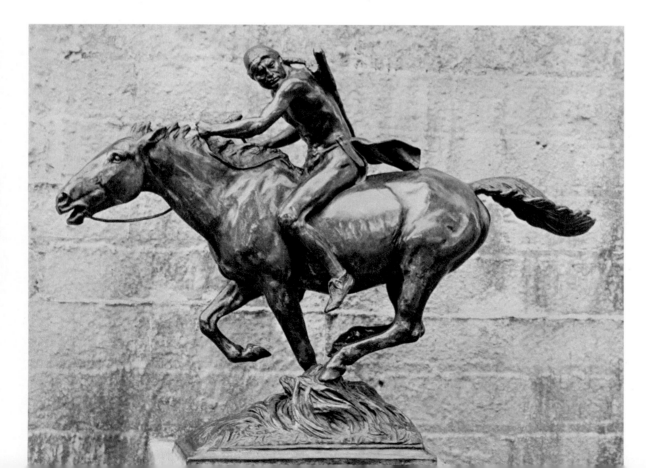

107. A. Phimister Proctor. *Pursued.* Copyright 1915 and 1928. Gorham and Co., N.Y. H. 16½". Brookgreen Gardens, Murrells Inlet, S.C. The Roman Bronze Works model (plate 106) varies considerably from Gorham's: note the differences in position of the rider, the weapon, and the base

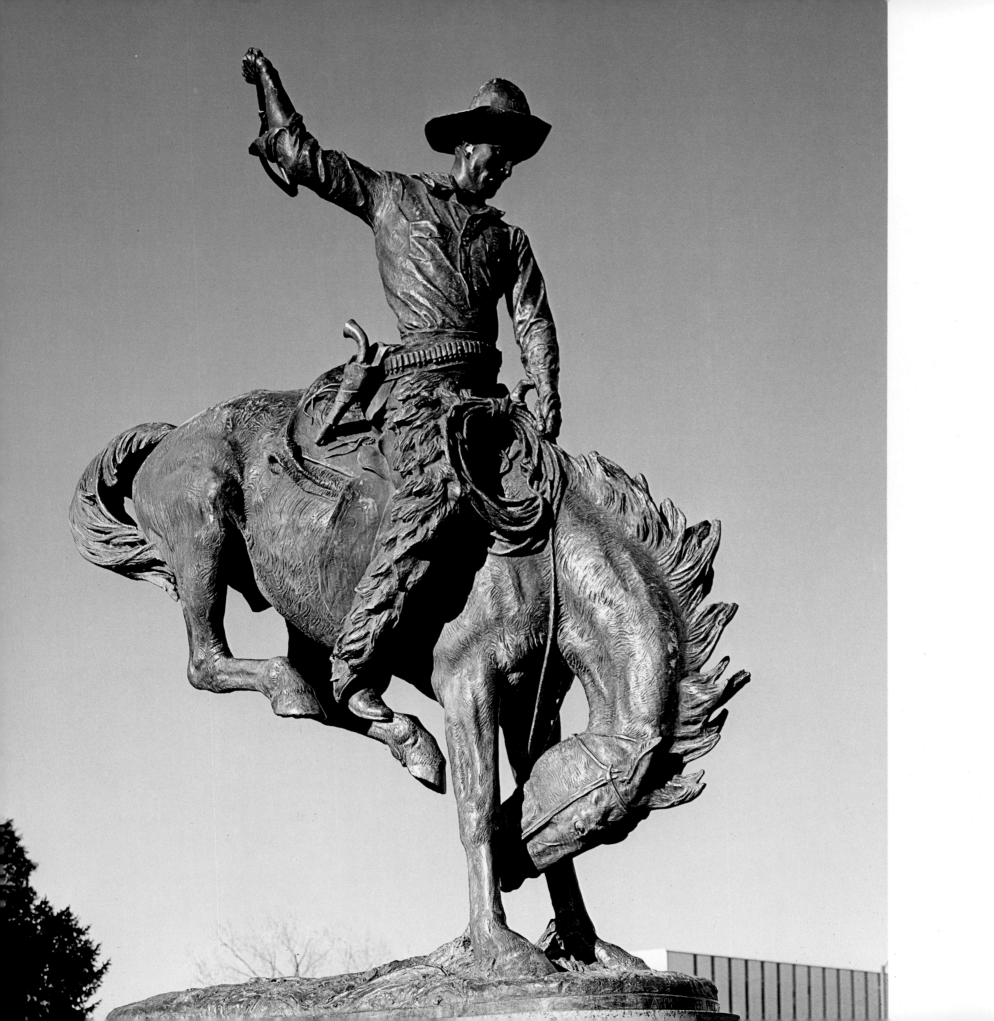

accused of stealing horses. Red, however, proclaimed his innocence: "Them fellers left them hosses in my corral. . . . How in hell'd I know they'd been stolt? I jes' cain't pick up a rope nowheres, but they's a goddam hoss on the other end."[10]

Proctor next returned to the theme of the Indian hunter pursuing the buffalo *(plate 109)*. He selected Jackson Sundown, nephew of Chief Joseph of the Nez-Percé tribe, as a model *(plate 229)*.

Proctor received a commission from Denver, the city of his childhood, for two statues which would decorate the Civic Center: an equestrian Indian and a bronco buster. He first completed *The Bronco Buster (plate 108)* by enlarging his statuette, *The Buckaroo*.

Proctor had accepted several commissions during these years, and thus had to work on more than one at a time. In Portland, Joseph N. Teal, a prominent lumberman, had commissioned Proctor to create as tribute to the Oregon settlers a giant figure, *The Pioneer (plate 110)*. Proctor had a particular model in mind—Jess Craven, a six-foot, long-haired, bewhiskered trapper, who posed in his own well-worn buckskins.

Proctor continued working on *On the War Trail (plate 112)*, the equestrian Indian statue for Denver's Civic Center. He obtained permission from the superintendent of the Nez-Percé Reservation for Sundown to pose for him once more. Artist and model so enjoyed visiting the local roundups that little work was ever accomplished. When Proctor was finally ready to settle down to serious work, Sundown decided to return home. Proctor then traveled to Montana and selected another model, Big Beaver. Big Beaver went to California with the Proctors and served as model for both *On the War Trail* and the Mohawk Indian in *The Indian Fountain*. *The Indian Fountain* was commissioned by George Pratt for Lake George in New York as a gift to the State.

Proctor also received a commission to do an equestrian statue of *Theodore Roosevelt as a Rough Rider*. He had a special attachment to Roosevelt and the Rough Riders, feeling that he would have joined the Rough Riders when they were first organized had it not been for the responsibilities of a wife and newborn child.

Before Roosevelt left the White House, he commissioned Proctor to do two models of bison heads for the State Dining Room of the White House, as he felt that British lions had no place in the home of the American President. When Roosevelt first saw the finished heads, he exclaimed, "Bully for you, Proctor!" Roosevelt's Cabinet selected Proctor's *Stalking Panther* as their farewell gift to their leader.

At about this time, Proctor received a commission for a large bronze buffalo head for the cornerstone of the Arlington Cemetery

108. A. Phimister Proctor. *The Bronco Buster*. 1918. H. 15'. Civic Center, Denver, Colo.

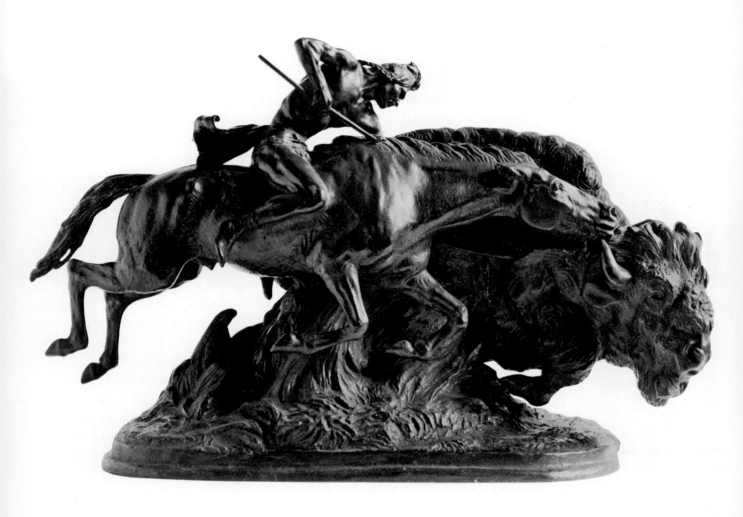

109. A. Phimister Proctor. *Indian and Buffalo Group (Death of the King of the Herd)*. 1916. Gorham and Co., N.Y. H. 18⅛″. The Corcoran Gallery of Art, Washington, D.C.

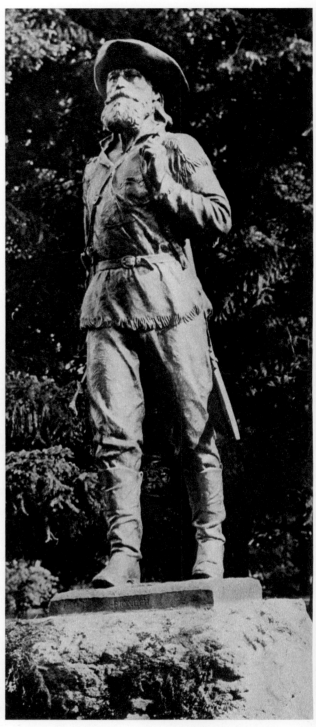

110. A. Phimister Proctor. *The Pioneer*. 1917–18. Presented 1919. Gorham and Co., N. Y. Heroic size. University of Oregon Campus, Eugene, Ore. Photo courtesy the Oregon Historical Society, Portland, Ore.

Bridge in Washington, D.C. Concurrently, he worked on his *Indian Maiden and Fawn* and on *The Circuit Rider (plate 111)*, an equestrian statue of a traveling Methodist preacher, commissioned by R.A. Booth of Salem, Oregon.

Proctor was inspired by many Western themes for which he had no commission. The theme of the pioneer mother had long been in his mind, and one night he envisioned exactly how he wished to show her:

My vision of the statue was a group of weary pioneers traveling westward over the prairie. The young mother, the principal figure,

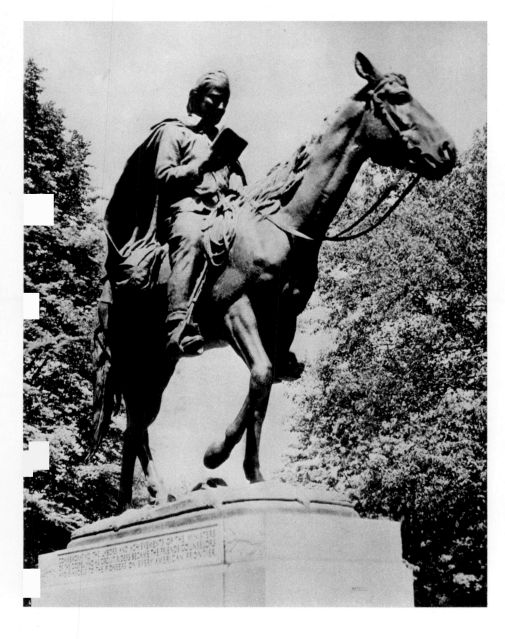

rode horseback, carrying a baby in her arms—the hope for the future of the West. My pioneers were not beginners. Their equipment and attitudes showed that they had already had much experience. I wanted to convey the sense of travel across the dreary expanse of plains under burning sun, rain, and storms, braving hunger and thirst, fording rivers, beset by many dangers on the way.[11]

Proctor carefully selected the perfect wagon horse, the correct packsaddles and sidesaddles, and a Hollywood Western character for his model of the trapper. He began *The Pioneer Mother (plate 502)* without a commission and, after much financial difficulty, secured the patronage of Howard Vanderslice of Kansas City. From his initial conception through the modeling, enlarging, final casting, and unveiling, the project took five years.

Proctor thrived on the commissions awarded him. He worked on *Indian and Trapper (plate 113)* for the McKnight Memorial Fountain in Wichita, Kansas, and executed a statue of *Til Taylor (plate 114)*, a well-known sheriff of Pendleton, Oregon, who was renowned for never having used a gun and never having killed a man. On returning from lunch one day, he was killed by several prisoners who had broken from jail and seized their jailers' weapons. The people of Pendleton, both Indian and white, erected the statue as a memorial to their beloved sheriff. This statue was financed by donations ranging from fifty cents to several hundred dollars.

Proctor did a second version of *The Pioneer Mother (plate 501)* for the University of Oregon. This statue, differing completely from the first, shows an old woman, seated, contemplating her frontier past.

In 1938, Proctor received a letter from J. Frank Dobie, the famous Western historian, commissioning a sculptural group of mustangs in their wild state. Proctor created a family group consisting of a stallion, a colt, and five mares. He lived in Texas on the Rancho Los Palos and used as models fifteen mares that had never been handled: ". . . they were as wild as the outdoors in which they lived. At first the horses wouldn't allow me near them, and I had to keep constant watch for their teeth, forefeet, and heels."[12]

111. A. Phimister Proctor. *The Circuit Rider*. 1922. Heroic size. State Capitol Grounds, Salem, Ore. Photo courtesy the Oregon Historical Society, Portland, Ore.

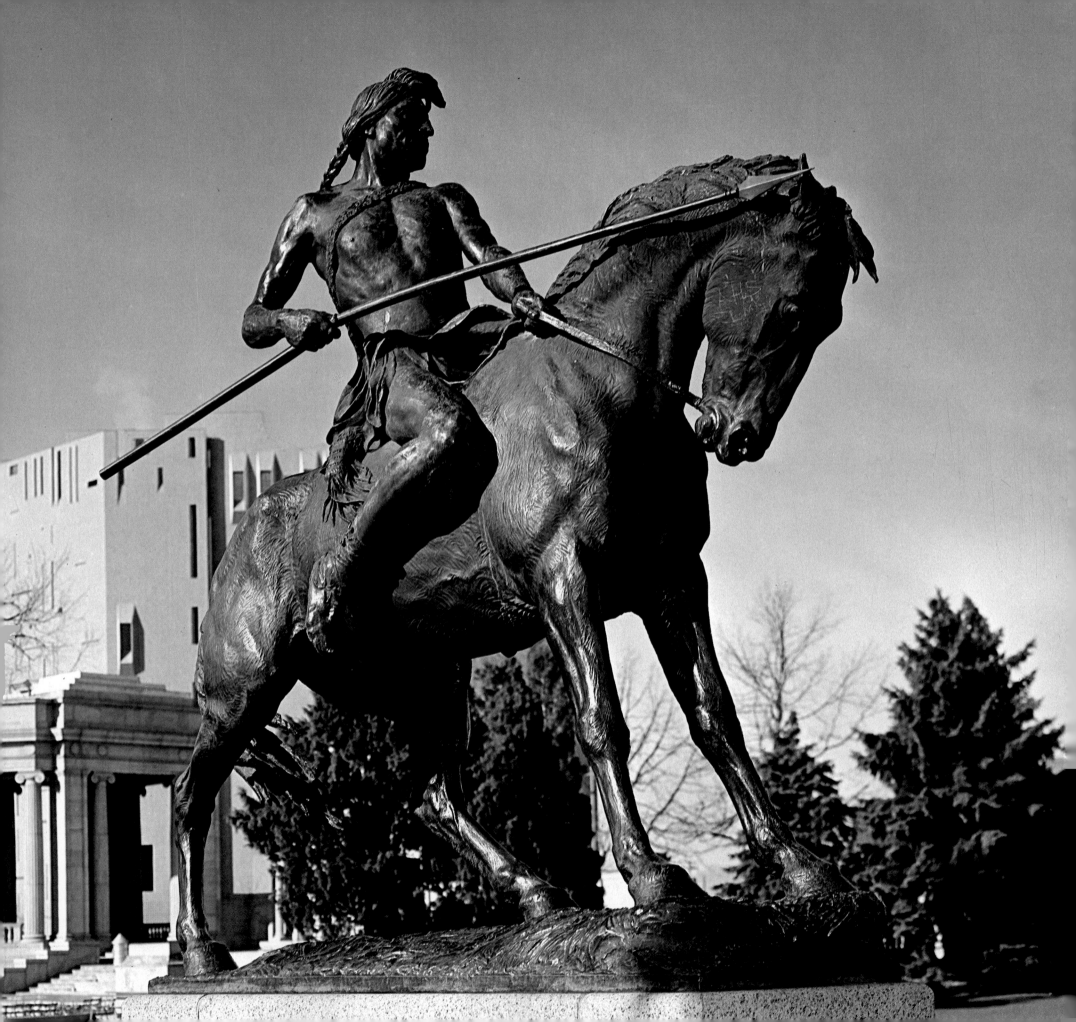

112. A Phimister Proctor. *On the War Trail*. Dedicated 1920. H. 15′. Civic Center, Denver, Colo.

113. A. Phimister Proctor. *Indian and Trapper* (original model for the McKnight Memorial Fountain, Wichita, Kans.). c. 1929. Heroic size. Whereabouts unknown. Photo: *Alexander Phimister Proctor, Sculptor in Buckskin: An Autobiography* © 1971 University of Oklahoma Press, Norman, Okla.

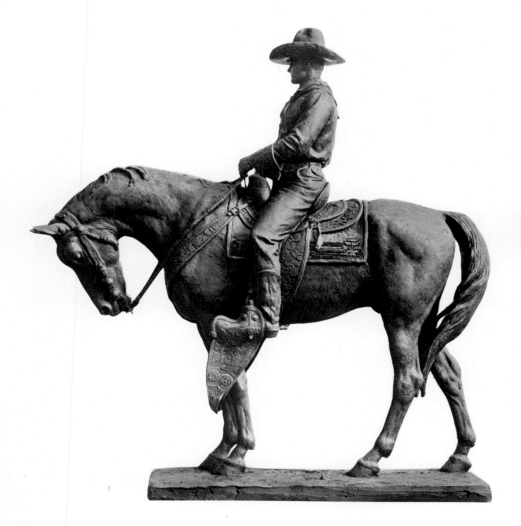

114. A. Phimister Proctor. *Til Taylor* (original model for the statue standing in Pendleton, Ore.). c. 1926. Plaster. Heroic size. Whereabouts unknown. Photo: *Alexander Phimister Proctor, Sculptor in Buckskin: An Autobiography* © 1971 University of Oklahoma Press, Norman, Okla.

115. A. Phimister Proctor. *Mustangs* (detail of plate 511). Unveiled 1948. H. 15′ from plinth to top of mustang's head. Texas Memorial Museum, University of Texas, Austin

The heat in Texas was intense and the temperature rose as high as 119 degrees. Proctor had to sprinkle his plasticine model with ice water to prevent its melting. When at last the monument was finished, he had to wait until after World War II to cast his model *(plates 115, 511)*. In 1948, at the dedication, Dobie spoke these words, now engraved on the base of the statue:

These horses bore Spanish explorers across two continents. They brought to the Plains Indians the age of horse culture. Texas cowboys rode them to extend the ranching occupation clear to the plains of Alberta. Spanish horse, Texas cow pony and mustang were all one in those times when, as sayings went, a man was no better than his horse and a man on foot was no man at all. Like the Longhorn, the mustang has been virtually bred out of existence. But mustang horses will always symbolize western frontiers, long trails of Longhorn herds, seas of pristine grass, and men riding free in a free land.[13]

Mustangs was Proctor's last major work, for he died two years later.

Through his sculpture, Proctor captured the majestic spirit of both the men and animals of the West. He left a permanent and vital record of the animals of the American wilderness. He had an intimate personal knowledge of both his animal and human subjects and was capable of endowing his animals with a sense of energy and his men and women with the vitality of the frontier and the strength of human dignity.

Proctor had the scientist's eye for observation of detail and the artist's ability to express it. His selection of the most critical movements and his reliance on essential details gave his work dramatic strength, and imparted a sense of individual identity to his animal as well as to his human models.

Throughout his life, Proctor had the adventurer's joy in the living world around him. He proclaimed his own philosophy of life thus:

I was born during the frontier period of the United States and grew up in Colorado in the best of it. It colored my life and influenced me greatly. I would not change my life for any other, but my love has always been divided. I am eternally obsessed with two deep desires— one, to spend as much time as possible in the wilderness, and the other, to accomplish something worthwhile in art.[14]

X

FREDERIC REMINGTON: THE GLORY OF HEROES AND HORSES

You have just sailed across the Atlantic Ocean. As you approach New York Harbor, you wait for your first view of the United States. The first sight to catch your eye is a giant bronze statue of an American Indian. This heroic welcome was the dream of Frederic Remington. Remington believed that Americans should create statues and monuments which were purely American in theme and felt that this tribute to the original inhabitants of the United States was the most suitable greeting both for travelers visiting from foreign shores and for Americans returning home. Remington had wanted his bronze Indian to be placed on that point of Staten Island where it extends furthest into the ocean—a magnificent tribute indeed to the original Americans.

Frederic Remington was America's greatest artist of heroic Western bronzes. The Indians of *The Scalp*, *The Savage*, and *The Cheyenne*; the soldiers of *Dragoons—1850*, *The Sergeant*, and *Trooper of the Plains—1868*; the cowboys of *The Bronco Buster*, *The Outlaw*, and *Coming Through the Rye*; the trapper of *The Mountain Man*—all of the protagonists in the drama of Western life were glorified as heroes *(plates 116–142)*. Remington's sculptures were valuable not only as exciting artistic creations, but as tangible documents of the colorful era of American history now past.

Remington's greatness was recognized in his own time. In 1905, Owen Wister wrote: "Remington is not merely an artist; he is a national treasure."[1] Theodore Roosevelt said of him: ". . . he has portrayed a most characteristic and yet vanishing type of American life. The soldier, the cowboy and rancher, the Indian, the horses and the cattle of the plains, will live in his pictures and bronzes, I verily believe, for all time."[2] When the Rough Riders disbanded after the Spanish-American War in Cuba, they selected *The Bronco Buster* by Remington as the most suitable gift to express their admiration for their leader. Roosevelt, in a letter to the sculptor, described this gift: "It was the most appropriate gift the Regiment could possibly have given me and the one I would have valued most. I have long looked

124

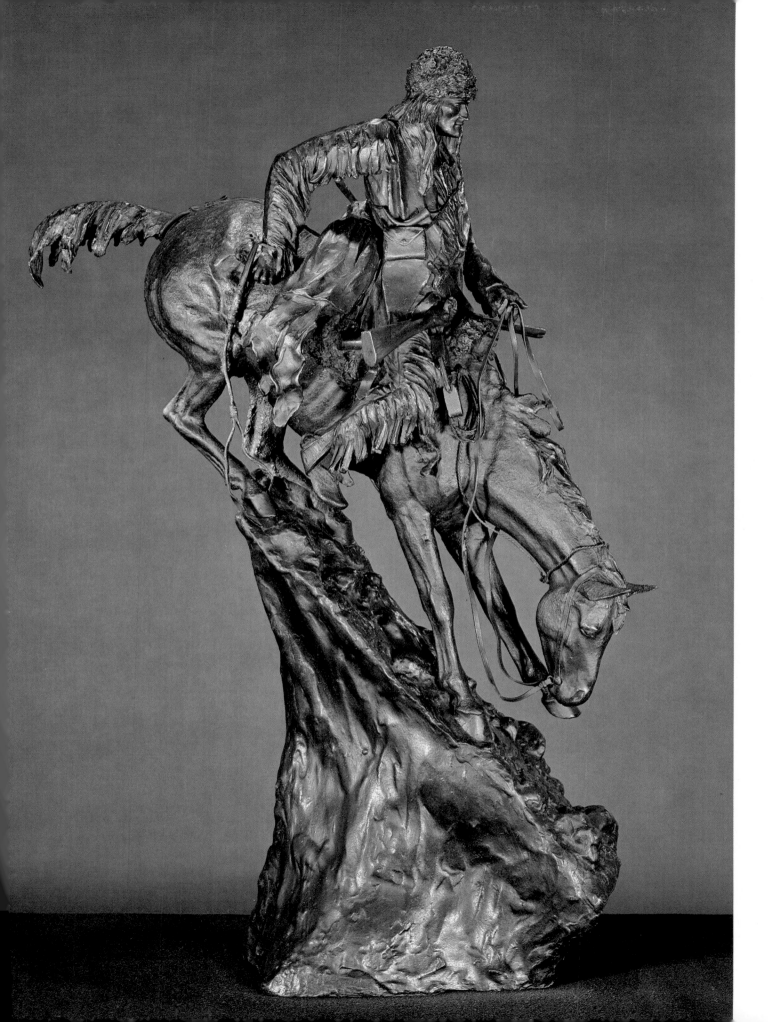

116. Frederic Remington. *The Mountain Man*. 1903. Roman Bronze Works, N.Y. H. 28⅛″ including artist's base. Amon Carter Museum, Fort Worth, Tex.

117. Frederic Remington. *Dragoons— 1850* (detail). National Cowboy Hall of Fame, Oklahoma City, Okla.

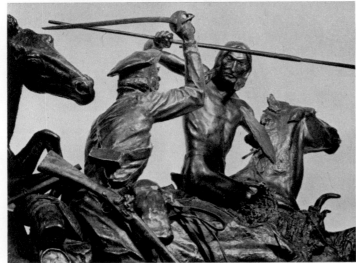

118. Frederic Remington. *Dragoons— 1850* (detail)

hungrily at that bronze, but to have it come to me in this precise way seemed almost too good."[3]

Frederic Sackrider Remington was born on October 1, 1861, in Canton, New York. His mother was Clara Bascomb Sackrider, daughter of a prominent New York State family. His father was Seth Pierrepont Remington, publisher of a newspaper, the *St. Lawrence Plaindealer*. At the outbreak of the Civil War, Seth Remington left the newspaper and his family to join a Northern regiment, Swain's Cavalry, which later won fame as the fighting Eleventh New York Cavalry. At the end of the war, Remington's father re-purchased the newspaper, and the family settled down for several years.

Young Frederic was an athletic boy, enjoying most sports and almost all aspects of nature and outdoor life. Throughout his boyhood, he found the discipline of school life distasteful and far preferred swimming, fishing, and hunting. Above all, he loved and was fascinated by horses. This romance lasted his lifetime and indeed, in later years, he proposed his own epitaph: "He knew the horse."

Remington's imagination was greatly stirred by stories of Western adventure and by tales of cowboys, soldiers, and Indians. He devoted many hours of his boyhood to sketching and drawing the horses, soldiers, and Indians of his dreams.

In 1872, when young Remington was eleven, his father, who had always been active in politics, was appointed Collector of Customs at Ogdensburg, New York. Remington first attended the public school there and then the Vermont Episcopal Institute in Burlington, Vermont. In 1876, thanks to his father's interest in military discipline and training, he was sent to the Highland Military Academy in Worcester, Massachusetts. Although the rigidity of military discipline was alien to Remington's nature, he did adequate schoolwork. Most of all, he enjoyed the military drills and the athletics.

When Frederic was seventeen, he entered Yale as one of two students in the newly formed Yale Art School. The other was Poultney Bigelow. Bigelow, who later became a well-known writer and editor, was a key figure in the development of Remington's artistic career.

Remington's reputation at Yale was as an athlete rather than as an artist. He was a member of the football varsities of 1878–79 and of 1879–80, which were captained by Walter Camp. During his two years at Yale, he developed a great distaste for academic art. In 1880, his father died, leaving Remington a modest inheritance. This inheritance gave him the temporary financial independence to leave Yale.

He first tried a minor political job in New York State. This clerical

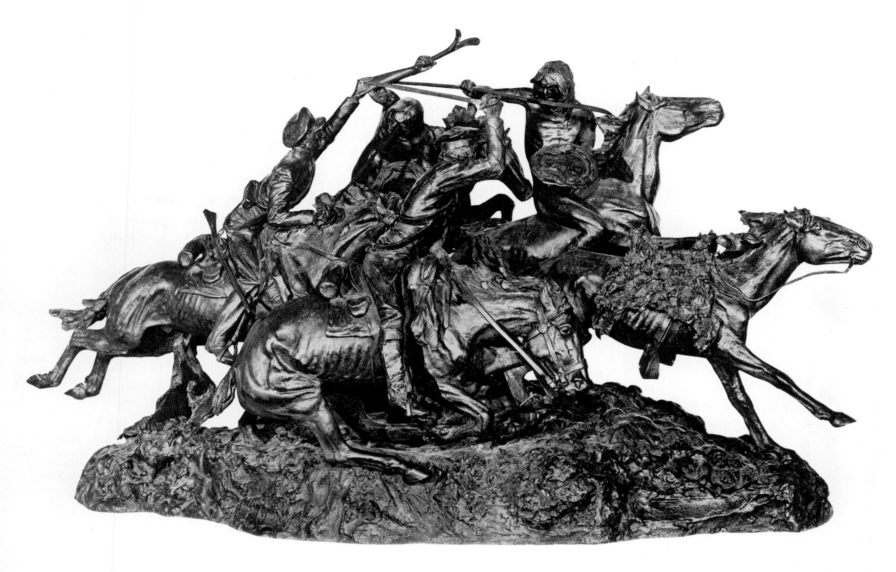

119. Frederic Remington. *Dragoons—1850*. 1905. Roman Bronze Works, N.Y. H. 28″. Remington Art Memorial Museum, Ogdensburg, N.Y.

work was followed by a series of other jobs, but Remington was too restless to endure the routine and confinement of office life. Jobless and rejected as a suitor by the father of his new-found love, Eva Caten, Remington traveled West in 1880, seeking both his fortune and an end to his restlessness.

To Remington, the West was a delight and an inspiration. During the next few years, he reveled in the phenomenal natural beauties and the excitement of life in the Dakotas, Wyoming, Montana, Kansas, and the Indian Territory. He felt an insatiable desire to travel to new places and to meet new people. He wanted to experience everything this new and wonderful world offered. Remington tasted every

aspect of Western life. He worked as a hired cowboy and as a sheep rancher. He traveled over plains, desert, and mountains with a wagon train and tried prospecting for gold. He even joined a military division during the final campaigns against outposts of renegade Sioux, which offered resistance to the dictates of Washington. Remington visited Indian settlements and learned to distinguish various Indian tribes. He followed in the footsteps of the pioneers over the Oregon and Santa Fe Trails.

Wherever Remington traveled, he studied and sketched the land and people around him. The great importance of these early travels was that here Remington discovered his mission as an artist. In an article in *Collier's* in 1905, the sculptor described the experience which acted as a catalyst in the realization of this mission:

Evening overtook me one night in Montana, and I by good luck made the camp-fire of an old wagon freighter who shared his bacon and coffee with me. I was nineteen years of age and he was a very old man. Over the pipes he developed that he was born in Western New York and had gone West at an early age. His West was Iowa. Thence during his long life he had followed the receding frontiers, always further and further West. "And now," said he, "there is no more West. In a few years the railroad will come along the Yellowstone and a poor man can not make living at all."

The old man had closed my very entrancing book almost at the first chapter. I knew the railroad was coming—I saw men already swarming into the land. I knew the derby hat, the smoking chimneys, the cord-binder, and the thirty-day note were upon us in a resistless surge. I knew the wild riders and the vacant land were about to vanish forever, and the more I considered the subject the bigger the Forever loomed.

Without knowing exactly how to do it, I began to try to record some facts around me, and the more I looked the more the panorama unfolded. . . . I saw the living, breathing end of three American centuries of smoke and dust and sweat. . . .[4]

To this goal Remington devoted his entire life. The last of the old Western world was still visible to his almost photographic eye. To fulfill his mission during his lifetime, he drew, painted, sculpted, and wrote about almost every aspect of Western life and history within his vision.

By 1884, Remington had sufficient funds to marry Eva Caten, and he returned with her to Kansas. He then bought a one-third interest in a saloon in Kansas City. This enterprise ended disastrously when

120. Frederic Remington. *The Stampede*. 1909. Roman Bronze Works, N.Y. H. 22″. Remington Art Memorial Museum, Ogdensburg, N. Y. This was the artist's last sculpture

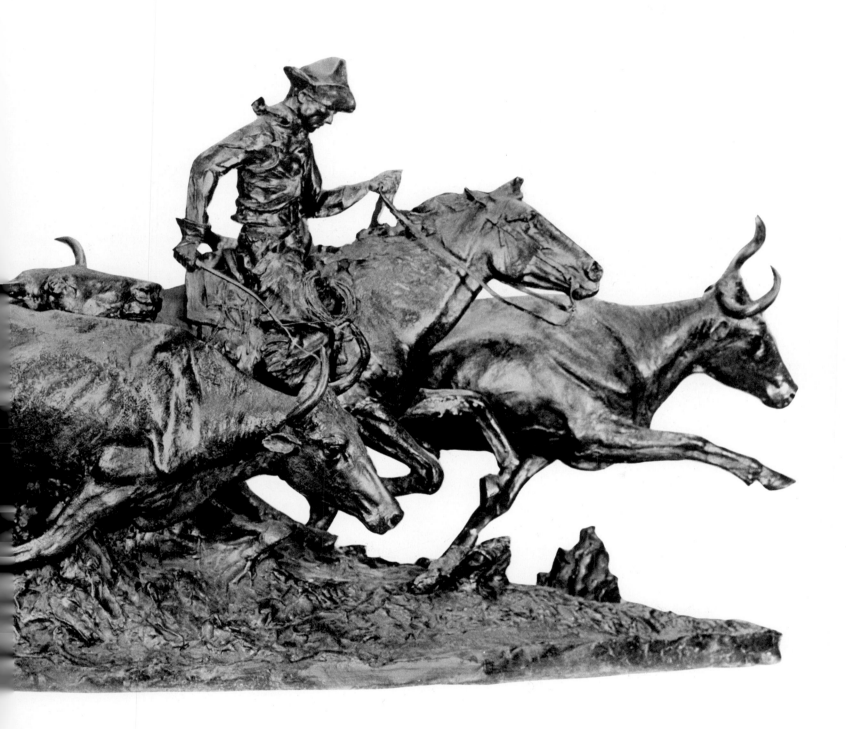

his partners cheated him out of all he had invested. Penniless, he temporarily returned his bride to her parents.

In 1885, Remington returned to New York with three dollars in his pocket and hundreds of drawings from his Western travels. Reunited with his wife, he moved into a furnished room in a Brooklyn boarding house. Up to this time, he had sold only two pictures. These were purchased by *Harper's Weekly* and had to be redrawn. The first one was published as *Cowboys of Arizona, Roused by a Scout, drawn by W.A. Rogers from a sketch by Frederic Remington.* Remington enrolled in the Art Students League, where he worked earnestly to improve his technique, however distasteful academic art instruction might seem. Although his dedication was sincere, his renewed schooling lasted only a short time for he was anxious to return to independent work. It was hard to sell his drawings to the periodicals at this time, since industrial America was doing its best to forget its pioneer background and its lingering Indian problems.

Slowly Remington won recognition as an illustrator. On January 9, 1886, the full-page cover illustration of *Harper's Weekly* was entitled *The Apache War—Indian Scouts on Geronimo's Trail.* This marked Remington's first illustration published under his own name. Poultney Bigelow, his former classmate at Yale, now editor of *Outing Magazine,* was one of the first to recognize Remington's genius. He bought Remington's entire portfolio and almost his entire artistic production over the next three years. Theodore Roosevelt selected Remington to illustrate his book, *Ranch Life and the Hunting Trail.* This book, published in 1888, was an artistic as well as a literary success.

Remington's popularity as an illustrator continued to grow and he sold dozens of illustrations to *Harper's Weekly* and *The Century Magazine,* as well as to *Outing Magazine.* In 1887, his watercolor, *The Flag of Truth in the Indian Wars,* was accepted for hanging in the annual exhibition of the American Watercolor Society. His paintings won prizes in exhibitions of the National Academy of Design and he was sought as an illustrator of both Western fiction and history.

Remington went West many times. He wrote many magazine articles which he collected into a number of volumes and then illustrated: *Pony Tracks* (1895), *Crooked Trails* (1898), *Stories of Peace and War* (1899), and *Men With the Bark On* (1900). In addition, he illustrated three great picture books: *Drawings* (1897), *Frontier Sketches* (1898), and *Done In The Open* (1902).

Remington wrote a book of short stories, *Sun-Down Leflare* (1899), and two historical novels, *John Ermine of the Yellowstone* (1902) and *The Way of An Indian* (1906). *The Way of An Indian* has been praised as "the best novel by a white man about Indian life—the loves,

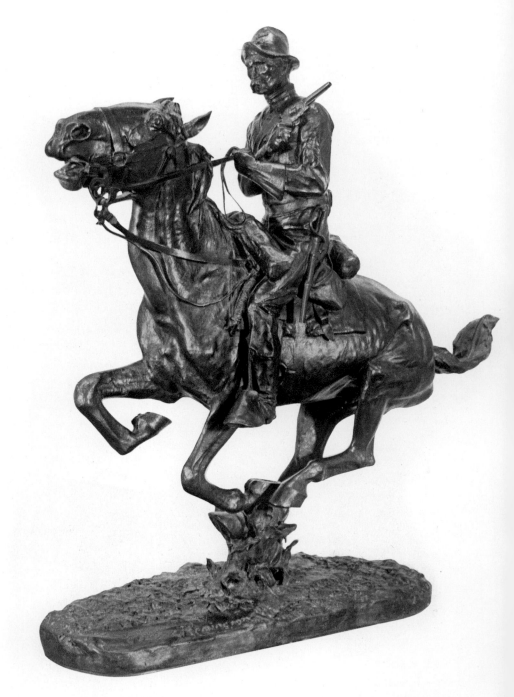

121. Frederic Remington. *Trooper of the Plains—1868.* 1909. Roman Bronze Works, N.Y. H. 26½". Thomas Gilcrease Institute, Tulsa, Okla.

domestic problems and the fighting mores of the red warriors. No one else has been able to look at these problems from the Indian viewpoint quite as well, before or since."[5]

By 1885, Remington was indeed successful, both artistically and financially. He had been a professional artist for ten years. Yet half of his artistic career had not yet begun: Frederic Remington—Sculptor of Western America. As a sculptor, he was an immediate success.

In his lifetime, Remington made twenty-five statues in bronze. Each of these creations is a variation of the heroic ideals of Western America. Bronze was the perfect medium for Remington. One art critic wrote: "The designs he created were possible only in cast metal. As a sculptor he seemed to think in bronze, or rather he thought first of his subject and then of the medium in which to fashion it. Bronze was the only answer."[6]

The story of Remington's first bronze was told in *The Century Magazine* of September 1913, in an article by the playwright Augustus Thomas entitled "The Print of My Remembrance." Thomas recalls that in 1895 Frederic Ruckstull, a popular sculptor of the 1890s, was working in a tent set up on a vacant lot in New Rochelle, New York. Ruckstull had a commission for an equestrian statue of General Hartranft which was to stand before the State House in Harrisburg, Pennsylvania. Remington, always fascinated with any representation of horse and rider, frequently dropped by the makeshift studio to follow Ruckstull's progress. This was Remington's first exposure to sculpture, and the young artist was excited by the possibilities of this new art medium.

At this time, Remington was working on an illustration for a story by Owen Wister entitled "The Second Missouri Compromise." There was, in the foreground of his initial studies, a cowboy pointing a six-shooter at figures in the background. Remington, sketching without models, realized that this arrangement obscured the details of the background and dwarfed the secondary figures. He quickly rubbed out this first attempt, moved the cowboy backward and the lesser figures forward. Remington intuitively visualized his figures from all sides, not just as flat images, as would be expected of an illustrator. Thomas said, "Fred, you're not a draftsman; you're a sculptor. You saw all around that fellow, and could have put him anywhere you wanted him. They call that the sculptor's degree of vision."[7] This illustration, which proved to be the turning point in Remington's life, was *Don't Nobody Hurt Anybody*. It appeared in *Harper's Magazine* on March 18, 1895.

Remington became more and more drawn to this new and untried medium of sculpture. Harold McCracken, in his superb biography of Remington, records a vital conversation between Ruckstull and Remington. Ruckstull recalled:

One Sunday morning I was loafing with him in his studio. "Ruck," he said suddenly, "do you think I could model? Thomas has suggested that I could." "Certainly you can." "What makes you say certainly?" he asked. "Because you *see*, in your mind, so very clearly anything that you want to draw. You will be able to draw just as clearly in wax as you do on paper." "But how about the technique of it?" he queried with a quizzical look. "Technique be hanged," I replied. "Forget it and it will take care of itself. Then you will have an individual technique, or surface modelling, personal and peculiar to you, and in this epoch of a craze for individuality that will be an added quality. All you need to think of is a popular subject, a fine composition, correct movement and expressive form. Begin right away. You can do it. Take that drawing of yours of a Bronco Buster—you can start with that. I'll get a modelling stand, and tools and modelling wax for you, and show you how to make a wire skeleton for supporting the wax, and all that." He jumped up eagerly. "By God!" he exclaimed boyishly, "I can try anyhow, can't I?" "And you can't fail," I replied.

I went to New York, ordered all the paraphernalia he needed, and soon he was busy as a bee modelling and producing his "Bronco Buster."[8]

The Bronco Buster (plates 122, 148, 188), Remington's first bronze, only two feet tall, is the first statue in America of a rider on a bucking horse. In the history of American Western bronzes, it is indeed a landmark and has provided the standard for what today has become the most popular subject in Western sculpture.

Remington faced extreme difficulties in modeling *The Bronco Buster*. Not only was this his initial attempt at sculpture, but he had never before seen a statue of a rider on a bucking horse. He had, however, once been for a ride on a bronco and recalled: "Only those who have ridden a bronco the first time it was saddled, or have lived through a railroad accident, can form any conception of such an experience."[9] Because of complex technical as well as aesthetic problems, he almost decided at one point not to have his model cast in bronze. However, the encouragement of his friends, especially of Augustus Thomas, enabled him to persevere and overcome his doubts and on October 1, 1895, *The Bronco Buster* was copyrighted.

Remington chose the bronco buster as his first subject because to him the bronco symbolized the story of the West:

As a saddle animal simply, the bronco has no superior. But this particular American horse lays claim to another quality, which in my estimation is not the least, and that is his wonderful picturesqueness. He graces the Western landscape, not because he reminds us of the equine ideal, but because he comes of the soil, and has borne the heat and burden and the vicissitudes of all that pale of romance which will cling about the Western frontier. As we see him hitched to the plow or the wagon he seems a living protest against utilitarianism; but, unlike his red master, he will not go. He has borne the Moor, the Spanish conqueror, the red Indian, the mountain-man, and the *vaquero* through all the glories of their careers; but they will soon be gone, with all their heritage of gallant deeds.[10]

Subject was always of prime importance to Remington, whereas technique was but a tool by which he could create his three-dimensional narratives of a vanishing Western America. Realism was the key to his storyteller's art and is still of primary importance in Western art today. Remington insisted on absolute realism of detail. He assembled a huge collection of cowboy and Indian clothing, weapons, artifacts, and other memorabilia which he used to achieve authenticity in his art. It was his skill in the selection of significant detail that elevates and dignifies his art. Helen Card, a Remington historian, wrote:

Remington's realism was a good realism, not "photographic," but done with a knowing discrimination of detail. The very men whose types he drew thoroughly approved of the result, for they felt his knowledge. Men of action, especially men from the cattle country, army post, and lands occupied by Indians, half-breeds, hunters, trappers, these men liked Remington. They give their stamp-or-snort of approval not only to the instant first effect of one of his compositions as a whole, but to its individual details as revealed on more careful inspection. They like his accuracy; they feel that this man has "been there."[11]

The Bronco Buster was a great success. Within three weeks of the copyright, Arthur Hoeber wrote in *Harper's Weekly*:

He has handled his clay in a masterly way, with great freedom and certainty of touch, and in a manner to call forth the surprise and admiration not only of his fellow craftsmen, but of sculptors as well. Mr. Remington has struck his gait, and that, much as he has accomplished in an illustrative way, more remains for him to do, and other roads are open to him. With youth, health and energy, who shall say how far he may not go? And his is a distinctly American field.[12]

122. Frederic Remington. *The Bronco Buster*. 1895. Roman Bronze Works, N.Y. H. 24¼″ including artist's base. Amon Carter Museum, Fort Worth, Tex. In this rare cast, the rider wears wooly chaps rather than the customary leather chaps (plate 148)

Remington rejoiced in his new success. He recognized that bronze offered the ideal medium for immortalizing the West:

I have always had a feeling for mud, and I did that [*The Bronco Buster*]—a long work attended with great difficulty on my part. I wanted to do something which a burglar wouldn't have, moths eat, or time blacken. It [sculpture] is a great art and satisfying to me, for my whole feeling is for form.[13]

Remington's heroes of the West were everyday people, never the celebrities of the day:

In Remington's work as a sculptor, just as in his work as an artist, his subjects are the unheralded people of the land and the soil, and not the glamourously publicized personalities, such as Buffalo Bill, General Miles or Sitting Bull. For him to have done a bust of Theodore Roosevelt as leader of the Rough Riders would have given Remington considerable prestige and profit; but instead he chose to devote his time and skill to perpetuating the unnamed cowboys, troopers and Indians.[14]

Remington's second sculpture was *The Wounded Bunkie (plate 456)*, copyrighted on July 9, 1896. The artist described his bronze as "Two horses in full gallop, side by side. Each horse carries a cavalry man, one of whom has been wounded and is supported in his saddle and kept from falling by arm of the other trooper."[15] Only one foot of each horse touches the ground. Three views of this bronze appeared in *Harper's Weekly* in 1896.

The third Remington bronze was *The Wicked Pony* or *The Fallen Rider (plate 457)*, copyrighted on December 3, 1898. It portrays a pony kicking at his rider, whom he has thrown to the ground. There is a story that Remington knew of such a "wicked pony" who had killed his rider. Ten days later, Remington copyrighted *The Scalp* or *The Triumph (plates 124–127)*, which portrays a mounted Indian holding up a scalp in a gesture of victory.

Prior to 1901, the Remington bronzes were cast by Henry-Bonnard according to the sand method. In 1901, the sculptor was able to achieve a new degree of realism by changing the method by which his bronzes were cast. Remington's use of the cire-perdue or lost-wax method of casting is one of the earliest in the United States. This process, however, dates back to the time of such Italian masters as Benvenuto Cellini.[16] Riccardo Bertelli, owner of the Roman Bronze Works in New York City, was one of the first to perfect this new

123. Frederic Remington. *The Horse Thief*. 1907. Roman Bronze Works, N.Y. H. 25¾". Thomas Gilcrease Institute, Tulsa, Okla. This is one of Remington's rarest bronzes

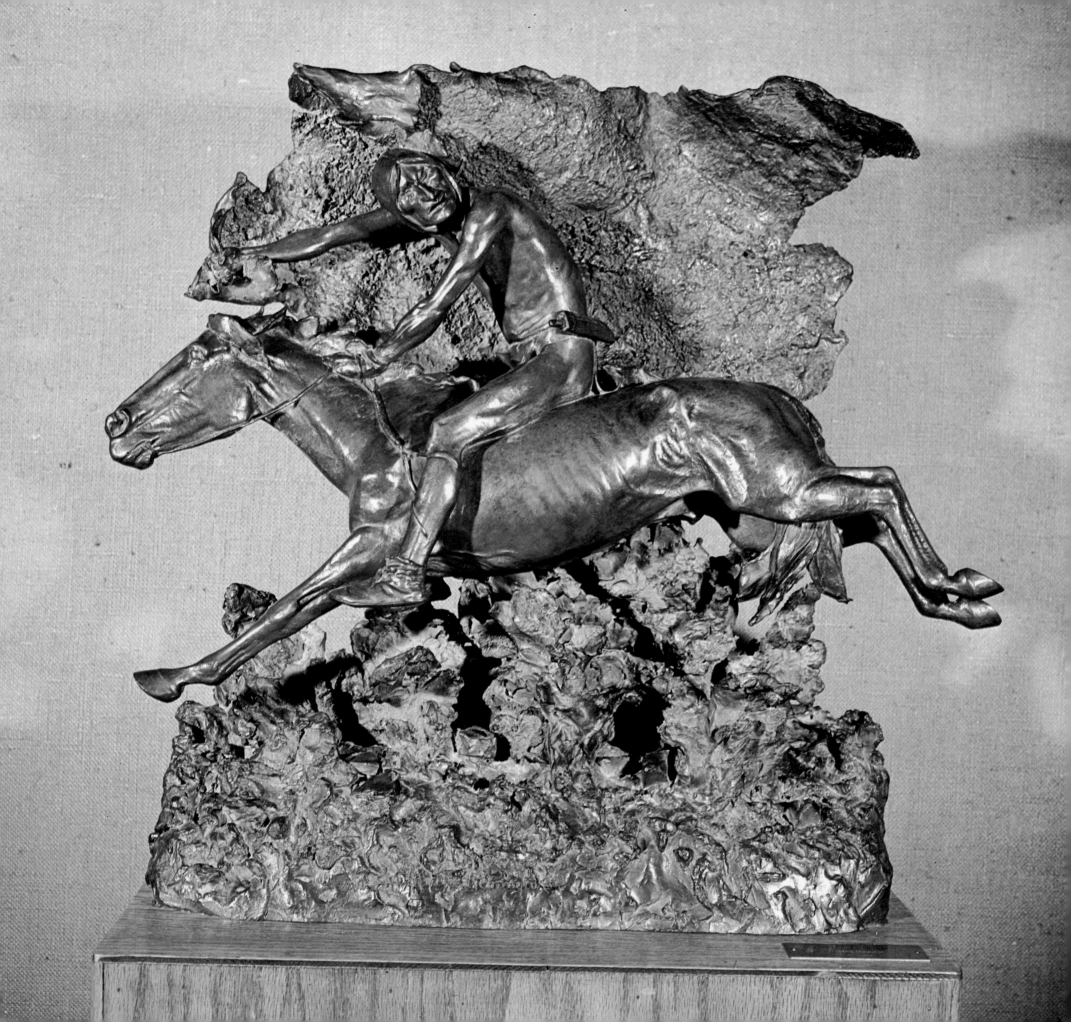

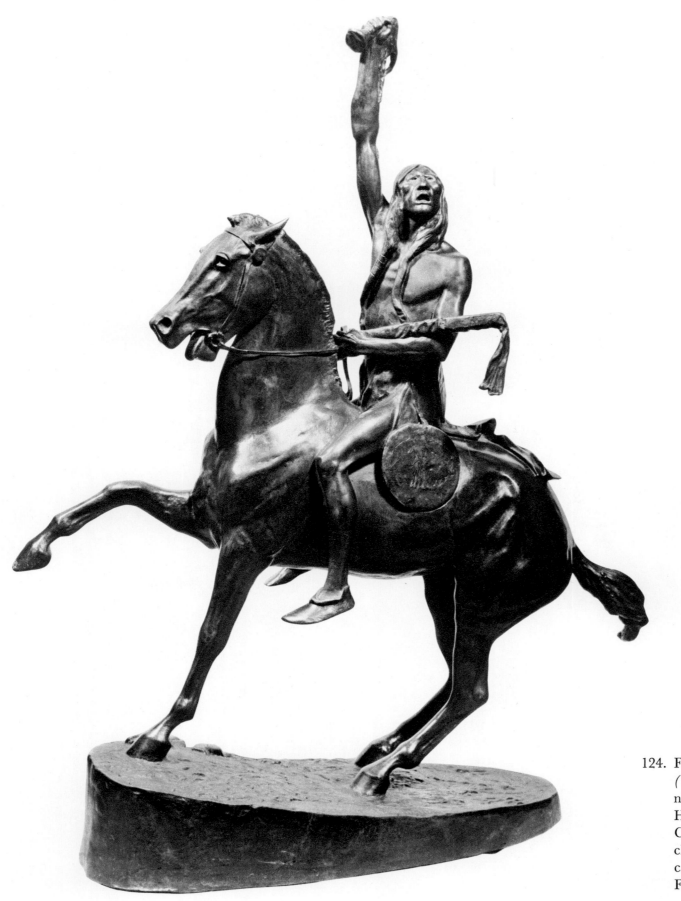

124. Frederic Remington. *The Scalp (The Triumph)*. 1898. Henry Bonnard Foundry, N.Y. H. 21½″. Hammer Gallery, New York City. Remington made extensive changes in his original model because of a fire at the Bonnard Foundry

125. Frederic Remington. *The Scalp (The Triumph)*. 1901. Roman Bronze Works, N.Y. H. 23¾". The Metropolitan Museum of Art, New York City. Bequest of Jacob Ruppert, 1939

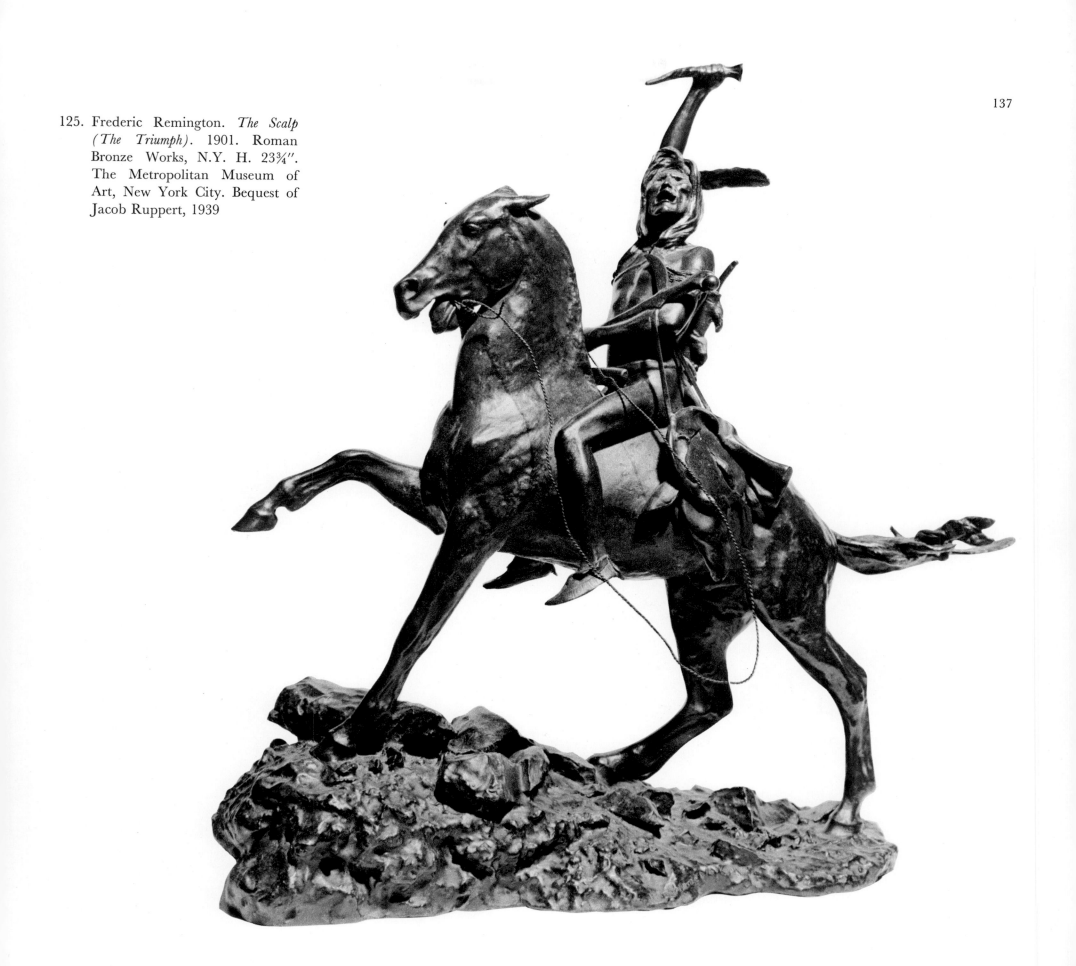

138

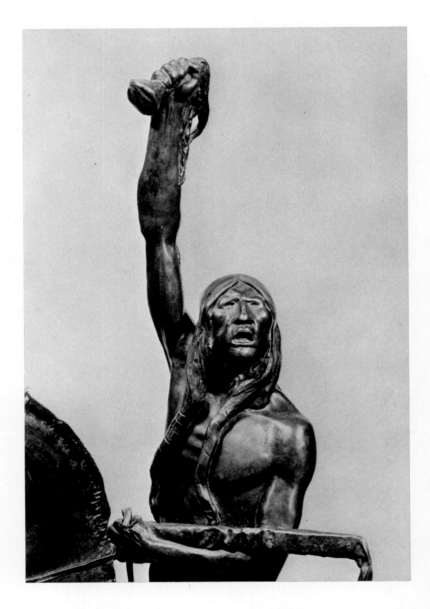

126. Frederic Remington. *The Scalp*
 (detail of plate 124)

127. Frederic Remington. *The Scalp*
(detail of plate 125)

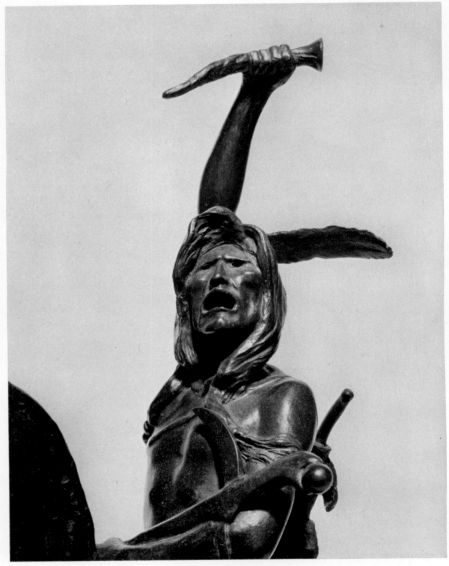

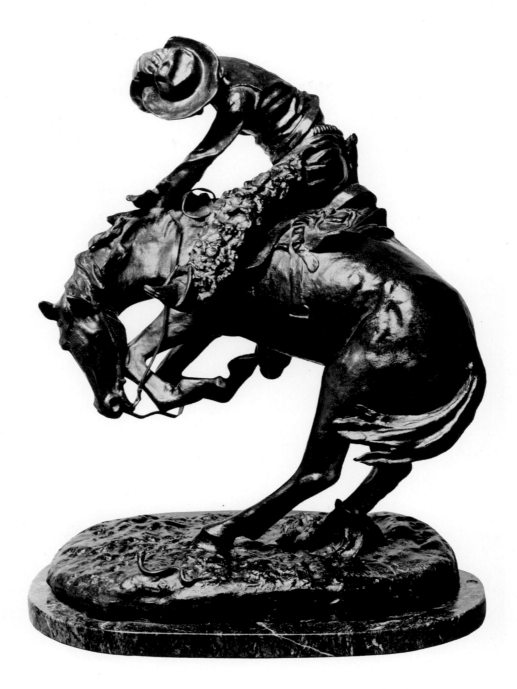

128. Frederic Remington. *The Rattle-snake (Snake in the Path)*. 1905. Roman Bronze Works, N.Y. H. 22″. Collection 21 Club, New York City

process in the United States. He became a close friend of Remington and was a most influential figure in his artistic career.

The lost-wax process gave a clarity of detail and fineness of texture heretofore unknown in American work. Another advantage of this method was that before the final casting, the artist had a thin wax model which he could move slowly and carefully. Remington now could produce variations from one casting to the next; for example, the elevation of a horse's hoofs or tail, or the position of a snake, as in *The Rattlesnake (plate 128)*.

In 1900, Remington copyrighted *The Norther (plate 129)*, a bronze portraying a cowboy on horseback in a snowstorm. This is one of the

129. Frederic Remington. *The Norther*. 1900. Roman Bronze Works, N.Y. H. 22″. Thomas Gilcrease Institute, Tulsa, Okla. This is the only known cast of *The Norther*. Remington stated that three castings were made

130. Frederic Remington. *The Buffalo Signal*. 1902. Roman Bronze Works, New York. H. 36″. Collection H. Kelsey Devereux, Del Ray, Fla. This bronze was a gift from the artist to French Devereux, then fifteen years old. Remington met the Devereux family while traveling out West. Only one cast was made. Photo copyright 1974 by Patricia Janis Broder

rarest of his bronzes. (A complete listing of Remington's Western bronzes appears in the Index of American Western Bronzes at the end of this book.)

In 1901, Remington created *The Cheyenne (plate 131)*. In 1902 he completed *The Buffalo Signal (plate 130)* and copyrighted the bronze that is most characteristic of the spirit of the West, *Coming Through the Rye (plates 133–138)*. Remington bronzes are renowned for a feeling of action. In *Coming Through the Rye,* of the sixteen galloping hoofs, only five touch the ground. The horses fly forward with the freedom symbolic of the West Remington loved and wished to immortalize. The cowboys are alive with the spirit of freedom, joy, and camaraderie. The source of this bronze was the painting *Cowboys Coming To Town For Christmas,* published by *Harper's Weekly* in 1889. A monumental plaster replica of the statue was exhibited in St. Louis at the Louisiana Purchase Exposition of 1904, and shown again at the Lewis and Clark Exposition in Portland in 1905. It was never cast in bronze in monumental size.

The only monumental bronze by Remington is *The Cowboy (plate 493)* standing in Fairmount Park in Philadelphia. The statue, unveiled on June 20, 1908, portrays a cowboy sharply reining a Spanish horse. In the negotiations for this monument, Remington demonstrated his refusal to compromise his vision of reality for either symmetry of design or the aesthetic sensibilities of the city fathers. Remington was always insistent upon realism of detail, both in the structure of his figures and animals as well as in the costumes and equipment of his riders.

Throughout his career, Remington held to his ideals of sculpture. Through his bronzes, he realized his own vision of Western action, despite frequent adverse criticism for going beyond the accepted artistic criteria of the times.

The Outlaw (plate 5), copyrighted in 1906, in which the horse balances on a single forefoot, his hind quarters straight in the air, aroused considerable critical disapproval. The wildest action ever given tangible form was *The Buffalo Horse,* copyrighted in 1907 *(plate 141; compare with plate 142)*. Here a buffalo rears on his hind legs, a pony lifted on his shoulder, crowned by a rider who is tossed to the sky. These poses, filled with the excitement and vitality of Western sculpture, are an inspiration to sculptors today, but were an affront to the artistic sensibilities of the critics of Remington's time.

Remington, enjoying financial success, lived in a large house in New Rochelle, New York, and spent summers at his beloved Ingleneuk Island in Chippewa Bay on the St. Lawrence River. He contin-

131. Frederic Remington. *The Cheyenne.* 1901. Tiffany and Co., N.Y. H. 22½″. The Metropolitan Museum of Art, New York City. Rogers Fund, 1907. The museum purchased this model directly from Remington

133. Frederic Remington. *Coming Through the Rye (Off the Range)*. 1902. Roman Bronze Works, N.Y. H. 27″. National Cowboy Hall of Fame, Oklahoma City, Okla.

132. Frederic Remington. *Coming Through the Rye*. 1888. Ink on paper. 13¼ × 14¼″. Collection Dr. Harold McCracken, Cody, Wyo. This is the original drawing for the sculpture of the same name

ued to travel to the West, but the land of his inspiration was vanishing. Remington wrote:

The West is no longer the West of picturesque and stirring events. Romance and adventure have been beated down in the rush of civilization. The country west of the Mississippi has become hopelessly commercialized, shackled in the chains of business, to its uttermost limits. The cowboy—the real thing, mark you, not the tame hired man who herds cattle for the mere wage of it, and who lives for weeks at a time in conventional store clothes—disappeared with the advent of the wire fence. As for the Indian, there are so few of him that he doesn't count; besides he has gone into trade, into politics, into real estate, and is sending his children to Eastern schools and colleges to learn how he may best outwit the white man's law. I have no interest in the industrial West of today—no more interest than I have in the agriculture of East Prussia, or the coal mines of Wales. My West passed utterly out of existence so long ago as to make it merely a dream. It took off its blankets, put on its hat and marched off the board; the curtain came down and a new act was in progress.[17]

Remington achieved both fame and wealth during his lifetime. In 1909, at the age of forty-eight, he was made an Associate Member of the National Academy of Design. This was the last year of his life. During this critical year, he moved to a ten-acre farm near Ridgefield, Connecticut. He had planned every detail of this farm, but an uncooperative stock market and real estate market necessitated trimming it from its original fifty acres. He had only a very short time to live

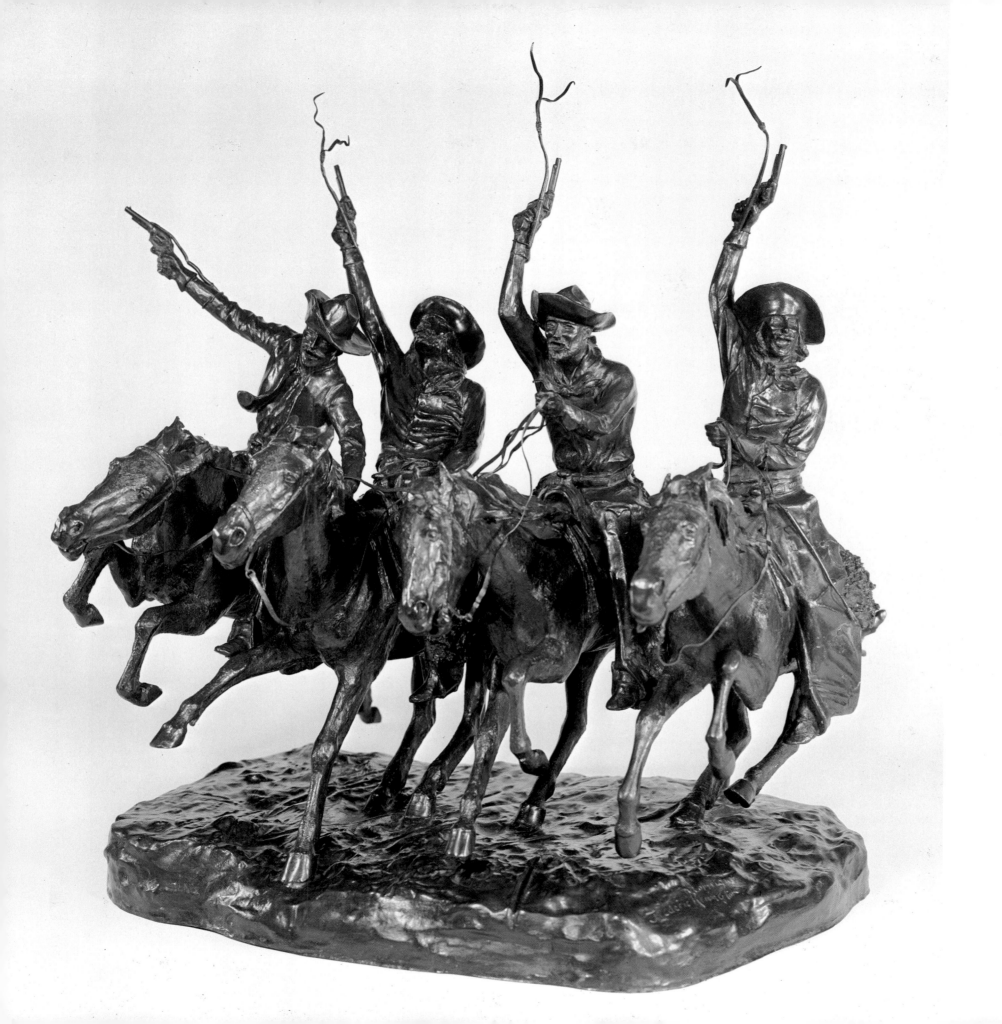

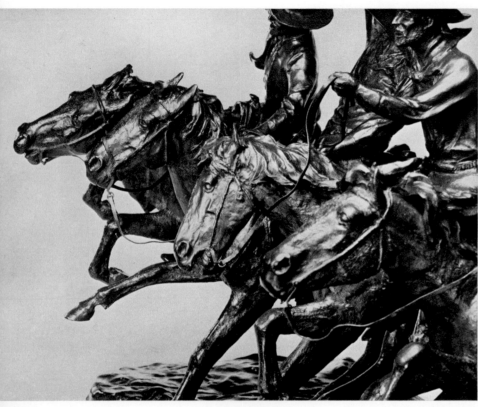

134. Frederic Remington. *Coming Through the Rye* (detail)

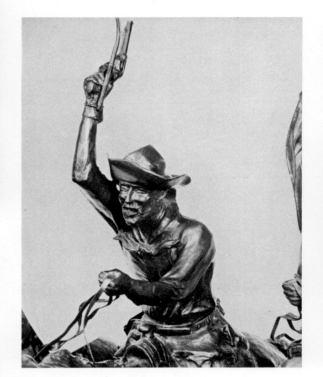

136. Frederic Remington. *Coming Through the Rye* (detail)

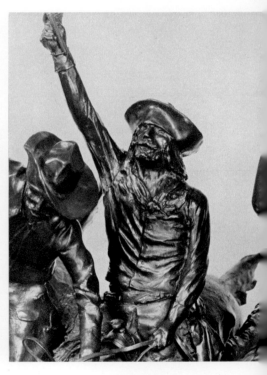

137. Frederic Remington. *Coming Through the Rye* (detail)

135. Frederic Remington. *Coming Through the Rye* (detail)

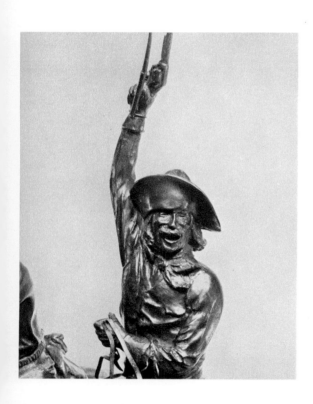

138. Frederic Remington. *Coming Through the Rye* (detail)

139. Frederic Remington. *The Sergeant*. 1904. Roman Bronze Works, N.Y. H. 10¼″. Remington Art Memorial Museum, Ogdensburg, N.Y.

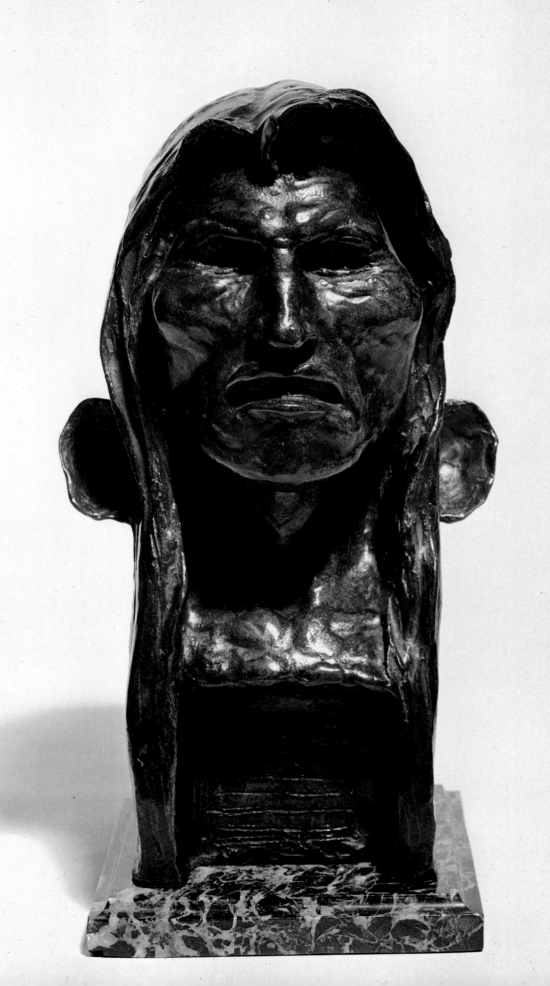

140. Frederic Remington. *The Savage.*
1908. Roman Bronze Works, N.Y.
H. 11″. The Metropolitan Museum of Art, New York City. Bequest of Jacob Ruppert, 1939

141. Frederic Remington. *The Buffalo Horse.* 1907. Roman Bronze Works, N.Y. H. 35″. Thomas Gilcrease Institute, Tulsa, Okla. This is the only casting of *The Buffalo Horse*

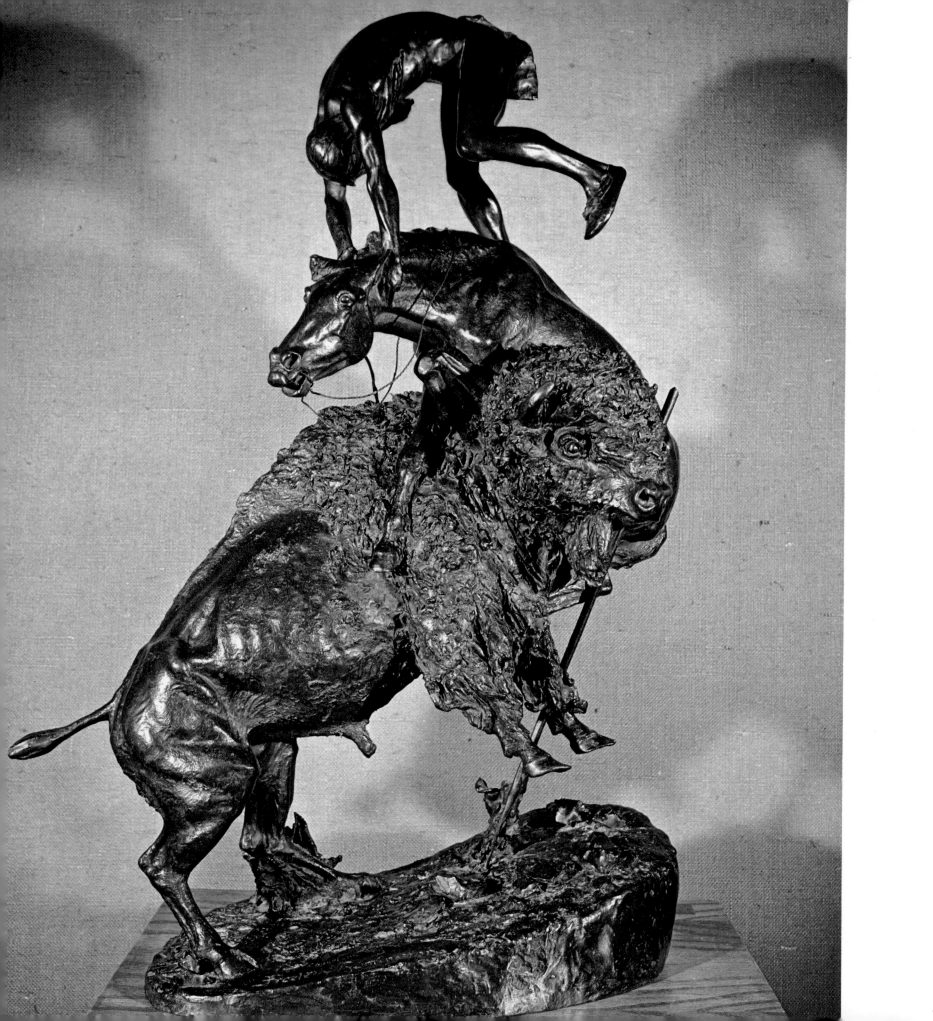

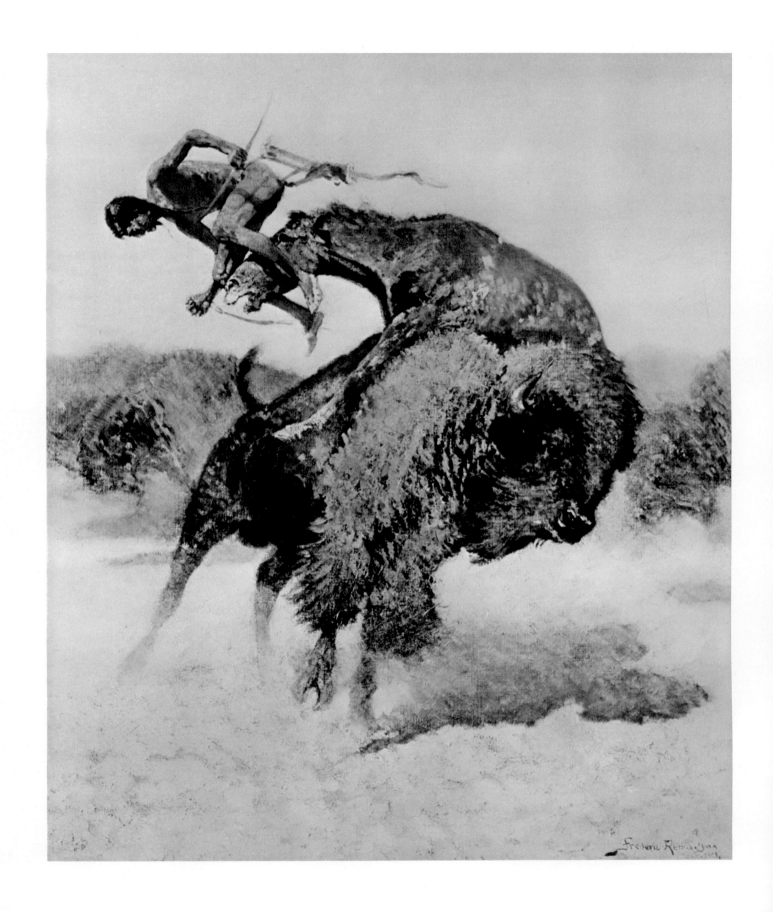

there, surrounded by his Western artifacts, memorabilia, his library, and his art gallery.

Remington throughout his life continued to write, sketch, and paint in watercolor and oil as well as to sculpt. It was a great loss to every aspect of American art when he died suddenly of appendicitis on December 26, 1909.

Today the work of Remington is being re-evaluated. The criticism that his sculpture is but his paintings given a third dimension is being examined in a new light. His sculpture, in many ways, offers an excitement and vitality which belong to that medium alone. The art of bronze sculpture has its own criteria, and Remington's bronzes must be studied and evaluated independently from his paintings.

Today there is a reawakened awareness that realism does not detract from aesthetic value and that obscurity is not a necessary ingredient of artistic creation. That Remington's work is easy to understand and a delight to view does not lessen its worth. Today the bronzes of Remington are valued by collectors and honored by museums across the United States.

Mrs. Remington requested in her will that all Remington models be broken. When she died in 1918, she left the Remington Collection to the Remington Art Memorial in Ogdensburg, New York. Thomas Gilcrease of Tulsa, Oklahoma, purchased twelve bronzes from the estate of Phillip Cole, one of the earliest collectors of Remington bronzes. Cole's bronzes, plus the many further acquisitions of the Gilcrease Institute, are in Tulsa. The R.W. Norton Gallery in Shreveport, Louisiana; the Rockwell Foundation in Corning, New York; the National Cowboy Hall of Fame in Oklahoma City, Oklahoma; the Amon G. Carter Museum in Fort Worth, Texas; and the Whitney Gallery of Western Art in Cody, Wyoming—all have permanent exhibitions of the bronzes of Frederic Remington, which enable the public to enjoy his art.

Remington indeed fulfilled his mission to create a permanent document of the American West. Harold McCracken best summarizes the sculptor's contribution to American art: "His work constitutes one of the most complete pictorializations of that most spectacular phase of the American scene—from the days when white men began to carve an empire out of a wilderness, to the days when the once noble red man had become but an ugly caricature of his conquerors."[18]

142. Frederic Remington. *Episode of a Buffalo Hunt*. 1908. Oil on canvas. 28½ × 26½". Thomas Gilcrease Institute, Tulsa, Okla. This painting is identical with the bronze, *The Buffalo Horse*

XI

CHARLES M. RUSSELL: REFLECTIONS IN BRONZE

The bronze sculptures of Charles Russell offer an intimate view of the world of this famous cowboy artist. A study of these bronzes provides an excellent key to Russell's philosophy and ideals. They reflect the character and personality of the artist more closely than any Western bronzes created before this time. The viewer of Russell's bronzes shares his feelings of delight and of despair, his moments of high excitement and those of quiet humor.

Russell's bronzes are personal rather than public statements. Through his paintings, Russell created glowing documents of cowboy and Indian life in a world he knew was vanishing, whereas his bronzes recaptured intimate moments which he loved in the world around him. They consist primarily of personal observations of animals, portraits of Indian life, and humorous reflections on the cowboy. The terrors and heroics of the conflict between Indian and white man, and the dangers and lawlessness of life on the frontier have no place in Russell's sculptural world.

The West of Remington's bronzes is a world of soldiers and outlaws, bronco busters and savages, protagonists in a heroic drama. By contrast, the West of Russell's bronzes is a world of cowpunchers, Indians, and animals, participants in the ceremonies and rituals of everyday Western life.

The West of Russell the sculptor is the world of Russell the homespun philosopher of the frontier. His philosophy is far more in harmony with the ideals of mid-twentieth century conservationists than with the frontier spirit of the nineteenth century.

Russell was indeed an ecologist who mourned the end of the wilderness and the wanton destruction of animal life. Nancy Russell wrote of her husband: "Charlie was here to see the change. He did not like the new; so started to record the old in ink, paint and clay. He liked the old ways best. He was a child of the West before wire or rail spanned it; now, civilization choked him."[1]

Russell shared very few of the beliefs or ambitions of his age. His personal philosophy isolated him from the soldiers, pioneers, trappers,

and even the majority of cowboys of his day. Russell had no sympathy with the soldiers or cavalrymen who came West to "solve the Indian problem," but had tremendous admiration for the Indians. He felt a rapport with their ideals and beliefs and held a high respect for their customs and traditions. Russell was filled with horror and indignation at the soldiers' belief, as voiced by General Sheridan, "that the only good Indian was a dead Indian," that the army's mission was to clear the Indian off the land with the greatest possible speed and to herd him onto reservations for safekeeping.

Russell had an ideal of harmony for all nature's creatures, and a belief in brotherhood for all men, red and white. Indeed, he expressed his friendship toward all men in Indian terms: "My brother, when you come to my lodge, the robe will be spread and the pipe lit for you."[2]

Russell longed for a bygone era and treasured his early days in the West, begrudging each ensuing year and its resultant changes. He did not share the pioneer view that the God-given mission of the white man was to carve a civilized world from the wilderness.

Thomas McKenney and James Hall, in *History of the Indian Tribes of North America* (1837), expressing the philosophy of the American pioneers, wrote:

Nor do we believe at all that migrating tribes, small in number and of very unsettled habits of life, have any right to appropriate to themselves as hunting grounds, and battle fields, those large domains which God designed to be reclaimed from the wilderness, and which under the culture of civilized man, are adapted to support millions of human beings and to be made subservient to the noblest purposes of human thought and industry.[3]

The pioneer came West to build the future; Russell traveled West to relive the past. The nineteenth-century concept that all progress was good was totally alien to Russell's beliefs. Russell felt that Indian civilization was superior in many ways to that of the white man, and he looked backward in longing for the golden era lost forever: "When I back track memory's trail, it seems all the best camps are behind."[4]

Russell was perhaps closer in spirit to the mountain men living in the isolation of the wilderness. However, he was not a trader at heart, for he was never motivated by financial profit, nor was he a hunter. During the years he lived with trapper Jake Hoover, Russell was never willing to kill. His great pleasure was to ride through the woods, enjoying the pageantry and harmony of undisturbed nature.

Russell is well-known as a cowboy artist, yet he shared none of the romanticized characteristics of today's stereotyped cowboy (plate 144). In 1922, Russell wrote:

The cow folks I see on the screen are mighty mussy gunmen and if thair had been as many people killed in real life as thair is on the screen with blank shells it's a sinch my red brothers would still be eating humpedbacked cows. It would have been a snap for the Injun to clean up the fiew of these gunfighters left. The barbwire and plow made the cowpuncher History and the onley place he's found now is on paper.[5]

Russell was never a great success as a bronco buster. His primary role as a cowboy was that of night herder or night hawk. This is a solitary and introspective life, filled with long nights spent singing to cattle and horses. Russell in fact thought of himself as a night herder, for this was the role he chose for his self-portrait in bronze (plate 174).

Sculpture was Russell's most spontaneous art form. Here he expressed with great intimacy and immediacy his feelings and beliefs about the age of transition in which he lived. Modeling was his relaxation. At all times he carried a small wax ball in his pocket and constantly delighted his friends and new acquaintances by spontaneously producing models. An elderly lady reminisced:

I remember one time that he came. . . He had his hat off and his hands were fumbling around underneath it. . . . But in a few moments he put his hat back on and with an even bigger grin he handed me a piece of clay, which he had been modeling out of sight into a funny little girl in a sunbonnet. I wish now I had kept that little piece of sculpture.[6]

Russell carefully created some wax models as gifts for special occasions. Others he created on the spot, perhaps to pay for an evening's drinking:

He was entertaining a group at a bar by fashioning various figures out of a handful of wax, when one of the onlookers offered to buy the subject he had just made. "Ten dollars!" said Russell. "I'll give you five!" countered the prospective purchaser. Grabbing up the model he squeezed it in his big hand; separated the wax into two equal parts; then quickly making a similar figure of half the size, set it down on the bar in front of the customer and shouted "Sold!" Then he bought a round of drinks for all.[7]

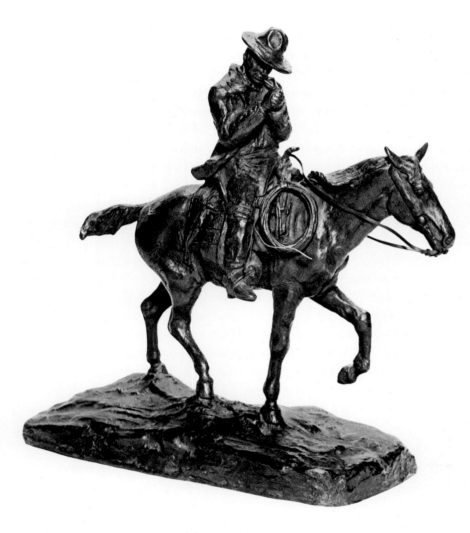

143. Charles M. Russell. *On Neenah (Self-Portrait)*. 1925. H. 10″. National Cowboy Hall of Fame, Oklahoma City, Okla.

Russell often used wax models as preparatory studies for a painting, because he naturally saw things in the round.

A study of Charles Russell the sculptor adds new dimension to the portrait of Russell the painter and Russell the man. Charles Marion Russell was born on March 19, 1864, in Oakhill, near St. Louis, Missouri. He was the third child of Mary Elizabeth Mead and Charles Silas Russell. Young Russell was born into an economically secure and comfortable world. His father was secretary of the Parker-Russell Firebrick Company, a family-owned business which was one of the largest manufacturers of firebricks in the United States.

St. Louis was a major supply-port for fur and Indian traders traveling on the Missouri River. As a boy, Charlie was drawn to the waterfront, where he listened to the local characters telling tales of Indian adventure and stories of the frontier. Often he played hooky from school to watch the boats traveling westward on the Missouri toward Fort Benton, Montana, and returning with cargoes of furs and buffalo hides.

Russell came from strong pioneer stock. Among his colorful ancestors were his mother's brothers—William, Charles, George, and Robert Bent. The Bent brothers were fur traders and men of the frontier. Uncle Charles was appointed Governor of New Mexico in 1848 and four months later was killed in the Pueblo uprising in Taos. Charlie's special hero was Uncle William, who built the first trading post on the Arkansas River and became the first white settler of what is today the state of Colorado. William Bent and Ceran St. Vrain built Bent's Fort, the famous trading post along the Santa Fe Trail in what is today Colorado.

Young Charlie avidly listened to stories of such past heroes of St. Louis as Lewis and Clark, Zebulon Pike, and Kit Carson. "Trappers and Indians" was a favorite childhood game. Charlie was especially excited by stories of the new hero of the West, the cowboy, who was "as virile, colorful, and distinctively dramatic as the scout, mountain-man, or any of the earlier-day paragons of frontier knighthood. He was a little of all of them rolled together—Indian fighter, gun man, vigilante, and pioneer."[8]

From earliest childhood, Russell showed artistic aptitude for drawing and modeling the heroes and animals of his dreams: cowboys, Indians, and horses. As a small child, he first carved in soap and potatoes, but soon graduated to modeling in a local clay. A family story tells how his first clay sculpture was inspired by a trained bear he saw on the road: on returning home, the four-year-old Russell scraped the clay from his shoes and used it to model the bear.[9] When Charlie was twelve, he modeled a horse and rider, using his school slate as a base.

His father had the sculpture cast in plaster and entered it at the St. Louis County Fair. It is said to have won a blue ribbon, Russell's first public success.

The gift of a horse for his tenth birthday added to Charlie's determination to become a cowboy and go West. Russell was a poor and totally indifferent student. Distraught by his constant absenteeism and poor grades, his parents sent him to Burlington College, a military school in Burlington, New Jersey. Once there, he did little work, but was lost in dreams of the West. His only accomplishment at Burlington was a book of twenty-six Western sketches. In desperation, Russell's father, hoping that perhaps a taste of the rough frontier life would cure his son's restlessness, seized the opportunity to send him West with Pike Miller, a family friend. He believed that Charlie might return ready to assume his responsibility in the family business.

Russell left home in 1880, just before his sixteenth birthday. He traveled to Helena, Montana, first by railroad and then by stagecoach. In a biographical introduction to her husband's letters, Nancy Russell described Montana at the time of Russell's arrival:

When they arrived there, the streets were lined with freight outfits. He saw bull teams, with their dusty whackers, swinging sixteen-foot lashes with rifle-like reports over seven or eight yoke teams. . . . These teams were sometimes horses and sometimes mules, and twelve to fourteen span to a team, often pulling three wagons chained together, all handled by one line.

It was also ration-time for the Indians in that section, so the red men were standing or riding in that quiet way of theirs, all wearing skin leggings and robes. . . . The picturesqueness of it all filled the heart and soul of this youthful traveler and he knew that he had found his country, the place he would make his home; but he did not know what a great part he was to take in recording its history for the coming generations.[10]

Russell, as usual, carried wax in his pocket and practiced modeling at every opportunity. Soon after his arrival in Helena, a new acquaintance asked him to show what he could do as an artist. Charlie took a piece of wax from his pocket and modeled a small horse.

Russell's job with Miller was sheep herding in the Judith Basin country. It did not fulfill his expectations of Western life, but rather than return home, as predicted, Russell bought two horses and set off for the mountains on a solitary adventure. As he wandered aimlessly, hungry and tired, Charlie had the good fortune to meet Jake Hoover, a well-known prospector, hunter, and cowboy. For two years

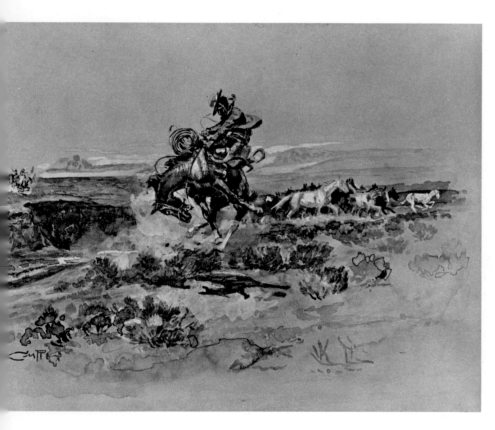

144. Charles M. Russell. *I'm Scarder of Him than I am of the Injuns.* 1926. Watercolor. 13½ × 19″. Montana Historical Society, Helena, Mont. Presented by C. R. Smith. This monochromatic work was done as an illustration for *Trails Plowed Under,* published by Doubleday and Co. in 1927

Hoover gave the young adventurer shelter and food and taught him the skills of survival in the wilderness.

Russell's years with Hoover were perhaps the happiest in his life, for here was an existence free from responsibility with the leisure to dream, draw, and model. Russell described the beauty of the south fork of the Judith:

These parks and the mountains behind them swarmed with deer, elk, mountain sheep, and bear, besides beaver and other small fur-bearing animals. The creeks were alive with trout. Nature had surely done her best, and no king of the old times could have claimed a more beautiful and bountiful domain.[11]

While living with Hoover, who was accepted by many tribes of the area, Russell made his first friendships with the Indians.

After two years, Charlie once again became restless. After a brief visit to St. Louis, he returned to the Judith Basin. Still dreaming of life as a cowboy, he took a lonely job as a night hawk, singing to the horses while the cowboys slept. Later he was a night herder of cattle. This life left him ample time to draw and model: during thirteen years as night herder, Russell studied every aspect of cowboy life. His photographic memory enabled him to reproduce with a perfection of detail both the cowboys' work on the range and their recreation in town.

The winter of 1886–87 was one of the worst in the history of Montana. Russell was herding about five thousand head of cattle belonging to Kaufman and Stadler. When it became necessary to describe to the owners the disastrous state of their cattle, Russell sent them a two-by-four-inch watercolor drawing of a starved steer entitled *Waiting for a Chinook* (a chinook is a warming wind). This sketch was displayed in a local Helena saloon and became well-known throughout the cattle country. It brought Russell local fame as an artist.

Russell's reputation grew as he continued to draw and paint cowboy life. Celebrated by the Helena press, he sold many works to wealthy Montana citizens.

In 1888, Russell traveled to Canada. On his journey homeward, he rode through the reservation of the Blackfoot tribe. He was invited by Black Eagle, the Chief, to spend the winter with the Indians. In later life, Russell attributed this stay with the Blackfeet as the basis of his knowledge of Indian life.

For six months, Russell lived with the Blood Indians. He learned both Piegan, the language of these Blackfeet, and the sign language used for inter-tribal conversation. Russell was physically and spirit-

145. Charles M. Russell. *Smoking Up*. Modeled 1903. Roman Bronze Works, N.Y. H. 11″. Thomas Gilcrease Institute, Tulsa, Okla.

146. Charles M. Russell. *Scalp Dance.* Modeled c. 1904. Roman Bronze Works, N.Y. H. 14". The Henry E. Huntington Library and Art Gallery, San Marino, Calif. Depicted is a brave dance with tomahawk and warclubs before a raid on the enemy

ually at home with the Indians. He discarded his cowboy clothes for Indian buckskins, grew long hair, and was tempted to become a "white Injun" or "squaw man."

Russell had brought some tubes of paint and wax with him to the reservation. He studied the Indians' clothing, weapons, and jewelry, and learned their beliefs and ceremonies. Throughout his life, this knowledge of the Indians was one of the principal subjects of both his paintings and sculptures. Many of the Indians felt Russell had special powers, similar to those of the Medicine Man, that enabled him to draw and model their life with such accuracy. His Indian friends occasionally pointed out errors in his representations of Indian costumes and rituals.

Russell was well accepted by the Indians. He became especially friendly with the young brave, Sleeping Thunder, who named him Ah-Wah-Cous ("Antelope") because the reinforced buckskin of Russell's pants reminded him of the white rump of an antelope. Occasionally Russell used his Indian name as a signature on his letters.

These six months left a deep impression on the young artist. Russell listened to the stories of Sleeping Thunder as well as to those of Medicine Whip, the warrior hero. From these stories, he acquired a wealth of Indian lore and legend. He developed a sincere respect and admiration for the Indian and his way of life and a burning indignation over the mistreatment of the Indian at the hands of the white man: "Unkle Sam lets him play Injun once a year and he dances under the flag that made a farmer out of him once nature gave him everything he wanted. now the agent gives him bib overalls hookes his hands around plow handles and tell him its a good thing to push it along maby it is but thair having a hell of a time prooving it."[12]

Russell never completed a full autobiography, but his bronzes and models of Indian life perhaps give the most intimate glimpse of this phase of his life.

Russell worked as a cowboy until 1893. Two years earlier, he had refused a contract offering seventy-five dollars a month with "grub" for everything he modeled or painted for a year. As he grew in repu-

tation as an artist, he received more commissions and eventually devoted his full working-time to his art.

Although Russell devoted most of his time to painting, he spent as much time as possible modeling. Russell enjoyed a tremendous facility in modeling and could easily transform the beeswax into life-size figures of animals or people, but at this time never considered these models as serious works of art.

In 1895, when visiting his friend and patron, Ben Roberts, Russell met and fell in love with Nancy Cooper. This was unquestionably the turning point in his artistic career. Although Nancy was only seventeen and Charlie thirty-one at the time of their marriage in 1896, Nancy believed in Russell's ability to become a great and successful artist. She completely managed her husband's finances, limited his drinking and carousing with his rowdy friends, and established a routine of regular working hours. Nancy was never popular with Russell's old friends, who believed that she was "ruining Charlie."

After a brief residence in Cascade, Montana, the Russells settled in Great Falls, Montana. In 1900, as a result of either a small legacy from Charlie's mother or a belated wedding gift from his father, the Russells were able to purchase a fine home in Great Falls. Three years later, on the property adjoining the house, Nancy arranged to have a studio built, made from telephone poles resembling a log cabin. Charlie filled the studio with his beloved Indian and cowboy paraphernalia.

In 1903, the Russells made their first trip to New York in hope of selling Russell's paintings to wealthy admirers of Western art. Disappointed in the lack of sales, Nancy next made the rounds of the publishers to sell Russell's paintings and drawings for reproduction in such weekly magazines as *Collier's* and *Leslie's Weekly*. Detesting city life, Charlie stayed at home and contented himself with modeling a drunken cowboy astride a rearing horse. The cowboy is joyfully firing a six-shooter. This eleven-inch model, called *Smoking Up (plate 145)*, was so popular with those who visited Russell's studio that he sold the reproduction rights to the Cooperative Art Society. Six castings were made of this first Russell bronze. One of these was later presented to President Theodore Roosevelt.

Although both Remington and Russell had gone West in 1880, Remington had won recognition and financial success far earlier than Russell. When Remington's first bronze, *The Bronco Buster,* was cast in 1895, he was already a successful painter and illustrator. When *Smoking Up* was cast in 1903, Russell was almost unknown outside of Montana, whereas Remington had completed his ninth bronze, *The*

147. Charles M. Russell. *Sleeping Thunder*. Modeled c. 1902. California Art Bronze Foundry, Los Angeles. H. 6⅞". National Cowboy Hall of Fame, Oklahoma City, Okla.

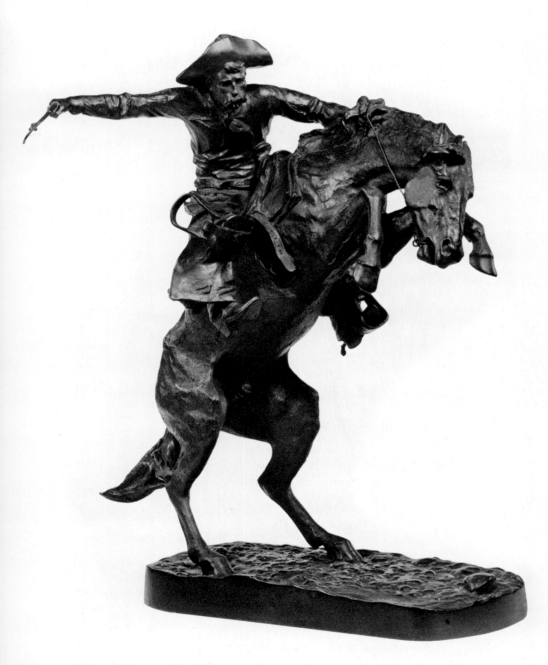

148. Frederic Remington. *The Bronco Buster*. 1895. Roman Bronze Works, N.Y. H. 23″. National Cowboy Hall of Fame, Oklahoma City, Okla.

Mountain Man (plate 116). Russell was familiar with Remington's spectacular success but was never envious of it.

On the Russells' next trip to New York, Charlie created three groups for bronze casting: *The Buffalo Hunt (plate 151)*; *Counting Coup (plate 150)*; and *Scalp Dance (plate 146)*. These were cast by the Roman Bronze Works and sold by Tiffany & Company. The first two sold for $450, and the third for $480. At this time, Tiffany also sold Remington's *The Bronco Buster* for $250 and *The Mountain Man* for $300. Because of their complex detail, the Russell bronzes were more expensive to cast and therefore had to be priced higher than the Remington bronzes. It is interesting to note that in 1969, Remington's *The Bronco Buster* sold for $19,000 and Russell's *The Buffalo Hunt* for $25,000.

In 1911, Russell's first major show in New York was held at the Folsom Galleries. The exhibition, entitled *The West that has Passed*, displayed six Russell bronzes as well as thirteen of his oils and twelve watercolors. *The New York Times* devoted a page to praise "The Cowboy Artist."

Russell's bronze sculptures were primarily of cowboys, Indians, and animals. In almost all of them, his approach is on a personal level. Most appear to be special observations or memories re-created in permanent form. Some bronzes are portraits of such personal friends as Will Rogers, Sleeping Thunder *(plate 147)*, and Medicine Whip.

Russell's bronzes of cowboy life are lighthearted and humorous. He once wrote of his rodeo skills:

I never got to be a bronk rider but in my youthfull days wanted to be and while that want lasted I had a fine chance to study hoss enatimy from under and over the under was the view a taripan gits The over while I hoverd ont the end of a Macarty rope was like the eagle sees grand but dam scary for folks without wings. . .[13]

It is interesting to compare Russell's *The Bronc Twister (plate 149)* with Remington's *The Bronco Buster (plate 148)*. The titles are most revealing of the character of the works. In Remington's sculpture, the cowboy is the conquering hero, whereas in Russell's, the horse is the object of admiration. Russell wrote of the bronco rider: "An Injun once told me that bravery came from the hart not the head. If my red brother is right Bronk riders and bull dogers are all hart above the wast band but its a good bet theres nothing under there hat but hair."[14] In *Where the Best Riders Quit (plate 153)*, the rider knows that even a hero must immediately bail out when a horse is going over

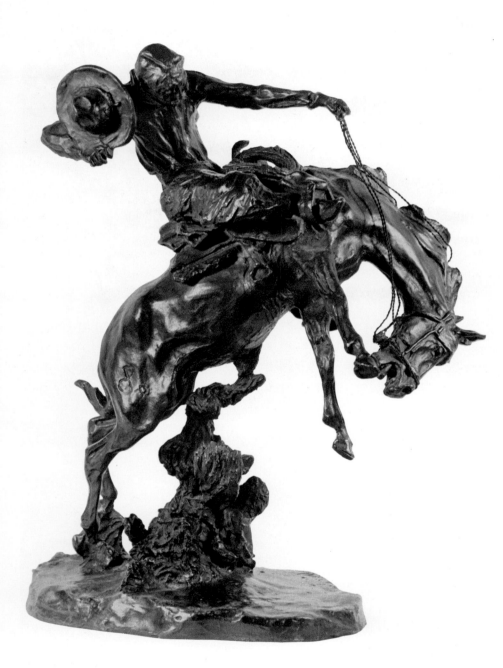

149. Charles M. Russell. *The Bronc Twister*. Modeled c. 1920. Roman Bronze Works, N.Y. H. 17⅛". Hammer Gallery, New York City

backward. In *Painting the Town (plate 154)*, Russell portrayed a popular form of cowboy entertainment, enjoyed at the expense of newcomers to the West.

Russell's bronzes of Indian life offer intimate glimpses of tribal ceremonies and family life. Russell portrayed tribal rituals and leaders in such bronzes as *The Medicine Man (plate 458), Smoking with the Spirit of the Buffalo, Watcher of the Plains (plate 157), The Snake Priest,* and *Peace (plate 155)*. Some bronzes, like *Indian Family, Piegan Girl (plate 156)*, and *Navajo,* are actual Indian portraits. The excitement and vitality of Indian life are recaptured in *Meat for Wild Men (plate 459)*, depicting a buffalo hunt; *The Cryer (plate 158); The Enemy's Tracks (plate 159)*; and *Blackfoot War Chief (plate 160)*.

One of Russell's most dramatic Indian sculptures is *Counting Coup.* Coup was the touching of one's enemy with a stick, a recognized sign of bravery and conquest. In *Secrets of the Night (plate 162)*, Russell portrayed the Medicine Man, the symbol of tribal wisdom, with an owl, the symbol of nature's wisdom, at his ear. The owl tells him where to find his enemies in the night.

Throughout his life, Russell was deeply sympathetic with the Indian cause. He wrote of the Indian: "I've known some bad Injuns, but for every bad one I kin match him with ten white men. Man for man, an Injun's as good as a white man. When he's your friend he's the best friend in the world. White man's whiskey caused all the Injun trouble in the West."[15]

Some of the most delightful of Russell's sculptures are of animal life. He knew the very heart and spirit of wild animals, understood their love of freedom and need for independence. Russell's keen powers of observation—united with his extraordinary, almost photographic memory—enriched these sculptures with a special feeling of life in the open. Russell created bronzes of most of the wild animals of the mountain and prairie: mountain goats, mountain sheep, coyote, and antelope.

Several of Russell's bronzes indicate his fondness for horses. He had four favorites: his cayuse, Monte, his companion for twenty-five years; Gray Eagle, his number-two mount until Monte died in 1903; his third favorite, Red Bird; and Neenah *(plate 143)*, chosen for his bronze self-portrait, *Night Herder (plate 174)*. Russell created portraits of both the thoroughbred and the cayuse, and modeled the horses at work and running free. Of these sculptures, *The Range Father (plate 164)* is one of the most moving. *Prairie Pals (plate 163)* depicts a quiet moment of communication between horse and hare.

Bears were another favorite subject of Russell's sculptures. They are never portrayed as powerful, frightening predators, but as part of

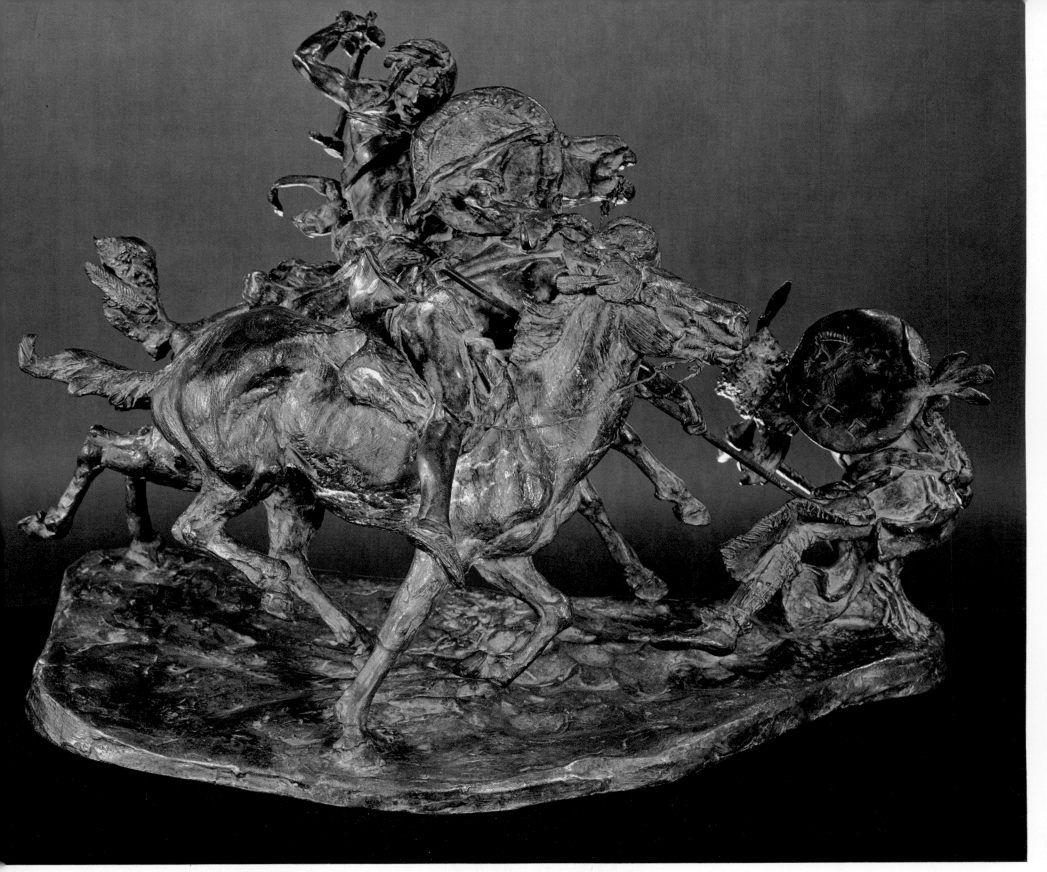

150. Charles M. Russell. *Counting Coup.* Modeled 1904. Roman Bronze Works, N.Y. H. 11¼″. Amon Carter Museum, Fort Worth, Tex. *Coup* refers to striking the enemy, alive or dead, with a weapon held in the hand. In this bronze the Blackfoot chieftain, Medicine Whip, strikes both of his Sioux enemies with a shield and lance simultaneously, scoring two coups —an extraordinary feat of bravery

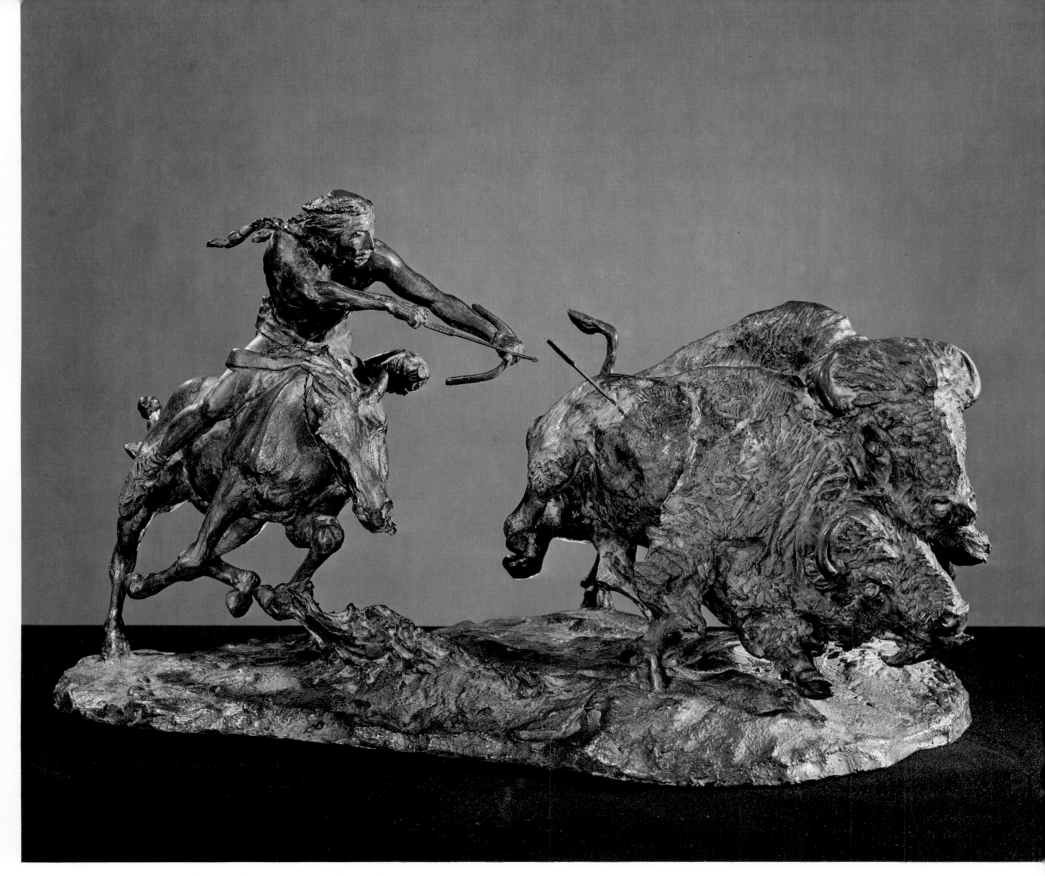

151. Charles M. Russell. *The Buffalo Hunt (The Buffalo Runner)*. Modeled c. 1904, copyright 1905. Roman Bronze Works, N.Y. H. 10″. Amon Carter Museum, Fort Worth, Tex.

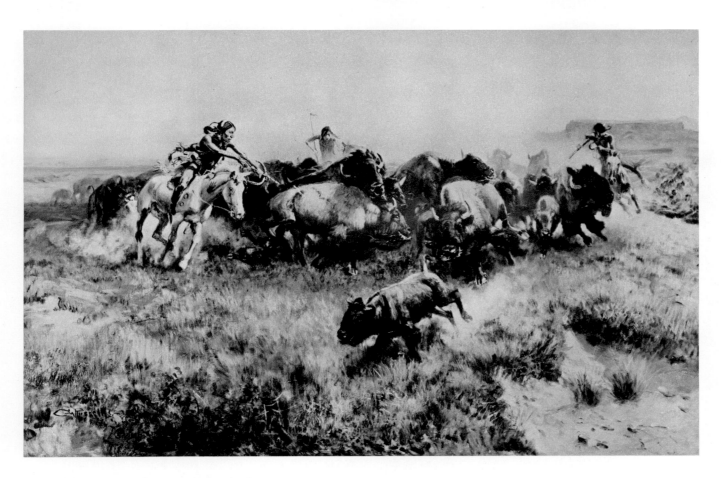

152. Charles M. Russell. *The Buffalo
Hunt #39*. 1919. Oil on canvas.
29 × 47½″. Amon Carter Muse-
um, Fort Worth, Tex.

nature's family. Russell projects on them an almost human obser-
vation of everyday life. *Oh! Mother, What Is It? (plate 165)* shows a
bear cub spying a porcupine for the first time. Many of the sculptures
are studies of mother bears teaching their cubs the ways of woodland
life: for example, *Montana Mother, Mountain Mother (plate 166), The
Bug Hunters*, and *A Happy Family*. In *The Bluffers (plate 167)*, bear and
buffalo confront each other.

The buffalo was one of Russell's most familiar themes. Russell felt
that the buffalo deserved special honor in the West. In 1915, he
wrote in a letter:

this is Thanksgiving day. . .
turkey is the emblem of this day and it should be in the east but the
west owes nothing to that bird but it owes much to the humped backed
beef in the sketch above
the Rocky mountians would have been hard to reach with out him
he fed the explorer the great fur trade wagon tranes felt safe when they
reached his range
he fed the men that layed the first ties across this great west Thair is no
day set aside where he is an emblem
the nickle weares his picture dam small money for so much meat he
was one of natures bigest gift and this country owes him thanks[16]

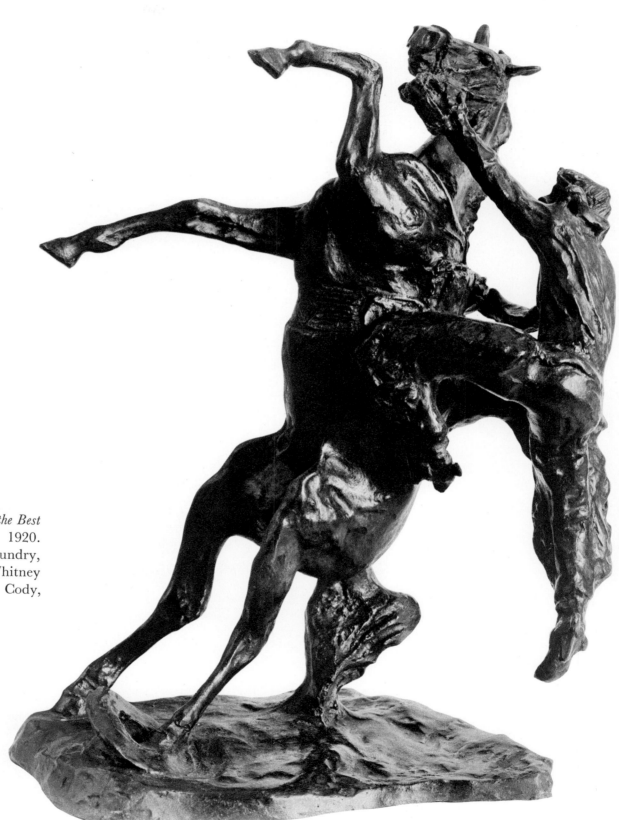

153. Charles M. Russell. *Where the Best Riders Quit*. Modeled c. 1920. California Art Bronze Foundry, Los Angeles. H. 14½″. Whitney Gallery of Western Art, Cody, Wyo.

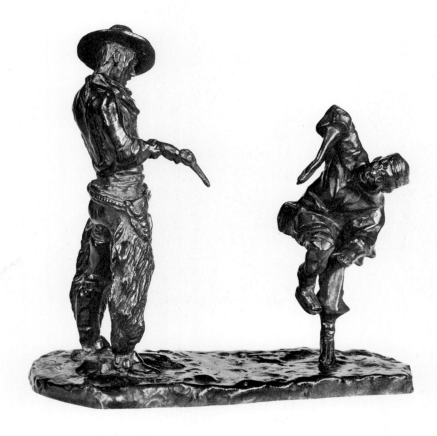

154. Charles M. Russell. *Painting the Town*. Modeled c. 1920. Nelli Art Bronze Foundry, Los Angeles. H. 11⅞". National Cowboy Hall of Fame, Oklahoma City, Okla.

It was the slaughter of the buffalo that led to the final defeat of the Indian. In 1875, General Sheridan said of the buffalo hunter: "These men have done in the last two years, and will do more in the next year to settle the vexed Indian question, than the entire regular army has done in the last thirty years. They are destroying the Indian's commissary."[17] To Russell, the buffalo was the tangible symbol of the world which was lost *(plates 170, 171)*. He referred to the buffalo as "nature's cattle" or "American cattle." Russell's buffalo, like his bears, were often portrayed as family creatures *(plate 169)*. Other bronzes are simple portraits of the noble buffalo *(plate 168)*.

After the destruction of the buffalo, wolves became a serious problem for the Montana cowboy. Without the buffalo to prey upon, wolves attacked the cattle. As in all of his bronzes of wildlife, Russell portrayed the wolf from the animal's point of view. In *The Last Laugh (plate 173)*, the wolf looks victoriously upon a human skull. In *To Noses That Read, A Smell That Spells Man (plate 172)*, the wolf spies an empty whiskey bottle. Other models of wolves illustrate moments of everyday animal life. *An Enemy That Warns* portrays a victorious wolf grinning at the skull of his victim, a buffalo.

One of Russell's most powerful sculptures is *The Spirit of Winter (plates 175–177)*. Here, the ferocity of Montana's winters, which often brought hunger and starvation to cattle and herders alike, is represented by a wolf pack accompanying a figure of death on a mission of vengeance.

Russell's bronzes have a spontaneity of creation, for the sculptor was blessed with an ability to see those critical details that give his works the excitement of life. J. Frank Dobie, the Western historian, wrote:

When one knows and loves the thousands of little truthful details that Charles Russell put into the ears of horses, the rumps of antelopes, the nostrils of deer, the eyes of buffaloes, the lifted heads of cattle, the lope of coyotes, the stance of a stage driver, the watching of a shadow of himself by a cowboy, the response of an Indian storyteller, the way of a she-bear with her cub, the you-be-damned independence of a monster grizzly. . . and a whole catalogue of other speaking details dear to any lover of Western life, then one cherishes all of Charles M. Russell.[18]

Russell never sacrificed unity of composition, always maintaining a delicate balance between structural mass and carefully selected detail. Some bronzes are more impressionistic than others, but all have

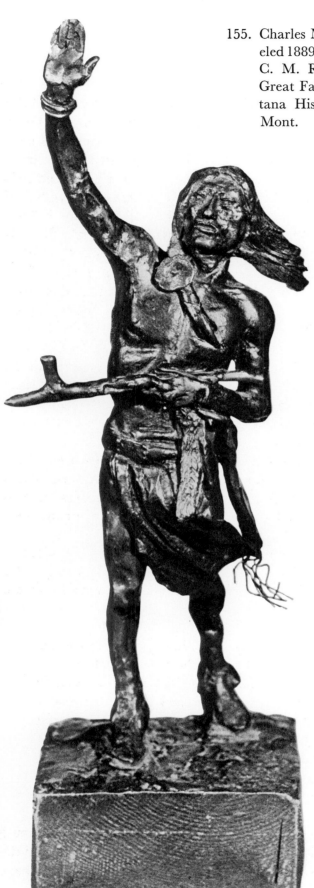

155. Charles M. Russell. *Peace.* Modeled 1889 (recent casting). Trigg—C. M. Russell Foundation Inc., Great Falls, Mont. H. 13″. Montana Historical Society, Helena, Mont.

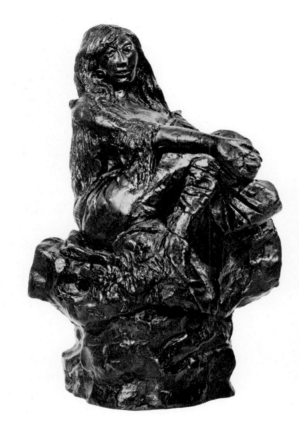

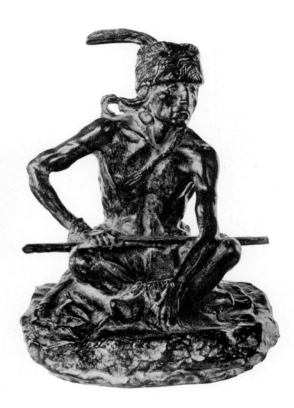

156. Charles M. Russell. *Piegan Girl.* Modeled 1902. Roman Bronze Works, N.Y. H. 10½″. Main Trail Galleries, Scottsdale, Ariz. The original model from the C. M. Russell Studio Collection is in Great Falls, Mont.

157. Charles M. Russell. *Watcher of the Plains.* Modeled c. 1902. California Art Bronze Foundry, Los Angeles. H. 11″. Amon Carter Museum, Fort Worth, Tex.

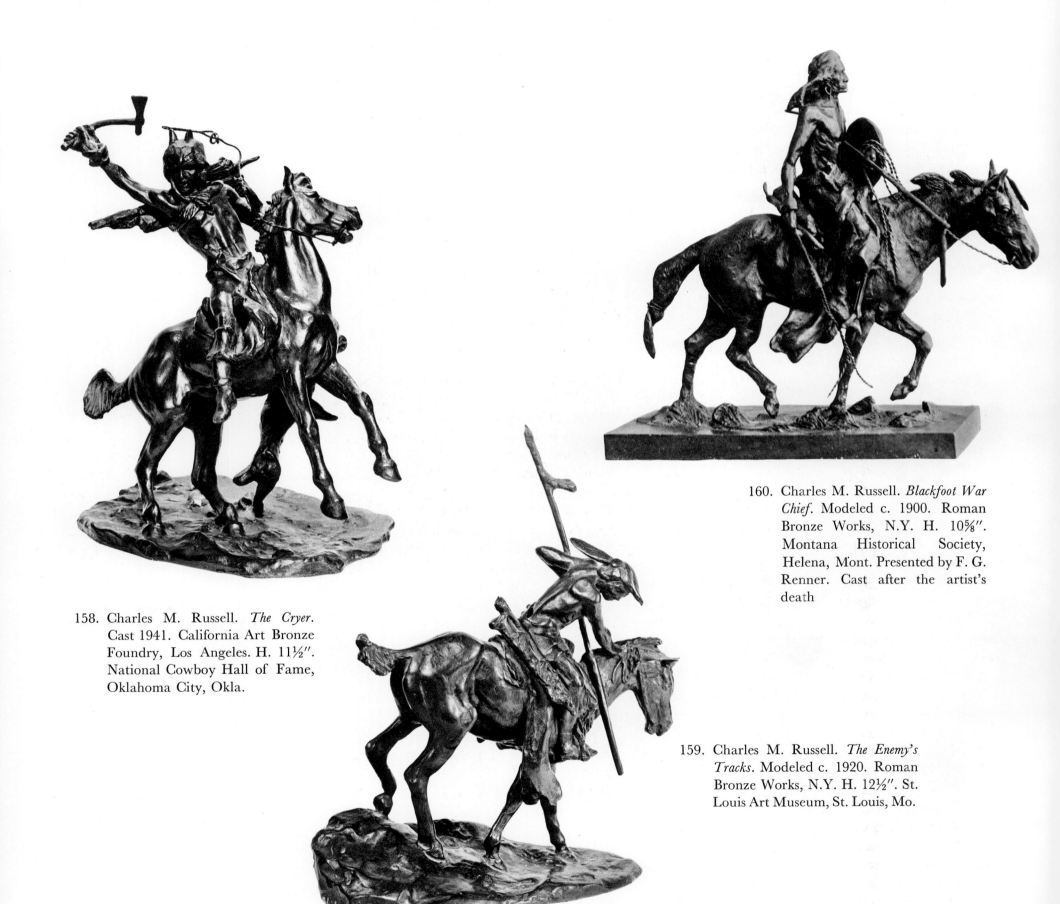

158. Charles M. Russell. *The Cryer*.
Cast 1941. California Art Bronze
Foundry, Los Angeles. H. 11½″.
National Cowboy Hall of Fame,
Oklahoma City, Okla.

160. Charles M. Russell. *Blackfoot War
Chief*. Modeled c. 1900. Roman
Bronze Works, N.Y. H. 10⅝″.
Montana Historical Society,
Helena, Mont. Presented by F. G.
Renner. Cast after the artist's
death

159. Charles M. Russell. *The Enemy's
Tracks*. Modeled c. 1920. Roman
Bronze Works, N.Y. H. 12½″. St.
Louis Art Museum, St. Louis, Mo.

the vigorous modeling that distinguishes Russell's work. The hand of the sculptor is always visible in Russell's sculpture.

In 1912, Russell had his second one-man show in New York and his first exhibition in Canada. In 1914, he had a show in London. He was, by then, a great success as both a painter and a sculptor, with his works on exhibit in shows all over the United States and Canada. Russell's work won the favor of art patrons from coast to coast. His art was especially admired by such Hollywood luminaries as Will Rogers, Noah Beery, Sr., William S. Hart, and Douglas Fairbanks. After 1919, the Russells spent their winters in California. Although these winters were profitable for art sales, Russell never felt a part of the warm and glittering California life.

Nancy continued to accept the commissions and determine the prices for her husband's art. As the years passed, Russell's works brought increasingly higher prices until it was said that they sold for "dead man's prices."

Russell was never overjoyed with his financial success or with the acclaim of prominent admirers. The world he loved had vanished: "I came west 31 years ago at that time baring the Indians an a fiew scaterd whites the country belonged to God but now the real estate man an nester have got moste of it grass side down an most of the cows that are left feed on shuger beet pulp but thank God I was here first. . ."[19]

Russell enjoyed writing his "Rawhide Rawlins" stories of incidents and individuals from the West of his youth. In 1925, the University of Montana honored him with the honorary degree of Doctor of Law. Russell was known by all in his home state as "Mr. Montana." In 1923, his health began to fail and on October 24, 1926, Charles Russell died of a heart attack, following a goiter operation.

During Russell's lifetime, almost all of his sculptures belonged to personal friends and collectors of Western art. It is only in recent years that excellent collections of his sculptures can be seen in several museums.

Today, Russell's sculpture is becoming as well-known and admired as his paintings. Frederic G. Renner, in his descriptive catalogue of Russell's paintings, drawings, and sculpture, paid tribute to Charles Russell, the sculptor:

It is no reflection on Russell the painter to say that as a sculptor he was more creative. Russell was no imitator in any medium but his sculpture has a special distinction that is always the mark of a great artist. One would expect vitality in Russell's sculpture. He was a vital

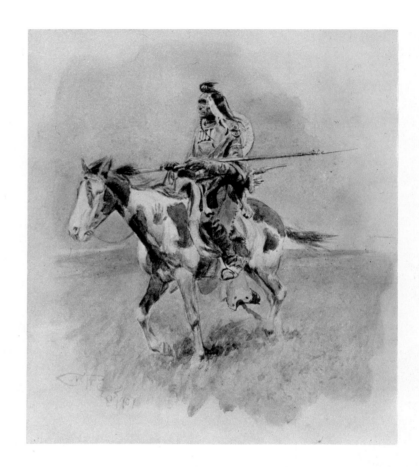

161. Charles M. Russell. *Indian on Horseback*. 1907. Watercolor on paper. 12¾ × 11″. Amon Carter Museum, Fort Worth, Tex. This sketch is identical to the sculpture entitled *Blackfoot War Chief* (plate 160)

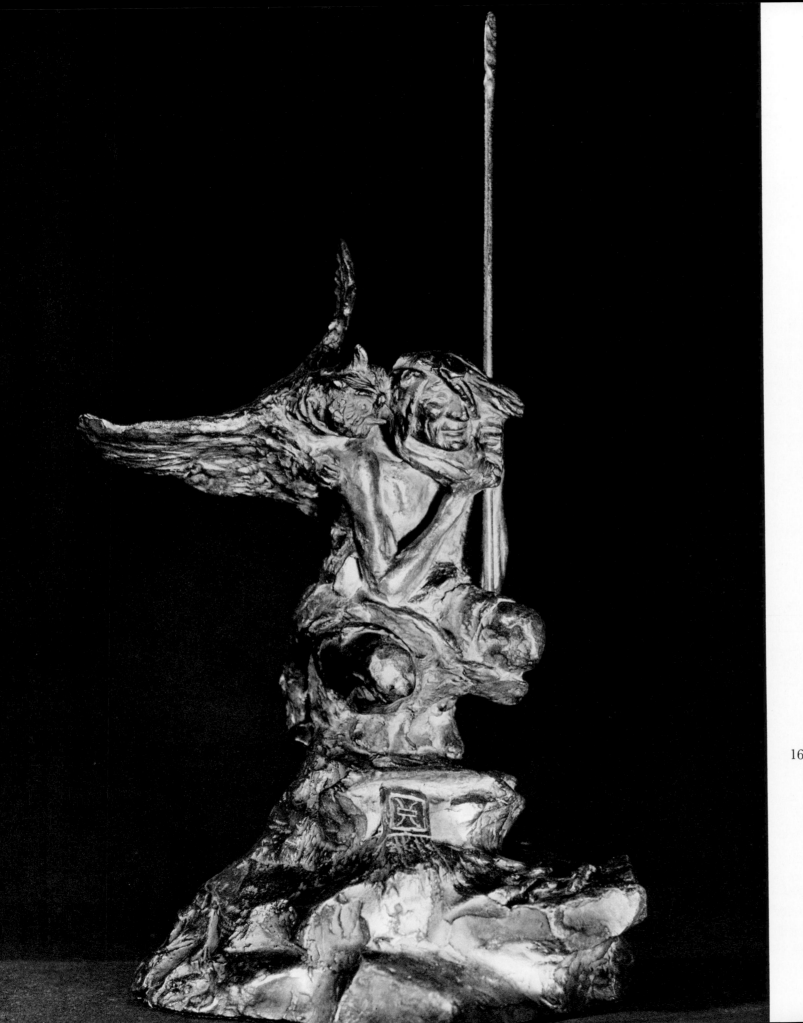

162. Charles M. Russell. *Secrets of the Night*. Modeled c. 1926. Roman Bronze Works, N.Y. H. 11½". National Cowboy Hall of Fame, Oklahoma City, Okla. This bronze depicts the allegorical story of a Piegan Indian who has summoned the owl—known as the "Ghost Bird" and who is a messenger from the dead—in order to locate the band of Crows that have stolen his horses

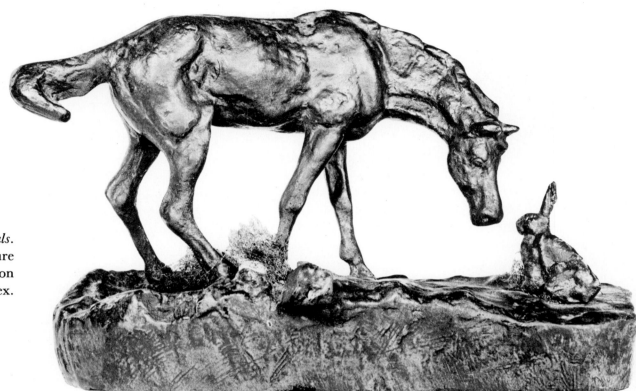

163. Charles M. Russell. *Prairie Pals*.
Modeled c. 1917. Sculpture
House, N.Y. H. 4½". Amon
Carter Museum, Fort Worth, Tex.
Cast after the artist's death

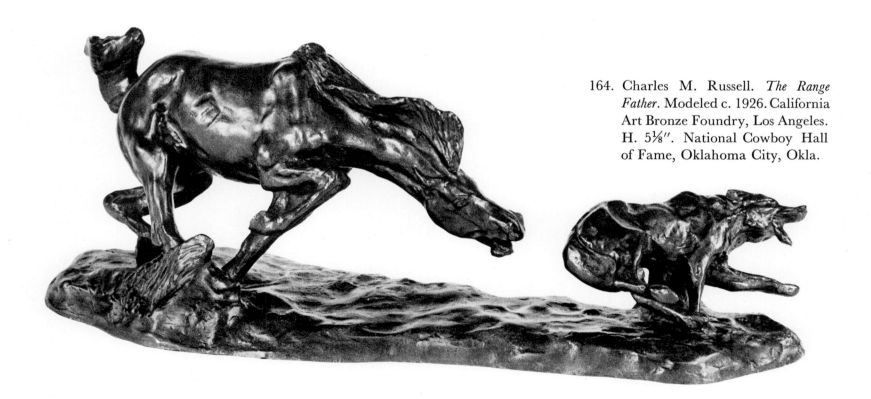

164. Charles M. Russell. *The Range
Father*. Modeled c. 1926. California
Art Bronze Foundry, Los Angeles.
H. 5⅛". National Cowboy Hall
of Fame, Oklahoma City, Okla.

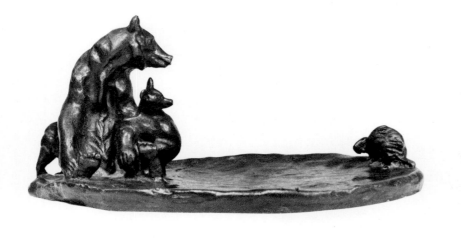

165. Charles M. Russell. *Oh! Mother, What Is It?* Modeled c. 1914. California Art Bronze Foundry, Los Angeles. H. 3¾″. National Cowboy Hall of Fame, Oklahoma City, Okla.

166. Charles M. Russell. *Mountain Mother*. Modeled c. 1924. Nelli Art Bronze Foundry, Los Angeles. H. 4⅞″. C. M. Russell Gallery, Great Falls, Mont. Cast after the artist's death

167. Charles M. Russell. *The Bluffers*. Modeled c. 1924. California Art Bronze Foundry, Los Angeles. H. 7½″. Amon Carter Museum, Fort Worth, Tex.

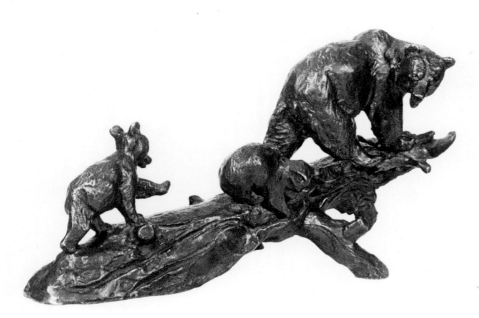

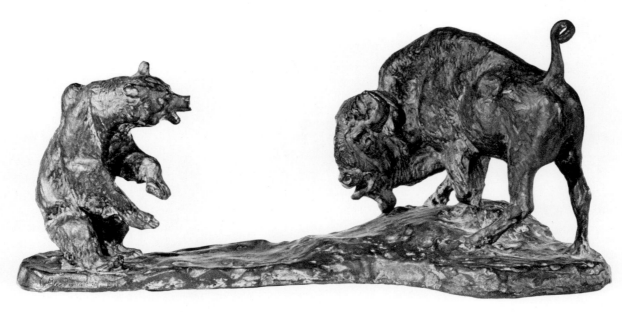

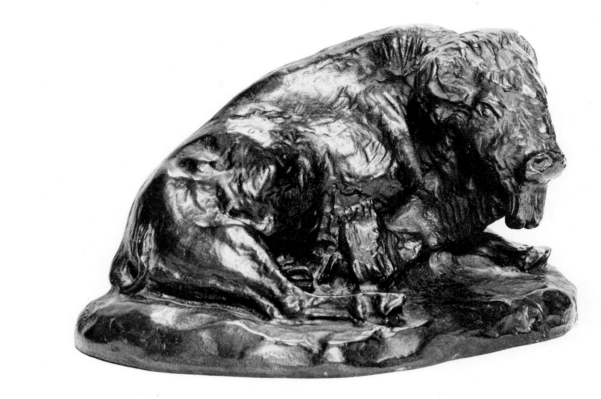

168. Charles M. Russell. *Lone Buffalo*.
Modeled c. 1900. Plaster. H. 4⅜″.
Montana Historical Society,
Helena, Mont.

169. Charles M. Russell. *The Buffalo
Family*. Modeled c. 1925. Roman
Bronze Works, N.Y. H. 6½″. Amon
Carter Museum, Fort Worth, Tex.

174

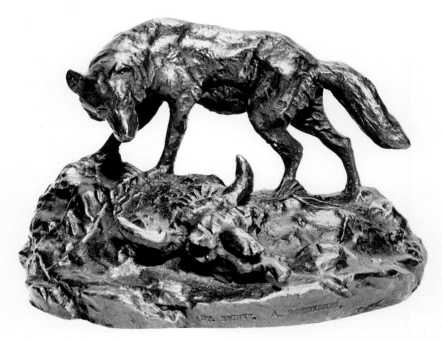

171. Charles M. Russell. *Fallen Monarch*. Modeled c. 1909. Roman Bronze Works, N.Y. H. 3⅞″. National Cowboy Hall of Fame, Oklahoma City, Okla.

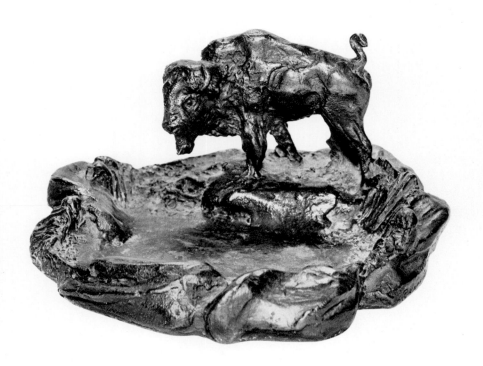

170. Charles M. Russell. *A Monarch of the Plains*. Modeled 1926. Nelli Art Bronze Foundry, Los Angeles. H. 2⅞″. National Cowboy Hall of Fame, Oklahoma City, Okla. Cast after the artist's death

172. Charles M. Russell. *To Noses That Read, A Smell That Spells Man*. Modeled c. 1920. Roman Bronze Works, N.Y. H. 4½″. Joslyn Art Museum, Omaha, Neb.

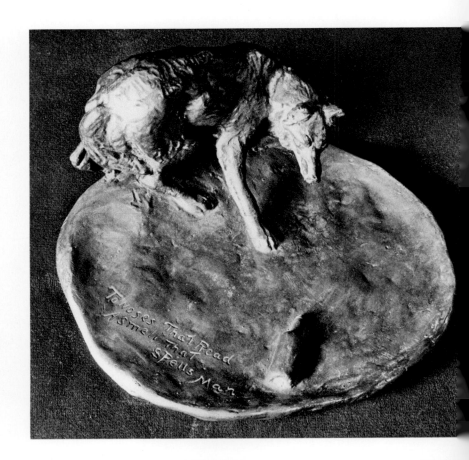

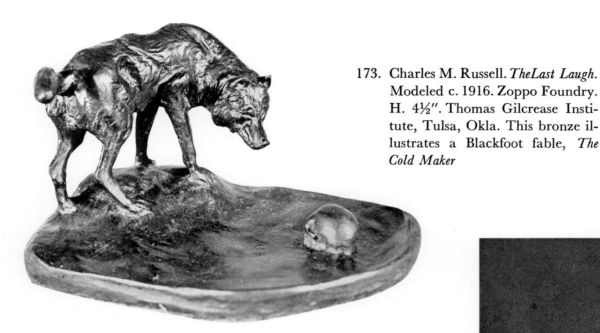

173. Charles M. Russell. *The Last Laugh.* Modeled c. 1916. Zoppo Foundry. H. 4½″. Thomas Gilcrease Institute, Tulsa, Okla. This bronze illustrates a Blackfoot fable, *The Cold Maker*

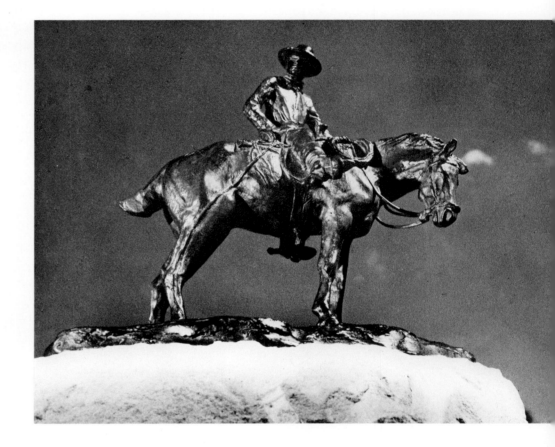

174. Charles M. Russell. *Night Herder (Self-Portrait).* Modeled 1925. Roman Bronze Works, N.Y. H. 13¼″. Bradford Brinton Memorial, Quarter Circle A Ranch, Big Horn, Wyo. This work was originally copyright as *The Horse Wrangler.* Russell wrote: "I was neither a good roper or rider. I was a nightwrangler—how good I was I'll leave for the people I worked for to say." (*Montana Magazine*)

person, concerned with vital subjects all of his life. This vitality is in his sculpture. There is also imagination and beauty, and with them a unity that arouses and holds the undivided interest of the observer. Most important of all, Russell's fingers had an extraordinary facility for capturing the feeling that his mind sought to express.[20]

It was not until years after Russell's death that the public became increasingly aware of the unique value of his bronzes. Many of his original wax models found their way into museum collections and some were cast for the first time in limited editions. In several cases, individuals who wished to retain the Russell models in their personal collections gave permission for limited bronze editions to be cast of their models. Other owners had limited castings made of models that they purchased solely for that purpose.

As the public appetite for bronzes has grown, more and more Russell bronzes have appeared on the market. These vary tremendously in quality. Some are unique sculptures, carefully created as gifts to special friends. They are prized works and casting has assured them of permanence. Other bronzes have been cast in small models never intended for public view. It is to be remembered that Russell modeled as a form of entertainment and relaxation. Often during an evening at the local saloon, he would model a small figure behind his back. His friends would guess what the finished product might be, loser to pay for the drinks. Russell destroyed most of these spontaneous models, but others were handed to admirers on the spot.

This helps to explain the tremendous number of "original" Russells on the market today and the great variation in quality.

The influence of Russell's bronzes on present-day Western sculptors is of the greatest importance. With very few exceptions, they have set the standard, both for subject matter and technique of execution. Some sculptors, rather than depict a subject that Russell created in bronze, will turn to one of his paintings and create a bronze group straight from the canvas. Two factors contribute to this widespread imitation of Russell's sculpture: first, the vitality and excellence of his bronzes invite admiration and emulation; second, the tremendous public demand for Russell's works has so elevated their prices that

175. Charles M. Russell. *The Spirit of Winter*. Modeled c. 1926. Roman Bronze Works, N.Y. H. 10″. Hammer Gallery, New York City. The spirit of a brave, who had been mistreated by his people during his lifetime, re-entered his body. Joined by wolves (symbols of hunger and starvation) and the North Wind (symbol of cold, starvation, and sickness), the spirit set forth on a mission of revenge

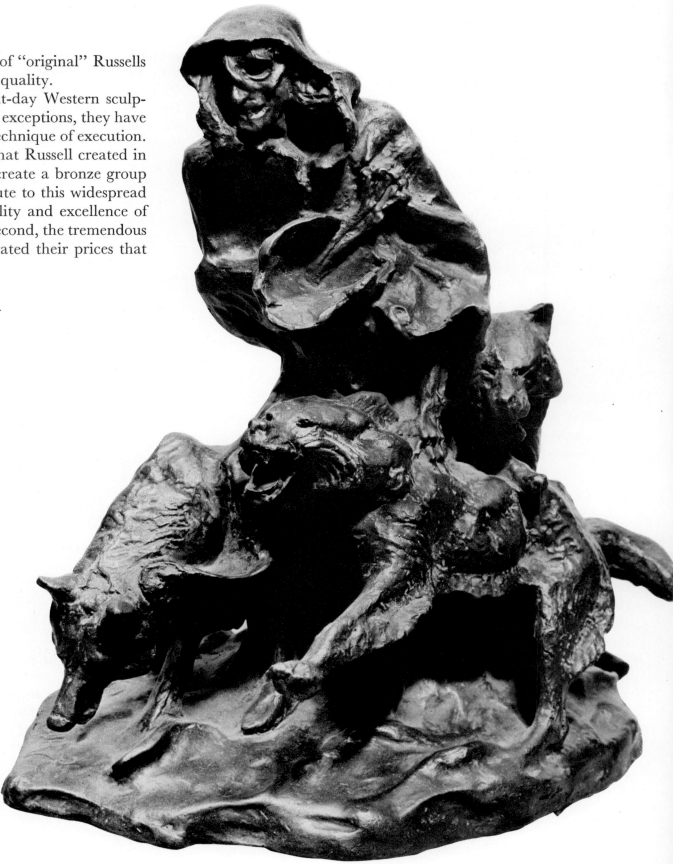

they are now within financial reach of only the wealthy. As Western sculpture grows in popularity, galleries seek artists who attempt to create "Russells for the average pocketbook." These new bronzes, however, will never possess the artistic validity and strength of Russell's works, which were created as personal documents of a vanishing Western life. A dream of the past, however vivid, can never compare with artistic creations based on experience and conviction.

J. Frank Dobie wrote of Russell: "Although barbed wire, population, the automobile, the airplane and World War I radically changed the West along with the rest of the world during Charles M. Russell's lifetime, he remained unchanged in his ways and allegiances."[21] It is through examining Russell's bronzes that one has the special opportunity to enjoy the wealth of knowledge of that era in Western history to which Russell was a witness. Through a study of his bronzes, we can better appreciate the unique talents of Charles Russell and understand his philosophy of the world in which he lived.

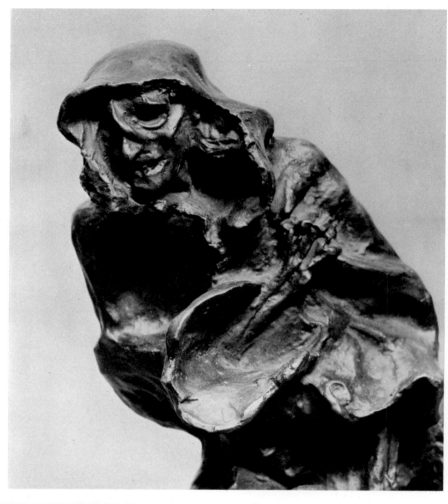

176. Charles M. Russell. *The Spirit of Winter* (detail of plate 175)

177. Charles M. Russell. *The Spirit of Winter* (detail of plate 175)

XII

JAMES EARLE FRASER: AN ARTIST OF THE WESTERN TRAIL

Probably the most famous sculpture of the American West is *The End of the Trail (plates 178–185, 489)* by James Earle Fraser. Since its exhibition at the Pan-Pacific Exposition in 1915, thousands of replicas have been sold to people from every part of the United States as well as to visitors from all over the world. It has been reproduced on post cards and stationery and has been made into paperweights and key chains. Fraser made several casts for museums during his lifetime. In recent years, *The End of the Trail* has been cast in several small sizes which are on exhibition in museums and private collections throughout the United States. The original giant plaster model *(plate 185)* is now the central attraction of an exhibition gallery in the National Cowboy Hall of Fame in Oklahoma City. Two monumental bronze castings stand in public parks, one in California *(plate 489)* and one in Wisconsin. *The End of the Trail* dramatizes the absolute despair of the American Indian at the final loss of his native land. It has become the symbol of the total defeat of the Indian by the white man.

With the exception of *The End of the Trail*, Fraser's fame as a sculptor of the West is of recent vintage. During his lifetime, he was renowned as the creator of heroic public statues and memorials. He was also a prolific designer of medals and medallions. In 1967, fourteen years after the death of the artist, Syracuse University acquired

178. James Earle Fraser. *The End of the Trail*. Modeled c. 1894. Cast 1918. Roman Bronze Works, N.Y. H. 30⅜″. Nelson Gallery-Atkins Museum, Kansas City, Mo. Gift of Mrs. Allan B. Sunderland in memory of Allan Boulter Sunderland. This is a small model of the heroic statue (plate 185)

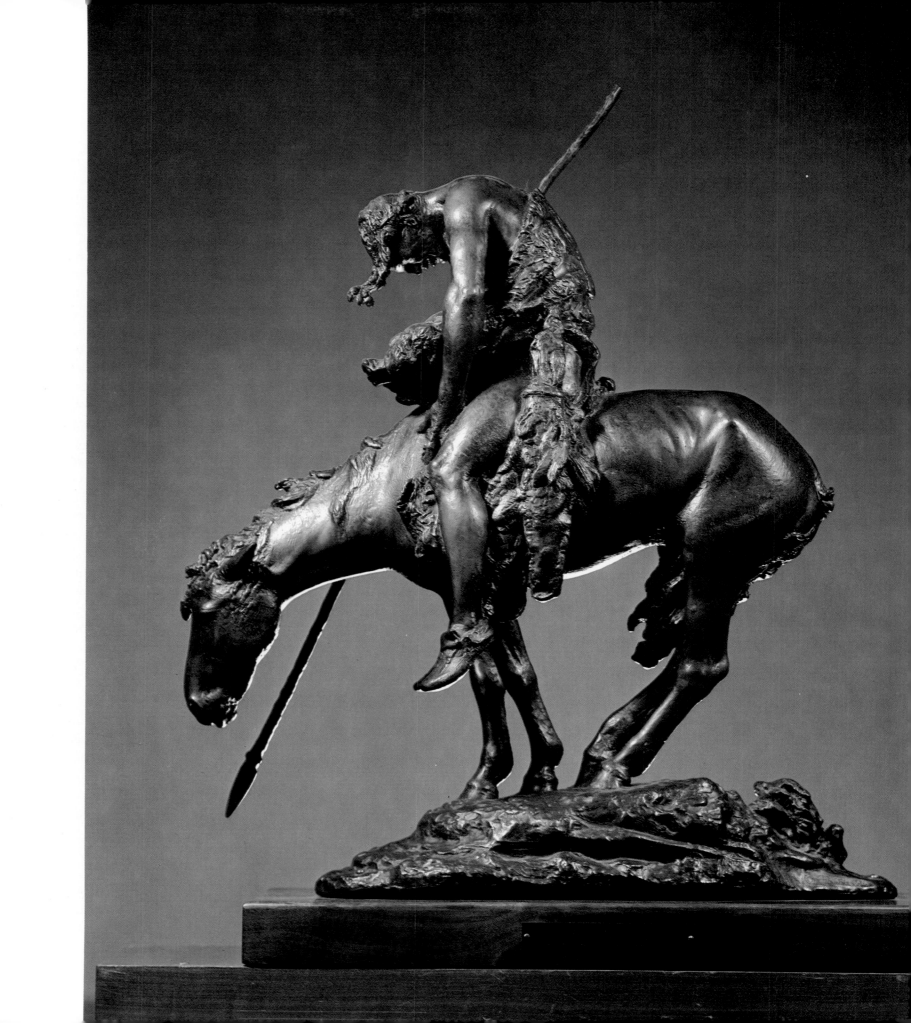

the Fraser studio as part of his estate. Here were several models of sculptures which were Western in character, done either as preparatory studies early in his career or created later in life for his own amusement. Their discovery led to a re-examination of his numerous portraits and monuments, several of which celebrated Western heroes and causes. These sculptures were re-cast in bronze in reduced size and offered to the public as were the bronze studies done early in his career. Other models of men and animals of the prairie were cast in bronze for the first time, many years after their initial creation. Today, in an anti-heroic age—while the artists of public portraits, monuments, and memorials remain in relative obscurity—Fraser enjoys renewed popularity as a sculptor of the American West.

James Earle Fraser was born in 1876 in Winona, Minnesota. His father, Thomas Alexander Fraser, was a railroad engineer and contractor. With each westward push of the railroad through the Dakota Territory, the nomadic Fraser family would pull up their stakes and move on to the next railroad camp. Around 1881, Thomas Fraser, realizing the need for his family to have a more permanent home, purchased a ranch in Mitchell, South Dakota. During the ten years of his boyhood in the Dakota Territory, the rugged land of open plains and wild animals made a deep impression on young James Fraser. This was a land still populated by the Plains Indians—a land of pioneer ranchers building new lives in the West and of rough railroad gangs working to tie the open prairie lands to the cities of the East.

Fraser witnessed the futile conflict between the Indians and the soldiers sent by the federal government to banish them from their native lands. He developed a deep sympathy for the red man:

179. James Earle Fraser. *The End of the Trail*. Charcoal on paper. 6 × 9⅜″. George Arents Research Library, Syracuse University, N.Y. (James Earle and Laura Gardin Fraser Collection). This is one of the original drawings for the sculpture of the same name

. . . I lived in the Indian country of Dakota, in the land that belonged to the Indians, and I saw them in their villages, crossing the prairies on their hunting expeditions. Often they stopped beside our ranch house; and camped and traded rabbits and other game for chickens. They seemed very happy until the order came to place them on reservations. One group after another was surrounded by soldiers and herded beyond the Missouri River. I realised that they were always being sent farther West, and I often heard my father say that the Indians would some day be pushed into the Pacific Ocean.[1]

This feeling of the absolute hopelessness of the American Indian would later be the inspiration for his most famous sculpture.

Near Fraser's home was a chalkstone quarry. This chalky clay, which hardened into stone, was used by the settlers to mold bricks for

180. James Earle Fraser. *The End of the Trail*. Charcoal on tinted paper. 4 × 5½". George Arents Research Library, Syracuse, N.Y. (James Earle and Laura Gardin Fraser Collection). This is one of the original drawings for the sculpture of the same name

their houses. Young James learned to model the clay into figures of men and animals. These figures won great local acclaim, which fired the young man with dreams of becoming a sculptor. His interest in art continued through the years he attended school in Minneapolis. When he was fifteen, James's family moved to Chicago. By this time, he had decided to follow a career as an artist. He enrolled at the Chicago Art Institute, where he studied for four years. He also worked for a year in the studio of the sculptor Richard Bock.

Chicago in the early 1900s was a vital center of artistic activity. The World's Columbian Exposition of 1893 attracted artists from all over the world. The sculpture at the fair was a tremendous inspiration to Fraser. He visited the exhibit of sculptures of native animals by Edward Kemeys and Alexander Phimister Proctor. He saw *The Signal of Peace* by Cyrus Dallin, *The Buffalo Hunt* by Henry Kirke Bush-Brown, as well as several Indian medallions by Olin Levi Warner. Fraser was most impressed by Proctor's monumental cowboy and Indian sculptures. Shortly after the fair, while in Bock's studio, he made his first model of *The End of the Trail (plate 181)*.

Fraser grew restless in Chicago, as he felt the greatest inspiration and instruction for young sculptors was in Paris. In 1894, he arrived in the French capital, bringing with him his model of *The End of the Trail*. Fraser studied under Falguière at the École des Beaux-Arts and with other masters at the Académies Julian and Colarossi. He exhibited a *Head of an Old Man* at the Salon of 1898 and won the prize of the American Artists Association. Augustus Saint-Gaudens, acting as one of the judges at the Salon, was so impressed by the young artist that he invited him to become an assistant in his Paris studio. For two years, Fraser worked with Saint-Gaudens. In 1900, he returned to the United States to work in Saint-Gaudens' studio in Cornish, New Hampshire.

In 1901, Fraser was commissioned to design a medal to honor Saint-Gaudens at the Pan-American Exposition in Buffalo. The officials were pleased with the medal and offered Fraser a second commission, for a large bronze vase in honor of the exposition.

By 1902, Fraser felt he was ready to work independently and opened a studio in McDougal Alley in New York's Greenwich Village. Here he had the opportunity to visit the studios of such established artists as Edwin W. Deming, Daniel Chester French, and Gertrude Vanderbilt Whitney.

Fraser was a successful sculptor from the start. His tender, lyrical style was in perfect harmony with the public taste of his times. He received a commission for the St. Louis Fair for two monumental statues —an equestrian model, *Cheyenne Chief (plate 186)*, and a portrait of

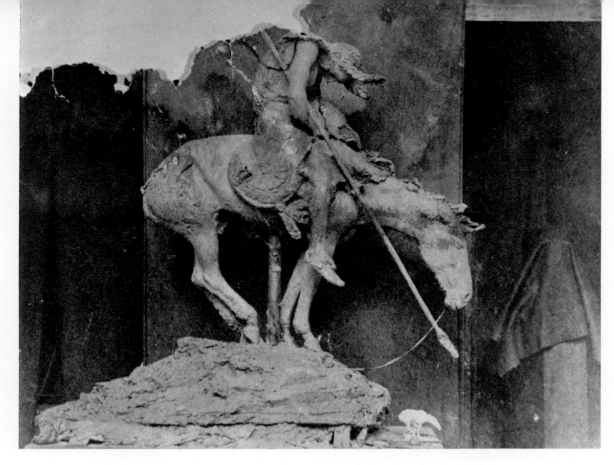

181. James Earle Fraser. *The End of the Trail* (early model). c. 1894. Plaster. H. 12″. Whereabouts unknown. Note the shield in this very early model

Thomas Jefferson. The statue of the Indian was exhibited in the Court of Honor at the fair. Fraser also received several commissions for romantic allegorical figures, as well as for many memorials.

In 1901, Fraser had become an instructor in sculpture at the Art Students League in New York. By 1911, his backlog of commissions was so extensive that he gave up his teaching position and devoted full attention to his sculptural output. Many of Fraser's early commissions were for portraits of children. These works followed the dominant style of art in Paris at the turn of the century, Romantic Naturalism. His figures are idealized in the Classic-Renaissance tradition, yet retain a sense of individuality through carefully chosen details. The romantic in Fraser flourished in these tender, almost melancholy portraits. Fraser skillfully employed the subtle low-relief designs he had learned in the Saint-Gaudens studio.

Fraser also completed portraits of many of the artistic, social, and political leaders of the day. In 1906, thanks to the influence of the Saint-Gaudens family, he received an important commission for a marble bust of Theodore Roosevelt for the Senate chamber. This was the first of many portraits of the vigorous leader which Fraser created through the years. The sculptor had intended this bust to be a portrait of Roosevelt as a Rough Rider, but the Senate required a formal portrait which would harmonize with the others in the chamber. A few years later, Fraser had the perfect opportunity to depict Roosevelt as a Rough Rider, for a memorial on San Juan Hill at Santiago

182. James Earle Fraser. *The End of the Trail*. Modeled c. 1894, cast 1971. Modern Art Foundry, Long Island City, N.Y. H. 12″. George Arents Research Library, Syracuse University, N.Y. (James Earle and Laura Gardin Fraser Collection). In this early model there is no spear

184

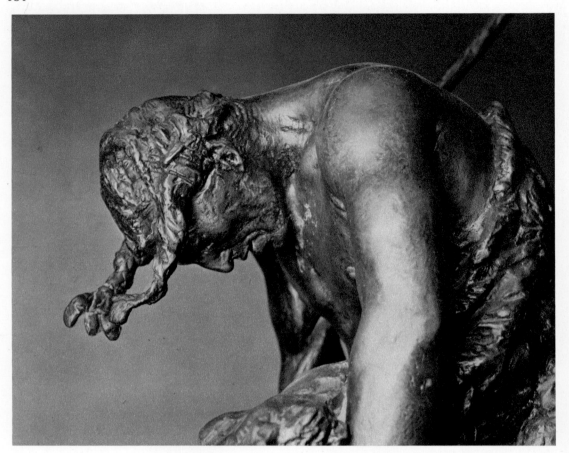

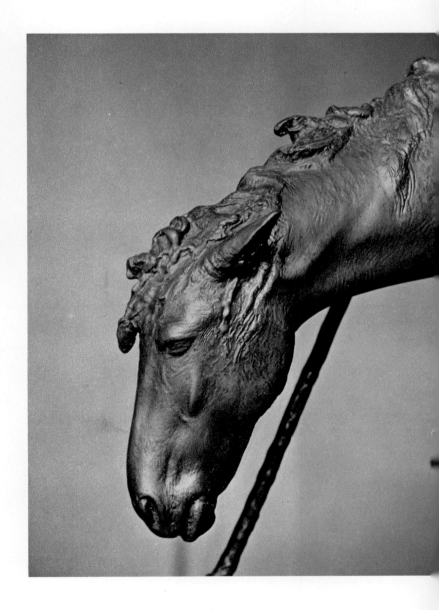

183. James Earle Fraser. *The End of the Trail* (detail of plate 181)

184. James Earle Fraser. *The End of the Trail* (detail of plate 181)

185. James Earle Fraser. *The End of the Trail* (original model). 1915. Plaster. H. 18′. The National Cowboy Hall of Fame, Oklahoma City, Okla. This is the original statue from the Pan-Pacific Exposition of 1915. In return for this model the National Cowboy Hall of Fame had a full-size bronze cast and sent to Visalia, Calif. (plate 489)

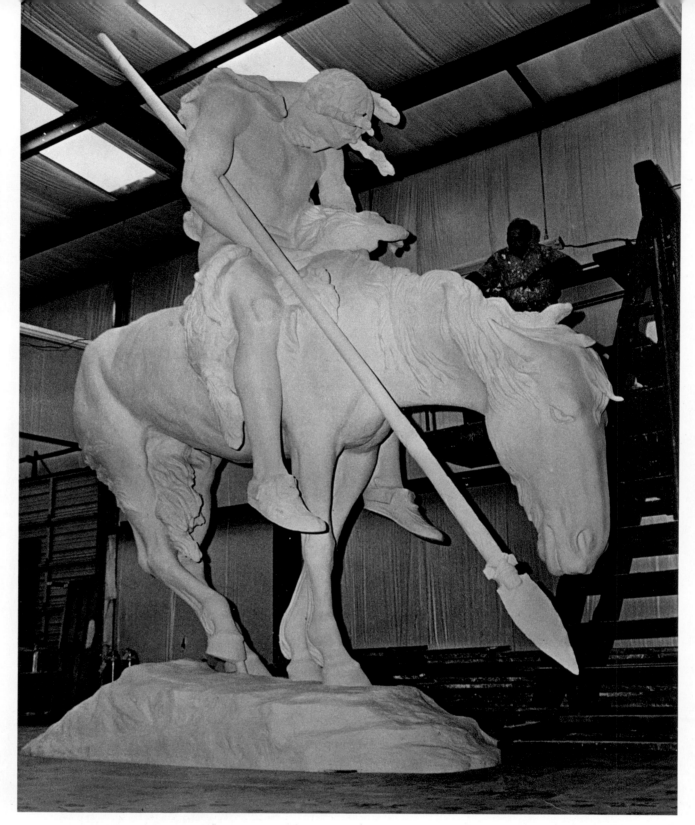

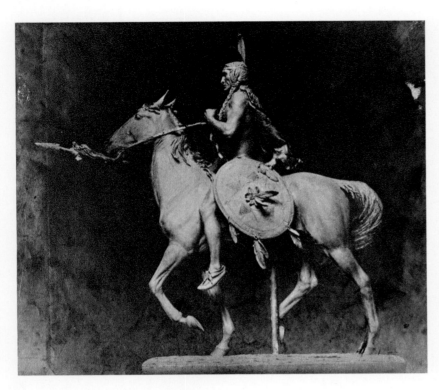

186. James Earle Fraser. *Cheyenne Chief*. 1904. Heroic size. Whereabouts unknown. This statue was exhibited in 1904 at the Louisiana Purchase Exposition held in St. Louis

de Cuba. This sculpture was copyrighted in 1910, but was sold in two sizes to the public in the 1920s.

Early in his career, Fraser created three heads of Indians *(plates 189, 190)* which served as models for the buffalo-Indian nickel. Fraser's models are impressionistic and have a greater vitality than his later works, which have more precise outlines and harder surfaces. Fraser designed the buffalo-Indian nickel in 1913. He believed that American coins lacked national character and that his nickel would be a totally American coin. His model for the buffalo was "Old Diamond" from the Bronx Zoo, while the Indian was an idealized composite of the three Indian heads he had modeled.

In 1915, Fraser received the most important commission of his career—*The End of the Trail* for the San Francisco Exposition. By that year, the United States had fulfilled its "manifest destiny"; the Indian had been pushed across the entire continent.

In 1953, Fraser recalled:

As a small boy living in Dakota Territory I came in close contact with the Sioux Indians from 1880 to 1888. Often hunters, wintering with the Indians, stopped over to visit my grandfather on their way south, and in that way I heard many stories of Indians. On one occasion a fine fuzzy-bearded old hunter remarked with much bitterness in his voice, "The Injuns will all be driven into the Pacific Ocean." The thought so impressed me that I couldn't forget it. In fact, it created a picture in my mind which eventually became "The End of the Trail." I liked the Indians and couldn't understand why they were to be pushed into the Pacific.[2]

Fraser acknowledged a poem by Marian Manville Pope as the specific inspiration for his vision of the horse and rider. "The trail is lost, the path is hid and the winds that blow from out the ages sweep me on to that chill borderland where Time's spent sands engulf lost peoples and lost trails."[3] The exhausted, defeated Indian and his weary horse have indeed come to the end of their westward trail. Their journey is over, for it is impossible to be pushed any further west. Fraser's dream was to place this statue on a crest overlooking the Pacific Ocean: "a weaker race. . . steadily pushed to the wall by a stronger [one] . . . driven at last to the edge of the continent. That would be, in very truth, 'The End of the Trail.' "[4]

In 1971, this dream became a reality as a giant bronze version of *The End of the Trail* was placed in Mooney Grove, a park near Visalia, California *(plate 489)*. During Fraser's lifetime, a life-size copy was donated by Thomas Schaller to Waupin, Wisconsin. At its dedication,

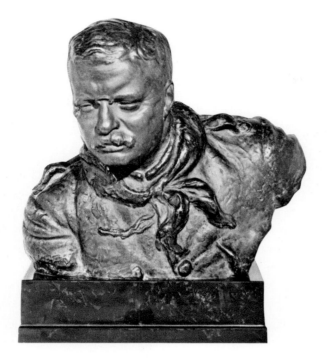

187. James Earle Fraser. *Theodore Roo-sevelt as a Rough Rider.* Modeled 1910, cast 1920. H. 8¼″. The New-York Historical Society, N.Y. Note the resemblance to Reming-ton's *The Bronco Buster* (plate 188)

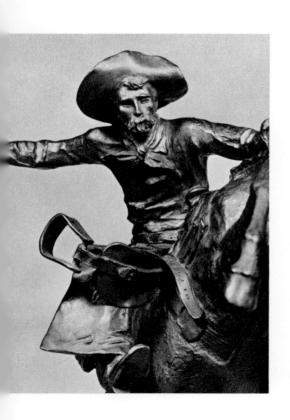

188. Frederic Remington. *The Bronco Buster* (detail of plate 148)

Fraser revealed that the Seneca chief, John Big Tree, was the model for the Indian. Chief Big Tree had posed in Coney Island during the summer of 1912.

Fraser had long contemplated this monument to the tragic fate of the American Indian. He had made several models of weary, weather-beaten ponies. One called *Wind Swept* or *In the Wind (plate 191)* was exhibited in 1916 at the National Academy of Design. A second model, showing two horses on a hilltop, was entitled *Storm-Driven (plate 192)*. Both pieces were originally cast in the 1920s and re-cast in the late 1960s. These studies showed the stoic despair of the Indian horses relentlessly battered by unmitigating winds. It is clear that the horse in *The End of the Trail* is based on the one in *In the Wind*.

A Western sculpture, cast posthumously in bronze, is *Buffalo Prayer (plate 193)*. Although copyrighted in 1931, it was modeled shortly after *The End of the Trail*. Fraser revealed his inspiration for this work:

In the early morning just at sunrise I saw a medicine man, or counselor of the tribe, make his prayer. It was for the return of the buffalo. His prayer to the Great Spirit was made after a night in a sweat lodge, having partaken of no food. He went to the creek, bathed himself, put on a few strips of buffalo hide, placed in front of him a buffalo skull, then built a fire of buffalo chips toward the east. A thin column of smoke lifted to the sky and the rising sun shed a glow over the whole scene. The bronze color of the man, his black hair with bits of red wound into his braids, and his religious attitude made an indelible picture in my mind.[5]

An article published in 1917 describes Fraser's Indian in prayer: "With great dignity and reverence he stands in the presence of his God. At his feet lie the bones of the buffalo."[6]

In 1917, Fraser received the commission for his first important public statue in the United States, *Alexander Hamilton*, for the Trea-sury Building in Washington, D.C. The success of this sculpture led to a career dedicated to public commissions. Of these, the statues of *The Pioneers* for the Michigan Avenue Memorial Bridge in Chicago, and those of Lewis and Clark for the Thomas Jefferson Memorial in

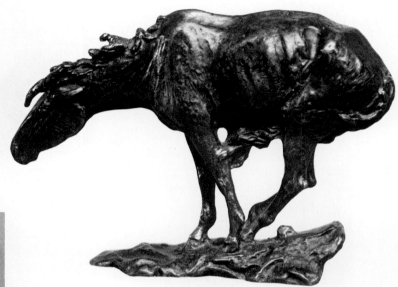

191. James Earle Fraser. *Wind Swept (In the Wind)*. c. 1916 (recent cast). Modern Art Foundry, Long Island City, N.Y. H. 5″. Kennedy Galleries, New York City

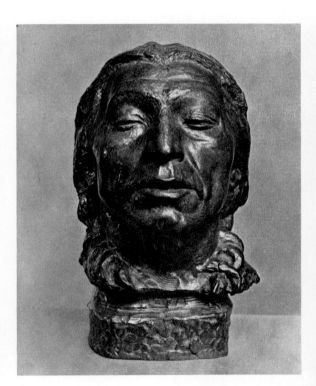

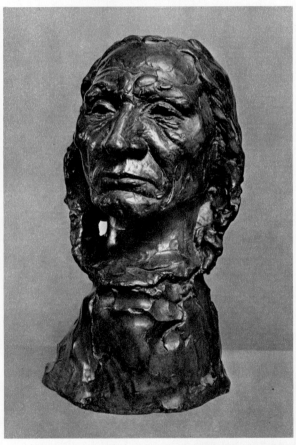

189. James Earle Fraser. *Indian Head: White Eagle*. 1919 (recent cast). Modern Art Foundry, Long Island City, N.Y. H. 14″. Kennedy Galleries, New York City

190. James Earle Fraser. *Indian Head: Two Moons*. c. 1919 (recent cast). Modern Art Foundry, Long Island City, N.Y. H. 13″. Kennedy Galleries, New York City

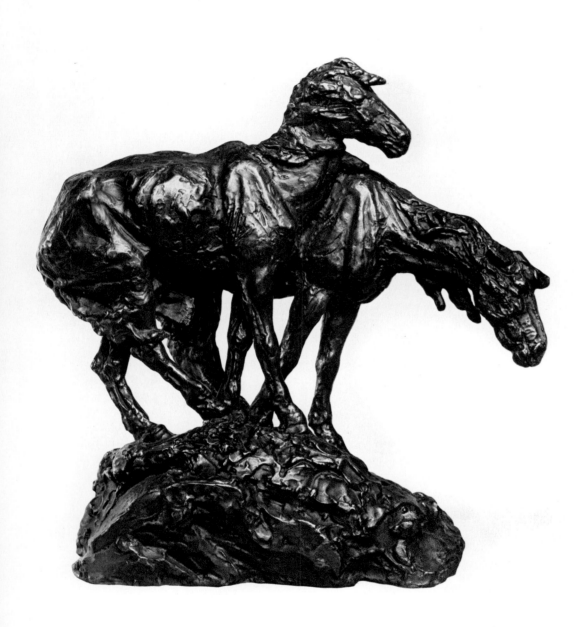

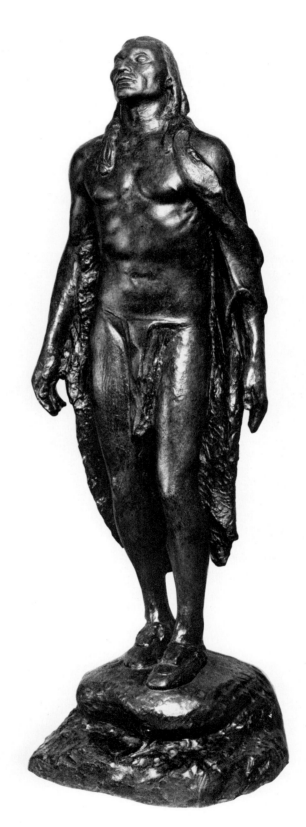

192. James Earle Fraser. *Storm-Driven*. c. 1918 (recent cast). Modern Art Foundry, Long Island City, N.Y. H. 16″. Kennedy Galleries, New York City

193. James Earle Fraser. *Buffalo Prayer*. Modeled c. 1917, cast c. 1931. Recent cast: Modern Art Foundry, Long Island City, N.Y. H. 44″. Kennedy Galleries, New York City

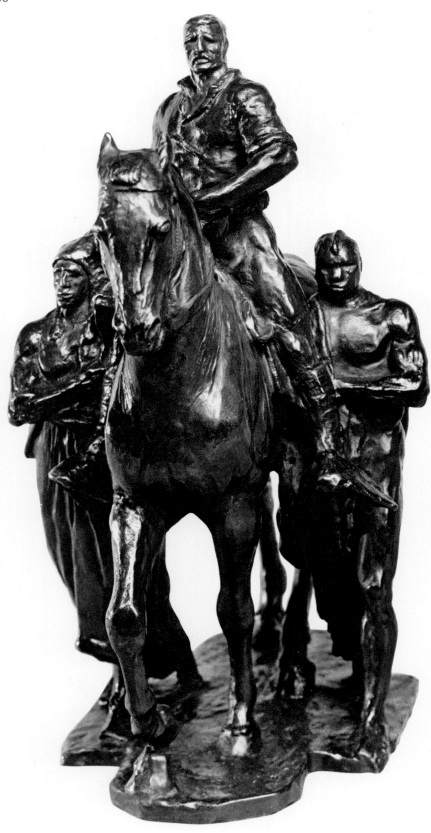

Jefferson City, Missouri, may be considered Western. Fraser, on traveling to the site of the Jefferson Memorial, remembered his own youthful days on the prairies. He recalled that his father had made a similar trip by steamboat as part of a Yellowstone Valley survey party. In later years, Fraser acknowledged that the figure of Meriwether Lewis was done from his memory of a trapper he once saw standing at the top of a mill dam on the Jim River near Mitchell, South Dakota. Fraser often saw the trappers come down the Fire, Steel, and Jim rivers in their canoes.

In 1923, Fraser created the Theodore Roosevelt memorial *(plate 194)* for the American Museum of Natural History in New York. The statue was to honor Theodore Roosevelt for donating his vast collection of natural history material to the museum. Fraser's group shows Roosevelt astride a great hunting horse, flanked by two gun-bearers —an American Indian and an African. They symbolize "the countries where he gathered trophies, and represent his love for all nations."[7] This portrait depicts Roosevelt as a man of the outdoors, a naturalist and hunter, not as a statesman or politician. The rapport that existed between the robust, nature-loving leader and the artist can be felt in the vitality of Fraser's portraits of Roosevelt *(plate 187)*.

In 1927, Fraser entered a competition for a memorial to the pioneer woman to be placed in Ponca City, Oklahoma, on the Cherokee Strip. The memory of his aunt on the ranch in Mitchell inspired his model of a heroic woman, gun at her side, nursing her infant. Fraser's *Pioneer Woman (plate 334)* did not win him the competition, but it did receive great critical approval.

The End of the Trail, Buffalo Prayer, and *Pioneer Woman* have a dramatic power and emotional appeal which is missing in Fraser's other monuments and memorials. Although Fraser worked through the 1940s, his creations remained bound to nineteenth-century traditions of public sculpture and architecture.

194. James Earle Fraser. *Theodore Roosevelt with Gunbearers.* c. 1939 (recent cast). Modern Art Foundry, Long Island City, N.Y. H. 12½". Kennedy Galleries, New York City. This is a small-scale model of the memorial outside the entrance to the American Museum of Natural History in New York

195. James Earle Fraser. *Buffalo Herd.*
1950 (recent cast). Modern Art
Foundry, Long Island City, N.Y.
H. 13″. Kennedy Galleries, New
York City

In 1950, Fraser became interested in creating a sculpture of a buffalo herd. Although he had officially retired from his public career two years earlier, now at age seventy-four he enjoyed the luxury of depicting a subject which simply caught his interest. Remembering the tales of the great buffalo herds which crossed the Great Plains, he decided to create a reminder of this chapter in Western history. With this sculpture, Fraser returned to the impressionistic technique of his earlier work. Photographs of the buffalo in the Bronx Zoo were his only models. Fraser died in Westport, Connecticut, in 1953, before his *Buffalo Herd (plate 195)* had been cast.

Although Fraser was financially successful and honored in his lifetime, many of his portrait commissions and public sculptures are but skillful continuations of the traditions of a past era. Perhaps it is his sculptural recollections of a vanished pioneer world of the prairie and his dramatic statements of the tragic story of the American Indian that give the greatest value to Fraser's art.

XIII

ADOLPH A. WEINMAN: EXHIBITION INDIANS

The bronzes of Adolph Alexander Weinman illustrate a highly stylized approach to sculpture of the American Indian. Weinman modeled a monumental Indian group for the St. Louis Exposition as well as a series of Indian portraits. It is not possible to say that his bronzes are Western, in the sense that they express the spirit or depict the life of the old or modern West. Nevertheless, in a study of bronzes of the American West, Weinman's Indian sculptures cannot be overlooked.

Weinman created his Indian works very early in the twentieth century, at a time when American artists were only beginning to appreciate the Indians as individuals rather than as aboriginal types. To Weinman, the Indian was an intrinsically interesting decorative and artistic subject.

Adolph Alexander Weinman was born in Karlsruhe, Germany, on December 11, 1870, to Gustav and Katherine Hyacinthe Weinman. He began his education in the local *Volksschule* and received some training in drawing. After the death of Gustav Weinman, his widow, with her ten-year-old son, emigrated to the United States. Adolph continued his basic education in a New York City public school.

At the age of fifteen, Adolph was apprenticed to Frederick Kaldenberg, a carver of wood and ivory. It was perhaps Weinman's early training in working in so delicate a medium as ivory that gave him such precision in his later work.

Weinman worked day and night to improve his artistic skill. He enrolled in evening classes at Cooper Union to study both drawing and modeling, and later studied at the Art Students League under Augustus Saint-Gaudens. At age twenty, he became an assistant to Philip Martiny, a sculptor who devoted much of his energy and skill to fulfilling architectural commissions for the many commemorative expositions at the turn of the century.

During the early years of his career, Weinman had the opportunity to work in the studios of many prominent sculptors of the day. He

assisted Charles Neihaus, Olin Levi Warner, Daniel Chester French, and his former teacher, Saint-Gaudens.

It was in Warner's studio that Weinman developed his interest in the American Indian as an artistic subject. Warner, believing the Indian to be a noble and inspiring subject, was one of the first sculptors to create in bronze individual portraits of Indians. Warner's relief portraits of several tribal chiefs were probably the initial inspiration for Weinman's Indian sculptures.

Weinman, like Warner, was interested in medallic arts. He achieved great success in this field and won many important commissions and awards. It was Weinman who created both the dime and half-dollar pieces of 1916.

In 1904, Weinman opened his own studio in New York City. He first won national recognition for a large sculptural group entitled *Destiny of the Red Man (plates 196–199)*, commissioned for the 1904 Louisiana Purchase Exposition in St. Louis. Weinman was given free rein to create a sculptural group on the subject of the American Indian. He wrote of his inspiration for the theme:

This tragic decline of a noble race has touched a sympathetic chord
in the minds of many writers and artists, resulting in the stories by
Fenimore Cooper and paintings by Jerome Brush, Deming, Couse,
and many illustrations by Remington as well as countless sculptures
in bronze and marble by such men as Borglum, Proctor, MacNeil,
Dallin and Fraser and many others. I, too, had long been wanting to
do some Indian subjects and my opportunity came when I was
commissioned to do an Indian group for the Louisiana Purchase
Exposition at St. Louis in 1904. . . .

In the composition of this group I have endeavored to symbolize
the passing of an heroic race, the North American Indian. With the
coming of the white man and its continual westward surge it was but
a matter of time for some of the many tribes, deprived of, or restrained
in, their freedom loving way of life, to gradually become greatly
reduced in numbers or completely extinct.[1]

Weinman approached the problem with the greatest enthusiasm and a complete disregard of cost. He studied the customs, manners, and costumes of the various tribes of North American Indians and consulted all possible sources of information, including books by Catlin and Parkman. One day, he learned that Colonel Cummings's Wild West Show was at Coney Island. Weinman arranged an introduction to Colonel Cummings and gained permission to make studies of the Indians in the troop. Colonel Cummings' Indians served as models for *Destiny of the Red Man* as well as for the individual Indian portraits which Weinman subsequently created.

During the summer of 1902, Weinman traveled to Coney Island to model Womboli, Swift Weasel, Thomas Grass, and Chief Blackbird's wife—all Sioux Indians. Later, the Colonel's show moved to the old Madison Square Garden in New York City. Here Weinman made studies of two other Sioux Indians, Chief Blackbird and Chief Flat-iron, and of an Onondaga woman.

In addition to Colonel Cummings's Indians, Thundercloud and Darkcloud, two Iroquois Indians from Canada and Maine, posed at the artist's studio. Thundercloud was the model for the Great Spirit in *Destiny of the Red Man*.

Weinman designed an intricate sculpture which dramatized the defeat of the Indian by white civilization. His sketch model was far simpler than his completed group. He originally conceived a group of three figures, whereas the finished model had nine Indians, a dog, a vulture, and a buffalo. This complex work barely fit into the artist's studio: "My studio was small, so small in fact that when I wanted to see the all over effect, I had to open the door and step out into the hall and a few steps down the stairs to get the proper perspective."[2]

A single dying buffalo is the central figure of the group. The buffalo was of prime importance to Indian civilization. Behind the buffalo stands a totem pole, a symbol of Indian traditions and culture. Perched on the totem pole is a vulture, the omen of destruction. There is little question that this bird is a predator, symbolic of the white man, ready to feast on the carrion of Indian civilization. To Weinman, the destruction of Indian civilization at the hand of the white man was the destiny of the red man.

Sitting with his back to the buffalo is the Medicine Man. Although the prophet of his tribe, he has no vision except one that relates to the past. His role is that of the storyteller "relating the folklore and hero tales of a vanishing race."[3] Striding forward with this lone dying buffalo are the Chief, the men, women, and children of the tribe. Weinman described his group thus:

The Chief, magnificent in his war regalia, strides resolutely on,
followed by the Hunter and his dog. The Indian Mother with her
pappoose, leading her sturdy little son by the hand, regards their future
with deep concern, while the Brave looks back nostalgically upon the
ever receding horizon of his days as a buffalo hunter and warrior,
days that will nevermore return. . . .

196. Adolph A. Weinman. *Destiny of the Red Man* (side view). Modeled 1903, cast 1947. Roman Bronze Works, N.Y. H. 55″. R. W. Norton Art Gallery, Shreveport, La. This work was exhibited in plaster at the Louisiana Purchase Exposition held in 1904 at St. Louis

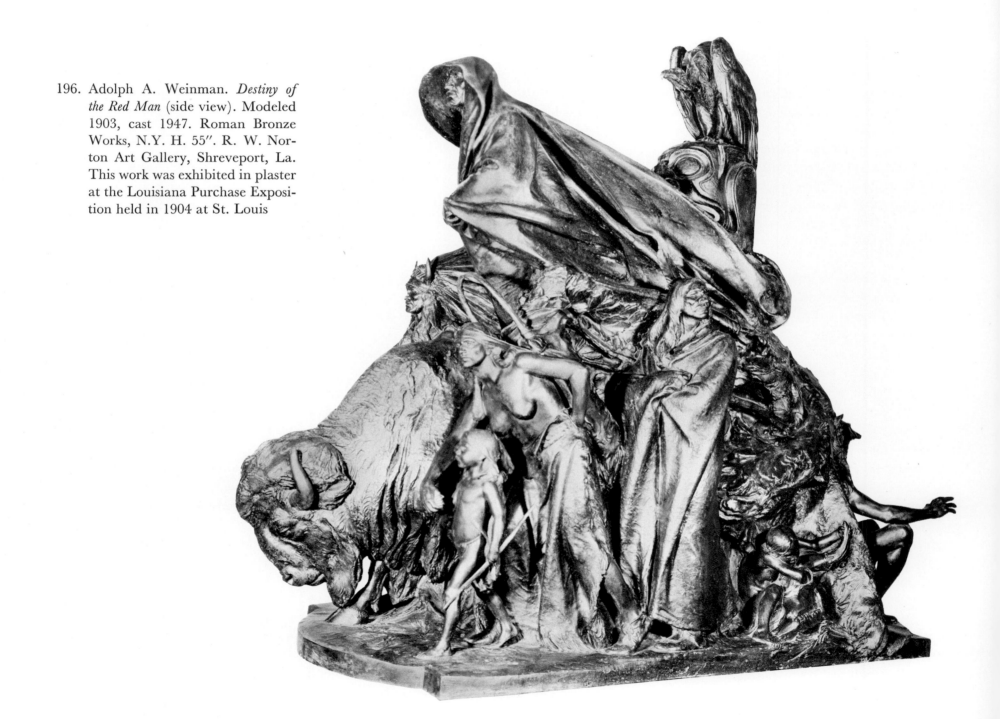

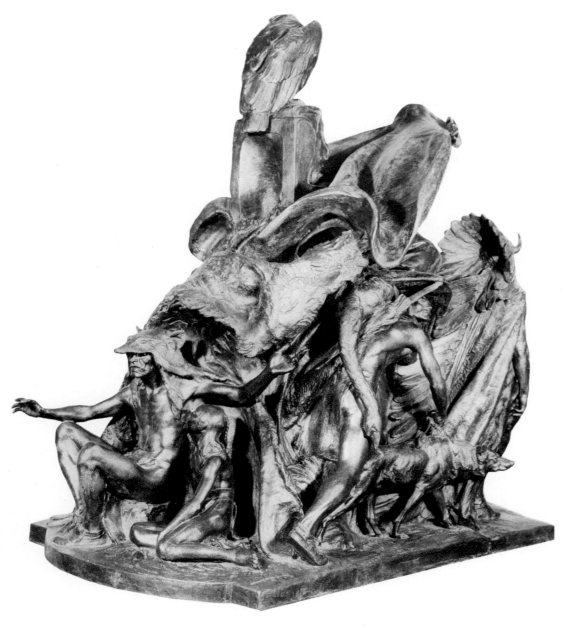

197. Adolph A. Weinman. *Destiny of the Red Man* (side view)

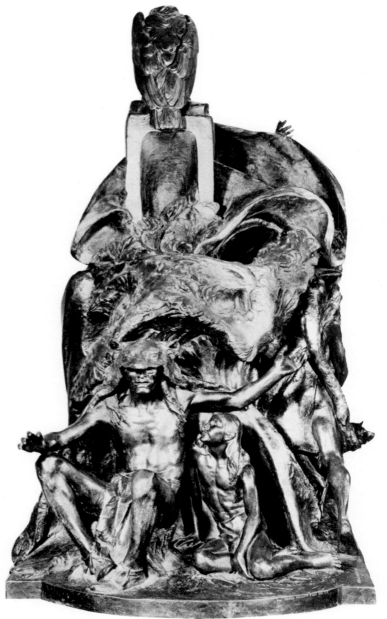

198. Adolph A. Weinman. *Destiny of the Red Man* (rear view)

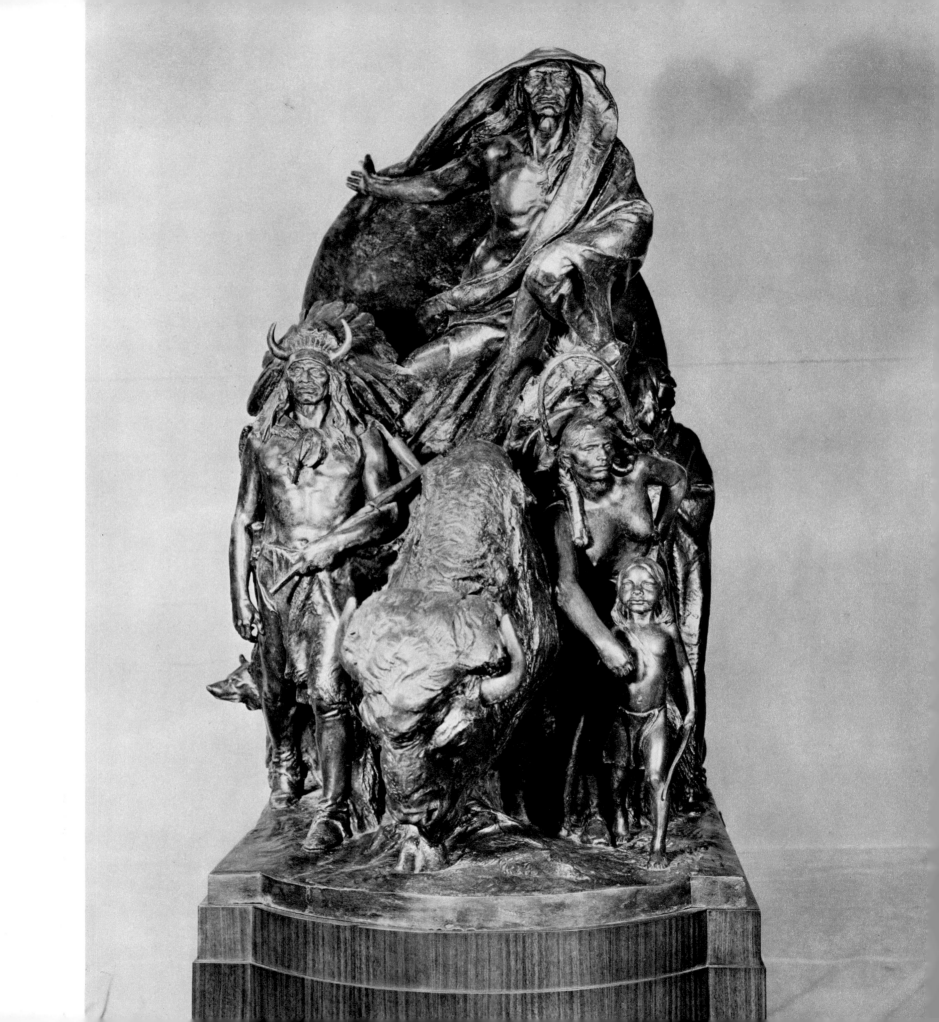

199. Adolph A. Weinman. *Destiny of the Red Man* (front view)

Surmounting the entire composition is the figure of the Great Spirit, shrouded in dark and inscrutable mystery, guiding his wards along the road of Destiny, foreordained and inexorable.[4]

One figure is a small child with his arm thrust through the hollow eye sockets of a buffalo's skull. This child is symbolic of the impending starvation the Indian would face following the destruction of the buffalo herds.

The group is a composite of precise individualized figures. Each figure, carefully detailed in form, facial expression, and costume, can be viewed as an independent sculpture. These individual forms, however, are an integral part of a carefully planned design. The *Destiny of the Red Man* was well received by visitors to the Louisiana Purchase Exposition. The figure of the blanketed warrior was reproduced separately long after the fair had closed.

Weinman devoted his fullest energy and skill to this group. The finished model required far more work than had been taken into consideration in determining the appropriation for the original commission. This did not disturb the artist, as he was totally absorbed in his project. "Looking at this in retrospect, I am convinced that it was the most romantic period of my carrere. Low in funds, but with boundless enthusiasm, and a good constitution to see me through, I had nothing to complain of, or to regret."[5]

The *Destiny of the Red Man,* originally exhibited in staff (a composition of plaster and straw), was cast in bronze many years later. A friend of Weinman's, Richard W. Norton, Jr., saw the original model in the artist's studio and prevailed upon Weinman to give the group permanent form. Norton acquired the original, finished working model and financed the elaborate casting procedure. The model was reduced to three-quarters of its original size and cast in 1947. Only one cast was made, and this bronze sculpture now stands in the R. W. Norton Art Gallery in Shreveport, Louisiana.

Weinman made several bronze Indian portraits from studies of Colonel Cummings' Indians. One was a portrait of an Indian child, Womboli *(plate 200)*, or "Little Eagle." Womboli was the daughter of Chief Blackbird. Weinman's interest in linear patterns is shown in the correspondence of the folds of the child's dress with the formal Indian designs on the base of the sculpture.

Weinman's best-known portrait is of Chief Blackbird *(plate 201),* whom he described as "a stoic, if ever there was one."[6] The portrait of Blackbird in his elaborate headdress is totally formal and stylized. The details follow intricate linear patterns which give the work a

rhythmic quality. *Chief Blackbird* is a decorative and aesthetically pleasing sculpture.

Weinman also created a portrait of Chief Flatiron *(plate 202)*. He wrote that Flatiron was "small, wiry and with a leathery skin, was quite talkative and loved to tell me of his travels in Europe with the Buffalo Bill Show, which made him a greater chief than Blackbird, who had never crossed the Great Waters."[7] This sculpture also exemplifies Weinman's dependence on linear design. His careful use of balanced low-relief design is evident in the facial wrinkles, the hair, and the dress of the Indian.

Weinman demonstrated a highly developed sense of style and rhythm in his Indian portraits. His designs are carefully planned and the precise details often have high ornamental value. His work followed the Classic-Renaissance traditions rather than those of French sculpture at the turn of the century. His modeling is at all times smooth and precise, with hard outlines, whereas the French demanded a more impressionistic style and more vigorous modeling. Weinman's sculpture has a decorative rather than emotional appeal. This interest in line and pattern may have been the result of the strong influence of Art Nouveau on artists during the early years of the twentieth century. In later years, Weinman's work became even more linear and stylized.

Weinman used a slightly freer approach in his sculpture of a bison *(plate 203)*. Because the details are still quite linear in quality, however, this sculpture lacks the vitality of the more impressionistic models of bison by some of his contemporaries. Weinman's sculptural style was better suited to individual portraits than to animal forms.

Weinman worked for many of the commemorative expositions,

200. Adolph A. Weinman. *Womboli*. Modeled 1902. Roman Bronze Works, N.Y. H. 8½". Brookgreen Gardens, Murrells Inlet, S.C. This bust was one of several studies of Indians exhibited by Weinman at the Louisiana Purchase Exposition held in 1904 at St. Louis

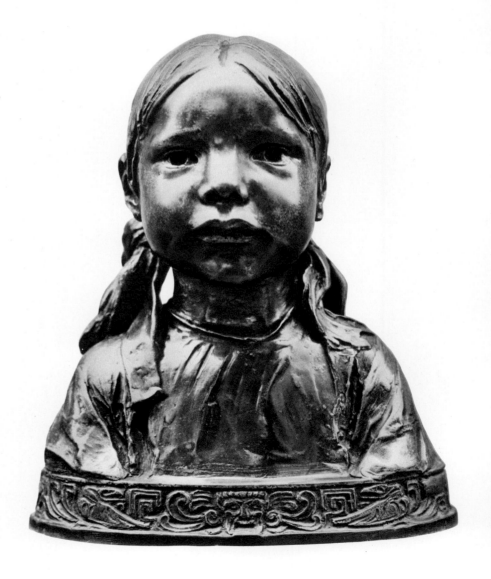

201. Adolph A. Weinman. *Chief Blackbird*. Modeled 1903, cast 1907. Roman Bronze Works, N.Y. H. 16½". Thomas Gilcrease Institute, Tulsa, Okla.

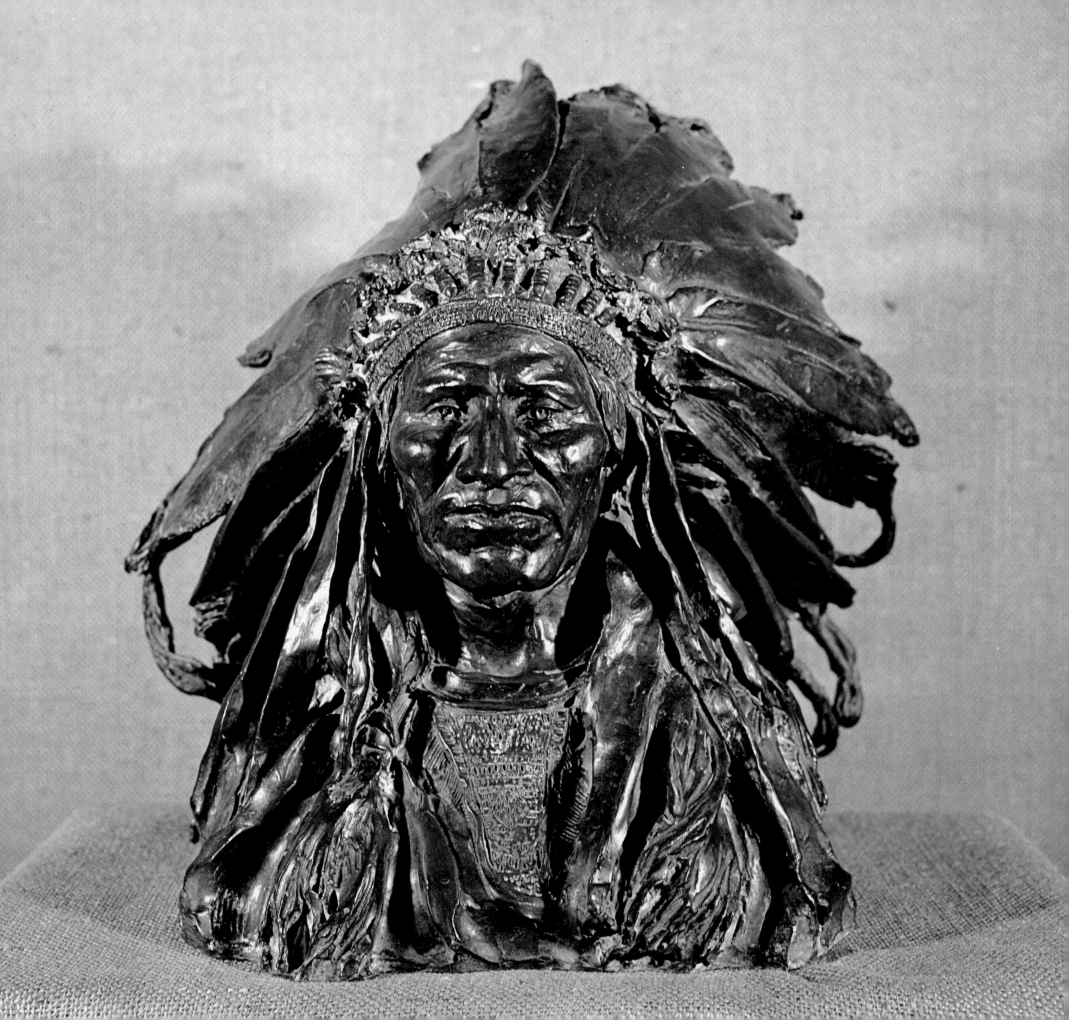

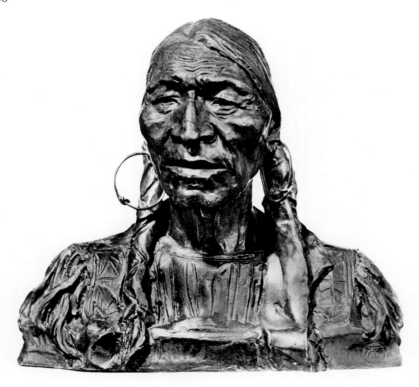

202. Adolph A. Weinman. *Chief Flatiron*. Modeled c. 1903. Roman Bronze Works, N.Y. H. 12″. Graham Gallery, New York City

primarily creating complex sculptural abstractions. *The Rising Sun* and *The Descending Night*, exhibited in 1915 at the Pan-Pacific Exposition in San Francisco, are examples of this phase of his art.

Weinman devoted much of his career to architectural decorations. He designed sculptural ornaments for the J.P. Morgan Library and Pennsylvania Railroad Terminal in New York City, the Louisiana Capitol in Baton Rouge, and many other important buildings of the early twentieth century. He also created war memorials and statues honoring heroes of the past as well as prominent citizens and political figures of the day.

Weinman was active in many American sculptural societies. He served on the New York City Arts Commission and the National Commission of Fine Arts, and was president of the National Sculptural Society. He died in Port Chester, New York, in 1952.

Weinman certainly cannot be considered a Western sculptor. During his lifetime, he won success as an artist by catering to the public taste. His heroic Neoclassical abstractions and figures of mythological deities are technically excellent expressions of a type of art enjoyed by a public hungry for the outward manifestations of European and Classical culture. Perhaps Weinman's Indian portraits and his single, monumental sculptural group which dramatized the impending destruction of Indian civilization will stand as his most interesting and enduring artistic statements.

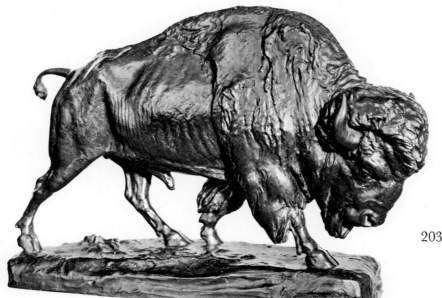

203. Adolph A. Weinman. *Bison*. c. 1922. H. 12″. Graham Gallery, New York City

XIV
FROM CANVAS TO BRONZE

By the turn of the century, bronze sculptures of the American West were rapidly growing in popularity. Artists who were devoted to drawing and painting were tempted to try their hand at this most effective and permanent medium. Many of them had created clay models as a preparatory step for their paintings. Working from clay models had some of the advantages of working from life, since many artists first visualized a subject in the round. Once a painter had created a model, he could best determine the most advantageous view for a two-dimensional representation. The small sculpture would also serve as a model for the individual figures in his painting. Often the artist was eager to have his clay models cast in bronze and thus give his creations permanent form.

These artists, translating subjects from one medium to another, re-created in bronze the narratives of their paintings and drawings. These paintings frequently were commissioned for reproduction in a periodical, or for reproduction in lithographs issued as a portfolio. They were often quite current in content. The resultant bronze models thus reflected the beliefs and prejudices of the popular culture as well as those of the artist.

With the surrender of Sitting Bull at the Battle of Wounded Knee in 1890, the period of Indian conflict was formally ended. The Indian ceased to be the official enemy of the United States government troops. Once he was no longer a rational object of fear and terror, the Indian became rapidly romanticized. The tranquillity of Indian life, the rugged beauty of the Indian's face, his harmonious relationship with nature, and the tragic destiny of his defeated civilization—all were inspirational subjects popular in early twentieth-century art.

Conversely, the Indian fighters who had pursued and captured the Indians also became the object of romantic idealization. A small number of troopers, about fourteen thousand, working for the lowest of wages, about thirty dollars a month, patrolled a vast area approximately 1,400,000 square miles in size. This was about one hundred square miles per man.[1] These troopers offered protection to the con-

201

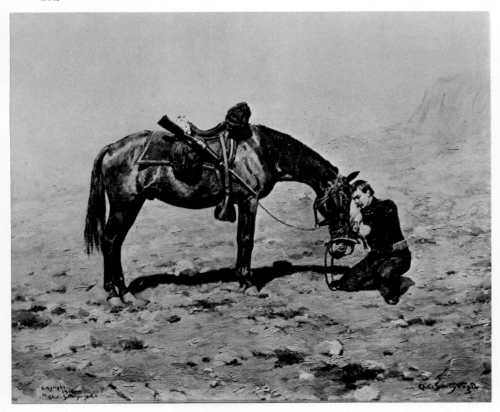

204. Charles Schreyvogel. *The Last Drop*. Copyright 1900. Oil on canvas. 16 × 20″. Private collection

voys traveling westward and provided a measure of security for the new, isolated communities. Several artists were inspired by these soldiers patrolling the Great Plains.

The glorification of the conflict between the Indians and United States troopers is still part of our mass culture. Each year there are new films in which the United States troops appear in the distance to assure the viewer that the settlement or fort, hero or heroine will be saved from an ignominious fate. It is only in recent years that attention has been given to the countless treaties broken by the federal government and to the atrocities committed in Indian communities by military leaders, hungry for the glory and publicity of victory at any cost.

In the early twentieth century, many artists could, with equanimity, simultaneously glorify both the noble, dignified Indian and the brave trooper who had defeated the "savages."

Charles Schreyvogel became famous for his paintings of violence and drama in the conflict between the Indians and the United States troopers. He painted the critical and usually most violent moments of battle: the moment of attack, the heroic rescue, a desperate last stand and hand-to-hand combat. His paintings and lithographs illustrate dramatic scenes of gunfire and death in the battlefield. Schreyvogel portrayed the Indians as dedicated, fierce warriors. They are men of dignity fighting to the death to save their land and way of life by halting the Western migration. The United States trooper is the hero and victor in these paintings. Schreyvogel glorified the soldier in the tradition which endures in today's Western movies. The heroic trooper is devoted to his horse, faithful to his fellow soldiers, and ready to face bloody battle at a minute's notice. In *Portrait of the Old West,* Harold McCracken pays tribute to Schreyvogel as "the man who most seriously and most successfully undertook to perpetuate the cavalryman in action against his red-skinned foe, and the foot soldier in defense of stockade and wagon train. . . . This was the theme to which he devoted practically his whole career, and no one has left us a finer or more graphic report on this particular phase of Western life. . . ."[2]

Charles Schreyvogel was born on January 4, 1861, on the Lower East Side of New York City. His parents, Theresa Erbe and Paul Schreyvogel, owned a neighborhood store which sold candy, beer, and baked goods. As a youth, Charles sold newspapers and worked as an office boy. Having shown early artistic talent, he was later apprenticed to a carver of meerschaum pipes, a gold engraver, and a lithographer.

In the 1870s the family moved to Hoboken, New Jersey. As Schreyvogel desired a career as an artist, he financed his art education by

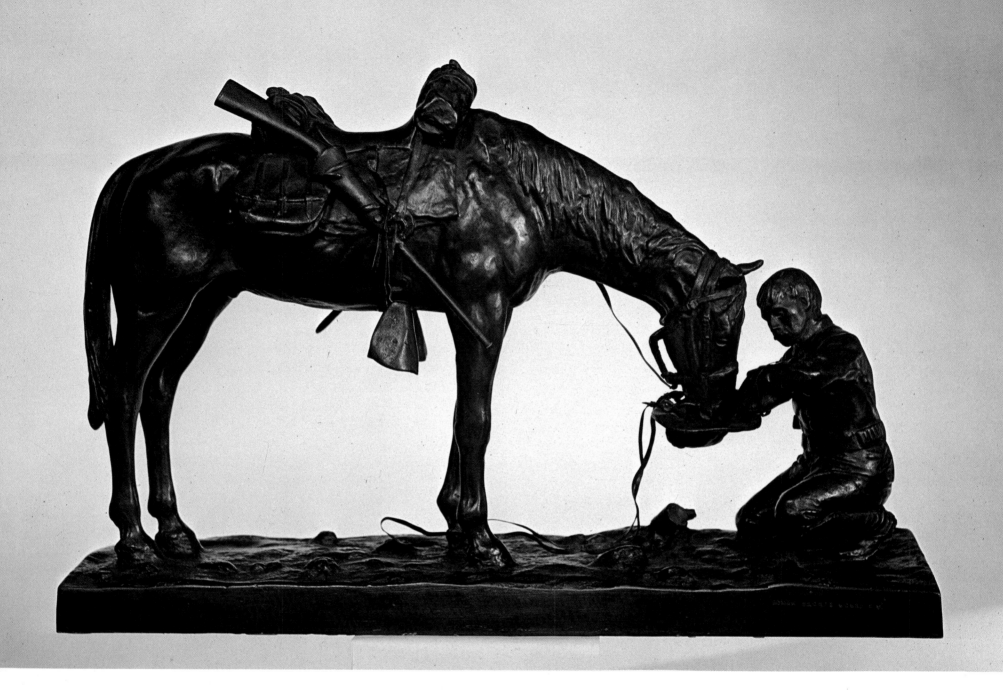

205. Charles Schreyvogel. *The Last Drop*. Copyright 1900, cast 1903. Hoboken Foundry, Hoboken, N.J. H. 12″. National Cowboy Hall of Fame, Oklahoma City, Okla.

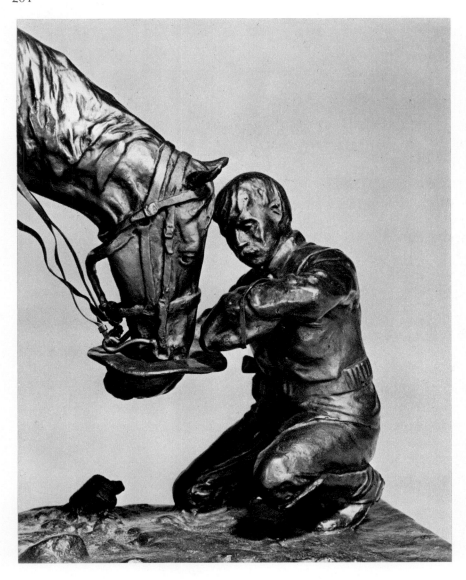

206. Charles Schreyvogel. *The Last Drop* (detail of plate 205)

selling some lithographic sketches and giving painting and drawing lessons. He first studied at the Newark Art League in Newark, New Jersey. He so impressed his teacher, H. August Schwabe, president of the school, that Schwabe and Dr. William A. Fisher helped to finance three years of European study for him. Schreyvogel studied at the Munich Art Academy under Carl von Marr and Frank Kirchbach. It was while studying with Von Marr that he first developed an interest in the American West.

On his return to the United States, Schreyvogel became friends with Nate Salsbury, manager of Buffalo Bill's Wild West Show. Through Salsbury, he met Buffalo Bill, who became his lifelong friend and admirer. Schreyvogel enjoyed complete freedom to sketch the cowboys and Indians on the show grounds.

Throughout his youth, Schreyvogel suffered from severe asthma. In 1893, Buffalo Bill made arrangements for Schreyvogel to travel West to the Ute Reservation in Ignatio, Colorado, as a guest of the army post surgeon, Dr. Thomas McDonald. Schreyvogel enjoyed life at the government's Supply Center in Ignatio, and his health improved rapidly in the dry mountain climate. At Ignatio, there was a regiment of United States troopers who had just returned from the Philippines. From them, Schreyvogel learned to ride and to use a rifle cavalry-style. From the Indians, he learned sign language so that he was able to communicate with those he sketched. After five months in Colorado, Schreyvogel traveled to Arizona, where he lived on a large ranch and enjoyed sketching the Apaches, the cowboys, and the horses. On his return to Hoboken, Schreyvogel determined to create through his paintings a record of the violent drama between the Indians and the United States during the thirty years following the Civil War.

Schreyvogel supported himself by painting portraits and landscapes, creating ivory miniatures, and making sketches for lithographs. All through his life, he adamantly refused to sell paintings or drawings for reproduction as illustrations.

Suddenly, in 1900, Schreyvogel achieved renown when an entry in a National Academy exhibition, *My Bunkie,* won the Thomas B. Clarke Prize, the Academy's highest honor. Schreyvogel's work skyrocketed in popularity. Overnight, he became an established artist and a financial success. He won the admiration of Theodore Roosevelt, who encouraged his work by giving him permanent permission to visit any Indian reservation or army post in the United States. Schreyvogel used this privilege to great advantage and traveled extensively through Ute, Sioux, Crow, and Blackfoot reservations, as well as to many army posts.

Schreyvogel acquired an excellent collection of Indian artifacts, clothes, weapons, and military memorabilia. He was particularly interested in historical accuracy and his collection helped him achieve the authenticity of detail he considered so important. He became involved with Remington in a well-publicized dispute over the accuracy of detail in the Schreyvogel painting, *Custer's Demand*. They disputed such trivia as the exact shade of blue in a soldier's trousers. After appealing to such authorities as Lieutenant Colonel Crosby (*aide-de-corps* to General Sheridan), Mrs. Elizabeth Custer, and Teddy Roosevelt, each artist established certain points, hardly justifying the hard feelings and antagonism which existed for many years between them. Remington was the best-known painter and illustrator of cowboy and military life of his day. Schreyvogel remained in his shadow until Remington's untimely death in 1909. Ironically, Schreyvogel also died prematurely, in 1912, from blood poisoning caused by a chicken bone sliver lodged in his gum.

Schreyvogel was a far gentler person than one visualizes from observing his violence-filled paintings. Although he created only two bronzes, these better reflect the kindhearted man described by those who knew him, a man who could not shoot any form of wildlife. Throughout his life, he loved animals and was particularly fond of horses. His daughter attributed his love of the West to "a longing . . . [caused by] the realities of a boyhood spent growing up in the Lower East Side of New York City. As a young man he took a strong liking to horses, be it a dray horse, policeman's, or the team on a trolley line. He would climb into a saddle whenever the opportunity presented itself."[3]

In one bronze, *The Last Drop (plates 205, 206)*, he portrayed a soldier giving his horse the last drop of his water. This scene was greatly admired by Buffalo Bill, and became a popular tableau in his Wild West Show. Originally, the sculpture was created as a model for a painting *(plate 204)*, as was his custom for scenes involving horses. Schreyvogel had the model cast in 1903.

The Last Drop was Schreyvogel's second bronze. His first, *White Eagle (plate 207)*, modeled in 1899, was a portrait of the last of the Ponca chiefs of Oklahoma. Schreyvogel modeled White Eagle on one of his visits to the Ponca Indian Reservation. The artist's daughter described the Indian's reaction to his portrait: "White Eagle was a magnificent-looking Indian, and when he saw the bust he told my father he was proud that he had been selected as the model. In later years he never failed to inform any of his visitors that he had posed for the Schreyvogel Indian chief bust."[4]

Despite his paintings of violent Indian conflicts, Schreyvogel was

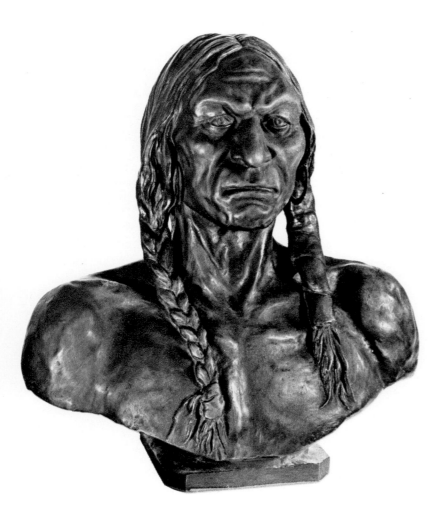

207. Charles Schreyvogel. *White Eagle.* c. 1899. Roman Bronze Works, N.Y. H. 20¾″. National Cowboy Hall of Fame, Oklahoma City, Okla.

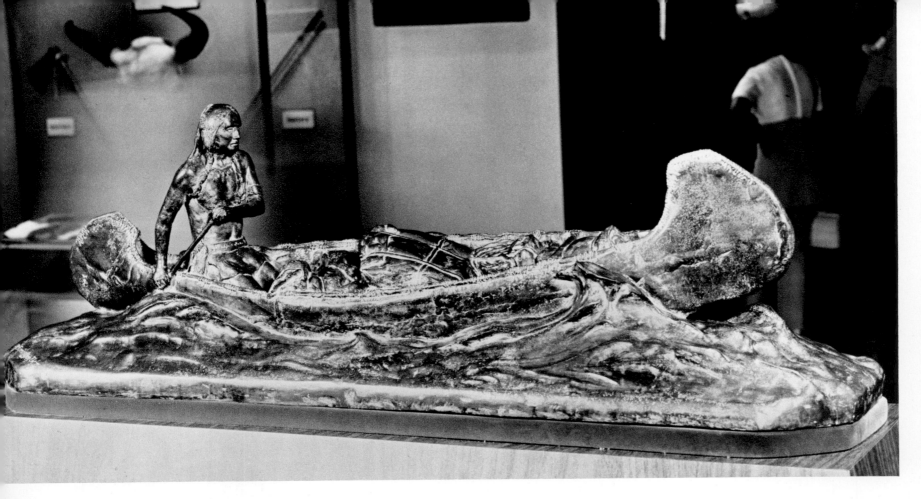

208. R. Farrington Elwell. *Indian in a Canoe*. Cast 1930s. Noggle Bronze Works, Prescott, Ariz. H. 11". Woolaroc Museum, Bartlesville, Okla.

basically sympathetic to the Indian. In the course of his visits to the Indian reservations, he made many friendships. Schreyvogel said in an interview: "I have not met any Fenimore Cooper Indians, although I have had the pleasure of knowing some good, honorable red men. The Indian is, as a rule, silent, stoical, and taciturn to a wonderful degree until he gets to know you. Then he thaws out. . . . I have many Indian friends and I have many friends in the Army."[5]

Shortly before his death, Schreyvogel was working on a complex bronze depicting a moment of conflict between Indians and troopers. After his death, the model was destroyed by the family for fear that it might fall into unscrupulous hands.

Another artist who was primarily dedicated to paintings of the West but who occasionally created bronze sculptures was R. Farrington Elwell. Born in Massachusetts in 1874, Elwell was a completely self-taught artist. As a boy, he often experimented with modeling in snow or clay. Like many of his contemporaries, his first contact with the West was at Buffalo Bill's Wild West Show. In 1890, Elwell visited the show in Boston. He sketched the horses, cowboys, and even Colonel Cody. The Colonel noticed the young man and admired his work. This was the beginning of a long and devoted friendship.

The following year, when Cody returned to Boston, he invited

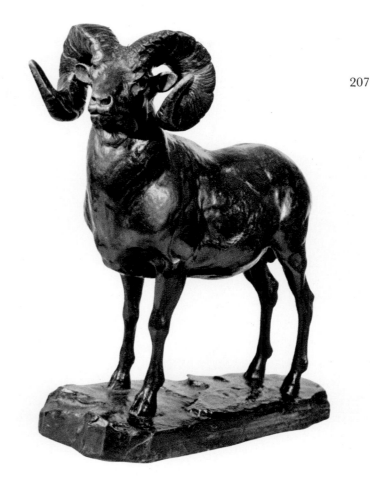

young Elwell to accompany him to Wyoming to work on his ranch. With the exception of several winters during which Elwell worked in New York and Boston, he was employed by Cody Enterprises for close to twenty-five years. Elwell managed Buffalo Bill's cattle and horse ranches and hotels, and engineered his irrigation projects.

Elwell sketched constantly and through practice developed a good, realistic style and a sharp sense of drama. Early in his career, he was primarily an illustrator for magazines and books. Later, he created paintings and illustrations to be used as advertisements for such companies as Winchester Arms and United States Cartridge. He also painted numerous Western scenes for use on commercial calendars. Many of his best-known advertisements were for Buffalo Bill's Wild West Show and the Congress of Rough Riders of the World. Elwell's art depicted typical cowboy-and-Indian scenes at the turn of the century. Originally, his sculpture also was primarily for commercial use. The Buchanan Company of Boston produced models of Elwell's sculptures for the Winchester Arms, Samoset Chocolate, and Tower Slicker companies, and for the *Ladies' Home Journal*.

After the end of Colonel Cody's empire, Elwell returned East and worked from his memories of Western life. However, he was never contented living in the East and after an unsuccessful investment in a Morgan horse ranch, Elwell moved to Wyoming and then to Utah. He finally established his home and studio in Phoenix, Arizona, where he lived and worked until the age of eighty-eight.

Elwell made several bronzes of Indian life. His *Indian in a Canoe (plate 208)* is in the Woolaroc Museum in Bartlesville, Oklahoma. Elwell felt that Indians were deeply misunderstood and mistreated. He respected their culture and traditions and believed them to be a humble and noble race. There is a dignity and beauty in his Indian sculptures which express his understanding and admiration for the Indian.

Several Western bronze sculptures were created by artists who were primarily naturalist painters. Carl Rungius was greatly admired and honored as a painter of American big-game animals. He created several bronze sculptures. One was of a bighorn sheep *(plate 209)*; another was of a bull moose *(plate 210)*.

Rungius's sculptures reflect his excellent academic training and fine knowledge of anatomy. They were probably studies for paintings which the artist later decided to have cast in bronze, and are valuable as they reflect the growing artistic interest in bronze sculpture.

Born in 1869 in Berlin, Rungius received a fine education at the Berlin Art School, the School of Applied Arts, and the Academy of Fine Arts. In 1894, he settled in the United States, and the following

209. Carl Rungius. *Bighorn Sheep*. c. 1915. Roman Bronze Works, N.Y. H. 16¾". Graham Gallery, New York City

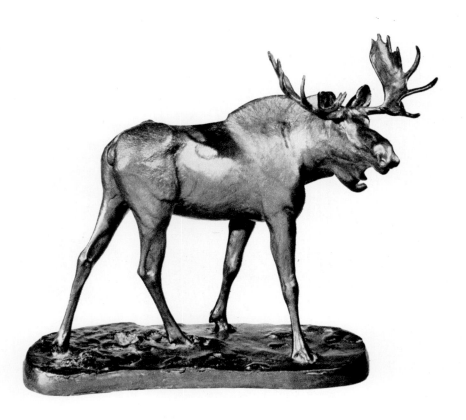

210. Carl Rungius. *Bull Moose*. 1905. Roman Bronze Works, N.Y. H. 17″. Rockwell Foundation, Corning, N.Y.

year traveled to Wyoming. Rungius especially enjoyed sketching the prolific wildlife in Yellowstone National Park. He won acclaim and recognition during his long career for his portraits of American wildlife set against magnificent Western landscapes.

Another animal bronze probably created as a study for a painting and later cast in bronze as an independent work is the *Buffalo (plate 211)* by William R. Leigh (1866–1955). Leigh made several trips West to study Indian life. Leigh was trained in the disciplines of the Royal Academy of Munich, where he learned to carefully develop his finished work from sketches, studies, and models. He violently objected to and criticized any form of impressionistic work.

Leigh made several trips West to study Indian life. His first Western trip was to New Mexico in 1906. He was thrilled by the natural beauty of the region, the Indian villages, and the romantic history of the West. Leigh later wrote: "My interest in the West began long before I can remember. I found it all and more than I had dared to expect to hope, and I believe it has called forth the best there is in me."[6] Leigh devoted his lifetime to painting scenes of the American West: colorful landscapes, the daily life of the Indians, and the excitement of cowboy life. He was not, however, a participant in any phase of Western life, but rather an observer of the world around him.

Leigh defined his artistic goals thus: "I wanted to go to the West to acquaint myself with our frontier, with the purpose of devoting my life to depicting the activities of the Indians, cattlemen, soldiers and pioneers. . . ."[7] I have devoted a lifetime to re-creating natural studies and have endeavored, above all else, to paint with fidelity to nature."[8] Leigh's finished works are not re-creations of an era but are idealized portraits or imaginative dramas of the West.

Leigh was one of the most academically skillful artists to portray the West. Today, some of his sketches and preparatory oil studies are considered to have far more vitality and spontaneity than his finished paintings, which were subjected to the severest academic disciplines.

Another artist whose reputation was as a painter and illustrator rather than sculptor is Frank Hoffman (1888–1958). Hoffman was born in Chicago, but early in his boyhood moved with his family to New Orleans, where his father had a racing stable. There, Hoffman began drawing horses. He soon left school, as he preferred working and sketching in the stable to studying his lessons. Hoffman enjoyed all types of stable work. Until he grew too heavy, he exercised the horses and raced them on the flats and over jumps. During his years working in the stable, he devoted his spare time to sketching and drawing the horses. Several years later, Hoffman used these drawings to obtain employment as an artist on the *Chicago American Daily*.

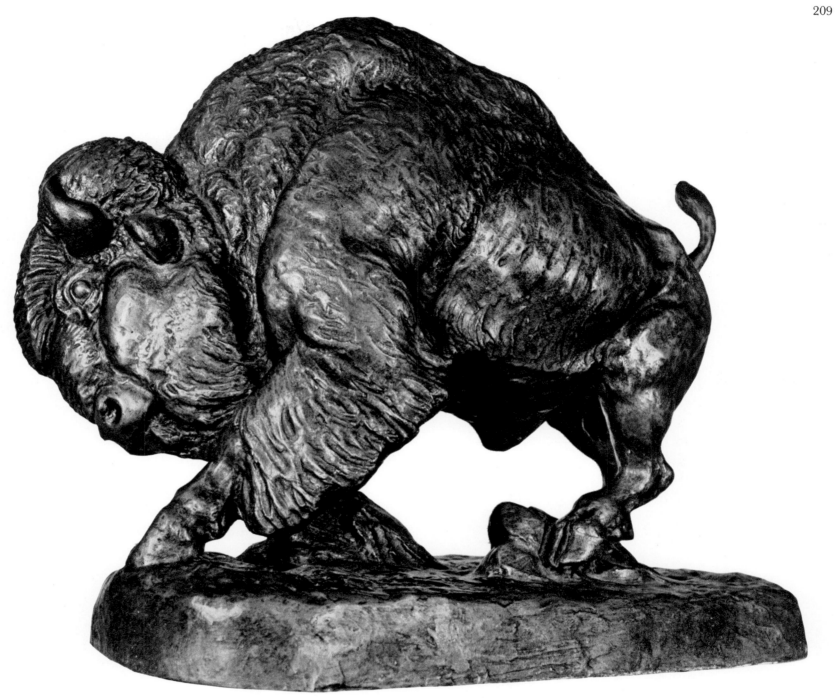

211. William R. Leigh. *Buffalo*. 1911.
Roman Bronze Works, N.Y. H.
15″. Thomas Gilcrease Institute,
Tulsa, Okla.

Eventually he became head of the paper's art department. While in Chicago, Hoffman studied painting for five years, primarily under J. Wellington Reynolds, a well-known instructor.

In 1916, Hoffman was rejected for military service because of an eye defect. Disappointed, he went West. Starting in Montana, he hunted and painted throughout the West, going as far south as old Mexico. Hoffman became fascinated with Indian life. He lived with the Blackfeet and learned their sign language and also visited and made friends with Indians of many other tribes. He loved the stories of the old days on the frontier and listened to tales told by the old-timers of the West—hunters, trappers, cowboys, and stagecoach drivers.

In 1920, Hoffman went to Taos, where he met and painted with many of the original members of its art colony: Ernest Blumenschen, Henry Sharp, Irving Couse, and many others.

Unable to support himself by his Western paintings, Hoffman turned to commercial art and created advertisements for many Western products. For years, he illustrated the Brown and Bigelow Calendars. During Hoffman's early days in the West, he was witness to the last round-up of buffalo shipped from the United States to Canada. The buffalo became one of his favorite artistic subjects. Two sculptures, *Standing Buffalo* and *Lying Down Buffalo (plate 212)*, were probably created as studies for paintings.

Schreyvogel, Elwell, Rungius, Leigh, and Hoffman were just a few of the painters who, at some point in their careers, turned to sculpture as a separate form of artistic expression. Their bronzes are today a valuable part of our heritage of Western sculpture.

212. Frank Hoffman. *Lying Down Buffalo*. Modeled 1920, cast c. 1971. Specialty Precision Casting, Tucson, Ariz. H. 6″. Collection Mr. and Mrs. Ed Trumble, Boulder, Colo.

XV
AMERICAN INSPIRATION

It would be a great oversight to limit a history of the bronzes of the American West to the work of American sculptors, for the West was a tremendous source of inspiration to artists from many parts of the world.

Sculptors from many countries traveled to the United States and journeyed West to visit the exciting world of cowboys and Indians. Some artists remained in the United States for many years to model and paint directly from their sources of inspiration. Others returned home and for years thereafter re-created Western bronzes from memory and imagination. Several artists remained in their native lands and gave tangible form to a world they knew only through their imaginations and dreams.

The European tours of Buffalo Bill's Wild West Show were a prime cause of the fascination with the American West which flourished on the Continent at the turn of the century. It is, however, almost impossible to estimate the impact of Colonel Cody's shows on artists, both in the United States and in Europe. The nineteenth-century European considered America a land inhabited by savages. Cody capitalized on this romantic myth in all phases of his presentation of the Wild West. His posters for the show advertised the chance to enjoy a world of daring, danger, and excitement. One poster—entitled *An American (plate 213)*—pictured a fierce Indian adorned with feathers and war paint.

Colonel Cody traveled to Europe with a huge troop of brightly costumed, painted Indians, and a company of sharp-shooting, rough-riding cowboys and cowgirls. His show was a phenomenal success, and audiences returned home delighted with their taste of American life and their glimpse of "native Americans."

Parisians, especially, delighted in the spirit of the Wild West. Fascinated by the world of cowboys and Indians, few artists could resist the temptation to create at least one work of art depicting its drama and pageantry. Many artists sketched and made models of the cowboys and Indians in Buffalo Bill's Wild West Show. The performers

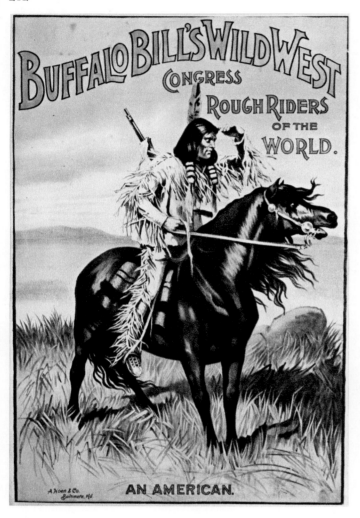

213. *An American.* c. 1887. This is an
original poster advertising Buffalo
Bill's Wild West Show. Shoshone
First National Bank, Cody, Wyo.

were usually most cooperative in posing for painters and sculptors.
Alfred Barye, son of the great French *animalier* Antoine Louis Barye,
created a bronze group entitled *Wakuta-Peau-Rouge de la Buffalo Bill's
Cy ("Wakuta Redskin of Buffalo Bill's Company") (plate 214).*

Both Rosa Bonheur (1822–1899) and her brother Isidore (1827–
1901) were frequent visitors to Buffalo Bill's Wild West Show. Rosa
painted several portraits of Buffalo Bill and was considered to have
been his mistress. During her lifetime, Rosa Bonheur received many
honors and achieved greater artistic recognition than her brother.
In 1895, she became the first woman to be made an officer in the
Order of the Legion of Honor. Rosa knew and influenced many of
the American sculptors who studied and worked in Paris in the late
nineteenth century. *Indian Scout and Buffalo (plate 217)* by Isidore
Bonheur is a truly Parisian interpretation of the American Wild West.
Both Bonheurs created many sculptures of bulls, bears, and deer such
as might be found in the American West *(plates 215, 216).*

The works of the Bonheurs are excellent examples of traditional
nineteenth-century French animal sculpture. Their animal bronzes
are technically sophisticated, naturalistic studies illustrating their
excellent knowledge of animal forms. Their extensive use of realistic
details typifies the desire of the French *animaliers* to achieve an almost
scientific accuracy in their sculpture. The Bonheurs' animals display
little of the dramatic intensity or violence often seen in the bronzes
of many of their contemporaries. Their animals are usually portrayed
in either standing or resting poses.

Two of the largest, most dramatic equestrian bronze Indian sculp-
tures in the United States, the *Bowman (plate 218)* and the *Spearman
(plate 219)*, were modeled and cast in his native Yugoslavia by Ivan
Mestrovic (1883–1962). Mestrovic studied sculpture in Vienna and
Paris with such masters as Rodin, Bourdelle, and Maillol. His own
sculpture is highly dramatic and stylized, reflecting the mystic and
poetic traditions of his Eastern heritage. A deeply religious man
throughout his life, Mestrovic emphasized the importance of both spiri-
tual inspiration and technical ability in artistic creation. Mestrovic
had a strong influence on many sculptors of the early twentieth cen-
tury. His best-known pupil was Malvina Hoffman. Miss Hoffman
traveled to Zagreb to study the sculpture of horses with him. Mestro-
vic taught his pupil to work from live models and classical studies.

Mestrovic first visited the United States in 1924 for nine months.
He brought with him a collection of over one hundred bronzes and
marbles which were first exhibited in the Brooklyn Museum in New
York and later sent on a tour of museums throughout the country.

Although Mestrovic returned to America in 1946 and became a

214. Alfred Barye. *Wakuta-Peau-Rouge de la Buffalo Bill's Cᵧ*. c. 1889. H. 22″. R. W. Norton Art Gallery, Shreveport, La.

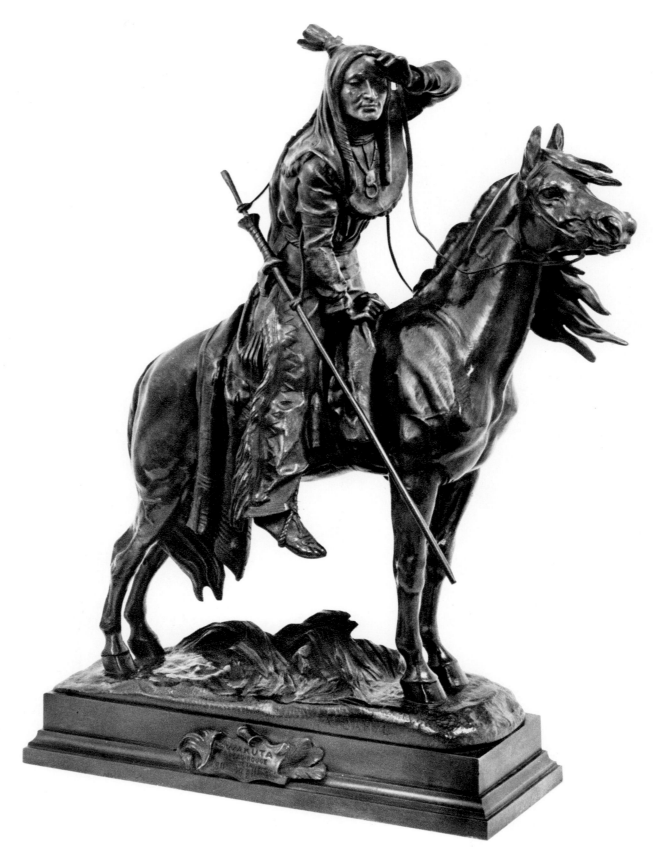

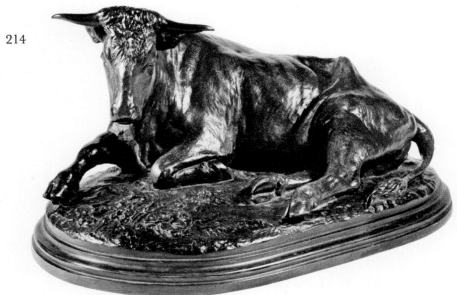

215. Rosa Bonheur. *A Bull Resting.* c. 1895. H. 6½″. Graham Gallery, New York City

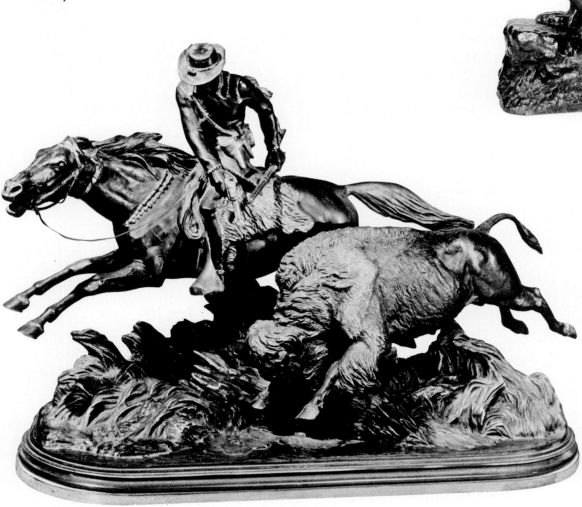

216. Isidore Bonheur. *Walking Bear.* c. 1880. H. 27½″. Graham Gallery, New York City

217. Isidore Bonheur. *Indian Scout and Buffalo.* c. 1880s. H. 19½″. Private collection

United States citizen in 1954, his heroic sculptures of the American Indian were created in Yugoslavia. In 1925, he was teaching there when he received a commission from the city of Chicago to create two giant equestrian statues of American Indians. These were to be placed on platforms in Grant Park facing the bridge on Michigan Avenue. The twenty-foot-high heroic Indians were modeled and cast in Zagreb. Mestrovic used the commission as a demonstration for his pupils. The giant equestrians were enlarged from four-foot plaster models and cast by the lost-wax process. Mestrovic permitted a series of motion pictures to be made of the preparation and casting of his statues.

The *Spearman* and the *Bowman* are heroic nudes wearing feathered headdresses. The facial features of the Indians are stylized and exaggerated to emphasize their racial characteristics. Their horses are heavy European draft horses rather than the small cayuses ridden by the Indians.

Paul Troubetzkoy, the son of a Russian prince, created many bronzes of life in the American West. It was, perhaps, from his American mother that he acquired his fascination with cowboys and Indians.

Troubetzkoy was born in 1866 in the Italian village of Intra on the shores of Lake Maggiore. From boyhood, he desired a career as a sculptor. As a small child, he practiced modeling in soft bread, and when he was seven began to work with modeling wax. One of his favorite childhood pastimes was modeling the household pets and other domestic animals.

Troubetzkoy's mother encouraged him to practice his art. When at the age of ten he created a horse's head, she took it to Milan for the opinion of the sculptor Giuseppe Grandi. Grandi pronounced the youthful piece the work of a genius and prophesied that Troubetzkoy would become a famous sculptor.

Prince Troubetzkoy, the sculptor's father, opposed his son's artistic ambitions. Having already permitted his eldest son, Pierre, to study portraiture, he desired a military career for Paul. When Paul was seventeen, he sent him to live with a relative in Russia, in the hope that he might forget his dreams of becoming a sculptor. Paul rejected all thoughts of a military career and after only a few months returned to Italy.

Troubetzkoy studied in Milan, first with Donato Bacaglia and then with Ernesto Bazzaro, but preferred to work independently. He opened his own studio, where he could best experiment with various techniques and form an individual style. Troubetzkoy also studied and worked in Russia and France. He was especially inspired and in-

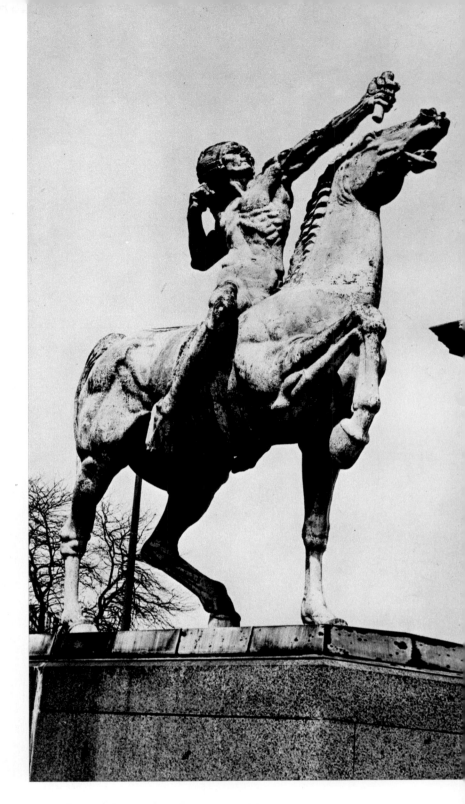

218. Ivan Mestrovic. *Bowman.* 1929.
Heroic size. Grant Park, Chicago

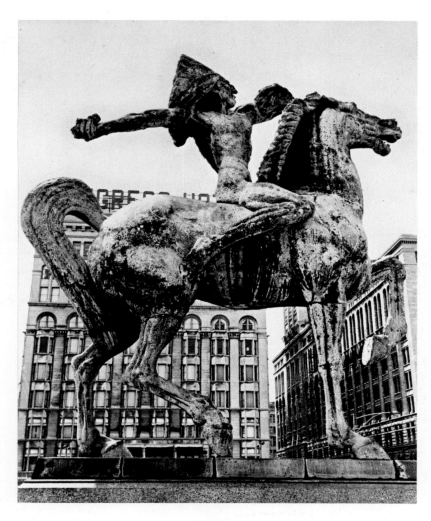

219. Ivan Mestrovic. *Spearman.* 1929.
Heroic size. Grant Park, Chicago

fluenced by the work of Auguste Rodin, as evidenced by the strong impressionistic modeling in his sculpture.

In 1894, Troubetzkoy won a Gold Medal at an exhibition in Rome for a sculpture entitled *The Indian Scout (plate 220)*. An Indian in full headdress, spear in hand, turns and looks into the distance. He seems to be momentarily suspended in action. In Troubetzkoy's early work, the horse serves merely as a platform for the rider. In *The Indian Scout*, for example, there is little communication between the Indian and his horse.

Troubetzkoy was best known for his portrait statuettes. During his career, he created many such portraits of famous artists, literary and historical figures, and Russian nobility. His impressionistic style was highly effective in capturing the spirit of his subjects.

In 1911, Troubetzkoy visited the United States when an exhibition of his work was held by the American Numismatic Society in New York. In 1914, he returned to the United States and remained there until 1920. Troubetzkoy spent considerable time in California, where he created several bronzes of cowboy life. *Two Cowboys (plate 364)* recaptures a moment in the everyday lives of the men. His impressionistic handling of the forms of the horses and riders gives the work spontaneity and vitality.

Troubetzkoy created some of his best Western bronzes in the years after his return to Europe. *Cattle Roping,* also called *The Wrangler (plate 221),* created in 1927, is a totally harmonious composition in which horse, rider, and steer are modeled with quick impressionistic strokes. The play of light on the rough surfaces gives a vivid sense of action. During the remainder of his career, his memory of American cowboy life was a strong inspirational force. Troubetzkoy lived and worked both in Paris and on the shores of Lake Maggiore until his death in 1938.

Carl Kauba is a unique figure in the history of American Western bronzes, for his works are without question Austrian bronzes. The polychrome finish, the intricate detail, and the realistic forms make Kauba's sculptures excellent examples of Viennese bronzes at the turn of the century. The major difference, though, is that his subjects were the troopers and Indians of the American West. Many of Kauba's bronzes were exported to the United States from 1895 to 1912. They were widely advertised and sold to the public by Latendorfer in New York during the 1950s.

There is very little available biographical information on Kauba. He was born in 1865 in Austria and studied sculpture in Vienna under Carl Waschmann and Stefan Schwartz.

There is considerable controversy over whether Kauba ever visited

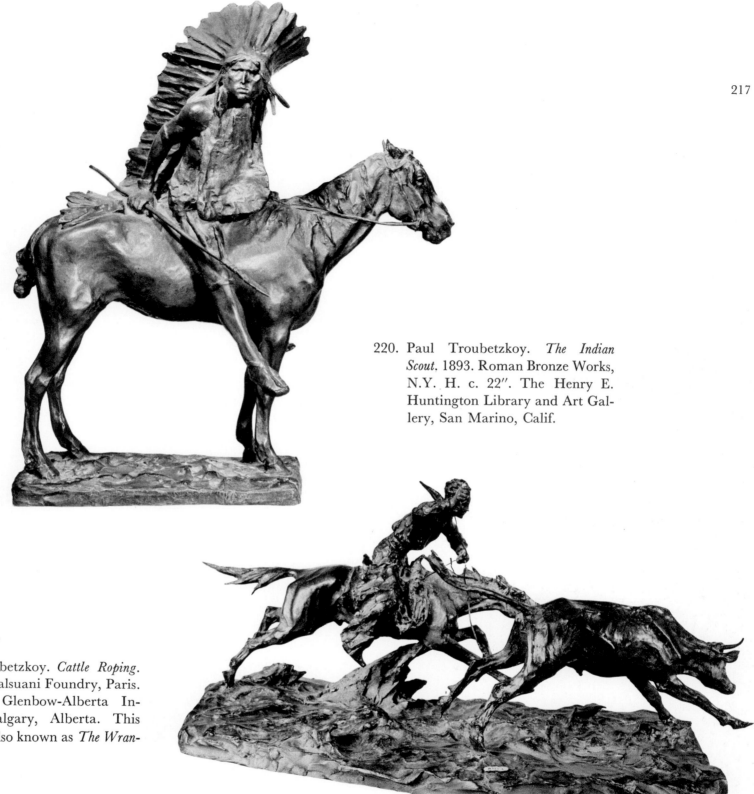

220. Paul Troubetzkoy. *The Indian Scout.* 1893. Roman Bronze Works, N.Y. H. c. 22″. The Henry E. Huntington Library and Art Gallery, San Marino, Calif.

221. Paul Troubetzkoy. *Cattle Roping.* 1927. A. Valsuani Foundry, Paris. H. 10¾″. Glenbow-Alberta Institute, Calgary, Alberta. This bronze is also known as *The Wrangler*

222. Carl Kauba. *Chief Wolfrobe*. Polychrome bronze. H. 26½". Thomas Gilcrease Institute, Tulsa, Okla.

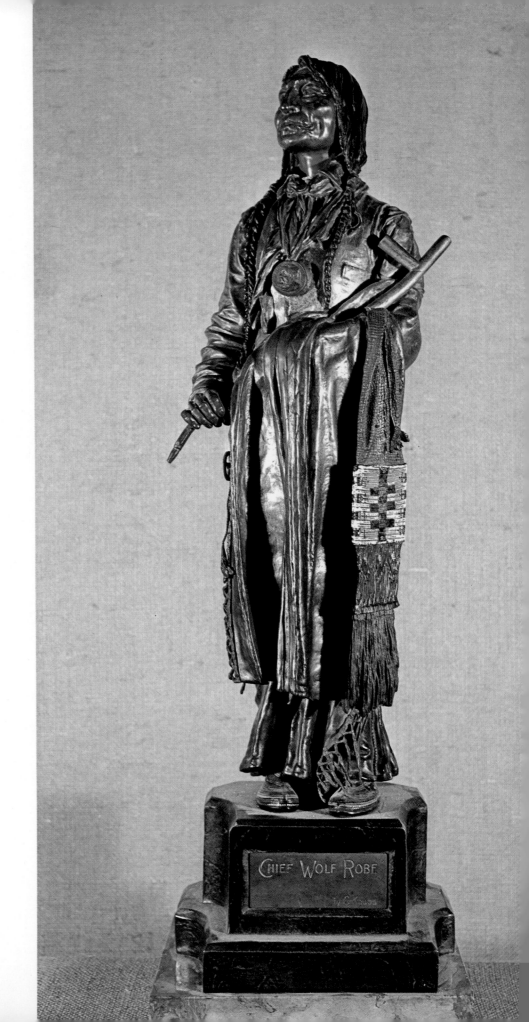

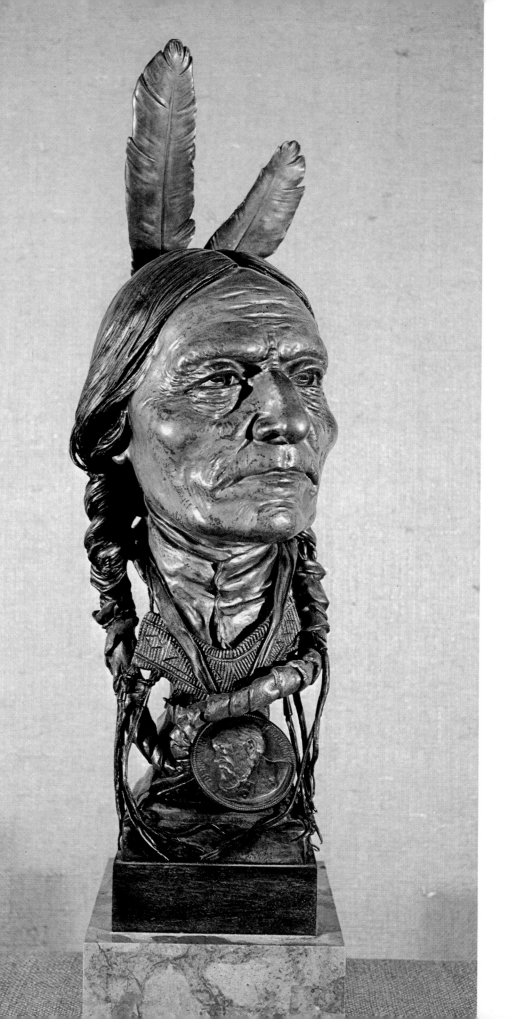

223. Carl Kauba. *Indian Chief*. H. 19″. Thomas Gilcrease Institute, Tulsa, Okla.

224. Carl Kauba. *A Friend in Need*. H. 19″. Thomas Gilcrease Institute, Tulsa, Okla.

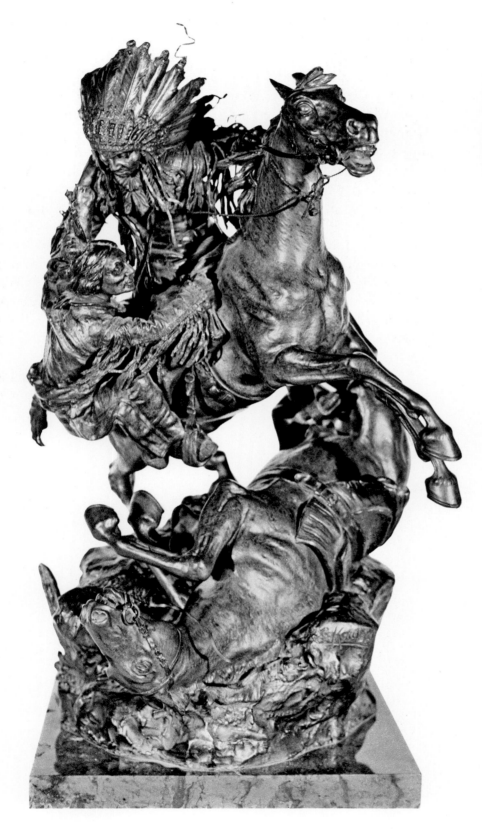

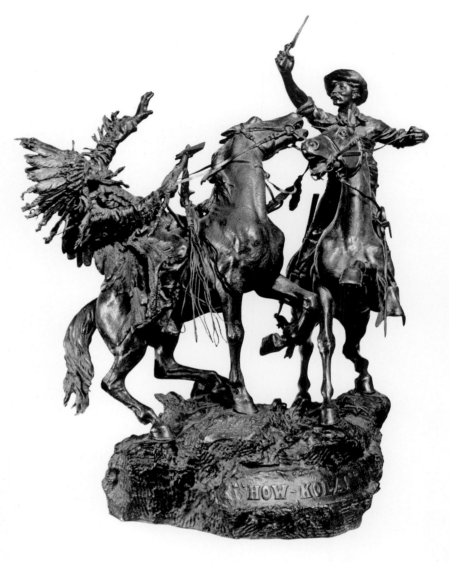

225. Carl Kauba. *How-Kola* ("Remember me, I'm the one who once saved your life so don't shoot!"). H. 20″. Kennedy Galleries, New York City

the United States. Several authorities feel that when he was about twenty-one years old, Kauba traveled through the West and returned to Austria with voluminous notes, sketches, and several small models of Western sculpture. Other critics feel that certain inaccuracies of costume, weapons, and equestrian gear indicate that Kauba drew much of his source material from illustrations circulated throughout Europe during the late nineteenth century. For example, several of his cavalrymen carry guns not used until the Cuban campaign.

It is believed that Kauba corresponded with a man in the United States who sent him Indian costumes and artifacts in order to improve the authenticity of his work. He also sent photographs of Indians from the files of historical societies, which Kauba used as the basis of several sculptures.

Kauba's initial fascination with the American West was fired by the stories of the German writer, Carl May. May's tales of Western adventure were well known throughout Europe. Kauba had the opportunity to observe American cowboys in the rodeos which visited Vienna, along with the Indians in the circuses which were popular in Austria early in the twentieth century.

Kauba created portraits of Indian chieftains and warriors and depicted their ceremonies and techniques of warfare. He also portrayed

226. Carl Kauba. *The War Chant.* 1920s. Polychrome bronze. H. 6⅜". Collection Mr. and Mrs. Stanley H. Broder

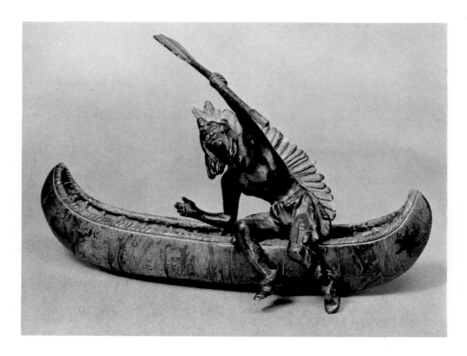

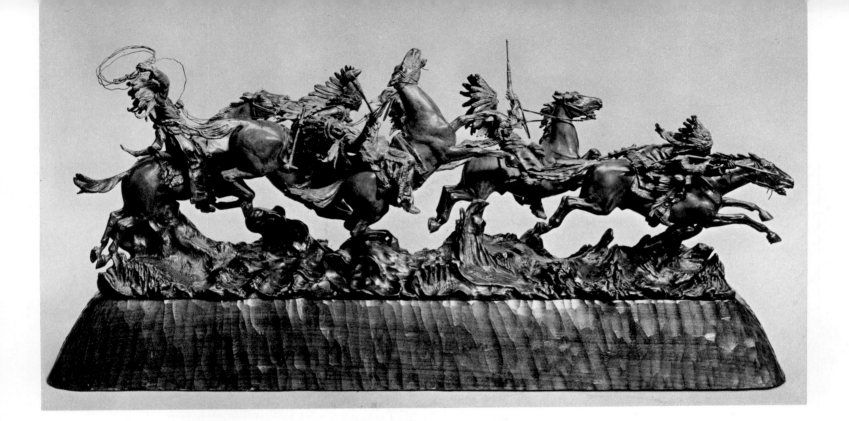

227. Carl Kauba. *Indian Attack*. H. 9½".
John Howell Books, San Francisco

cavalrymen and rough riders. He often created such scenes of high drama as *How-Kola (plate 225)* and *A Friend in Need (plate 224)*, as well as many models of genre scenes—for example, an Indian brave calling from the edge of his canoe *(plate 226)*, or a lookout awaiting the approach of the enemy. The faces of the Indians in some of his small sculptures are frequently quite coarse in contrast with the meticulously detailed costumes and weapons of the Indians.

Kauba loved ornament. He employed an excess of coiled bronze wire to decorate Indian headdresses and tacked his horses with a tangle of reins. The maze of twisted wire in *A Friend in Need* detracts from the dramatic impact of the sculpture. His most effective bronzes are, by contrast, the simple polychrome portraits, such as that of *Chief Wolfrobe (plate 222)*. This colorful sculpture has a beauty that one can immediately recognize as Kauba's creation.

During Kauba's lifetime all of his bronzes were cast in Vienna. Today many sculptures bearing Kauba's name are once again being cast in Vienna.

A Wakuta brave, created by a French *animalier* visiting Buffalo Bill's Wild West Show; a world of Indian chieftains and cavalrymen, re-created in Austria; moments in the life of a California cowboy, modeled in Italy; two monumental Indians, cast in an art school in Yugoslavia: these are but a few outstanding examples of the work of sculptors from distant lands. The inspirational power of the American West is indeed worldwide.

XVI
PORTRAITS IN BRONZE

During the early years of the twentieth century, the attitude of sculptors toward the American Indian changed considerably. Most mid-nineteenth century sculptors looked on the Indian as an exotic, primitive creature. Their works had such titles as *The Savage, The Indian Hunter,* or *The Indian Mother*. These were created as portraits of "native specimens" of the land, similar in intent to representations of elk or buffalo.

As sculptors became interested in portraying Indian life, many of them traveled West to study the customs and rituals of the Indians. For many, the Indians became a symbol of a world about to vanish. These artists portrayed the Indian as a truly civilized race of men, living in harmony and abiding by the laws of nature. Other sculptors portrayed the Indian as the noble foe of the cavalryman or settler.

Most bronze sculpture represented the American Indian as a general type rather than as a member of a specific tribe or as an individual within a tribe. Yet from North to South, from East to West, even within the borders of a single state like Arizona or New Mexico, tremendous differences in physical appearance existed between members of different Indian tribes. The Nez-Percé has little resemblance to the Navaho, or the Hopi to the Sioux. As the days when the Indian threat to frontier civilization became only a memory or a story told of times forever past, sculptors developed a greater interest in portraying specific tribal rituals and individual members of the tribes. Artists began to depict the Indian as a man or woman with distinctive features, characteristics, and habits. As sculptors became interested in Indian portraiture, they created bronzes of individuals within a tribe or area whom they felt were the most interesting or aesthetically desirable subjects. Many sculptors saw the Indian face as highly expressive of the basic emotions of mankind.

Olin Levi Warner was the first sculptor to create individual portraits of specific Indians *(plates 29–36)*. Hermon Atkins MacNeil was another of the earliest artists to create bronze sculptures of specific tribesmen. His bronzes depicted the rituals as well as the facial char-

acteristics of the Hopi, Moqui, and Navaho *(plate 228)*. Charles M. Russell left an unequalled sculptural record of the life of the men and women of the Blackfoot tribe. Russell also created bronze portraits of several of his Blackfoot Indian friends and of famous Westerners *(plates 230, 231)*.

Many of the better-known Western sculptors completed at least one bronze Indian portrait. James Earle Fraser created his models, White Eagle *(plate 189)* and Two Moons *(plate 190)*. Adolph Weinman modeled bronze busts of several of his models for the *Destiny of the Red Man (plates 196–199)*. Charles Schreyvogel created a bronze portrait of his friend, White Eagle *(plate 207)*, and Alexander Phimister Proctor made a portrait of Jackson Sundown *(plate 229)*, his model for *Indian Pursuing Buffalo*.

Several artists took an anthropological approach, and made portraits and studies of Indians of the various tribes to illustrate the physiognomical differences between tribes from different regions. They saw the Indian tribesman as representatives of a race, part of the family of man. Still other artists depicted the dances and rituals of the various tribes of the American West, and tried to retain the facial characteristics of the members of each tribe.

As twentieth-century Americans re-evaluate their treatment of the

229. A. Phimister Proctor. *Jackson Sundown*. 1916. Original clay model. Heroic size. Whereabouts unknown

228. Hermon A. MacNeil. *Navaho Orator*. 1905. H. 17½″. Thomas Gilcrease Institute, Tulsa, Okla.

original inhabitants of the land, they begin to acquire a new appreciation and understanding of Indian civilization. Many sculptors have been commissioned to create bronze portraits of Indian men and women. These portraits range from regional tributes to prominent Indians of the area to national monuments to those Indians who have made outstanding contributions to both Indian and white civilization.

During the 1920s, Hans Egon Reiss (1885–1968) created a series of ten life-size Indian portrait heads. Reiss was born in the Black Forest of Germany. His father, Fritz Reiss, was a well-known artist and teacher. Professor Reiss instructed his two sons, Hans and Winold, in the fundamentals of art.

After leaving Germany, Hans first settled in Sweden and became a Swedish citizen. Winold had settled in the United States, where he had won recognition as a painter. Hans decided to leave Sweden and

230. Charles M. Russell. *Jim Bridger*. Modeled c. 1925. California Art Bronze Foundry, Los Angeles. H. 14⅜". Amon Carter Museum, Fort Worth, Tex. Bridger was the famous frontiersman who discovered the Great Salt Lake

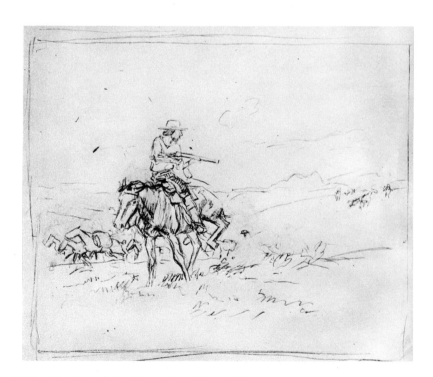

231. Charles M. Russell. *Composition Study—Jim Bridger*. c. 1918–22. Pencil. 5⅞ × 8¼". Amon Carter Museum, Fort Worth, Tex. Compare the horse and rider with the bronze version (plate 230)

232. Hans Reiss. *Falling-Over-the-Banks—Blackfoot Indian.* c. 1925–30. Cast in Germany. H. 13″. Collection Count Juan Dessewffy, Brazil

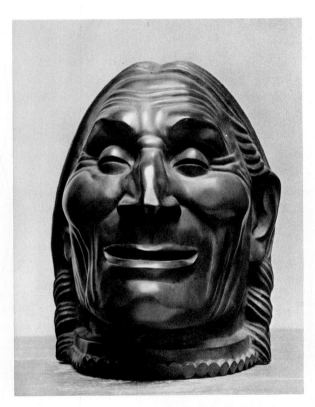

join his brother in America. During his early years in the United States, Hans worked and taught in his brother's New York studio. Once he had established a reputation as a sculptor, he opened his own studio in the city. He became an American citizen in 1931.

Winold and Hans met each summer to travel to Glacier National Park to study the Blackfoot Indians. Winold created a series of paintings of the Blackfeet that were reproduced for many years on the calendars of the Great Northern Railway. Hans modeled the Blackfoot Indians and was inducted into the Blackfoot tribe. He earned his name, Lone Eagle, because he was always scaling the highest mountain peaks alone. Indeed, his great confidence in climbing with ropes and pitons earned him his certification as a licensed guide from the National Park Service.

In 1941, Reiss visited Lake Tahoe, intending to remain only for the summer. Captivated by the lakes and mountains reminiscent of his former home in Sweden, he decided to settle there permanently. For many years, Reiss worked and taught in Lake Tahoe. Throughout his career, he was equally dedicated to achieving perfection and beauty in both the art of sculpture and the art of living.

Reiss believed and taught that good sculpture must be interesting and beautiful from all sides. His Indian heads are highly stylized and have strong linear patterns. The tremendous exaggeration of the features gives these sculptures a mask-like quality *(plates 232, 233)*. Reiss created his Indian sculptures directly from life. He returned to his New York studio with plasticine models, and then made plaster casts which he sent to a Munich foundry for casting in bronze. This foundry was bombed during World War II and all of Reiss's plaster models were destroyed. He had authorized only a single casting of each bronze, and the ten bronzes are today scattered throughout the world. Three models of Reiss's work are in Lake Tahoe in the home of his close friend and patron, Mrs. Francis Wallace. Mrs. Wallace has traced seven of his ten bronzes.

One sculpture is of a 106-year-old Indian *(plate 234)*. This bronze is covered with pure gold. This golden finish is done by a process forbidden in the United States, as the workers in the factory ultimately

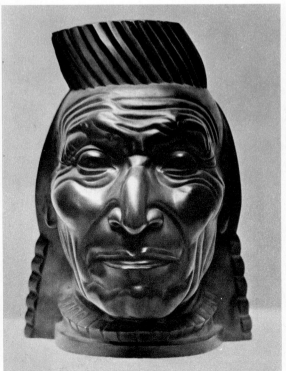

233. Hans Reiss. *Louis Straw Hat—Crow Indian.* c. 1925–30. Cast in Germany. H. 13″. Collection Frances Wallace, San Francisco

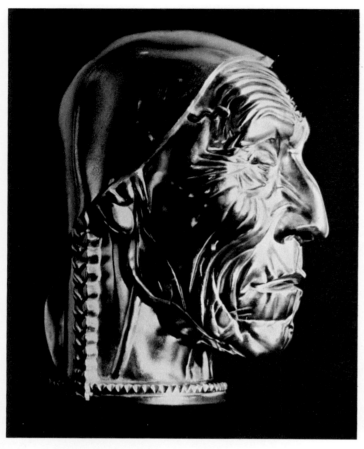

234. Hans Reiss. *106-Year-Old Indian*
(possibly Many Mules). c. 1925–30.
Cast in Germany, covered with
24-karat gold. H. 13″. Collection
Frances Wallace, San Francisco

die of arsenic poisoning. Reiss sold his sculpture of the old Indian to
Count Gero von Gaevernitz, who returned to Germany with the
sculpture. The Count willed the bronze to a friend, Count Juan Des-
sewffy, who lives in Brazil.

Emry Kopta (1884–1953) throughout his lifetime modeled many
portrait busts of the Hopi Indians, primarily in terra cotta. Many of
his models have been destroyed, but several were cast in bronze
during his lifetime and posthumously.

Kopta's father, Wenzel Kopta, was a prominent Czechoslovakian
concert violinist and music teacher. His mother was a Philadelphian
whom the elder Kopta had met while on tour in the United States.
Emry was born in Graz, Austria, but grew up in Czechoslovakia,
where he was educated by private tutors. He then attended school
in Cologne, Germany.

The Kopta family moved to the United States and settled in San
Francisco when Emry was sixteen. His first dreams of life in the new
land were of becoming a cowboy and rancher—Wenzel Kopta pur-
chased Red Rock, a ranch along the Sacramento River in northern
California, where Emry worked until a serious permanent injury re-
sulting from a fall from a horse ended all hopes of life in the saddle.

Kopta returned to San Francisco and enrolled in a fashionable art
school on the top of Nob Hill. When the school was destroyed in
1906 by the great San Francisco fires following the earthquake, he
traveled to Paris and enrolled at the Sorbonne.

After five years of study in Paris, Kopta returned to the United
States and opened a studio in Los Angeles. In 1912 Don Lorenzo
Hubbell, owner of a trading post on the Navaho Reservation, which
was the oldest continuously operated business in northern Arizona,
invited Kopta and Lon Megargee (an Arizona artist living in Los
Angeles) to visit the Indian reservations of northern Arizona. The two
artists studied and sketched the daily life of the Navaho and Hopi
tribes. Kopta was so impressed by the Hopi Indians that he closed his
studio in Los Angeles and returned to Arizona. For twelve years
Kopta lived with the Indian trader Tom Tavatewa on the Hopi
Reservation and worked in a studio at the base of the First Mesa.

In 1923, following his marriage, Kopta and his bride Anna moved
to Santa Fe, but remained for only one winter. In the spring of 1924
they settled in Phoenix, their permanent home until Kopta's death
in 1953. Almost every summer Kopta returned to the Hopi Reserva-
tion to live and work in many of the villages of the First, Second, and
Third Mesas.

Kopta's portraits are strong, emotional statements of the tragedy
of the Indian confined to life on the reservation *(plate 235)*. His

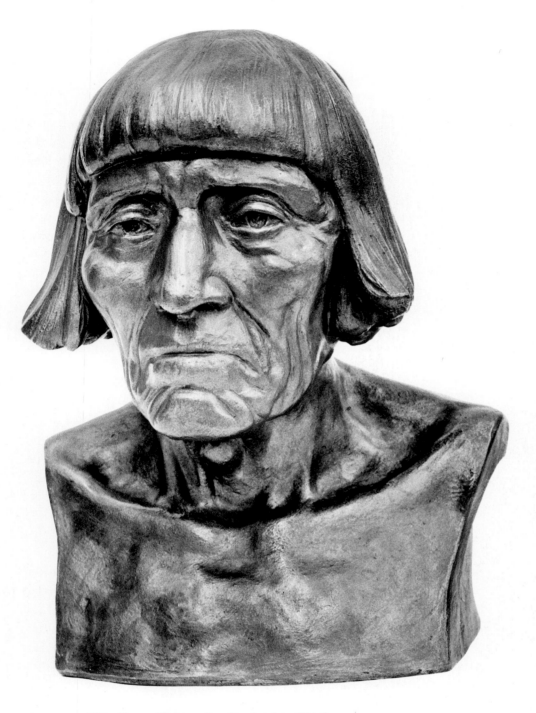

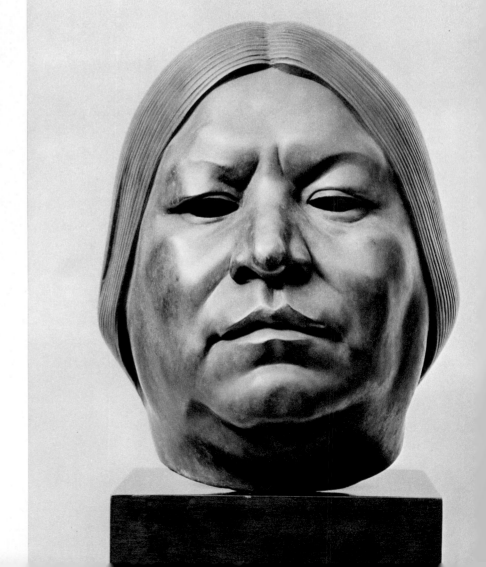

236. George Winslow Blodgett. *Head of a Tewa Indian (Portrait of Albert Lujan of the Taos Pueblo)*. 1930. Roman Bronze Works, N.Y. H. 10¼″. The Metropolitan Museum of Art, New York City. Francis Lathrop Bequest Fund, 1933

235. Emry Kopta. *Saaci—Antelope Chief*. 1930. Roman Bronze Works, N.Y. H. 10¼″. Collection Walter R. Bimson, Phoenix, Ariz.

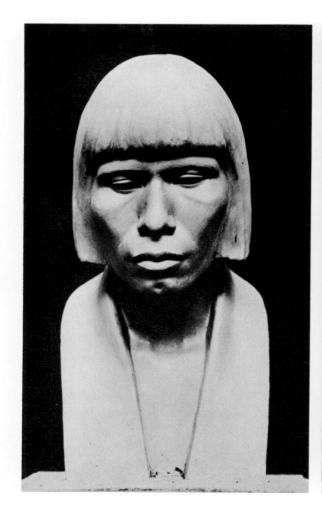

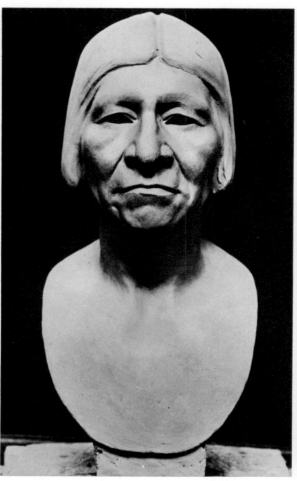

237. George Winslow Blodgett. *Ascension Chama—Santo Domingo Pueblo.* c. 1930s. H. 20″. The Museum of New Mexico, Santa Fe

238. George Winslow Blodgett. *Marcial Quintana—Cochiti Pueblo.* c. 1930s. H. 22″. The Museum of New Mexico, Santa Fe

239. George Winslow Blodgett. *Rose Chaves—Navaho Pueblo.* c. 1930s

sculptures express a deep sense of weariness and sorrow. The heads are realistically conceived, yet simplified in detail, to insure the strongest dramatic impact.

In 1929, George Winslow Blodgett (1888–1958) traveled to Santa Fe, New Mexico. He hoped to fulfill his lifetime dream of creating a great hall of sculptures of the American Indian as part of a Gallery of the American Indian which would be located in Washington, D.C. Blodgett envisioned a display of one hundred greater-than-life-size heads, torsos, and full figures of the Southwestern Indians. In addition to the sculpture hall, the museum was to contain outstanding examples of Indian arts and crafts as well as a collection of paintings and sculptures depicting all phases of Indian life.

Blodgett was born in Faribault, Minnesota. At age nineteen, following in the pioneer tradition of his family, he traveled to the Pacific Northwest. He spent nineteen years in the lumbering, heavy construction, and ranching businesses in the Cascade Mountains of western Oregon.

In 1926, he realized that frontier life was forever finished in Oregon. He consulted a psychologist, David Seabury, about selecting a new vocation and was advised that, as he had creative ability, he should choose a career in the arts. Blodgett decided to become a sculptor. His first efforts were a self-portrait bust and a study of Mrs. Marcus Whitman, the first woman to cross the North American continent along the Oregon Trail.

Encouraged by the response to these early works, Blodgett traveled East for artistic training. His formal art education was minimal, consisting of two weeks at the Beaux-Arts Institute of Design in New York and ten days at the Académie Julian in Paris. Unable to profit from formal academic study, he worked independently in a Paris studio for two-and-a-half years.

One day in Paris, while walking down his studio steps, Blodgett suddenly conceived his monumental tribute to the American Indian. He journeyed to Santa Fe, where he began his work. Blodgett wished to endow each statue with the spirit and character of the Indian portrayed. He looked upon his subjects as complex human beings, not as generalized ethnological types. Blodgett studied the life and knew the background of each of his models intimately. He quoted Albert Lujan as saying: "Since my father died I'm head of my family. My brothers and sisters and all their wives and mine, we are seven. We were all around when my father died. He said: 'Leave the door open —I'm going out that way. Albert, you are the oldest; you will look after your mother and sisters first, and your wife and yourself last.' "[1] The sculpture of Lujan, which is in the Metropolitan Museum of Art in New York as well as Brookgreen Gardens in South Carolina, depicts a man of great strength and responsibility.

Blodgett completed his monumental undertaking and in 1933 exhibited over one hundred life-size bronzes in New York. However, he died in 1958 with his vision of a permanent Gallery of the American Indian an unfulfilled dream. Several of his Indian portraits (plates 237, 238) are in the collection of the Museum of New Mexico in Santa Fe.

Bruce Wilder Saville (1893–1938) also worked in bronze to immortalize the Indians of the Southwest. He created a series of bronze dance groups of the Indians of New Mexico. Born in Quincy, Massa-chusetts, Saville studied sculpture at the National Art School under Cyrus Dallin and for a short time at the Museum of Fine Arts in Boston. He also worked for four years in the studio of Mr. and Mrs. Henry Kitson. During World War I, Saville served in the French Ambulance Corps and then with the United States Army Engineers. He later taught modeling at Ohio State University and at the Columbus Art School.

Saville worked for several years in New York. His early efforts were widely acclaimed and he completed portrait busts of many prominent figures of the day. Saville created many war memorials which are primarily in Massachusetts, New York, and Ohio. Although he had become highly successful in New York, Saville suffered from ill-health and was forced to move to Santa Fe. There he completed six bronze sculptures of Indian dance groups, which today are in the collection of the Museum of New Mexico (plates 240–245). They have a monumentality achieved through great simplicity unfettered by extraneous detail. In 1937, Ina Sizer Cassidy wrote in praise of Saville's Indians: ". . . he has absorbed the spirit and atmosphere of this ancient land. . . . In his small Indian dance figures . . . [he has] caught and will preserve for all time the ritualistic dance rhythms of Pueblo Indians, as no one so far has succeeded in doing."[2]

In June of 1933, the Field Museum, also known as the Chicago Natural History Museum, opened a permanent exhibition gallery named The Hall of Man. Here were unveiled more than one hundred life-size figures and heads of men, women, and children of the many races of the world. All but two of the sculptures were bronze. This Herculean undertaking was the work of Malvina Hoffman (1887–1966). For five years, Miss Hoffman traveled around the world modeling racial types, posed in characteristic occupations in their native environment (plates 250, 251). Her husband, Samuel B. Grimson, accompanied her on her travels and took most of the photographs. A record of twelve thousand racial types are on file at the Field Museum. Miss Hoffman described this monumental commission in her book Heads and Tales, published in 1936.

The Hall of Man was hailed as the wedding of art and anthropology: ". . . all are portraits of distinct personalities, vibrant with life, unique as individuals, revealing in pose and facial expression the experiences and the way of life that has made them what they are. Through them, the artist is revealed as an interpreter of man to his brother. Through them, we are made to see with our own eyes that the brotherhood of man is a fact and not just a pious phrase."[3]

Miss Hoffman worked with the British anthropologist Sir Arthur

240. Bruce W. Saville. *Koshare*. c. 1937. H. 18½″. The Museum of New Mexico, Santa Fe

241. Bruce W. Saville. *Snake Dancers*. c. 1937. H. 24¼″. The Museum of New Mexico, Santa Fe

242. Bruce W. Saville. *Buffalo Dancer*. c. 1937. H. 20¼″. The Museum of New Mexico, Santa Fe

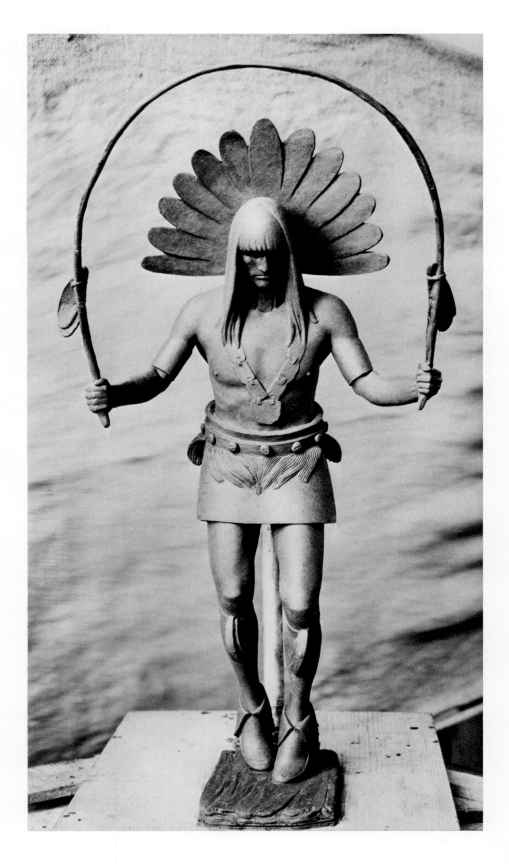

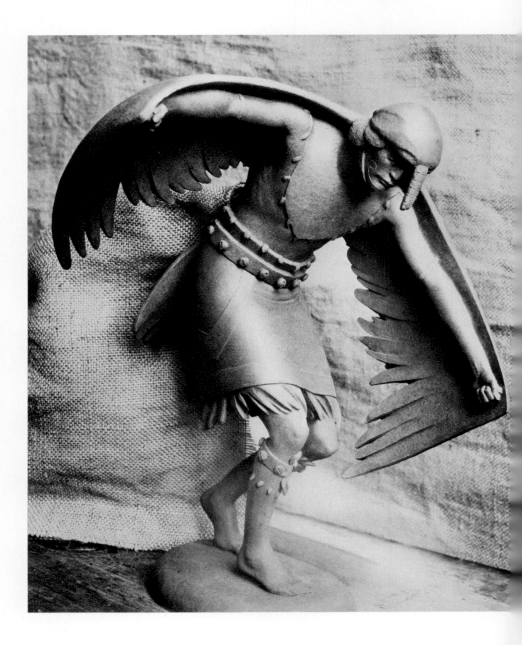

244. Bruce W. Saville. *Eagle Dancer*. c. 1973. H. 14½". The Museum of New Mexico, Santa Fe

243. Bruce W. Saville. *Rainbow Dancer*. c. 1937. H. 22½". The Museum of New Mexico, Santa Fe

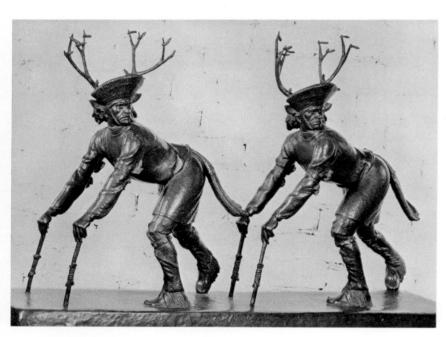

245. Bruce W. Saville. *Deer Dancers*. c. 1937. H. 22″. The Museum of New Mexico, Santa Fe

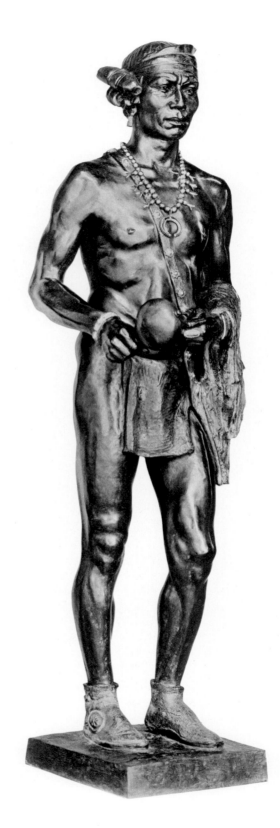

246. Malvina Hoffman. *Blackfoot Man*. c. 1930. Alexis Rudier, Paris. H. 24″. Field Museum of Natural History, Chicago

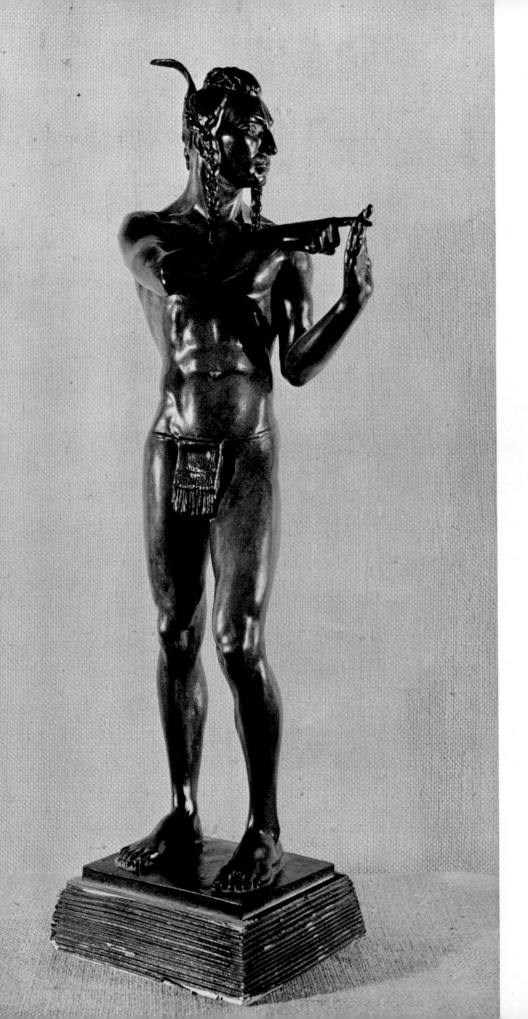

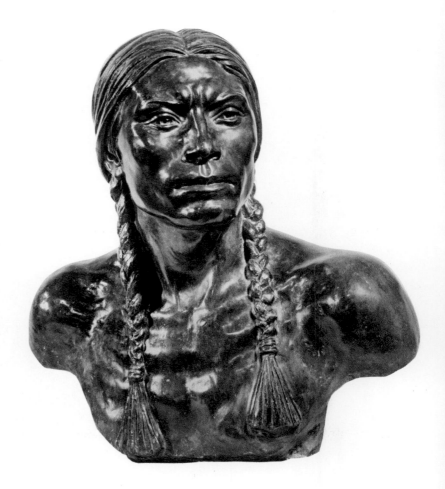

248. Malvina Hoffman. *Apache—Jicarilla.* 1934. Roman Bronze Works, N.Y. H. 20″. Graham Gallery, New York City

247. Malvina Hoffman. *Sign Talk—Blackfoot Man.* 1930. Alexis Rudier, Paris. H. 24″. Thomas Gilcrease Institute, Tulsa, Okla. The gesture of the hand signifies "I have seen my enemy and killed him"

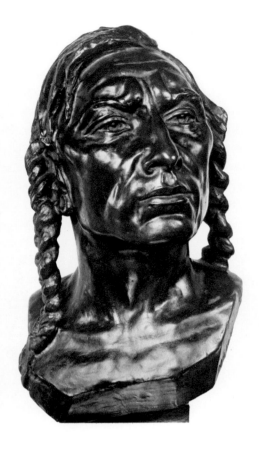

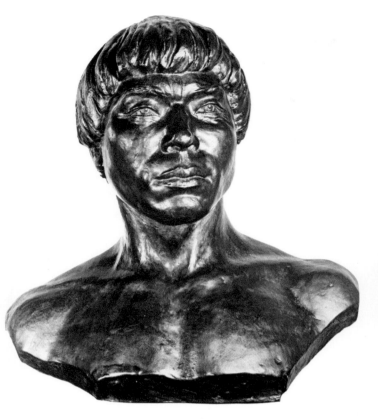

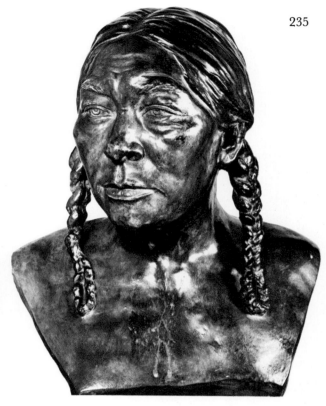

249. Malvina Hoffman. *Sioux Man.*
1930. Alexis Rudier, Paris. H.
17″. Field Museum of Natural
History, Chicago

250. Malvina Hoffman. *Eskimo Man.*
1930. Alexis Rudier, Paris. H.
18½″. Field Museum of Natural
History, Chicago

251. Malvina Hoffman. *Eskimo Woman.*
1930. Alexis Rudier, Paris. H.
16″. Field Museum of Natural
History, Chicago

252. Jo Davidson. *Will Rogers*. 1938. H. 85″. Will Rogers Memorial, Claremore, Okla.

253. Electra Waggoner Biggs. *Riding Into the Sunset (Will Rogers on "Soapsuds")*. Dedicated 1950. H. 9′5″. Will Rogers Memorial, Claremore, Okla. Gift of Amon G. Carter

Keith in order that her portrait work have scientific accuracy as well as artistic competence. She even varied the patinas of the bronze to represent different shades and qualities of the skin.

Malvina Hoffman was born in New York City. She was the daughter of concert pianist Richard Hoffman. Although she first studied painting, she experimented with two sculptural portraits: one of Samuel B. Grimson, then a family friend, and the second, a bust of her father. She entered the portrait of her father in the National Academy Exposition of 1910. Delighted with her success there, she embarked on a career as a sculptor.

Miss Hoffman learned from many famous sculptors. While struggling with the armature for her father's portrait, she had the good fortune to meet Gutzon Borglum, who instructed her in the technical preparation of a sculpture. In 1910, Miss Hoffman traveled to Paris to study with Auguste Rodin. Although she was his pupil for over a year, she was little influenced by his impressionistic style. In 1927, she went to Zagreb, Yugoslavia, to study with Ivan Mestrovic.

Throughout her career, Miss Hoffman worked to attain the greatest possible skill in order to overcome the prevailing prejudice against women sculptors. She spent a year in New York studying dissection at the College of Physicians and Surgeons to perfect her knowledge of anatomy.

Miss Hoffman won worldwide praise for her bronze portraits. In 1930, she accepted the commission to travel around the world creating sculptural studies for the *Races of Man*. Miss Hoffman saved for last the portraits of the Indians of the United States *(plates 246–249)*. She traveled extensively in Arizona and New Mexico, often fighting to overcome the taboo (also extant in parts of Africa) against creating a resemblance of a human face. It is believed that once a tribesman permits an image to be made of him, that image steals away his strength, causing him to die. In several New Mexican tribes, no member is ever permitted to be photographed.

Miss Hoffman visited the Sioux, Pueblo, Navaho, Apache, and many tribes in the Southwest and studied the customs and arts of each tribe she visited. She tried to understand the spirit of the tribesmen and their lives: "To understand Indian life, one must be aware of Nature—her moods and seasons—the element of sky and sunlight —the mystic evolution of seed, fructification, growth, harvest—death —lightning and clouds, in ourselves as well as in the heavens—seasons in our own lives: birth, youth, maturity, old age, and death, synchronizing with the cosmic cycle."[4]

During her travels, Miss Hoffman developed an understanding of the hardships of twentieth-century Indian life:

To be sure, the Indians of today are not as strong as the white man who controls them by law and military force, but they manage to survive in spite of the barren hardships they have been forced to accept and despite the battle against disease introduced by the white man, and they can still stir us by the primitive art of contacting their life currents with those of the elements about them and by their profound understanding of earth's eternal miracles.[5]

Although she worked with an almost scientific realism, Miss Hoffman attempted to go beyond physical resemblances and to capture the spirit and personality of her subjects. Nevertheless, her individual portraits, which were created free from the requirements of anthropological accuracy, often have a greater vitality and artistic strength than those made in response to the Field Museum's commissions.

Many prominent sculptors have been commissioned to create bronze portraits as tributes to famous Indians. Jo Davidson (1883–1952) was one of the most successful portrait sculptors of the twentieth century. In his lifetime, he modeled portraits of artists, political figures, and world dignitaries. During his early years as a sculptor, he worked as an assistant to Hermon Atkins MacNeil at the St. Louis Exposition. Davidson was not greatly influenced by MacNeil. He felt that the menial tasks designated to him contributed little to his education as a sculptor. Models of Davidson's full-length portrait of Will Rogers stand today in the Will Rogers Memorial in Claremore, Oklahoma *(plate 252)*, and in the Statuary Hall of the Capitol in Washington, D.C.

As Will Rogers was part Cherokee, he was honored by both Indians and white men. Known for saying, "I never met a man I didn't like," he has become the symbol of the brotherhood of men. The equestrian portrait of Rogers on his horse Soapsuds created by Electra Waggoner Biggs stands in the Will Rogers Memorial in Claremore *(plate 253)*, in the Will Rogers Memorial in Fort Worth, Texas, and at the Texas Technical College in Lubbock.

In 1912, a statue of Chief Seattle *(plate 254)* by James Wehn was unveiled in Pioneer Square in Seattle. Wehn, a Washington artist, long associated with the Puget Sound Indians, also created a bust of Chief Seattle to decorate a fountain. Wehn's bronzes were the first statue and first public fountain in Seattle.

In 1953, the National Hall of Fame for Famous American Indians was founded in Anadarko, Oklahoma. The ten-acre outdoor museum contains a series of bronze portraits *(plates 255–259)* of Indians noted in American history. The Indians represented in the Hall of Fame are "recognized by the Federal Government as American Indians by

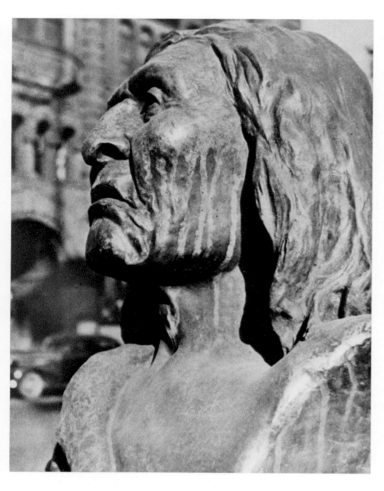

254. James Wehn. *Chief Seattle* (detail). c. 1912. Heroic bust. Pioneer Square, Seattle, Wash. Photo courtesy of the Seattle Historical Society, Seattle, Wash.

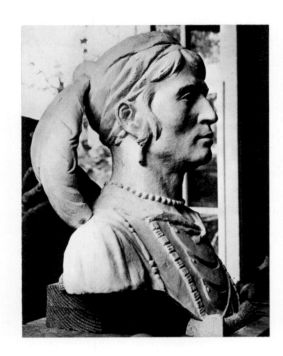

255. Madeleine Park. *Osceola—Seminole.* Dedicated 1958. 1¼ times life-size. National Hall of Fame for Famous American Indians, Anadarko, Okla.

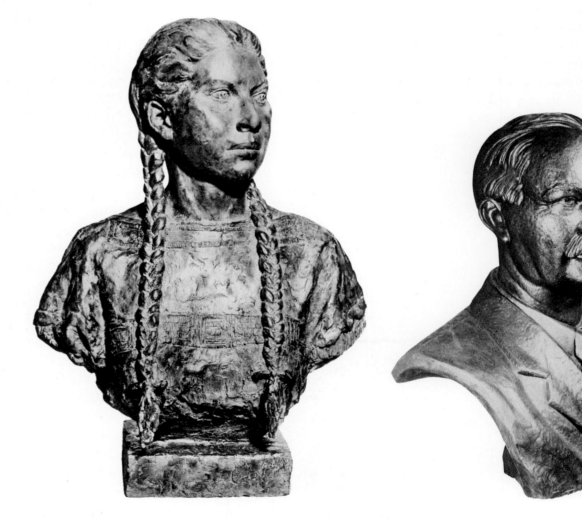

256. Leonard McMurry. *Sacajawea—Shoshoni.* Dedicated 1959. 1¼ times life-size. National Hall of Fame for Famous American Indians, Anadarko, Okla.

257. Madeleine Park. *Charles Curtis—Kaw.* Dedicated 1959. 1¼ times life-size. National Hall of Fame for Famous American Indians, Anadarko, Okla.

blood or their descendants and who have been deceased for fifteen years prior to their nomination to the Indian Hall of Fame."[6] The Indians elected have a wide range of histories and backgrounds. Here, honored side by side, are Pocahontas and Jim Thorpe, Sequoya and Will Rogers. The bronzes are modeled by such prominent regional sculptors as Madeleine Park, Leonard McMurry, Willard Stone, and Kenneth F. Campbell.

Many twentieth-century sculptors like Malvina Hoffman and Jo Davidson are seldom, if ever, thought of as Western artists. However, they do play an important role in the history of bronze sculpture, for their Indian portraits are uniquely American and a valuable part of America's Western heritage. With today's phenomenal interest in Indian culture and history, bronze portraits of the American Indian, even those virtually ignored at the time of their creation, have a new importance and relevance.

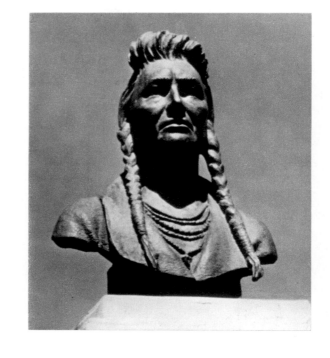

258. Kenneth F. Campbell. *Joseph—Nez-Percé*. Dedicated 1957. 1¼ times life-size. National Hall of Fame for Famous American Indians, Anadarko, Okla.

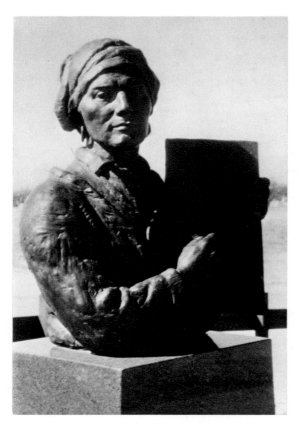

259. Leonard McMurry. *Sequoyah—Cherokee*. Dedicated 1962. 1¼ times life-size. National Hall of Fame for Famous American Indians, Anadarko, Okla.

XVII

THE NATURALISTS' VISION

The artists of the early twentieth century were conscious of a world that was ending and lamented its loss. Many delighted in re-creating in their imagination the vanished past. Others worked to preserve a record of what remained of America's natural heritage. As areas that only a few years before had been isolated outposts became thriving towns and as acres of wilderness became cultivated farmland, artists created landscapes which idealized the glory and tranquillity of untouched natural beauty. Whereas painters glorified both landscapes and animal life, sculptors chose representations of animals to express their full appreciation of nature. Alexander Phimister Proctor and Charles Russell were two of the best-known Western artists to devote great time and energy to sculptures of animal life.

Many artists dedicated their entire careers to animal sculpture. The popularity of the nineteenth-century French sculptors and the success of the early American *animalier* Edward Kemeys increased the public awareness of animal sculpture as an important art form.

The popularity of wildlife sculpture was a reaction against the mechanization and urbanization of life in the new century. To people who lived in urban areas, the animals of the forest, plains, and mountains became symbols of freedom. In the early years of the twentieth century, there existed a feeling, akin to worship, for the beauty and spontaneity of the creatures of the wilderness.

Although railroads were just beginning to web the nation, travel was expensive and still the privilege of the wealthy. In a world of limited travel, many found the West almost as remote and exotic as the Orient or South Africa. Artists and hunters made expeditions to all parts of the world. Adventurers brought back specimens of animals for the zoos and natural history museums that were founded in cities throughout the United States. In New York City, the North American Hall of Mammals in the American Museum of Natural History provided the public with a naturalistic view of the most exotic forms of American wildlife.

As the art of taxidermy grew in sophistication, men were trained

to mount animal specimens in characteristic poses amid a simulated natural habitat. The practice of mounting these specimens afforded many prospective artists the rare opportunity to learn the anatomy and natural habits of America's native animals. Ideally, these men applied the eye of the artist to taxidermy, and the knowledge and precision of the scientist and craftsman to their sculpture.

Others became taxidermists with no aspirations of becoming sculptors. Once they had acquired an extensive knowledge of an animal's anatomy, surface texture, and movement, however, many were tempted to explore the creative possibilities of independent sculpture. Free of the demands and limitations of scientific reconstruction, they could explore the potentialities of a plastic medium. Moreover, once cast in bronze, their creations acquired a permanent form.

A new generation of sculptors emerged who combined the skill and knowledge of the scientist with the vision and imagination of the artist. The public was delighted with bronze sculptures which offered them the opportunity to bring into their homes creations which expressed the spirit of the wild.

There were tremendous variations in style and technique among the animal sculptors of the early twentieth century. Some, following in the tradition of the nineteenth-century French *animaliers* Barye and Mène, created vivid naturalistic sculptures. Others, influenced by Rodin, produced highly impressionistic models. Some artists were trained in the best art academies of the United States and Paris, while others were self-taught, dependent upon careful observation, studies from life, and endless practice. Several sculptors chose to portray moments of great drama and excitement, while others preferred an intimate glimpse of the everyday animal world.

Although Henry Merwin Shrady (1871–1922) cannot be considered a Western sculptor or naturalist, he created some of the finest bronze sculptures of American Western wildlife. His major work, the *Appomattox Memorial Monument to General Ulysses S. Grant* in Washington, D.C., occupied twenty-two of his twenty-four years as a sculptor. Shrady died only two weeks before the achievement of his lifetime was unveiled. In the very early years of his career, Shrady created several animal sculptures which today are in museums across the United States and which delight many collectors of Western bronzes.

Henry Shrady was born in New York City. Ironically, his father, Dr. George F. Shrady, had treated General Grant during his final illness. Dr. Shrady was artistically talented and often drew and modeled for his own amusement. Shrady had no formal art instruction. He studied law at Columbia University and, after graduation, worked for his brother-in-law at the Continental Match Corporation.

Shrady enjoyed drawing and, on his way home from work, would often stop at a pet shop to sketch the dogs and cats on display in the window. Having studied biology at Columbia, he had some knowledge of animal anatomy. On weekends and holidays, he visited the Bronx Zoo, where he entertained himself by making sketches and studies of the animals. He was particularly fascinated by the moose and buffalo. At home, Shrady occasionally painted portraits of the family pets.

Shrady's first model was a group entitled *Artillery Going Into Action*. This complex group consisted of six horses and riders drawing a cannon. Shrady used as a model his own saddle horse which he often rode in Central Park. In order to familiarize himself with the muscle structure of the horse, Shrady would first thoroughly soak his horse with water from a hose. Then he could study in detail the animal's various movements.

Shrady showed his model to a family friend, Alan Southworth. Impressed by Shrady's skill, Southworth persuaded him to finish his model. Southworth had the model photographed and published an engraving made from the photograph.

A representative of the Gorham Silver Company, which specialized in Russian bronzes at that time, saw the engraving and suggested that Shrady pursue a career in sculpture. The company offered to have Shrady's model cast, provided he added two horses to heighten the dramatic effect of the group.

During the following two years, Shrady made several animal models which were cast by Gorham. He used his sketches and studies of zoo-life to create a bull moose *(plate 261)* and an elk buffalo *(plate 260)*. One day, the sculptor Karl Bitter saw these models while visiting the Gorham factory. Impressed by the young artist's talent, he offered Shrady the opportunity to exhibit the moose and the buffalo at the 1901 Pan-American Exposition in Buffalo, New York. The buffalo was to be enlarged to eight feet and the moose to nine feet. Bitter offered Shrady the use of his studio for this purpose. The enlarged animals were duplicated in staff, and eight Shrady animals decorated the bridges spanning the canals at the fair.

Shrady also created a bronze of a grazing cavalry horse for Gorham. He named this sculpture *The Empty Saddle (plate 262)*. A representative of a committee sponsoring a competition for an equestrian statue of *Washington at Valley Forge* saw *The Empty Saddle* in a Fifth Avenue store-window. He invited Shrady to enter the competition. Shrady, submitting only two additional plaster models, won the contest. His completed statue was placed on the Williamsburg Bridge Plaza in Brooklyn.

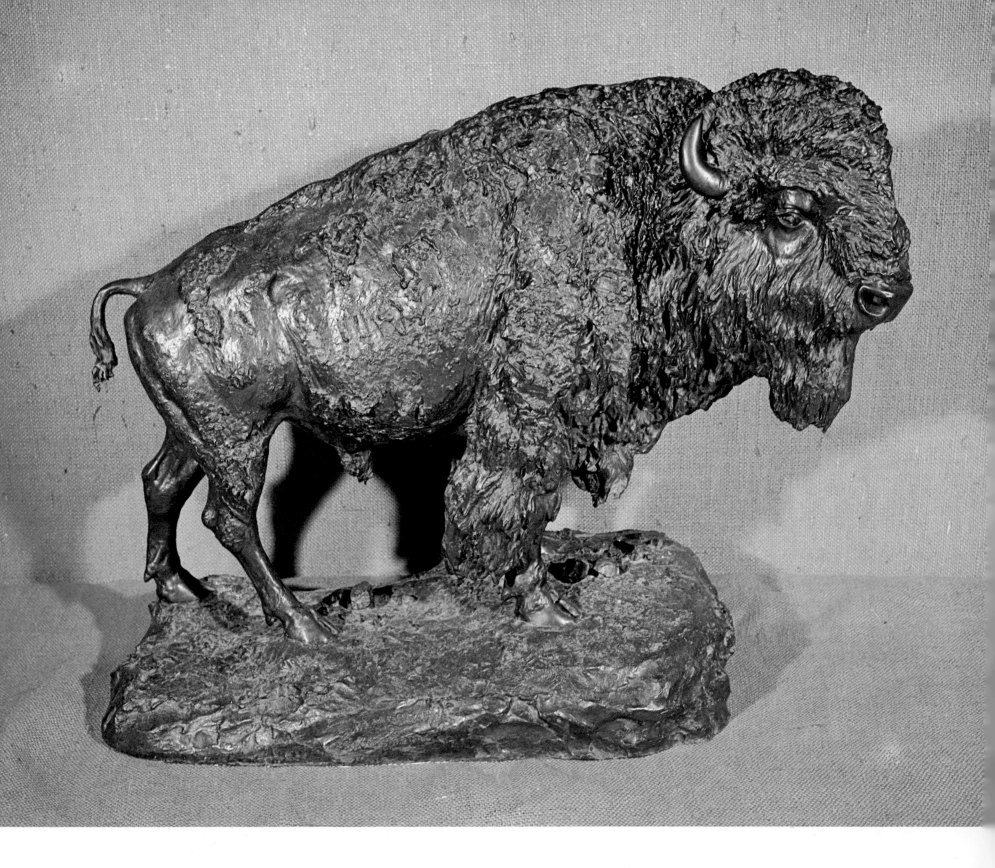

260. Henry Merwin Shrady. *Elk Buffalo (Monarch of the Plains)*. 1901. Roman Bronze Works, N.Y. H. 33″. Thomas Gilcrease Institute, Tulsa, Okla.

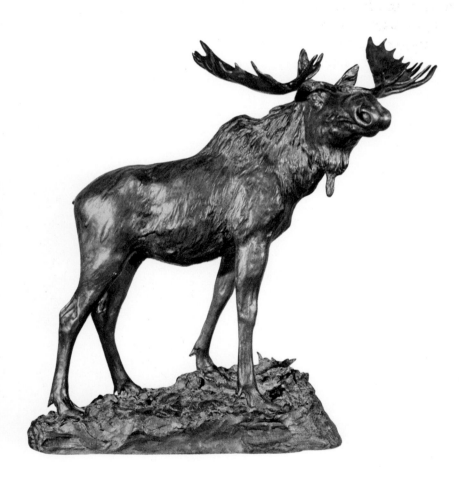

261. Henry Merwin Shrady. *Bull Moose*. 1900. Roman Bronze Works, N.Y. H. 20¾″. Thomas Gilcrease Institute, Tulsa, Okla.

Shrady next entered a competition against fifty-one other sculptors for the $250,000 commission for the *Appomattox Memorial Monument to General Ulysses S. Grant*. His winning the competition was hailed as "one of the most remarkable incidents in the history of American art."[1] The judges included such prominent sculptors as Augustus Saint-Gaudens and Daniel Chester French.

Shrady devoted the remainder of his career to this commission. Several of his later bronzes are reduced models of designs made for the many groups which were part of this monument. He also created several public monuments of heroes and political figures.

Despite the popularity of Shrady's monumental sculptures during his lifetime, his early animal bronzes are of special interest today. Completed before his spectacular success, these possess a vitality and naturalistic beauty enjoyed today by a public apathetic to heroic monuments. Shrady's animal sculptures are highly realistic, with skillfully modeled details. They have a vivid sense of action and are close in feeling to the work of the French *animaliers*.

For most animal sculptors of the early twentieth century, the fauna of the American West was but one facet of their art. They were primarily naturalists, interested in re-creating the beauty of wild animals throughout the world. Their sculptural record of the American West, nevertheless, is extensive and their creations are of the greatest value as contributions to both the scientific and artistic heritage of America.

Throughout his short career, Arthur Putnam (1873–1930) was devoted to animal sculpture. Putnam worked in California in the first decade of the twentieth century and was primarily interested in depicting that state's wildlife. Today his sculpture is well represented in museums, galleries, and collections throughout California, although relatively little of his work is found in other parts of the United States.

Arthur Putnam was born in Waveland, Mississippi. The son of an army officer, he spent many boyhood years on the plains of the Southwest. Putnam was witness to the last of the great herds of buffalo and wild horses. He was fascinated by the drama of life and death in the animal world. His earliest sculpture depicted the struggle for the survival of the fittest.

Putnam moved to California when he was a very young man. He arrived alone and with no money. He earned his living and studied animal anatomy by working in the slaughter yards of San Francisco. Later, he worked as a butcher, acquiring still greater knowledge of muscle and bone structure. His opportunity to study past and contemporary examples of sculpture was limited to the artistic resources available in San Francisco at the turn of the century. There were few

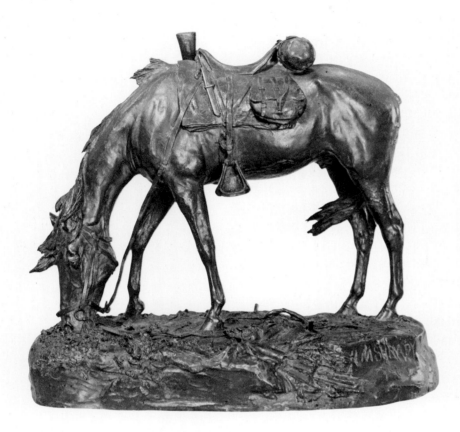

262. Henry Merwin Shrady. *The Empty Saddle*. Copyright 1900. Roman Bronze Works, N.Y. H. 11″. The National Gallery of Art, Washington, D.C. Gift of Joseph Ternbach

outstanding examples of either European or American sculpture in California during this period.

Putnam, with little money for either study or travel, had limited formal artistic training. In 1894, he studied for a short period at the San Francisco Art Students League. Dissatisfied with his progress there, he traveled to Chicago, which—following the World's Columbian Exposition of 1893—was one of the thriving art centers in the United States. In Chicago, Putnam had the opportunity to work with Edward Kemeys, the first American artist to devote his entire career to animal sculpture.

Putnam felt confined and unhappy in Chicago. He hated city life and, in 1899, returned to California to be married. Following his marriage, the young artist struggled against severe poverty. Nevertheless, he pursued his studies of wild animals, concentrating on those native to California and modeled several animals which were cast in bronze. Putnam's first financial success was the purchase of these sculptures by a member of the Crocker family. The money from this sale enabled him to go to France and Italy in 1905.

In Paris, Putnam studied the work of the nineteenth-century *animaliers* as well as that of Rodin. Impressed by young Putnam's work, Rodin was reported to have said of his animal sculpture: "This is the work of a master."[2] Putnam was greatly influenced by Rodin's impressionistic style. Rich modeling and lively surfaces give Putnam's sculpture tremendous vitality. Putnam's later works differed from those of the French *animaliers* in one major respect: whereas the French generally presented their subjects in animated and dramatic poses, Putnam often portrayed his animals in a quiet moment of relaxation and rest.

In Paris, Putnam studied casting procedures and experimented with new techniques. In 1906 and 1907, he exhibited several bronzes which were received with great enthusiasm by the Parisians. Despite his critical success and the abundance of artistic stimulation in Paris, he was once more unable to endure the strain of city life.

Putnam returned to San Francisco in 1906, to a city that had been almost completely destroyed by earthquake and fire. He turned to archaeological sculpture as a means of support. His commissions ranged from designing the bases of the street lamps on Market and Center streets with friezes celebrating the winning of the West to designing the drinking fountain in the lobby of the St. Francis Hotel.

Putnam built a small cottage in a part of San Francisco that was then barren wasteland. This cottage served as both home and studio. In 1909, he set up a foundry at home, where, with the aid of his brother-in-law, he cast his own sculptures. Putnam's sculptures grew

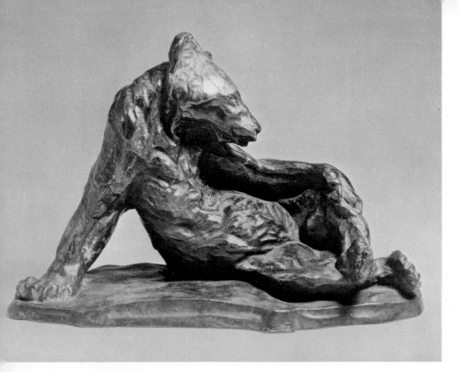

263. Arthur Putnam. *Bear Scratching Hind Paw*. Cast 1921. Alexis Rudier, Paris. H. 7½″. California Palace of the Legion of Honor, San Francisco. Gift of Mrs. A. B. Spreckels

in popularity and examples of his work were purchased by many California collectors.

Putnam had returned from Paris with dozens of casts and clay models. After a disastrous fire reduced the fruits of his labor to powder and dust, Putnam worked up to twenty-two hours a day to recreate his lost models. When he had almost completed this Herculean task and had several models cast in bronze, his foundry forge touched off a second fire. Putnam was crushed beyond consolation.

Putnam developed a brain tumor and in 1911 underwent surgery. Although his life was saved, he was left paralyzed and suffering from a severe personality disorder. His career as a sculptor ended. In 1917, Putnam moved to Paris, where he lived until his death in 1930.

In 1921, the Spreckels family in San Francisco sent a group of Putnam models to Paris and ordered two sets to be cast in bronze. The French foundries, busy with munitions contracts, were unwilling to cast the models. They were then taken to Rodin, who had not forgotten the young *animalier* he had met and admired many years before. Rodin brought the models to his private *fondeur*, Alexis Rudier *(plates 263–266, 366)*. Rodin personally supervised the casting and traveled to the United States with the first large collection of Putnam bronzes. The sculptures won wide acclaim and Putnam was awarded a Gold Medal. One set of bronzes was given to the California Palace of the Legion of Honor and the other to the Fine Arts Gallery of San Diego.

264. Arthur Putnam. *Coyote Frightened*. Cast 1921. Alexis Rudier, Paris. H. 7½″. California Palace of the Legion of Honor, San Francisco. Gift of Mrs. A. B. Spreckels

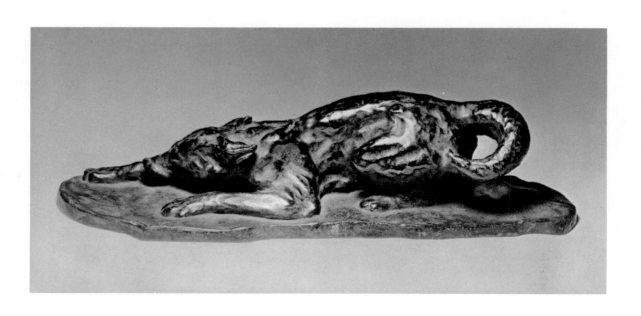

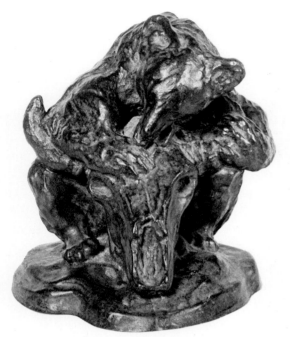

265. Arthur Putnam. *Bear and Ox Skull.*
Cast 1921. Alexis Rudier, Paris.
H. 6″. The Fine Arts Gallery of
San Diego, Calif.

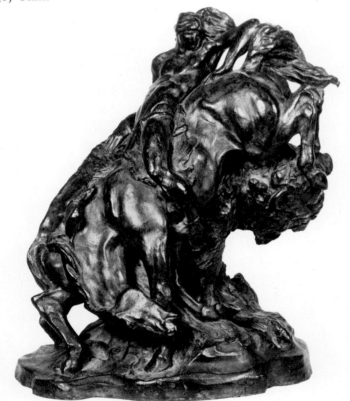

266. Arthur Putnam. *Buffalo, Indian,
and Horse.* Cast 1921 (first cast
1906–11). Alexis Rudier, Paris.
H. 14″. The Fine Arts Gallery of
San Diego, Calif.

In 1929, a great collection of one hundred and twenty-seven Putnam bronzes was exhibited at the California Palace of the Legion of Honor. A critic wrote in *The American Magazine of Art* in praise of Putnam's sculpture:

Putnam has modelled most of the animals native to the West. In presenting them the range of his subject-matter is superb; it extends all the way from relaxation in satisfied, peaceful sleep to the stiffened tenseness of a death struggle. There are prowling wolves, slinking coyotes, snarling jaguars; deer attacked by wildcats, pumas in the strangling coil of serpents; dogs and deer in hunting frays; buffalo bulls butting in each other's skulls; and the little cub bears that bring a smile with their lubberly awkwardness. In his delineation of animal life, Putnam parallels the life of mankind: There are the tragedies of starvation, of pursuit and possession, of love and hate, of death and desolation.[3]

Anna Hyatt Huntington (1876–1973) was one of the most prolific and successful sculptors in the history of American art. Her bronze portraits of animal life stand in museums throughout the United States. She was born Anna Vaughn Hyatt in Cambridge, Massachusetts. Her father, Altheus Hyatt, was an eminent professor of paleontology at Harvard University. From him, she developed an interest in all species of animal life. Although Miss Hyatt was first drawn to studying the violin, her fascination with animals influenced her to follow a career in sculpture.

She first studied sculpture in Boston with Henry Kittleson and then moved to New York to take classes at the Art Students League with Hermon Atkins MacNeil. She also profited from Gutzon Borglum's criticism of her work. Determined to increase her knowledge of animals, she lived on a farm in Porto Bello, Maryland, where she modeled domestic animals. Periodically she traveled to New York to study wildlife at the Bronx Zoo.

In 1902, Miss Hyatt completed one of her best-known sculptures, a composition of two dray horses entitled *Winter (plate 267)*. She first exhibited her model in 1903 at the Society of American Artists in New York. In 1904, she exhibited *Winter* at the Louisiana Purchase Exposition and, in later years, in museums and expositions throughout the United States.

Although Anna Hyatt's early sculptures were primarily of dogs and domestic animals, her visits to the zoo fired her with the enthusiasm to portray wild animals, especially the magnificent specimens of the cat family. In 1906, she created companion pieces, *Reaching Jag-*

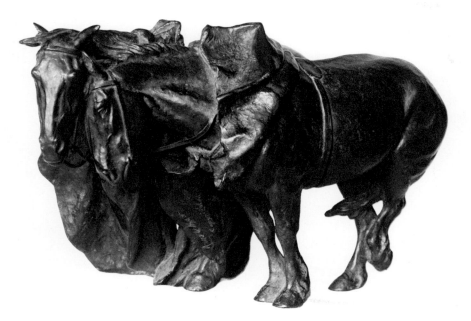

267. Anna Hyatt Huntington. *Winter.* c. 1902. Roman Bronze Works, N.Y. H. 7½". The Metropolitan Museum of Art, New York City. Rogers Fund, 1906

uar (or *Reaching Panther*) and *Jaguar* (*plates 268, 269*), for a pair of gateposts. Lorado Taft hailed these as among "the most original things in American art."[4] Plaster models of the jaguars were exhibited in Paris in 1908.

Miss Hyatt worked in France and Italy and, on her return to the United States, devoted herself to many commissions for heroic public monuments. She won the Purple Rosette of the French government and was made a Chevalier of the Legion of Honor for her equestrian statue of Joan of Arc. This statue stands on Riverside Drive in New York City.

Following her marriage in 1923 to philanthropist Archer Huntington, Miss Hyatt spent many years traveling, during which time she created several sculptures of Spanish heroic and literary figures. In 1931, Archer Huntington established Brookgreen Gardens in South Carolina to display his wife's sculptures (*plate 270*) in a natural setting: "a quiet joining of hands between science and art."[5] Today, Brookgreen Gardens has been expanded into a major sculpture museum displaying the works of many important Americans.

Mrs. Huntington achieved fame as a sculptor of animals and heroic monuments, and received honors and awards from art societies throughout the world. In 1959, she was designated "Woman of the Americas" by the Unión de Mujeres.

Her monumental works follow in the tradition of heroic public statuary of the early twentieth century, while her animal bronzes are in the French naturalist tradition. Dramatically conceived, realistically portrayed, her animals are creatures of action and excitement.

Although Mrs. Huntington could never be considered a Western artist, nevertheless, her animal bronzes are frequently in collections of American wildlife sculpture. Two of her bronze groups, one of bears and one of wolves (*plate 271*), stand outdoors in Anadarko, Oklahoma, at the National Hall of Fame for Famous American Indians. There, surrounded by representations of the great Indians of American history, Mrs. Huntington's animals indeed breathe the spirit of the American West.

One of the first taxidermist-sculptors was Carl E. Akeley (1864–1926). Born in Clarendon, New York, Akeley worked for the Field Museum in Chicago from 1885 to 1909 and then moved to New York to join the staff of the American Museum of Natural History. Akeley was highly influential in transforming taxidermy into a sculptural art. He raised that art to its highest level when, as a memorial to Theodore Roosevelt, he presented the elephants shot by the President to the Museum's African Hall.

Akeley created several sculptures which reveal his profound knowl-

268. Anna Hyatt Huntington. *Jaguar (Panther)*. Modeled 1906, cast 1926. Jno Williams Founder, N.Y. H. 28½". The Metropolitan Museum of Art, New York City. Gift of Archer M. Huntington, 1926

269. Anna Hyatt Huntington. *Reaching Jaguar (Reaching Panther)*. Modeled 1906, cast 1926. Jno Williams Founder, N.Y. H. 45". The Metropolitan Museum of Art, New York City. Gift of Archer M. Huntington, 1925

270. Anna Hyatt Huntington. *Brown Bears*. 1935. Gorham and Co., N.Y. H. 45″. Brookgreen Gardens, Murrells Inlet, S.C.

edge of the anatomy and movements of animals. Akeley's bronzes of American wildlife are highly realistic, and have a strong sense of scientific detail.

Akeley traveled on expeditions throughout the globe and inspired several talented assistants to follow the dual career of taxidermy and animal sculpture. His chief assistant at the Museum was Robert H. Rockwell (b.1885). A successful taxidermist-sculptor, Rockwell traveled the world in search of adventure and animal specimens. He created many small bronzes of animal life.

Charles R. Knight (1874–1953) was also associated with the American Museum of Natural History. Born in Brooklyn, New York, he received his formal art training at the Metropolitan Museum of Art and at the Art Students League.

Knight was successful both as a painter and as a sculptor. One of his major achievements was a series of mural paintings of prehistoric men and animals for the Museum. He also made models from fossils which were displayed in museums throughout the United States. Knight devoted many years to studying the animals of the American West and created several realistic bronzes of bison, grizzlies *(plate 276)*, and wildcats.

Although Carl Akeley was the undisputed founder of modern taxidermy, James Lippitt Clark (1883–1969) has been described as "its major prophet."[6] Clark's career as a successful animal sculptor lasted over sixty years, and he devoted almost fifty of those years to a career with the American Museum of Natural History in New York. For many years, the Director of Arts, Preparation, and Installation at the Museum, Clark was responsible for the creation of the Vernay Faunthorpe Hall of Asiatic Mammals, the Akeley African Hall, and the North American Hall of Mammals—all of which displayed groups of animals in simulated natural settings. The creation of the settings and the positioning of the animals required artistic sensitivity and ability as well as extensive scientific knowledge.

Clark was born in Providence, Rhode Island. After attending the Providence public schools, he worked as a designer for the Gorham Silver Company. He subsequently developed an interest in sculpture and enrolled at the Rhode Island School of Design for formal study.

Clark was particularly interested in animal forms and some of his early models were cast by Gorham. These early works, on display in Gorham's New York windows, were admired by many passersby who were interested in animal sculpture. In 1902, he was offered a job mounting animal specimens for the American Museum of Natural History. The Museum sent Clark to Chicago, where he was trained by Akeley for two months in the techniques of modern taxidermy.

250

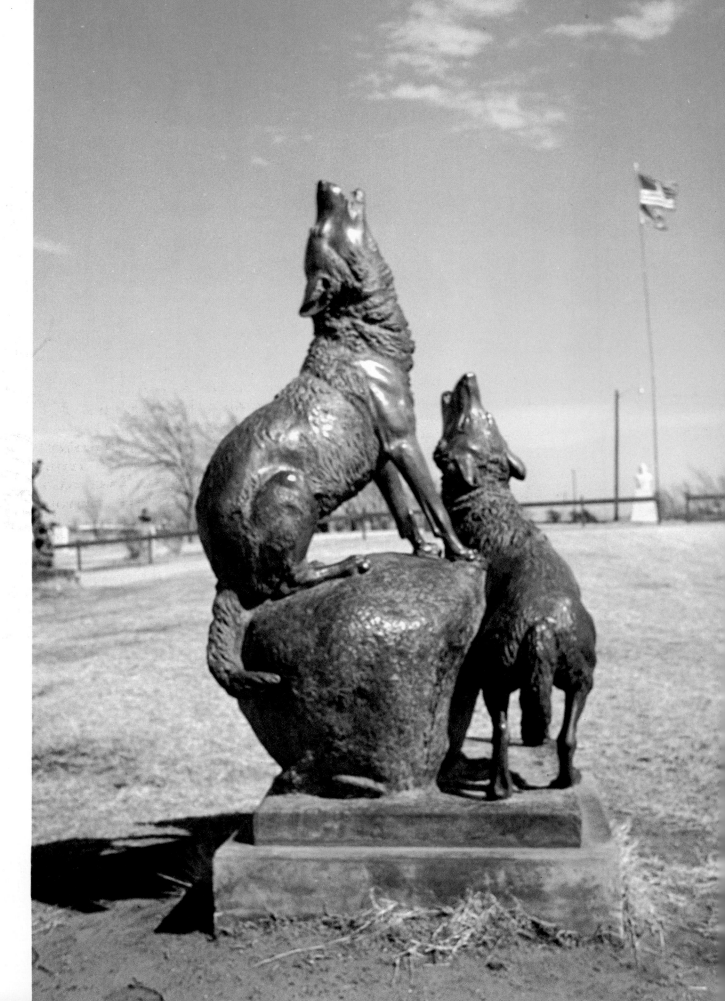

271. Anna Hyatt Huntington. *Wolves*.
1960. H. 78″. The National Hall
of Fame for Famous American In-
dians, Anadarko, Okla.

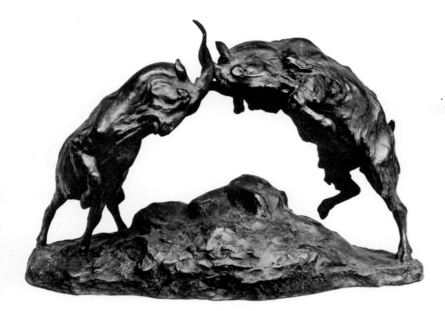

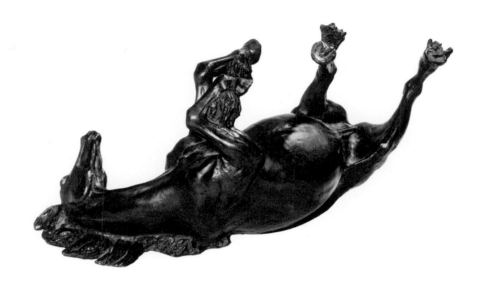

272. Anna Hyatt Huntington. *Goats Butting*. 1904. Roman Bronze Works, N.Y. H. 10¼″. The Metropolitan Museum of Art, New York City. Rogers Fund, 1912

273. Anna Hyatt Huntington. *Rolling Horse*. H. 7″. The National Cowboy Hall of Fame, Oklahoma City, Okla.

274. Anna Hyatt Huntington. *Rolling Bear*. Before 1914. Roman Bronze Works, N.Y. H. 3¼″. The Newark Museum, Newark, N.J.

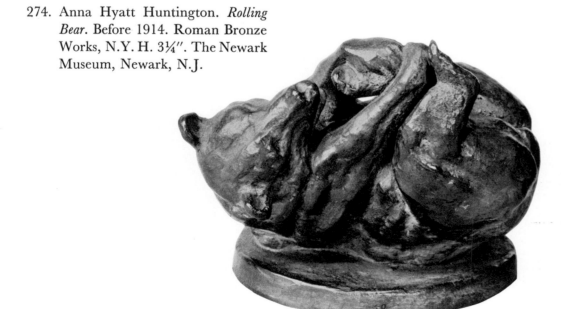

275. Anna Hyatt Huntington. *Reaching Jaguar (Reaching Panther)*. 1906 (early study). Gorham and Co., N.Y. H. 6⅜″. Joslyn Art Museum, Omaha, Neb.

..

The method of taxidermy employed by the American Museum of Natural History involved mounting the skin of an animal on a full-sized form. Before completing this form, Clark always made a small model to determine the proper pose. This method required the most precise knowledge of muscle and bone structure as well as complete familiarity with the habits and movements of living animals. Often Clark's small models were so successful that they were later made permanent through bronze casting.

Throughout his life, Clark based his art on firsthand knowledge of animal life. Daily, before starting work at the Museum, he would sketch the animals at the Central Park Zoo. Weekends, he studied those at the Bronx Zoo.

In 1906, dissatisfied with the limitations of studying caged animals, Clark traveled to Wyoming to study animals in their natural setting. He made extensive notes and sketches which he later used in his habitat mountings at the Museum.

Clark visited museums and zoological parks throughout Europe, and in 1908 made his first expedition to Africa. On this trip he made the first motion picture of African wildlife. The expedition was the beginning of a lifetime of travel, which included such exotic adventures as being captured by the Mongols.

Clark created sculptures of wild animals from every part of the globe. He made models of wild horses *(plate 277)*, grizzly bears, Alaskan kodiak bears, pronghorn antelopes, rams, and many other forms of American wildlife. With the exception of an occasional impressionistic study, Clark's sculpture is traditionally realistic, with highly polished, detailed surfaces. His animals are portrayed in characteristic poses, and the precise naturalistic details illustrate Clark's total familiarity with the physical structure of each animal.

In 1949, Clark retired from the Museum and devoted the remainder of his life to travel, writing, and sculpture. Clark wrote many books on his adventures and was active in art and natural history societies throughout the country.

A younger artist whose combined studies of taxidermy and sculpture provided him with a varied and successful career was Louis Paul Jonas (1894–1971). Jonas studied art in Hungary before emigrating

277. James Lippitt Clark. *Wild Horses.* c. 1930. H. 6½″. Graham Gallery, New York City. Clark exhibited this bronze at the National Academy of Design in 1930 and received the Speyer Memorial Award for animal sculpture. It depicts a stallion herding a group of wild mares away from danger. Clark was inspired by the wild horses he saw in southern Utah while on an expedition collecting mountain lions for the American Museum of Natural History

276. Charles R. Knight. *Grizzlies.* 1924. Roman Bronze Works, N.Y. H. 21½″. Kennedy Galleries, New York City

254

to the United States at the age of fourteen. He settled in Denver, where his brother was an established taxidermist. Jonas worked in his brother's studio and became a skillful artisan.

Jonas, however, wished to resume his study of sculpture and moved to New York. He enrolled in classes at the New York Academy of Design, where he had the opportunity to study under Hermon Atkins MacNeil and George Bridgman. During the 1920s, Jonas was employed as a taxidermist, working on Akeley's animal groups for the American Museum of Natural History, but he was primarily interested in developing his skill as a sculptor *(plate 278)*.

In 1930, Jonas completed *Grizzly's Last Stand,* a commission for Denver's City Park *(plate 279)*. The sculpture of a giant grizzly bear standing on her hind legs protecting her small cub is a protest against the wanton destruction of wildlife. It is also known as *Commemorating the Grizzly Bear.*

Jonas's sculpture is more stylized than that of other naturalists. Since his vision was that of the artist rather than that of the naturalist, he subordinated realistic details to patterns of decorative curves. He selected the pose of the animal for its ornamental and aesthetic effect, rather than attempting to achieve a scientific re-creation of life.

Jonas, throughout his career, made many dramatic and decorative bronzes of Western wildlife. His elk and caribou in the Woolaroc Museum in Bartlesville, Oklahoma, are especially fine examples of his art.

In the early years of the twentieth century there was a nostalgia for the era when survival in the wilderness was the principal challenge of life in the West. The days when the West was an unknown and dangerous world were over, but great uninhabited regions of mountain, desert, and plain offered the opportunity to enjoy the natural wonders of scenery and wildlife. Sportsmen, artists, and naturalists traveled westward to hunt, sightsee, and study. Sculptors created models of the animals of the West and the public purchased these as symbols of a romantic past or of a daring adventure.

Today there is renewed interest in wildlife sculpture. Men have become aware that the phenomenal expansion of urban life and industry has greatly altered their natural environment. By disturbing the ecological balance of nature, mankind has endangered the survival of many species of animals. Awakened to the necessity of restoring the ecological balance, protecting wildlife, and conserving natural resources, the public has developed a new appreciation for animal sculpture, especially for those animals which are native to the American West and which have thus become symbolic of America.

278. Louis Paul Jonas. *Chief Eagle Head.* Terra cotta with bronze finish. H. 14⅜". Lauren Rogers Library and Museum of Art, Laurel, Miss.

279. Louis Paul Jonas. *Grizzly's Last Stand.* 1930. H. 12'6". City Park, Denver, Colo. The grizzly is native to Colorado and was once found in great numbers in the Rocky Mountains, but it is now almost extinct. Denver was the first city to honor the grizzly

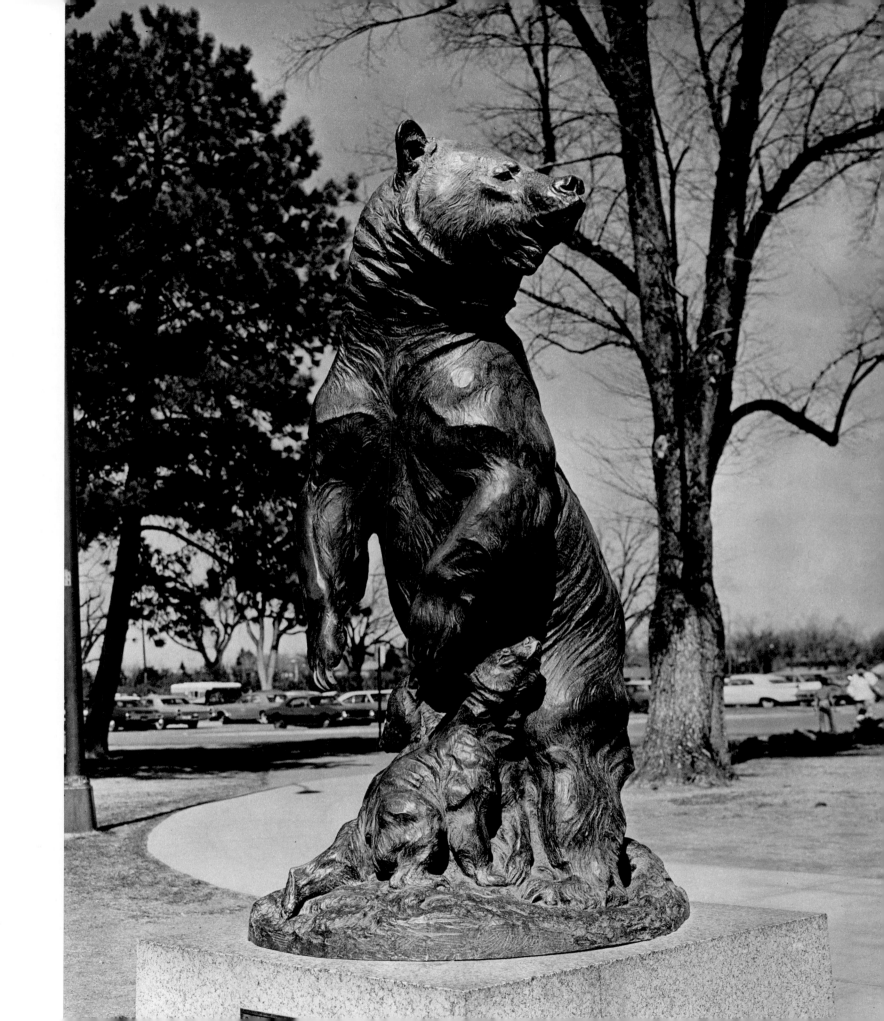

XVIII

A WORLD TO REMEMBER

Many sculptors worked during an era which saw great transitions in the American West. Born in the late nineteenth century, this generation of artists became the final witness to the vanishing frontier. As the years passed, the West of their youth existed only in memory or artistic representation.

Free from the threat of Indian attacks or reprisals, many artists idealized the Indian and his way of life. As the brutal conflict between the cavalry forces and the Indian tribes ended, artists dramatized the violence between them. As the days of the open range ended, artists rhapsodized about the freedom and romance of cowboy life. As the United States became an industrial nation, artists celebrated the wonders of nature.

Some artists had experienced a frontier childhood. Others were inspired by a youthful visit West or adventure stories told by their fathers and grandfathers. Several artists had studied in the studios of the great sculptors of the West and, impressed by the work of their instructors, wished to express their personal vision of the historic West. During the first half of the twentieth century, many sculptors worked to give permanent form to memories of the romantic world of cowboys and Indians, pioneers and troopers, outlaws and heroes.

The knowledge that the West was rapidly changing was evident during the last decades of the nineteenth century. The great expositions, which began in the United States with the Philadelphia Centennial, proclaimed the achievements of a century of independence. At these expositions there were exhibition halls from many nations

280. Theodore Baur. *The Buffalo Hunt.* c. 1875. The Meriden Britannia Co. (now International Silver Co.), Meriden, Conn. H. 22¾". Remington Art Memorial Museum, Ogdensburg, N.Y.

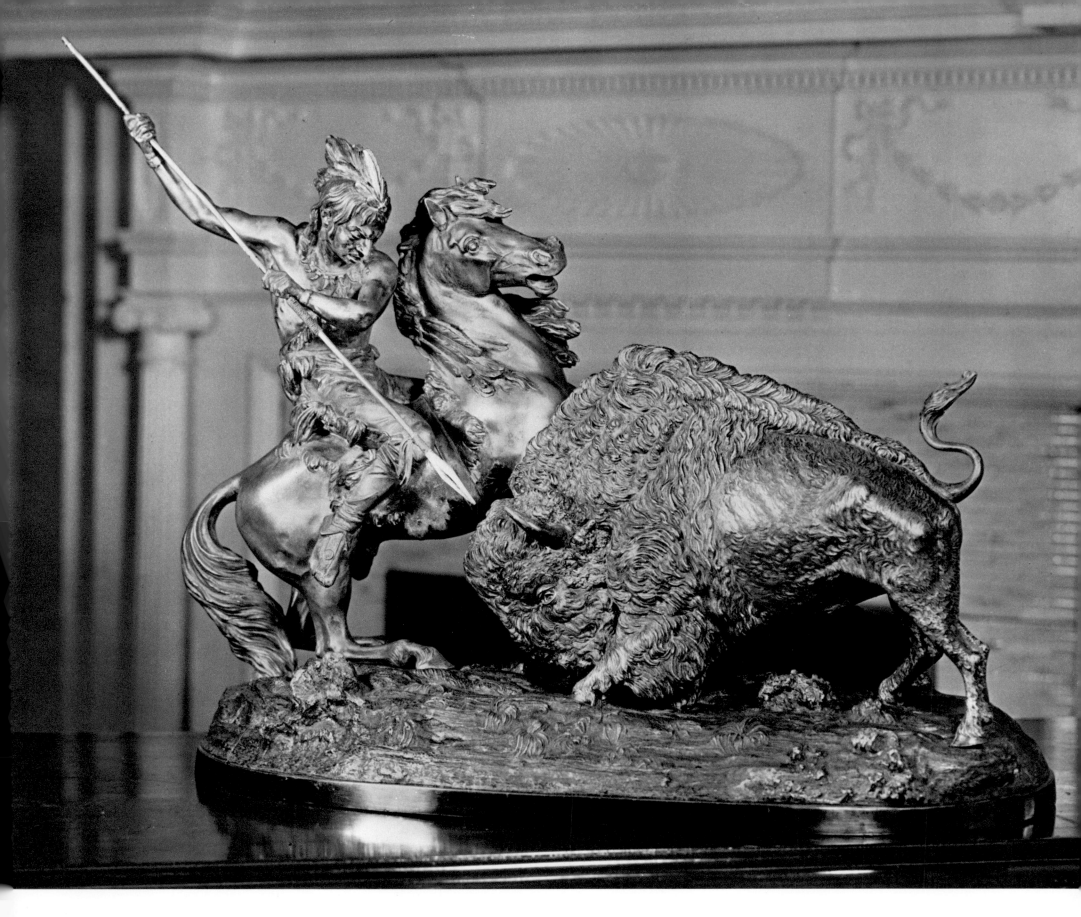

281. Theodore Baur. *Buffalo* (silver paperweight). c. 1882. Meriden Britannia Co. (now International Silver Co.), Meriden, Conn. H. 4½″. The International Silver Company Historical Library, Meriden, Conn.

and every American state. Here were displayed the architecture, artistic creations, and scientific inventions of the modern age. Manufacturers used these expositions to display their newest designs. They sought publicity and acclaim by creating special displays to hail the achievements of the American nation.

In the name of progress, the end of the frontier was hailed as the country's ultimate goal, the accomplishment of its "manifest destiny." By the Centennial year, the great herds of buffalo had vanished from the plains. During the previous three years, hunters had killed over four million buffalo for the giant reward of one dollar per skin. The slaughter of the buffalo dealt an almost fatal blow to the civilization of the Plains Indians, for it deprived them of economic independence.

At the Centennial, the Meriden Britannia Company, forerunner of the International Silver Company, exhibited Theodore Baur's *The Buffalo Hunt (plate 280)*. This bronze sculpture, which they had commissioned especially for the Centennial, was later exhibited at the International Cotton Exposition in Atlanta, Georgia (1881), the International Exposition in Paris (1889), the Trans-Mississippi and International Exposition at Omaha, Nebraska (1898), and at many other expositions of the late nineteenth century. The work won great popularity. Models were later sold to the public, finished in "old silver" and "gold inlaid." The buffalo alone was also available in a smaller size to be used as a paperweight *(plate 281)*.

Theodore Baur was born in Württemberg, Germany, in 1835. At the age of fifteen, he came to America. Baur became popular in the United States and in Canada for his architectural sculpture. He modeled *The Buffalo Hunt* in New York City in his Washington Square studio. The buffalo hunt was the symbol of an era of Indian civilization which had only recently ended. Bauer based the Indian on sketches and studies made at museum exhibitions and the buffalo on specimens in the New York Zoo. He chose to portray the moment of the kill.

Another of Baur's sculptures is a head of an Indian chief. Modeled in 1885, it is considered to be a portrait of Chief Crazy Horse *(plate 282)*. Records indicate, however, that Baur had begun the work as a portrait of Chief Sitting Bull.

A romantic celebration of Indian life, similar to *The Buffalo Hunt*, was *The Bear Hunt* exhibited in 1893 by Douglas Tilden at the World's Columbian Exposition in Chicago.

The Indians portrayed by Tilden, like those of Baur, are noble savages. The tradition of idealizing the Indian lasted well into the

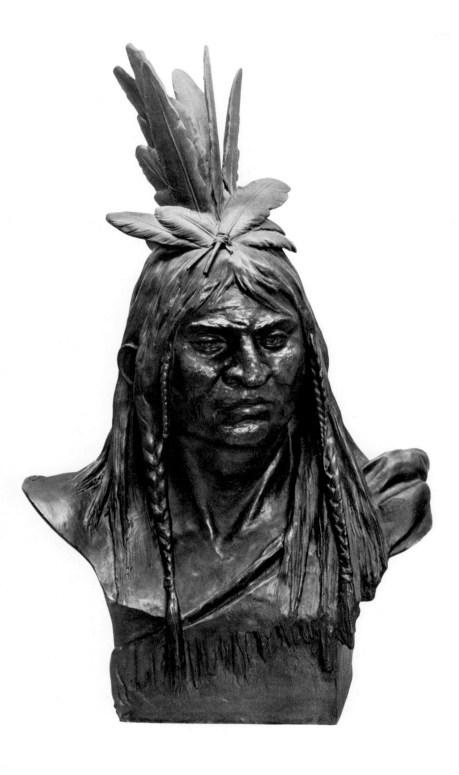

282. Theodore Baur. *Chief Crazy Horse.* 1885. Henry Bonnard Foundry, N.Y. H. 29″. The Denver Art Museum, Colo.

twentieth century. Modeled in 1892, Tilden's sculpture depicts the struggle between a giant bear and two Indians. Lorado Taft proclaimed Tilden to be "the most eminent sculptor of the Western coast," but condemned *The Bear Hunt* as "much science and much savagery. . . . the result is unpleasant and hardly worthy of a sculpture."[1]

Douglas Tilden (1860–1935) was born in Chico, California. During childhood, he lost his hearing as a result of a severe case of scarlet fever. He was educated at the Institute for the Deaf and Dumb at Berkeley and at the University of California. Determined to become a sculptor, Tilden studied at the Academy of Design in New York and in Paris with M. Paul Chopin, himself a deaf-mute sculptor.

In 1894, Tilden created for the city of San Francisco a *Native Sons Fountain*—an allegorical composition of a miner and an angel. He next completed the *Mechanics Fountain,* a memorial in honor of Peter Donahue, a pioneer ship- and railroad builder. This monument, glorifying the workers of the West, portrayed muscular men operating a lever punch. Taft admired the Western character of the monument: "In allowing himself 'full swing,' the sculptor of the Pacific slope has given us a historic document, full of significance of time and place."[2] Tilden often indulged in nineteenth-century melodramatic heroics. His sculptures of working men have greater strength than his allegorical or symbolic figures.

Charles H. Humphriss (1867–1934) specialized in Indian subjects throughout his sculptural career. Born in England, Humphriss settled in New York, where he won the recognition of his peers and became a member of the National Association of Sculptors. Although he lived and exhibited his work in the East, he modeled primarily Western subjects.

In many of his bronzes, Humphriss portrayed forms of Indian worship. Two studies of Indians in prayer are *Indian's Appeal to Manitou (plate 283)* and *Appeal to the Great Spirit (plate 284)*. Humphriss saw the Indian as a man of peace, not as a warrior. These bronzes dramatize the Indian's need to turn to the Great Spirit for help and deliverance.

Although Humphriss specialized in sculptures of mounted *(plate 285)* and standing Indians, he occasionally modeled a soldier or cowboy. These bronzes were less successful than his Indian figures, which have great dignity and power. Humphriss's model of a *Cowboy on a Bucking Horse (plate 286)* is awkward and lacking in conviction.

Charles C. Rumsey (1879–1922), like many of his generation, often looked backward in American history for the subjects of his sculpture. In 1916, he created a frieze, *The Buffalo Hunt,* for the approach

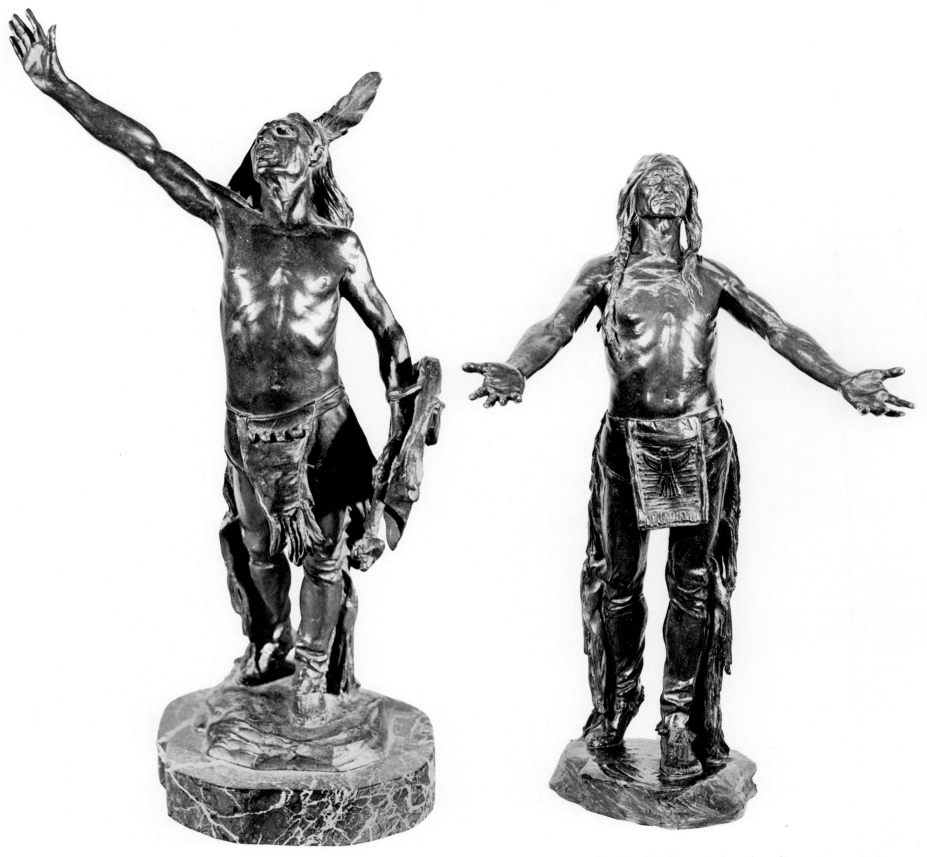

283. Charles H. Humphriss. *Indian's Appeal to Manitou*. 1906. H. 16½". Thomas Gilcrease Institute, Tulsa, Okla.

284. Charles H. Humphriss. *Appeal to the Great Spirit*. 1900. Roman Bronze Works, N.Y. H. 30½". Thomas Gilcrease Institute, Tulsa, Okla.

to the Manhattan Bridge in New York. His best-known Indian bronze is the *Dying Indian (plate 288)*, owned by the Brooklyn Museum in New York.

Rumsey was born in Buffalo, New York. He studied for two years in France with Paul Wayland Bartlett and on his second trip to Paris studied with Emmanuel Frémiet. Through his association with the French *animaliers,* Rumsey acquired a preference for animal subjects. He was more influenced in his style, however, by the French Impressionists. Quick modeling and a lack of surface detail give his work a sense of immediacy and dramatic power.

While sculptors such as Theodore Baur, Charles Humphriss, and Charles Rumsey idealized the Indian in his primeval freedom, others —including Jo Mora, J. Clinton Shepherd, and Sally James Farnham—romanticized the life of the cowboy on the open range.

Jo Mora (1876–1947) was one of the most versatile Western artists. Sculptor and painter, historian and ethnologist, he created sculptures for many Western cities and painted several dioramas celebrating heroes of the West. He depicted scenes of everyday Western life, as well as of tribal rituals of the Southwest. Mora wrote and illustrated two books, *Trail Dust and Saddle Leather* and *California.*

Joseph J. Mora was born in Montevideo, Uruguay. His father, Domingo Mora, was a well-known Spanish sculptor. Early in Jo's childhood, the Mora family moved to the United States. Jo and his brother Luis, who later became a painter, studied at the Art Students League and Chase's Art School in New York, and at Cowell's Art School in Boston. Both artists also studied in Europe.

Jo was first employed as an artist on *The Boston Traveler* and *The Boston Herald.* He soon left Boston to begin a lifetime of Western travel and study. Jo journeyed by horseback through Mexico. From the Mexican frontier, he rode to San Jose, California, stopping at many of the large *ranchos* where he enjoyed the excitement of ranch life.

Mora was in California during the years when the old *vaquero,* or herdsman, was still a familiar figure. Mora admired his style of riding and followed the old California method of horse training with the hackamore and spade bit. Mora had ridden since childhood, taking his first spill at age ten. Throughout his life, he was an excellent horseman and enjoyed the pleasures of riding. Mora acquired a vast collection of saddles, bridles, and other equestrian paraphernalia from the days of the conquistador to modern times. He used this collection to achieve authenticity in both his painting and sculpture.

Leaving California, Mora traveled through Arizona and New Mexico. He lived for four years with the Hopi and Navaho Indians and made extensive ethnological studies of both tribes. An authority on

285. Charles H. Humphriss. *Indian Chief.* Roman Bronze Works, N.Y. H. 49″. Thomas Gilcrease Institute, Tulsa, Okla.

286. Charles H. Humphriss. *Cowboy on a Bucking Horse.* c. 1910. Graham Gallery, New York City

287. Charles H. Humphriss. *Dance Leader.* H. 19". Berry-Hill Galleries, New York City

the lore of the Southwest, he was especially interested in the Kachina ceremonial dances.

In 1906, Mora returned to California. In his studio at Pebble Beach, he created sculptural monuments for many Western cities. Among his many accomplishments are the so-called Jo Mora maps, a series of illustrated cowboy and rodeo charts; thirteen biographical dioramas for the Will Rogers Memorial at Claremore, Oklahoma; and a bas-relief plaque on Rainbow Natural Bridge commemorating the first Indian to lead the white man to the bridge.

Mora loved every aspect of Western life. He lived for over fifty years in the West, working with and studying cowboys and *vaqueros* from Canada to Southern California. His paintings and sculptures of Indians and cowboys as well as of the heroes and heroines of Western lore testify to his lifelong celebration of the West *(plates 289–294)*.

J. Clinton Shepherd (b.1888) created many sculptures of Western life. He was especially interested in modeling the cowboy and his horse. Born in Des Moines, Iowa, Shepherd studied at the Chicago Art Institute and at the Beaux-Arts Institute of Design. He created several paintings of the West, but is better known as a sculptor.

Shepherd's bronzes illustrate some of the equestrian events of Western life. *The Herder (plate 295)*, a study of the quiet of the night watch, *Maverick (plate 296)*, showing a cowboy roping a calf, and *Pony Tracks (plate 297)*, a model of an Indian warrior, all illustrate experiences of the Western horseman. Shepherd's bronzes are realistically conceived in the naturalist tradition.

Charles A. Beil arrived in Great Falls, Montana, in 1922. He fell in love with the West and all phases of Western life. He worked as a cowboy and created models of the other cowboys, as well as of the Indians and animal life of the area *(plates 305, 306)*. He became great friends with another cowboy-artist living in the area, Charles M. Russell.

Russell took a paternal interest in young Beil. They spent long hours together, talking of the West of the past and the changes the twentieth century would bring. They often worked together and Russell helped his young friend with both modeling and composition. At Russell's funeral, Beil led a horse with an empty saddle, a dramatic symbol of the loss of his friend.

In 1926, the year of Russell's death, Beil modeled the *Seven Piegans (plates 298–304)*, a group of portrait busts of members of the largest branch of the Blackfoot tribe. Each sculpture gives a keen sense of the character of the Indian portrayed, his racial pride, his tribal wisdom and inner strength. In 1929, Syd Willis, owner of the Mint

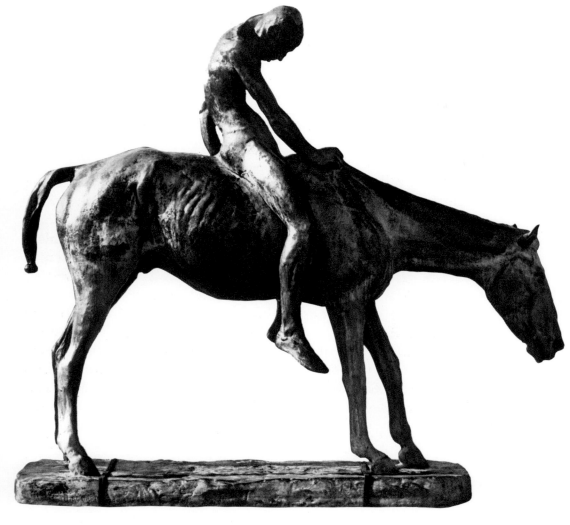

288. Charles C. Rumsey. *Dying Indian* (first sketch dated 1901). H. 8′5″. Brooklyn Museum, N.Y. Gift of Mrs. Charles Cary Rumsey

289. Joseph J. ("Jo") Mora. *Cowboy on Horseback*. 1915. Gorham and Co., N.Y. H. 9½″. John Howell Books, San Francisco, Calif.

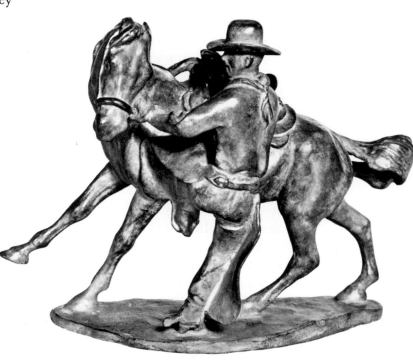

290. Joseph J. ("Jo") Mora. *Bronco Buster*. 1930. California Art Bronze Foundry, Los Angeles. H. 7½″. The National Cowboy Hall of Fame, Oklahoma City, Okla.

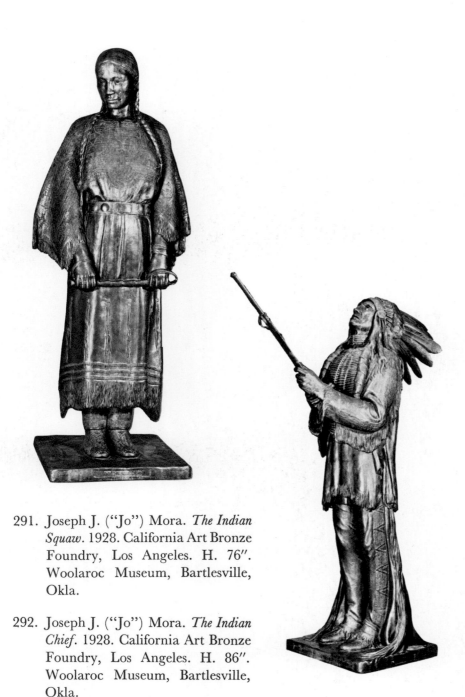

291. Joseph J. ("Jo") Mora. *The Indian Squaw*. 1928. California Art Bronze Foundry, Los Angeles. H. 76″. Woolaroc Museum, Bartlesville, Okla.

292. Joseph J. ("Jo") Mora. *The Indian Chief*. 1928. California Art Bronze Foundry, Los Angeles. H. 86″. Woolaroc Museum, Bartlesville, Okla.

Saloon in Great Falls, bought the models and exhibited them in a glass case in the Mint. Dick Flood acquired the models in 1956 and had them cast in bronze.

In 1930, Beil traveled to Canada, where he married and settled permanently. Since then, he has created the trophies awarded annually at the Calgary Stampede.

Lawrence Barrett (1897–1973) portrayed frontier days in Colorado in his sculptures. As a young man, he enjoyed riding to Denver to study the local characters. He sketched both cowboys and outlaws through his right-angle mirror, a technique which left the subject totally unaware that he would someday be the hero in one of Barrett's sculptures.

Barrett pursued a career in lithography before turning to sculpture. As the indisputable expert on lithography, he wrote the article on this subject for the Encyclopaedia Britannica. When he was past seventy years old, Barrett, feeling he had exhausted the creative possibilities of lithography, turned to sculpture. Using the studies he had made many years before, he re-created characters and situations from his Colorado youth. *The Gunslinger (plate 307)* was studied many years ago on the streets of Denver. Barrett occasionally portrayed traditional Western subjects. *Off Balance (plate 308)* is an impressionistic study of a cowboy on a rearing horse.

Sally James Farnham (1876–1943) was born and attended public school in Ogdensburg, New York, the home of Frederic Remington. Sally was a good friend of Remington's and was strongly influenced by him through much of her career. Mrs. Farnham had no formal training. During her youth, she had had the good fortune to accompany her father, Colonel Edward Christopher James, a well-known trial lawyer, on his trips to Europe. It was while visiting the museums abroad that she first developed an interest in sculpture.

Sally did not attempt sculpture until several years after her marriage to Pauling Farnham. In 1901, while recuperating in a New York hospital, Mrs. Farnham made her first work in that medium. She modeled a Spanish dancer in plasticine and took it to Frederic Remington for criticism. Remington gave her first creation his approval and urged her to continue in her efforts.

Greatly encouraged, Sally Farnham began her career as a sculptor. Although she never attended formal art classes, she had the advantage of receiving criticism from such masters as Henry Merwin Shrady, Augustus Lukeman, and Frederick Roth. She continued to work during the years in which she raised three children. Slowly she received commissions and gained stature as a sculptor.

Since childhood, Mrs. Farnham had had a great love of horses and

293. Joseph J. ("Jo") Mora. *The Cowboy*. 1929. California Art Bronze Foundry, Los Angeles. H. 88″. Woolaroc Museum, Bartlesville, Okla.

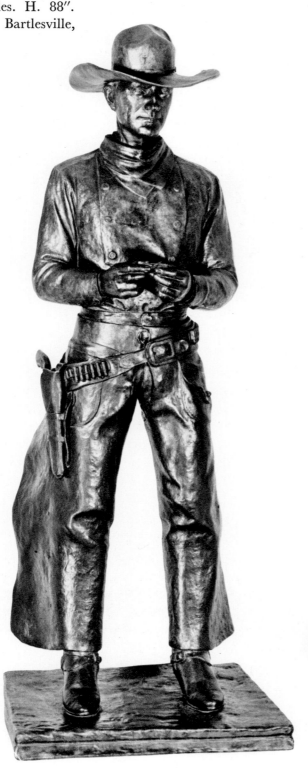

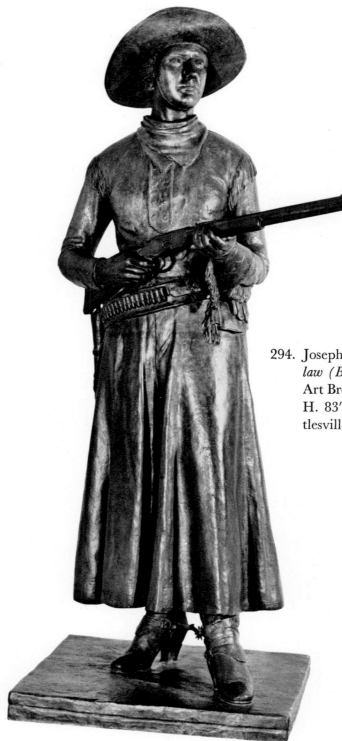

294. Joseph J. ("Jo") Mora. *The Outlaw (Belle Starr)*. 1929. California Art Bronze Foundry, Los Angeles. H. 83″. Woolaroc Museum, Bartlesville, Okla.

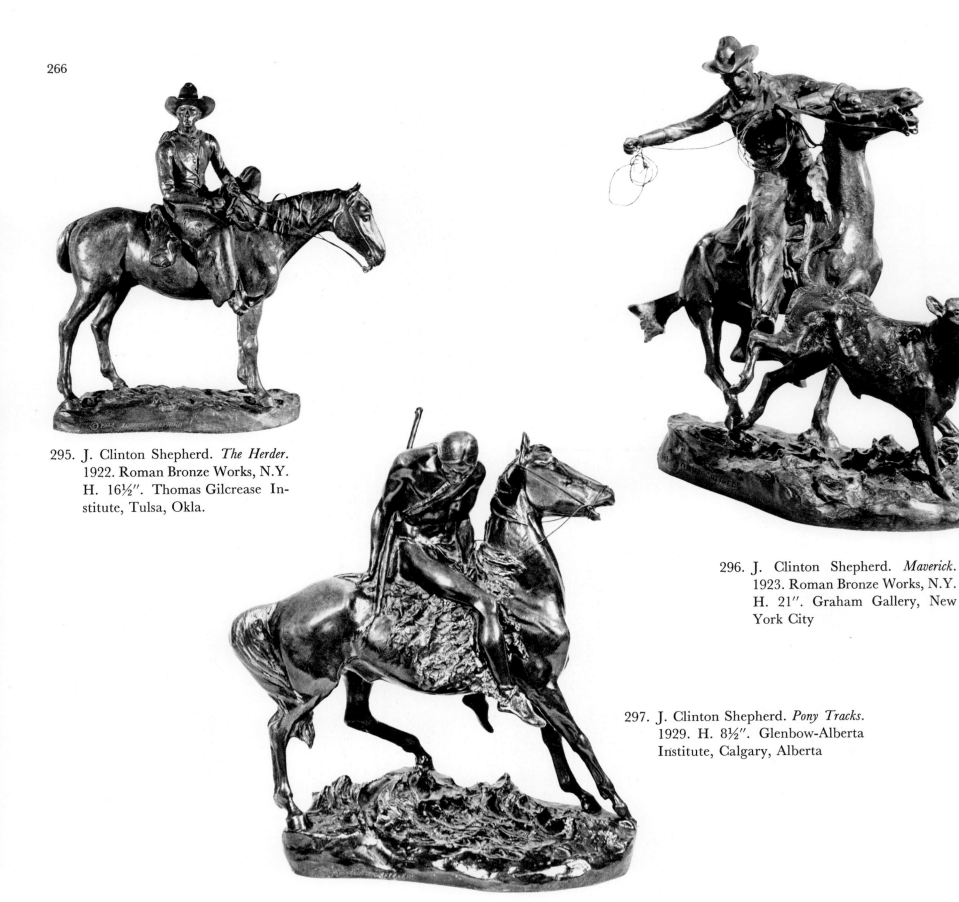

266

295. J. Clinton Shepherd. *The Herder*. 1922. Roman Bronze Works, N.Y. H. 16½″. Thomas Gilcrease Institute, Tulsa, Okla.

296. J. Clinton Shepherd. *Maverick*. 1923. Roman Bronze Works, N.Y. H. 21″. Graham Gallery, New York City

297. J. Clinton Shepherd. *Pony Tracks*. 1929. H. 8½″. Glenbow-Alberta Institute, Calgary, Alberta

*298. Charles A. Beil. *Weasel Feather— Seven Piegans*. Modeled 1926, cast 1968. Avnet Shaw Foundry, Plainview, N.Y. H. 8½".

*299. Charles A. Beil. *Calf Tail—Seven Piegans*. Modeled 1926, cast 1968. Avnet Shaw Foundry, Plainview, N.Y. H. 8⅛".

*300. Charles A. Beil. *Eagle Calf—Seven Piegans*. Modeled 1926, cast 1968. Avnet Shaw Foundry, Plainview, N.Y. H. 7½".

*301. Charles A. Beil. *Medicine Bassribs —Seven Piegans*. Modeled 1926, cast 1968. Avnet Shaw Foundry, Plainview, N.Y. H. 7¾".

*302. Charles A. Beil. *Turtle—Seven Piegans*. Modeled 1926, cast 1968. Avnet Shaw Foundry, Plainview, N.Y. H. 7½".

*303. Charles A. Beil. *Two Guns White Calf—Seven Piegans*. Modeled 1926, cast 1968. Avnet Shaw Foundry, Plainview, N.Y. H. 8".

*304. Charles A. Beil. *Last Stone—Seven Piegans*. Modeled 1926, cast 1968. Avnet Shaw Foundry, Plainview, N.Y. H. 7¾".

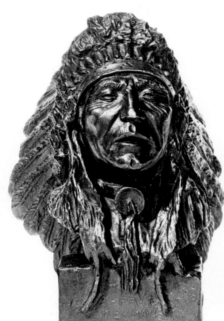

298

299

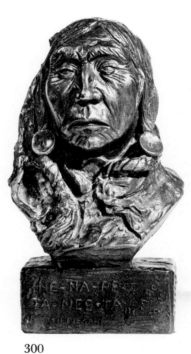

300

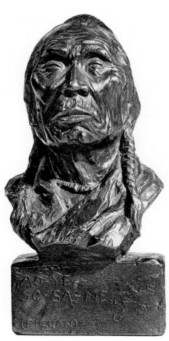

301

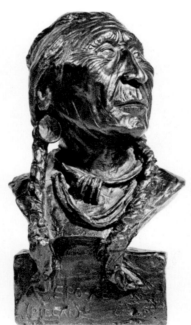

302

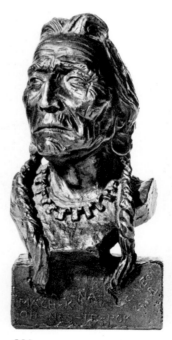

303

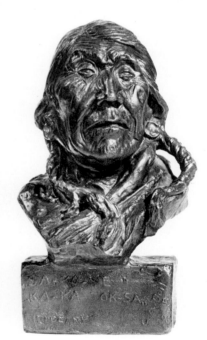

304

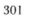 Main Trail Galleries, Scottsdale, Ariz.

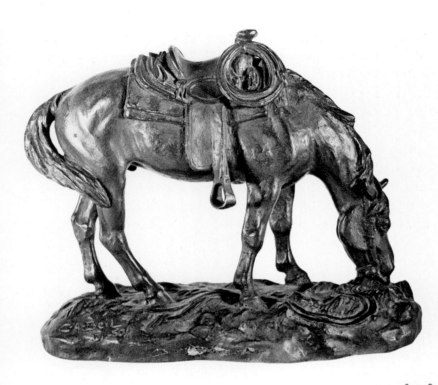

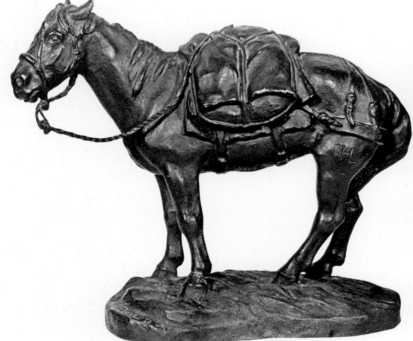

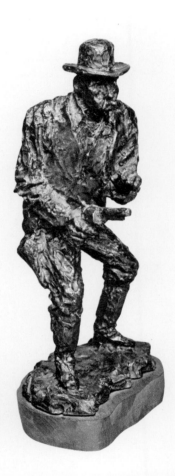

305. Charles A. Beil. *Saddle Horse Grazing*. 1948. Cast by the artist in Banff, Alberta. H. 11½″. C. M. Russell Gallery, Great Falls, Mont.

306. Charles A. Beil. *Pack Horse*. 1948. Cast by the artist in Banff, Alberta. H. 12″. C. M. Russell Gallery, Great Falls, Mont.

307. Lawrence Barrett. *The Gunslinger*. 1967. Cast by the artist. H. 10⅝″. Private collection

horseback riding. She was especially interested in equestrian sculpture and while visiting a ranch in British Columbia, she decided to create sculptures on Western themes. She was clearly influenced by Remington in her selection of subjects. Her largest equestrian group, entitled *Payday Going to Town (plate 309)*, is similar in theme and composition to Remington's *Coming Through the Rye (plate 133)*. She also created a sculpture entitled *Horse and Rider (plate 310)*, in which a cowboy performs the acrobatic feat of retrieving his hat from the ground. Two motion-filled equestrian bronzes are entitled *The Sun Fisher (plate 312)* and *Scratchin' 'Im (plate 311)*.

Sally Farnham's bronzes are highly realistic, although they lack much of the energy and dynamic power of Remington's works. Her sculptures have instead an elegant naturalism, close in feeling to that of the nineteenth-century French animal sculptors.

Mrs. Farnham enjoyed a most successful career. She created many war memorials and heroic portraits. In 1916, she won a competition for an equestrian statue of Simón Bólivar for Central Park in New York. The statue was unveiled in 1921. Although she made many portraits of famous political leaders and artists, the only one which can be considered Western is a statue of Will Rogers on his pony, *Soapsuds (plate 313)*.

Gertrude Vanderbilt Whitney's equestrian portrait of Buffalo Bill *(plate 314)* is the essence of the romanticized Western horseman. Her sculpture stands in front of the Buffalo Bill Historical Center in Cody, Wyoming, the home town of William S. Cody. Here, with the Wyoming mountains as a background, her portrait truly breathes the spirit of the West.

Gertrude Vanderbilt (1877–1942) was the daughter of Cornelius and Alice Claypoole Vanderbilt. After her marriage to Harry Payne Whitney, she began her career as a sculptor. She studied under James Earle Fraser and Henrik Andersen in New York, and Andrew O'Connor and Auguste Rodin in Paris.

Her best-known sculptures are commemorative monuments and memorials. In 1912, she designed the *Aztec Fountain* to be placed in front of the courtyard of the Pan-American Union Building in Washington, D.C. During her lifetime, Mrs. Whitney won many medals and honors. She was the founder of the Whitney Museum of American Art in New York.

Although primarily a sculptor of animal life, Madeleine Park (1891–1960) created several Western bronzes. Her portraits of two Indian leaders, Osceola *(plate 255)*, the Seminole war leader, and Charles Curtis *(plate 257)*, Vice-President of the United States under Herbert Hoover, stand in the National Hall of Fame for Famous American

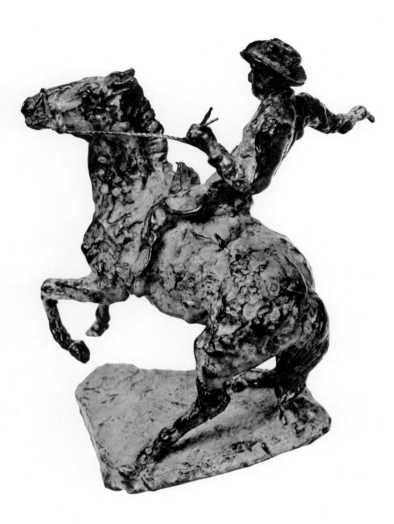

308. Lawrence Barrett. *Off Balance*. 1966. Cast by the artist. H. 8″. Colorado Springs Fine Arts Center, Colo.

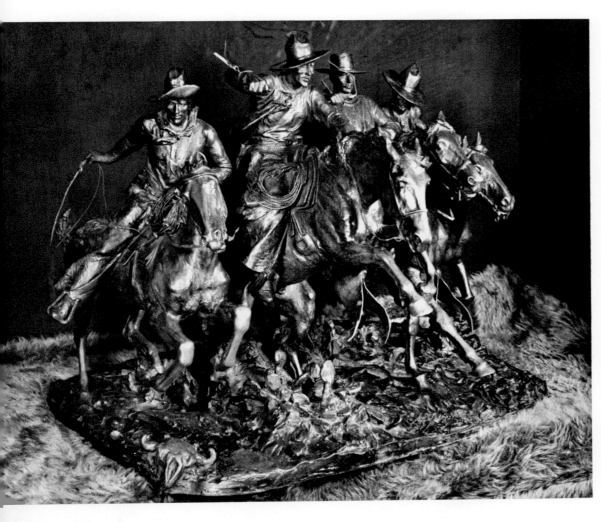

309. Sally James Farnham. *Payday Going to Town*. 1931. Roman Bronze Works, N.Y. H. 18″. Woolaroc Museum, Bartlesville, Okla.

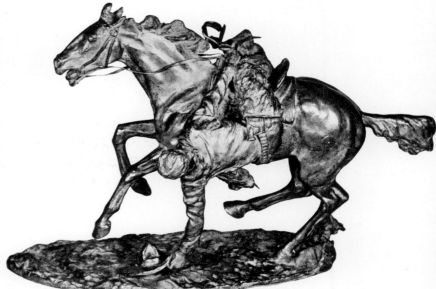

310. Sally James Farnham. *Horse and Rider*. c. 1900. Roman Bronze Works, N.Y. H. 9½″. Remington Art Memorial Museum, Ogdensburg, N.Y. This bronze, one of the artist's earliest works, was a gift to Remington

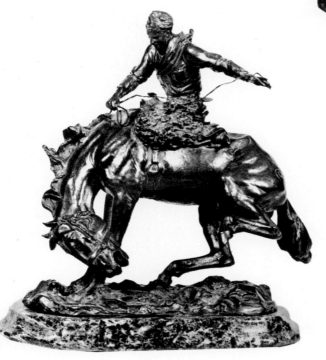

311. Sally James Farnham. *Scratchin' 'Im*. Roman Bronze Works, N.Y. H. 12¾″. R. W. Norton Art Gallery, Shreveport, La.

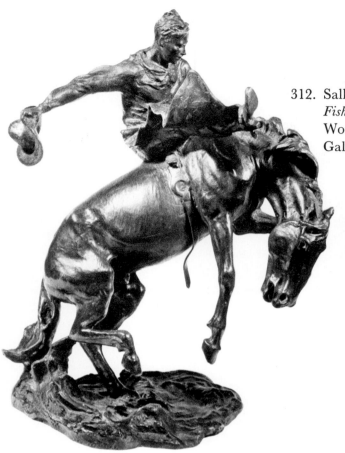

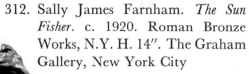

312. Sally James Farnham. *The Sun Fisher*. c. 1920. Roman Bronze Works, N.Y. H. 14″. The Graham Gallery, New York City

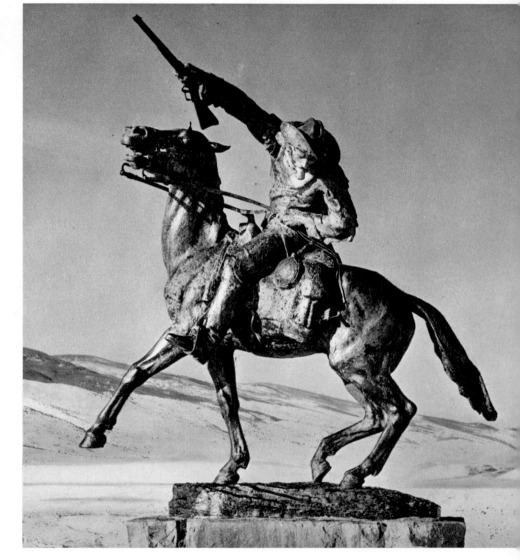

313. Sally James Farnham. *Will Rogers*. Modeled 1938. Roman Bronze Works, N.Y. H. 21″. The Graham Gallery, New York City

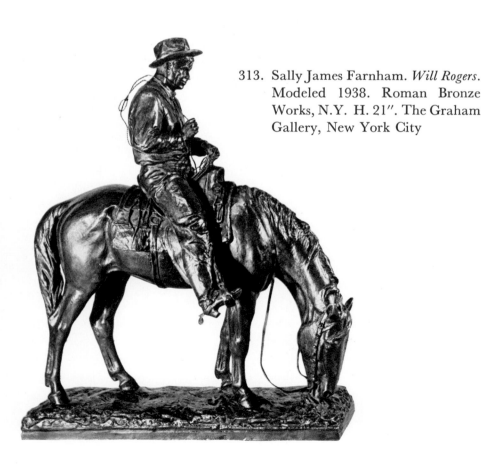

314. Gertrude Vanderbilt Whitney. *Buffalo Bill Cody—The Scout*. 1923. Roman Bronze Works, N.Y. H. 12′5″. Buffalo Bill Historical Center, Whitney Gallery of Western Art, Cody, Wyo.

315. Madeleine Park. *Brahma Bull*. H. 13″. Whitney Gallery of Western Art, Cody, Wyo.

Indians in Anadarko, Oklahoma.

Miss Park had the opportunity to study under Alexander Phimister Proctor, a master sculptor of both animal life and pioneer history. It is possible that Proctor's work was the inspiration for her Western sculptures. *Brahma Bull (plate 315),* Miss Park's bronze of a cowboy tossed from a bull, is in the Whitney Gallery of Western Art in Cody, Wyoming (which forms part of the Buffalo Bill Historical Center). In later life, Miss Park traveled around the world to study animal forms, but her favorite place to study animals remained the circus.

One of the most important migrations westward was that of the Mormons in the 1830s and 1840s. Joseph Smith, founder of Mormonism, organized the Church of Jesus Christ of the Latter-Day Saints at Fayetteville, New York, in 1830 and printed *The Book of Mormon.* The new religion attracted many followers. Seeking a land where they could practice their religion freely and live by their own precepts and laws, the Mormons migrated westward and established headquarters at Kirkland, Ohio, in 1833; at Independence, Missouri, in 1838; and at Nauvoo, Illinois, in 1839. At each new settlement, the Mormons found it impossible to co-exist with the non-Mormons. In Illinois, this conflict grew more bitter and the Mormon leaders were jailed. On June 27, 1844, a mob stormed the jail in Carthage and killed Joseph Smith.

The quorum of Mormon Apostles selected Brigham Young as their new leader. Young and his followers traveled westward over a thousand miles, to the Valley of the Great Salt Lake in Utah. They reached their promised land in July of 1847. Young, on viewing the valley which was to be their new home, declared: "This is the place." Salt Lake City was built as "the New Jerusalem." After Utah became a Territory of the United States, Young served as its Governor from 1850 until 1857.

The history of the Mormons' migration and the settlement of their promised land in Utah has been a source of artistic inspiration for sculptors of several generations. The first prominent Mormon sculptor was Cyrus Dallin, discussed earlier in this book.

Mahonri MacIntosh Young (1877–1957) was a grandson of Brigham Young and the son of Mahonri M. Young and Agnes MacIntosh Young. His father was a skilled woodcarver. As a very small boy, Mahonri lived at the Deseret Woolen Mills, outside of Salt Lake City. Here he practiced modeling birds and animals from clay. When he was seven, shortly after the death of his father, Mahonri, his mother, and twin brothers moved to Salt Lake City, where the children attended public school. Having won considerable praise for his

316. Mahonri MacIntosh Young. *This is the Place Monument* (detail of plate 318)

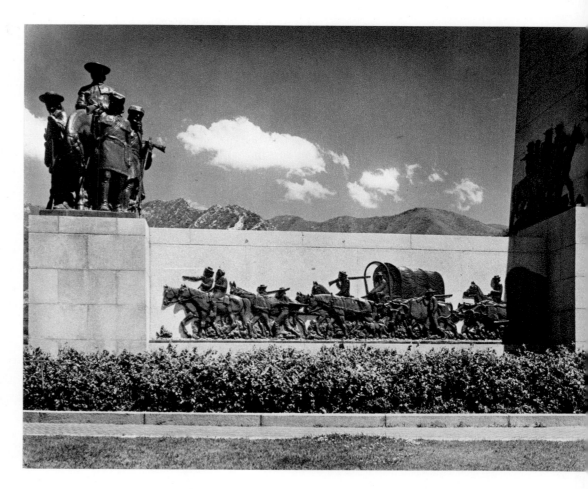

317. Mahonri MacIntosh Young. *This is the Place Monument* (detail of plate 318)

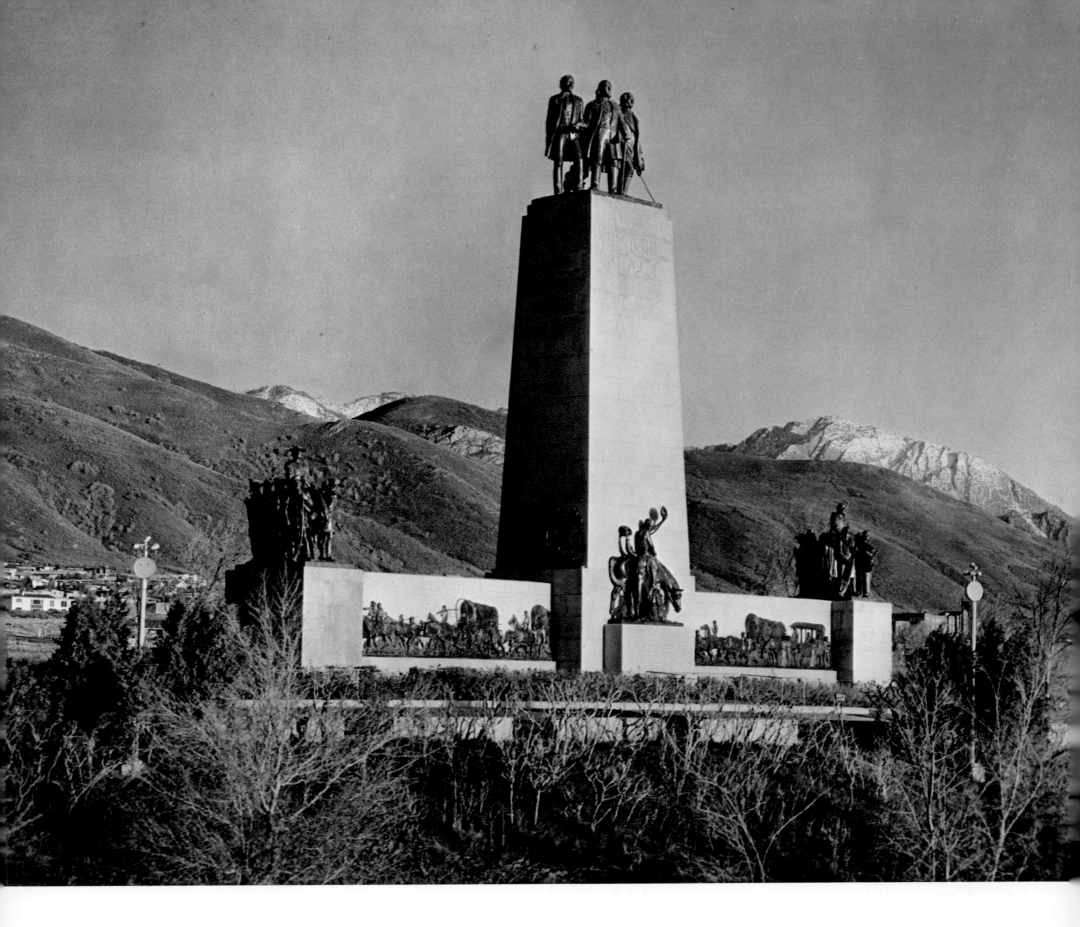

318. Mahonri MacIntosh Young. *This is the Place Monument.* 1947. Rochette and Parzini Corp. Heroic size. Emigration Canyon State Park, Salt Lake City, Utah

drawing ability, Mahonri decided to become an illustrator and studied drawing in Salt Lake City under James T. Harwood.

The visit of Cyrus Dallin to Salt Lake City to create the *Brigham Young Pioneer Monument (plates 503, 506)* excited Mahonri's imagination and he developed the ambition to become a sculptor. In order to earn the money for a formal art education, Young worked for the *Salt Lake Tribune* as an illustrator. He then studied in New York at the Art Students League and in Paris at the Académie Julian and the Académie Recluse. Although he had initially studied drawing and painting, he renewed his ambition to become a sculptor after a visit to Italy.

Young's first bronzes were studies of men working at everyday labors. On his return to Salt Lake City, he was commissioned to create a monument to the sea gulls *(plate 505)*, dedicated to the birds that had saved the Mormon crops from the locust plague. In 1912, Young traveled to Arizona. His visits to the Apache, Navaho, and Hopi reservations stimulated his interest in Western subjects. He made several habitat Indian groups for the American Museum of Natural History in New York City. Following this trip, he also created many drawings, paintings, and sculptures of the American West. Young's Western bronzes are of Indians, cowboys, and animal life *(plates 319–323)*. However, throughout his career, Young remained interested in extolling his Mormon heritage. He created a *This is the Place Monument (plates 316–318)* for Emigration Canyon State Park along the Mormon Pioneer Trail in Salt Lake City, Utah.

Young won many honors and awards for his work. In later years, he taught sculpture and wrote the article on modeling for the Encyclopaedia Britannica. His finest works are those portraying the dignity of labor *(plate 324)*. Young's sculptures are not didactic, but illustrate the harmony and beauty of the human figure.

One of the most interesting tributes to the historic West is *The Pioneer Woman* by Bryant Baker in Ponca City, Oklahoma. The monu-

319. Mahonri MacIntosh Young. *Rolling His Own.* c. 1928. Roman Bronze Works, N.Y. H. 13¼". Philip Ashton Rollins Collection of Western Americana, Princeton University, Princeton, N.J.

320. Mahonri MacIntosh Young. *Rolling His Own* (detail of plate 319)

ment carries this inscription: "In appreciation of the heroic character of the women who braved the dangers and endured the hardships incident to the daily life of the pioneer and homesteader in this country."

Earnest W. Marland, an oilman-philanthropist and tenth Governor of Oklahoma, conceived the idea of this giant memorial honoring the pioneer woman. In October 1926, he invited twelve leading American sculptors to submit a design in the form of a bronze model, for which they were paid two thousand dollars to cover expenses. The artists who entered the competition were: James Earle Fraser, Hermon Atkins MacNeil, Mahonri MacIntosh Young, A. Sterling Calder, Jo Davidson, John Gregory, F. Lynn Jenkins, Bryant Baker, Wheeler Williams, Maurice Sterne, Mario J. Korbel, and Arthur Lee. Four months later, the bronzes were sent on a tour across the nation and 750,000 people voted for their selection.

Bryant Baker's model *(plate 325)* was the popular choice by an almost two-to-one margin. His model was enlarged into a giant monument seventeen feet high, weighing twelve thousand pounds. On April 22, 1930, the anniversary of the first run for land in Oklahoma, the statue was unveiled in its permanent location at Ponca City. Will Rogers gave the dedication address. The site, taken from a corner of

321. Mahonri MacIntosh Young. *Pony Express Rider*. c. 1932. Roman Bronze Works, N.Y. H. 15″. B. F. Larsen Gallery, Harris Fine Art Center, Brigham Young University, Provo, Utah

322. Mahonri MacIntosh Young. *Lunch in the Desert*. c. 1930. Roman Bronze Works, N.Y. H. 8″. B. F. Larsen Gallery, Harris Fine Art Center, Brigham Young University, Provo, Utah

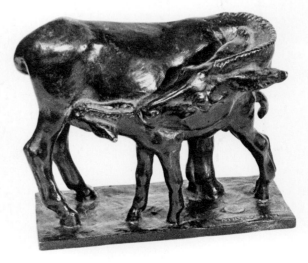

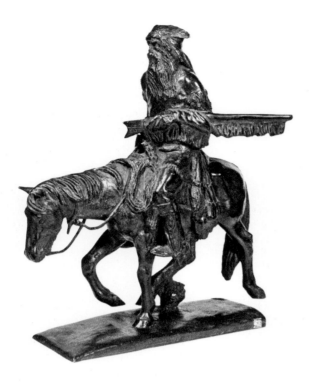

323. Mahonri MacIntosh Young. *Frontiersman and Indian Scout.* c. 1932. Plaster. H. 16″. B. F. Larsen Gallery, Harris Fine Art Center, Brigham Young University, Provo Utah

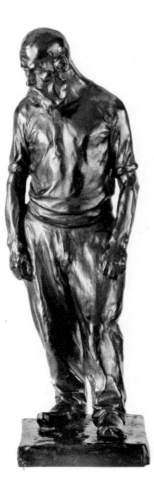

324. Mahonri MacIntosh Young. *Laborer.* c. 1907. Roman Bronze Works, N.Y. H. 16″. Cranbrook Art Gallery, Bloomfield Hills, Mich.

Mr. Marland's estate, is a quarter-section of the land homesteaded in 1893. It was chosen because it was part of the last "free" land in America, the Cherokee Strip.

Baker's model depicts a heroic woman, striding forward in her sunbonnet, leading her young son by the hand. Holding a Bible, she looks fearlessly to the future. The boy, like his mother, is unafraid. His fist is clenched with determination.

Baker was born in England in 1881. He completed several royal portrait commissions before going to the United States in 1916. In America, he enjoyed great popularity for his commemorative statues and portrait busts. Baker's bronze statues of prominent political figures are in public locations throughout the United States.

Baker was the last man to enter the competition sponsored by Marland. He had only a month to prepare his model and obtain a casting. He used a New York actress as his model. Baker wrote of his composition:

The subject held special appeal for me. . . . I always think of her as a mother, looking with proud eyes on her son. He is to be the man of to-morrow who will achieve the big things she has dreamed about in the prairie schooner and back on the farm she left to go adventuring. Therefore I have shown her with her son. She has him by the hand, both leading and protecting him. Some one told me a pioneer boy of a hundred years ago would not have worn a double-breasted vest; that a woolen shirt would have been more in keeping with the times. Now, I have chosen to think a little differently of the boy and his mother. She was proud of him and back there in the East, where she started from, there was a father or grandfather who wore a vest like that, keeping up the traditions of other days. So I have fancied that my pioneer woman would want a vest of the same kind for her son.

She seems young to me, young enough to be a sweetheart and a mother, too. But she has known struggle and overcome trials. You can see it in her poise, in the way she looks upon the world. There is a fine courage about her. She is going on to meet whatever lies ahead.[3]

Baker, however, finally yielded to public pressure and changed the boy's costume to the woolen shirt more typical of frontier life.

Baker said of his creation: "I wanted to depict courage and faith as my pioneer woman stepped out without fear, doubt, or uncertainty—a moving force like the great nation itself."[4] Baker also created a *Pioneer Man (plate 326)* as a companion piece to his *Pioneer Woman.*

The model by F. Lynn Jenkins was second in the popular vote, although many of the urban art critics preferred the models by Fra-

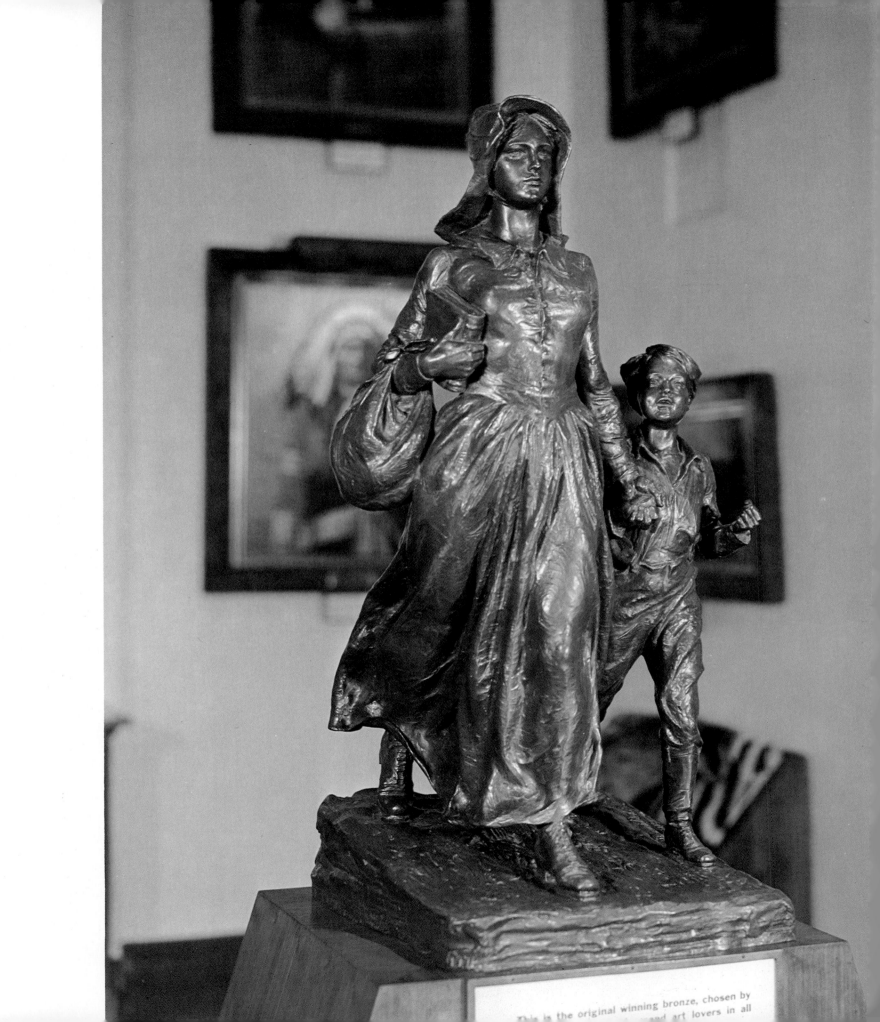

This is the original winning bronze, chosen by
_____ and art lovers in all

325. Bryant Baker. *Pioneer Woman.* c. 1927. H. 32″. Woolaroc Museum, Bartlesville, Okla. This is the smaller version of the monument in Ponca City, Oklahoma

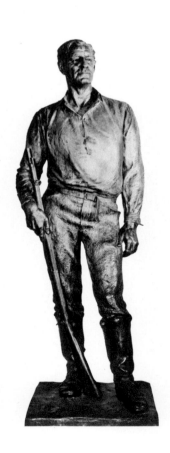

326. Bryant Baker. *Pioneer Man.* 1928. H. 87″. Woolaroc Museum, Bartlesville, Okla.

ser and MacNeil to those by Baker and Jenkins. The only artist not to include a child in his interpretation of the pioneer woman was Jo Davidson. Five of the models bear firearms, and MacNeil's woman carries a fire axe, the symbol of her hard work. All but three artists portrayed her in a sunbonnet, for Marland had told the competing artists that he wanted a figure of heroic proportions to express "the spirit of the pioneer woman. . . . all women of the sunbonnet everywhere."[5] A. Sterling Calder described the inspiration for his model:

I went out to Oklahoma looking for a woman in a sunbonnet, such as Mr. Marland's idea suggested, and had been there only a few days when a court-house was dedicated at Newkirk. This was an occasion of no little importance, and the people came to town in holiday numbers. . . . In all the host of people, going in and out, up-stairs and down, I failed to note my pioneer woman. There were many sturdy matrons about, untouched by fashion, but hardly a frontier woman.

Then toward the close of the afternoon, and the ceremonies as well, my search was unexpectedly rewarded. My pioneer woman passed me and went up-stairs—a spare middle-aged woman, simply drest, wearing a black sunbonnet. I never shall forget the throbbing of my heart as she passed. The sunbonnet was not a legend of the past, but still in use. And I sat there in patience until the woman came down again, noting every line of her face and person.

She carries life and death in her hands, a child and a gun. Both were such familiar parts of frontier life that I have sought to express them in the model. And it seems to me the vigorous mother was a more perfect expression of frontier days than the withered woman sometimes depicted. It has been my effort to interpret her simply. I have thought of no school or sculptural style, but of the woman herself and the times in which she lived.[6]

At the dedication ceremony, Marland declared his purpose in commemorating the pioneer women:

We have erected monuments to our war heroes, to the hearty pioneers who wrested from the wilderness, from the plains and from the desert this nation of ours, but have we preserved the memory of the women, the blue-eyed Saxon maid and her dark-eyed Latin sister who married their men and set out with them on their conquest of the west, faced with them the months of arduous toil and terrible dangers?

All nations, all races, all creeds, gave their best and bravest women, who became the unknown soldiers in the great battle for civilization and homesteads. They won. Theirs was a lonely victory, with no eyes

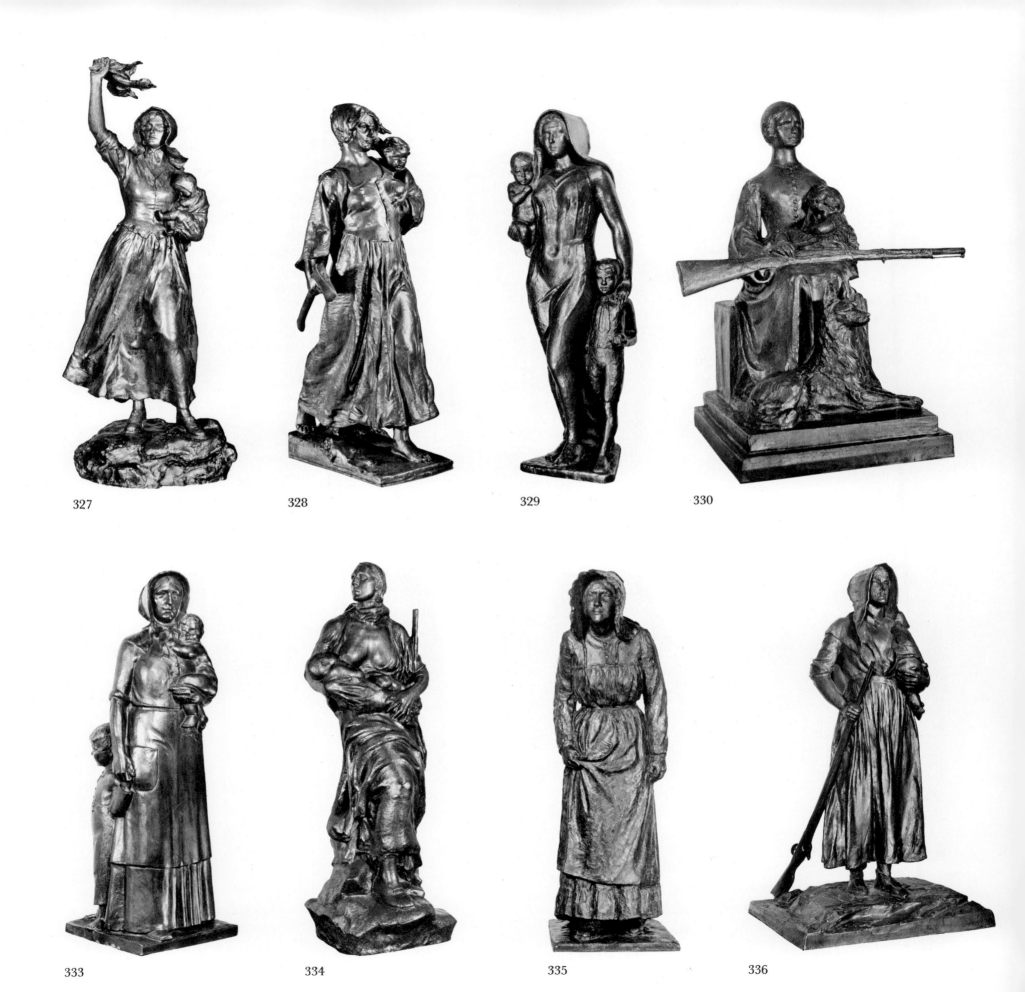

327

328

329

330

333

334

335

336

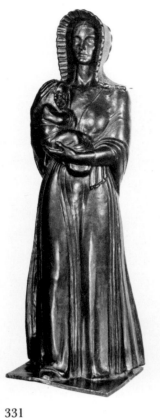

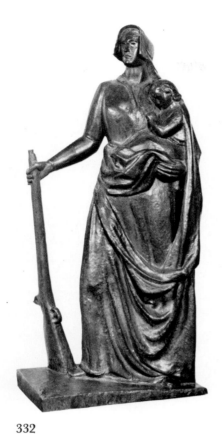

331

332

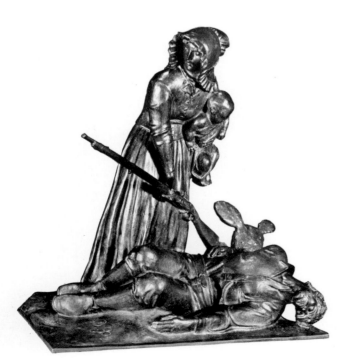

337

327. F. Lynn Jenkins. *Pioneer Woman.*
1927. H. 36″. Woolaroc Museum,
Bartlesville, Okla.

328. Hermon A. MacNeil. *Pioneer Woman.* 1926. H. 35″. Woolaroc Museum, Bartlesville, Okla.

329. Arthur Lee. *Pioneer Woman.* c.
1927. Kunst Foundry, N.Y. H.
36″. Woolaroc Museum, Bartlesville, Okla.

330. Mario J. Korbel. *Pioneer Woman.*
1927. Roman Bronze Works, N.Y.
H. 34″. Woolaroc Museum, Bartlesville, Okla.

331. Wheeler Williams. *Pioneer Woman.*
1926. Siot Deraucville. H. 35″.
Woolaroc Museum, Bartlesville,
Okla.

332. Maurice Sterne. *Pioneer Woman.*
1927. H. 43″. Woolaroc Museum,
Bartlesville, Okla.

333. Mahonri MacIntosh Young. *Pioneer Woman.* 1927. Roman Bronze
Works, N.Y. H. 36″. Woolaroc
Museum, Bartlesville, Okla.

334. James Earle Fraser. *Pioneer Woman.* 1927. Roman Bronze Works,
N.Y. H. 36″. Woolaroc Museum,
Bartlesville, Okla.

335. Jo Davidson. *Pioneer Woman.* 1927.
Roman Bronze Works, N.Y. H.
35″. Woolaroc Museum, Bartlesville, Okla.

336. A. Sterling Calder. *Pioneer Woman.*
1927. Roman Bronze Works, N.Y.
H. 40″. Woolaroc Museum, Bartlesville, Okla.

337. John Gregory. *Pioneer Woman.*
1926. H. 32″. Woolaroc Museum,
Bartlesville, Okla.

to watch the gallant charge on the enemy. With this monument, I
hope to preserve for the children of our children the story of our
mothers' fight and toil and courage.[7]

The eleven artists who did not win the competition each received
ten thousand dollars from Marland, who later sold the bronzes to
Frank Phillips for the Woolaroc Museum in Bartlesville, Oklahoma.
All twelve models *(plates 325, 327–337)* are on display in a single room
of the museum, a most impressive tribute to the pioneer woman.

The sculptors who participated in the competition for *The Pioneer
Woman* monument were the last generation of artists to have personal
memories of the American frontier. Bryant Baker, the winner, had no
personal experience of Western pioneer life; but among the other
sculptors, a few remained who had witnessed first-hand the last days
of the pioneer West. Contemporary artists, born in the twentieth cen-
tury, have created many bronzes depicting different aspects of the
Western frontier. These bronzes, however, portray scenes and people
known to them only through historical research, stories of the past,
and a colorful imagination.

The pioneers, trappers, and Indian warriors of the historic West
belong to a bygone era. The cowboys, Indians, and animals of the
twentieth-century American West still inspire sculptures of great
merit. For these works to have artistic validity, however, sculptors
must have a fresh vision of the American West.

XIX
INNOVATION AND EXPERIMENT

The art of the American West is basically a realistic art. By definition, both painting and sculpture which are Western must be representational creations. To many viewers, much of the pleasure of Western art comes from the recognition of the familiar, whether it is an animal in a natural pose or a glimpse of historic persons and events. Others, interested in Western history, require authenticity in the re-creation of the past.

Western sculptors continued to create representational works throughout the twentieth century in defiance of sweeping worldwide changes in art styles and subjects. Although sculptors in general were slower than painters to embrace highly abstract and nonobjective art, most Western sculptors remained completely immune to the temptations of modern art.

Part of the change from naturalism to abstraction was due to the perfection of the camera. In the achievement of absolute realism, the results of the photographer were unsurpassable. Artists therefore became interested in exploring different forms of expression and experimented with the possibilities unique to each medium. To many sculptors, variations of surface texture, form, line, and space became more interesting than their chosen subject. Indeed, much twentieth-century sculpture became completely nonrepresentational.

Yet as the emphasis in art shifted from subject to technique, the art of the American West remained an exception. Western art is a form of romantic art. There is a spirit of the West, a celebration of a way of life, a delight in nature which the camera cannot recapture. Western sculpture idealizes the past and glorifies the present, and each sculptor has an ideal vision which he feels he alone can portray. The admirer of Western art is also a romantic, and the romantic's enjoyment of Western sculpture depends on artistic inspiration, not scientific re-creation.

Many Western sculptors early in the century had a sense of mission about their artistic creations. They wished to use their skill to give permanent form to life in the rapidly changing West. Each re-created

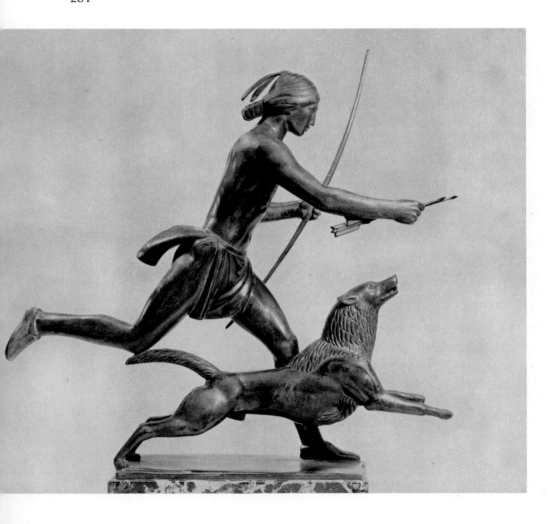

338. Paul Manship. *Indian Hunter with
Dog* (right view). 1926. H. 23¼".
The Metropolitan Museum of Art,
New York City. Gift of Thomas
Cochran, 1929

and extolled the world to which he had been an inspired witness.

During the twentieth century, several sculptors of Western themes, although faithful to representational art, began to experiment with new forms of expression. As they became interested in technical innovation, the subject represented often became secondary in importance to the means of artistic expression. Innovation in Western sculpture took two basic directions: Stylized (Academic) Abstraction and Impressionism.

In Stylized Abstraction, the artist reduced nature to its decorative essence or to the ultimate in abstract form and composition. Some artists worked to obtain ornamental patterns and rhythms in their work. Others experimented with the simplification and abstraction of form, and studied the interplay of mass and space. Many sculptors working in this style were strongly influenced by the eclecticism of the American Academy in Rome.

Most of these early Academic Abstractionists were not "Western" artists. They saw the Indian as a classic subject, a basic form of American life, high in decorative value. They also created bronzes of animal life. In these sculptures, the artists were interested in the aesthetic value of their subjects, not the creation of a historic or a contemporary portrait of the West.

Several of the followers of the Academic Abstractionists used a similar style to portray cowboys and bucking horses. These later artists, however, were interested in capturing the spirit of the American West in their formal aesthetic creations.

In 1912, at an exhibition in New York, Paul Manship (1885–1966) introduced a new style of sculpture to America. Using the themes and techniques of many ancient civilizations, Manship simplified and abstracted his subject to produce a classic and personal work of art. Beatrice Gilman Proske hailed Manship as "the sculptor who more than any other determined the character of at least two decades of American sculpture."[1]

Born in St. Paul, Minnesota, Manship first studied art at Mechanics Art High School and at evening classes at the St. Paul Institute of Art. Manship initially had hoped to become a painter, but discovering he had little sensitivity for color, decided to become a sculptor. He first practiced modeling masks of members of his family. Manship left school at age seventeen to begin his career as an artist. He worked for a year for an engraving company before deciding to work independently as an illustrator and designer.

At nineteen, Manship went to New York in hopes of improved artistic instruction and better opportunities to advance his career. He studied at the Art Students League for a few months. During his first

summer in New York, he had the good fortune to become Solon Borglum's assistant. This was the opportunity he had hoped for. Borglum taught Manship to dissect dogs and horses in order to acquire a thorough knowledge of anatomy. Manship assisted Borglum in the execution of two heroic-size equestrian monuments, *General John B. Gordon* and *Bucky O'Neill (plate 76)*. Manship and Borglum remained friends for many years.

Manship next studied under Charles Grafly at the Pennsylvania Academy of the Fine Arts. In the summer of 1907, Manship and the sculptor Hunt Diederich traveled to Spain for a walking tour through Andalusia. This was Manship's first contact with the artistic traditions of the past.

Following his return from Spain, Manship spent two years as an assistant to Isidore Konti. In 1909, Konti persuaded Manship to enter a sculpture entitled *Rest After Toil* in a competition for a scholarship at the American Academy in Rome. Manship was less impressed by the art of Renaissance Italy than by that of ancient Rome. In studying Roman and Greek sculpture, he found his models in the creations of Pompeii and Naples, Athens and Delphi.

During these years, Manship traveled East, where he was influenced by Egyptian, Minoan, and Assyrian styles. He was especially inspired by the decorative motifs on Greek vases. He believed these achieved the ideal balance between silhouettes and free space.

Manship used the techniques of Renaissance, Roman, and Greek sculpture to achieve a personal style. He possessed the ability to immerse himself in the art of other civilizations without losing his identity.

When Manship returned to New York in 1912, his work was praised by both progressive and conservative critics. A craze for his work developed. The young artist was besieged with commissions and bestowed with medals and prizes of every description. His most famous creation is the *Prometheus Fountain* at Rockefeller Center in New York City.

Manship's early sculpture is totally decorative in quality, the details conforming to rhythmic patterns. Manship believed the role of the artist was to give formal structure to nature.

In about 1916, Manship added elements of the art of India to his already eclectic style. In 1914, he had created the bronze sculpture group *Indian and Pronghorn Antelope (plate 340)*, which is an excellent example of his decorative art. The forms are reduced to stylized silhouettes and the details appear to be drawn rather than modeled.

In 1926, Manship created a sculpture entitled *Indian Hunter with Dog (plates 338, 339)*. In this work, he achieved a decorative balance

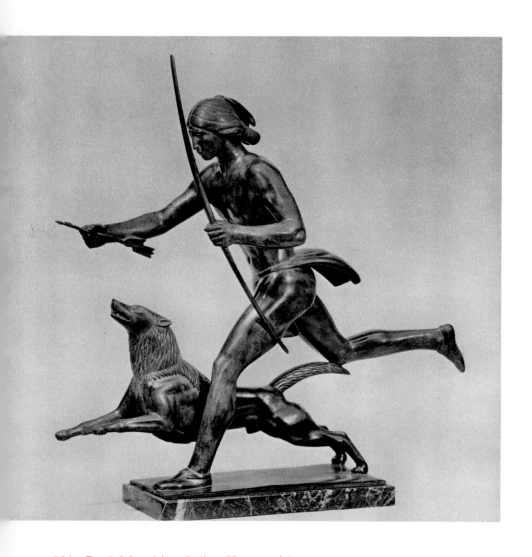

339. Paul Manship. *Indian Hunter with Dog* (left view)

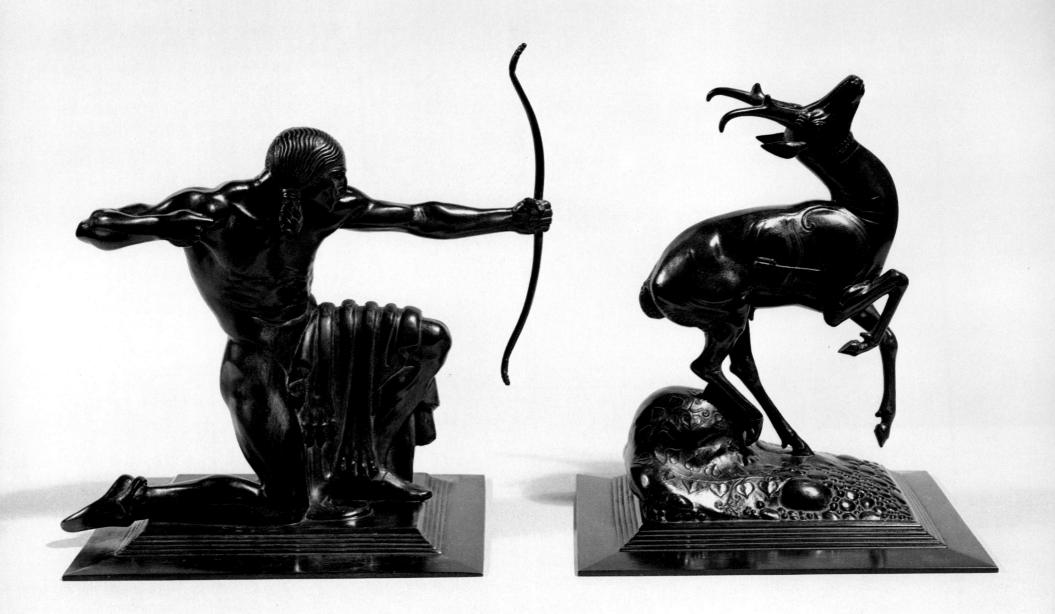

340. Paul Manship. *Indian and Pronghorn Antelope*. 1914. Roman Bronze Works, N.Y. Indian: H. 13″; Antelope: H. 12½″. The Metropolitan Museum of Art, New York City. Bequest of George Dupont Pratt, 1935

of forms whose effect is heightened by the interplay of line and open space.

There is a great similarity between Manship's stylized two-dimensional interpretations of Indian and animal forms and those seen in paintings by American Indian artists. This is especially true of those paintings which were the products of the Santa Fe Indian School Studio during the 1930s and the work of many contemporary Indian artists who work in the traditional stylized manner. It is difficult to account for this resemblance, but the similarity gives Manship's sculpture an added dimension of interest.

Manship was interested in finding a style of art which would blend with contemporary life. Much of the architecture, furniture, and decorations of the 1920s and 1930s are in a style now referred to as Art Deco—a style primarily concerned with the formal patterns of lines. Many of Manship's early sculptures can be seen as expressions of Art Deco.

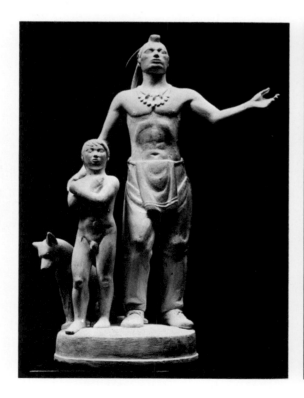 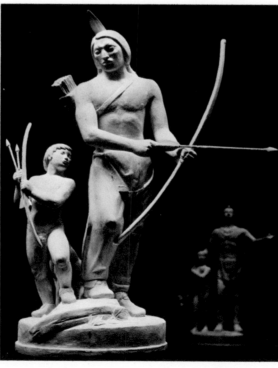 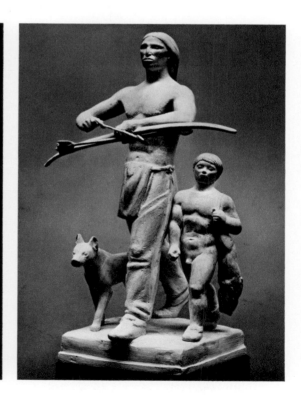

341. Paul Manship. *Appeal to the Great Spirit*. 1947. Bruno Bearzi Foundry, Florence, Italy. H. 12½". Photo courtesy of John Manship

342. Paul Manship. *Lesson in Archery*. 1947. Bruno Bearzi Foundry, Florence, Italy. H. 11½". Photo courtesy of John Manship

343. Paul Manship. *Indian Hunter*. 1947. Bruno Bearzi Foundry, Florence, Italy. H. 11½". Photo courtesy of John Manship

During the late 1920s, Manship's style changed. He became more concerned with the abstraction of sculptural mass. He greatly simplified his design and became economical in his use of decorative detail. These more realistic bronzes *(plates 341–345)* have a greater monumentality than his earlier work.

During these years, Manship created a portrait of *Abraham Lincoln the Hoosier Youth*. Even in his portraits, Manship's primary concern was with his artistic creation rather than the subject represented. Edwin Murth, in his study of Manship, wrote of the Lincoln portrait:

The *Abraham Lincoln the Hoosier Youth* is not dependent upon the dignity of its subject for its value. Its strength would hardly be diminished even if the young man represented were other than Lincoln, for it lies in the powerful composition that has been imposed upon the subject. Every part of the statue is blended into a unified design—the hound, the axe, the oak stump, and the folds in the shirt and trousers—a design that leads upward in an elongated pyramid to the noble head of the young Lincoln.[2]

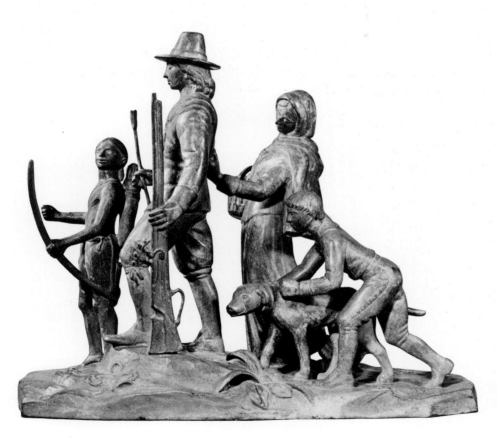

344. Paul Manship. *Colonial Settlers.* 1962. Bruno Bearzi Foundry, Florence, Italy. H. c. 6″. Photo courtesy of John Manship. This statue was designed to decorate the steps of the Capitol Building in Washington, D.C.

Paul Manship created a stylistic revolution in American sculpture. Beatrice Gilman Proske's tribute to him underlines the essentials of Manship's contribution:

Manship had the rare gift of historical imagination. He could project himself into another culture, extract its essence, and make it his own. What he took from archaic Greece was not so much the formal curls of hair and sharply folded garments as a way of seeing the human form; from Eastern art not so much certain postures as a sinuous grace, a concept of the body moving through space. These diverse elements were fused by the white heat of his imagination into something entirely his own.[3]

The sculpture of C. Paul Jennewein (b.1890) followed in the tradition of Manship's work. Basically an academic sculptor, Jennewein worked in an eclectic, decorative style which was highly praised by conservative critics of American sculpture. During his lifetime, Jennewein was recognized as the leader of academic sculpture in America.

Jennewein was born in Stuttgart, Germany. He left school at age thirteen to serve an apprenticeship to a museum technician. For three years, he learned painting, modeling, casting, and many other skills which served him throughout his life. During this time, he also studied the history of art.

Jennewein decided to travel to the United States in hopes of enter-

ing an architectural office. He accepted an apprenticeship with a firm of architectural carvers and studied painting and sculpture in evening classes at the Art Students League. In 1912, having won the Avery Prize offered by the Architectural League, he left on a two-year tour of Italy, Germany, France, and Egypt.

After his return to the United States, Jennewein entered the competition for the Prix de Rome. While awaiting the outcome, he enlisted in the National Guard and served on the Mexican border. In 1916, while in Mexico, he received the news that he had won the prize. He received an honorable discharge and in 1917 set out for Rome.

Jennewein studied from 1917 to 1919 at the American Academy in Rome. Like Manship, he utilized the decorative motifs of Greco-Roman art in his stylized and graceful sculpture. He created highly polished surfaces to explore the rhythms and harmony of line and mass.

In 1921, Jennewein returned to New York and opened a studio. He enjoyed great success and received many commissions for architectural sculpture, commemorative statues, and memorials.

Jennewein, like Manship, saw the American Indian as a classical subject. While serving on the Mexican border, he had many opportunities to study the Indian. For a war memorial at Tours, France, he created the statue *Indian and Eagle (plate 346)*. The sculpture portrays an Indian releasing an eagle, the symbol of freedom. Jennewein exhibited this sculpture at the Pennsylvania Academy of the Fine Arts and won the Weidener Gold Medal Award.

A. Sterling Calder (1870–1945) is a transitional figure in the history of American sculpture. His early works followed the traditions of the Beaux-Arts style. In about 1920, however, he developed a style based on simplified, stylized forms. *Indian Brave (plate 347)* exemplifies Calder's more abstract approach to a traditional Western theme.

The first American sculptor to transform the eclecticism taught by the American Academy in Rome and the decorative abstractions of Paul Manship into a formal celebration of the American West was Lawrence Tenney Stevens (1896–1972). Stevens devoted twelve years to the creation of his *Rodeo Series* of nine bronze sculptures *(plates 348–356)*.

Born in Boston, Stevens spent his boyhood making sculptures and drawings of cowboys and Indians and animals of the forest, mountains, and plains:

I'd never been West, but I wanted to express it. I used to make 12-inch models in high action, day after day, in the stable hay-loft I used as

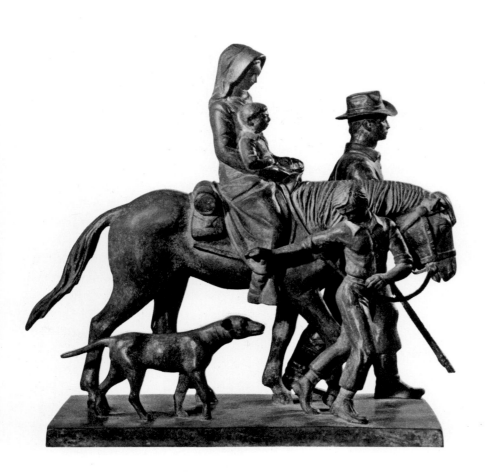

345. Paul Manship. *Western Pioneers.* 1962. Bruno Bearzi Foundry, Florence, Italy. H. c. 6″. Photo courtesy of John Manship. This statue was designed to decorate the steps of the Capitol Building in Washington, D.C.

346. C. Paul Jennewein. *Indian and Eagle*. 1929. Roman Bronze Works, N.Y. H. 58″. Brookgreen Gardens, Murrells Inlet, S.C.

my studio. Then, at sundown, I'd place one of these before the window looking West, retire to the other end of the loft and sit and dream as I looked at the model silhouetted against the fiery red sunset.

Looking back, I can now realize that this seed was nurtured through years of learning to take bloom these past twelve years in the execution of the Series.[4]

Stevens' formal training began at the Boston Museum School of Fine Arts. He studied with Charles Grafly and took several courses in anatomy at Tufts University's Medical School. Stevens won the Prix de Rome Scholarship for the years 1922 to 1925. While abroad, he had the opportunity to travel in Greece and Egypt, as well as Constantinople and many other art centers of the Near East. Stevens' art was strongly influenced both by the eclecticism of the American Academy in Rome and by his Eastern travels. He developed a style which had elements of Greek Classic and Archaic sculpture.

When Stevens returned to the United States, his sculpture was well received, since his style was perfectly attuned to the aesthetic tastes of the 1930s. He completed many commissions for reliefs, portrait statues, and public monuments. He also created several sculptures of animals.

In 1936, Stevens was in charge of sculpture at the Texas Centennial Exposition in Dallas. He executed three giant statues which were symbolic of Spain, the Confederacy, and Texas.

Stevens made several trips to the Far West. In 1937, he enjoyed an extended Western trip in a trailer equipped as a studio. He developed a fanatical love for the life and natural beauty of the West. Stevens lived in many parts of the West, and following World War II settled in Tulsa, Oklahoma. In 1954, he moved to Tempe, Arizona, where he lived until his death.

In Arizona, while helping one of his students model a "cutting horse," he developed the idea for his *Rodeo Series*. He planned to portray each event at the high point of action. Though he had worked in many media during his career, he chose bronze, his favorite medium, for the series, "for it lends itself to the sculptor's final finishing (chasing), using files, chisels, emery, steel wool and elbow grease."[5]

A vehement realist, Stevens tried to capture the spirit and the classic beauty of the rodeo: "I made a decision years ago when I visited the Delphi Museum in Greece and saw the perfected structural form and detailed figure of the 5th century, B.C. 'Charioteer,' that any similar work I might create would have this same beauty and historical value through the use of detail and a perfected basic

347. A. Sterling Calder. *Indian Brave.*
c. 1910. H. 24″. Graham Gallery,
New York City

figure."[6] In preparation for this project, Stevens sketched and photographed the men, women, and animals from hundreds of rodeos. Each bronze took two to three years to complete.

A unique characteristic of Stevens' bronze sculpture is that he retained the natural patina or gold surface color of the bronze. Most sculptors use chemicals to achieve the final color of their bronze. Stevens wished his sculptures to be handled by those who enjoy them, for the oily secretions of the hands give added beauty to the surface of the metal.

Stevens' sculpture is highly stylized. He simplified his basic forms, employed patterned linear details, and strove for the most dramatic silhouettes possible. His handling of the anatomy of the horse is ornamental rather than structural. His models even include stylized representations of the dust kicked up by rodeo horses.

Although Stevens wished to capture the spirit of the rodeo, he in no way attempted to re-create Western life. He wrote of his sculptures that they are "first art and lastly history."[7]

One of the sculptures commissioned under Stevens' directorship for the Hall of State at the Texas Exposition was *Archer—Tejas Warrior (plate 358)* by Allie Victoria Tennant (d. 1971). This bronze is another example of a Western subject modeled in an Academic Abstract style. Miss Tennant chose an Indian warrior as her tribute to Texas, for the state was named for the friendly Tejas Indians. Her sculpture of the Indian archer is stylized in the neoclassic tradition first popularized by Paul Manship, though it lacks the vitality and originality of Manship's work.

Miss Tennant moved to Texas while still a child. After studying for many years in the art academies of New York, Rome, and Paris, she opened a studio in Dallas. Her work was popular in the 1930s and she won many commissions and awards.

The influence of the Academic-Abstractionist sculptors is also evident in the work of Clemente Spampinato (b. 1912). Born in Rome, Spampinato had an excellent education in the art academies of his native city. From the 1930s to the 1950s, he worked primarily on sculptures of sporting figures. In 1941, he modeled the ski trophies for the Olympic Games. These figures are greatly simplified and stylized. In each sport, the figure is suspended in motion at a critical moment. Spampinato states that his aim in sculpture is "to reduce to its simple essentials the meaning of movement."[8] Like Stevens, he creates much of the dramatic impact of his work through a stylized silhouette.

Spampinato settled permanently in the United States in 1946. Since the 1950s he has been interested in rodeo sculpture, especially in portraying the perils of bronc riding *(plates 359–361)*. He has also

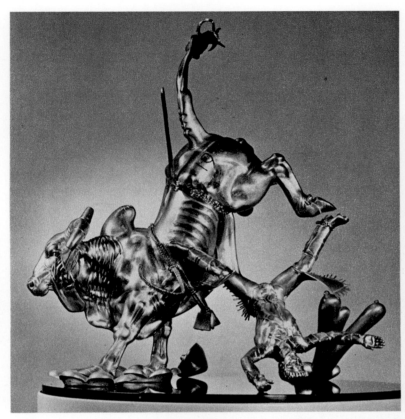

348

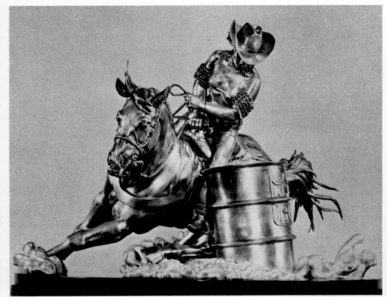

349

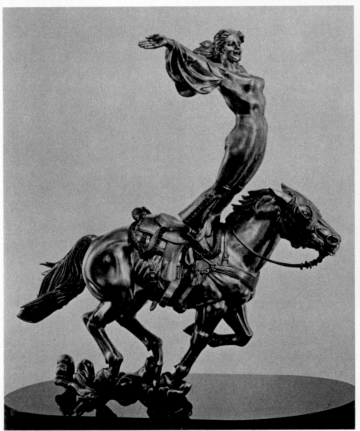

350

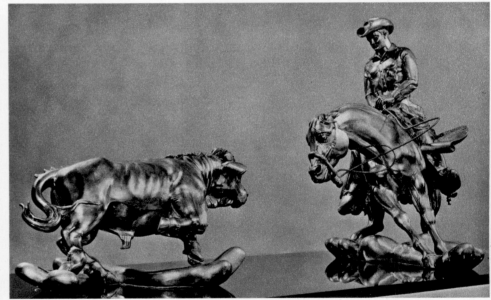

351

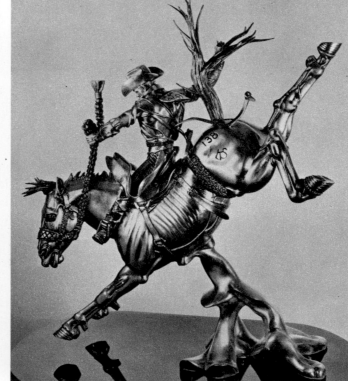

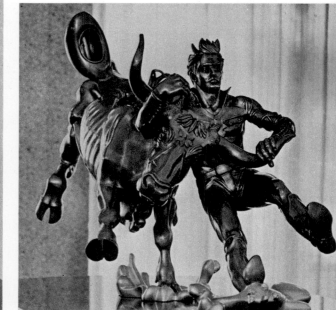

352

348. Lawrence Tenney Stevens. *Brahma Bull Riding—Rodeo Series*. 1962. H. 34″. Collection the artist

349. Lawrence Tenney Stevens. *Barrel Racer—Rodeo Series*. 1969. H. 22½″. Collection the artist

350. Lawrence Tenney Stevens. *Trick Riding—Rodeo Series*. 1968. H. 35″. Collection the artist

351. Lawrence Tenney Stevens. *The Cutting Horse—Rodeo Series*. 1960. H. 20″. Collection the artist

352. Lawrence Tenney Stevens. *Bareback Rider—Rodeo Series*. 1964. H. 33″. Collection the artist

353. Lawrence Tenney Stevens. *Saddle Bronc Riding—Rodeo Series*. 1970. H. 37″. Collection the artist

354. Lawrence Tenney Stevens. *The Bull-Dogger—Rodeo Series*. 1964. H. 21″. Collection the artist

355. Lawrence Tenney Stevens. *Team Tying—Rodeo Series*. 1963. H. 22″. Collection the artist

356. Lawrence Tenney Stevens. *Calf Roping—Rodeo Series*. 1965. H. 18″. Collection the artist

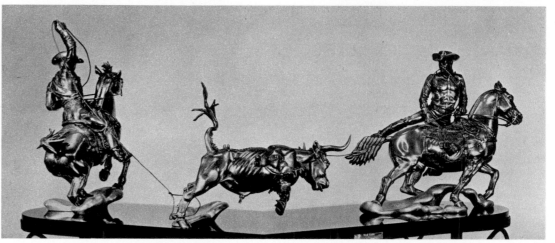

355

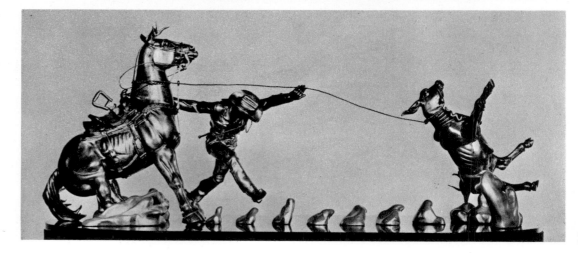

356

357. Lawrence Tenney Stevens. *Saddle Bronc Riding—Rodeo Series* (detail of plate 353)

created some models of Indian life of the past. His strongest sculptures are his simplest compositions, showing a figure in motion or the interaction of horse and rider. In 1968, he had an exhibition of his work at the National Art Museum of Sport in New York City.

Bernard Frazier (b. 1906) believes that "though western art is now great documentation, it is moving toward great aesthetic expression of a more pure nature."[9] He looks upon the American pioneer and Indian as subjects of classic dimension:

Viewing the entire three centuries of human drama created by the European invasion of the American continents, we of today have clearly decided that no other epoch of action—no other combination of man and beast and circumstance can possibly outrank the furious grandeur of those who "won the West." . . .

It is then, the man who won the West and the man who, for the time, lost it, who stands much tallest in our hearts and in our developing folklore. . . . This image of Western man is in the process of becoming immortal. The high prairie American on his horse and the Indian on his mustang will soon join Mercury and Diana and Thor and Attila and Napoleon and George Washington and all the other super-heroes or heroines who are or will be deities.[10]

Frazier grew up on the high prairie of west Kansas. As a boy, he became interested in the lives of the old-timers who remembered the days of the frontier. He made his first sculptures while working as a ranch boy in partnership with his grandfather, who had gone West after the Civil War to earn his fortune as a buffalo hunter. He joined the gold rush to the Black Hills and then became a homesteader. Frazier enjoyed modeling the horses of the prairies as well as buffalo and pumas—animals he knew only from stories of the past.

Frazier studied at the University of Kansas and at the Chicago School of Sculpture. For five years he served as an apprentice to Lorado Taft. Early in his career, he received national recognition for his sculpture. By 1950, he had won six first-place awards in nation-wide art competitions.

Throughout his career, Frazier has been devoted to recognizing and developing the artistic potential of young sculptors. He has taught sculpture since 1938, when he received a Carnegie Foundation grant for assignment as Sculptor-in-Residence at the University of Kansas. He has also worked for many years to give Indian artists museum status. For six years he served as director of the Philbrook Museum, the city art museum of Tulsa, Oklahoma. While at

295

358. Allie Victoria Tennant. *Archer—Tejas Warrior.*1936. Roman Bronze Works, N.Y. H. 53″. Brookgreen Gardens, Murrells Inlet, S.C.

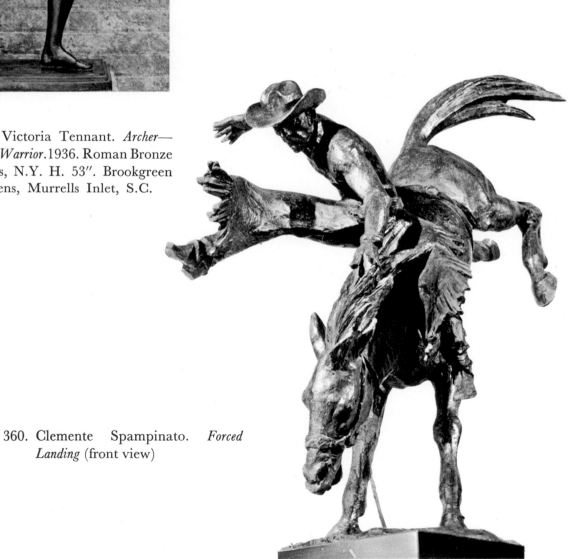

359. Clemente Spampinato. *Forced Landing* (right view). 1972. Modern Art Foundry, Long Island City, N.Y. H. 29″. Private collection

360. Clemente Spampinato. *Forced Landing* (front view)

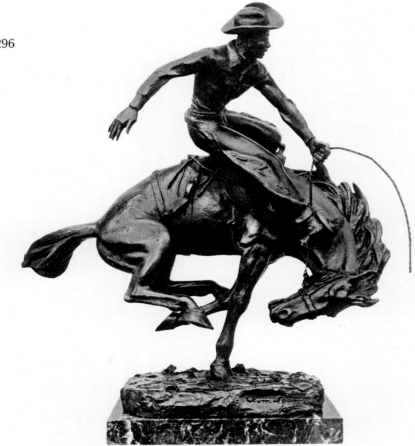

361. Clemente Spampinato. *Saddle Bronc Rider*. 1953. Modern Art Foundry, Long Island City, N.Y. H. 23¼". Oklahoma Art Center, Oklahoma City, Okla. Gift of Gian Campanile Gallery, Chicago, and of the artist

Philbrook, he founded the annual competition for artists of American Indian extraction.

Frazier tries to achieve in his work a creative synthesis of abstract and traditional art. He frequently applies the techniques of abstract art to themes proclaiming his pioneer heritage. Frazier is not a documentary artist, but tries to go beyond the details of costume and equipment to capture the spirit of his subject. One of his finest Western sculptures is a frieze entitled *The Hunt (plate 362)*. He described his work in this manner:

My HUNTERS—near ten feet long and in bronze, seem to be Indians. They are on horses and they do seem armed with bow and lance. Very far beyond these vague facts is the more real thing that they are a portrait of purpose—total purpose, done in such a way that any man of any time who ever rode on, regardless, for the sake of food for his family or for the protection of them, is riding with these riders. I am certain that we of today can join them in spirit, and rejoice that they were there.[11]

The Impressionist sculptors were primarily influenced by the creations of Auguste Rodin during the late nineteenth century. They utilized rich modeling to explore the dramatic possibilities of light and shade, and created an independent life in the fragmented surfaces of their work. They were aware of the creative potential of the unsculptured mass and of emerging forms.

Many Western sculptors were strongly influenced by the Impressionists in their work. Solon Borglum was one of the earliest sculptors to use Impressionistic techniques in his dramatic models of Western life *(plate 365)*. Edwin W. Deming, Arthur Putnam, and Paul Troubetzkoy were only a few of the turn-of-the-century sculptors to be influenced by the French Impressionists *(plates 363, 364, 366)*. Many of the bronze sculptures of Charles Russell are highly Impressionistic. Today, Impressionist techniques are employed by several Western sculptors to achieve dramatic impact and immediacy in their art.

Wolf Pogzeba (b. 1936) has one of the boldest and most imaginative styles in contemporary sculpture. Since he is interested primarily in the creation of a work of art, his goals are aesthetic rather than narrative or documentary.

Pogzeba explores the fullest possibilities of his medium. He casts his own sculptures, after which he reworks the surface and applies several patinas to a single bronze. Smooth surfaces of gleaming bronze contrast with dark, rough, and unpolished areas. *Confronted*

362. Bernard Frazier. *The Hunt.* Cast
1971 by the artist. 38 × 111 ×
9″. Fidelity Bank, Oklahoma City,
Okla.

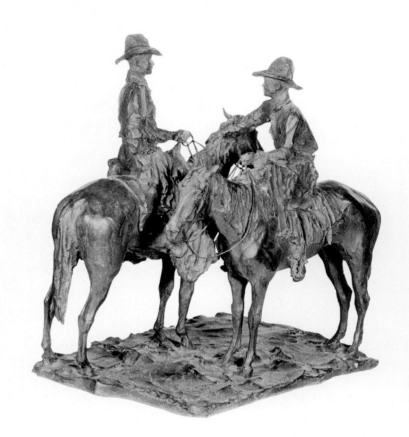

363. Edwin W. Deming. *Bears in Combat*. 1916. Roman Bronze Works, N.Y. H. 6½″. Collection Mr. and Mrs. Stanley H. Broder

364. Paul Troubetzkoy. *Two Cowboys*. 1916. H. 19″. The Henry E. Huntington Library and Art Gallery, San Marino, Calif.

365. Solon H. Borglum. *Pioneer in a Storm*. Modeled c. 1904 (modern cast). H. 11″. Thomas Gilcrease Institute, Tulsa, Okla. The original giant statue in staff was exhibited at the 1904 Louisiana Purchase Exposition in St. Louis

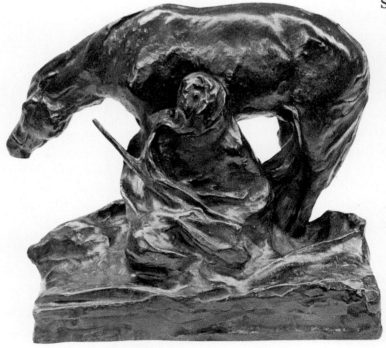

Elks (plate 369) shows Pogzeba's ability to utilize the full dramatic potential of light and surface texture.

Pogzeba often simplifies the forms of his sculpture by abstracting the surfaces into broad planes. He often distorts his figures to achieve full dramatic power. In companion studies of a brahma bull rider and a bronc *(plates 367, 368)*, the head of each cowboy is very small and the face is completely undefined. The cowboy's legs, covered by shining chaps, are emphasized to indicate the physical strength of the rider and to illustrate that bronc and bull riding are physical rather than intellectual occupations. In the *Riderless Horse (plate 370)*, Pogzeba demonstrates his ability to balance mass and space. He depicts the horse in a pose of power and rhythmic grace.

Pogzeba was born in Munich, Germany. After many difficult years in wartime Germany, the Pogzeba family went to the United States in 1948. After a short stay in the East, they moved West and settled in Denver.

Pogzeba has a sound academic background. He first studied engineering at the Colorado School of Mines but, as he preferred a more creative vocation, transferred to the University of Colorado School of Architecture, where he majored in art history. Pogzeba also attended the University of Mexico in Mexico City, the Kunstakademie in Munich, and the École des Beaux-Arts in Paris.

Pogzeba's career flourished following an exhibition of his work at the Montana Historical Society. Pogzeba's creations captured the fancy of the Western art public, and during the next few years his work was exhibited throughout the United States. His sculptures won the praise of both those who championed realistic art and those who favored abstraction.

Some of Pogzeba's finest works are steel abstractions of rodeo riders and bison herds. These are far more abstract than his bronze sculptures. Several of his reliefs are completely two-dimensional. Pogzeba also won favor for his drawings and ink washes.

Unfortunately, in recent years, Pogzeba has all but abandoned his Western sculpture for experiments in different media and with various techniques. His early works, however, are valued as outstanding contributions to contemporary Western bronze sculpture.

George Carlson (b. 1940) is a highly skillful Impressionist sculptor. Technical excellence is only part of Carlson's goal, however, since he regards sculptures of the American Indian as a means of expressing his philosophical beliefs. One of the younger Western sculptors, Carlson is deeply interested in the character and mystical nature of the American Indian. His work brings a new dimension of meaning to the theme of the American Indian. Many of the young people in

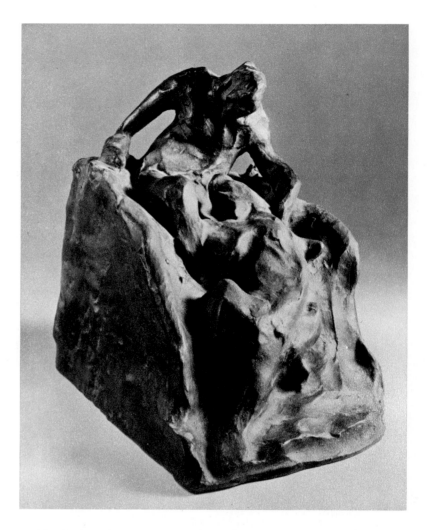

366. Arthur Putnam. *Indian and Puma.* Cast 1921. Alexis Rudier, Paris. H. 16½″. California Palace of the Legion of Honor, San Francisco. Gift of Mrs. A. B. Spreckels

367 Wolf Pogzeba. *Brahma Bull Rider*.
1965 Cast by the artist. H. 11½″.
Private collection

368. Wolf Pogzeba. *Bronc Rider*. 1965.
Cast by the artist. H. 12″. Private
collection

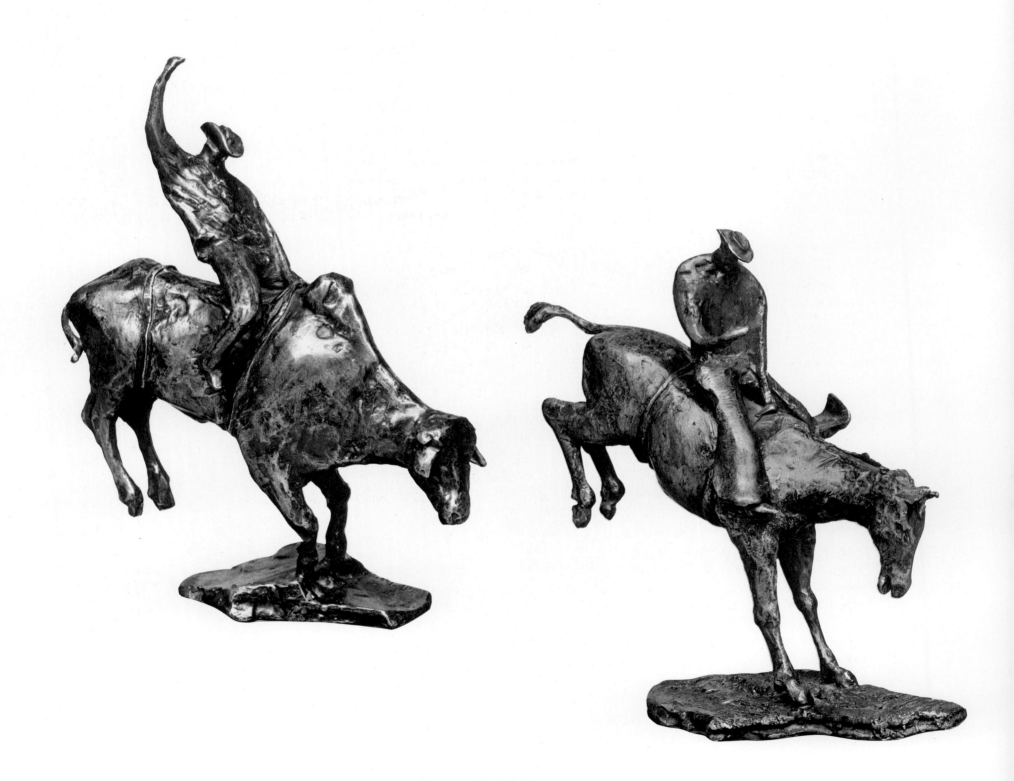

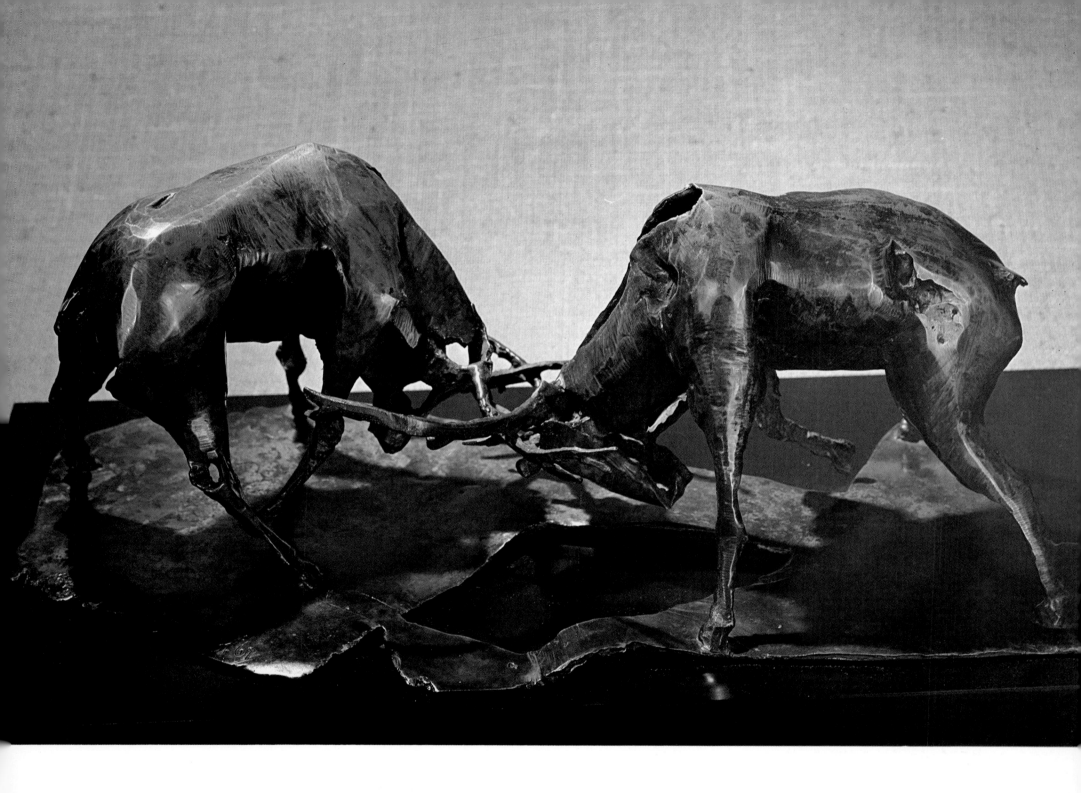

369. Wolf Pogzeba. *Confronted Elks.*
1967. Cast by the artist. H. 8″.
Collection Mr. and Mrs. Norman
B. Trenton, Denver, Colo.

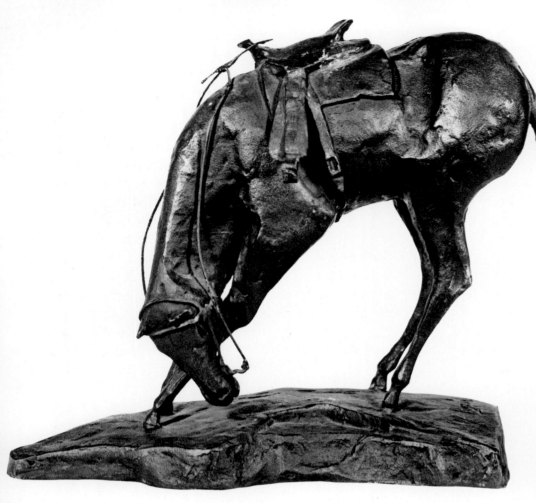

370. Wolf Pogzeba. *Riderless Horse (Lone Horse)*. 1963. Cast by the artist. H. 10½". Collection Walter R. Bimson, Phoenix, Ariz.

America today, in their quest for relevancy in life, have turned like Carlson to the American Indian as their hero and model.

Carlson states as his goal "to show the spirit of the Indian today, the enormous relevance of his religion and values to his life. That is the most valid focus of the contemporary Western artist—not the furious braves on the warpath of an earlier age."[12]

Carlson periodically lives on Indian reservations of the Yaqui tribe in Arizona and the Pueblo tribes in Santa Clara and Taos, New Mexico. He has many good friends among the Indians. Through them, he has learned some of the philosophical beliefs and ideals as well as the traditions and folklores of their people.

Carlson was born in Elmhurst, Illinois, and attended the American Academy of Art, the Chicago Art Institute, and the University of Arizona. He has lived in the West since 1964. His home and studio are in Franktown, Colorado.

Carlson concentrates on the peaceful aspects of Indian society: food gathering, vision seeking, meditation, and the many tribal ceremonies of life and death. He looks to the Indian as his ideal:

The people have not resisted, but rather synchronized themselves with Mother Earth, thus evolving a meaningful philosophy and mythology. Their war clubs have long been silenced in museums, but their ancient order continues today.

Telstar and other sophisticated forms of communication have let us forget how to extend ourselves to our natural world, to other cultures, and often . . . to one another. After spending much time with various tribes, studying their customs, the inter-relationship of persons and the subtleties of daily life, I feel that their contribution to us is a striking lesson in basic humanity.[13]

Zuni Medicine Man (plate 371) and *Navaho Mountain Chant (plate 372)* are excellent examples of Carlson's Impressionistic sculptures of the American Indian.

One of Carlson's most interesting sculptures is called *The Last*

Breath (plate 373). Having killed the rabbit, the hunter participates in a religious ceremony. Carlson explains the ceremony:

This Zuñi rabbit hunt is of a religious character. The hunt occurs in the farming districts of the Zuñis, as Thanksgiving for abundant crops, and takes place immediately after the gathering of the corn and wheat. . . . When the first rabbit is taken the dying breath is inhaled to represent all that is good.

After the hunt, each hunter takes his rabbits to his home, placing them abreast on their sides with their heads to the East and facing South. An ear of corn is placed between the fore paws of each rabbit. And each member of the household sprinkles meal and prays that the beings of the rabbits may return home and send many more rabbits.[14]

Carlson, however, is not merely illustrating an interesting ceremony, but sees in the Indian ritual a basic attitude toward wildlife which differs from that practiced by the white man:

Contrasting the attitude of hunters today and the Indian hunters of yesterday, many today kill to conquer the victim whereas the Indian was aware of the gentle spirit in each living thing and treated this with respect and reverence. As in "The Last Breath" the hunter is taking in the dying breath of the rabbit to communicate to the rabbit spirit he has no ill will toward them.[15]

The wildlife bronzes of Kenneth Bunn (b. 1938) are dynamic examples of contemporary Impressionist sculpture. Bunn has won national recognition for his work, which expresses the vitality and natural beauty of the wild animals of the American West.

Bunn has a keen sense of observation and a sensitivity to the spirit of life around him. He is fascinated by the energy of animal life, and his bronze sculptures project a sense of freedom and a joy in motion. Although his models are realistically conceived and anatomically correct, Bunn completely eliminates all distracting details and through rich modeling and lively surfaces creates a feeling of movement and immediacy. The sculptor himself describes his work:

The surface alone never expresses the essence of an animal. I work in a loose interpretive way, leaving out detail to get to the spiritual aspect of the sculpture. When the surface is handled that way—casting aside what happens only on the skin—it gives far more opportunity to develop movement and life. The elements I work with—light, shadow, texture, the movement that takes place in the push of my thumb across the surface—express life.[16]

Bunn has had limited academic art training, but an extensive technical education and a wide variety of practical experience have given his work authority and authenticity. Bunn was born and educated in Denver, Colorado. For a short time he studied anatomy at the University of Utah's School of Medicine, then went to Washington, D.C., where he served as an apprentice at the Museum of Natural History of the Smithsonian Institution. Interested in the preparation of museum exhibitions, he helped to assemble skeletons and to re-create in clay anatomical molds to be used for taxidermy forms. These forms became the structure over which the animal skin was stretched in order to reproduce the wildlife figures. While in Washington, Bunn also prepared exhibits and dioramas for the National Park Service. Today he is still deeply involved with problems of game conservation.

On his return to Denver, Bunn worked for four years under Coleman Jonas, the septuagenarian brother of the sculptor Louis Jonas, who helped Bunn perfect his ability to create anatomical models and molds. After leaving the Jonas studio, he became art director of Magic Mountain, a Disney-type project in Denver, where he designed and created three-dimensional animated animal figures.

All through the years during which he was gaining practical experience, Bunn worked on his own to create individual wildlife sculptures. In 1969, he had his first models cast in bronze. One of them, *The Bounding Doe*, won the 1969 Exhibition Bronze Model Prize at the National Sculpture Society Show. This was the first of many awards and honors that Bunn has received in recent years.

Bunn has traveled extensively throughout the American West and has made three trips to East Africa. He has also had the opportunity to study sculpture in the museums and galleries of Europe and the United States. Though primarily an animal sculptor, he has modeled several American Indian and African figures. Influenced in his work by both European and American Impressionist sculptors, Bunn has great admiration for Medardo Rosso, Auguste Rodin, Rembrandt Bugatti, and Arthur Putnam, whom he considers one of the finest yet least known American sculptors.

Ted De Grazia has made several Impressionistic studies in bronze. De Grazia is one of the most commercially successful Western artists in America. His sentimental, Impressionistic paintings of angels and Indian children have been reproduced by the thousands in prints and greeting cards. His most famous, *Niños*, a circle of Indian children, was created for a UNICEF greeting card and sold over eight million copies.

De Grazia was born in 1909 in the mining town of Morenci, Ari-

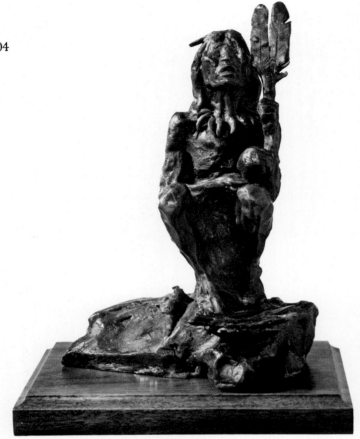

371. George Carlson. *Zuni Medicine Man*. 1965. Peterson Bronze Foundry, Venice, Calif. H. 9″. Blair Galleries, Santa Fe, N.M.

zona. The desert mountains of Morenci are rich in copper ore. One of his youthful pastimes was to model figures from the desert clay and bake them in his mother's bread oven. When De Grazia was eleven, the mine could no longer produce sufficient work for his father, and the family was forced to return to Italy. There De Grazia developed a love for and understanding of religious art.

When he was sixteen, his family returned to Morenci and De Grazia had to re-learn English. He graduated from high school at age twenty-three, but continued to study until he received a Master of Fine Arts from the University of Arizona.

As a young man, De Grazia was friendly with many of the immigrant Mexican miners working in Morenci and developed an understanding of the problems of the Mexican-American. He often accompanied them on visits to their homes in Mexico. He found a sympathetic bond with the people of the land. As he grew older, De Grazia spent much of his time in Mexico. He became friends with José Clemente Orozco and Diego Rivera, two of Mexico's most important artists. They were influential in giving him his first opportunity for artistic recognition—a one-man show in November, 1942, in the Palacio de Bellas Artes in Mexico City. De Grazia's paintings were enjoyed in Mexico many years before they gained public acceptance in the United States.

De Grazia's bronzes are not as well-known as his paintings. Most of them are Impressionistic studies of Indians, animals, and religious

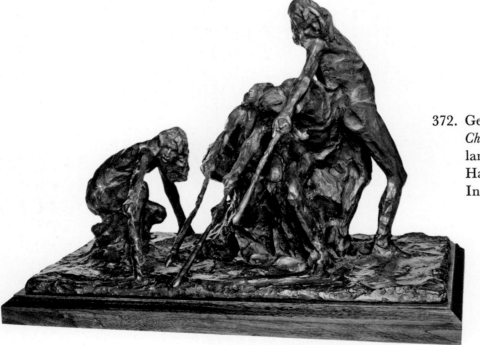

372. George Carlson. *Navaho Mountain Chant*. 1970. Bronze Images, Loveland, Colo. H. 15″. Collection Harrison Eiteljorg, Indianapolis, Ind.

373. George Carlson. *The Last Breath*. 1968. Bronze Images, Loveland, Colo. H. 8″. Collection Harrison Eiteljorg, Indianapolis, Ind.

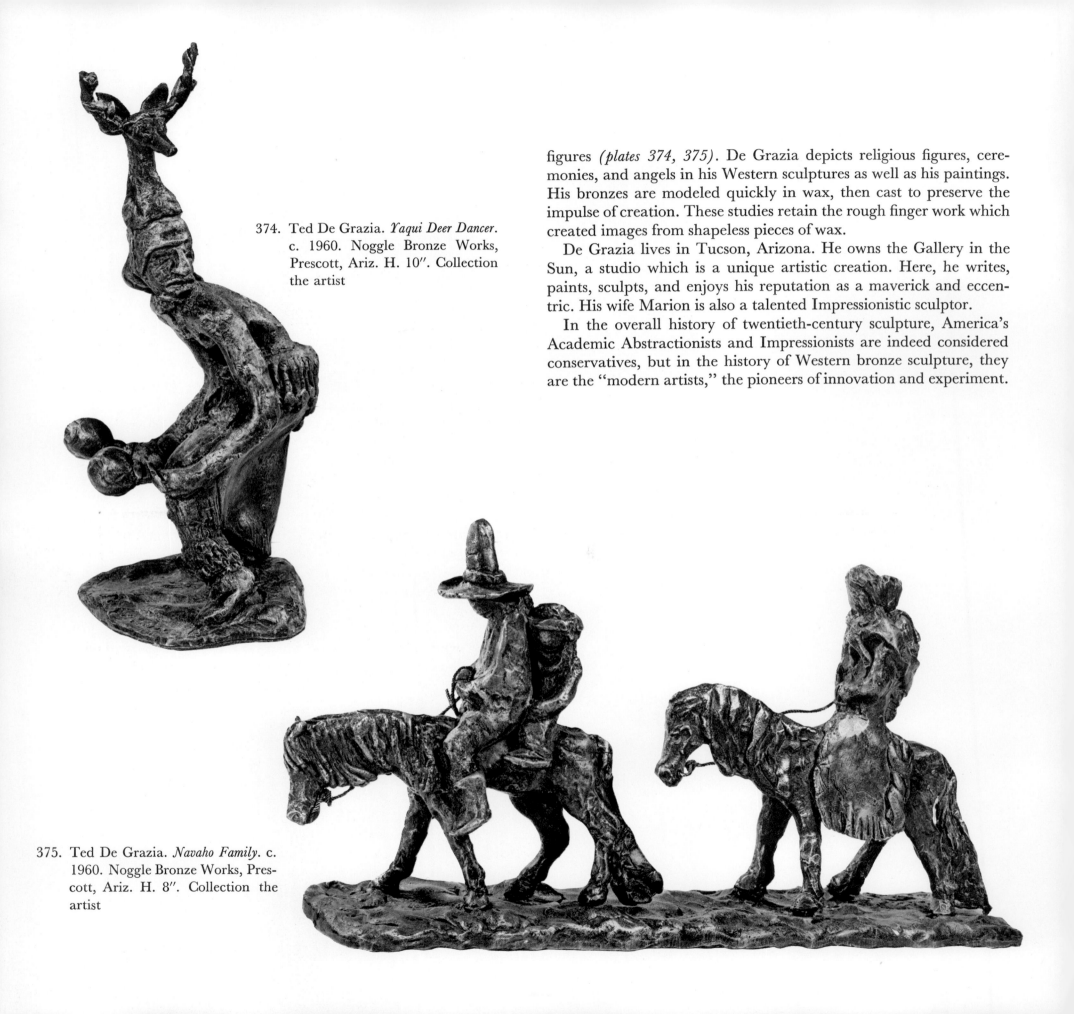

374. Ted De Grazia. *Yaqui Deer Dancer.* c. 1960. Noggle Bronze Works, Prescott, Ariz. H. 10″. Collection the artist

figures *(plates 374, 375)*. De Grazia depicts religious figures, ceremonies, and angels in his Western sculptures as well as his paintings. His bronzes are modeled quickly in wax, then cast to preserve the impulse of creation. These studies retain the rough finger work which created images from shapeless pieces of wax.

De Grazia lives in Tucson, Arizona. He owns the Gallery in the Sun, a studio which is a unique artistic creation. Here, he writes, paints, sculpts, and enjoys his reputation as a maverick and eccentric. His wife Marion is also a talented Impressionistic sculptor.

In the overall history of twentieth-century sculpture, America's Academic Abstractionists and Impressionists are indeed considered conservatives, but in the history of Western bronze sculpture, they are the "modern artists," the pioneers of innovation and experiment.

375. Ted De Grazia. *Navaho Family.* c. 1960. Noggle Bronze Works, Prescott, Ariz. H. 8″. Collection the artist

XX

THE INDIAN SPIRIT

The bronzes of most American Indian sculptors differ considerably from the work of other Western sculptors. The creations of the Indian sculptor express the spirit of Indian life. He looks beyond the details of reality to capture the essence of the culture and the traditions of his people. The Indian sculptor endows his work with a spiritual insight. He creates not only what he sees and what he has learned from history, but what he feels in his heart.

The Indian artist feels a bond from generation to generation. All he has learned from his grandfather and his father, he will pass on to his sons. Most young Oklahoma Indians feel the tragedy of the Trail of Tears almost as deeply as those who survived the ordeal. (The Trail of Tears is the name for the forced migration during the 1830s of the Indians from the Southern states to Indian Territory. This area now comprises part of Oklahoma.

Many Indian artists have little interest in seeing their work on display in large museums or for sale in well-known galleries of Western art. They feel they cannot communicate with the white man, for although the white man has forcibly changed the Indian's way of life, he has not been able to change his way of thinking. The Indian's art embodies his beliefs and dreams, his joys and sorrows. His creations are uniquely Indian and he will not offer these to the white man to be judged.

It is for these reasons that most of the finest Indian sculpture is hardly known to the public. To see more than an isolated example of Indian sculpture, it is necessary to visit museums specializing in Indian art, such as the Five Civilized Tribes Museum in Muskogee, Oklahoma; the Southern Plains Indian Museum in Anadarko, Oklahoma; the Heard Museum in Phoenix, Arizona; and the Philbrook Museum in Tulsa, Oklahoma. At the Indian Art School of Bacone College in Muskogee and at the Institute of American Indian Art at Santa Fe, New Mexico, the visitor has the opportunity to see the work of the instructors as well as the efforts of their students.

Hart Merriam Schultz (1882–1970) was best known by his Blackfoot name, "Lone Wolf." Lone Wolf was one of the first Indian artists

to win nationwide public acclaim. His paintings and sculptures of cowboy and Indian life in the American West are in museums and collections throughout the United States.

Lone Wolf was born on Birch Creek near Browning, Montana. His mother, a Blackfoot woman, was named Na-tah-ki, meaning "Fine Shield Woman." His father, James Willard Schultz, was a young adventurer who married Na-tah-ki and lived for many years as an Indian. The elder Schultz was adopted into the Blackfoot tribe and given the Indian name of Apikuni, meaning "Far Away Robe." In later years, he became famous as a writer on Indian life.

Lone Wolf grew up on the Blackfoot Indian reservation near Glacier Park. Throughout his life, he remembered the misery and hardship of life on the reservation. On several occasions, the family was forced to leave their home and hide on a nearby island because his father had reported to George Bird Grinnell, the well-known writer and ethnologist, the desperate conditions on the reservation.

During the 1880s, the Blackfoot, Cree, and Crow tribes still went on horse raids. Although these raids were forbidden by the reservation agent and by the police, the tribesmen considered them a test of manhood and would return victorious with the scalps of their enemies.

At age eight, Lone Wolf was forced to attend a government school. He described the beginnings of his white man's education:

It was very cold that day when we were loaded into the wagons. None of us wanted to go and our parents didn't want to let us go. Oh, we cried for this was the first time we were to be separated from our parents. I remember looking back at Na-tah-ki and she was crying too. Nobody waved as the wagons, escorted by the soldiers, took us toward the school at Fort Shaw. Once there our belongings were taken from us, even the little medicine bags our mothers had given us to protect us from harm. Everything was placed in a heap and set afire.

Next was the long hair, the pride of all the Indians. The boys, one by one, would break down and cry when they saw their braids thrown on the floor. All of the buckskin clothes had to go and we had to put on the clothes of the White Man.

If we thought that the days were bad, the nights were much worse. This was the time when real loneliness set in, for it was then we knew that we were all alone. Many boys ran away from the school because the treatment was so bad but most of them were caught and brought back by the police. We were told never to talk Indian and if we were caught, we got a strapping with a leather belt.[1]

Lone Wolf rebelled against the severe discipline and was expelled from the government school. For a short time, he attended Willow Creek School on the reservation. Most of the day was devoted to manual labor. Lone Wolf again fought with "Mr. Disciplinarian" and this time was sent to the agency jail. This was the end of his school days.

Lone Wolf's early art education came from his grandfather, Yellow Wolf, an old warrior. Yellow Wolf taught his grandson to draw animals and people. He showed the boy the ancient art of preparing paint from natural pigments. Yellow Wolf also taught him to tell a story in his work. Lone Wolf watched his grandfather paint his war history on a buffalo robe. Yellow Wolf would take his grandson to the river bed and teach him to model buffalo and horses from the rich clay. As they worked, he told him stories of Indian life during his youth and manhood. Yellow Wolf taught his grandson the importance of his Blackfoot heritage. Many years later, Lone Wolf recorded these stories of buffalo hunts and Indian wars in his paintings and sculptures.

Lone Wolf lived in an age of transition. He was greatly influenced by his mother's advice: "You will have to follow the White Man's way so it is best to learn how to make a living right here."[2] During his youth, the cowboy and rancher had become a familiar part of Western life. Lone Wolf first went to work as a cowboy and bronc buster. He often entertained his fellow cowboys with sketches of ranch life. In later life, he painted and modeled scenes of life on the range.

Lone Wolf's father worked as a guide for wealthy sportsmen from the East and the West. Apikuni knew many of the famous men who came to Montana to hunt, paint, and study life in the West. As a boy, Lone Wolf met Frederic Remington, Teddy Roosevelt, George Bird Grinnell, Owen Wister, and Buffalo Bill.

In 1903, Na-tah-ki died. James Schultz, in despair, abandoned his adopted people and left Montana. He settled in California, where he became a literary critic for The Los Angeles Times. During his lifetime, he wrote thirty-seven books about the Blackfoot people. Lone Wolf illustrated several of these.

Lone Wolf suffered from poor health as a result of constant exposure to the cold during his childhood. In 1904, he traveled to the Southwest to escape the bitter cold of Montana's winter. For many years thereafter he migrated to the Southwest each winter. Lone Wolf lived and worked in Montana and Arizona until his death at the age of eighty-eight.

In 1919, while visiting the Grand Canyon, Lone Wolf met the painter Thomas Moran. Moran took an interest in the talented

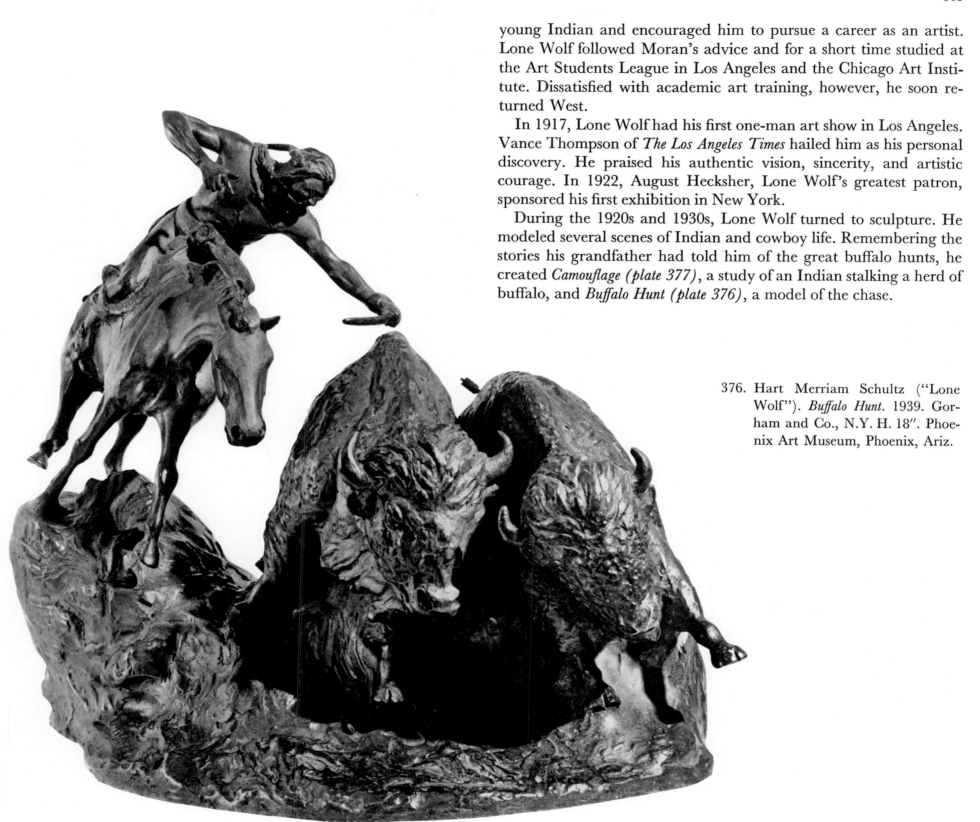

young Indian and encouraged him to pursue a career as an artist. Lone Wolf followed Moran's advice and for a short time studied at the Art Students League in Los Angeles and the Chicago Art Institute. Dissatisfied with academic art training, however, he soon returned West.

In 1917, Lone Wolf had his first one-man art show in Los Angeles. Vance Thompson of *The Los Angeles Times* hailed him as his personal discovery. He praised his authentic vision, sincerity, and artistic courage. In 1922, August Hecksher, Lone Wolf's greatest patron, sponsored his first exhibition in New York.

During the 1920s and 1930s, Lone Wolf turned to sculpture. He modeled several scenes of Indian and cowboy life. Remembering the stories his grandfather had told him of the great buffalo hunts, he created *Camouflage (plate 377)*, a study of an Indian stalking a herd of buffalo, and *Buffalo Hunt (plate 376)*, a model of the chase.

376. Hart Merriam Schultz ("Lone Wolf"). *Buffalo Hunt*. 1939. Gorham and Co., N.Y. H. 18″. Phoenix Art Museum, Phoenix, Ariz.

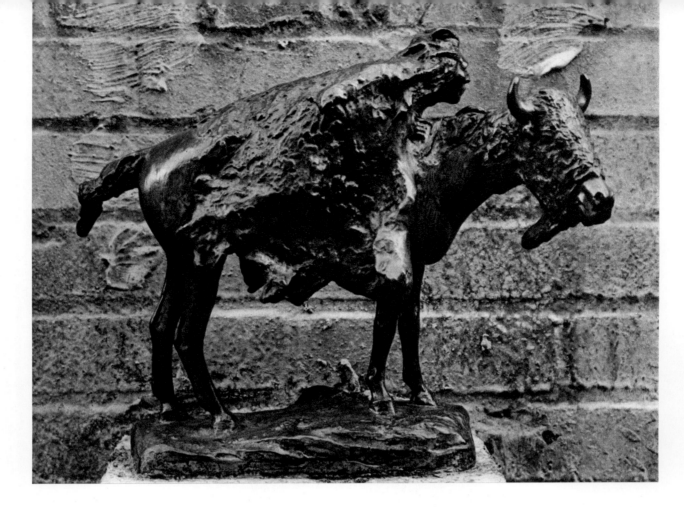

During the 1930s, the years of his greatest activity as a sculptor, Lone Wolf lacked the funds necessary to have his models cast. Over the years, most of these models were broken or lost; however, *Riding High (plate 379)* and *Red Warriors (plate 378)* were finally cast after almost thirty-five years.

Lone Wolf's sculptures, which are highly realistic and rich in decorative detail, are action-filled documents of life in the West. His works follow more in the artistic traditions of the white man than of the Indian, and are close in style and subject matter to the creations of his fellow Montanan, Charles Russell. Lone Wolf's work lacks the spirituality which characterizes Indian art.

Allan C. Houser (b. 1914), a member of the Apache tribe, is a sculptor of national stature. Houser's name is derived from the Indian name Ha-oz-ous, meaning "Pulling Roots."

Houser's father, Sam Ha-oz-ous, was one of Geronimo's warriors. When Geronimo was captured, the Indians were sent to Florida as prisoners of war of the United States government. The government later removed the Apaches to Fort Sill, Oklahoma, where they were given a choice of taking farm allotments in Oklahoma or living on the Mescalero Reservation in New Mexico. Houser's father and mother decided to live as Oklahoma farmers.

Houser grew up on their farm. During his youth, he heard stories of the days when the Indians were prisoners of war and of the hard-

377. Hart Merriam Schultz ("Lone Wolf"). *Camouflage*. Cast 1929. Gorham and Co., N.Y. H. 12¼". Brookgreen Gardens, Murrells Inlet, S.C.

378. Hart Merriam Schultz ("Lone Wolf"). *Red Warriors*. Modeled 1930, cast 1967. Roman Bronze Works, N.Y. H. 15". Montana Historical Society, Helena, Mont.

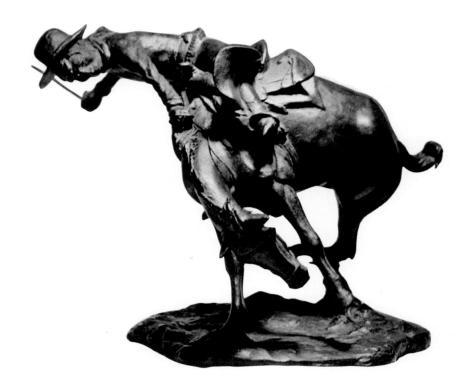

379. Hart Merriam Schultz ("Lone Wolf"). *Riding High.* Modeled 1930, cast 1967. Roman Bronze Works, N.Y. H. 10½". Montana Historical Society, Helena, Mont.

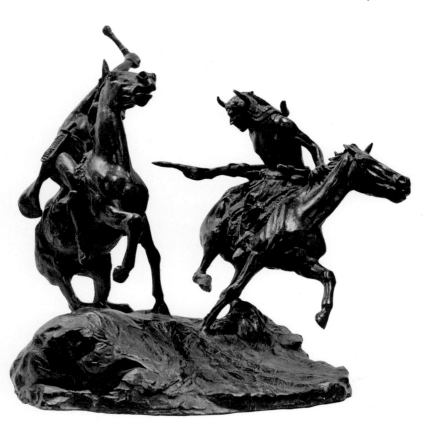

ships endured during their removal to Oklahoma. He listened to his father's adventure stories about life on the warpath with Geronimo. Sam Ha-oz-ous knew all of Geronimo's songs and often sang them. Houser recalled:

Growing up with Dad, hearing him talk;—I've kept a strong feeling for my people. He relived the early days. People came from all over to hear him sing, not for his voice;—but for his memory which was the best. He knew all of Geronimo's medicine songs. I can remember old people with tears running down their cheeks when he sang about things they remembered.[3]

Houser developed a strong sense of identity with the American Indian and a deep dedication to his people. All of his sculptures proclaim this heritage. They are neither narratives nor documents of Indian life, but works of art which express the Indian spirit. Throughout his career, he has worked to develop artistic ability in young Indians.

Houser was first educated in the Oklahoma public schools. He hoped to become a professional athlete but, following an illness during his high school years, he became interested in drawing.

In 1936, Houser was sent to the Indian School in Santa Fe, where he had the good fortune to study under Dorothy Dunn. Miss Dunn encouraged a style of painting utilizing simplified, stylized two-dimensional forms which were high in decorative value and in symbolic meaning. She believed that this style and these symbols were based on authentic Indian prototypes and were the primary ingredients of a purely Indian art form. She was highly influential in discovering many Indian artists. Miss Dunn was impressed by Houser's native ability, and he became one of her protégés. After graduation, Houser was permitted to remain an additional year as a special art student at the Institute.

Houser first worked in Santa Fe as a free-lance artist. In 1938, he received a commission to paint several murals for the Department of the Interior in Washington, D.C. He also executed murals for the Intermountain School in Brigham City, Utah, the Fort Sill School at Lawton, Oklahoma, and made a mural and four dioramas for the Southern Plains Indian Museum in Anadarko, Oklahoma.

During World War II, Houser worked at a defense job in California. He was a frequent visitor to the art galleries and museums there, where for the first time he had the opportunity to study the classic works of the old masters and the experimental techniques of contemporary artists.

Before the war, Houser had been primarily interested in painting,

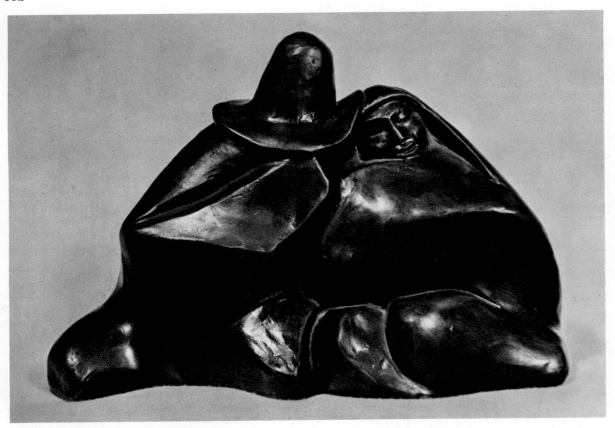

381. Allan C. Houser. *Herding Goats.* 1971. Nambe Mills Foundry, Santa Fe, N.M. H. 16½″. Southern Plains Indian Museum and Craft Center, Anadarko, Okla.

380. Allan C. Houser. *Morning Song.* 1971. Nambe Mills Foundry, Santa Fe, N.M. H. 7″. Institute of American Indian Arts, Santa Fe, N.M.

but during his years in California, he became devoted to sculpture. He broke with the traditions of Indian art taught to him by Miss Dunn, and although the rituals and traditions of Indian life remained his principal subject, he used the techniques of abstract art to express them. Houser felt he had grown beyond the prescribed stylization of the Santa Fe School. As an Indian, he was devoted to portraying his heritage, but as an artist, he needed to be free to choose his means of expression.

Houser's first sculptural commission was a war memorial in Carrara marble for the Haskel Institute in Lawrence, Kansas. Dedicated to the young Indians who died in World War II, the statue is called *Comrade in Mourning.* It is a towering abstraction of a sorrowing Indian brave, his war bonnet at his feet.

Houser achieves a tremendous sense of monumentality in his bronze sculpture. He simplifies the basic forms and completely eliminates distracting details *(plates 382, 383).* His bronzes of Indian life have dignity, power, and a sense of timelessness. Houser's Indians belong to an eternal race. *Morning Song (plate 380),* a study of two Indians

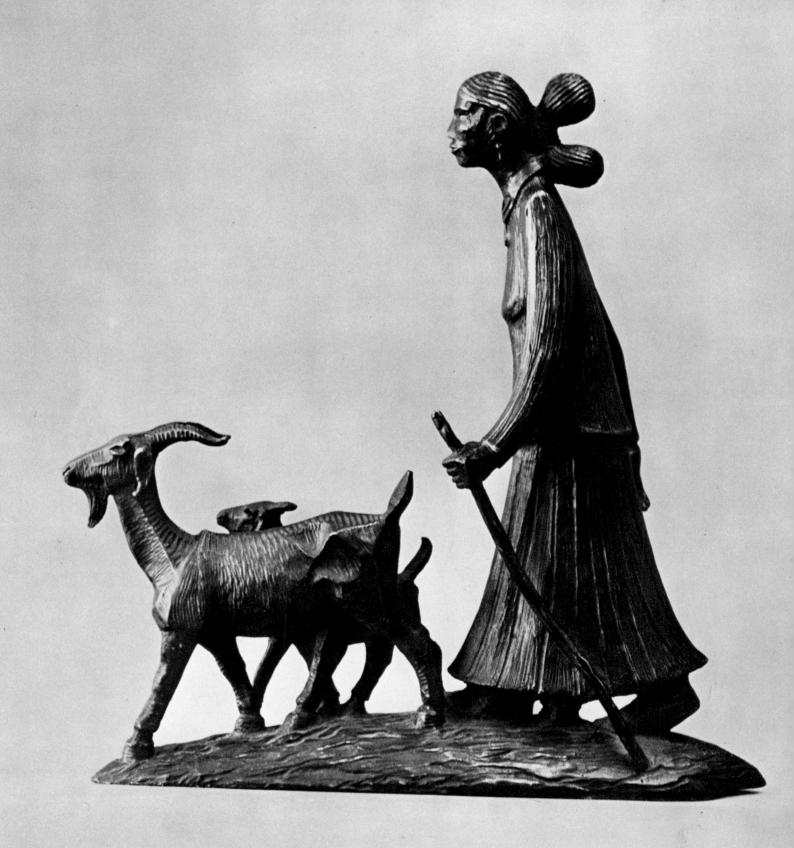

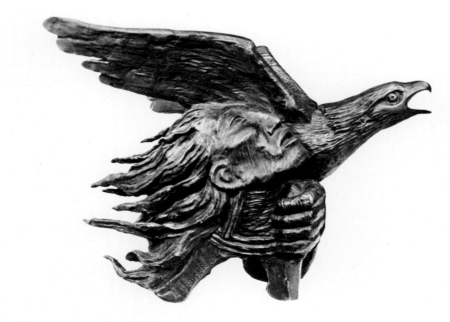

382. Allan C. Houser. *Indian and Hawk* (right view). 1971. Nambe Mills Foundry, Santa Fe, N.M. H. 18". Institute of American Indian Arts, Santa Fe, N.M. When Houser was a boy, his father tamed wild hawks by feeding them

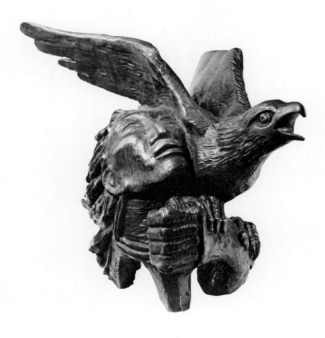

383. Allan C. Houser. *Indian and Hawk* (front view)

hunched under a blanket waiting for dawn when the dance festival will begin, has a feeling of total serenity. The Indians wait for a ceremony which has its roots in the past and will endure for generations.

Houser's sculpture of an Indian woman herding goats *(plate 381)* imparts great dignity to simple labor. The strong silhouette of the figure has a sense of rhythm and harmony. Through his sculpture, Houser transforms everyday life into ritual *(plate 384)*.

Houser has received many honors and awards. In 1948, he was awarded the Guggenheim Scholarship for Sculpture and Painting and, in 1954, he received the Order of the Palmes Académiques from the French government for his contribution to the advancement of Indian art. Houser was awarded the Waite Phillips Trophy by the Philbrook Museum of Tulsa, Oklahoma, for his outstanding contributions to Indian art.

For many years, Houser has taught in Indian schools throughout the United States. Since 1962, he has taught painting and sculpture at his first art school, the Institute for American Indian Art in Santa Fe, where Indian artists have the opportunity to study the innovations of twentieth-century art. Houser advises his students: "Be an Indian but allow something for creativity too."[4]

Roland N. Whitehorse (b. 1920), a Kiowa artist, has won many awards for his sculpture in competitions throughout Oklahoma. In 1970, he won both first and second prize in sculpture at the Oklahoma Indian Trade Fair in Oklahoma City.

Whitehorse was born in Carnegie, Oklahoma, and attended public school in Washita, Oklahoma. He studied art at Bacone College in Muskogee, Oklahoma, and the Dallas Art Institute in Texas. He frequently portrays the historic scenes and ceremonies of the Indian tribes of the Southwest *(plate 385)*. Whitehorse's bronze sculpture is close in feeling to traditional Indian painting, which is characterized by decorative, stylized figures and forms.

Jerome Tiger, during his brief lifetime, was recognized as one of the most gifted Indian artists. Although his career lasted only five years, Tiger developed a style which had unique spiritual power and dramatic impact. In 1966, he won first prize in all four major competitions for traditional Indian art held in the United States: the first National Exhibition of American Indian Artists in Oakland, California; the twenty-first Annual American Indian Artists Exhibition at the Philbrook Art Center in Tulsa, Oklahoma; the Inter-Tribal Indian Ceremonial Exhibit in Gallup, New Mexico; and the All American Indian Days Art Show in Sheridan, Wyoming.

A full-blooded Creek-Seminole, Jerome recorded in his work the legends and customs of his people. Peggy Tiger wrote of her husband:

I believe Jerome, as is true of most Indian artists, was not so concerned with making his work true to history as to make it show a spirit of the Indian. He never studied from books to see what the Indians of a certain period or era wore, but he did spend a lot of time with other Indians young and old to store up subjects.[5]

Tiger endowed the traditional forms of Indian painting with a poetic spirit and dramatic power.

Jerome Tiger (1941–1967) was born in Tahlequah, Oklahoma, capital of the Cherokee Indian Nation. He grew up in nearby Eufaula, a predominantly Creek Indian town. As a boy, Jerome developed a passion for drawing. He was greatly influenced by his maternal grandfather, Reverend Coleman C. Lewis, a Creek mission preacher, who advised him to "put onto paper what the Creek has in his heart."[6]

After he left school, Jerome continued to draw and paint. Following his service in the United States Navy, Jerome studied for one year at the Cleveland Institute of Engineering in Ohio. This was his only formal art training.

In 1962, Jerome brought some photographs of his paintings to Nettie Wheeler's Thunderbird Shop in Muskogee, Oklahoma. Miss Wheeler has totally dedicated her life to Indian art. For many years, she has encouraged and financed the careers of talented young Indians, being well-known throughout Oklahoma as an outspoken

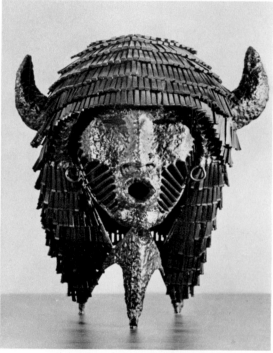

384. Allan C. Houser. *Buffalo Dancer.* c. 1969. Metal, masonry nails, and welding rods. Nambe Mills Foundry, Santa Fe, N.M. H. 15″. The Heard Museum of Anthropology and Primitive Art, Phoenix, Ariz. (Indian Collection)

385. Roland N. Whitehorse. *Apache Fire Dancers.* 1969. Southwestern Bronze Foundry, Fletcher, Okla. H. 9½″. Southern Plains Indian Museum and Craft Center, Anadarko, Okla.

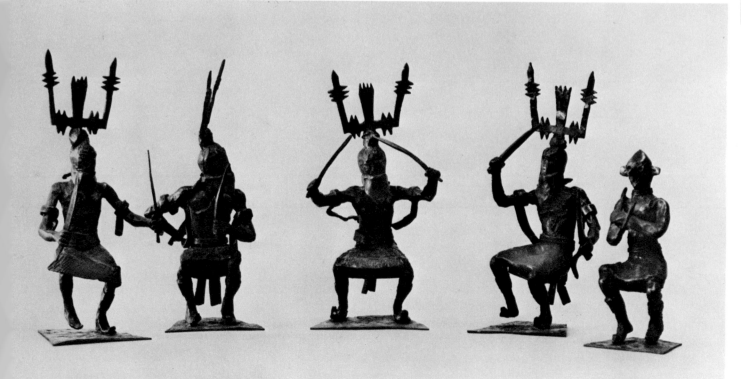

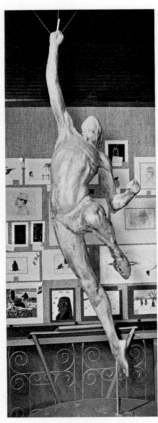

386. Jerome Tiger. *The Stickball Player* (model). 1967. Clay. H. 64″. Five Civilized Tribes Museum, Muskogee, Okla.

387. Jerome Tiger. *The Stickball Game.* 1966. Casein. 11¼ × 14″. Private collection

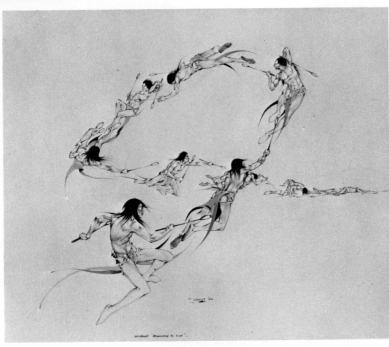

critic of Indian art. Tiger asked whether she thought he had the ability to become an artist. Miss Wheeler was greatly impressed by the work of the young Indian. She advised Tiger to enter the Inter-Tribal Competition in Gallup, New Mexico. He did so, and won a third prize.

During the next year, Miss Wheeler gave Tiger the opportunity to see the finest traditional Indian art. Tiger studied these examples and slowly developed an individual style. He had a natural sense of color and design as well as an excellent knowledge of anatomy. Tiger's work evokes the mood and meaning of an event rather than presenting a narrative history of it. His paintings suggest the misery and isolation of a people buffeted about by the cold and alien winds of the modern world.

Toward the end of his life, Tiger began to work in clay. One of his most successful paintings was *The Stickball Game (plate 387)*. Tiger's interpretation goes beyond illustrating a traditional game to portraying the aspirations and defeat of the players. Tiger attempted to translate the poetry and drama of the stickball game into sculpture. He used himself as a model: by looking over his shoulder into a large studio mirror, he was able to study muscle structure. The clay version —*The Stickball Player (plate 386)*, which he had just completed at the time of his death—is Tiger's finest sculpture. The Five Civilized Tribes Museum purchased the original clay and the rights to the first bronze for $30,000. The sculpture must be suspended in air, since the player is shown in a moment of flight. He transcends life and is in no way restricted by the limitations of the earth.

Before undertaking his model of *The Stickball Player,* Tiger wished to get the feeling of working with clay. His earlier models had been created as studies and were not originally intended for casting. The model of a woman and child entitled *Resting (plate 389)* evokes a feeling of despair and of the heaviness of the mother's burden.

Jerome Tiger died at age twenty-six of a gunshot wound. His works have had an enormous influence on many young Indian artists, especially those working in Oklahoma.

Jerome's older brother, Johnny (b. 1940), had often considered becoming an artist. For a short time, he had studied at Bacone College with the Cheyenne artist, Dick West. Jerome recognized Johnny's talent and encouraged him to pursue a career as a professional artist.

Following Jerome's untimely death, Johnny honored his mother's wishes that he justify Jerome's faith in his work. Johnny has natural ability as both a painter and sculptor. In recent years, he has exhibited his work in many galleries and museums and received awards in Indian competitions.

Johnny's style of painting is strongly influenced by his brother's

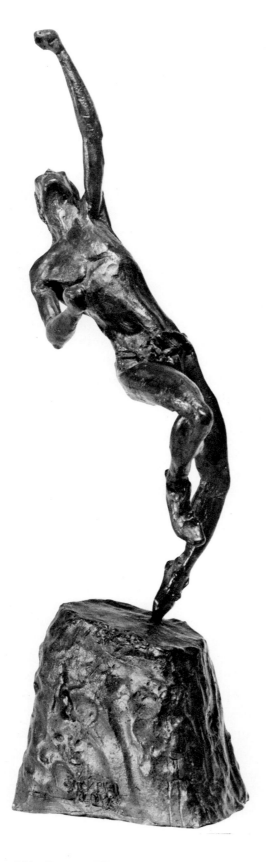

388. Jerome Tiger. *The Stickball Player*. 1967. Arapaho Art Foundry, Oklahoma City. H. 15¾″. Private collection

works, although his sculpture is more individual and has greater power. Johnny thoroughly enjoys working in clay. His strongest models are his expressive Indian portraits, which are not likenesses of specific Indians, but evoke the spirit of his people. In his first sculpture, *Beyond (plate 390)*, Johnny portrays the power of the Indian to transcend his misery on earth by looking toward a life beyond death.

In recent years, Johnny Tiger, Sr. (b. 1915), the father of Jerome and Johnny, Jr., has also become interested in sculpture *(plate 391)*. Both of his grandfathers were Seminole and both of his grandmothers were Creek. The elder Tiger grew up in Hughes County, Oklahoma, where his father worked as a stockman.

Often after helping his father tend cattle, Johnny rode down to the nearby creek to take home some moist clay from the banks. He practiced modeling horses, riders, cattle, and birds and used these clay models as his toys. During his teens, Tiger enjoyed stomp dances and often joined the men's stickball games. As he grew older, he abandoned sculpture. Tiger did not work with clay until after the tragic death of his son.

John L. Clarke (1881–1971) is a well-known Indian woodcarver. In his later years, he created several bronzes of Montana wildlife. Clarke's grandfather, Malcolm Clarke, went West with the United States Army. Grandfather Clarke, a West Point graduate, settled in Montana and bought a toll road, chartered by the first territorial legislation. The road was at the north end of Prickly Pear Canyon. Clarke married a Blackfoot woman and had several children. A daughter, Helen Clarke, became a leading educator in Montana. In 1869, Piegan Indians, feeling they had been treated unfairly in a horse trade, murdered Malcolm Clarke and wounded his son, Horace. It is believed that Clarke's murder led to the Baker Massacre a year later. Young Horace settled in the territory of the Blackfoot Indians and married Margaret, daughter of the Blackfoot chief, Stands Alone. John L. Clarke was their son.

During his youth, John lived in the Sweet Grass Hills and in the land which is now Glacier National Park. Because he became deaf when he was three years old, he never had the opportunity of learning to speak. Life was frustrating and unhappy for the young deaf-mute. His greatest happiness was to wander through the mountains and forest, where he acquired excellent powers of observation and developed a love for all forms of wildlife. Clarke learned to draw pictures as a means of communication.

John attended several schools for the deaf. While at Saint John's School for the Deaf in Milwaukee, Wisconsin, he worked in a furni-

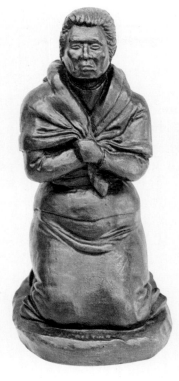

389. Jerome Tiger. *Resting*. 1967. H. 12". Collection Mrs. Jerome Tiger, Muskogee, Okla.

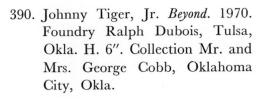

390. Johnny Tiger, Jr. *Beyond*. 1970. Foundry Ralph Dubois, Tulsa, Okla. H. 6". Collection Mr. and Mrs. George Cobb, Oklahoma City, Okla.

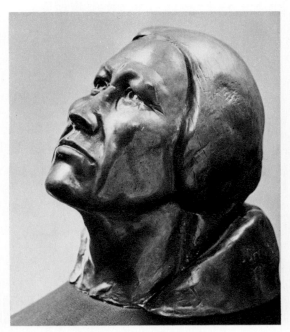

ture factory where he learned to carve. For a short time, he specialized in altar carving. In 1913, Clarke returned to Montana and opened a studio in East Glacier Park. He was encouraged by his friend, Charles Russell. Three years later, Clarke exhibited his first woodcarvings. An admirer sent one of his animal groups to New York. This group came to the attention of W. Frank Purdy of the American School of Sculpture. Purdy was among the first of Clarke's many admirers. The sculptor had several important exhibitions and won many honors. Today his woodcarvings are in museums throughout the United States.

Clarke is best known for his sculptures of animal life *(plate 392)*. His favorite subjects are bears and mountain goats in both wood and bronze. His animal sculptures are skillful, naturalistic studies which show his great love and understanding of animal life.

Gary Schildt (b. 1938) has chosen as the subject for his paintings and bronzes the way of life of the men, women, and children of his people, the Blackfoot Indians of Montana.

Schildt is three-eighths Indian. Born in Helena, he was adopted by his grandparents and raised on their ranch near Browning. As he grew up, Schildt began to identify with the Blackfeet and became interested in the history of the tribe.

During his school years, Gary often thought of becoming an artist. After graduation from high school, he studied commercial art and photography at the City College in San Francisco before receiving a scholarship to the Academy of Fine Arts.

When he completed his training, Schildt returned to Montana to begin his career as an artist of the Blackfeet. He worked as a painter before turning to bronze sculptures. Schildt is more interested in depicting the everyday life of the Indians today than in dramatizing their colorful history. "Very often a small and easily-ignored or overlooked event expresses or conveys a larger, more graphic meaning of life. I try to find those incidents."[7]

Schildt is especially interested in the very young and the very old *(plate 393)*. "They have no pretenses. They're true to themselves, while most of the in-betweens act out a part as though they're not sure of who they are."[8]

Schildt's bronzes are highly competent, naturalistic studies. His Impressionistic modeling gives a sense of immediacy to his work. Like Lone Wolf, Schildt considers himself an Indian artist, but is greatly influenced by traditional Western art, particularly that of Charles Russell. Schildt's bronzes are the creations of an observer rather than a participant in Indian life.

Several Indian sculptors have chosen the role of spokesmen of their

people. Through their art, they try to express the feelings and beliefs of the Indian in America today.

Willard Stone is one of the foremost woodcarvers in the United States. In recent years, he has begun to translate into bronze the themes of his carvings. He is completing a commission from the Five Civilized Tribes Museum for a series of portraits of the chieftains of each of the Five Civilized Tribes at the time of the re-settlement in Oklahoma *(plate 395)*. Desiring to commission an Oklahoma Indian as sculptor, the museum selected Stone, who is part Cherokee.

Stone's art is both narrative and didactic. He is an outspoken man who uses his work to express his firm beliefs and convictions. Almost every one of Stone's creations has a written explanation and a message. The recurrent themes of his work are the horrors of war, the unjust treatment of the Indian by the white man—especially during the years of the tragedy of the Trail of Tears—and the power of friendship and love.

Stone has a fine sense of humor. He creates many light-hearted sculptures of birds, rabbits, and road runners. He is especially fond of children and sees them as universal creatures, all sharing the same joys and sorrows.

Stone (b. 1916) grew up near Oktaha, Oklahoma. His father died when he was an infant and his mother worked as a sharecropper in the cotton fields. As a young boy, Stone enjoyed drawing. When he was thirteen, a dynamite cap exploded and he lost part of his right thumb and two fingers.

Stone left school and joined his mother in the cotton fields. On his way home from work, he would walk along the river banks. One rainy day he began to experiment with the damp red clay, and discovered that he had a natural facility for modeling. During those unhappy years in the cotton fields, creating small clay animals was one of his few enjoyments.

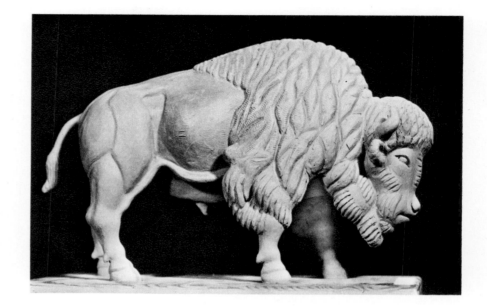

391. Johnny Tiger, Sr. *The Buffalo* (model). 1972. Clay. H. 7¼″. Nettie Wheeler's Thunderbird Shop, Muskogee, Okla.

392. John L. Clarke. *Porcupine Quill.* 1969. Ed Bohlin Founder, Los Angeles. H. 10″. C. M. Russell Gallery, Great Falls, Mont.

393. Gary Schildt. *Old Man Winter*. c. 1966. Ka-eyta Foundry, Harlem, Mont. H. 12″. Main Trail Galleries, Scottsdale, Ariz.

Encouraged by his friends, Stone entered his models at the Muskogee State Fair. Grant Foremann, a famous Oklahoma historian, saw Stone's work and was impressed by his talent. Foremann advised him to seek formal art training. In 1936, Stone enrolled at Bacone College and studied under Acee Blue Eagle and Woody Crumbo. As Stone began to develop a personal style, he found wood sculpture the most expressive medium.

During the 1940s, Thomas Gilcrease gave Stone a three-year grant as an Artist-in-Residence at the Thomas Gilcrease Institute of American History and Art in Tulsa, Oklahoma. Free from financial worry, Stone worked to develop his skills. After leaving Gilcrease, Stone struggled for many years to support his family, but slowly gained recognition for his work.

Wood is Stone's ideal medium. He always selects the perfect variety, and the graining must be in harmony with his design. Stone spends weeks hand-rubbing linseed oil into his sculptures to achieve a rich, warm patina.

Stone is a perfectionist in his work. A deeply religious man, he defines his artistic goal in these words: "A man spends his whole lifetime trying for perfection, but he never makes it. . . .this is for God alone."[9]

Stone's first bronze was created from a woodcarving entitled *Something in Common (plate 394)*, a model of an Indian child saying his prayers. Stone described his bronze and its message:

Our kids may do things that seem to have no reason. But their hearts still go out to the old terripan who is trying to cross today's highways. In all the speeding traffic he has very little chance of getting across.

Maybe the kids feel their position in our world is mutual with the terripan. Both are being neglected and over run, squashed and confused in the rush of our modern world.

This two-year-old has discarded everything that wasn't important to him. Told to say his prayers and go to bed, he has kept his cap pistols for protection, his dad's old hat, and his pet terripan for a bed partner.

His prayer is sincere, straight from his heart. Help him and his terripan cross tomorrow's roads.[10]

Stone's next bronze was also of a child and a turtle.

Stone is not totally successful in translating sculpture from wood to bronze, for although his bronzes illustrate his natural feeling for line and form, they lack the warmth and harmony of his grained, polished carvings.

394. Willard Stone. *Something in Common*. 1969. Roman Bronze Works, N.Y. H. 14″. National Cowboy Hall of Fame, Oklahoma City, Okla.

395. Willard Stone. *Tah'chee*. 1969. Roman Bronze Works, N.Y. H. 12″. Five Civilized Tribes Museum, Muskogee, Okla.

Saint Clair Homer II is one of the most interesting and talented contemporary Indian artists. The son of a German mother and Choctaw father, he was born and raised in Oklahoma. He had extensive academic art training: he attended James Millikin University in Decatur, Illinois, and after serving with General Patton in Europe during World War II, he studied at Biarritz University in France. In Rome, Saint Clair attended seminars in modeling and casting techniques. After returning to the United States, he studied at the Oklahoma State University, Missouri University, and Oklahoma University. For several years, Saint Clair cast his own models, but as this was time-consuming, he now has most of his bronzes cast in Rome.

Saint Clair identifies totally with the American Indian. He is devoted to the study of the Indian during the settlement of the West and protests against the unjust treatment of the red man throughout United States history. Saint Clair follows the unique custom of sending his friends cards each year on the anniversary of General Custer's defeat. He signs his bronzes *Homma*, meaning "Red Man."

At first Homer created traditional Western bronze sculptures. *A Bulldogger* and *A Sheriff* are typical examples of his early work. As Saint Clair's art developed, he began to make sculptures of Indian subjects or of incidents in American history as seen from the red man's point of view.

Like Willard Stone, Homer offers a full explanation for his bronzes. He described a portrait head entitled *A Sioux Called Hump (plate 396)* in the following manner: "Although Hump was Sioux, he came in with the remnants of Dull Knife's Cheyenne camp after the Mackenzie raid in November, 1876, and surrendered to General Miles in August, 1877. He, like many of the warriors, enlisted as scout and thereafter fought with the 'Long Knives'."[11] Hump was chief of the Minneconjuns division of the Sioux tribe which was victorious over Custer at the Battle of Big Horn.

One of Homer's most interesting models is entitled *The Only Shield on the Staked Plain (plate 397)*. Homer explains his bronze:

The man, part scout, part mountain man, part Indian has been jumped by a Kiowa war party. They have this "white-eye," for there's no place to hide on the Staked Plains. It run—keep him running, the fun of getting his hair is the chase. Gun out his horse then rush him from four sides. He has only one shot—then four, maybe three men on him. But he does not run? He pulls his horse down? "Come on Red Brothers, I have gifts for you!" this man shouts, "five small solid lead packages for you my friends, this rifle speaks loudly more than once!"[12]

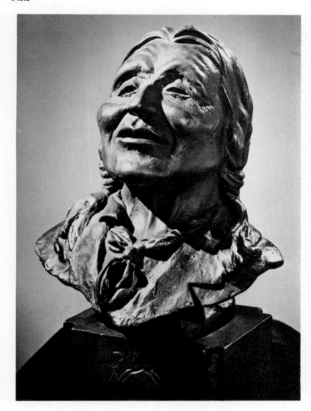

The "Staked Plains" refers to an area which includes the Oklahoma and Texas panhandles, eastern New Mexico, southwestern Kansas, and southern Nebraska. The rolling plains were a sea of buffalo grass. The Jesuit priests, one of the first groups to pass this way, often drove stakes into the ground and topped them with buffalo skins or pieces of cloth in order that others could find their way.

Homer's sculpture has evolved from narratives of the West to poetic creations which express the dreams and desires of the Indian. These bronzes have the spiritual intensity that is the soul of Indian sculpture. His finest sculpture is *The Star Shooter (plate 398)*. The artist explained the origin of the bronze:

This piece evolved from a bit of legend; man's constant striving for perfection and possibly the curiosity about nature, with which the Indian was so akin.

396. Saint Clair Homer II. *A Sioux Called Hump*. 1958. Cast by the artist. H. 11″. Collection the artist

397. Saint Clair Homer II. *The Only Shield on the Staked Plain*. 1964. Precision Metal Smiths, Cleveland, Ohio. H. 8″. Collection the artist

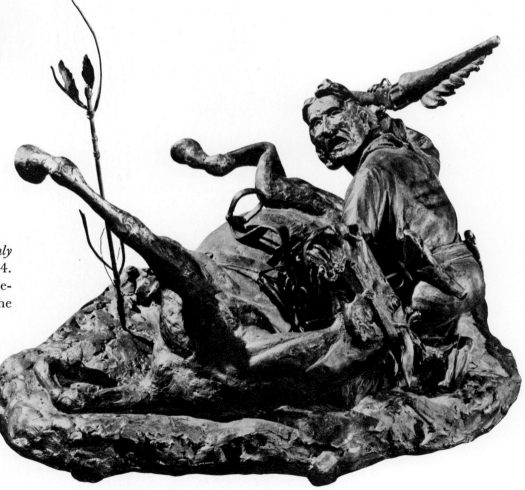

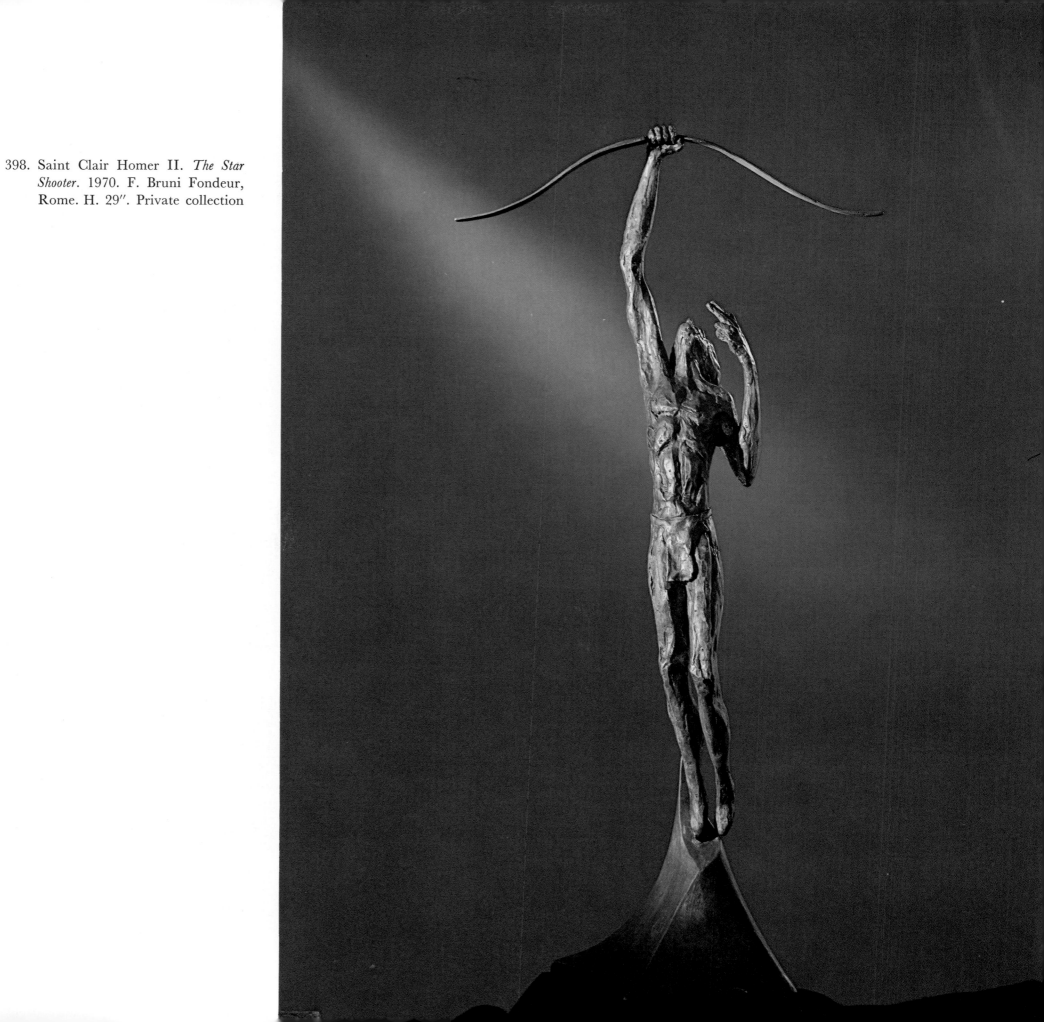

398. Saint Clair Homer II. *The Star Shooter*. 1970. F. Bruni Fondeur, Rome. H. 29″. Private collection

The best wood for bows was bodarc (bois d'arc) or Osage Orange and was much sought after by all the tribes.

But some said, there was a spirit tree deep in the forest and if you could find it and make a bow from this tree every arrow shot would hit its mark. . . no matter how far.

One with such a bow would be the greatest hunter and there would always be food for the people.

Then, at night, while watching the heavens, the Indians knew that somewhere there was such a warrior with such a bow for what else could make the stars fall from their places in the dark sky?[13]

The Star Shooter has a beauty and poetic quality that far surpasses Homer's earlier work. The Indian, his bow overhead, reaches for the sky, his arrow traveling toward a star. The composition is simple and dramatic. The Indian rises in a powerful line from the base to the bow, the instrument of power which will send the arrow soaring toward heaven. The sculpture expresses the ultimate aspiration, which is not only the spirit of the Indian but the essence of creativity.

Michael Naranho's bronzes are Impressionistic models of the Indian rituals he remembers from his childhood in the Santa Clara Pueblo in northern New Mexico *(plate 399)*. His father came from the Taos Pueblo, his mother from the Santa Clara Pueblo. After Michael was born (1944), his family lived in the Santa Clara Pueblo. When he was nine, they moved to Taos, where he attended school. For two years, Michael was an art major at Highlands College in Las Vegas, New Mexico. In 1967, he was drafted and sent to Viet Nam, where he was totally blinded in the war.

Although Naranho had enjoyed modeling during his years in college, he first considered a career in sculpture while at the Rehabilitation Center in Palo Alto, California. He returned to Taos and began work. Naranho had one-man shows in galleries in Santa Fe and Alamosa, and in 1972 at the Heard Museum. He received considerable publicity when he presented his *Dance of the Eagle* to President Nixon.

In expressing the spirit of Indian life, many Indian artists often go beyond historical accuracy and ethnological identity. They ask universal questions and express the beliefs and feelings that are fundamental to all ways of life. They strive to understand the nature of man, his aspirations and limitations, and the meaning and value of life and death.

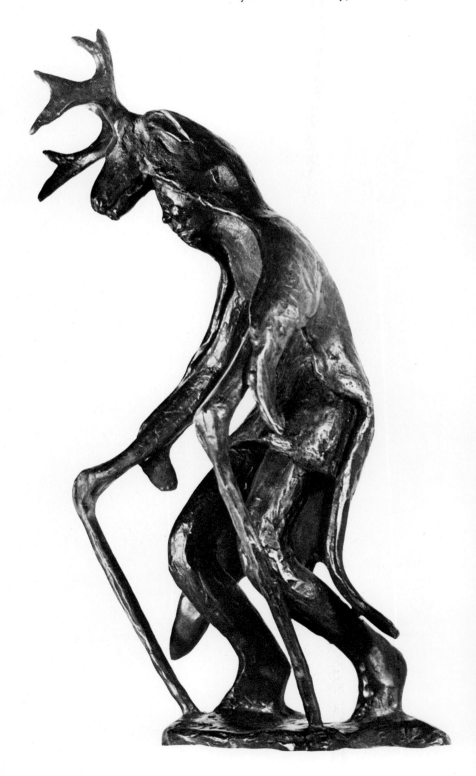

399. Michael Naranho. *Deer Spirit.* 1970. H. 13¾". Jean Seth's Canyon Road Gallery, Santa Fe, N.M.

XXI
CONTEMPORARY COWBOY ARTISTS

In the mid-nineteenth century, after the completion of the railroad connecting the Midwest to the East, Texans began to drive their cattle north to Kansas. The Longhorns had run wild in Texas since men could remember. As Texans realized there were fortunes to be made in cattle, they herded the Longhorns together and drove them to Abilene, Kansas, to be shipped to Eastern markets. These trail drivers were the first cowboys.

Many cowboys through the years have become painters and sculptors. There appears to be no other way of life that even comes close to having the inspirational powers of cowboy life. Cowboy artists have created some of the West's finest bronze sculpture. Solon Borglum, Frederic Remington, and Charles Russell began a tradition of cowboy sculpture which has flourished over the years.

The trail drives have long since ended and the work of the cowboy has changed many times through the years, but whatever his job, the cowboy has lived close to nature, combining a life of excitement with a life of contemplation. The cowboy has become a symbol of the American West, and since the 1890s, sculptors have worked to recreate in bronze all phases and moods of cowboy life. The hardships and joys, the excitement and tranquillity of cowboy life have been an inspiration to artists throughout the years. Cowboy artists are among the most productive and admired creators of contemporary Western sculpture.

The term "cowboy artist" has two definitions. One refers to the group of artists devoted to portraying in painting and in sculpture cowboy life in the West. The cowboy sculptor models incidents from the working world of the cowboy: rodeo life, ranch life, as well as portraits and scenes of Indian life in the West today. The term also refers to the members of the Cowboy Artists of America. This is a formal association devoted to increasing public interest in Western art, to preserving America's Western heritage, and to maintaining the highest standards in realistic Western art.

The Cowboy Artists of America was founded in 1965. The original

325

group of fourteen artists had its first collective show in September, 1966, at the National Cowboy Hall of Fame in Oklahoma City. For seven years, the Cowboy Artists held their annual exhibition there, with presentations of gold and silver awards and purchase-prize awards for sculptures, paintings, and drawings. The first-prize works were frequently acquired as part of the permanent collection of the National Cowboy Hall of Fame. At this time, people from all over the country met at the Hall of Fame for a three-day seminar on Western art.

The originators of the Cowboy Artists outlined standards for their work, and appointed a committee to determine membership qualifications. Today the group has grown to thirty members. These artists add the letters C.A. to their name; those who have been admitted to the National Academy of Design add N.A. The public, in its enthusiasm for Western art, avidly seeks out works by the Cowboy Artists, confident of a recognized standard of quality. It thus has become a tremendous financial advantage to belong to this group. The association, wishing to remain small, has become more and more selective in its admission requirements.

Since 1973, the Cowboy Hall of Fame has been the location of a separate conference and competition sponsored by the newly formed National Academy of Western Art. Entries are by invitation, not by membership in any organization (members add the letters N.A.W.A. to their names). The Cowboy Artists of America now hold their annual exhibition and contest in Phoenix, Arizona.

Since all the artists in the Cowboy Artists of America can be included in the wider non-organizational definition of the term "cowboy artists," this chapter will cover some of the outstanding sculptors of contemporary Western life, regardless of their affiliation with any formal group.

The cowboy artists are, without exception, realists. Each artist, in defining his artistic goal, states as a primary object accuracy and authenticity in the re-creation of the American West. Those devoted to Indian portraiture study the distinctive racial characteristics of each tribe and the individual features of their subjects. Those who create action sculptures display their first-hand knowledge of the movements of bulls, broncs, and riders and often portray authentic saddles and bridles.

There are several reasons for this devotion to absolute authenticity. First, most of these artists at some time in their life have participated in or witnessed many of the scenes they portray. Frank Polk, Grant Speed, and William Moyers all knew the thrills of rodeo riding; Joe Beeler, Melvin C. Warren, and Bob Scriver grew up in the Western world of cowboys and Indians; others, such as Harry Jackson and John Kittleson, ran away from home for the glory and excitement of Western life. The cowboy artists portray the world they live in or have lived in. It is their intimate knowledge of that world as well as their artistic ability that they wish to demonstrate in their work.

Most of the cowboy artists collect each other's work. They either trade with one another or purchase admired bronzes and paintings. These artists strive to win the approval of their peers and deeply admire the work of their fellow artists.

Many of the admirers of cowboy art are active participants in contemporary Western life. They enjoy sculptures which reproduce the life they know, and delight in authenticity of subject, action, and detail. For Westerners, cowboy artists portray life the way it really is.

Most cowboy artists look to Remington and Russell as their models. They consider their work to be the finest achievements in Western art. Many proudly own drawings, paintings, or sculptures by both artists. Remington's bronzes are their models for the drama of the acrobatic heroics of the cowboy and the bucking, wicked horse, while Russell's bronzes greatly influence their creations of Indian and animal life.

The cowboy artists are romantics who glory in the world they live in. Generally they do not long for the days of the frontier nor mourn the West that has passed, for although they have a feeling of continuity with the past and are proud of their heritage, they are exhilarated by the West as it is today. They create portraits of Indians they have known or scenes of Indian life they have witnessed. The cowboy artists romanticize and idealize the life of the cowboy, but it is the modern cowhand, ranchman, and rodeo rider rather than the cowboy of the nineteenth-century cattle drives. The cowboy artists often portray the rich animal life of the West as well. Although these artists yield on many occasions to the temptation of creating scenes of frontier life or dramas of Indian history, it is their celebration of contemporary life in the West that gives cowboy art its vitality and importance.

Harry Jackson (b. 1924) is one of the best-known cowboy artists. His bronzes are in collections, art galleries, and museums throughout the United States. Jackson was born in Chicago and as a very small child was greatly excited by watching polo practice at a local armory. By age five, he began to ride and draw horses. He attended children's classes at the Chicago Art Institute. One Christmas, the gift of a cowboy suit, lariat, and toy gun transformed the city child into a confirmed Westerner. This love of the West has lasted throughout Jackson's life.

Young Harry often practiced drawing the cowboys and cattle traders who came in from the Chicago stockyards to eat at his mother's lunchroom. He often visited the G. F. Harding Museum to admire and study the Remington bronzes. He had no interest in schoolwork and frequently ran away from home. When he was fourteen, Jackson was so impressed by an article in *Life* magazine on the Pitchfork Ranch in Wyoming that he deserted home for life in the West.

Jackson's first job was at the Diamond Lumber Yard in Cody, Wyoming. He drifted on, willing to work at any available job. He later became a ranch hand and finally attained his boyhood goal of becoming a cowboy. During these early years in the West, Jackson eagerly practiced drawing cowboys, horses, and cattle.

During World War II, Jackson became a Marine combat artist. Following the war, he lived for one year in Mexico and then moved to New York. There he studied art with Jackson Pollock, Rufino Tamayo, and Hans Hofmann and became a highly competent and successful abstract painter. He then spent several years in Europe studying the works of the old masters.

On returning to the United States, Jackson decided to study traditional American art. He was particularly attracted to the work of the realist masters Eakins, Homer, Hopper, Remington, and Russell. When Jackson returned to Wyoming, he abandoned abstract art for realistic representations of American life, particularly life in the West. Today, he still considers Wyoming his home, although he spends most of his time in Camaiore, Lucca, Italy, where his bronzes are cast.

Jackson's best-known sculptures are *The Range Burial (plate 401)* and *Stampede (plates 405, 406)*. These giant groups are among his finest creations and are among the most eloquent sculptures in contemporary Western art. They depict dramatic episodes in Western life with artistic power and emotional depth.

In *Stampede*, the cattle charge forward, creating a great sense of movement. The fallen steer and the lone trampled cowboy are barely noticeable in the forward rush of horn and hoof. Jackson retains sufficient detail to give the group a realistic appearance, but avoids minute detail which would detract from the feeling of the stampede's force.

While *Stampede* is a monumental study of movement and excitement, *The Range Burial* is a study of stillness and contemplation. It represents the burial of the cowboy killed in the stampede. One can imagine that among the mourners are the same cowboys who fought to quiet the stampede. Jackson's talent for composition adds to the

dramatic force of his work. In *Stampede*, the earth over which the cattle charge is almost entirely obscured. In *The Range Burial*, the hard, rugged mass of ground is of central importance to the composition, for it adds to the sense of smallness of man and the power and finality of the earth.

In both sculptures, Jackson achieves a fine balance of realistic detail and abstraction. The details, however, never detract from the emotional impact or dramatic intensity.

Both bronzes resulted from a commission by Robert Coe, the American Ambassador to Denmark, for a pair of epic paintings based on the life of the American cowboy. While in Europe, Jackson had greatly admired Gustave Courbet's painting, *Burial at Ornans*. He told Coe of his desire to create a mural-size painting of a cowboy in cattle country. Coe approved Jackson's idea and commissioned *The Range Burial (plate 400)* as well as the companion painting, *Stampede (plate 404)*, showing the violent death of the cowboy. Both represent themes basic to Western tradition. Similar tales are retold in countless stories and songs of heroism and sorrow.

While working on *The Range Burial*, Jackson completed two models of cowboy figures. Through these models he hoped to solve problems of scale and composition in his painting. He took the models to Coe, who purchased them for his own collection. These early models, *Trail Boss (plate 402)* and *Center Fire*, were his first bronzes.

Following the successful acceptance of these models, Jackson returned to Italy to work on the final version of *The Range Burial*. He created the larger composition directly in wax. The epic work was then cast in bronze.

Jackson worked for eight years on his painting of *The Range Burial*. He used his sculpture as the model for the final version of the painting. By 1963, the year of its completion, Jackson said: "I was certain that sculpture had taken an equal place in my heart alongside of painting and that the two were destined to complement and aid each other in the most provocative and as yet undreamt-of ways."[1]

Jackson's sculpture has changed drastically in the course of his career. His early work was highly Impressionistic. *Sittin' Purty (plate 403)*, a study of a cowboy on a bucking horse, exemplifies Jackson's use of quickly modeled, simplified form to achieve a sense of motion and dramatic impact. In this work he carefully composed and balanced the forms to create a dramatic silhouette.

During the late 1950s, Jackson created many Impressionistic models of cowboys. Many are far more abstract than *Stampede* or *The Range Burial*. *Lone Ballad*, *Ground Ropin'*, and *The Steer Roper (plate 407)* are examples of this more Impressionistic work. Jackson's sculpture

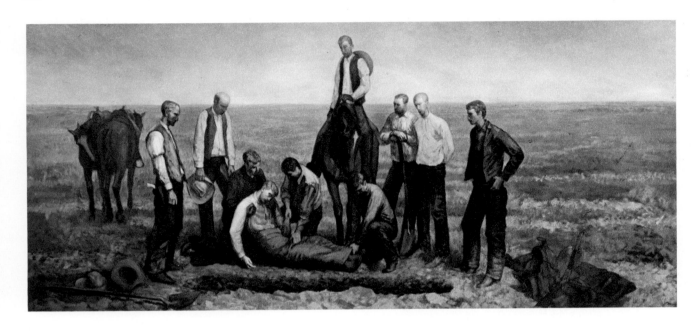

400. Harry Jackson. *The Range Burial*. 1963. Oil on canvas. 10 × 21'. Whitney Gallery of Western Art, Cody, Wyo.

401. Harry Jackson. *The Range Burial*. 1958. Vignali-Tommasi, Pietrasanta Art Foundry, Pietrasanta, Italy. H. 15¼". R. W. Norton Art Gallery, Shreveport, La.

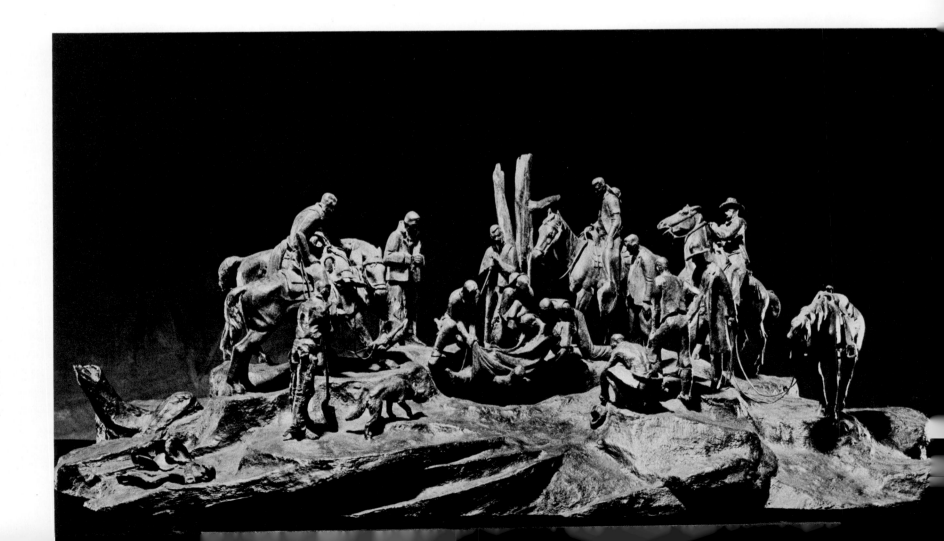

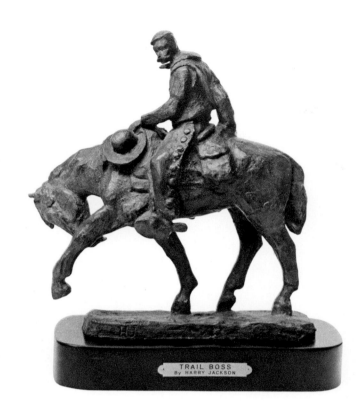

402. Harry Jackson. *Trail Boss*. 1958. Vignali-Tommasi, Pietrasanta Art Foundry, Pietrasanta, Italy. H. 8½″. Kennedy Galleries, New York City

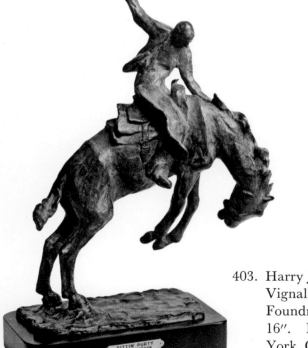

403. Harry Jackson. *Sittin' Purty*. 1959. Vignali-Tommasi, Pietrasanta Art Foundry, Pietrasanta, Italy. H. 16″. Kennedy Galleries, New York City

slowly became more realistic. *The Salty Dog* and *The Bronc Stomper* illustrate his more realistic approach, which follows in the Remington tradition.

Jackson's later sculptures, such as *The Frontiersman* and *The Pony Express (plate 408)*, are totally realistic. Indeed, they are almost three-dimensional illustrations. This photographic approach is suitable for his current technique of painting the finished bronze. It is his newest refinement of the photographic approach. Jackson's portrait of John Wayne was used on the cover of *Time* magazine in conjunction with a feature story on John Wayne as the last cowboy hero. Jackson portrayed Wayne in his costume for the movie *True Grit*. He re-created this costume in detail, from the eyepatch down to the last button and tie, and painted the bronze so that it might have authenticity of color. This and other photographic bronzes lack the greater force of Jackson's earlier work. Of Jackson's totally realistic bronzes, *The Pony Express* has the most vitality and power.

For many years, Jackson has depended on *The Range Burial* for a large portion of his artistic output. He has cast the individual figures separately and given each a title. One bronze of a standing mourner is entitled *The Gunsil* (a cowboy abbreviation for a gun slinger), another *Where the Trail Forks*. Jackson has also painted the individual figures from *The Range Burial*. The high-keyed colors add to the realism of his figures, but detract from their dramatic force and change the character of the work.

In 1960, Jackson created a smaller and simplified version of *The Range Burial* entitled *The Plantin'*. Most of the figures are the same as in his larger work but are rearranged in a simpler composition. This bronze retains the dramatic impact of the original group.

Jackson's bronzes have won wide public acclaim. The painter Peter Hurd, in a tribute to Jackson, underlines the appeal of his work: "To know how completely he communicates as an artist you have only to consider the wide range of emotions expressed in his work: from the wild tumult of *Stampede* with the palpable terror of this animal cataclysm to the deeply affecting pathos of the heroic *Range Burial*. Here there is no need to learn a new and obscure language!"[2]

George Phippen (1915–1966) was one of the most popular and successful cowboy artists. He devoted most of his life to portraying the world of the American cowboy in painting and sculpture, and to developing public interest in America's Western heritage as expressed through cowboy art. During the days when the public was interested only in works by Remington and Russell, Phippen worked to gain recognition for contemporary artists. He was the founder of the Cow-

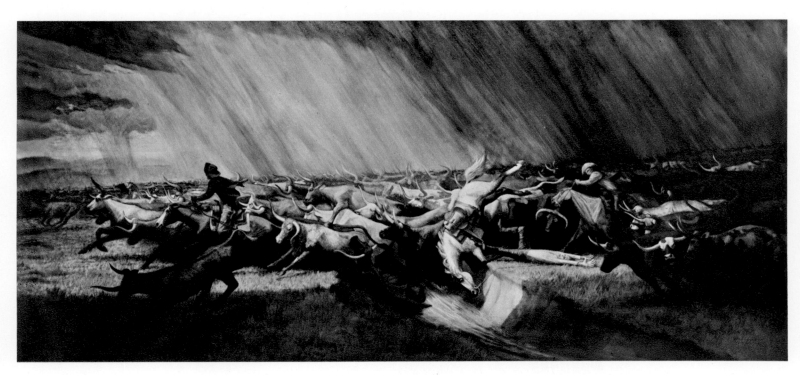

404. Harry Jackson. *Stampede*. 1965.
Oil on canvas. 10 × 21′. Whitney
Gallery of Western Art, Cody,
Wyo.

405. Harry Jackson. *Stampede*. 1958–59.
Vignali-Tommasi, Pietrasanta Art
Foundry, Pietrasanta, Italy. H.
14½″. Kennedy Galleries, New
York City

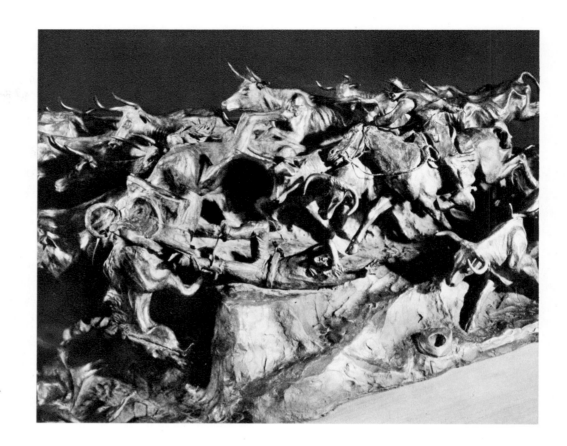

406. Harry Jackson. *Stampede* (detail of
plate 405)

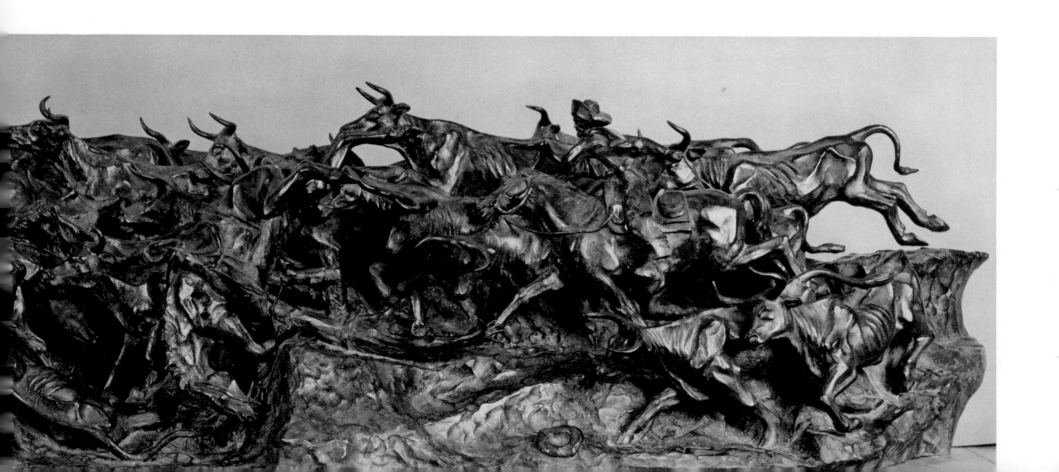

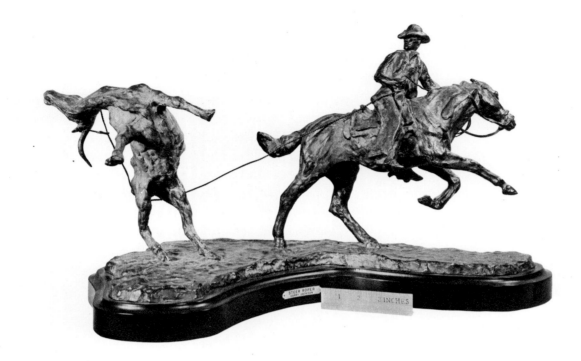

407. Harry Jackson. *The Steer Roper*. 1959. Vignali-Tommasi, Pietrasanta Art Foundry, Pietrasanta, Italy. H. 12″. Glenbow-Alberta Institute, Calgary, Alberta

408. Harry Jackson. *The Pony Express*. 1967. Polychrome bronze. Wyoming Foundry Studios, Lucca, Italy. H. 19″. Kennedy Galleries, New York City

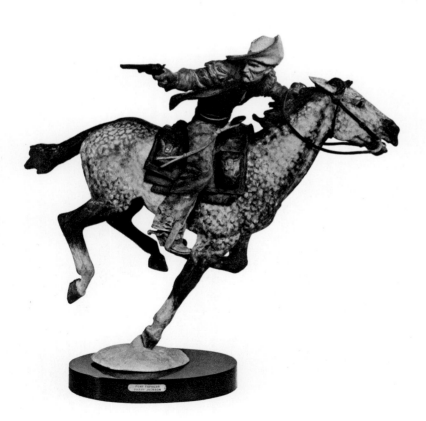

boy Artists of America, and was elected the group's first president.

Phippen grew up near Emmett, a prairie town in north central Kansas. Although the last of the Texas Longhorns had passed through Kansas many years before, young George often dreamed of the days when the cowboys rode on the Chisholm Trail. After a rainstorm, he would try to model horses, cattle, and cowboys from the gumbo clay of the creek banks. Sometimes he would bake these in his mother's oven, while at other times he would put them out to dry in the sun. For many years, George delighted his brothers and sisters with models of all forms of domestic animals and wildlife *(plate 409)*.

Phippen had no formal artistic training. As he worked in the fields or rode through the forests and over the desert, he studied the forms, habits, and mannerisms of animal life around him. He studied the rugged plants and rock formations of the landscape and later used many rock and cactus forms in his sculpture.

Phippen was deeply interested in the history of the West. He enjoyed the prints and paintings of Remington and Russell and studied these until he knew them in detail. All through his life, he loved horses and especially liked working with the green colts. Once school days were over, George, the fifth of nine children, went to work on the family farm. Here, he learned firsthand the details of cowboy life which later gave great authenticity to his work.

In 1941, Phippen entered the army. During five years of service, he continued to draw and model and, for the first time, his work won praise from artists and collectors. Once discharged, he was determined to succeed as an artist, specializing in Western subjects. He traveled to Santa Fe and for three months worked with Henry Balink. This was the extent of his formal art training. Phippen's earliest

works were illustrations for magazines. Slowly he began to sell watercolors and drawings. A few years later, he began to work with oil.

It was not until 1958 that Phippen began his career as a professional sculptor. He was commissioned by Robert Kleberg of the King Ranch in Texas to model the famous horse, Winpy P 1, for the American Quarter Horse Association. The sculpture was received with great enthusiasm. He next modeled several highly successful cowboy scenes. For the remainder of his short life, Phippen's bronzes were tremendously popular.

Phippen's best-known work is *The Rock Hopper (plate 410)*. The base of the sculpture represents the jagged rocks of Arizona. This

409. George Phippen. *Brahma Bull.* Modeled 1929, cast 1959. Noggle Bronze Works, Prescott, Ariz. H. 6½″. Collection Dr. and Mrs. Robert Sukman, Edmond, Okla.

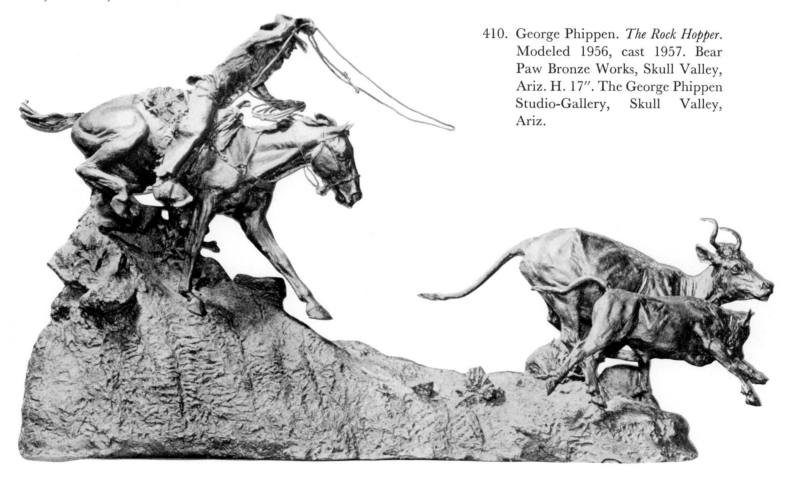

410. George Phippen. *The Rock Hopper.* Modeled 1956, cast 1957. Bear Paw Bronze Works, Skull Valley, Ariz. H. 17″. The George Phippen Studio-Gallery, Skull Valley, Ariz.

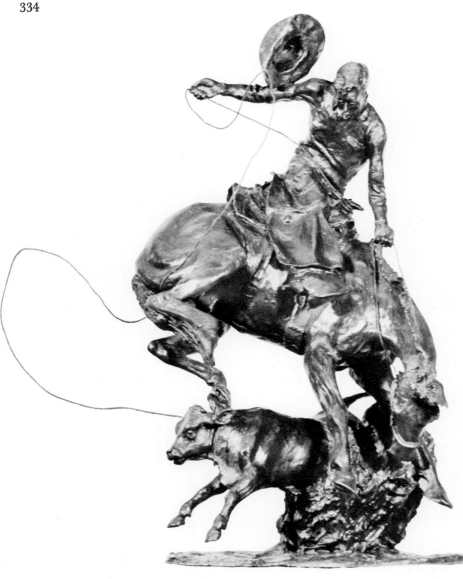

411. George Phippen. *Cowboy in a Storm*. 1966. Bear Paw Bronze Works, Skull Valley, Ariz. H. 17″. The May Gallery, Jackson, Wyo.

highly realistic bronze is filled with the tremendous energy and excitement of the pursuit. Phippen's excellent knowledge of the movements of horses and cattle gave authenticity to his work. He had a natural sense of rhythm and the ability to recapture in his sculpture the harmony and energy of motion *(plate 411)*. Phippen occasionally created a humorous work, such as the bronze of the Cowboy's Devil who has come up from Hell's Rim Rock to gather in the cowboys' souls. Phippen made *The Cowboy's Devil (plate 412)* after he had illustrated Gail Gardner's poem, *Tying the Knots in the Devil's Tail*.

Throughout his life, Phippen was determined to achieve excellence in both the modeling and casting of his bronzes. A perfectionist with regard to detail, he made extensive studies before beginning each work.

Phippen's career was at its height when he was stricken with cancer and died in 1966. The previous year, he had founded the Bear Paw Bronze Works, which is now operated by his son Loren. Today, his widow and sons are issuing the remaining casts of Phippen's bronzes as well as casting the plaster models not cast during his lifetime.

Olaf Wieghorst (b. 1899), like Phippen, was one of the first contemporary artists to win public recognition at a time when only the work of Remington and Russell was considered of value.

Born in Denmark, Wieghorst was devoted to horses throughout his life. As a boy, he was trained to become a circus acrobat. Olaf had his first taste of cowboys and Indians in 1912 when the Jack Joyce Circus and Wild West Show came to Copenhagen. Olaf left home at age fourteen and tried farm work before he worked his way to America. He longed for the excitement of the American West, which he knew from *Buffalo Bill Western Magazines* and Remington's illustrations. In America, he jumped ship and enlisted in the cavalry, hoping to serve on the Mexican border. Cavalry life in the West was his boyhood dream come true. In his off-duty time, Olaf worked part-time as a cowboy on the neighboring ranches and entered rodeo contests.

After discharge from service, he wandered through the West and for a while settled down as a working cowboy in New Mexico. By 1923, Olaf had worked his way back to New York, where for twenty years he was a mounted patrolman with the city's police force.

Wieghorst had drawn and painted since childhood. In 1940, he began to work as an illustrator for Western magazines and art calendars. Slowly he attracted private commissions. In 1944, following his retirement from the police force, he headed West to begin life as an

412. George Phippen. *The Cowboy's Devil*. 1966. Bear Paw Bronze Works, Skull Valley, Ariz. H. 8½". Tanner's-Troy's, Scottsdale, Ariz.

As they was a-ridin' back to camp,
A-packin' a pretty good load,
Who should they meet but the Devil himself,
A-prancin' down the road.

Sez he, "You ornery cowboy skunks,
"You'd better hunt yer holes,
"Fer I've come up from Hell's Rim Rock,
"To gather in yer souls."

413. Olaf Wieghorst. *Indian by the Campfire*. c. 1964. Roman Bronze Works, N.Y. H. 3½". Collection the artist

414. Olaf Wieghorst. *Restin' and Reminiscin'*. c. 1965. Roman Bronze Works, N.Y. H. 7⅞". Collection the artist

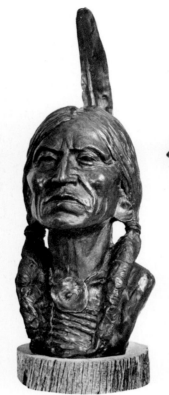

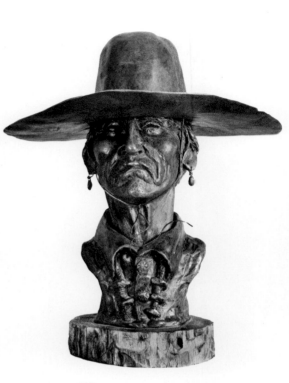

415 416 417 418

artist. He settled in El Cajon, California. Wieghorst based his art on careful research, personal experience, and observation.

The galleries at this time were totally unreceptive to contemporary artists. Wieghorst, after several years' work, held a private exhibition at his home. It was both a financial and critical success, and from this time on he was recognized as an outstanding contemporary artist by collectors, galleries, and museums both in the United States and in Denmark.

In recent years, Wieghorst has created several bronze sculptures. They are very much like his painting, re-creating scenes of cowboys, horses, and Indians remembered from his youthful days in the West. Wieghorst's bronzes have the same gentle Impressionism that is characteristic of his paintings. His models are unquestionably realistic representations, but he limits his use of detail to the essentials. These details, however, are always authentically portrayed.

The study of an Indian by a campfire *(plate 413)* is a skillful Impressionistic work. The old Indian stares at a buffalo skull. In the firelight, he remembers a world which, like the buffalo, belongs to the past.

Wieghorst's bronze of a cowboy sitting beside his horse evokes a similar mood. It is entitled *Restin' and Reminiscin' (plate 414)*. Like the

415. Joe Beeler. *The Apache*. 1966. Noggle Bronze Works, Prescott, Ariz. H. 13″. Collection the artist

416. Joe Beeler. *The Cheyenne*. 1971. Noggle Bronze Works, Prescott, Ariz. H. 12″. Collection the artist

417. Joe Beeler. *The Sioux*. 1967. Noggle Bronze Works, Prescott, Ariz. H. 16″. Collection the artist

418. Joe Beeler. *The Navaho*. 1964. Noggle Bronze Works, Prescott, Ariz. H. 14″. Collection the artist

419. Joe Beeler. *Thanks for the Rain*. 1970. Buffalo Bronze Works, Sedona, Ariz. H. 11″. Collection the artist

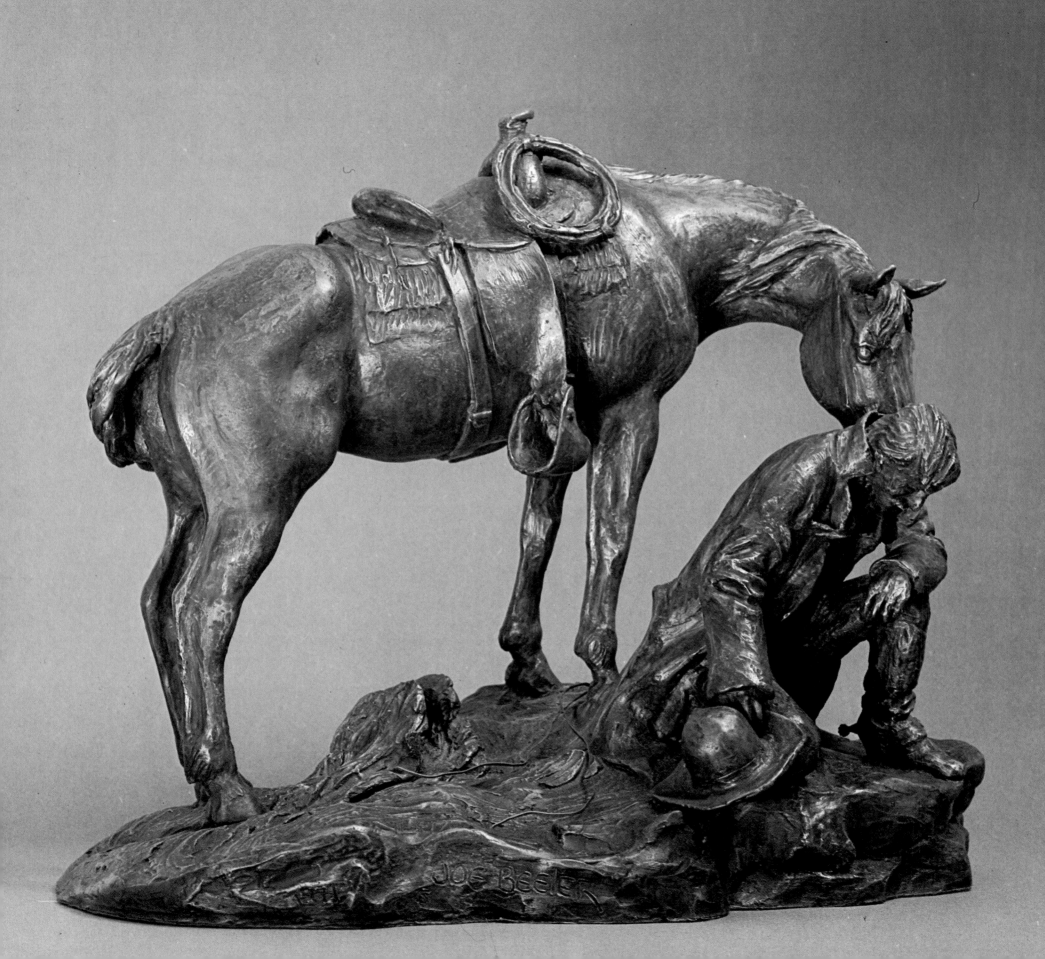

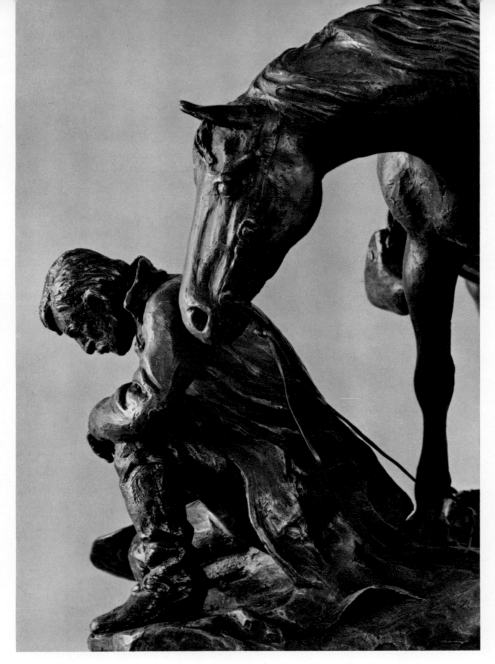

420. Joe Beeler. *Thanks for the Rain* (detail of plate 419)

Indian and the cowboy, Wieghorst, working in El Cajon, California, remembers the West of his youth in his sculpture and painting.

Joe Beeler (b. 1931) is the most eloquent spokesman of contemporary cowboy artists. He believes that the cowboy artist must create a work of art which has intrinsic artistic value as well as documentary importance. For Beeler, authenticity and realism are not enough in Western art: the Western artist must have a dual role, as artist and historian. First of all, however, he must be judged as an artist. Beeler writes:

A really fine or great piece of western art will not only show care in the documentary aspects of the work, but it also will be a fine piece judged primarily on its merits as art alone. When you know and understand the subject matter well enough, the two elements will blend to please the historian, the cowboy, and the art critic.[3]

Beeler's bronze sculpture exemplifies his theory. His Indian portraits are his finest work. He has created a series of portrait heads of members of the Sioux, Apache, Cheyenne, and Navaho tribes *(plates 415–418)*. Beeler is an excellent technician. Through his knowledge of facial structure, he illustrates the physical differences between the tribes. All his Indians, however, have a unity of spirit. Beeler shows their pride and determination, their independence and despair. There is almost no communication between the Indian and the spectator. Each Indian lives in a world which he alone understands and which he wishes to retain as his own. Beeler's Indians look forward, but not at the viewer. They look beyond him and turn within themselves.

Beeler's cowboy bronzes, like his Indian portraits, capture the spirit of Western life rather than offering a mirror-image of it. In *Thanks for the Rain (plates 419, 420)*, he illustrates the unity between the cowboy and his horse and expresses the cowboy's closeness to nature and his dependence on God for the survival of his herd.

Beeler's background has had a great influence on his work. Born in Joplin, Missouri, he is a fourth-generation Westerner. His great-grandfather fought in the Civil War and then went West to Texas to work as a cowhand. His grandparents were pioneers on the Oregon frontier and took part in the Gold Rush to California. Beeler's father, who is part Cherokee, instilled in his son his own love of nature and a respect for animal life.

Beeler grew up among the Indian tribes of northeast Oklahoma. He listened to the tales of his parents and grandparents, and loved the excitement of local rodeos and Indian pow-wows:

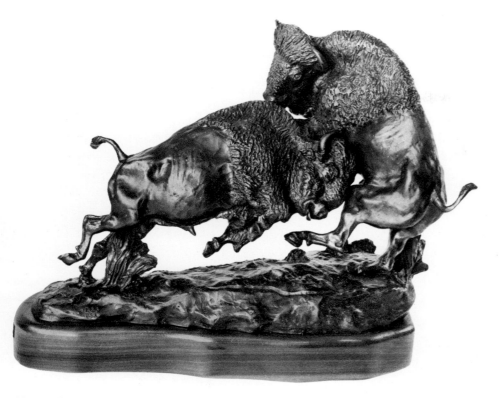

421. William Moyers. *The Price of a Herd*. 1972. Artists and Sculptors Foundry, Burbank, Calif. H. 11". Collection the artist

Pow wow meant fun and dancing, games and large feasts and visiting friends. I war-danced in feathered costume and stirred up the dust when the stomp dance started later in the night. I have held hands and danced and sung the forty-nine songs and then gone to the creeks to bathe as the other Indian youths did.[4]

Beeler began to paint and draw cowboys, horses, and cattle: " . . . it was along about the same time I was trying to decide whether Santa's reindeer really could fly or if they had to walk every step of the way."[5] As he grew up, he took part in all phases of cowboy life, but his primary goal was to become an artist. His art studies at Tulsa University were interrupted by two years of military service during the Korean War. Following the war, he graduated from college and continued his studies at the Art Center School of Los Angeles.

Slowly, Beeler received commissions for his work and obtained recognition. In 1960, he had his first one-man show at the Thomas Gilcrease Institute of American History and Art and, in 1965, he became the first contemporary artist to have a one-man show at the National Cowboy Hall of Fame in Oklahoma City.

George Phippen encouraged Beeler to begin his work in sculpture. *The Navaho (plate 418)* was his first bronze. In 1967, *The Sioux (plate 417)* won the award for the best sculpture exhibited at the National Cowboy Hall of Fame.

Today, Beeler lives in Sedona, Arizona, amid the red rocks of Oak Creek Canyon where he enjoys life as a professional artist. Although Beeler calls Charles Russell "the Father of Cowboy Art" and especially admires his work, he is conscious that contemporary artists must create a vital and independent art.

William Moyers (b. 1916) is one of the most successful cowboy artists. His favorite subject is Western range life. His bronze, *Range War (plate 422)*, a scene of two wild stallions fighting for supremacy, won the National Cowboy Hall of Fame Purchase Award and plaque as the outstanding bronze sculpture of 1968. In it, Moyers tried to suggest that despite the brutality of the conflict, there is also a grace of movement which is almost a fierce ballet. In 1972, Moyers again won the Best Sculpture Award in the annual competition of the Cowboy Artists of America for *The Price of a Herd (plate 421)*.

Moyers grew up in Atlanta, Georgia. When he was a teenager, his family moved to Alamosa, Colorado. Moyers quickly adopted the West as his home. During his high school and college years, he worked as a cowboy. Today, Moyers often draws on his memories of cowboy life for his subject matter. He still travels extensively through

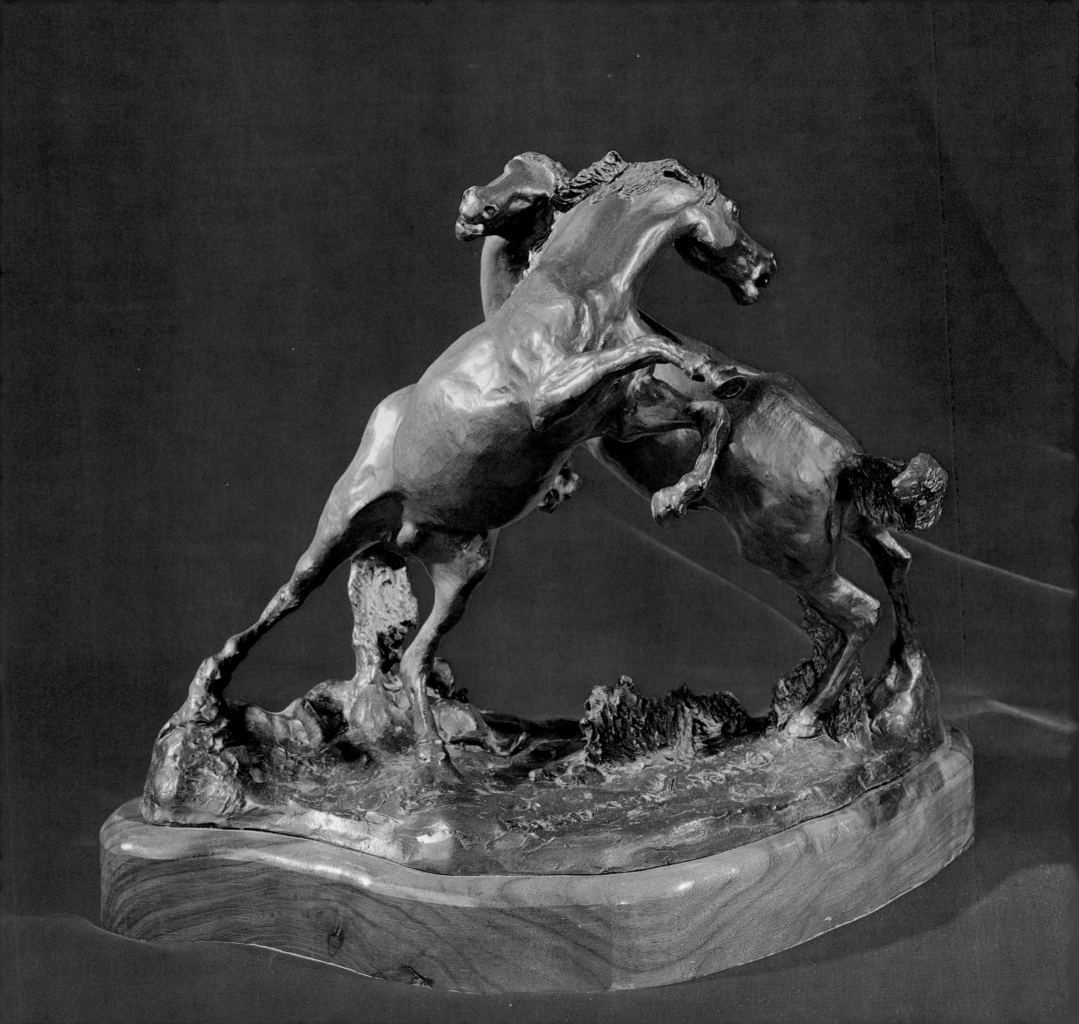

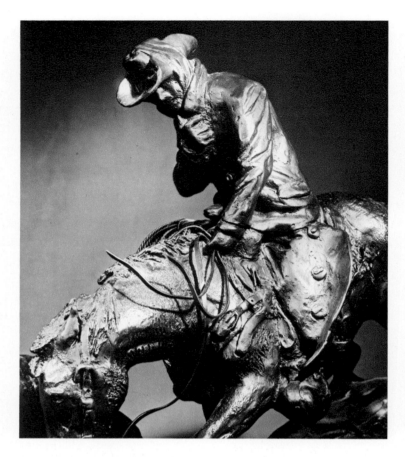

423. William Moyers. *Winter* (detail of plate 424)

422. William Moyers. *Range War*. 1968. Artists and Sculptors Foundry, Burbank, Calif. H. 11″. Collection the artist

Arizona and New Mexico to study the horses, cattle, and cowboys.

One of Moyers' most beautiful bronzes is *Winter (plates 423–424)*. A mounted cowboy herds his cattle through the deep snow, which forms the base of the sculpture. Through the rhythm of his composition, Moyers achieves a sense of forward motion. One can almost feel the severity of the cold and snow. The snow is part of everyday Western life and will not prevent the cowboys from herding their cattle. Moyers' bronzes are realistic but use a minimum of decorative detail in order not to lessen the dramatic impact of his work.

Moyers is a collector of contemporary Western art and of historic cowboy and Indian memorabilia. He is regarded by his peers as a Western scholar, and was the 1971–72 president of the Cowboy Artists of America.

Bob Scriver (b. 1914) is one of the most accomplished of contemporary Western sculptors. His dynamic bronzes of bull and bronc riders have a power that is unsurpassable. He has twice won the first prize for sculpture at the Cowboy Artists' annual exhibitions—for *An Honest Try (plates 426–428)* in 1970 and for *Pay Window (plate 429)* in 1971. *An Honest Try* is one of the most dynamic bronzes created by a contemporary Western sculptor. *Pay Window*, a bronze in which the flying horse and rider are supported by a single horse's hoof, is a triumph of technical skill.

Scriver was born in Browning, in the northwest corner of Montana. Following his success as a cornet player in high school, Bob first pursued a career in music. He played with Ted Weems's orchestra and was accepted for Vaughn Monroe's band. He was listed in the 1950 edition of *Who's Who in Music*. Scriver played with most local Montana bands and became the leader of his own combo. He was director of the all-Indian band which played in full regalia at events such as the Calgary Stampede.

During World War II, Scriver enlisted in the Army Air Corps and played in the military band. Following his discharge from service, he developed his hobby of taxidermy into a business and transformed his personal game trophy collection into the Museum of Montana Wildlife.

Following the tradition of Akeley, Rockwell, and Clark—all of whom were taxidermists turned sculptors—Scriver attempted to model small animal figures, first as preparation for his taxidermy mountings and ultimately as independent works of art. His first sculptures were a set of miniature souvenir animals. In 1953, he cast his first serious model, *White Tail Buck*. Scriver personally casts his bronzes at his own foundry, the Big Paw Foundry in Browning.

In 1956, Scriver entered a heroic plaster model of Charles M.

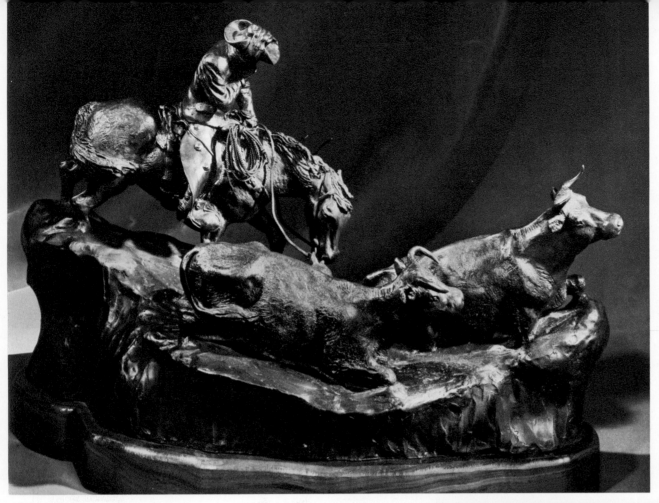

425. William Moyers. *Winter* (left view)

424. William Moyers. *Winter* (right view). 1970. Artists and Sculptors Foundry, Burbank, Calif. H. 12⅛″. Collection the artist

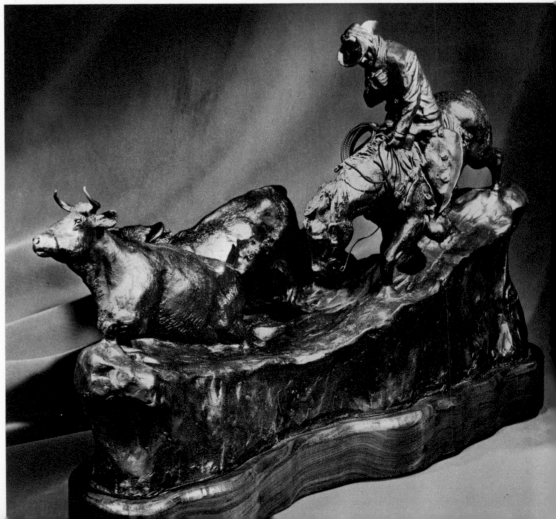

Russell in a contest for a statue that was to stand in the Statuary Hall of the U.S. Capitol in Washington, D.C. Scriver lost the competition and analyzed the reasons for his failure. He then returned to work and study in order to improve the technical and artistic levels of his sculpture.

During the early 1960s, Scriver began to create models of cowboy and Indian life. His Indian bronzes are heavily dependent on Russell's sculpture: *Enemy Tracks*, *The Buffalo Runner*, and *The Price of the Scalp* are all competent variations of Russell's bronzes and even bear similar names. His earliest cowboy bronzes lack the creative force of his later work.

Since the mid-1960s, Scriver has achieved a technical excellence and dramatic power which has made him one of the foremost cowboy sculptors. Scriver has long admired the work of wildlife artist Carl Rungius and throughout his career has been attracted to themes of Western woodland life. His animal sculptures are excellent naturalistic studies of bears, deer, caribou, bighorn rams, and other species of Montana wildlife. *Grizzly in a Trap* and *Fighting Elk* are among his most powerful early works, while *Mountain Sentinels (plate 430)*, a study of two mountain goats, is one of his strongest later works.

Scriver reached the height of his career with his dynamic bronzes of rodeo scenes. These bronzes are outstanding examples of realistic sculpture. In 1969, Scriver had a one-man exhibition of seventy bronzes at the Whitney Gallery of Western Art in Cody, Wyoming. He is a member of the National Sculpture Society.

The bronze sculptures of Grant Speed (b. 1930) are among the most dramatic in contemporary Western art *(plate 433)*. In *The End of a Short Acquaintance*, the horse is attached to the ground only by his forefeet, and the airborne rider's only contact with the horse are his feet and a rope. Horse and rider each appear to be suspended in air. In *Earnin' His Dollar a Day (plate 432)*, the bronco's only contact with the earth is one hoof on the edge of a rock.

Speed has the ability to re-create in bronze a sense of the action and excitement he remembers from his days on the rodeo circuit. He grew up in San Angelo, Texas. As a boy, his only heroes were cowboys. He could hardly wait to leave school to begin "cowboying." As a cowboy, Speed wandered from ranch to ranch, working throughout Arizona, Wyoming, and Texas.

In 1952, Speed started college at Brigham Young University in Provo, Utah. He joined the rodeo team and specialized in saddle bronc riding. His rodeo career was ended when Big Piny, a champion bucking horse, fell on his leg and broke his ankle. While recovering,

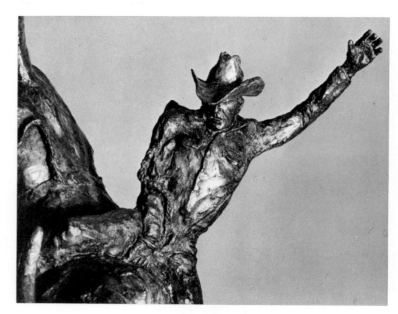

426. Bob Scriver. *An Honest Try* (detail of plate 428)

427. Bob Scriver. *An Honest Try* (detail of plate 428)

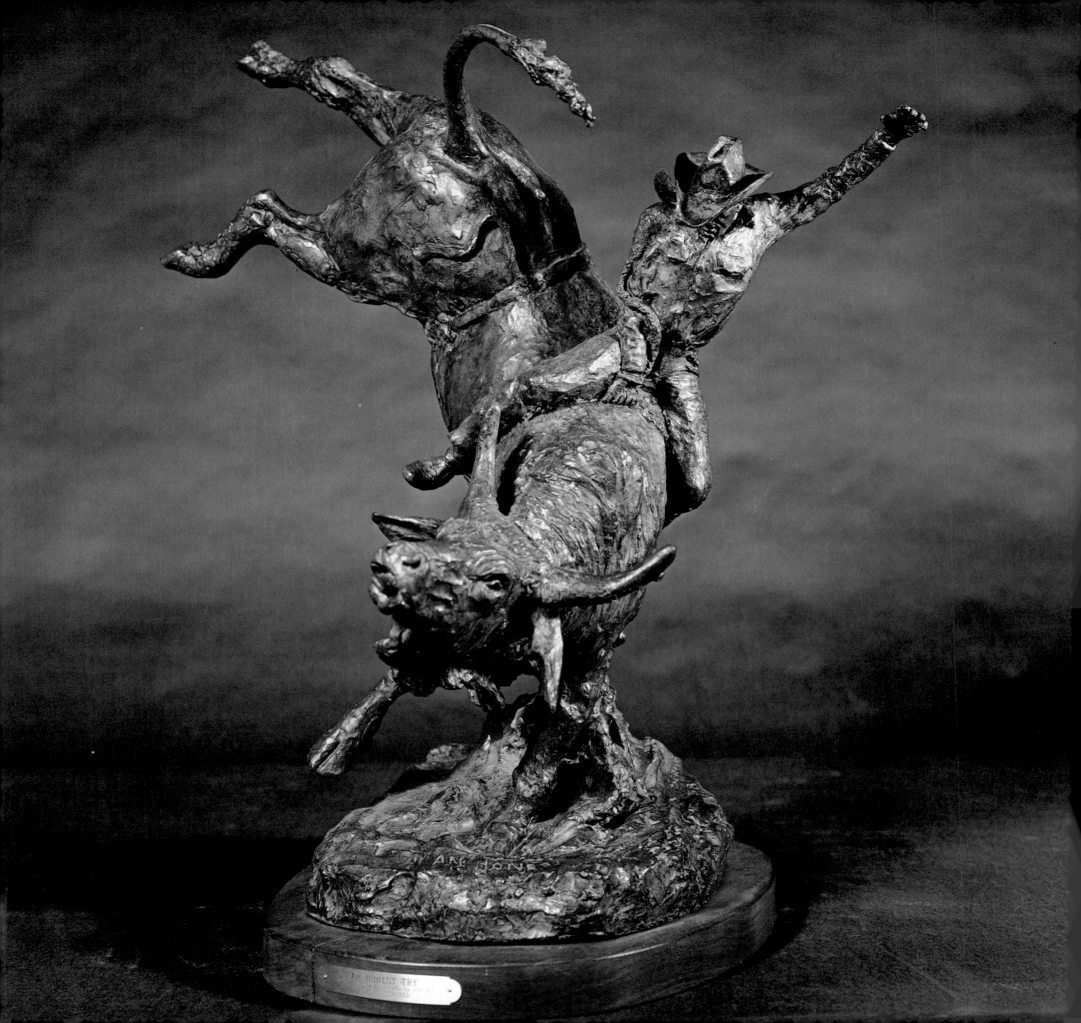

AN HONEST TRY

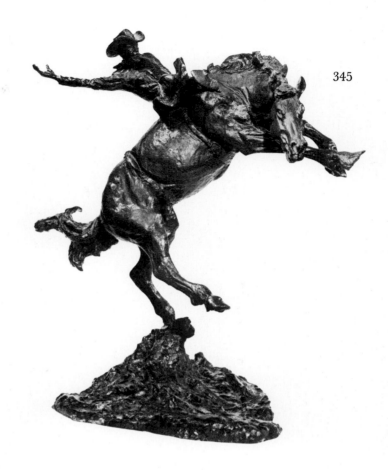

428. Bob Scriver. *An Honest Try*. 1968. Cast by the artist. H. 28″. National Cowboy Hall of Fame, Oklahoma City, Okla.

429. Bob Scriver. *Pay Window*. 1968. Cast by the artist. H. 28″. National Cowboy Hall of Fame, Oklahoma City, Okla.

430. Bob Scriver. *Mountain Sentinels*. 1968. Cast by the artist. H. 13″. Collection the artist

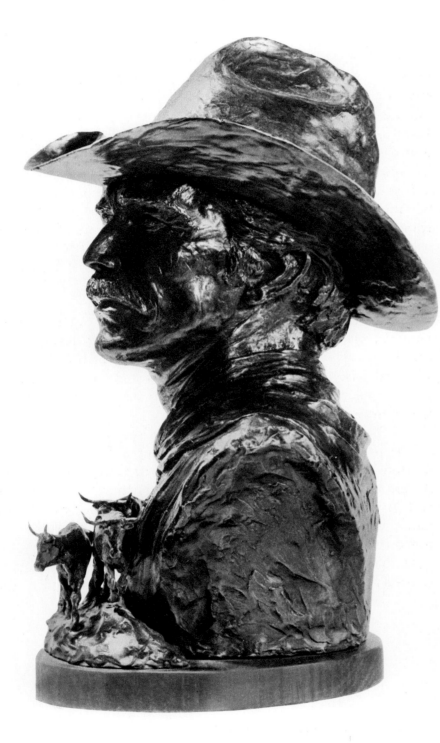

431. Grant Speed. *Ridin' Point*. 1970. Cast by the artist. H. 14″. Trailside Gallery, Jackson, Wyo.

Speed decided that life as a sculptor might be less hazardous. Between his sophomore and junior years of college, he spent two and a half years as a missionary of the Mormon Church. After leaving school, he became a teacher, settling down in Provo. Speed continued to study and improve his artistic skills.

In 1966, the Rodeo Cowboys' Association used Speed's *Doubtful Outcome*, a bronze of a bull rider, as the Tom Watly Award to be presented to the All-Around Champion at the National Rodeo Finals in Oklahoma City.

Speed's latest bronzes, *Ridin' Point (plate 431)* and *The Free Spirit*, are heroic busts of cowboys with small, three-dimensional panoramas of Western life in the foreground. It is as though scenes from history pass before the heroes of the West. These bronzes have a strong sense of monumentality and express Speed's lifelong admiration of and devotion to his idol, the American cowboy.

John D. Free (b. 1929), in his realistic sculptures of the West, depicts with precision and accuracy life in the land where he was born, raised, and still works today—the cattle and horse country of Pawhuska, Oklahoma. His grandmother was a full-blooded Osage Indian. Free spent most of his boyhood on his grandfather's ranch. His greatest joy during his youth was riding in the rodeo. During his college years, sobered by a severe rodeo accident, he decided to study pre-veterinary medicine and animal husbandry.

Free has sketched and modeled cowboys as long as he can remember. As a boy, he modeled herds of horses from wax crayons. His only formal artistic training was a few elective courses in college. These courses emphasized abstraction, which was completely alien to his natural artistic style.

After school Free worked as a rancher. For many years he painted and modeled as a hobby. A friend, Ralph DuBois, the owner of a foundry in Tulsa, cast his first works. DuBois encouraged Free to devote his entire time to sculpture. Following his advice, Free studied for four years with Thomas Lewis of the Taos Art Gallery.

Free portrays the West that he knows best, the West of horses, cattle, and rodeos. His bronzes are small and precise, but they have a vitality which reflects the artist's love of Western life *(plate 434)*. His bronze group, *Two Party Line (plate 436)*, depicts the excitement of life in the open country.

Free strives for complete authenticity of detail. He feels that Western art is a unique form of American art and sees his works as documents of Western life.

George Marks (b. 1923), in both his painting and sculpture, is devoted to portraying the everyday world of the American cowboy. As

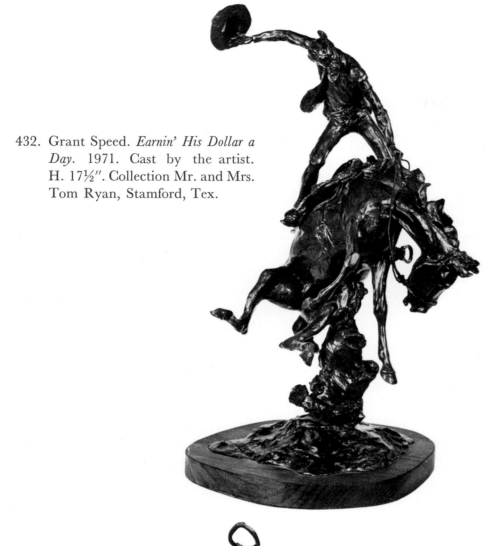

432. Grant Speed. *Earnin' His Dollar a Day*. 1971. Cast by the artist. H. 17½". Collection Mr. and Mrs. Tom Ryan, Stamford, Tex.

a boy, Marks idealized his grandfather, who had been a stagecoach driver in South Dakota during the era of the Indian battles. He taught young George to ride and work with horses and cattle. Marks has been drawing since boyhood. He studied art at the University of Iowa and with several teachers in New Mexico, then worked for fourteen years as a technical illustrator before becoming a full-time Western artist.

Marks's highly realistic art reflects the world around him—a world of ranch work, rodeos, and trail rides; a world of excitement and tranquillity. One day, on reading in the newspaper of a local bank robbery, he decided to create *The Get-A-Way (plate 437)*.

Marks considers Western art an important part of America's heritage:

To me, the cowboy symbolizes a man born free, an individualist who loves his country in its natural state. The mountains and plains of our West is the cowboy's workshop and he is representative of those who work hard to preserve our forests, wildlife and natural resources. The different phases of cowboy life offer unlimited subject matter in expressing and recording a way of life.[6]

The rodeo *(plate 435)* has been the central focus of Frank Polk's life and art. Polk (b. 1908) traveled the rodeo circuit for many years. At age ten, he performed with a trained burro at the rodeo in Prescott, Arizona. At age fifteen, he began cowboying and a year later joined the rodeo circuit as a roper and rodeo contestant. Polk was a rodeo rider for over twenty years.

During his youth, Polk also worked as a dude wrangler, guiding tourists at the Grand Canyon and Rainbow Natural Bridge. During

433. Grant Speed. *Stampedin' Over a Cutbank*. 1972. Cast by the artist. H. 24". Collection the artist

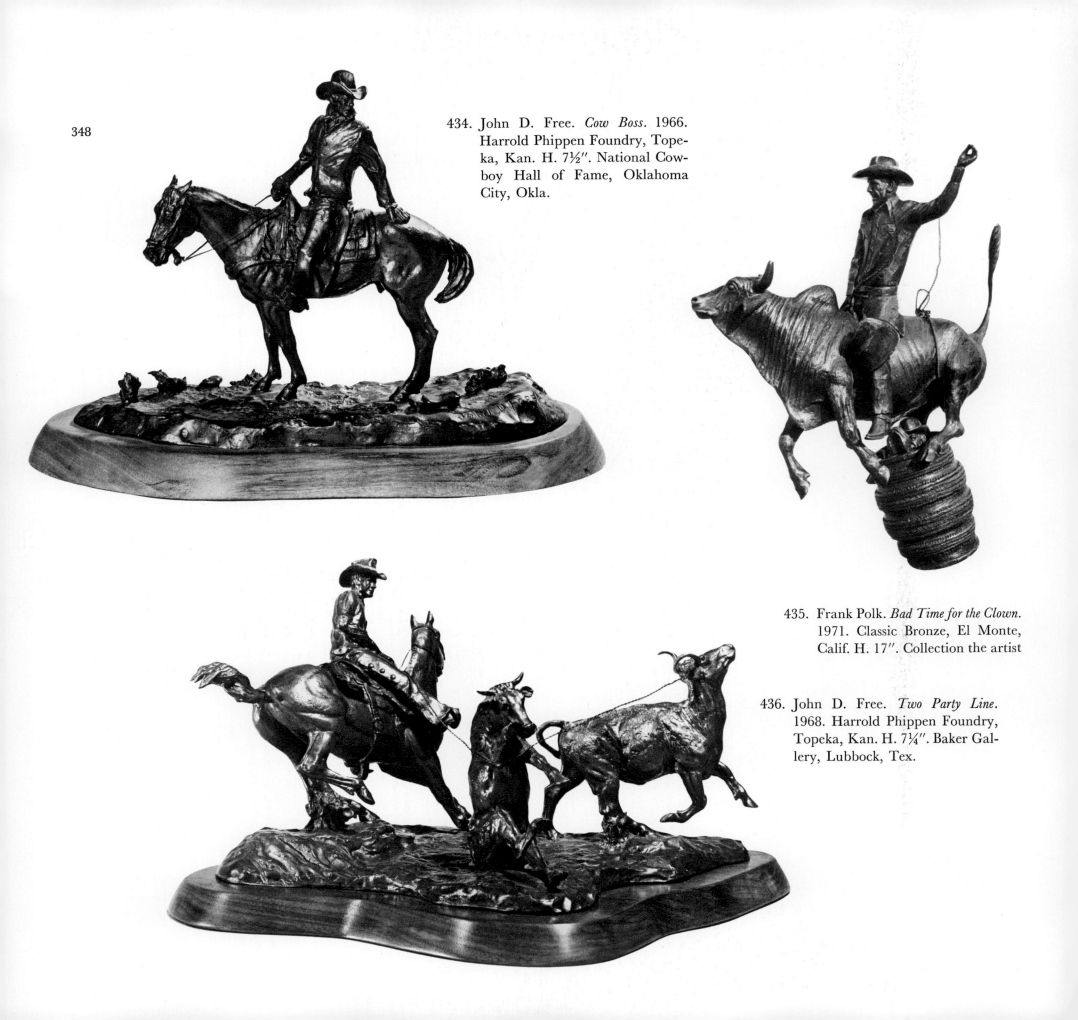

348

434. John D. Free. *Cow Boss*. 1966. Harrold Phippen Foundry, Topeka, Kan. H. 7½″. National Cowboy Hall of Fame, Oklahoma City, Okla.

435. Frank Polk. *Bad Time for the Clown*. 1971. Classic Bronze, El Monte, Calif. H. 17″. Collection the artist

436. John D. Free. *Two Party Line*. 1968. Harrold Phippen Foundry, Topeka, Kan. H. 7¼″. Baker Gallery, Lubbock, Tex.

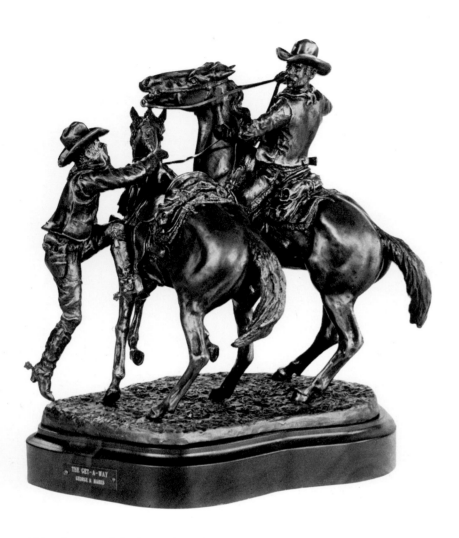

437. George Marks. *The Get-A-Way*. 1972. Artists and Sculptors Foundry, Burbank, Calif. H. 11½". Collection the artist

the 1930s, he went to Hollywood, where he did stunts and bit parts in Western movies.

It was in California, while recovering from an illness, that Polk began to whittle to pass the time. He decided to go to carving school but found the instruction unsatisfactory. Since then, he has continuously studied on his own.

Polk's first carvings were crude and mass-produced but enabled him to earn a living. His top seller was a carved boot for a tie tack. Over the years, he became famous as the "Cowboy Whittler," and his carvings of rodeo actors and famous Westerners are highly valued by collectors today.

It is only recently that Polk has turned from wood to bronze in his sculptures of the American cowboy. He bases his work on personal experience. Known for absolute authenticity in his woodcarvings, he strives for the same perfection of detail in his bronze sculpture. At first Polk often used wood instead of clay for his original models. In 1968, Polk's *The Bulldogger* won the Rodeo Cowboy Association's Golden Spur Award for the Best Livestock Sculpture.

While most Western sculptors delight in the excitement of cowboy life, Jim Hamilton (b. 1919) portrays the quieter family life of the American cowboy, the everyday pleasures as well as the special occasions. Jim has modeled *Drummin' (plate 438)*, showing a bashful cowboy courting his girl and *The Four Horsemen (plate 439)*, with four children astride the faithful family horse. These bronzes are part of a series entitled *The Fun of the West*, in which he portrays the cycle of family life from the courtship of a young ranch hand to the rearing of his son through manhood. His sentimental models of family life follow in the tradition of the Rogers Groups, which extolled the virtues of the Victorian family.

Hamilton only recently began his career as a sculptor. After college at Oklahoma A. & M., he spent most of his life as a rancher. Hamilton lives and works in Pawhuska, the town in Osage County where he was born and went to school. He describes himself as "the only child of a cowboy and schoolmarm marriage," and learned from his parents an appreciation of traditional moral values. Hamilton, like his fellow cowboy artists, has a deep pride in his Western heritage. In his bronzes, he extols the pioneer virtues of honesty, respect, hard work, and friendship.

Hughes Curtis (1904–1972) was a barber turned artist. Curtis was born, raised, and lived all his life in Springville, Utah. Inspired by a talented uncle, he first modeled platoons of soldiers from classroom chalk, and then turned from chalk to woodcarving.

Curtis had the opportunity of knowing Cyrus Dallin. Dallin too

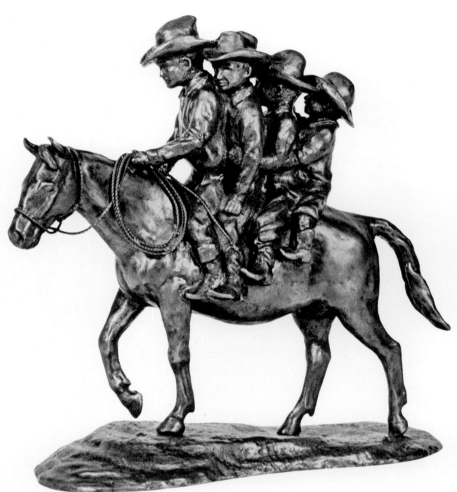

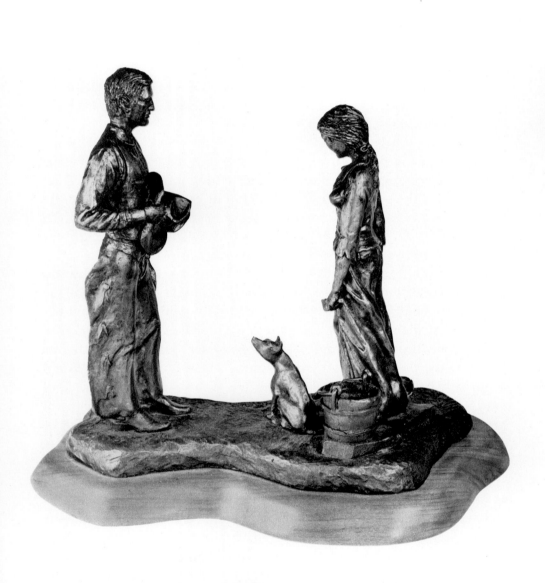

438. Jim Hamilton. *Drummin'*. 1968. Harrold Phippen Foundry, Topeka, Kan. H. 10¼". The Baker Gallery, Lubbock, Tex.

439. Jim Hamilton. *The Four Horsemen*. 1971. Turkey Track Foundry, Pawhuska, Okla. H. 10½". Collection the artist

440. Hughes Curtis. *Rim Rock*. 1968. Cast by the artist. H. 16". Springville Art Gallery, Springville, Utah

was born in Springville and, after many years, returned there to work. He advised Curtis in his early efforts and encouraged him to abandon woodcarving and work in clay.

Curtis spent much of his life among cowboys, living in their camps and riding with their herds. "There's a certain freedom to their lives. They are not bound by convention; I guess in a way it is the sort of life all of us would like."[7]

Curtis's bronzes show his understanding and appreciation of the cowboy's way of life. He depicted the personal side of that life, typical moments in the daily routine of the cowboy *(plate 441)*. Curtis also modeled scenes from the life of the Navaho Indians. He often traveled to the southeast corner of Utah, an area rich in local color, to find ideas for his sculpture.

For many years Curtis made his living as a barber, regarding a career in sculpture as "a nineteen-year-old's dream." As his work won public acceptance, however, the dream became a reality. His sculptures *Rim Rock (plate 440)*, *Saddling Up*, and *Death and the Drunkard* are in the permanent collection of the Springville Art Gallery.

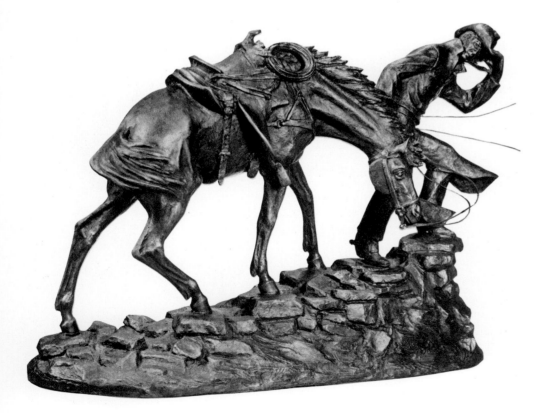

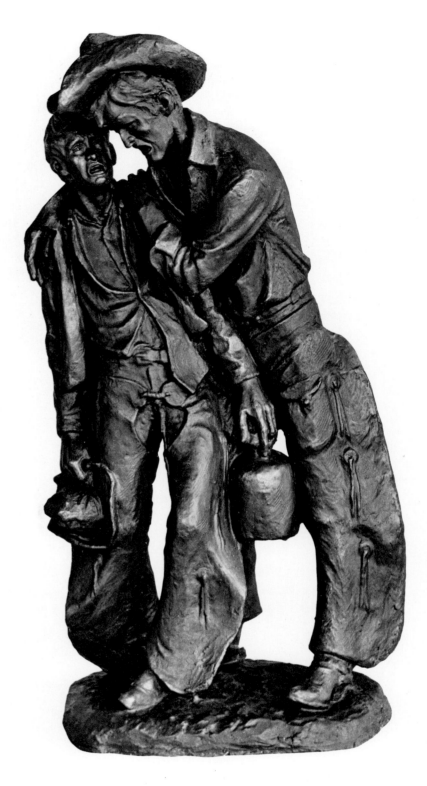

441. Hughes Curtis. *Cowboy Serenade.* 1948. Cast by the artist. H. 22″. Collection Rell G. Francis, Springville, Utah

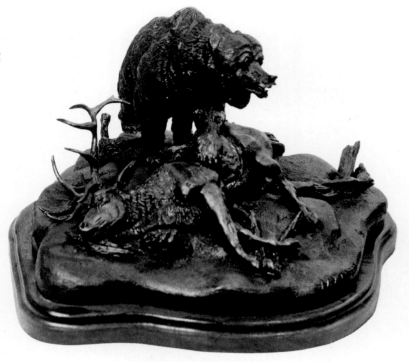

Curtis preferred to work in bronze because of its durability and wide range of color. In 1947, in order to cast his own bronzes, he built a gas-fired foundry in the back of his shop. He used a vacuum cleaner blower as the motor until he rebuilt his equipment in 1969.

John Kittleson (b. 1930) grew up on a ranch in South Dakota. He began "stumpin' bronc" at the age of fourteen. A completely self-taught artist, he worked as a woodcarver before becoming interested in bronze sculpture.

Today, Kittleson is a professional success. He creates Western and wildlife sculptures of wood and bronze *(plate 442)*. He lives and works in Fort Collins, Colorado. Riding and roping are still his favorite means of relaxation.

Many cowboy artists still work with horses and cattle. J. N. Swanson (b. 1927), a successful painter and sculptor, owns a ranch in Carmel Valley, California, where he breeds, raises, and trains stock horses. Throughout his career, horses have been of central importance in his art and life. Swanson began working with horses in his early teens. He first trained standard-bred racehorses, but preferred the excitement of breaking wild horses.

Swanson has always enjoyed sketching horses. After service in the

442. John Kittleson. *My Meat*. 1970. Bronze Images, Loveland, Colo. H. 13″. Collection the artist

443. Jack N. Swanson. *Her First Look*. 1969. Franco Vianello Foundry, Richmond, Calif. H. 6¾″. Blair Galleries, Santa Fe, N.M.

Navy during World War II, he took advantage of the G.I. Bill to attend art classes in Oakland and Carmel. He supplemented his income by buying and training wild horses and touring the racing circuit with his studhorse. Swanson lived in the mountains, sleeping in the open and sharing his blanket with his horse.

Donald Teague, a member of the National Academy, used Swanson as a model for a number of Western illustrations. Teague admired Swanson's sketches and took an active interest in his art career.

Swanson first won recognition for his painting of ranch country. In 1968, Swanson decided to concentrate on sculpture. His sculptures, like his paintings, are realistically detailed studies. His finest works are his naturalistic models of horses: *Her First Look (plate 443)* is a sensitive study of a mare admiring her newborn foal.

Bill Chappell (b. 1919) is a self-taught cowboy artist. He was raised on a Texas ranch, and while still a boy left school to go traveling and cowboying in Texas, New Mexico, and Colorado.

At the age of ten, Chappell began to work with leather. He first made belts and later made boots, saddles, and every conceivable type of ornately carved Western riding gear and decoration. Bill became one of the best-known leather carvers in the country. His leather masterpiece is the life-size figure of Will Rogers, which was displayed in the National Cowboy Hall of Fame.

During the 1950s, Chappell began painting and modeling. Like many cowboy artists, he attributes his success to firsthand experience. His bronzes show his familiarity with local wildlife and his knowledge of horses and riders. Chappell's bust of an Apache warrior *(plate 444)* demonstrates his fine sense of composition and rhythm. The simplicity and strength of this bronze make it his most powerful work to date.

Melvin C. Warren (b. 1920) has achieved great success as both a painter and a sculptor. Many of his paintings and bronzes are in the permanent collection of the Lyndon B. Johnson Library in Austin, Texas.

Born in Los Angeles, he moved to ranch country with his family while still a child. The Warren family led a nomadic life. As a boy, Melvin sampled ranch life in California, Arizona, New Mexico, and Texas. He grew up surrounded by horses, cowboys, and cattle. At age five, Melvin began to ride and draw; and at age twelve, he became interested in oil painting.

During the early years of his career, Warren supplemented his income by working as a commercial artist, but was soon able to devote full time to his paintings and sculptures of life in the Southwest.

Warren's work is both romantic and realistic *(plates 445–447)*,

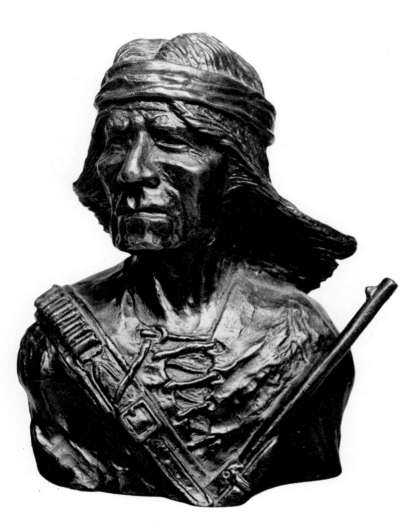

444. William Chappell. *Apache Warrior*. 1968. Nambe Mills Foundry, Santa Fe, N.M. H. 5¾″. Collection the artist

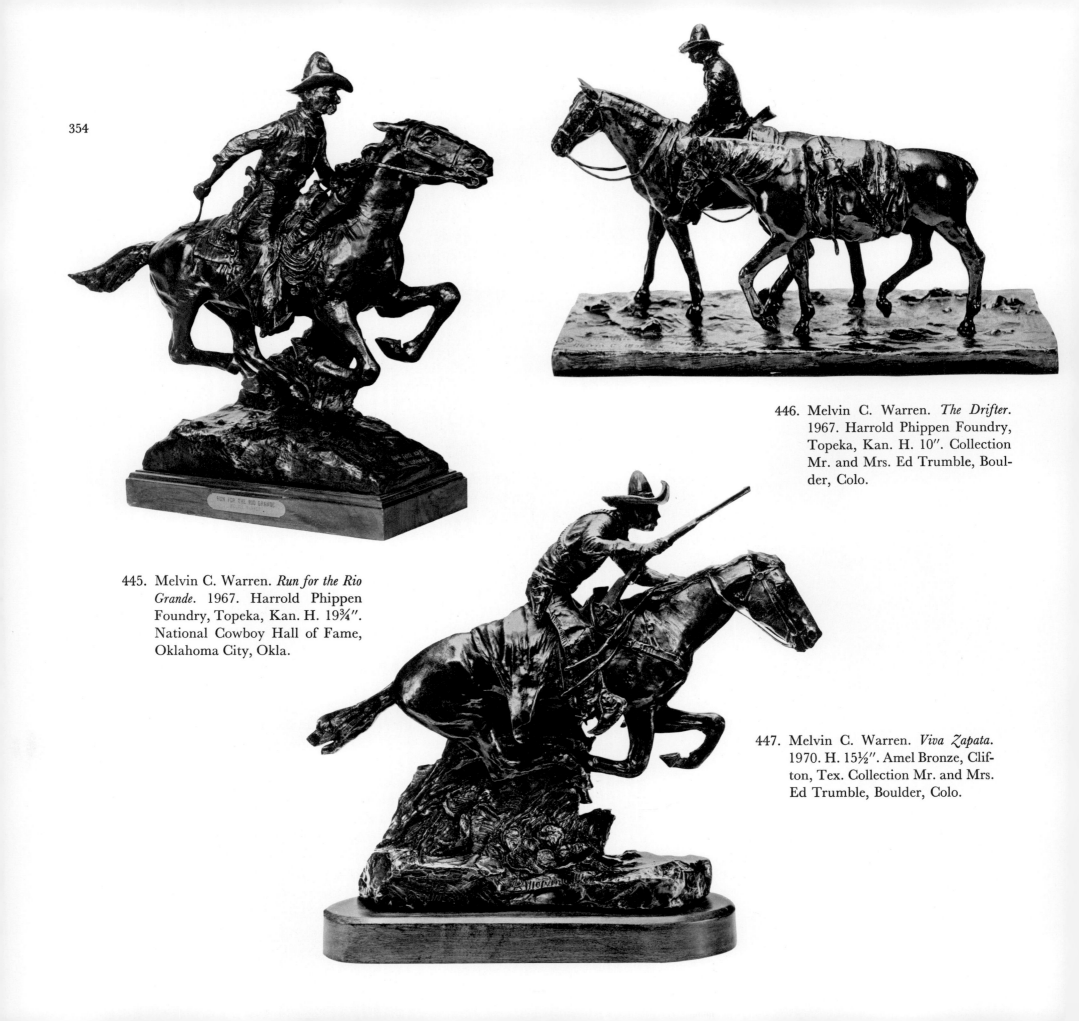

354

446. Melvin C. Warren. *The Drifter*. 1967. Harrold Phippen Foundry, Topeka, Kan. H. 10″. Collection Mr. and Mrs. Ed Trumble, Boulder, Colo.

445. Melvin C. Warren. *Run for the Rio Grande*. 1967. Harrold Phippen Foundry, Topeka, Kan. H. 19¾″. National Cowboy Hall of Fame, Oklahoma City, Okla.

447. Melvin C. Warren. *Viva Zapata*. 1970. H. 15½″. Amel Bronze, Clifton, Tex. Collection Mr. and Mrs. Ed Trumble, Boulder, Colo.

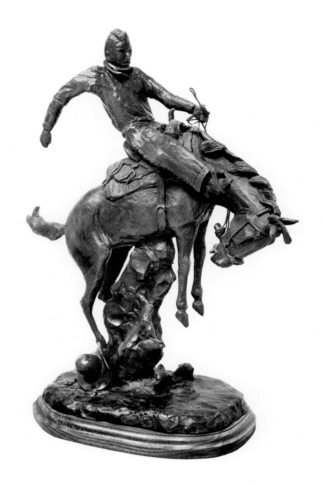

448. Curtis Wingate. *The Bronc Buster.*
1970. Bear Paw Bronze Works,
Skull Valley, Ariz. H. 14″. Cross
Gallery, Fort Worth, Tex.

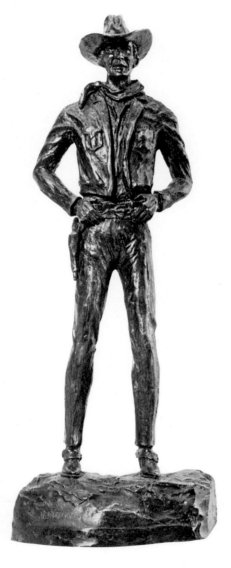

449. Wayne C. Hunt. *Tom Jeffords.*
Cast 1969. Classic Bronze, El
Monte, Calif. H. 16″. Collection
Walter R. Bimson, Phoenix, Ariz.

for he captures the colorful spirit of the West without sacrificing the
authenticity of form and detail which is a prerequisite for Texas art.
Today, Warren lives and works in Austin, where he is loved by the
Texans.

Wayne Hunt (b. 1904) portrays the daily life of the American cow-
boy and ranch hand *(plate 449)*. He was born in Bear Valley, Wiscon-
sin. When he was four, his father homesteaded near The Dalles,
Oregon, where Wayne was educated in a one-room schoolhouse.
Hunt has worked with clay since he was six. His only formal study
was with Michael Van Myer in San Francisco.

Hunt has worked as a teamster, ranch hand, logger, mustanger,
and bronc buster. For a while, he owned a cattle ranch in Arizona.
He still prefers the nomadic life, however, and his only bonds are to
his art: "Horses and cowboys are the only subjects I know. An artist
is born with a talent. I believe he is obligated to use it. I will use mine
to preserve in bronze the cowboy and horses of my era."[8]

Curtis Wingate (b. 1929), like many cowboy sculptors, is a rodeo
rider turned artist. Born in Denison, Texas, Wingate grew up in
Austin. As a boy, he often visited his grandfather's ranch near Taylor,
where he listened to the tales of the old-timers and developed a keen

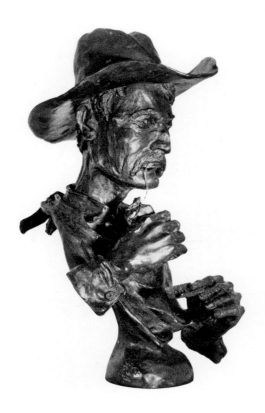

interest in the history of the West. On the ranch, he first discovered the joys of horseback riding.

Wingate had dreams of becoming a professional rodeo rider, but a serious injury sent him in pursuit of a safer career. He studied at the Arizona School of Art and with William B. Shimmel, a leading Arizona watercolorist. Wingate tries to re-create in his sculpture the excitement of the rodeo world *(plate 448)*.

L. E. ("Gus") Shafer (b. 1907) became interested in Western art as a hobby and as a way to supplement his income from Social Security. Shafer was born on a farm in Hoisington, Kansas. He grew up surrounded by horses and cattle. At age twelve, his first paying job was herding cattle for his uncle: "The first year I went off to work on a ranch I got room and board and at the end of the year I

450. L. E. ("Gus") Shafer. *Top Hand.* 1967. Harrold Phippen Foundry, Topeka, Kan. H. 15″. Collection the artist

451. L. E. ("Gus") Shafer. *Country Doctor.* 1971. Harrold Phippen Foundry, Topeka, Kan. H. 11½″. Collection the artist

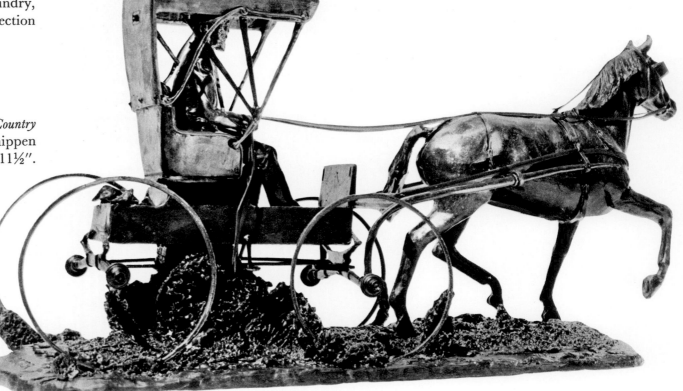

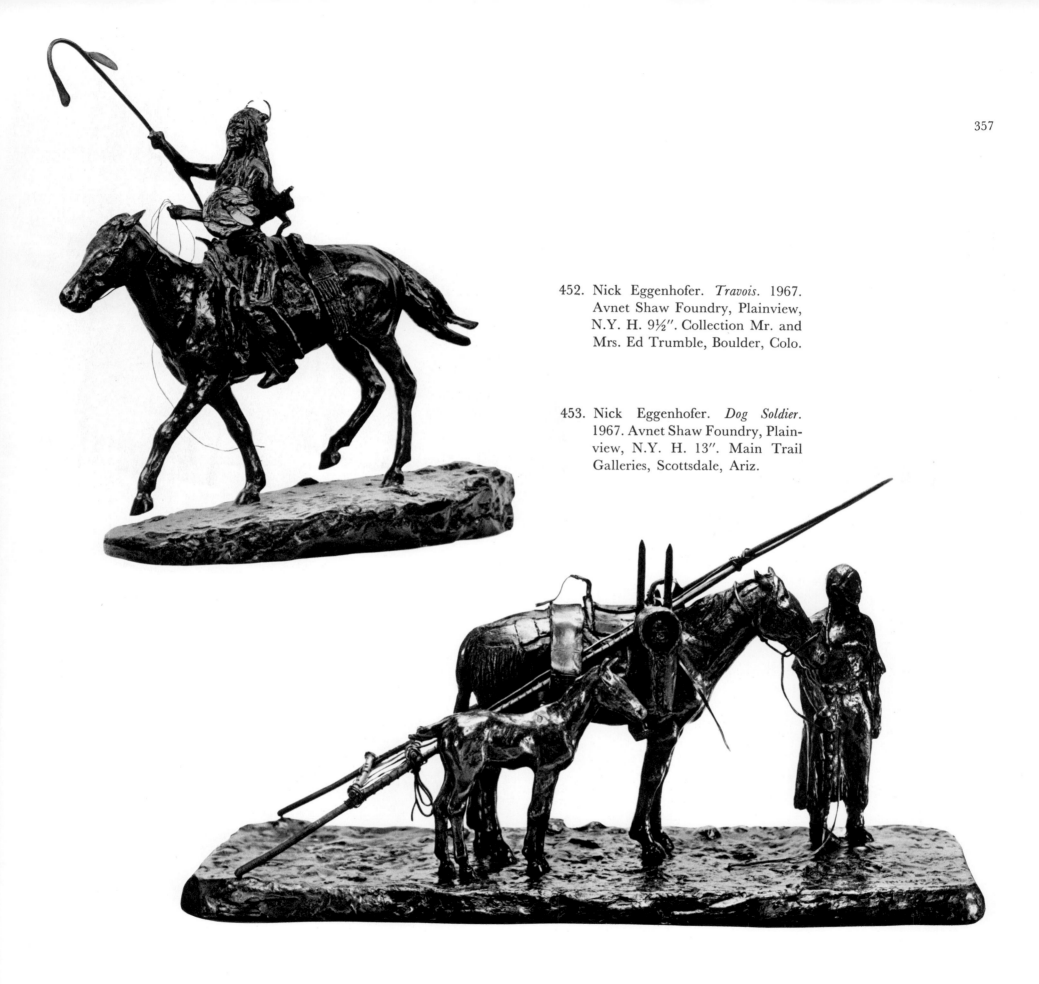

452. Nick Eggenhofer. *Travois*. 1967. Avnet Shaw Foundry, Plainview, N.Y. H. 9½″. Collection Mr. and Mrs. Ed Trumble, Boulder, Colo.

453. Nick Eggenhofer. *Dog Soldier*. 1967. Avnet Shaw Foundry, Plainview, N.Y. H. 13″. Main Trail Galleries, Scottsdale, Ariz.

got to keep my pony. That was my first year's pay. The second year I got the saddle."[9]

Shafer studied art at Grinnell College in Iowa and at Kansas State Teachers College. He worked for forty years as a commercial artist before devoting full time to his career as a Western artist. He began as a painter exploring ghost towns but soon abandoned painting for woodcarving. Woodcarving resulted in the loss of two fingers. Unable to hold the chisel, Shafer began to work in wax, which he found had far greater flexibility than wood.

In 1964, Shafer sold his first model to the Montana Historical Society and received a small royalty. Pleased with the success of this first piece, he decided to gamble and finance his own casting. By 1968 Shafer was able to devote full time to sculpture.

Shafer first modeled Indians but soon changed to scenes of ranch life, which he based on youthful memories. His memory of Old Ben, his father's top ranch hand, inspired one of his most effective sculptures, *Top Hand (plate 450)*. Old Ben taught Shafer most of what he learned about horses.

Like the majority of contemporary Western sculptors, Shafer is most successful when he bases his work on personal experience. His bronzes of the people and events he remembers from his youth in Kansas are his most original and interesting works. *Saturday Night*, a model of two cowboys riding home from the local saloon, and *Country Doctor (plate 451)*, a recollection of the days when the doctor made his calls by horse and buggy, are two of his most appealing sculptures.

454. John La Prade. *Desert Sport*. 1969. Noggle Bronze Works, Prescott, Ariz. H. 16″. Collection Walter R. Bimson, Phoenix, Ariz.

Shafer has been commissioned to create a bronze statue, *The Wagon Master*, for Country Club Plaza in Kansas City. He is also working on a commission granted by the Royal Worcester Porcelain Company in England for a Western Americana series of fourteen colorful porcelain figures.

Today there is tremendous activity among the cowboy artists. Since 1967, Gordon Snidow (b. 1936), the winner of many awards for painting and drawing, has devoted more and more time to sculpture of the contemporary West. He is particularly interested in animal life *(plate 455)*. In 1973, he won the Gold Medal for Sculpture at the annual competition of the Cowboy Artists of America. His winning bronze was *Racing the Wind*, a study of a herd of deer in flight. Other prominent cowboy painters occasionally create bronze sculptures. Nick Eggenhofer *(plates 452, 453)* and John La Prade *(plate 454)* have modeled several excellent realistic models of life in the West.

There is no simple description of contemporary cowboy sculpture. Some of the artists have devoted their lives to improving their artistic skills, studying the history and traditions of the American West and observing the contemporary world. Others have only recently developed an interest in portraying the color and excitement of Western life. Many of the cowboy artists are self-taught, while others have had extensive academic training. Many are recognized painters who have turned to sculpture as a new means of artistic expression. Other artists have had successful careers as illustrators, woodcarvers, and leather carvers.

All of the contemporary cowboy artists have a solid firsthand knowledge of Western life. In their sculptures of wildlife and of the rodeo circuit and ranch life, they portray the world that has been the central focus of their lives. It is their devotion to illustrating life in today's West—a life that is uniquely American—and their dedication to re-creating this life with authenticity and accuracy that characterize the works of the present-day cowboy artists.

455. Gordon Snidow. *Springtime*. 1967. Cast by the artist. H. 3½″. Collection the artist

XXII

IN THE TRADITION

Currently, there is an extraordinary renewal of interest in American art. Throughout the United States and in many countries of Europe, the art-buying public has discovered the excitement and romance of cowboys and Indians. Western bronzes are especially valued as documents of America's heritage, true examples of Americana.

Until the second half of the twentieth century, most contemporary Western art was considered mere illustration. For years, Remington and Russell were the only Western sculptors to interest art buyers, and Western bronzes were purchased primarily as decorative objects. Even Remington's and Russell's bronzes were often offered at furniture sales rather than at art auctions.

Today, Remington and Russell are the most celebrated Western sculptors. Remington's *The Bronco Buster (plate 122)* is *the* representative Western sculpture found in most museums in large cities throughout the United States. It is the bronzes of Remington and Russell which bring the record prices at auctions. *The Wounded Bunkie (plate 456)* by Remington sold in 1971 for $60,000. In 1915, this bronze was sold at Tiffany & Company in New York for $150.

Artists, galleries, and collectors look upon the meteoric rise in the prices of Remington's and Russell's work as a symbol of the potential appreciation in the market value of Western art. As this art grows in popularity, the number of museums and galleries specializing in Western paintings and sculptures increases yearly.

As the public's appetite for Western art grows, dealers and collectors, as well as the descendants of famous sculptors, look with new interest at the plasters and wax models by well-known sculptors which were never cast during their lifetimes. During the last decade, bronzes have been cast for the first time from models made by Edward Kemeys, James Earle Fraser, Charles Russell, Solon Borglum, A. Phimister Proctor, George Phippen, and many others.

As the bronzes of Remington and Russell bring record prices, galleries as well as collectors view the work of contemporary sculptors with new interest. Many galleries sponsor and publicize the work of

456. Frederic Remington. *The Wounded Bunkie*. 1896. Henry Bonnard Foundry, N.Y. H. 20¼″. Thomas Gilcrease Institute, Tulsa, Okla.

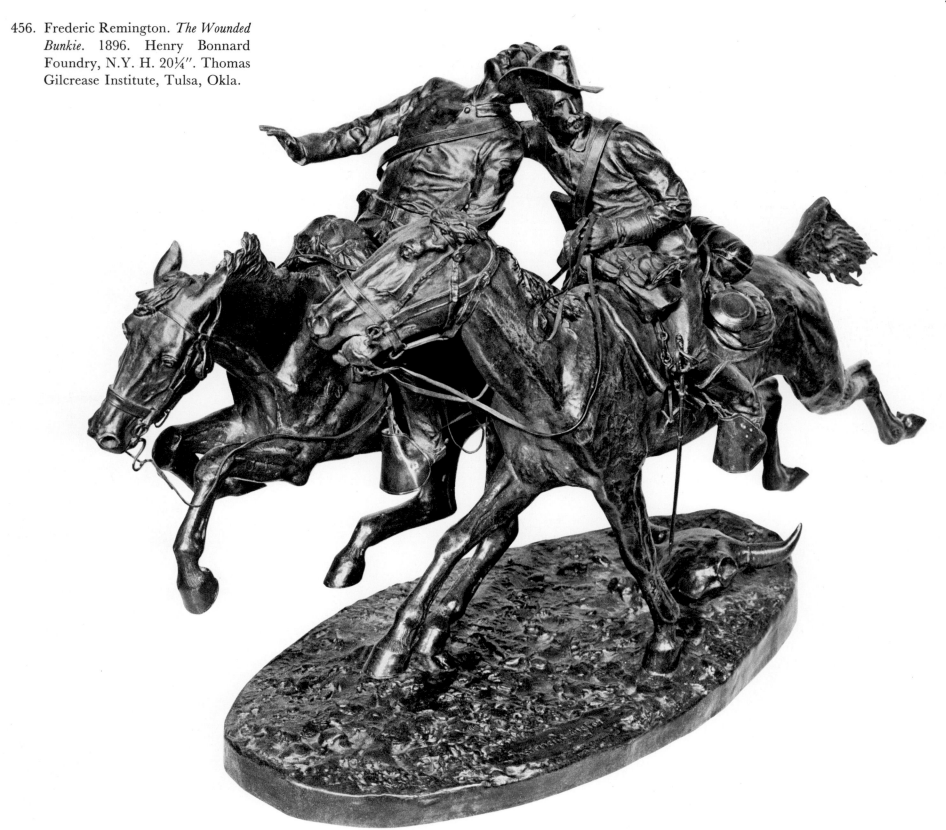

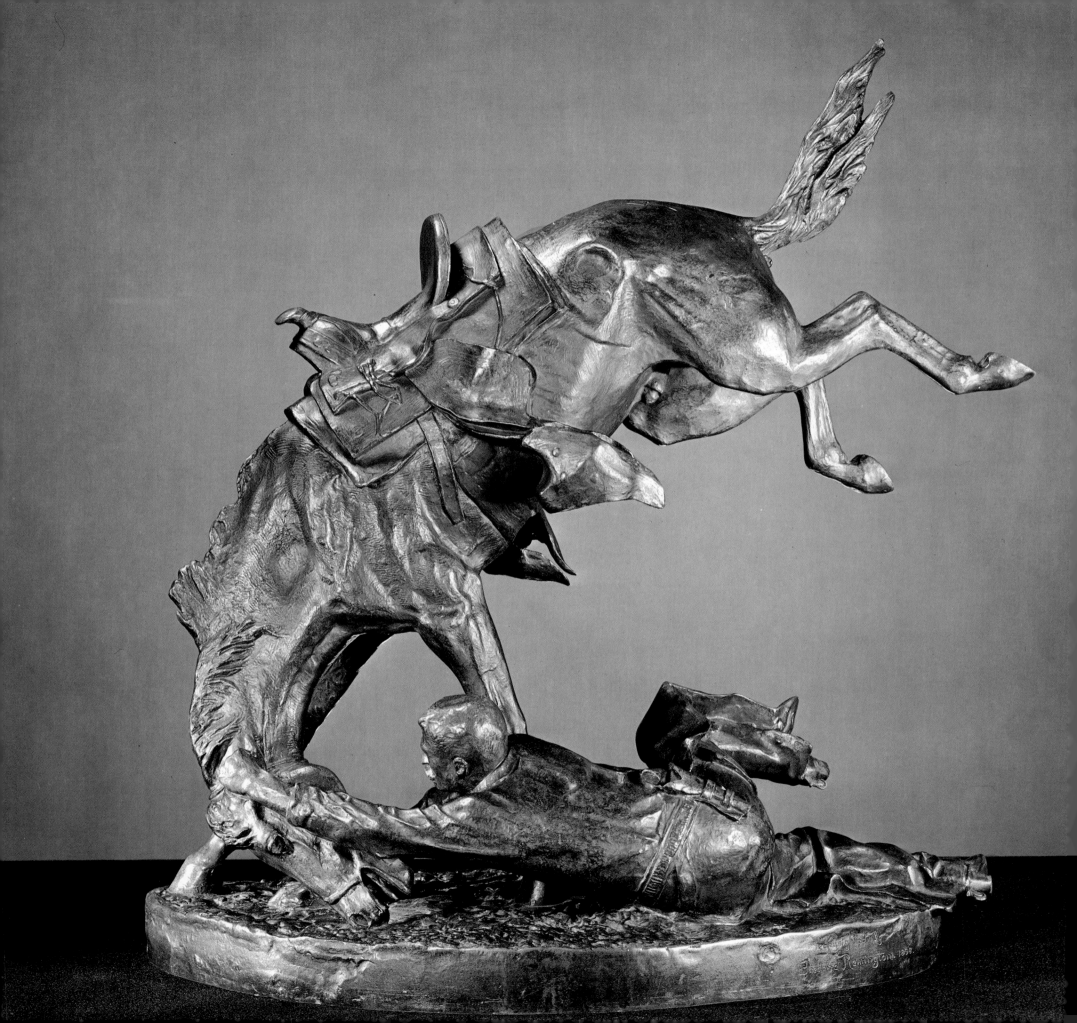

457. Frederic Remington. *The Wicked Pony (The Fallen Rider)*. 1898. Henry Bonnard Foundry, N.Y. H. c. 22". The Amon Carter Museum, Fort Worth, Tex. Remington created this sculpture after witnessing an incident in which the rider was killed

458. Charles M. Russell. *The Medicine Man*. Modeled c. 1920, cast during the artist's lifetime. Roman Bronze Works, N.Y. H. 7". Amon Carter Museum, Fort Worth, Tex. Nancy Russell explained this sculpture: "*The Medicine Man* is beating on his tom-tom for a person (or God). In his hair is his medicine whistle from an eagle's wing, and a weasel's skin is fastened beneath it. Across his knees is a sacred otter skin, a wolf skull and a bear claw. The otter is cunning, the wolf is smart, and the bear is strong; and *The Medicine Man* is invoking the spirits and 'good medicine' of these three animals to help him drive away bad medicine." (*Montana Magazine*)

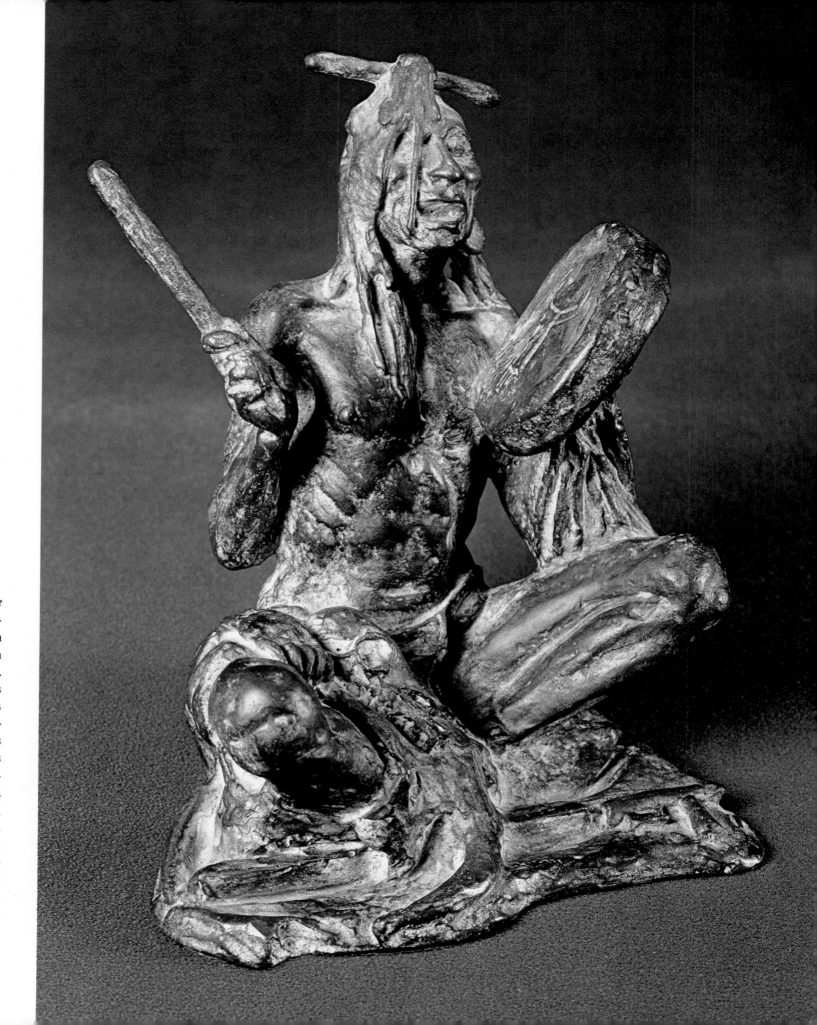

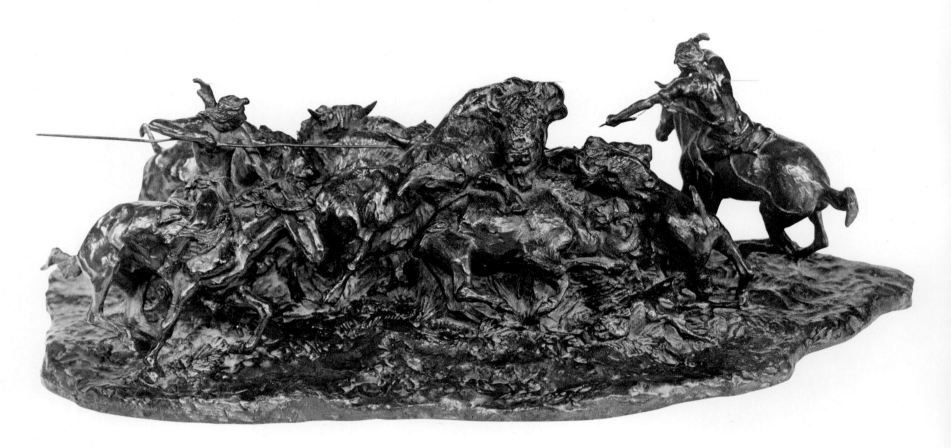

459. Charles M. Russell. *Meat for Wild Men*. Modeled c. 1920, cast 1924. Nelli Art Bronze Foundry, Los Angeles, Calif. H. 11½". National Cowboy Hall of Fame, Oklahoma City, Okla.

artists whom they feel will appeal to an art-hungry public. They hope they have chosen the work of a potential Remington or Russell. Consequently, the bronzes of these two artists *(plates 456–459)* have a tremendous influence on the subject matter and style of most contemporary Western sculptors. Following in the tradition of Remington and Russell, countless artists today model scenes of frontier days and Indian life, of range cowboys and rodeo riders.

This chapter is not a comprehensive study of contemporary Western art, but a survey of some of the interesting bronze sculptures by artists working in different parts of the country.

Richard Flood was one of the first dealers to realize the potential of the market for Western sculpture. At a time when it was unthinkable to offer the public bronzes by sculptors other than Remington and Russell, Flood, Dr. K. Ross O'Toole, director of the Montana Historical Society, and Michael Kennedy, editor of *Montana*

460. Earle Heikka. *Montana Wolf*. Cast 1961. Modern Art Foundry, Long Island City, N.Y. H. 8″. C. M. Russell Gallery, Great Falls, Mont.

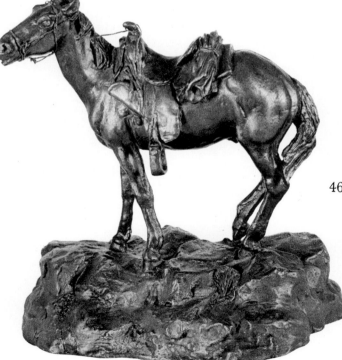

461. Earle Heikka. *Piegan Scout*. Modeled 1931 (recent cast). Classic Bronze, El Monte, Calif. H. 15″. Biltmore Gallery, Los Angeles. Note the resemblance to Russell's *Blackfoot War Chief* (plate 160)

462. Charles M. Russell. *Best of the String*. Cast 1968. Roman Bronze Works, N.Y. H. 5¾″. Hammer Gallery, New York City

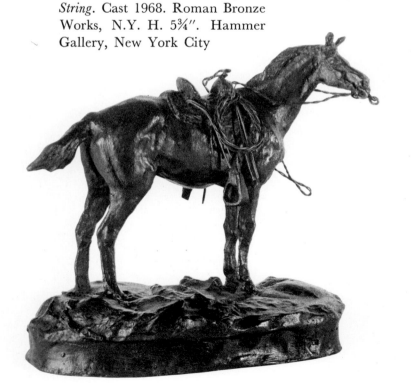

463. Earle Heikka. *Saddle Horse*. Modeled 1930s (recent cast). Avnet Shaw Foundry, Plainview, N.Y. H. 11″. C. M. Russell Gallery, Great Falls, Mont.

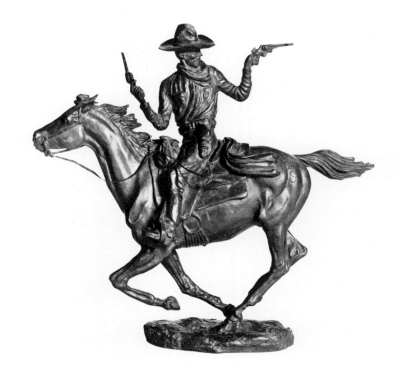

Magazine, purchased casting rights to models by little-known artists.

Flood, as a publisher of art, finances the casting, publicity, and sale of bronze sculpture in the same manner as a publisher purchases a manuscript and markets a book.

The first bronze Flood published was *Montana Wolf (plate 460)*, by Earle Heikka. Heikka was a talented artist who committed suicide at the age of thirty-one. Although he created many sculptures of Western life, his work was never cast during his lifetime. Heikka's models were often made from combinations of wood, leather, cloth, papier-mâché, plaster, and metal.

Heikka (1910–1941) grew up in Great Falls, Montana, during the years in which Charles Russell lived and worked there. As a child, he was interested in modeling and spent many hours watching Russell at work. Like Russell, Heikka worked as a ranch hand and studied life on the Blackfoot Reservation before devoting full time to a career as an artist.

464. Earle Heikka. *Road Agent*. Modeled 1930s, cast 1960s. Classic Bronze, El Monte, Calif. H. 11½″. National Cowboy Hall of Fame, Oklahoma City, Okla.

465. Earle Heikka. *Three-Figure Pack Train*. Modeled 1930s (recent cast). Roman Bronze Works, N.Y. H. 11½″. C. M. Russell Gallery, Great Falls, Mont.

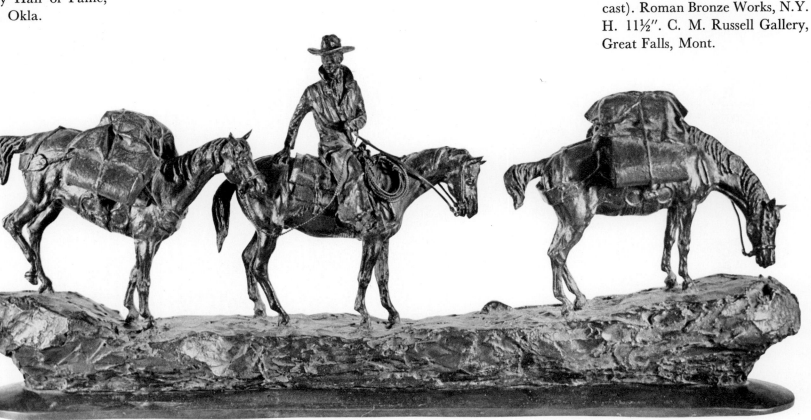

Heikka also followed in the tradition of Russell in his choice of subjects. He made models of the Piegan Indians, mounted cowboys, and stagecoaches. A comparison of *Piegan Scout (plate 461)* with Russell's *Blackfoot War Chief (plate 160)* and of *Saddle Horse (plate 463)* with Russell's *Best of the String (plate 462)* quickly establishes Heikka's frequent dependence upon Russell. Heikka's models of pack trains of the Old West *(plates 465, 466)* are his most interesting and original work. These extremely realistic groups illustrate his skill in modeling. Heikka created more highly polished surfaces and included more extensive realistic details than did Russell, whose sculpture was basically Impressionistic.

Asa L. ("Ace") Powell (b. 1912) grew up in the northwest corner of Montana. His father worked as a cowboy, stable boss, and guide in Glacier National Park; his mother taught school. Powell attended school on the Blackfoot Reservation. As he grew up, he enjoyed the pageant of cowboy and Indian life around him and developed a deep pride in the traditions of the Western pioneer. Since Charles and Nancy Russell were neighbors of the Powell family, Ace had the chance to watch Russell at work as a boy, and was greatly inspired by his skill. Both Russell and his wife encouraged and helped young

466. Earle Heikka. *Trophy Hunters.* Modeled 1930 (recent cast). Classic Bronze, El Monte, Calif. H. 14½". Biltmore Gallery, Los Angeles

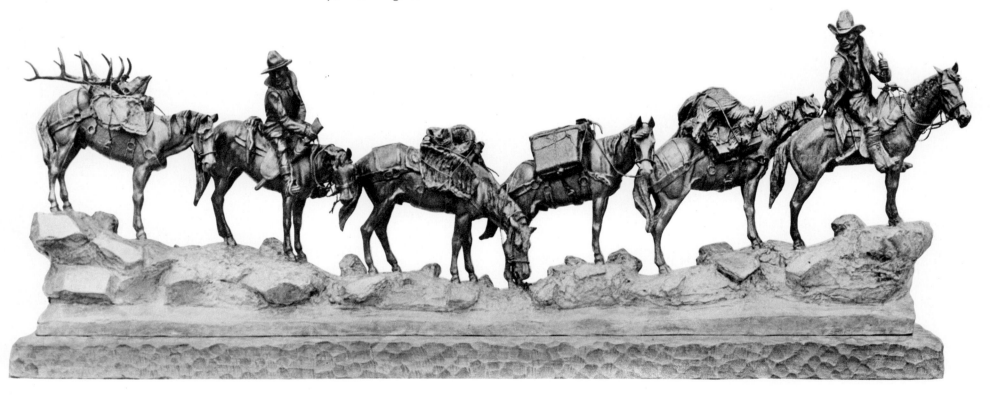

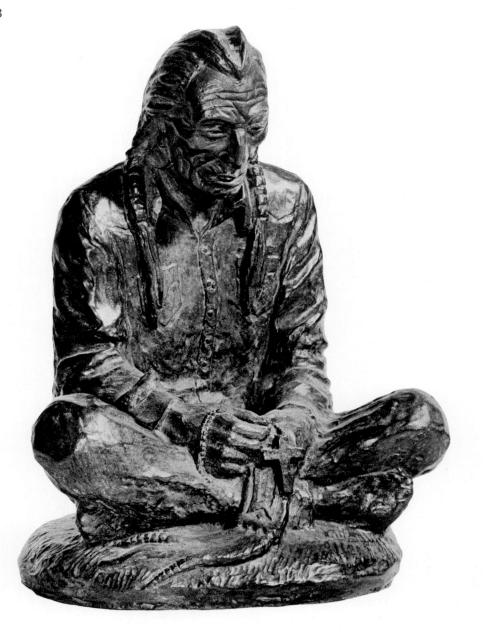

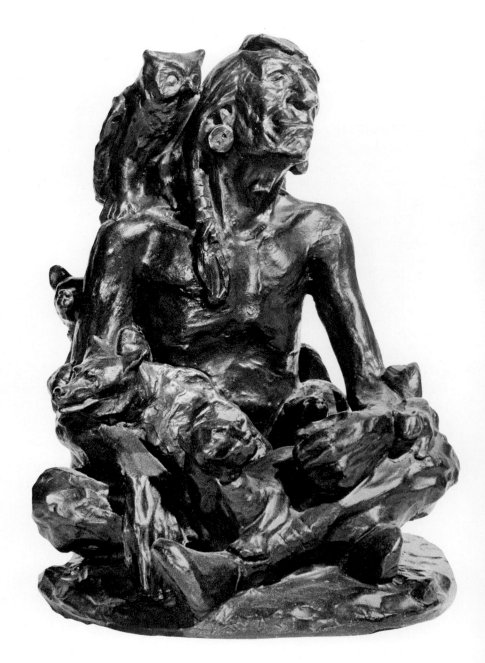

467. Asa L. ("Ace") Powell. *Two Trails to God*. 1960. Modern Art Foundry, Long Island City, N.Y. H. 10¼″. C. M. Russell Gallery, Great Falls, Mont.

468. Asa L. ("Ace") Powell. *Napi and His Friends*. 1961. Avnet Shaw Foundry, Plainview, N.Y. H. 11″. Main Trail Galleries, Scottsdale, Ariz.

Powell with his early artistic efforts. Like Russell, Powell spent many years as a cowboy. Powell worked on a ranch in Blackfoot country, herding cows, breaking horses, and guiding dudes through Glacier National Park. During these years, he spent many hours drawing and carving models of the cowboys and Indians in the area.

In 1938, Powell decided to devote full time to art. He chose as his signature the ace of diamonds. Powell's art is basically the product of observation, memory, and practice, for his formal study of painting was limited to one year at Montana State University. Powell studied Blackfoot history and acquired an extensive knowledge of tribal customs, ceremonies, and religious beliefs. He learned to understand the problems of the Indian in the twentieth century, stating: " . . . my basic interest has been to interpret the transition of the Blackfeet into a way of life the white man has made for them. I was and am fascinated with these people, and I feel strongly about the Blackfeet being absorbed by the white culture."[1]

In recent years, Powell has devoted much of his time to sculpture and has created many fine bronzes of the Montana Indians. In his works, Powell selects only those details that contribute to the overall effect of the sculpture. In *Two Trails to God (plate 467)*, an understanding of the Indian's dress gives meaning to the work. Powell's Indian lives in a period of transition. He is filled with doubt, for the white man has only partially changed his world. He is caught between the religious beliefs and customs of his own people and those of the white man. He wears the long, braided hair which is traditionally Indian, and the white man's clothes. He holds both a cross and a medicine bag. This Indian stands at the crossroads, unable to decide which world he belongs to or which civilization can offer him salvation.

Powell's sculpture expresses his great admiration and affection for the Blackfeet. In *Napi and His Friends (plate 468)*, he portrays the Blackfoot god who is responsible for creation and destruction in the world. Napi is shown surrounded by some of his creations: the owl, the wolf, and the bear. One of Powell's most dramatic bronzes is *Medicine Horse (plate 469)*, a symbolic representation of the Indians' belief in the horse spirit.

The bronze sculptures of Richard V. Greeves are highly realistic representations of nineteenth-century Western America. Although Greeves's favorite subject is the Indian, he also portrays the trapper, trader, and cowboy of the past. He has modeled a series of Western characters entitled *Mr. Cowboy, Mr. Indian, Mr. Cavalryman, Mr. Miner,* and *Mr. Gambler (plates 470–474)*.

Greeves is as devoted to the Indian in his way of life as in his art.

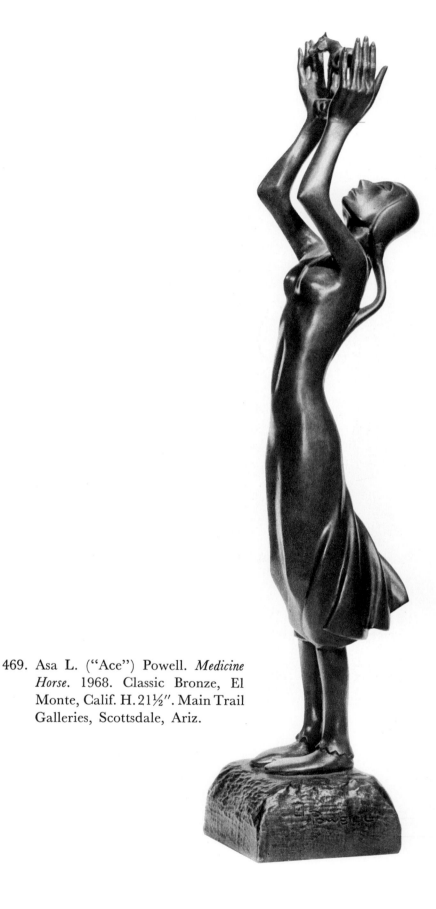

469. Asa L. ("Ace") Powell. *Medicine Horse*. 1968. Classic Bronze, El Monte, Calif. H. 21½". Main Trail Galleries, Scottsdale, Ariz.

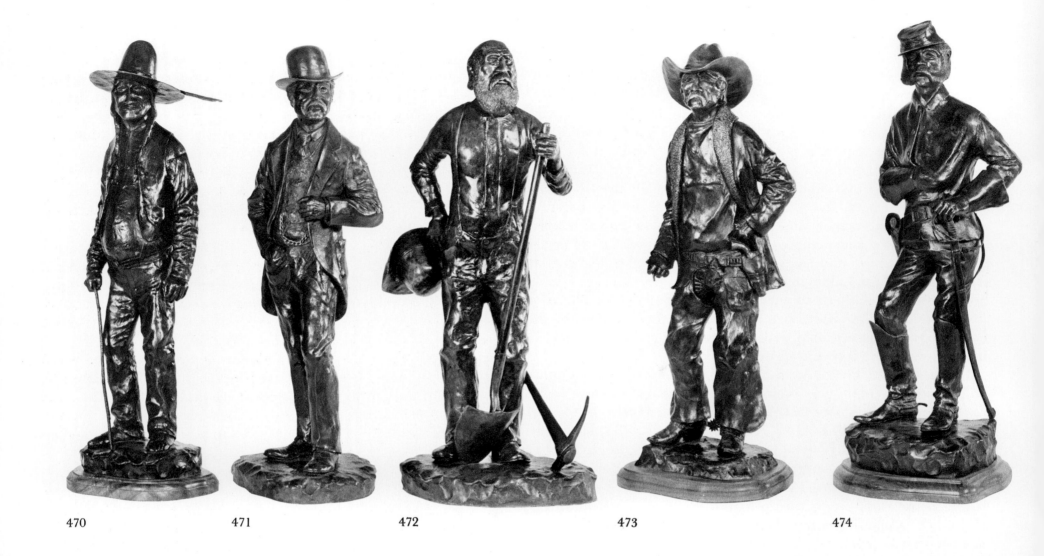

470 471 472 473 474

470. Richard V. Greeves. *Mr. Indian.* 1970. Bear Paw Bronze Works, Skull Valley, Ariz. H. 18¾″. Main Trail Galleries, Scottsdale, Ariz.

471. Richard V. Greeves. *Mr. Gambler.* 1970. Bear Paw Bronze Works, Skull Valley, Ariz. H. 18″. Main Trail Galleries, Scottsdale, Ariz.

472. Richard V. Greeves. *Mr. Miner.* 1970. Bear Paw Bronze Works, Skull Valley, Ariz. H. 18″. Main Trail Galleries, Scottsdale, Ariz.

473. Richard V. Greeves. *Mr. Cowboy.* 1970. Bear Paw Bronze Works, Skull Valley, Ariz. H. 18″. Main Trail Galleries, Scottsdale, Ariz.

474. Richard V. Greeves. *Mr. Cavalryman.* 1970. Bear Paw Bronze Works, Skull Valley, Ariz. H. 19″. Main Trail Galleries, Scottsdale, Ariz.

He is married to Jeri, a full-blooded Kiowa woman. They live in Fort Washakie on the Wind River Reservation in Wyoming. The couple own a business which was originally a café, grocery store, and meat market, but has developed into a trading post, art gallery, and craft shop. It is known as the Fort Washakie Trading Company.

Greeves was born in 1934 in a small town near St. Louis, Missouri. When he was fifteen, he traveled to Fort Washakie and lived with an Indian family on the reservation. Although he returned to St. Louis to finish his education, Greeves knew that Wind River country would be his permanent home.

Greeves has spent many years studying the history and customs of the Indian people. He has a collection of period items of Indian culture as well as relics of the mountain men and trappers. Greeves observes Indian customs in his life and enjoys participating in Indian ceremonies. He is an accomplished war dancer.

For many years Greeves has worked to become an accomplished documentary artist. He first painted historic scenes of Indian life, then turned to sculpture. Greeves is self-taught both as a painter and a sculptor. His bronzes are more naturalistic than his paintings, which have an ornamental quality close to that of American Indian painting.

Paul Rossi (b. 1929), a well-known Western historian, has recently chosen to devote full time to research, painting, and sculpture of the West. For eight years, he was the director of the Thomas Gilcrease Institute of American History and Art. An authority on frontier military history and Western art, Rossi was co-author of *The Art of the Old West*, a history of the West as seen through the eyes of the artists in the Gilcrease Collection.

Born in Denver, Rossi studied art at Denver University. During his teens, he spent his summers working on cattle ranches in Colorado and western Nebraska. For many years, Rossi pursued dual careers in museum administration and commercial illustration.

Rossi has created a series of twelve bronzes entitled *Great Saddles of the West*. The first of the series reproduces the type of Spanish war saddle used by the conquistadors in the sixteenth century *(plate 475)* and the last, the turn-of-the-century stock saddle. As a historian, Rossi is dedicated to accuracy in construction and design.

Several Western artists today are in reality Easterners inspired by a romantic imagination or by an interest in the most colorful part of America's history. Whereas the sculptors of previous generations based their work on experiences remembered from their youth or on tales told by their parents and grandparents, many of today's Western artists approach their subjects as historians devoted to research.

475. Paul Rossi. *Spanish War Saddle— 1840*. 1971. Graves Foundry, Tucson, Ariz. H. 5½". Collection the artist. These armored war saddles were brought to the New World by the Spaniards and used by Coronado in the Southwest

476. Frederic Remington. *If Skulls Could Speak*. 1902. Oil on canvas. 44 × 33″. Private collection

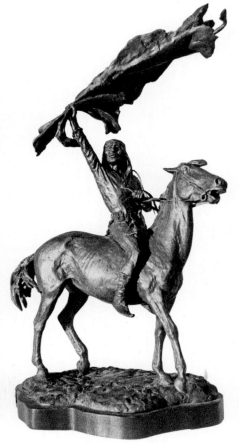

477. Ernest Berke. *Apache Signal*. 1966. Avnet Shaw Foundry, Plainview, N.Y. H. 14½″. Phoenix Art Museum, Phoenix, Ariz.

Ernest Berke (b. 1921) is the sophisticated urbanite among Western sculptors. Berke is dedicated to portraying a way of life he has known primarily through research and study. Born in New York City and educated in the Bronx, he first worked as a pressing machine mechanic, a pattern maker, and an engineer on B-17s during World War II. Following military service, he created animated backgrounds for the Fletcher Smith Studios and fashion art for Sears Roebuck and Company. While working for Sears, Berke became interested in the West. He began to study frontier history and the customs and traditions of the Indian.

Berke has created bronze sculptures of the West for almost twenty years. Throughout his career, he has been devoted to historical research. For each of his sculptures, he describes the historical background of the tribe and the ritual illustrated. He has written and illustrated a book entitled *North American Indians*.

Berke is a highly competent technician. Although his bronzes are basically realistic, he tries to create the most dramatic silhouette possible *(plate 478)*. He stylizes the streaming hair and trailing robes of the Indian, the tail of his horse, and the branches of trees. The effect is often theatrical.

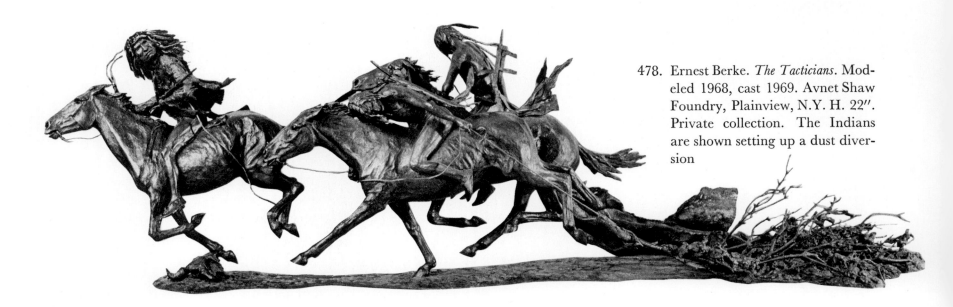

478. Ernest Berke. *The Tacticians*. Modeled 1968, cast 1969. Avnet Shaw Foundry, Plainview, N.Y. H. 22″. Private collection. The Indians are shown setting up a dust diversion

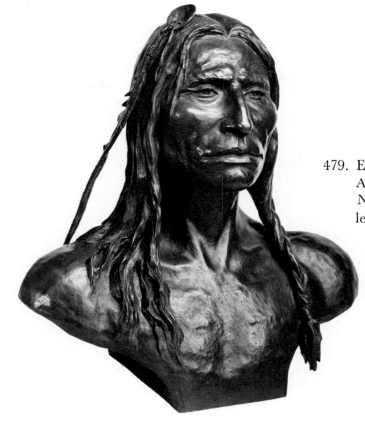

479. Ernest Berke. *Crazy Horse*. 1955. Avnet Shaw Foundry, Plainview, N.Y. H. 17″. Main Trail Galleries, Scottsdale, Ariz.

480. Gordon Phillips. *Coffee, Beans, and Broncs*. 1970. Avnet Shaw Foundry, Plainview, N.Y. H. 17″. Kennedy Galleries, New York City

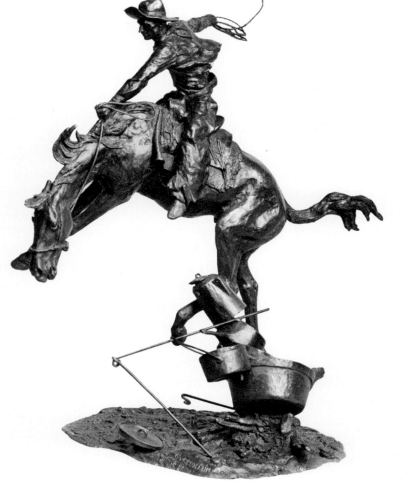

481. Charles M. Russell. *A Bronc to Breakfast*. 1912. Oil on canvas. 29 × 43″. Thomas Gilcrease Institute, Tulsa, Okla.

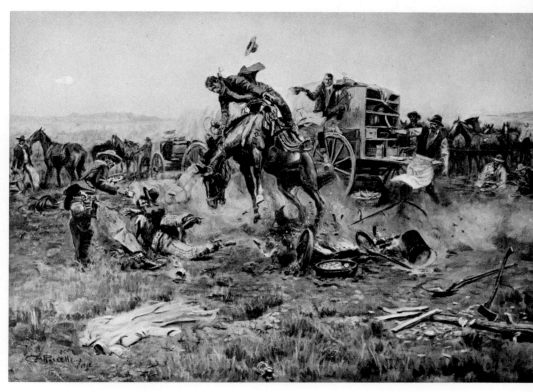

482. Noah Beery. *The Ghost Stage*. 1967. Classic Bronze, El Monte, Calif. H. 8″. Maxwell Galleries, Ltd., San Francisco, Calif. This bronze is also known as *Last Coach to Bodfish*

483. Noah Beery. *Gunfight on Front Street*. 1964. Classic Bronze, El Monte, Calif. H. 6″. Maxwell Galleries, Ltd., San Francisco, Calif.

Berke frequently finds inspiration in the paintings and illlustrations of Remington and Russell. *Apache Signal (plate 477)*, one of his most popular bronzes, shows the influence of Remington's painting *If Skulls Could Speak (plate 476)*.

Berke has achieved great success as a sculptor. His bronzes have been exhibited in several museums and are highly valued by many galleries and collectors. Although always a devotee of Western art, for many years Berke remained an Easterner, working on Long Island and making a yearly pilgrimage to Wyoming. In 1973, however, he chose Santa Fe as his permanent home.

Gordon Phillips (b. 1927) is often inspired by traditional paintings of Western life, and creates realistic sculptures of cowboys and horses. *Coffee, Beans, and Broncs (plate 480)*, an action-filled model of a bucking horse interrupting breakfast, is in the tradition of Russell's *A Bronc to Breakfast (plate 481)*. Phillips is an excellent technician and strives for perfection in detail. His bronzes display his fine knowledge of anatomy as well as his familiarity with horses and the costumes of the American cowboy.

The bronzes of Noah Beery (b. 1916) have great freshness and originality. Noah is part of a theatrical family: he is the nephew of Wallace and the son of Noah Beery, Sr. For many years, he worked in the movies and television. He enjoyed sculpture as a hobby long before

485. Hank Richter. *Shearin' Time*. 1972. Prescott Metal Casters, Prescott, Ariz. H. 5¼". Collection the artist

484. Hank Richter. *Hopi Snake Dancers*. 1970. Noggle Bronze Works, Prescott, Ariz. H. 14½". Collection the artist

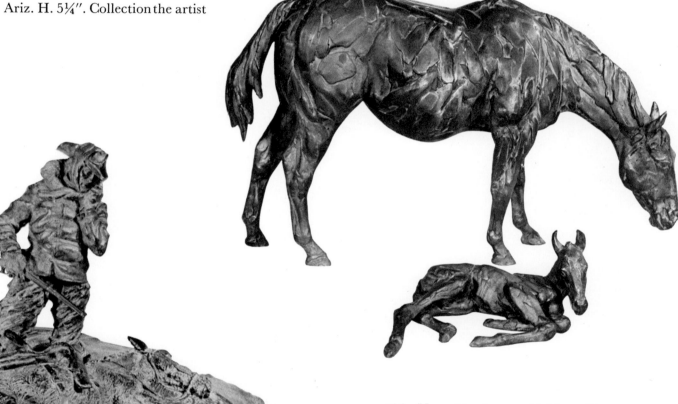

486. Una Hanbury. *Maid to Please*. 1971. Nambe Mills Foundry, Santa Fe, N.M. H. 9". Baker Gallery of Fine Arts, Lubbock, Tex.

487. Edward J. Fraughton. *Where the Trail Ends*. 1973. Cast by the artist. H. 15½". Winner of the 1973 Sculpture Award of the National Academy of Western Art, Oklahoma City, Okla.

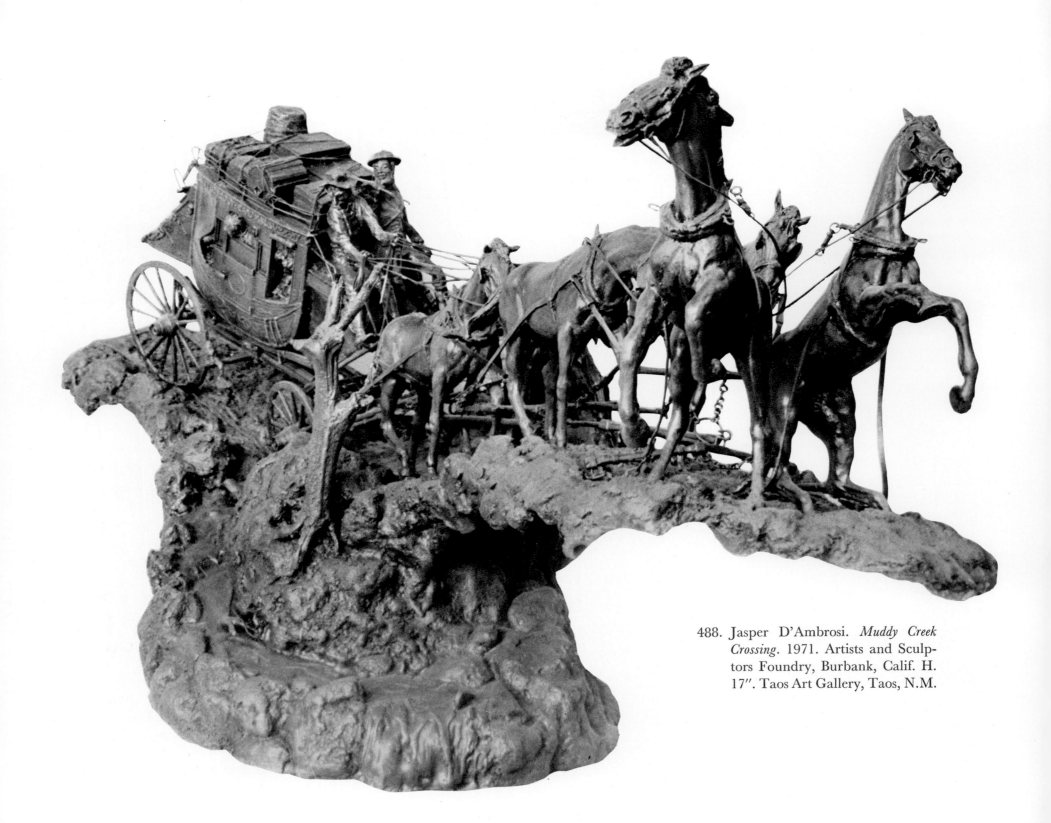

488. Jasper D'Ambrosi. *Muddy Creek Crossing*. 1971. Artists and Sculptors Foundry, Burbank, Calif. H. 17″. Taos Art Gallery, Taos, N.M.

considering the possibility of becoming a professional artist. Completely self-taught, he creates his models from papier-mâché.

Beery's sculptures often have a gentle humor. The West he portrays is neither the historic West nor the West of the working cowboy, but that of the Western movie. *Gunfight on Front Street (plate 483)* portrays a traditional Hollywood showdown. Beery's spontaneous Impressionistic style is well suited to these lighthearted theatrical pieces. His bronze of a stagecoach with horses is not a document of the past, but a "ghost stage" returning as a vision *(plate 482)*.

Hank Richter (b. 1928) has shown artistic ability since childhood. Born in Cleveland, he studied at the Philadelphia School of Art before choosing a career in advertising. In 1957, Richter moved to Arizona and soon became interested in Western history and art.

Richter studies the ceremonies and customs of the Navaho and Hopi tribes. He travels extensively through the Southwest to observe the Indians in their daily routine and special dance ceremonies *(plate 484)*. His best sculptures are models of daily life on the reservation. *Shearin' Time (plate 485)* depicts a typical scene of Navaho life on the northern mesas. Richter's paintings and sculptures have been enthusiastically received by local patrons.

Una Hanbury (b. 1905), world-famous portraitist and sculptor of horses, has recently begun to create Western bronze sculptures. A graduate of the Royal Academy of Fine Arts in London, she also studied with Jacob Epstein. Mrs. Hanbury lived for twenty-five years in Washington, D.C. Her work has been exhibited in galleries throughout the world and she has won many awards for her sculpture. Recently she moved to Santa Fe, where she models scenes from Western animal life. Horses are among her favorite subjects *(plate 486)*.

In June 1973 the first competition of the National Academy of Western Art was held at the Cowboy Hall of Fame in Oklahoma City, Oklahoma. Eight artists submitted entries for the sculpture award. Edward J. Fraughton (b. 1939) won the Gold Medal for his bronze sculpture *Where the Trail Ends (plate 487)*.

Fraughton was born and grew up in Park City, Utah. Once a thriving mining town, Park City was practically a ghost town during the years of Fraughton's youth. During his college years, Fraughton studied sculpture with Avard T. Fairbanks and after graduation studied techniques of bronze casting.

A devout Mormon, Fraughton's first commission was for the *Mormon Battalion Monument,* portraying a soldier, which stands in Presidio Park in San Diego. Recently Fraughton has devoted most of his time to portraying Western themes.

Fraughton described his objectives in *Where the Trail Ends:* I have tried to encompass the struggle of man. Despite the most terrible circumstances man always finds himself involved in, he finds a way to survive and to continue in the struggle to live. I have tried to create a simple yet strong composition embodying the great emotions we encounter—love, empathy, sympathy, understanding, respect, solace, and optimism. The past, present and future are embodied in the imagination contained within the work and its name. . . .

"I thought of a subject which might have universal significance to each person's life challenges. The horse is nearly totally lifeless yet is still loaded with all the gear of the rider and his journey. The rider stands over his mount with whom he has shared an important portion of his life and is face to face with himself and his future. His hairy face tells you he has been on the trail for several days and is perhaps some distance from his destination. The expression of his face, the way he stands alone into the wind is meant to be tragic heroism of the most extreme—evoking that wind or emotion. . . . The drifting swirling snow, quickly covers anything which becomes inanimate and makes it look fixed and cold. . . . Underneath all this coldness is the warmth that radiates from the man, who, through self-discipline and self-mastery, will somehow manage to rise above this adversity."[2]

Fraughton employs a special patina to evoke a sensation of extreme cold. The contrasting surface textures heighten the dramatic impact of the struggle of man against the forces of nature.

Today, endless variations of Western sculpture are offered to the public in limited editions. These works range from the miniatures of Don C. Polland of Prescott, Arizona, to the giant creations of Jasper D'Ambrosi of Manhattan Beach, California. D'Ambrosi recently modeled a 133-pound, historically accurate representation of the Butterfield Overland Mail Company's stage coach; the work is entitled *Muddy Creek Crossing (plate 488)*.

Each year there are many new artists creating bronze sculptures of the American West. Only time and the artistic criteria of the future will determine the importance of their work and which sculptors will in the future be considered the leaders of mid-twentieth century Western art.

XXIII
THE MONUMENTAL WEST

Today, all across the United States, the American West is celebrated through statues glorifying the Indian, the cowboy, and the pioneer. Since the middle of the nineteenth century, bronze monuments extolling the history and traditions of the West have been chosen to stand before state and municipal buildings, in parks and civic centers, and along highway landmarks throughout the country. Many were commissioned by federal, state, and city governments, while others were the gifts of private donors.

In almost every state there are monumental tributes to the Indian tribes who inhabited the lands in the years before the settlers arrived. Many statues portray the chieftains and scouts who befriended and aided the settlers during their early struggles for survival in the new land. Michigan hails Chief Pontiac; Minnesota, Chief Winnoah; Washington, Chief Seattle; Wisconsin, Chief Oshkosh; and Utah, Chief Washakie. Many monuments honor famous Indians like Sacajawea and Sequoya.

Throughout the United States, bronze statues dramatize the irreconcilable conflict between the Indians and white civilization. *The Coming of the White Man (plate 83)* by Hermon Atkins MacNeil in Portland, Oregon, depicts the Indians' reaction to their first sight of the strangers. *The Signal of Peace (plate 88)* in Chicago, *Medicine Man (plate 90)* in Philadelphia, and *Appeal to the Great Spirit (plate 96)* in Boston are part of a series of monuments by Cyrus Dallin which dramatize the unjust treatment of the Indians throughout American history. *The Protest (plates 91, 92)*, the third sculpture in the series, was never cast in monumental size. In Denver, *The Closing Era (plate 490)* by John Preston Powers stands as a reminder of the tragic blow dealt to Indian civilization by the wanton destruction of the buffalo.

Perhaps the most famous of all Western bronze sculptures is *The End of the Trail* by James Earle Fraser. Fraser's monument depicts the ultimate despair of the American Indian driven to the edge of his native land. Giant casts of *The End of the Trail* stand in Visalia, California *(plate 489)*, and Waupan, Wisconsin.

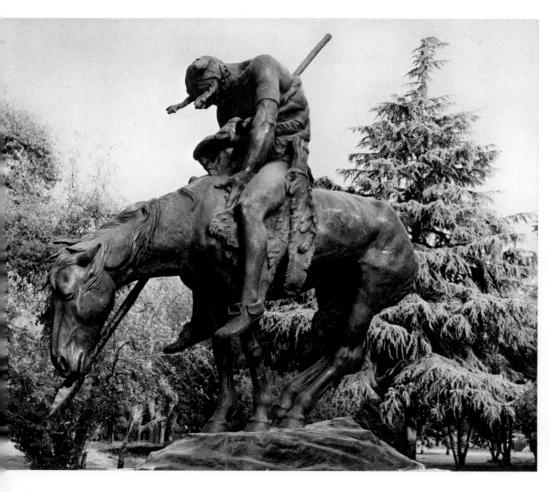

489. James Earle Fraser. *The End of the Trail*. Cast 1971. Mooney Grove, Visalia, Calif.

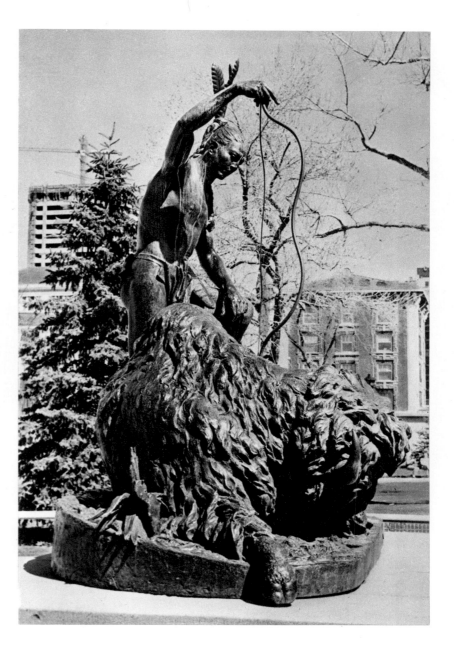

490. John Preston Powers. *The Closing Era*. Modeled 1893, erected 1898. Life-size. State Capitol Grounds, Denver, Colo. This statue was first exhibited as part of the Colorado Exhibition at the 1893 World's Columbian Exposition in Chicago, Ill.

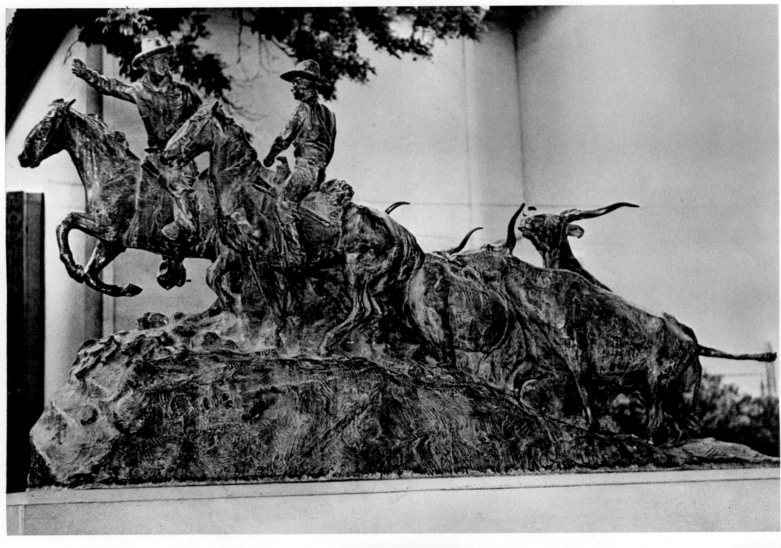

493. Frederic Remington. *The Cowboy.* Unveiled 1908. Life-size. Fairmount Park, Philadelphia. Charlie Trego, manager of Buffalo Bill's Wild West Show, was the model for the cowboy. Charlie, a well-known horseman and crack shooter with a rifle, was chosen because of his perfect physique. He was a native of Honey Brook Township, Pa.

491. Gutzon Borglum. *Texas Cowboys.* Modeled 1927, dedicated 1942. H. 32′. San Antonio, Tex.

492. Gutzon Borglum. *Texas Cowboys* (detail of plate 491)

494

494. Frederick MacMonnies. *The Pioneer Monument to Kit Carson.* 1936. Heroic size. Denver, Colo.

495. Frederick MacMonnies. *The Pioneer Monument to Kit Carson* (detail of Kit Carson)

496. Frederick MacMonnies. *The Pioneer Monument to Kit Carson* (detail of Pioneer Man)

497. Frederick MacMonnies. *The Pioneer Monument to Carson Kit* (detail of Pioneer Mother and Child)

498. Frederick MacMonnies. *The Pioneer Monument to Kit Carson* (detail of Prospector)

495

496

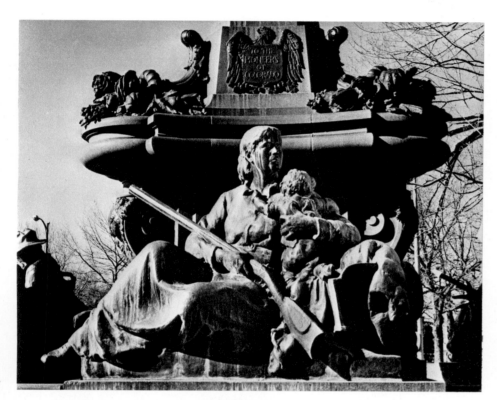

497

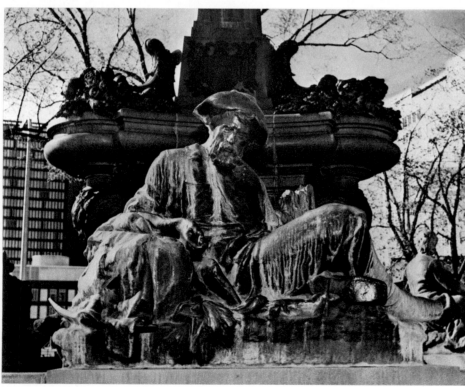

498

In Denver, *On the War Trail (plate 112)* by A. Phimister Proctor presents a total contrast to Fraser's work by celebrating the dignity and spirit of the American Indian. Proctor's Indian is a man of great courage and strength. Although his monument was created over fifty years ago, it expresses the spirit of renewed vitality and racial pride of the mid-twentieth century American Indians.

Countless monuments idealize and romanticize the American cowboy, who is truly the principal folk hero of the West. *Texas Cowboys (plates 491, 492)* by Gutzon Borglum in San Antonio, Texas, marks the site where the original cowboys set forth on the Chisholm Trail. This bronze was erected in 1942 to honor and perpetuate the memory of the old trail drivers who drove over ten million Longhorn cattle to Northern markets between 1866 and 1895. *The Cowboy (plate 493)*, in Fairmount Park in Philadelphia, is Frederic Remington's only monumental bronze. In it Remington portrayed the hard-working, rough-riding cowboy of the early twentieth century. *The Bronco Buster (plate 108)* by A. Phimister Proctor stands opposite *On the War Trail* at Denver's Civic Center. Proctor's cowboy, like his Indian, is truly a heroic figure. Constance Whitney Warren created several statues which idealize the rodeo-riding cowboy of the twentieth century.

Monuments throughout the United States also pay tribute to the American pioneers. In Denver, Frederick MacMonnies' *The Pioneer Monument to Kit Carson (plates 494–498)* honors Kit Carson, the hunters, prospectors, and settlers of the West. More recently, Avard T. Fairbanks has created two Mormon monuments, *Pioneer Family* and *Winter Quarters*. *Pioneer Family* stands in front of the State Capitol in Bismarck, North Dakota. *Winter Quarters (plates 508, 509)*, located in the Mormon Pioneer Cemetery near Florence, Nebraska, dramatizes the great personal tragedies endured by those who first crossed the continent.

The history of the Mormon migration is among the most widely celebrated themes of Western monumental sculpture. Throughout Utah, monuments honor the Mormon leaders and pioneers who endured tremendous hardships and tragedy in order to reach their promised land. In Salt Lake City, three generations of Mormon sculpture are represented by the *Brigham Young Pioneer Monument (plates 503, 506)*, *Massasoit (plate 504)*, and *The Angel* by Cyrus Dallin; *Sea Gulls (plate 505)* by Mahonri MacIntosh Young; *Ute Brave (plate 507)* by Avard T. Fairbanks; and the *Handcart Pioneer Monument (plate 500)* by Thorlief S. Knaphus. One of the most elaborate Mormon monuments is the *This is the Place Monument (plates 316–318)* by Mahonri M. Young in Emigration Canyon State Park near Salt Lake City. Here is the site where Brigham Young first saw the valley which he

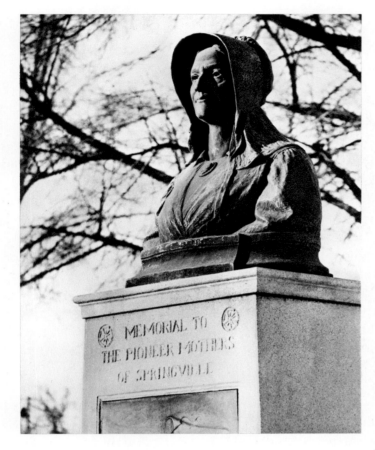

500. Thorlief S. Knaphus. *Handcart Pioneer Monument.* 1947. Roman Bronze Works, N.Y. H. 6'10". Temple Square, Salt Lake City, Utah. During the years from 1856 to 1860, an estimated 3,000 Mormons, too poor for a covered wagon or even a horse and wagon, hauled their belongings by hand more than 1,300 miles across the United States. This monument commemorates their hardships and sacrifices

499. Cyrus Dallin. *Pioneer Mother (A Memorial to the Pioneer Mothers of Springville, Utah).* 1931. Life-size. Springville, Utah

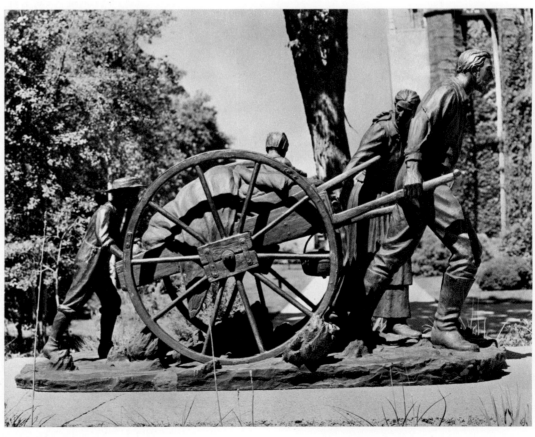

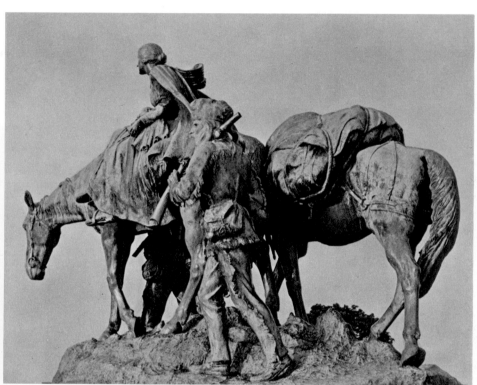

502. A Phimister Proctor. *The Pioneer Mother*. 1923–27. Heroic size. Penn Valley Park, Kansas City, Mo.

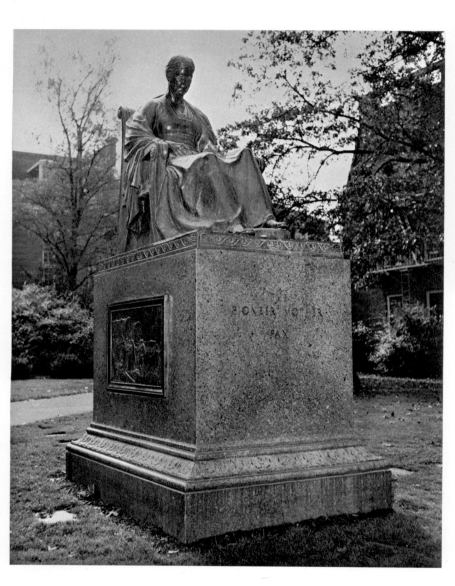

501. A. Phimister Proctor. *The Pioneer Mother*. 1934. Heroic size. University of Oregon Campus, Eugene, Ore.

503. Cyrus Dallin. *Brigham Young* from the *Brigham Young Pioneer Monument*. Dedicated 1897. Life-size. Temple Square, Salt Lake City, Utah

504. Cyrus Dallin. *Massasoit*. c. 1921. Life-size. Entrance to the State Capitol, Salt Lake City, Utah

505. Mahonri MacIntosh Young. *Sea Gulls*. 1913. Life-size. Temple Square, Salt Lake City, Utah

507. Avard T. Fairbanks. *Ute Brave*. Union Building, University of Utah, Salt Lake City

506. Cyrus Dallin. *Chief Washakie* from the *Brigham Young Pioneer Monument*. Dedicated 1897. Life-size. Temple Square, Salt Lake City, Utah

hoped would be the Mormons' promised land. Mahonri Young created a series of reliefs and statues portraying the history and the leaders of Brigham Young's expedition.

The courage and fortitude of the pioneer woman has always been a favorite theme of Western sculptors. Most artists follow two basic traditions in creating monuments on this theme. The first depicts a determined, courageous woman setting forth on her westward journey. This is the vigorous young mother celebrated by Bryant Baker in *The Pioneer Woman (plate 325)* in Ponca City, Oklahoma, and by A. Phimister Proctor in *The Pioneer Mother (plate 502)* in Kansas City, Missouri. The second tradition depicts the pioneer woman in old age, contemplating the adventures and accomplishments of her life. Such a woman was created by Proctor in *The Pioneer Mother (plate 501)* in Eugene, Oregon, and by Cyrus Dallin in his *Pioneer Mother (plate 499)* in Springville, Utah.

Throughout the United States, monuments honor such famous Westerners of the past as Kit Carson and Buffalo Bill. Many states

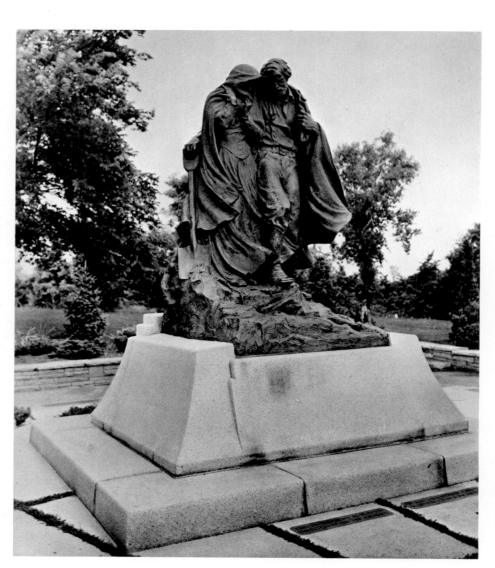

508. Avard T. Fairbanks. *Winter Quarters*. Modeled 1935, dedicated 1936. Roman Bronze Works, N.Y. H. 8′. Mormon Pioneer Cemetery, west of Florence, Neb. Photo courtesy of the Nebraska State Historical Society

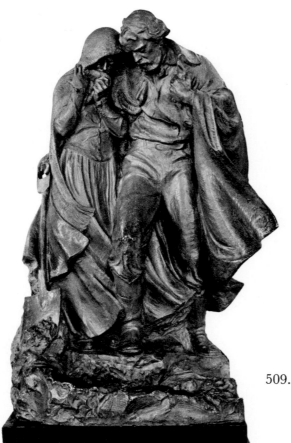

509. Avard T. Fairbanks. *Winter Quarters* (scale model). 1935. Roman Bronze Works, N.Y. H. 8′. Temple Square Museum, Salt Lake City, Utah

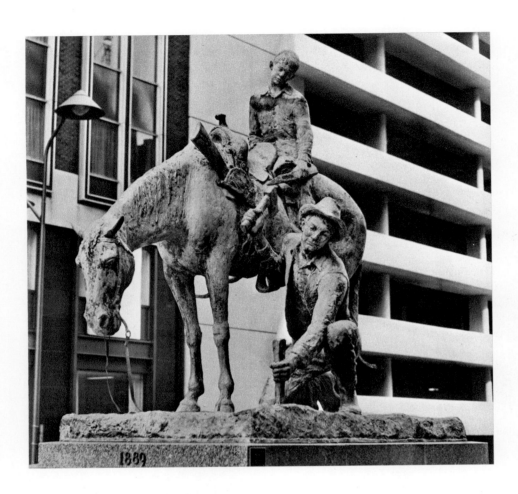

510. Leonard McMurry. *The Eighty-Niners*. c. 1958. Cast in Mexico. 1½ times life-size. Civic Center, Oklahoma City, Okla.

have public landmarks commemorating outstanding events in the history of their settlement. The *Eighty-Niners (plate 510)* by Leonard McMurry stands in the heart of Oklahoma City as a tribute to the great land race which opened the state of Oklahoma to settlers. In Cheyenne, a monument by Avard T. Fairbanks has been erected in front of the State Capitol in memory of Esther Morris, the first woman judge in the state of Wyoming (the first state to give women the franchise, in 1869). Esther Morris is celebrated in popular legend as the "Mother of Women's Suffrage."

Monuments in several states pay homage to the wildlife of the West. In Austin, Texas, *Mustangs (plates 115, 511)* by A. Phimister Proctor celebrates the wild horses of the West, which only recently came under the protection of federal legislation. In 1930, J. A. Maguire donated *Grizzly's Last Stand (plate 279)* by Louis Paul Jonas to the city of Denver. This statue, which dramatizes the impending extinction of the grizzly, was part of Maguire's crusade to win protective legislation for the grizzly bear in the Rocky Mountains.

Today, the American West is as popular a subject for monumental sculpture as at any time in previous history. As Americans become increasingly fascinated with the days of the frontier and develop a deep pride in the heroes and heroines of the West, new statues are commissioned to honor the country's pioneer heritage. As Americans re-evaluate over three centuries of their relationship with the Indian, modern sculptors develop an increased interest in Indian history, traditions, values, and beliefs. They create bronze statues which have little in common with the "noble savages" of a century ago. As Americans become concerned with ecology, especially with the conservation of wildlife, artists create sculptures of animals native to the West. It has become a tradition for American sculptors to work in bronze—a medium of remarkable versatility, endurance, and beauty—to pay tribute to the world of the American West.

511. A. Phimister Proctor. *Mustangs*. Unveiled 1948. H. 15′ from plinth to top of mustang's head. Texas Memorial Museum, University of Texas, Austin

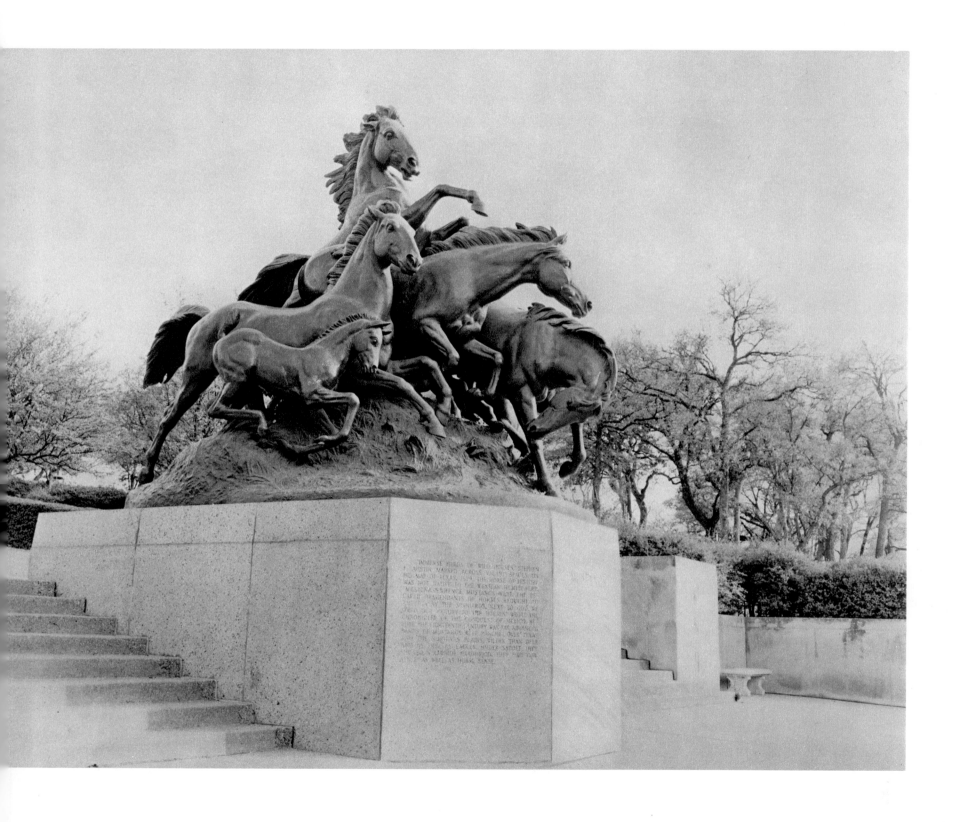

NOTES

CHAPTER I

[1] *Good Medicine: The Illustrated Letters of Charles M. Russell.* Garden City, N.Y.: Doubleday & Co., 1929 (new ed. 1966), p. 140.

[2] *Ibid.,* p. 111.

CHAPTER II

[1] *The History of American Sculpture.* New York: Macmillan Co., 1903 (rev. ed. 1930), p. 8.

[2] *Ibid.,* p. 440.

[3] *Ibid.,* p. 488.

[4] *Ibid.,* p. 220.

[5] Beatrice Gilman Proske, *Brookgreen Gardens Sculpture.* Murrells Inlet, S. C.: Brookgreen Gardens, 1943 (rev. ed. 1968), as quoted by Wayne Craven, *Sculpture in America.* New York: Thomas Y. Crowell, 1968, p. 514.

[6] *Sculpture in America,* p. 514.

CHAPTER III

[1] *The History of American Sculpture.* New York: Macmillan Co., 1903 (rev. ed. 1930), pp. 114, 123.

[2] Wayne Craven, *Sculpture in America.* New York: Thomas Y. Crowell, 1968, p. 146.

[3] *Ibid.,* p. 149.

[4] *Ibid.,* p. 146.

[5] Beatrice Gilman Proske, *Brookgreen Gardens Sculpture.* Murrells Inlet, S. C.: Brookgreen Gardens, 1943 (rev. ed. 1968), p. 6.

[6] *The Spirit of American Sculpture.* New York: Gillis Press, 1923, pp. 60–61.

[7] *Great American Sculptures.* Philadelphia: Gebbie Bassie Co., 1877, p. 115.

[8] *The History of American Sculpture,* p. 374.

[9] *Ibid.,* p. 408.

[10] *Ibid.,* p. 409.

[11] Charles H. Caffin, *American Masters of Sculpture.* New York: Doubleday, Page & Co., 1903, p. 136.

CHAPTER IV

[1] Wayne Gard, "How They Killed the Buffalo," *American Heritage,* vol. VII, no. 5 (August 1956), p. 37.

[2] Albert Ten Eyck Gardner, *American Sculpture: A Catalogue of the Collection of the Metropolitan Museum of Art.* Greenwich, Conn.: New York Graphic Society, 1965, p. 39.

[3] *American Masters of Sculpture.* New York: Doubleday, Page & Co., 1903, pp. 197–98.

[4] Gardner, *American Sculpture: A Catalogue of the Collection of the Metropolitan Museum of Art,* p. 39.

[5] "American Wild Animals in Art," *Century Magazine,* vol. VI (June 1884), p. 214.

[6] *The History of American Sculpture.* New York: Macmillan Co., 1903 (rev. ed. 1930), p. 473.

[7] Maurice Frink, "Edwin W. Deming, 'That Man, He Paint,'" *The American Scene,* vol. XII, no. 3 (1971), p. 11.

[8] Beatrice Gilman Proske, *Brookgreen Gardens Sculpture.* Murrells Inlet, S. C.: Brookgreen Gardens, 1943 (rev. ed. 1968), p. 162.

[9] *The Spirit of American Sculpture.* New York: Gillis Press, 1923, p. 142.

CHAPTER V

[1] Arthur Goodrich, "The Frontier in Sculpture," *World's Work,* vol. 3 (March 1902), p. 1857.

[2] James C. Derieux, "A Sculptor Who Rode to Fame on Horseback," *American Magazine,* vol. 97 (January 1924), p. 14.

[3] *Ibid.,* p. 14.

[4] *Ibid.,* p. 13.

[5] *Ibid.,* p. 14.

[6] "Art That Is Real And American," *World's Work,* vol. 28 (June 1914), p. 202.

[7] Derieux, "A Sculptor Who Rode to Fame on Horseback," p. 14.

[8] Beatrice Gilman Proske, *Brookgreen Gardens Sculpture.* Murrells Inlet, S. C.: Brookgreen Gardens, 1943 (rev. ed. 1968), p. 64.

[9] Borglum, "Art That Is Real And American," p. 209.

[10] *Ibid.,* p. 200.

[11] *Ibid.,* p. 201.

[12] Quoted by Wayne Craven, *Sculpture in America.* New York: Thomas Y. Crowell, 1968, p. 490. Craven is quoting here from a work in the New York Public Library.

[13] Borglum, "Art That Is Real And American," p. 203.

CHAPTER VI

[1] "The Frontier in Sculpture," *World's Work,* vol. 3 (March 1902), pp. 1860–61.

[2] *Ibid.,* pp. 1863–64.

[3] "In Recognition of an American Sculptor," *Scribner's Magazine,* vol. 72 (September 1922), p. 382.

[4] *Ibid.,* p. 379.

[5] Goodrich, "The Frontier in Sculpture," p. 1873.

[6] Eberle, "In Recognition of an American Sculptor," p. 383.

[7] *The History of American Sculpture.* New York: Macmillan Co., 1903 (rev. ed. 1930), p. 483.

[8] Wayne Craven, *Sculpture in America.* New York: Thomas Y. Crowell, 1968, p. 526.

[9] Eberle, "In Recognition of an American Sculptor," p. 384.

[10] *The History of American Sculpture,* p. 481.

[11] *Ibid.,* pp. 478–81.

CHAPTER VII

[1] Lorado Taft, *The History of American Sculpture.* New York: Macmillan Co., 1903 (rev. ed. 1930), pp. 438–39.

[2] Jean Stansbury Holden, "The Sculpture of MacNeil," *World's Work,* vol. 14 (October 1907), p. 9409.

[3] Letter to the author, November 12, 1971.

[4] *Ibid.*

[5] Letter of November 24, 1939, supplied to author.

CHAPTER VIII

[1] E. Waldo Long, "Dallin, Sculptor of Indians," *World's Work,* vol. 54 (September 1927), p. 565.

[2] *Ibid.,* p. 565.

[3] *Ibid.,* p. 566.

[4] *Ibid.,* pp. 565–66.

[5] *Ibid.,* p. 566.

[6] *Ibid.,* p. 568.

[7] William Howe Downes, "Mr. Dallin's Indian Sculptures," *Scribner's Magazine,* vol. 57 (June 1915), p. 781.

[8] Downes, "Mr. Dallin's Indian Sculptures," p. 782.

[9] *Sculpture in America.* New York: Thomas Y. Crowell, 1968, p. 527.

[10] Long, "Dallin, Sculptor of Indians," p. 566.

CHAPTER IX

[1] *Alexander Phimister Proctor, Sculptor in Buckskin* (ed. by Hester Elizabeth Proctor). Norman, Okla.: University of Oklahoma Press, 1971, p. 6.

[2] *Ibid.,* p. 8.

[3] *Ibid.,* p. 81.

[4] *Ibid.,* p. 96.

[5] *Ibid.,* pp. 96–97.

[6] *Sculpture in America.* New York: Thomas Y. Crowell, 1968, p. 521.

[7] *Alexander Phimister Proctor, Sculptor in Buckskin,* pp. 119–20.

[8] *Ibid.,* p. 159.

[9] *Ibid.,* p. 167.

[10] *Ibid.,* p. 172.

[11] *Ibid.,* p. 184.

[12] *Ibid.,* p. 199.

[13] Quoted in *Alexander Phimister Proctor, Sculptor in Buckskin,* p. 200.

[14] *Ibid.,* p. 202.

CHAPTER X

[1] "Remington, an Appreciation," *Collier's,* vol. II (March 18, 1905), p. 15.

[2] Quoted in Theodore Roosevelt, "An Appreciation of the Art of Frederic Remington," *Pearson's Magazine,* vol. 18 (October 1907), p. 392 (facsimile of a letter by Remington).

[3] Harold McCracken, *Frederic Remington: Artist of the Old West.* Philadelphia and New York: J. B. Lippincott Co., 1947, p. 104.

[4] "A Few Words From Mr. Remington," *Collier's,* vol. II (March 18, 1905), p. 16.

[5] Jeff C. Dykes, "Frederic Remington—Western Historian," *The American Scene,* vol. IV, no. 2 (Summer 1961), p. 5.

[6] Quoted in McCracken, *Frederic Remington: Artist of the Old West,* p. 11.

[7] Augustus Thomas, *The Print of My Remembrance.* New York: Charles Scribner's Sons, 1922, p. 327.

[8] Quoted in McCracken, *Frederic Remington: Artist of the Old West,* p. 92.

[9] Frederic Remington, "Chasing a Major General," *Harper's Weekly,* vol. XXXIV (December 6, 1890), p. 946.

[10] *Ibid.,* p. 946.

[11] *The Collector's Remington (Bronzes), The Story of Frederic Remington's Bronzes,* privately printed, Woonsocket, R.I., 1946, p. 4.

[12] Quoted in McCracken, *Frederic Remington: Artist of the Old West,* p. 93.

[13] *Ibid.,* p. 93.

[14] *Ibid.,* p. 96.

[15] Library of Congress, copyright July 19, 1896.

[16] To appreciate the advantages of the lost-wax process, it is necessary to have a general understanding of both the sand and lost-wax casting methods. Both processes vary

from foundry to foundry, but certain basic principles remain constant. The following simplified explanation outlines the fundamentals of these techniques.

In the sand process, the original plaster model is divided into several parts. Each piece of the model is packed in fine sand. The sand is usually a composition of clay silica and alumina. The molder hammers the damp sand against the model, then removes the model. The packed sand bears a detailed impression of the model. These packed sand pieces are re-composed in iron frames to constitute a complete mold. A core is built into the mold, shaved, and suspended on iron pins.

After the sand mold has been dried in an oven, liquid bronze is poured into it. When the bronze cools, the sand is removed and the core shaken out. The resultant bronze is then cleaned and chased (polished and chiseled) and the final patina is applied.

The patina, which is the ultimate color and finish, is the result of the application of different combinations of chemicals. The creation of the patina is a highly technical scientific process.

In the lost-wax process, the founder makes a negative mold from the artist's original model. This mold shows the precise details of the model in reverse. From this mold, the founder creates a separate wax model for each cast. At this point in the casting process, the artist has the opportunity to work on the wax and to create variations which will distinguish one cast from another.

Gates and vents are then attached to the wax. The wax is next covered by a semi-liquid composition which hardens. The wax may be solid or have a core which is also filled. During the forging process, the mold is heated and the wax melts, leaving a hollow. Liquid bronze is poured into the hollow. The bronze fills the open space because the air escapes through the vents. When the metal hardens, the bronze is removed and dipped in a cleansing acid. It is then chiseled and the patina is applied.

The lost-wax process permits the sculptor to create variations between casts, to model more complex compositions, to reproduce greater detail, and to achieve cleaner, clearer results. (Compare plates 124 and 126 with plates 125 and 127.)

In the United States, the bronze used for sculpture is an alloy which is generally 85 to 90 per cent copper and 10 to 15 per cent tin, zinc, and other non-ferrous metals.

For a comprehensive discussion of the lost-wax technique, the reader is referred to Harry Jackson's *Lost Wax Bronze Casting*, published in 1972 by the Northland Press in Flagstaff, Arizona.

[17] Quoted in McCracken, *Frederic Remington:*

Artist of the Old West, p. 105:
[18] *Ibid.*, p. 21.

CHAPTER XI

[1] Quoted in *Good Medicine: The Illustrated Letters of Charles M. Russell*. Garden City, N. Y.: Doubleday & Co., 1929 (new ed. 1966), p. 20.
[2] *Ibid.*, p. 5.
[3] Quoted in Paul Rossi and David C. Hunt, *The Art of the Old West*. New York: Alfred A. Knopf, 1971, p. 47.
[4] Quoted in James T. Forest, "The Philosophy of Charles Russell," *The American Scene*, vol. III, no. 2 (Summer 1960), p. 27.
[5] *Good Medicine: The Illustrated Letters of Charles M. Russell*, p. 113.
[6] Quoted in Harold McCracken, *The Charles M. Russell Book*. Garden City, N. Y.: Doubleday & Co., p. 110.
[7] *Ibid.*, p. 154.
[8] *Ibid.*, p. 25.
[9] Frederic G. Renner, *Charles M. Russell: Paintings, Drawings and Sculpture in the Amon G. Carter Collection*. Austin and London: University of Texas Press, 1966, p. 3.
[10] Quoted in *Good Medicine: The Illustrated Letters of Charles M. Russell*, p. 16.
[11] Quoted in Renner, *Charles M. Russell: Paintings, Drawings and Sculpture in the Amon G. Carter Collection*, p. 4.
[12] *Good Medicine: The Illustrated Letters of Charles M. Russell*, p. 59.
[13] *Ibid.*, p. 73.
[14] *Ibid.*, p. 159.
[15] Quoted in Forest, "The Philosophy of Charles Russell," p. 27.
[16] *Good Medicine: The Illustrated Letters of Charles M. Russell*, p. 32.
[17] Quoted in Wayne Gard, "How They Killed the Buffalo," *American Heritage*, vol. VII, no. 5 (August 1956), p. 39.
[18] "The Art of Charles Russell," *The American Scene*, vol. III, no. 2 (Summer 1960), p. 3.
[19] *Good Medicine: The Illustrated Letters of Charles M. Russell*, p. 30.
[20] *Charles M. Russell: Paintings, Drawings and Sculpture in the Amon G. Carter Collection*, p. 109.
[21] Dobie, "The Art of Charles Russell," p. 3.

CHAPTER XII

[1] Quoted in Martin Bush, *James Earle Fraser, American Sculptor: A Retrospective Exhibition of Bronzes from Works of 1913 to 1953*, Kennedy Galleries, Inc., N. Y., 1969, p. 7.

[2] Quoted in Ed Ainsworth, *The Cowboy in Art*. New York and Cleveland: World Publishing Co., 1968, p. 166.
[3] Quoted in Wayne Craven, *Sculpture in America*. New York: Thomas Y. Crowell, 1968, p. 493.
[4] *Ibid.*, p. 493.
[5] Quoted in Bush, *James Earle Fraser, American Sculptor: A Retrospective Exhibition of Bronzes from Works of 1913 to 1953*, p. 34.
[6] Effie Seachrest, "James Earle Fraser," *The American Magazine of Art*, vol. 8 (May 1917), p. 278.
[7] *James Earle Fraser, American Sculptor: A Retrospective Exhibition of Bronzes from Works of 1913 to 1953*, p. 42.

CHAPTER XIII

[1] Unpublished correspondence between Adolph A. Weinman and R. W. Norton, Jr., May 3, 1947, supplied to the author.
[2] *Ibid.*
[3] *Ibid.*
[4] *Ibid.*
[5] *Ibid.*
[6] *Ibid.*
[7] *Ibid.*

CHAPTER XIV

[1] Harold McCracken, *Portrait of the Old West*. New York: McGraw-Hill Book Co., 1952, p. 196.
[2] *Ibid.*, p. 197.
[3] James D. Horan, *The Life and Art of Charles Schreyvogel*. New York: Crown Publishers, 1969, p. 3.
[4] *Ibid.*, p. 57.
[5] Quoted in McCracken, *Portrait of the Old West*, p. 202.
[6] Quoted in Donnie D. Good, "W. R. Leigh, The Artist's Studio Collection," *The American Scene*, vol. IX, no. 4 (1968), p. 8.
[7] David C. Hunt, "W. R. Leigh, Portfolio of an American Artist," *The American Scene*, vol. VII, no. 1 (1966), p. 6.
[8] *Ibid.*, p. 2.

CHAPTER XVI

[1] Albert Ten Eyck Gardner, *American Sculpture: A Catalogue of the Collection of the Metropolitan Museum of Art*. Greenwich, Conn.: New York Graphic Society, 1965, p. 162.
[2] "Art and Artists of New Mexico," *New Mexico Magazine*, October 1937.
[3] Mildred Burgess, "A Sculptor Demon-

strates the Unity of Man," *Independent Woman*, p. 18. From the vertical files of the New York Public Library (undated material).
[4] Malvina Hoffman, *Heads and Tales*. New York: Charles Scribner's Sons, 1936, p. 359.
[5] *Ibid.*, p. 397.
[6] *The National Hall of Fame for Famous American Indians Catalogue*. Oklahoma City, Okla.: Oklahoma Historical Society, 1970–71, p. 25.

CHAPTER XVII

[1] Charles Hall Garrett, "The New American Sculptor," *Munsey's Magazine*, vol. 29 (July 1903), p. 545.
[2] Quoted in Rose V. S. Berry, "Arthur Putnam—California Sculptor," *The American Magazine of Art* (May 1929), p. 279.
[3] *Ibid.*, p. 281.
[4] *The History of American Sculpture*. New York: Macmillan Co., 1903 (rev. ed. 1930), p. 575.
[5] Beatrice Gilman Proske, *Brookgreen Gardens Sculpture*. Murrells Inlet, S. C.: Brookgreen Gardens, 1943 (rev. ed. 1968), p. ix.
[6] D. R. Barton, "Adventures of an Artist-Explorer," *Natural History Magazine* (January 1942), p. 50.

CHAPTER XVIII

[1] *The History of American Sculpture*. New York: Macmillan Co., 1903 (rev. ed. 1930), pp. 533, 534.
[2] *Ibid.*, p. 536.
[3] Quoted in "The Woman with a Sunbonnet," *The Literary Digest*, April 9, 1927, pp. 26–27.
[4] Quoted in Patrick Peterson (Ke Mo Ha), *Woolaroc Museum Catalogue*. Bartlesville, Okla.: Frank Phillips Foundation, 1965, p. 37.
[5] Quoted in Bill Harman, "Oklahoma's Pioneer Women," *Oklahoma's Orbit*, April 21, 1963, p. 4.
[6] "The Woman with a Sunbonnet," p. 27.
[7] Quoted in booklet issued by the Ponca City Chamber of Commerce, Ponca City, Okla. (n.d.).

CHAPTER XIX

[1] *Brookgreen Garden Sculpture*. Murrells Inlet, S. C.: Brookgreen Gardens, 1943 (rev. ed. 1968), p. 285.
[2] *Paul Manship*. New York: Macmillan Co., 1957, p. 16.

[3] *Brookgreen Gardens Sculpture*, p. 288.

[4] Quoted in *The Spirit of the West*, catalogue of the Rodeo Series of bronzes by Lawrence Tenney Stevens, from the Collection of the Valley National Bank of Arizona, Phoenix, c. 1971, pp. 1–2.

[5] *Ibid.*, p. 2.

[6] *Ibid.*, p. 11.

[7] Letter to the author, October 31, 1971.

[8] Quoted in *Sport and Western Sculpture by Clemente Spampinato*, catalogue of the National Art Museum of Sport Inc., Madison Square Garden Center, N. Y., October 1–November 30, 1968, p. 6.

[9] Letter to the author, July 28, 1972.

[10] *Ibid.*

[11] *Ibid.*

[12] *George Carlson.* Biographical pamphlet issued 1967 by the Blair Gallery, Santa Fe, N.M.

[13] *George Carlson.* Biographical pamphlet issued by the Rive Gauche Gallery, Santa Fe, N.M.

[14] Artist's description supplied to the author.

[15] Letter to the author, March 16, 1972.

[16] Letter to the author, February 4, 1974.

CHAPTER XX

[1] Quoted in Paul Dyke, "Lone Wolf Returns to That Long-Ago Time," *Montana, the Magazine of Western History*, vol. XXII, no. 1 (Winter 1972), p. 24.

[2] *Ibid.*, p. 27.

[3] Quoted in *Sculpture by Allan Houser*, catalogue of the Southern Plains Indian Museum and Crafts Center Exhibitions, Anadarko, Okla., October 3–November 13, 1971, p. 1.

[4] *Ibid.*, p. 1.

[5] Letter to the author, September 12, 1971.

[6] *Ibid.*

[7] Dale A. Burke, *New Interpretations*. Missoula, Mont.: Western Life Publications, 1969, p. 126.

[8] *Ibid.*, p. 126.

[9] Quoted in Joann Boatman, *Willard Stone, Wood Sculptor,* Catalogue of the Five Civilized Tribes Museum, Muskogee, Okla., p. 5.

[10] *Ibid.*, p. 10.

[11] Description supplied to the author.

[12] *Ibid.*

[13] *Ibid.*

CHAPTER XXI

[1] Quoted in Frank Getlein, *Harry Jackson*, Kennedy Galleries, Inc., N. Y., 1969, p. 72.

[2] Introduction to *Harry Jackson: Western Bronzes*, Kennedy Galleries, Inc., N. Y., 1965, p. 3.

[3] *Joe Beeler Shows at the C. M. Russell Gallery, Great Falls, Montana, July 14-August 30, 1970* (catalogue). Flagstaff, Ariz.: Northland Press, 1970, p. 3.

[4] *Ibid.*, p. 4.

[5] Joe Beeler, "An Artist Looks at the American Indian," *Montana, the Magazine of Western History*, vol. XIV, no. 2 (April 1964), p. 84.

[6] Marks, "The Cowboy Artists of America," *Persimmon Hill Magazine*, vol. 1, no. 4 (Summer 1971), p. 37.

[7] Josephine Zimmerman, "Springville Sculptor Preparing Long-Awaited New Pieces for Art Exhibit," *Daily Herald*, Utah County, Utah, March 21, 1968, p. 8.

[8] Quoted in Ed Ainsworth, *The Cowboy in Art*. New York & Cleveland: World Publishing Co., 1968, p. 170.

[9] Quoted in Jim Lapham, "Gus Shafer Molds a Career in Retirement," *Kansas City Star Sunday Magazine*, April 18, 1971, p. 37.

CHAPTER XXII

[1] Quoted in Dale A. Burke, *New Interpretations*. Missoula, Mont.: Western Life Publications, 1969, p. 25.

[2] Letter to the author, June 1973.

SELECTED BIBLIOGRAPHY

SURVEYS OF AMERICAN SCULPTURE

ADAMS, ADELINE. *The Spirit of American Sculpture.* New York: Gillis Press, 1923.

CAFFIN, CHARLES H. *American Masters of Sculpture.* New York: Doubleday, Page & Co., 1903.

CLARK, W. J. *Great American Sculptures.* Philadelphia: George Barrie Co., 1878.

Compilation of Works of Art and Other Objects in the United States Capitol, prepared by the Architect of the Capitol under the direction of the Joint Committee on the Library (House Document No. 362, 88th Congress, 2nd session). Washington, D.C.: United States Government Printing Office, 1965.

CORTISSOZ, ROYAL. *American Artists.* New York: Charles Scribner's Sons, 1923.

CRAVEN, WAYNE. *Sculpture in America.* New York: Thomas Y. Crowell, 1968.

DODD, LORING HOLMES. *The Golden Age of American Sculpture.* Boston: Chapman & Grimes, Mount Vernon Press, 1936.

GARDNER, ALBERT TEN EYCK. *American Sculpture: A Catalogue of the Collection of the Metropolitan Museum of Art.* Greenwich, Conn.: New York Graphic Society, 1965.

MCSPADDEN, JOSEPH. *Famous Sculptors of America.* New York: Dodd, Mead & Co., 1924.

POST, CHANDLER RATHFON. *A History of European and American Sculpture from the Early Christian Period to the Present Day* (Vol. II). Cambridge, Mass.: Harvard University Press, 1921.

PROSKE, BEATRICE GILMAN. *Brookgreen Gardens Sculpture.* Murrells Inlet, S. C.: By order of the Trustees, 1943. Revised Edition, 1968.

TAFT, LOREDO. *The History of American Sculpture.* New York: Macmillan Co., 1903. Revised Edition, 1930.

_____. *Modern Tendencies in Sculpture.* Chicago: University of Chicago Press, 1921.

EXHIBITIONS AND EXPOSITIONS

Contemporary American Sculpture Issued for the Exhibition Held by The National Sculpture Society in Cooperation with the Trustees of the California Palace of the Legion of Honor, 1929, Lincoln Park, San Francisco. New York: National Sculpture Society, Press of the Kalkhoff Co., 1929.

Exhibition of American Sculpture Catalogue, Held by The National Sculpture Society, 1923. New York: National Sculpture Society, 1923.

GRAY, DAVID. *Official Handbook of Architecture and Sculpture and Art Catalogue to the Pan-American Exposition.* Buffalo: David Gray, 1901.

MCCABE, JAMES D. *The Illustrated History of the Centennial Exhibition Held in Commemoration of the 100th Anniversary of American Independence.* Philadelphia: National Publishing Co., 1876.

Official Catalogue of Exhibitors, Universal Exposition, St. Louis, U.S.A., 1904. St. Louis: The Official Catalogue Co., 1904.

Official Catalogue of Exhibits, World's Columbian Exposition (Dept. K. Fine Arts, Part X). Chicago: W. B. Conkey Co., 1893.

Official Catalogue of the United States Exhibition, Paris Universal Exposition, 1889. Paris: Charles Noblet et Fils, 1889.

Official Directory of the World's Columbian Exposition (ed. Moses P. Handy). Chicago: W. B. Conkey Co., 1893.

Official Illustrated Catalogue, Fine Arts Exhibition, United States of America, Paris Exposition of 1900. Boston: Noyes, Platt & Co., 1900.

PERRY, STELLA G. *The Sculpture and Mural Decoration of the Exposition.* Introduction by A. Sterling Calder. San Francisco: Paul Elder & Co., 1915.

TODD, FRANK MORTON. *The Story of the Exposition, Being the Official History of the International Celebration Held at San Francisco in 1915 to Commemorate the Discovery of the Pacific Ocean and the Construction of the Panama Canal* (Vol. II). London and New York: G. P. Putnam's Sons, Knickerbocker Press, 1921.

FRENCH ANIMAL SCULPTURE

CIECHANOWIECKI, ANDREW W. "Bronzes by French Animalier Sculptors of the 19th and 20th Centuries." *Antiques International* (ed. Peter Wilson). New York: G. P. Putnam's Sons, 1967, 308–21.

HORSWELL, JANE. *Bronze Sculpture of "Les Animaliers."* Woodbridge, Suffolk: Baron Publishing Co., 1971.

AMERICAN INDIAN ART

DUNN, DOROTHY. *American Indian Painting of the Southwest and Plains Areas.* Albuquerque: University of New Mexico Press, 1968.

GRIDLEY, MARION. *Indians of Today.* Chicago: Towertown Press, 1966.

SNODGRASS, JEANNE OWENS. *American Indian Painters: A Biographical Dictionary.* New York: Museum of the American Indian, Heye Foundation, 1968.

WESTERN ART

AINSWORTH, ED. *The Cowboy in Art.* New York and Cleveland: World Publishing Co., 1968.

BURKE, DALE A. *New Interpretations.* Missoula, Mont.: Western Life Publications, 1969.

CARD, HELEN. "Salute to the Westerners," *Latendorfer Catalogue Number One* (1959), 1–48.

"A Cowboy Artists of America Gallery," *Persimmon Hill,* Vol. 1, No. 4 (Summer, 1971), 18–39.

EXHIBITION CATALOGUES, COWBOY ARTISTS OF AMERICA. Oklahoma City: National Cowboy Hall of Fame, 1968–72.

GARD, WAYNE. "How They Killed the Buffalo," *American Heritage,* Vol. VII, No. 5 (Aug., 1956), 34–39.

GETLEIN, FRANK. *The Lure of the West.* Waukesha, Wis.: Country Beautiful Corp., 1973.

GRIDLEY, MARION E. *America's Indian Statuary.* Chicago: Towertown Press, 1966.

Kennedy Quarterly Magazines. New York: Kennedy Galleries, Inc. (Dec., 1959–Mar., 1972).

KRAKEL, DEAN, and HEDGPETH, DON. "Short Grass, Stetsons, and Paint Brushes: A Survey of Cowboy Art," *Persimmon Hill,* Vol. 1, No. 4 (Summer, 1971), 2–17.

LYON, PETER. "The Wild, Wild West," *American Heritage,* Vol. XI, No. 5 (Aug., 1960), 32–48.

MCCRACKEN, HAROLD. *Portrait of the Old West.* New York: McGraw-Hill Book Co., 1952.

MUNO, RICHARD. "The West in Contemporary Art," *Persimmon Hill,* Vol. 1, No. 1 (Summer, 1970), 30–33.

The National Hall of Fame for Famous American Indians Catalogue. Anadarko, Okla. Oklahoma City: Oklahoma Historical Society, 1970–71.

PETERSON, PATRICK (Ke Mo Ha). *Woolaroc Museum Catalogue.* Bartlesville, Okla.: Frank Phillips Foundation, Inc., 1965.

ROSSI, PAUL, and HUNT, DAVID C. *The Art of the Old West.* New York: Alfred A. Knopf, 1971.

The West and Walter Bimson. Tucson: University of Arizona Press, 1971.

INDIVIDUAL SCULPTORS

Baker, Bryant

DE LUE, DONALD. "Bryant Baker," *National Sculpture Review,* Vol. 13, No. 3 (Fall, 1964), 20–21, 27–28.

NELSON, W. H. DE B. "Bryant Baker," *The International Studio,* Vol. LXIII, No. 250 (Dec., 1917), XXXVIII–XLIV.

Bartlett, Paul Wayland

BARTLETT, ELLEN. "Paul Bartlett: an American Sculptor," *The New England Magazine,* Vol. 33 (Dec., 1905), 369–82.

STUART, EVELYN MARIE. "Paul Bartlett: Eminent Sculptor," *Fine Arts Journal,* Vol. 30 (June 1914), 315–20.

WHEELER, CHARLES. "Bartlett," *American Magazine of Art,* Vol. 16 (Nov., 1925), 573–85.

Beeler, Joe

BEELER, JOE. "An Artist Looks at the American Indian," *Montana, the Magazine of Western History,* Vol. XIV, No. 2 (Apr., 1964), 83–90.

_____. *Cowboys and Indians.* Norman, Okla.: University of Oklahoma Press, 1967.

_____. *Joe Beeler Shows at the C. M. Russell Gallery, Great Falls, Montana, July 14–Aug. 30, 1970.* Flagstaff, Ariz.: Northland Press, 1970.

_____. "Joe Beeler." *Southwestern Art,* Autumn 1971, 26–35.

Blodgett, George Winslow

SEABURY, DAVID. "George Winslow Blodgett's Indian Sculpture," *Creative Art,* Vol. 12 (May, 1933), 366–68.

Borglum, Gutzon

BORGLUM, GUTZON. "Art That is Real and American," *The World's Work,* Vol. 28 (June, 1914), 200–217.

CASEY, ROBERT JOSEPH, and BORGLUM, MARY WILLIAMS. *Give the Man Room: the Story of Gutzon Borglum.* Indianapolis and New York: Bobbs-Merrill Co., 1952.

DERIEUX, JAMES C. "A Sculptor Who Rode to Fame on Horseback," *American Magazine,* Vol. 97 (Jan., 1924), 12–14, 66, 68, 70, 72.

Borglum, Solon H.

BORGLUM, GUTZON. "Solon H. Borglum," *The American Magazine of Art,* Vol. 13 (Nov., 1922), 471–75.

BORGLUM, SOLON. *Sound Construction.* New York: The Committee of the Solon Borglum Memorial Fund, 1923.

DAVIES, A. MERVYN. *Solon H. Borglum: "A Man Who Stands Alone."* Chester, Conn.: Pequot Press, 1974.

EBERLE, LOUISE. "In Recognition of an American Sculptor," *Scribner's Magazine,* Vol. 72 (Sept., 1922), 379–84.

GOODRICH, ARTHUR. "The Frontier in Sculpture," *World's Work,* Vol. 3 (Mar., 1902), 1857–74.

KEPEL, FREDERICK, and Co. *Catalogue of Exhibition of Bronzes, Marbles and Other Sculpture by Solon H. Borglum with Introduction by Charles H. Caffin.* New York: Frederick Keppel and Co., 1904.

SEWELL, FRANK. "A Sculptor of the Prairie," *Century Magazine,* Vol. 68 (June, 1904), 247–51.

Calder, A. Sterling

BOWES, JULIAN. "The Sculpture of Sterling Calder," *The American Magazine of Art,* Vol. 16 (May, 1925), 229–37.

HOEBER, ARTHUR. "Calder—A 'Various' Sculptor," *The World's Work,* Vol. 20 (Sept., 1910), 1377–88.

POORE, HENRY RANKIN. "Sterling Calder, Sculptor," *The International Studio,* Vol. 67 (Apr., 1919), XXXVII–LI.

Cary, William de la Montagne

"William de la Montagne Cary," *The American Scene,* Vol. 1, No. 4 (Winter, 1958–59), 3, 8.

Chappell, William

WARD, NANCY. "Western Artist Bill Chappell," *The Western Horseman* (Sept., 1971), 46–47, 121–22.

Clark, James Lippitt

BARTON, D. R. "Adventures of an Artist-Explorer," *Natural History Magazine* (Jan., 1942), 50–52, 62–63.

CLARK, JAMES LIPPITT. *The Bronzes of James Lippitt Clark.* New York: The American Museum of Natural History (privately printed), 1949.

_____, *The Bronzes of James L. Clark.* New York: Hunting World, 1967. (Catalogue edited and enlarged from the original above.)

Dallin, Cyrus

DOWNES, WILLIAM HOWE. "Cyrus E. Dallin, Sculptor," *Brush and Pencil,* Vol. 5 (Oct., 1899), 1–18.

_____. "Mr. Dallin's Indian Sculptures," *Scribner's Magazine,* Vol. 57 (June, 1915), 779–82.

EWERS, JOHN C. "Cyrus E. Dallin, Master Sculptor of the Plains Indian," *Montana, the Magazine of Western History* (Winter, 1968), 35–43.

LONG, E. WALDO. "Dallin, Sculptor of Indians," *The World's Work,* Vol. 54 (Sept., 1927), 563–68.

MAY, M. STANNARD. "The Work of Cyrus E. Dallin," *New England Magazine,* Vol. 48 (Nov., 1912), 408–15.

POMEROY, E. WILBUR. "Cyrus E. Dallin and the North American Indian," *Arts and Decoration,* Vol. 4 (Feb., 1914), 152–53.

SEATON-SCHMIDT, ANNE. "An American Sculptor: Cyrus E. Dallin," *The International Studio,* Vol. 58 (Apr., 1916), 109–14.

Davidson, Jo

ANDERSON, EUALALIA. "Jo Davidson's Portrait Busts," *The American Magazine of Art,* Vol. 11 (Nov., 1920), 469–72.

DAVIDSON, JO. *Between Sittings.* New York: Dial Press, 1951.

DU BOIS, RENE. "Jo Davidson," *The International Studio,* Vol. 76 (Nov., 1922), 77–81.

GRIFFIN, HENRY F. "Jo Davidson, Sculptor," *The World's Work,* Vol. 22 (Aug., 1911), 14746–55.

De Grazia, Ted

REED, WILLIAM. *The Irreverent Angel.* San Diego: Frontier Heritage Press, 1971.

Deming, Edwin W.

DEMING, THERESE OSTERHELD. *Edwin Willard Deming.* New York: The Riverside Press, 1925.

"The Deming Bronzes," *The Spur,* Vol. 65, No. 4 (Apr., 1940), 19.

"Edwin W. Deming and the Return of the Red Man," *The International Studio,* Vol. 27 (1905), XV–XX.

FRINK, MAURICE. "Edwin W. Deming 'That Man, He Paint'," *The American Scene,* Vol. XII, No 3 (1971), entire issue.

TSCHUDY, HERBERT BOLIVER. "The Art of Edwin Willard Deming," *Brooklyn Museum Quarterly,* Vol. 10 (Jan., 1923), 32–36.

Eggenhofer, Nick

MUNO, RICHARD. "Nick Eggenhofer's 50 Years of Painting the West," *Persimmon Hill,* Vol. 1, No. 3 (Winter, 1971), 20–27.

Elwell, R. Farrington

MARK, FREDERICK A. "Last of the Old West Artists, R. Farrington Elwell," *Montana, the Magazine of Western History,* Vol. VII, No. 1 (Jan., 1957), 58–63.

Fairbanks, Avard T.

"Avard Fairbanks, Sculptor and Teacher," *Town and Country Review,* Vol. 5 (July, 1934), 26–29.

Farnham, Sally James

WOOLCOTT, ALEXANDER. "Sally Farnham's Art," *The Delineator,* Vol. 98, No. 4 (May, 1921), 16.

Fraser, James Earle

BENNETT, HELEN CHRISTINE. "James Earle Fraser, Sculptor," *Arts and Decoration,* Vol. 1 (July, 1911), 375–76.

BUSH, MARTIN. *James Earle Fraser, American Sculptor: A Retrospective Exhibition of Bronzes from Works of 1913 to 1953.* New York: Kennedy Galleries, Inc., 1969.

"James E. Fraser's Sculptures in Bronze," *The Metal Arts,* Vol. 2, (Aug., 1929), 365–68, 382.

"James Earle Fraser," *Pan American Union Bulletin,* Vol. 46 (May, 1918), 648–55.

KRAKEL, DEAN. *End of the Trail, Odyssey of a Statue.* Norman, Okla.: University of Oklahoma Press, 1973.

SAINT-GAUDENS, HOMER. "James Earle Fraser," *The Critic,* Vol. 47 (Nov., 1905), 425.

"A Sculptor of People and Ideals: Illustrated with the Works of James Earle Fraser," *The Touchstone,* Vol. 7 (May, 1920), 87–93, 161.

SEACHREST, EFFIE. "James Earle Fraser," *The American Magazine of Art,* Vol. 8 (May, 1917), 276–78.

SEMPLE, ELIZABETH. "James Earle Fraser, Sculptor," *The Century Magazine,* Vol. 79 (Apr., 1910), 929–32.

Greeves, Richard V.

BLAIR, NEAL. "R. V. Greeves, Western Artist and Sculptor," *Wyoming Wildlife,* Vol. XXXIII, No. 2 (Dec., 1969), 5–7.

Harvey, Eli

LAMONT, JESSIE. "Impressions in the Studio of an Animal Sculptor," *The International Studio,* Vol. 51 (Nov., 1913), CVI–CVIII.

MCINTYRE, R. G. "Eli Harvey—Sculptor," *Arts and Decoration,* Vol. 3 (Dec., 1912), 58–59.

Hoffman, Malvina

BOUVÉ, PAULINE CARRINGTON. "The Two Foremost Women Sculptors in America: Anna Vaughan Hyatt and Malvina Hoffman," *Art and Archeology,* Vol. 26 (Sept., 1928), 74–82.

BURGESS, MILDRED. "A Sculptor Demonstrates the Unity of Man," *Independent Woman,* 18. From the vertical files of the New York Public Library (undated material).

CRESSON, MARGARET. "Malvina Hoffman, a Great Lady of Sculpture," *National Sculpture Review,* Vol. II, No. 2 (Summer, 1962), 16–17, 24.

HOFFMAN, MALVINA. *Heads and Tales.* New York: Charles Scribner's Sons, 1936.

_____. *Sculpture Inside and Out.* New York: W. W. Norton Co., 1939.

_____. *Yesterday is Tomorrow.* New York: Crown Publishers, Inc., 1965.

MOORE, MARIANNE. "Malvina Hoffman: 1887–1966," *National Sculpture Review,* Vol. 15, No. 3 (Fall, 1966), 7, 30.

Houser, Allan C.

CORCOS, CHRYSTAL. "The Sculpture of Allan Houser," *American Artist,* Vol. 32, No. 7 (Sept., 1968), 44–51, 70.

Huntington, Anna Hyatt

BOUVÉ, PAULINE CARRINGTON. "The Two Foremost Women Sculptors in America: Anna Vaughan Hyatt and Malvina Hoffman," *Art and Archeology,* Vol. 26 (Sept., 1928), 74–82.

LADD, ANNA COLEMAN. "Anna V. Hyatt—Animal Sculptor," *Art and Progress,* Vol. 4 (Nov., 1912), 773–76.

PARKES, KINETON. "An American Sculptress of Animals: Anna Hyatt Huntington," *Apollo,* Vol. 16 (Aug., 1932), 61–66.

PRICE, FREDERICK NEWLIN. "Anna Hyatt Huntington," *The International Studio,* Vol. 79 (Aug., 1924), 319–23.

Jackson, Harry

GETLEIN, FRANK. *Harry Jackson.* New York: Kennedy Galleries, Inc., 1969.

HURD, PETER. *Harry Jackson: Western Bronzes.* New York: Kennedy Galleries, Inc., 1965.

JACKSON, HARRY. *Lost Wax Bronze Casting.* Flagstaff, Ariz.: Northland Press, 1972.

Jennewein, C. Paul

CUNNINGHAM, JOHN J. (ed.). *C. Paul Jennewein.* ("The American Sculpture Series.") Athens, Ga.: University of Georgia Press, 1950.

Jonas, Louis Paul

JONES, H. D. "Louis Jonas—Sculptor and Taxidermist," *The Mentor,* Vol. 17, No. 4 (May, 1929), 29–32.

MERRITT, ZELLA JONAS. "The World of Louis Paul Jonas," *American Artist,* Vol. 31, No. 1 (Jan., 1967), 54–60.

Kemeys, Edward

GARLAND, HAMLIN. "Edward Kemeys, A Sculptor of Frontier Life and Wild Animals," *McClure's,* Vol. 5 (July, 1895), 120–131.

HAWTHORNE, JULIAN. "American Wild Animals in Art," *Century Magazine,* Vol. 28 (June, 1884), 213–19.

MECHLIN, LEILA. "Edward Kemeys: An Appreciation," *The International Studio,* Vol. 26 (July–Oct., 1905), X–XIV.

RICHMAN, MICHAEL. "Edward Kemeys (1843–1907): America's First Animal Sculptor," *Fine Art Source Material Newsletter,* Vol. 1, No. 5 (May, 1971), 87–136. (The newsletter is published by John Alan Walker, Panorama City, Calif.)

Leigh, William R.

GOOD, DONNIE D. "W. R. Leigh, The Artist's Studio Collection," *The American Scene,* Vol. IX, No. 4 (1968), entire issue.

HUNT, DAVID C. "W. R. Leigh, Portfolio of an American Artist," *The American*

Scene, Vol. VII, No. 1 (1966), entire issue.

KRAKEL, DEAN. "Mr. Leigh and His Studio," *Montana, the Magazine of Western History,* Vol. XVII, No. 3 (July, 1967), 40–59.

MacMonnies, Frederick

CORTISSOZ, ROYAL. "An American Sculptor," *The Studio,* Vol. 6 (Oct., 1895), 17–26.

GREER, H. H. "Frederick MacMonnies, Sculptor," *Brush and Pencil,* Vol. 10 (Apr., 1902), 1–15.

LOW, WILL H. "Frederick MacMonnies," *Scribner's Magazine,* Vol. 18 (November, 1895), 617–28.

MERTZER, C. H. "Frederick MacMonnies, Sculptor," *Cosmopolitan Magazine,* Vol. 53 (July, 1912), 207–10.

STROTHER, FRENCH. "Frederick Mac-Monnies, Sculptor," *World's Work,* Vol. 11 (Dec., 1905), 6965–81.

MacNeil, Hermon Atkins

BLOCK, ADOLPH. "Hermon A. MacNeil —Fifth President National Sculpture Society," *National Sculpture Review* (Winter, 1963–Spring 1964), 17–18, 28.

HOLDEN, JEAN STANSBURY. "The Sculpture of MacNeil," *World's Work,* Vol. 14, (Oct., 1907), 9403–19.

Manship, Paul

GALLATIN, A. E. *Paul Manship.* New York: John Lane Co., 1917.

MANSHIP, PAULINE. *Paul Manship.* New York: W. W. Norton & Co., 1947.

MURTHA, EDWIN. *Paul Manship.* New York: Macmillan Co., 1957.

ROGERS, CAMERON. "The Compleat Sculptor," *The New Yorker* (Sept. 1, 1928), 21–23.

Mestrovic, Ivan

CRESSON, MARGARET FRENCH. "Mestrovic . . . Titan Among Sculptors," *National Sculpture Review* (Spring, 1973), 20–22.

SCHMECKEBIER, LAWRENCE. *Mestrovic, Sculptor and Painter.* Syracuse, N. Y.: Syracuse University Press, 1959.

Mora, Joseph J. ("Jo")

"Jo Mora's 'Horsemen of the West,'" *Arizona Highways* (Sept., 1952), 16–25.

KIRK, C. N. "Jo Mora Rides On," *The Western Horseman* (Oct., 1948), 16–25.

Powell, Asa L. ("Ace")

ROGERS, SHERMAN E. "Montana's Ace Powell," *The Western Horseman* (Sept., 1972), 58–59, 96.

Powers, John Preston

HENDERSON, JOHN R. "The Indian and Buffalo Statue on the State Capitol Grounds," *Colorado Magazine* (Sept., 1936), 183–86.

Proctor, A. Phimister

BRUSH, EDWARD HALE. "An Animal Sculptor," *Arts and Decoration,* Vol. 1 (Aug., 1911), 392–94.

CORTISSOZ, ROYAL. "Some Wild Beasts Sculptured by A. Phimister Proctor," *Scribner's Magazine,* Vol. 48 (Nov., 1910), 637–40.

PALADIN, VIVIAN. "A Phimister Proctor: Master Sculptor of Horses,," *Montana, the Magazine of Western History,* Vol. 14, No. 1 (Jan., 1964), 10–24.

PEIXOTTO, ERNEST. "A Sculptor of the West," *Scribner's Magazine,* Vol. 68 (Sept., 1920), 266–77.

PROCTOR, HESTER ELIZABETH (ed.). *Alexander Phimister Proctor, Sculptor in Buckskin: An Autobiography.* Norman, Okla.: University of Oklahoma Press, 1971.

SMITH, BERTHA H. "The Wild Animal in Art," *The Outlook,* Vol. 81 (Sept. 23, 1905), 210–11.

WHITTEMORE, MARGARET. "Phimister Proctor's Statue of a Pioneer Mother," *The American Magazine of Art,* Vol. 19 (July, 1928), 376–78.

Putnam, Arthur

BERRY, ROSE V. S. "Arthur Putnam—California Sculptor," *The American Magazine of Art* (May, 1929), 276–82.

"Four San Francisco Sculptors, Part One," *Bulletin of the California Palace of the Legion of Honor,* New Series: Vol. 1, No. 1 (July–Aug. 1967), 1–6.

HEYNEMAN, JULIE HELEN. *Arthur Putnam, Sculptor.* San Francisco: Johnck & Seeger, 1932.

Remington, Frederic

BARNES, JAMES. "Frederic Remington—Sculptor," *Collier's* (Mar. 18, 1905), 21.

CARD, HELEN. *The Collector's Remington (Bronzes), The Story of Frederic Remington's Bronzes.* Woonsocket, R. I.: privately printed, 1946.

———. "Frederic Remington's Bronzes," *The American Scene,* Vol. IX, No. 4 (Fall, 1964), 48–53.

DAVIS, CHARLES BELMONT. "Remington, the Man and His Work," *Collier's* (Mar. 18, 1905), 15.

DYKES, JEFF C. "Frederic Remington—Western Historian," *The American Scene,* Vol. IV, No. 2 (Summer, 1901), 4–5.

EDGERTON, GILES. "Frederic Remington, Painter and Sculptor: A Pioneer in Distinctive American Art," *The Craftsman,* Vol. 15 (Mar., 1909), 658–70.

"Frederic Remington," *The American Scene,*

Vol. IV, No. 2 (Summer, 1961), 1–35.

"Frederic Remington, Storyteller on Canvas and in Bronze," *The American Scene,* Vol. 1, No. 1 (Spring, 1958), 3.

GREGG, RICHARD N. "The Art of Frederic Remington," *The Connoisseur,* Vol. 165 (Aug., 1967), 269–73.

McCRACKEN, HAROLD. *Frederic Remington: Artist of the Old West.* Philadelphia and New York: J. B. Lippincott Co., 1947.

———. *The Frederic Remington Book: A Picture History of the West.* Garden City, N. Y.: Doubleday & Co., 1966.

MAXWELL, PERRITON. "Frederic Remington," *Pearson's Magazine,* Vol. 18 (Oct., 1907), 394–407.

REMINGTON, FREDERIC. "Chasing a Major General," *Harper's Weekly,* Vol. XXXIV (Dec. 6, 1890), 946–47.

———. "A Few Words From Mr. Remington," *Collier's,* Vol. 34, No. 25 (Mar. 18, 1905), 20.

ROOSEVELT, THEODORE. "An Appreciation of the Art of Frederic Remington," *Pearson's Magazine,* Vol. 18 (Oct., 1907), 392–93.

RUSH, N. ORWIN. "Remington the Letter Writer," *The American Scene,* Vol. V, No. 4 (1964), 28–29, 36–37.

THOMAS, AUGUSTUS. "Recollections of Frederic Remington," *Century Magazine,* Vol. 86 (July, 1913), 354–61.

———. *The Print of My Remembrance.* New York: Charles Scribner's Sons, 1922.

WEAR, BRUCE. "The Art of Frederic Remington," *The American Scene,* Vol. IV, No. 2 (Summer, 1961), 18.

———. "The Making of a Bronze," *The American Scene,* Vol. IV, No. 2 (Summer, 1961), 19.

———. *The Bronze World of Frederic Remington.* Tulsa, Okla.: Gaylord, Ltd., 1966.

WISTER, OWEN. "Remington, An Appreciation," *Collier's,* Vol. 34, No. 25 (Mar. 18, 1905), 15.

Rossi, Paul

ROSSI, PAUL. "The Vaquero," *The American Scene,* Vol. XI, No. 4 (1971), entire issue.

Rungius, Carl

CROMELIN, LILIAN. "Artists of the Outdoors—Carl Rungius—Huntsman—Painter," *American Forests* (June, 1929), 338–41.

SCHALDACH, WILLIAM J. *Carl Rungius, Big Game Painter, Fifty Years.* West Hartford, Vt.: The Countryman Press, 1945.

Russell, Charles M.

ADAMS, RAMON F. "Legacy of C. M. Russell," *The American Scene,* Vol. V, No. 4

(Summer, 1960), 39–43.

———, and BRITZMAN, HOMER E. *Charles M. Russell, the Cowboy Artist.* Pasadena: Trail End Publishing Co., 1948. (Biographical checklist by Carl Yost.)

BRITZMAN, HOMER E. "The West in Bronze," *The Westerner's Brand Book,* Los Angeles: Westerner's, 1945, 89–136.

DOBIE, J. FRANK. "The Art of Charles Russell," *The American Scene,* Vol. III, No. 2 (Summer, 1960), 3.

ELLSBERG, WILLIAM. "Charles, Thou Art a Rare Blade," *The American West,* Part One, Vol. VI, No. 2 (Mar. 1969), 4–9; Part Two, Vol. VI, No. 3 (May, 1969) 40–43, 62.

FOREST, JAMES T. "The Philosophy of Charles Russell," *The American Scene,* Vol. III, No. 2 (Summer, 1960), 27.

HOEBER, ARTHUR. "The Painter of the West That Has Passed," *World's Work,* Vol. 22, No. 3 (July, 1911), 14626–35.

McCRACKEN, HAROLD. *The Charles M. Russell Book.* Garden City, N. Y.: Doubleday & Co., 1957.

MOSIER, V. M. "The Beginning: A Collection of the Art of Charles M. Russell," *Persimmon Hill,* Vol. 1, No. 1 (Summer, 1970), 15–23.

RENNER, FREDERIC G. "Rangeland Rembrandt: The Incomparable Charles Marion Russell," *Montana, the Magazine of Western History,* Vol. 7, No. 4 (Autumn, 1957), 15–28.

———. *Charles M. Russell: Paintings, Drawings and Sculpture in the Amon G. Carter Collection.* Austin and London: University of Texas Press, 1966.

RUSSELL, CHARLES M. *Good Medicine: The Illustrated Letters of Charles M. Russell.* Garden City, N. Y.: Doubleday & Co., 1929 (new ed., 1966). Introduction by Will Rogers; Biographical Note by Nancy C. Russell.

"The Works of Charles Russell in the Gilcrease Institute of American History," *American Scene,* Vol. III, No. 2 (Summer, 1960), 1–27.

Saville, Bruce

CASSIDY, INA SIZER. "Art and Artists of New Mexico," *New Mexico Magazine* (Oct., 1937).

Schreyvogel, Charles

CAROTHERS, ARCHIE D. "The Charles Schreyvogel Memorial Studio Collection," *Persimmon Hill,* Vol. 1, No. 2 (Fall, 1970), 14–22.

HORAN, JAMES D. *The Life and Art of Charles Schreyvogel.* New York: Crown Publishers, 1969. Introduction by Ruth Schreyvogel Carothers.

Schultz, Hart Merriam ("Lone Wolf")

DYCK, PAUL. "Lone Wolf Returns to That Long-Ago Time," *Montana, the Magazine of Western History,* Vol. XXII, No. 1 (Winter, 1972), 19–41.

SCHULTZ, JAMES WILLARD. *Blackfeet and Buffalo; Memories of Life Among the Indians.* Norman, Okla.: University of Oklahoma Press, 1962.

Shafer, L.E. ("Gus")

ALTHOFF, SHIRLEY. "The Old West Rides Again," *St. Louis Globe—Democrat Sunday Magazine* (Dec. 12, 1971), 20–22.

EDGE, L. L. "Gus Shafer and Yesterday's West," *K. C., The Kansas City Magazine* (Jan., 1972), 345. (Published by The Chamber of Commerce of Greater Kansas City.)

LAPHAM, JIM. "Gus Shafer Molds a Career in Retirement," *Kansas City Star Sunday Magazine* (Apr., 18, 1971), 34–37.

Shrady, Henry Merwin

GARRETT, CHARLES HILL. "The New American Sculptor," *Munsey's Magazine,* Vol. 29 (July, 1903), 545–52.

Speed, Grant

SPEED, GRANT. "Hooked on Cowboying," *The Western Horseman* (Jan., 1970), 60–61, 98–101.

Stone, Willard

BOATMAN, JOANN. *Willard Stone, Wood Sculptor.* Muskogee, Okla.: Five Civilized Tribes Museum.

Tilden, Douglas

TOMPKINS, ELIZABETH K. "A California Sculptor," *Munsey's Magazine,* Vol. 19 (Sept., 1898), 914–16.

Troubetzkoy, Paul

JARVIS, WILLIAM. "Paul Troubetzkoy, Sculptor," *Scribner's Magazine,* Vol. 31 (Feb., 1902), 181–88.

JEFFERIS, JESSIE WILLIS. "Paul and Pierre Troubetzkoy," *The International Studio,* Vol. 68 (July, 1919), x–xv.

SEGARD, ACHILLE. "The Sculpture of Prince Paul Troubetzkoy," *The Studio,* Vol. 48 (Jan., 1910), 266–74.

Ward, John Quincy Adams

ADAMS, ADELINE. *John Quincy Adams Ward: An Appreciation.* New York: The National Sculpture Society, 1912.

SHELDON, G. W. "J. Q. A. Ward, the Sculptor," *Harper's Monthly,* Vol. 57 (June, 1878), 62–68.

STURGIS, RUSSELL. "The Work of J. Q. A. Ward," *Scribner's Magazine,* Vol. 32 (Oct., 1902), 385–92.

WALTON, WILLIAM. "The Work of John Quincy Adams Ward, 1830–1910," *The International Studio,* Vol. 40 (June, 1910), LXXXI–LXXXVIII.

Warner, Olin Levi

BROWNELL, W. C. "The Sculpture of Olin Warner," *Scribner's Magazine,* Vol. 20 (Oct., 1898), 429–41.

ECKFORD, HENRY. "Olin Warner, Sculptor," *The Century Magazine,* Vol. 37 (Jan., 1889), 392–401.

HITCHCOCK, RIPLEY. "Notes on an American Sculptor," *Art Review,* Vol. 1 (Mar., 1887), 1–5.

WOOD, C.E.S. "Famous Indians. Portraits of Some Indian Chiefs," *The Century Magazine,* Vol. 46 (July, 1893), 436–45.

Weinman, Adolph A.

"Adolph A. Weinman's Sculptures in Bronze," *The Metal Arts,* Vol. 2 (Sept., 1929), 422–27, 436.

NOE, SYDNEY P. *The Medallic Work of A. A. Weinman.* New York: The American Numismatic Society, 1921 (Numismatic Notes and Monographs #7).

"The Sculptor Weinman and a Few Examples of His Work," *The Century Magazine,* Vol. 81 (Mar., 1911), 705–07.

WEINMAN, ROBERT ALEXANDER. "Adolph A. Weinman, 1870–1952, Eleventh President, National Sculpture Society," *National Sculpture Review,* Vol. 14, No. 4 (Winter, 1965–66), 22, 28.

Whitney, Gertrude Vanderbilt

DU BOIS, GUY PÈNE. "Mrs. Whitney's Journey in Art," *The International Studio,* Vol. 76 (Jan., 1923), 351–54.

"Gertrude V. Whitney," *The Art Digest,* Vol. 16 (May 1, 1942), 6.

Wieghorst, Olaf

REED, WILLIAM. *Olaf Wieghorst.* Flagstaff, Ariz.: Northland Press, 1969.

———. "The Southwest of Olaf Wieghorst," *Arizona Highways* (Mar., 1971), 12–44.

Young, Mahonri MacIntosh

CARSON, CHRISTINE. "Brigham Young University Acquires Works of Famed Sculptor," *Church News* (Feb. 23, 1965), published in Salt Lake City.

DOUGHERTY, PAUL. "Rolling His Own— A New Bronze by Mahonri Young," *Vanity Fair,* Vol. 24, No. 3 (May, 1925), 59.

DU BOIS, GUY PÈNE. "Mahonri Young— Sculptor," *Arts and Decoration,* Vol. 8 (Feb., 1918), 169, 188.

LEWINE, J. LESTER. "Bronzes of Mahonri Young," *The International Studio,* Vol. 47,

Supplement 55 (Oct, 1912), LV–LVIII.

"Mahonri Young's Sculpture Preserves His Mormon Past," *Life,* Vol. 10, No. 6 (Feb. 17, 1941), 76, 79.

WILSON, JAMES PATTERSON. "Art and Artists of the Golden West: A Sculptor and a Painter of Utah," *Fine Arts Journal,* Vol. 24 (Feb., 1911), 96–99.

Young, Mahonri Sharp. "Mahonri M. Young," *Directory of Exhibits,* Franklin S. Harris Fine Arts Center, Brigham Young University, Provo, Utah. Dedicatory Exhibit. 1965.

LIST OF ILLUSTRATIONS

(*indicates color plate)

Signal. 1902

*131. Frederic Remington. *The Cheyenne.* 1901

132. Frederic Remington. *Coming Through the Rye* (drawing). 1888

*133. Frederic Remington. *Coming Through the Rye (Off the Range).* 1902

134. Frederic Remington. *Coming Through the Rye* (detail of plate 133)

135. Frederic Remington. *Coming Through the Rye* (detail of plate 133)

136. Frederic Remington. *Coming Through the Rye* (detail of plate 133)

137. Frederic Remington. *Coming Through the Rye* (detail of plate 133)

138. Frederic Remington. *Coming Through the Rye* (detail of plate 129)

139. Frederic Remington. *The Sergeant.* 1904

*140. Frederic Remington. *The Savage.* 1908

*141. Frederic Remington. *The Buffalo Horse.* 1907

142. Frederic Remington. *Episode of a Buffalo Hunt.* 1908

143. Charles M. Russell. *On Neenah (Self-Portrait).* 1925

144. Charles M. Russell. *I'm Scarder of Him than I am of the Injuns.* 1926

*145. Charles M. Russell. *Smoking Up.* Modeled 1903.

146. Charles M. Russell. *Scalp Dance.* Modeled c. 1904.

147. Charles M. Russell. *Sleeping Thunder.* Modeled c. 1902

148. Frederic Remington. *The Bronco Buster.* 1895

149. Charles M. Russell. *The Bronc Twister.* Modeled c. 1920

*150. Charles M. Russell. *Counting Coup.* Modeled 1904

*151. Charles M. Russell. *The Buffalo Hunt (The Buffalo Runner).* Modeled c. 1904

152. Charles M. Russell. *The Buffalo Hunt #39.* 1919

153. Charles M. Russell. *Where the Best Riders Quit.* Modeled c. 1920

154. Charles M. Russell. *Painting the Town.* Modeled c. 1920

155. Charles M. Russell. *Peace.* Modeled 1889

156. Charles M. Russell. *Piegan Girl.* Modeled 1902

157. Charles M. Russell. *Watcher of the Plains.* Modeled c. 1902

158. Charles M. Russell. *The Cryer.* Cast 1941

159. Charles M. Russell. *The Enemy's Tracks.* Modeled c. 1920

160. Charles M. Russell. *Blackfoot War Chief.* Modeled c. 1900

161. Charles M. Russell. *Indian on Horseback.* 1907

162. Charles M. Russell. *Secrets of the Night.* Modeled c. 1926

163. Charles M. Russell. *Prairie Pals.*

Modeled c. 1917

164. Charles M. Russell. *The Range Father.* Modeled c. 1926

165. Charles M. Russell. *Oh! Mother, What Is It?* Modeled c. 1914

166. Charles M. Russell. *Mountain Mother.* Modeled c. 1924

167. Charles M. Russell. *The Bluffers.* Modeled c. 1924

168. Charles M. Russell. *Lone Buffalo.* Modeled c. 1900

169. Charles M. Russell. *The Buffalo Family.* Modeled c. 1925

170. Charles M. Russell. *A Monarch of the Plains.* Modeled 1926

171. Charles M. Russell. *Fallen Monarch.* Modeled c. 1909

172. Charles M. Russell. *To Noses That Read, A Smell That Spells Man.* Modeled c. 1920

173. Charles M. Russell. *The Last Laugh.* Modeled c. 1916

174. Charles M. Russell. *Night Herder (Self-Portrait).* Modeled 1925

175. Charles M. Russell. *The Spirit of Winter.* Modeled c. 1926

176. Charles M. Russell. *The Spirit of Winter* (detail of plate 175)

177. Charles M. Russell. *The Spirit of Winter* (detail of plate 175)

*178. James Earle Fraser. *The End of the Trail.* Cast 1918

179. James Earle Fraser. *The End of the Trail* (drawing)

180. James Earle Fraser. *The End of the Trail* (drawing)

181. James Earle Fraser. *The End of the Trail* (early model). c. 1894

182. James Earle Fraser. *The End of the Trail.* Modeled c. 1894, cast 1971

183. James Earle Fraser. *The End of the Trail* (detail of plate 181)

184. James Earle Fraser. *The End of the Trail* (detail of plate 181)

185. James Earle Fraser. *The End of the Trail* (original model). 1915

186. James Earle Fraser. *Cheyenne Chief.* 1904

187. James Earle Fraser. *Theodore Roosevelt as a Rough Rider.* Modeled 1910, cast 1920

188. Frederic Remington. *The Bronco Buster* (detail of plate 148)

189. James Earle Fraser. *Indian Head: White Eagle.* 1919

190. James Earle Fraser. *Indian Head: Two Moons.* c. 1919

191. James Earle Fraser. *Wind Swept (In the Wind).* c. 1916

192. James Earle Fraser. *Storm-Driven.* c. 1918

193. James Earle Fraser. *Buffalo Prayer.* Modeled c. 1917, cast c. 1931

194. James Earle Fraser. *Theodore Roosevelt with Gunbearers.* c. 1939

195. James Earle Fraser. *Buffalo Herd.* 1950

196. Adolph A. Weinman. *Destiny of the Red Man* (side view). Modeled 1903, cast 1947

197. Adolph A. Weinman. *Destiny of the Red Man* (side view)

198. Adolph A. Weinman. *Destiny of the Red Man* (rear view)

199. Adolph A. Weinman. *Destiny of the Red Man* (front view)

200. Adolph A. Weinman. *Womboli.* Modeled 1902

*201. Adolph A. Weinman. *Chief Blackbird.* Modeled 1903, cast 1907

202. Adolph A. Weinman. *Chief Flatiron.* Modeled c. 1903

203. Adolph A. Weinman. *Bison.* c. 1922

204. Charles Schreyvogel. *The Last Drop* (painting). Copyright 1900

*205. Charles Schreyvogel. *The Last Drop.* Copyright 1900, cast 1903

206. Charles Schreyvogel. *The Last Drop* (detail of plate 205)

207. Charles Schreyvogel. *White Eagle.* c. 1899

208. R. Farrington Elwell. *Indian in a Canoe.* Cast 1930s

209. Carl Rungius. *Bighorn Sheep.* c. 1915

210. Carl Rungius. *Bull Moose.* 1905

211. William R. Leigh. *Buffalo.* 1911

212. Frank Hoffman. *Lying Down Buffalo.* Modeled 1920, cast c. 1971

213. *An American.* c. 1887 (poster)

214. Alfred Barye. *Wakuta-Peau-Rouge de la Buffalo Bill's Cⁱ.* c. 1889

215. Rosa Bonheur. *A Bull Resting.* c. 1895

216. Isidore Bonheur. *Walking Bear.* c. 1880

217. Isidore Bonheur. *Indian Scout and Buffalo.* c. 1880s

218. Ivan Mestrovic. *Bowman.* 1929

219. Ivan Mestrovic. *Spearman.* 1929

220. Paul Troubetzkoy. *The Indian Scout.* 1893

221. Paul Troubetzkoy. *Cattle Roping (The Wrangler).* 1927

*222. Carl Kauba. *Chief Wolfrobe*

*223. Carl Kauba. *Indian Chief*

224. Carl Kauba. *A Friend in Need*

225. Carl Kauba. *How-Kola*

226. Carl Kauba. *The War Chant.* 1920s

227. Carl Kauba. *Indian Attack*

228. Hermon A. MacNeil. *Navaho Orator.* 1905

229. A. Phimister Proctor. *Jackson Sundown.* 1916

230. Charles M. Russell. *Jim Bridger.* Modeled c. 1925

231. Charles M. Russell. *Composition Study—Jim Bridger.* c. 1918–22

232. Hans Reiss. *Falling-Over-the-Banks—Blackfoot Indian.* c. 1925–30

233. Hans Reiss. *Louis Straw Hat—Crow Indian.* c. 1925–30

234. Hans Reiss. *106-Year-Old Indian.* c.

1925–30

235. Emry Kopta. *Saaci—Antelope Chief.* 1930

236. George Winslow Blodgett. *Head of a Tewa Indian (Portrait of Albert Lujan of the Taos Pueblo).* 1930

237. George Winslow Blodgett. *Ascension Chama—Santo Domingo Pueblo.* c. 1930s

238. George Winslow Blodgett. *Marcial Quintana—Cochiti Pueblo.* c. 1930s

239. George Winslow Blodgett. *Rose Chaves—Navaho Pueblo.* c. 1930s

240. Bruce W. Saville. *Koshare.* c. 1937

241. Bruce W. Saville. *Snake Dancers.* c. 1937

242. Bruce W. Saville. *Buffalo Dancer.* c. 1937

243. Bruce W. Saville. *Rainbow Dancer.* c. 1937

244. Bruce W. Saville. *Eagle Dancer.* c. 1937

245. Bruce W. Saville. *Deer Dancers.* c. 1937

246. Malvina Hoffman. *Blackfoot Man.* c. 1930

247. Malvina Hoffman. *Sign Talk—Blackfoot Man.* 1930

248. Malvina Hoffman. *Apache—Jicarilla.* 1934

249. Malvina Hoffman. *Sioux Man.* 1930

250. Malvina Hoffman. *Eskimo Man.* 1930

251. Malvina Hoffman. *Eskimo Woman.* 1930

252. Jo Davidson. *Will Rogers.* 1938

253. Electra Waggoner Biggs. *Riding Into the Sunset (Will Rogers on "Soapsuds").* Dedicated 1950

254. James Wehn. *Chief Seattle* (detail). c. 1912

255. Madeleine Park. *Osceola—Seminole.* Dedicated 1958

256. Leonard McMurry. *Sacajawea—Shoshoni.* Dedicated 1959

257. Madeleine Park. *Charles Curtis—Kaw.* Dedicated 1959

258. Kenneth F. Campbell. *Joseph—Nez-Percé Tribe.* Dedicated 1957

259. Leonard McMurry. *Sequoyah—Cherokee.* Dedicated 1962

*260. Henry Merwin Shrady. *Elk Buffalo (Monarch of the Plains).* 1901

261. Henry Merwin Shrady. *Bull Moose.* 1900

262. Henry Merwin Shrady. *The Empty Saddle.* Copyright 1900

263. Arthur Putnam. *Bear Scratching Hind Paw.* Cast 1921

264. Arthur Putnam. *Coyote Frightened.* Cast 1921

265. Arthur Putnam. *Bear and Ox Skull.* Cast 1921

266. Arthur Putnam. *Buffalo, Indian, and Horse.* Cast 1921

267. Anna Hyatt Huntington. *Winter.*

c. 1902

268. Anna Hyatt Huntington. *Jaguar (Panther)*. Modeled 1906, cast 1926

269. Anna Hyatt Huntington. *Reaching Jaguar (Reaching Panther)*. Modeled 1906, cast 1926

270. Anna Hyatt Huntington. *Brown Bears*. 1935

*271. Anna Hyatt Huntington. *Wolves*. 1960

272. Anna Hyatt Huntington. *Goats Butting*. 1904

273. Anna Hyatt Huntington. *Rolling Horse*

274. Anna Hyatt Huntington. *Rolling Bear*. Before 1914

275. Anna Hyatt Huntington. *Reaching Jaguar (Reaching Panther)*. 1906

276. Charles R. Knight. *Grizzlies*. 1924

277. James Lippitt Clark. *Wild Horses*. c. 1930

278. Louis Paul Jonas. *Chief Eagle Head*

279. Louis Paul Jonas. *Grizzly's Last Stand*. 1930

280. Theodore Baur. *The Buffalo Hunt*. c. 1875

281. Theodore Baur. *Buffalo* (silver paperweight). c. 1882

282. Theodore Baur. *Chief Crazy Horse*. 1885

283. Charles H. Humphriss. *Indian's Appeal to Manitou*. 1906

284. Charles H. Humphriss. *Appeal to the Great Spirit*. 1900

285. Charles H. Humphriss. *Indian Chief*

286. Charles H. Humphriss. *Cowboy on a Bucking Horse*. c. 1910

287. Charles H. Humphriss. *Dance Leader*

288. Charles C. Rumsey. *Dying Indian* (first sketch dated 1901)

289. Joseph J. ("Jo") Mora. *Cowboy on Horseback*. 1915

290. Joseph J. ("Jo") Mora. *Bronco Buster*. 1930

291. Joseph J. ("Jo") Mora. *The Indian Squaw*. 1928

292. Joseph J. ("Jo") Mora. *The Indian Chief*. 1928

293. Joseph J. ("Jo") Mora. *The Cowboy*. 1929

294. Joseph J. ("Jo") Mora. *The Outlaw (Belle Starr)*. 1929

295. J. Clinton Shepherd. *The Herder*. 1922

296. J. Clinton Shepherd. *Maverick*. 1923

297. J. Clinton Shepherd. *Pony Tracks*. 1929

298. Charles A. Beil. *Weasel Feather—Seven Piegans*. Modeled 1926, cast 1968

299. Charles A. Beil. *Calf Tail—Seven Piegans*. Modeled 1926, cast 1968

300. Charles A. Beil. *Eagle Calf—Seven Piegans*. Modeled 1926, cast 1968

301. Charles A. Beil. *Medicine Bassribs—Seven Piegans*. Modeled 1926, cast

1968

302. Charles A. Beil. *Turtle—Seven Piegans*. Modeled 1926, cast 1968

303. Charles A. Beil. *Two Guns White Calf—Seven Piegans*. Modeled 1926, cast 1968

304. Charles A. Beil. *Last Stone—Seven Piegans*. Modeled 1926, cast 1968

305. Charles A. Beil. *Saddle Horse Grazing*. 1948

306. Charles A. Beil. *Pack Horse*. 1948

307. Lawrence Barrett. *The Gunslinger*. 1967

308. Lawrence Barrett. *Off Balance*. 1966

309. Sally James Farnham. *Payday Going to Town*. 1931

310. Sally James Farnham. *Horse and Rider*. c. 1900

311. Sally James Farnham. *Scratchin' 'Im*

312. Sally James Farnham. *The Sun Fisher*. c. 1920

313. Sally James Farnham. *Will Rogers*. Modeled 1938

314. Gertrude Vanderbilt Whitney. *Buffalo Bill Cody—The Scout*. 1923

315. Madeleine Park. *Brahma Bull*

316. Mahonri MacIntosh Young. *This is the Place Monument* (detail of plate 318)

317. Mahonri MacIntosh Young. *This is the Place Monument* (detail of plate 318)

318. Mahonri MacIntosh Young. *This is the Place Monument*. 1947

319. Mahonri MacIntosh Young. *Rolling His Own*. c. 1928

320. Mahonri MacIntosh Young. *Rolling His Own* (detail of plate 319)

321. Mahonri MacIntosh Young. *Pony Express Rider*. c. 1932

322. Mahonri MacIntosh Young. *Lunch in the Desert*. c. 1930

323. Mahonri MacIntosh Young. *Frontiersman and Indian Scout*. c. 1932

324. Mahonri MacIntosh Young. *Laborer*. c. 1907

*325. Bryant Baker. *Pioneer Woman*. c. 1927

326. Bryant Baker. *Pioneer Man*. 1928

327. F. Lynn Jenkins. *Pioneer Woman*. 1927

328. Hermon A. MacNeil. *Pioneer Woman*. 1926

329. Arthur Lee. *Pioneer Woman*. c. 1927

330. Mario J. Korbel. *Pioneer Woman*. 1927

331. Wheeler Williams. *Pioneer Woman*. 1926

332. Maurice Sterne. *Pioneer Woman*. 1927

333. Mahonri MacIntosh Young. *Pioneer Woman*. 1927

334. James Earle Fraser. *Pioneer Woman*. 1927

335. Jo Davidson. *Pioneer Woman*. 1927

336. A. Sterling Calder. *Pioneer Woman*.

1927

337. John Gregory. *Pioneer Woman*. 1926

338. Paul Manship. *Indian Hunter with Dog* (right view). 1926

339. Paul Manship. *Indian Hunter with Dog* (left view)

*340. Paul Manship. *Indian and Pronghorn Antelope*. 1914

341. Paul Manship. *Appeal to the Great Spirit*. 1947

342. Paul Manship. *Lesson in Archery*. 1947

343. Paul Manship. *Indian Hunter*. 1947

344. Paul Manship. *Colonial Settlers*. 1962

345. Paul Manship. *Western Pioneers*. 1962

346. C. Paul Jennewein. *Indian and Eagle*. 1929

347. A. Sterling Calder. *Indian Brave*. c. 1910

348. Lawrence Tenney Stevens. *Brahma Bull Riding—Rodeo Series*. 1962

349. Lawrence Tenney Stevens. *Barrel Racer—Rodeo Series*. 1969

350. Lawrence Tenney Stevens. *Trick Riding—Rodeo Series*. 1968

351. Lawrence Tenney Stevens. *The Cutting Horse—Rodeo Series*. 1960

352. Lawrence Tenney Stevens. *Bareback Rider—Rodeo Series*. 1964

353. Lawrence Tenney Stevens. *Saddle Bronc Riding—Rodeo Series*. 1970

354. Lawrence Tenney Stevens. *The Bull-Dogger—Rodeo Series*. 1964

355. Lawrence Tenney Stevens. *Team Tying—Rodeo Series*. 1963

356. Lawrence Tenney Stevens. *Calf Roping—Rodeo Series*. 1965

357. Lawrence Tenney Stevens. *Saddle Bronc Riding—Rodeo Series* (detail of plate 353)

358. Allie Victoria Tennant. *Archer—Tejas Warrior*. 1936

359. Clemente Spampinato. *Forced Landing* (right view). 1972

360. Clemente Spampinato. *Forced Landing* (front view)

361. Clemente Spampinato. *Saddle Bronc Rider*. 1953

362. Bernard Frazier. *The Hunt*. Cast 1971

363. Edwin W. Deming. *Bears in Combat*. 1916

364. Paul Troubetzkoy. *Two Cowboys*. 1916

365. Solon H. Borglum. *Pioneer in a Storm*. Modeled c. 1904

366. Arthur Putnam. *Indian and Puma*. Cast 1921

367. Wolf Pogzeba. *Brahma Bull Rider*. 1965

368. Wolf Pogzeba. *Bronc Rider*. 1965

*369. Wolf Pogzeba. *Confronted Elks*. 1967

370. Wolf Pogzeba. *Riderless Horse (Lone Horse)*. 1963

371. George Carlson. *Zuni Medicine Man*. 1965

372. George Carlson. *Navaho Mountain Chant*. 1970

*373. George Carlson. *The Last Breath*. 1968

374. Ted De Grazia. *Yaqui Deer Dancer*. c. 1960

375. Ted De Grazia. *Navaho Family*. c. 1960

376. Hart Merriam Schultz ("Lone Wolf"). *Buffalo Hunt*. 1939

377. Hart Merriam Schultz ("Lone Wolf"). *Camouflage*. Cast 1929

378. Hart Merriam Schultz ("Lone Wolf"). *Red Warriors*. Modeled 1930, cast 1967

379. Hart Merriam Schultz ("Lone Wolf"). *Riding High*. Modeled 1930, cast 1967

380. Allan C. Houser. *Morning Song*. 1971

381. Allan C. Houser. *Herding Goats*. 1971

382. Allan C. Houser. *Indian and Hawk* (right view). 1971

383. Allan C. Houser. *Indian and Hawk* (front view)

384. Allan C. Houser. *Buffalo Dancer*. c. 1969

385. Roland N. Whitehorse. *Apache Fire Dancers*. 1969

386. Jerome Tiger. *The Stickball Player* (model). 1967

387. Jerome Tiger. *The Stickball Game*. 1966

388. Jerome Tiger. *The Stickball Player*. 1967

389. Jerome Tiger. *Resting*. 1967

390. Johnny Tiger, Jr. *Beyond*. 1970

391. Johnny Tiger, Sr. *The Buffalo* (model). 1972

392. John L. Clarke. *Porcupine Quill*. 1969

393. Gary Schildt. *Old Man Winter*. c. 1966

394. Willard Stone. *Something in Common*. 1969

395. Willard Stone. *Tah'chee*. 1969

396. Saint Clair Homer II. *A Sioux Called Hump*. 1958

397. Saint Clair Homer II. *The Only Shield on the Staked Plain*. 1964

*398. Saint Clair Homer II. *The Star Shooter*. 1970

399. Michael Naranho. *Deer Spirit*. 1970

400. Harry Jackson. *The Range Burial* (painting). 1963

401. Harry Jackson. *The Range Burial*. 1958

402. Harry Jackson. *Trail Boss*. 1958

403. Harry Jackson. *Sittin' Purty*. 1959

404. Harry Jackson. *Stampede* (painting). 1965

405. Harry Jackson. *Stampede*. 1958–59

406. Harry Jackson. *Stampede* (detail of plate 405)

407. Harry Jackson. *The Steer Roper*. 1959

408. Harry Jackson. *The Pony Express*. 1967

409. George Phippen. *Brahma Bull*. Modeled 1929, cast 1959

410. George Phippen. *The Rock Hopper*. Modeled 1956, cast 1957

411. George Phippen. *Cowboy in a Storm*. 1966

412. George Phippen. *The Cowboy's Devil*. 1966

413. Olaf Wieghorst. *Indian by the Campfire*. c. 1964

414. Olaf Wieghorst. *Restin' and Reminiscin'*. c. 1965

415. Joe Beeler. *The Apache*. 1966

416. Joe Beeler. *The Cheyenne*. 1971

417. Joe Beeler. *The Sioux*. 1967

418. Joe Beeler. *The Navaho*. 1964

*419. Joe Beeler. *Thanks for the Rain*. 1970

420. Joe Beeler. *Thanks for the Rain* (detail of plate 419)

421. William Moyers. *The Price of a Herd*. 1972

*422. William Moyers. *Range War*. 1968

423. William Moyers. *Winter* (detail of plate 424)

424. William Moyers. *Winter* (right view). 1970

425. William Moyers. *Winter* (left view)

426. Bob Scriver. *An Honest Try* (detail of plate 428)

427. Bob Scriver. *An Honest Try* (detail of plate 428)

*428. Bob Scriver. *An Honest Try*. 1968

429. Bob Scriver. *Pay Window*. 1968

430. Bob Scriver. *Mountain Sentinels*. 1968

431. Grant Speed. *Ridin' Point*. 1970

432. Grant Speed. *Earnin' His Dollar a Day*. 1971

433. Grant Speed. *Stampedin' Over a Cutbank*. 1972

434. John D. Free. *Cow Boss*. 1966

435. Frank Polk. *Bad Time for the Clown*. 1971

436. John D. Free. *Two Party Line*. 1968

437. George Marks. *The Get-A-Way*. 1972

438. Jim Hamilton. *Drummin'*. 1968

439. Jim Hamilton. *The Four Horsemen*. 1971

440. Hughes Curtis. *Rim Rock*. 1968

441. Hughes Curtis. *Cowboy Serenade*. 1948

442. John Kittleson. *My Meat*. 1970

443. Jack N. Swanson. *Her First Look*. 1969

444. William Chappell. *Apache Warrior*. 1968

445. Melvin C. Warren. *Run for the Rio Grande*. 1967

446. Melvin C. Warren. *The Drifter*. 1967

447. Melvin C. Warren. *Viva Zapata*. 1970

448. Curtis Wingate. *The Bronc Buster*. 1970

449. Wayne C. Hunt. *Tom Jeffords*. Cast 1969

450. L. E. ("Gus") Shafer. *Top Hand*. 1967

451. L. E. ("Gus") Shafer. *Country Doctor*. 1971

452. Nick Eggenhofer. *Travois*. 1967

453. Nick Eggenhofer. *Dog Soldier*. 1967

454. John La Prade. *Desert Sport*. 1969

455. Gordon Snidow. *Springtime*. 1967

456. Frederic Remington. *The Wounded Bunkie*. 1896

*457. Frederic Remington. *The Wicked Pony (The Fallen Rider)*. 1898

*458. Charles M. Russell. *The Medicine Man*. Modeled c. 1920

459. Charles M. Russell. *Meat for Wild Men*. Modeled c. 1920, cast 1924

460. Earle Heikka. *Montana Wolf*. Cast 1961

461. Earle Heikka. *Piegan Scout*. Modeled 1931

462. Charles M. Russell. *Best of the String*. Cast 1968

463. Earle Heikka. *Saddle Horse*. Modeled 1930s

464. Earle Heikka. *Road Agent*. Modeled 1930s, cast 1960s

465. Earle Heikka. *Three-Figure Pack Train*. Modeled 1930s

466. Earle Heikka. *Trophy Hunters*. Modeled 1930

467. Asa L. ("Ace") Powell. *Two Trails to God*. 1960

468. Asa L. ("Ace") Powell. *Napi and His Friends*. 1961

469. Asa L. ("Ace") Powell. *Medicine Horse*. 1968

470. Richard V. Greeves. *Mr. Indian*. 1970

471. Richard V. Greeves. *Mr. Gambler*. 1970

472. Richard V. Greeves. *Mr. Miner*. 1970

473. Richard V. Greeves. *Mr. Cowboy*. 1970

474. Richard V. Greeves. *Mr. Cavalryman*. 1970

475. Paul Rossi. *Spanish War Saddle— 1840*. 1971

476. Frederic Remington. *If Skulls Could Speak*. 1902

477. Ernest Berke. *Apache Signal*. 1966

478. Ernest Berke. *The Tacticians*. Modeled 1968, cast 1969

479. Ernest Berke. *Crazy Horse*. 1955

480. Gordon Phillips. *Coffee, Beans, and Broncs*. 1970

481. Charles M. Russell. *A Bronc to Breakfast*. 1912.

482. Noah Beery. *The Ghost Stage*. 1967

483. Noah Beery. *Gunfight on Front Street*. 1964

484. Hank Richter. *Hopi Snake Dancers*. 1970

485. Hank Richter. *Shearin' Time*. 1972

486. Una Hanbury. *Maid to Please*. 1971

487. Edward J. Fraughton. *Where the Trail Ends*. 1973

488. Jasper D'Ambrosi. *Muddy Creek Crossing*. 1971

489. James Earle Fraser. *The End of the Trail*. Modeled 1894, cast 1971

490. John Preston Powers. *The Closing Era*. Modeled 1893, erected 1898

491. Gutzon Borglum. *Texas Cowboys*. Modeled 1927, dedicated 1942

492. Gutzon Borglum. *Texas Cowboys* (detail of plate 491)

*493. Frederic Remington. *The Cowboy*. Unveiled 1908

494. Frederick MacMonnies. *The Pioneer Monument to Kit Carson*. 1936

495. Frederick MacMonnies. *The Pioneer Monument to Kit Carson* (detail of Kit Carson). 1936

496. Frederick MacMonnies. *The Pioneer Monument to Kit Carson* (detail of Pioneer Man). 1936

497. Frederick MacMonnies. *The Pioneer Monument to Kit Carson* (detail of Pioneer Mother and Child). 1936

498. Frederick MacMonnies. *The Pioneer Monument to Kit Carson* (detail of Prospector). 1936

499. Cyrus Dallin. *Pioneer Mother (A Memorial to the Pioneer Mothers of Springville, Utah)*. 1931

500. Thorlief S. Knaphus. *Handcart Pioneer Monument*. 1947

501. A. Phimister Proctor. *The Pioneer Mother*. 1934

502. A. Phimister Proctor. *The Pioneer Mother*. 1923–27

503. Cyrus Dallin. *Brigham Young* from the *Brigham Young Pioneer Monument*. Dedicated 1897

504. Cyrus Dallin. *Massasoit*. c. 1921

505. Mahonri MacIntosh Young. *Sea Gulls*. 1913

506. Cyrus Dallin. *Chief Washakie* from the *Brigham Young Pioneer Monument*. Dedicated 1897

507. Avard T. Fairbanks. *Ute Brave*

508. Avard T. Fairbanks. *Winter Quarters*. Modeled 1935, dedicated 1936

509. Avard T. Fairbanks. *Winter Quarters* (scale model). 1935

510. Leonard McMurry. *The Eighty-Niners*. c. 1958

511. A. Phimister Proctor. *Mustangs*. Unveiled 1948

INDEX OF SCULPTORS OF AMERICAN WESTERN BRONZES

FREEMAN, BILL. Contemporary. Wildlife sculpture. Studio in Scottsdale, Ariz.

FRENCH, JOHN. Contemporary. Texas woodcarver and painter. Occasional bronze sculpture.

GILBERTSON, BORIS. Contemporary. Animal sculpture. Studio in Santa Fe, N.M.

GRAFLY, CHARLES. b. 1862 Philadelphia, Pa.; d. 1929 Philadelphia, Pa. Monumental sculpture, some Western subjects. Member National Academy of Design, Fellow National Sculpture Society. See Chapter XIX.

GRANDEE, JOE RUIZ. Contemporary. Cowboy sculpture. Studio in Arlington, Tex.

GREEVES, RICHARD V. b. 1934 near St. Louis, Mo. Studio in Fort Washakie, Wyo. See Chapter XXII.

GREGORY, JOHN. b. 1879 London, England; d. 1958, New York, N.Y. Architectural sculpture. Contestant in Pioneer Woman Competition. Member National Academy of Design, Past President and Fellow National Sculpture Society. See Chapter XVIII.

HAMILTON, JIM. b. 1919 Pawhuska, Okla. Cowboy sculpture. Studio in Pawhuska, Okla. See Chapter XXI.

HAMPTON, LUCILLE. Contemporary. b. New York, N.Y. Studio in New York City.

HANBURY, UNA. b. 1905 Middlesex County, England. Recent sculpture of horses and wildlife of the Southwest. Studio in Santa Fe, N.M. Member National Sculpture Society. See Chapter XXII.

HARVEY, ELI. b. 1860 Ogden, Ohio; d. 1957 Alhambra, Calif. Animal sculpture. See Chapter IV.

HAZZARD, HARRY. b. 1900 Devil's Lake, N.D.; d. 1966.

HEIKKA, EARLE. b. 1910 Belt, Mont.; d. 1941 Great Falls, Mont. See Chapter XXII.

HELD, JR., JOHN. b. 1899 Salt Lake City, Utah; d. 1958 Westport, Conn. Cartoonist. Cowboy sculpture.

HERBERT, GARY N. b. 1934 Tulsa, Okla. Studio in Breckenridge, Colo.

HERRON, RON. b. about 1949 Havre, Mont. Miniature sculpture. Studio in Missoula, Mont.

HILL, JACK. Contemporary. Portrait sculpture, occasional Indian portraits.

HOFFMAN, FRANK. b. 1888 Chicago, Ill.; d. 1958 Taos, N.M. Occasional animal sculpture. See Chapter XIV.

HOFFMAN, MALVINA. b. 1887 New York, N.Y.; d. 1966 New York, N.Y. Ethnological sculpture, numerous Indian subjects. Member National Academy of Design, Fellow National Sculpture Society. See Chapter XVI.

HOMER II, SAINT CLAIR. Contemporary. b. Okla. (Choctaw-German). Sculpture of Indian history and ritual. Studio in Tulsa, Okla. See Chapter XX.

HOUSER, ALLAN C. b. 1914 Apache, Okla. Sculpture of Indian life in the Southwest. Studio in Santa Fe, N.M. See Chapter XX.

HUMPHRISS, CHARLES H. b. 1867 England; d. 1934. Indian sculpture. See Chapter XVIII.

HUNT, WAYNE C. b. 1904 Bear Valley, Wis. Member Cowboy Artists of America. Studio in San Diego, Calif. See Chapter XXI.

HUNTINGTON, ANNA HYATT. b. 1876 Cambridge, Mass.; d. 1973 Redding, Conn. Monumental sculpture, many animal subjects. Studio in Beth El, Conn. Member National Academy of Design, Fellow National Sculpture Society. See Chapter XVII.

JACKSON, HARRY. b. 1924 Chicago, Ill. Member Cowboy Artists of America, National Academy of Western Art, National Sculpture Society. Studio in Lucca, Italy. See Chapter XXI.

JENKINS, F. LYNN. b. 1870 Torquay, England; d. 1929 New York, N.Y. Monumental sculpture. Contestant in Pioneer Woman Competition. Member National Sculpture Society. See Chapter XVIII.

JENNEWEIN, C. PAUL. b. 1890 Stuttgart, Germany. Monumental sculpture, occasional Indian subjects. Studio in the Bronx, N.Y. Member National Academy of Design, Fellow National Sculpture Society. See Chapter XIX.

JOHNSON, R. A. Contemporary. Studio in Borger, Tex.

JONAS, LOUIS PAUL. b. 1894 Budapest, Hungary; d. 1971 Churchtown, N.Y. Animal sculpture. See Chapter XVII.

KAUBA, CARL. b. 1865 Austria; d. 1922 Vienna, Austria. Sculptures of life in the West around 1900. See Chapter XV.

KELLEY, J. P. b. 1927 Phoenix, Ariz. Studio in Kalispell, Mont.

KEMEYS, EDWARD. b. 1843 Savannah, Ga.; d. 1907 Washington, D.C. Animal sculptor. Member National Sculpture Society. See Chapter IV.

KITTLESON, JOHN. b. 1930 Arlington, S.D. Member Cowboy Artists of America. Studio in Fort Collins, Colo. See Chapter XXI.

KNAPHUS, THORLIEF S. b. 1881 Vats, Norway; d. 1965 Salt Lake City, Utah.

KNAPP, TOM. b. 1925 Gillette, Wyo. Studio in Ruidoso Downs, N.M.

KNIGHT, CHARLES R. b. 1874 Brooklyn, N.Y.; d. 1953 New York, N.Y. Animal sculpture. See Chapter XVII.

KOPTA, EMRY. b. 1884 Graz, Austria; d. 1953 Phoenix, Ariz. Indian portraiture. See Chapter XVI.

KORBEL, MARIO J. b. 1882 Osik, Czech.; d. 1954 New York, N.Y. Contestant in Pioneer Woman Competition. Member National Academy of Design, National

Sculpture Society. See Chapter XVIII.

LA FOUNTAIN, ALEX. b. 1940s North Dakota; d. about 1971. Part Chippewa. Worked in Lewistown, Mont.

LA PRADE, JOHN. b. 1951 Phoenix, Ariz. Studio in La Jolla, Calif. See Chapter XXI.

LAWRIE, LEE O. b. 1877 Rixford, Germany; d. 1963 Easton, Md. Monumental statuary. Contestant in Pioneer Woman Competition. Member National Academy of Design, Fellow National Sculpture Society.

LEARNED, JOHN. Contemporary. b. Lawrence, Kan. Studio in Oklahoma City, Okla.

LEE, ARTHUR. b. 1881 Trondheim, Norway; d. 1961 Newton, Conn. Contestant in Pioneer Woman Competition. See Chapter XVIII.

LENNBERG, ROY. Contemporary. Woodcarver. Studio in Citrus Heights, Calif.

LEIGH, WILLIAM R. b. 1866 Falling Water, W. Va.; d. 1955 New York, N.Y. See Chapter XIV.

LEONARD, N. FRANK. b. 1888; d. 1917. Animal sculpture.

LION, HENRY. b. 1900 Fresno, Calif.; d. between 1962–67, Los Angeles, Calif. California statuary, several Western bronzes.

LONG, TED. b. 1932 North Platte, Neb. Studio in North Platte, Neb.

LONN, KENNETH. Contemporary. Studio in Colfax, Wash.

LYON, FRANK. Contemporary. Western sculpture. Studio in Taos, N.M.

McLAUGHLIN, NANCY. b. 1932 Kalispell, Mont. Sculpture of Indians of the Southwest and Northwest. Studio in Scottsdale, Ariz.

McMURRY, LEONARD. b. 1913 Memphis, Tex. Monumental statuary and portraiture. Occasionally depicts Oklahoma history. Several Indian portraits. Studio in Oklahoma City, Okla. See Chapter XVI.

MacMONNIES, FREDERICK. b. 1863 Brooklyn, N.Y.; d. 1937 New York, N.Y. Monumental statuary, some Western subjects. Member Society of American Artists and National Academy of Design, Fellow National Sculpture Society. See Chapter XXIII.

MacNEIL, HERMON A. b. 1866 Chelsea, Mass.; d. 1947 College Point, Long Island Sound, N.Y. Monumental statuary, many Indian subjects. Member Society of American Artists and National Academy of Design, Fellow National Sculpture Society. See Chapter VII.

MANSHIP, PAUL. b. 1885 St. Paul, Minn.; d. 1966 New York, N.Y. Several Indian sculptures. Member National Academy of Design, Former President and Fellow National Sculpture Society. See Chapter XIX.

MARCHAND, JOHN. b. 1875 Leavenworth, Kan.; d. 1921 Westport, Conn.

MARKS, GEORGE. b. 1923 Conrad, Iowa. Member Cowboy Artists of America. Studio in Albuquerque, N.M. See Chapter XXI.

MESTROVIC, IVAN. b. 1883 Otavice, Yugoslavia; d. 1962 South Bend, Ind. Several Indian sculptures. Member National Academy of Design, Fellow National Sculpture Society. See Chapter XV.

MILLER, VEL. b. 1936 Nekoosa, Wis. Studio in Canoga Park, Calif.

MONTANA, PIETRO. b. 1890 Alcamo, Italy. Portrait sculpture, several Indian subjects. Studio in Rome, Italy. Member National Academy of Design, Fellow National Sculpture Society.

MORA, JOSEPH J. ("Jo"). b. 1876 Montevideo, Uruguay; d. 1947. Cowboy sculpture. See Chapter XVIII.

MORGAN, ROB. Contemporary. b. Helena, Mont. Studio in Helena, Mont.

MORGAN, FRANK. b. 1929 Helena, Mont. Studio in Helena, Mont.

MORI, P. Worked about 1910. Several Indian subjects.

MORRIS, HAROLD. Contemporary. Studio in Fort Worth, Tex.

MOYERS, WILLIAM. b. 1916 Atlanta, Ga. Studio in Albuquerque, N.M. Member Cowboy Artists of America. See Chapter XXI.

MUNO, RICHARD. b. 1939 Arapaho, Okla. Studio in Oklahoma City, Okla.

MYER, RICHARD A. b. 1933 New York, N.Y. Studio in El Monte, Calif.

NARANHO, MICHAEL. b. 1944 Santa Fe, N.M. Pueblo Indian. Sculpture of Indian ceremonial dances. Studio in Taos, N.M. See Chapter XX.

OLSON, MERLE. Contemporary. Studio in Big Fork, Mont.

OSMER, JACK. b. 1932 Prescott, Ariz. Studio and foundry in Prescott, Ariz.

PAPLEO, CATALDO. b. 1912. Studio in El Monte, Calif.

PARK, MADELEINE. b. 1891 Mt. Kisco, N.Y.; d. 1960 Sarasota, Fla. Associate Member National Academy of Design, Fellow National Sculpture Society. See Chapter XVIII.

PETERS, LES. Contemporary. b. Mont. Studio in Great Falls, Mont.

PHILLIPS, GORDON. b. 1927 Boone, N.C. Cowboy sculptor. Studio in Maryland. See Chapter XXII.

PHILLIPS, W. S. ("EL COMANCHO"). b. 1875; d. 1921. Worked in Seattle area. Adopted and named by the Indians.

PHIPPEN, GEORGE. b. 1915 Kan.; d. 1966 Skull Valley, Ariz. Worked in Skull Valley, Ariz. Member Cowboy Artists of America. See Chapter XXI.

POGZEBA, WOLF. b. 1936 Munich, Germany. Studio in Denver, Colo. See Chapter XIX.

POLK, FRANK. b. 1908 Louisville, Ky. Member Cowboy Artists of America. Studio in Hemet, Calif. See Chapter XXI.

POLLAND, DON C. Contemporary. b. Utah. Miniature Western sculptures. Studio in Prescott, Ariz. See Chapter XXII.

POLLIA, JOSEPH P. b. 1893 Italy; d. 1954. Monumental statuary, several Indian subjects. Associate Member National Academy of Design, Member National Sculpture Society.

POMEROY, LYNDON. Contemporary. b. Sidney, Mont. Studio in Billings, Mont.

POTTER, EDWARD CLARK. b. 1857 New London, Conn.; d. 1923 New Haven, Conn. Monumental equestrian statuary, occasional Western subjects. Member Society of American Artists and National Academy of Design, Fellow National Sculpture Society.

POTTER, LOUIS. b. 1873 Troy, N.Y.; d. 1912 Seattle, Wash. Indian groups.

POWELL, ASA L. ("ACE"). b. 1912 Tularosa, N.M. Sculpture of Indian life in the Northwest. Studio in Kalispell, Mont. See Chapter XXII.

POWERS, JOHN PRESTON. b. 1843 Florence, Italy; d. 1904 Florence, Italy. Son of Hiram Powers. Worked in Boston, Washington, and Florence. Occasional Indian subjects. See Chapter XXIII.

PROCTOR, A. PHIMISTER. b. 1862 Bozanquit, Ontario, Canada; d. 1950 Palo Alto, Calif. Monumental statuary, many Western and wildlife subjects. Member Society of American Artists and National Academy of Design, Fellow National Sculpture Society. See Chapter IX.

PRUITT, A. KELLY. b. 1924 Waxahachie, Tex. Cowboy sculpture. Studio in Taos, N.M.

PUTNAM, ARTHUR. b. 1873 Waveland, Miss.; d. 1930 Ville D'Avray, France. Animal sculpture. Member National Sculpture Society. See Chapter XVII.

PUTNAM, DONALD ("PUTT"). b. 1926 Spokane, Wash. Studio in Hermosa Beach, Calif.

RATTEY, HARVEY L. Contemporary. Cowboy and rodeo sculpture. Studio in Cascade, Mont.

REISS, HANS E. b. 1885 Lahr Baden, Black Forest, Germany; d. 1968 San Francisco, Calif. Indian portraiture. See Chapter XVI.

REMINGTON, FREDERIC. b. 1861 Canton, N.Y.; d. 1909 Ridgefield, Conn. Associate Member National Academy of Design. See Chapter X.

RHIND, JOHN MASSEY. b. 1858 Edinburgh, Scotland; d. 1936. Monumental sculpture, several Indian subjects. Fellow National Sculpture Society.

RICHARDSON, A. J. ("JACK"). Contemporary. Wildlife sculpture. Studio in Choteau, Mont.

RICHTER, HANK. b. 1928 Cleveland, Ohio. Studio in Phoenix, Ariz. See Chapter XXII.

RIEKE, REX. b. 1939 Auburn, Ind. Studio in Billings, Mont.

RIGDEN, CYNTHIA. b. 1943 Prescott, Ariz. Horse sculpture. Studio in Kirkland, Ariz.

ROBERTS, QUENTIN. Contemporary. b. Texas. Studio in Lander, Wyo.

ROBLES, JULIAN. Contemporary. b. New York, N.Y. Portrait artist, occasional sculpture. Studio in Taos, N.M.

ROCKWELL, ROBERT H. b. 1885 Oswego County, N.Y. Animal sculpture. See Chapter XVII.

ROGERS, RANDOLPH. b. 1825 New York, N.Y.; d. 1892 Rome, Italy. Monumental statuary, several Indian subjects. See Chapter III.

ROHL-SMITH, CARL. b. 1848 Roskilde, Denmark; d. 1900 Copenhagen, Denmark. Monumental sculpture, occasional Indian subjects. Member National Sculpture Society. See Chapter III.

ROSSI, PAUL. b. 1929 Denver, Colo. Studio in Tucson, Ariz. See Chapter XXII.

ROTH, FREDERICK G. b. 1872 Brooklyn, N.Y.; d. 1944 Englewood, N.J. Animal sculpture. Member Society of American Artists and National Academy of Design, Fellow National Sculpture Society. See Chapter XVIII.

RUMSEY, CHARLES C. b. 1879 Buffalo, N.Y.; d. 1922 New York, N.Y. Heroic statuary, occasional Indian subjects. Member National Sculpture Society. See Chapter XVIII.

RUNGIUS, CARL. b. 1869 Berlin, Germany; d. 1959 New York, N.Y. Wildlife artist. Occasional animal sculptures. See Chapter XIV.

RUSSELL, CHARLES M. b. 1864 Oakhill, Mo.; d. 1926 Great Falls, Mont. See Chapter XI.

SAINT-GAUDENS, AUGUSTUS. b. 1848 Dublin, Ireland; d. 1907 Cornish, N.H. Monumental sculpture. Member Society of American Artists and National Academy of Design, Founder and Fellow National Sculpture Society.

SANDERSON, R. PHILLIPS. b. 1908 Missouri. Woodcarver. Occasional bronze sculpture. Studio in Scottsdale, Ariz.

SANTEE, ROSS. b. 1889 Thornburg, Iowa. Worked in Arizona. Occasional sculpture.

SAVILLE, BRUCE W. b. 1893 Quincy, Mass.; d. 1939 Santa Fe, N.M. Monumental sculpture and sculpture of Indian ceremonial dances. Member National Sculpture Society. See Chapter XVI.

SCHELBAUER, MEL. b. 1931 Sheboygan, Wis. Studio in El Monte, Calif.

SCHILDT, GARY. b. 1938 Helena, Mont. Part Blackfoot Indian. Studio in Kalispell, Mont. See Chapter XX.

SCHREYVOGEL, CHARLES. b. 1861 New York, N.Y.; d. 1912 Hoboken, N.J. Occasional Western sculpture. See Chapter XIV.

SCHULTZ, HART MERRIAM ("Lone Wolf"). b. 1882 Birch Creek, Mont.; d. 1970. Part Blackfoot Indian. See Chapter XX.

SCRIVER, BOB. b. 1914 Browning, Mont. Member Cowboy Artists of America, National Academy of Western Art. Studio in Browning, Mont. Owns Bighorn Foundry. Member National Sculpture Society. See Chapter XXI.

SEARS, PHILLIP B. d. 1953 Brookline, Mass. Heroic statuary, several Indian subjects. Member National Sculpture Society.

SHAFER, L. E. ("GUS"). b. 1907 Hoisington, Kan. Studio in Merriam, Kan. See Chapter XXI.

SHEBL, JOSEPH. b. 1913 Crete, Neb.

SHEPHERD, J. CLINTON. b. 1888 Des Moines, Iowa. Cowboy sculptor. See Chapter XVIII.

SHORTRIDGE, EUGENE W. b. 1926 Flasher, N.D. Studio in Nemo, S.D.

SHRADY, HENRY MERWIN. b. 1871 New York, N.Y.; d. 1922 New York, N.Y. Monumental sculpture, several Western wildlife sculptures. Associate Member National Academy of Design, Member National Sculpture Society. See Chapter XVII.

SNIDOW, GORDON. b. 1936 Paris, Mo. Member Cowboy Artists of America. Studio in Belen, N.M. See Chapter XXI.

SOWELL, BILL JOE. b. 1940 Corpus Christi, Tex. Studio in Pawhuska, Okla.

SPAMPINATO, CLEMENTE. b. 1912 Rome, Italy. Heroic sculpture, several cowboy sculptures. Studio in Sea Cliff, N.Y. Fellow National Sculpture Society. See Chapter XIX.

SPEED, GRANT. b. 1930 San Angelo, Tex. Member Cowboy Artists of America. Studio in Provo, Utah. See Chapter XXI.

STEFFEN, RANDY. Contemporary. Illustrations and sculptures of Indian and wildlife subjects. Studio in Waco, Tex.

STERNE, MAURICE. b. 1878 Libau, Russia; d. 1957 Mt. Kisco, N.Y. Contestant in Pioneer Woman Competition. See Chapter XVIII.

STEVENS, LAWRENCE TENNEY. b. 1896 Boston, Mass.; d. 1972 Tempe, Ariz. Heroic rodeo sculpture. Fellow National Sculpture Society. See Chapter XIX.

STEVENSON, BRANSON. b. 1901 Georgia. Studio in Great Falls, Mont.

STONE, WILLARD. b. 1916 Oktaha, Okla. Part Cherokee. Woodcarver. Occasional bronze sculpture. See Chapter XX.

SUMMERS, ROBERT. Contemporary. b. Glenrose, Tex. Studio in Glenrose, Tex.

SVENSON, JOHN E. b. 1923 Los Angeles, Calif. Studio in Green Valley Lake, Calif.

SWANSON, J. N. b. 1927 Duluth, Minn. Member Cowboy Artists of America. Studio in Carmel Valley, Calif. See Chapter XXI.

TENNANT, ALLIE VICTORIA. b. St. Louis, Mo.; d. 1971 Dallas, Tex. Heroic statuary, occasional Indian subjects. Fellow National Sculpture Society. See Chapter XIX.

THOMAS, JIM. Contemporary. Studio in Amarillo, Tex.

TIGER, JEROME. b. 1941 Tahlequah, Okla.; d. 1967 Eufaula, Okla. Creek-Seminole. Worked in Muskogee, Okla. See Chapter XX.

TIGER, JR., JOHNNY. b. 1940 Tahlequah, Okla. Creek-Seminole. Studio in Muskogee, Okla. See Chapter XX.

TIGER, SR., JOHNNY. b. 1915 Spaulding, Okla. Creek-Seminole. Studio in Muskogee, Okla. See Chapter XX.

TILDEN, DOUGLAS. b. 1860 Chico, Calif.; d. 1935 Oakland, Calif. Monumental statuary. See Chapter XVIII.

TOGNONI, GEORGE-ANN. b. 1919 Minneapolis, Minn. Studio in Phoenix, Ariz.

TROUBETZKOY, PAUL. b. 1866 Intra, Lake Maggiore, Italy; d. 1938 Suna, Lake Maggiore, Italy. Cowboy life in the nineteenth century. See Chapter XV.

TURNER, JAMES. Contemporary. b. Telluride, Colo. Studio in Fairplay, Colo.

TURPEN, JR., JAMES COSTELLO. b. 1930 Winslow, Ariz. Specializes in Indian subjects.

UMLAUF, CHARLES. b. 1911 South Haven, Mich. Professor of Art, University of Texas, Austin, Tex.

VOISIN, ADRIEN. b. 1890 Long Island, N.Y. Studio in Palos Verdes, Calif. Sculpture of the Pacific-Northwest Indians.

WARD, JIM. Contemporary. b. Texas. Studio in Canyon, Tex.

WARD, JOHN QUINCY ADAMS. b. 1830 Urbana, Ohio; d. 1910 New York, N.Y. Monumental statuary, occasional Western subjects. Member National Academy of Design, Founder and Fellow National Sculpture Society. See Chapter III.

WARNEKE, HEINZ. b. 1895 Bremen, Germany. Animal sculptor. Studio in East Haddam, Conn. Member National Academy of Design, Fellow National Sculpture Society.

WARNER, OLIN LEVI. b. 1844 Suffield, Conn.; d. 1896 New York, N.Y. First Indian portraiture. Member Society of American Artists and National Academy of Design, Founder and Fellow National Sculpture Society. See Chapter III.

WARREN, CONSTANCE WHITNEY. b. 1888 New York, N.Y.; d. c.1945 Paris, France. Cowboy sculpture.

WARREN, MELVIN C. b. 1920 Los Angeles,

Calif. Member Cowboy Artists of America. Studio in Clifton, Tex. See Chapter XXI.

WEATHERBEE, J. FRANK. b. 1928 Maine. Specializes in Indian subjects. Studio in Chino Valley, Ariz.

WEAVER, JOHN B. b. 1920 Anaconda, Mont. Monumental statuary, some small models. Specializes in the history of Alberta, Canada. Member National Sculpture Society.

WEHN, JAMES. b. Indianapolis, Ind. Worked in Seattle during the nineteenth century. See Chapter XVI.

WEINMAN, ADOLPH A. b. 1870 Karlsruhe, Germany; d. 1952 Port Chester, N.Y. Monumental statuary, several Indian sculptures. Member Society of American Artists and National Academy of Design, Past President and Fellow National Sculpture Society. See Chapter XIII.

WHEELER, HUGHLET O.L. ("TEX"). b. 1901; d. 1954. Member Cowboy Artists of America.

WHITE, FRITZ. b. 1930 Milford, Ohio. Member Cowboy Artists of America. Studio in Denver, Colo.

WHITEHORSE, ROLAND N. b. 1920 Carnegie, Okla. Indian ceremonies. Studio in Elgin, Okla. See Chapter XX.

WHITNEY, GERTRUDE VANDERBILT. b. 1877 New York, N.Y.; d. 1942 New York, N.Y. Monumental sculpture, occasional Western subjects. Associate Member National Academy of Design, Member National Sculpture Society. See Chapter XVIII.

WIEGHORST, OLAF. b. 1899 Viborg, Jutland, Denmark. Member Cowboy Artists of America, Honorary Member National Academy of Western Art. Studio in El Cajon, Calif. See Chapter XXI.

WILLIAMS, J. R. Contemporary. b. Nova Scotia. Cartoonist. Cowboy sculpture.

WILLIAMS, WHEELER. b. 1897 Chicago, Ill.; d. 1972 Madison, Conn. Contestant in Pioneer Woman Competition. Member National Academy of Design, Fellow National Sculpture Society. See Chapter XVIII.

WINGATE, CURTIS. b. 1926 Denison, Tex. Studio in Phoenix, Ariz. See Chapter XXI.

YOUNG, MAHONRI MACINTOSH. b. 1877 Salt Lake City, Utah; d. 1957 Norwalk, Conn. Monumental Mormon statuary and smaller sculptures of life in the West. Member National Academy of Design, Fellow National Sculpture Society. See Chapter XVIII.

INDEX OF AMERICAN WESTERN BRONZES

This index represents an attempt to locate bronze sculptures of the American West in museum collections throughout the United States, to list and identify the most important bronzes by those Western sculptors discussed in the text, and to describe many of the best-known Western bronzes by contemporary sculptors. I have limited the number of works by the latter to ten unless more than that number are in permanent public collections.

Many museums were not able to answer my request for information on dates, heights, and foundries. Many of the bronzes themselves, glued to their bases, show neither dates nor foundry marks. Some were given to the museums with little identification; others are in inaccessible storage areas and cannot be measured or examined. I have therefore consolidated the available data in order to give as much information as possible about a specific sculpture. I have listed the date a work was modeled, the date of its casting, its height, and the foundry which cast the work. Whenever a work has several casting dates, was cast in several sizes, or by various foundries, this information is also given.

This index is by no means comprehensive, but I hope it will be of value and serve as a checklist for those interested in sculpture of the American West.

BAKER, BRYANT

Pioneer Man. 1928. H. 87". Coll.: Woolaroc Museum.
Pioneer Woman. Heroic size: Ponca City, Okla. Bronze model: c. 1927; H. 32". Coll.: Woolaroc Museum. Another model cast: H. 18".
Will Rogers (bust). H. 23".

BARRETT, LAWRENCE

The Gunslinger. 1967. H. 10⅝". Cast by the artist.
Mare and Colt. 1967. H. 8". Cast by the artist.
Off Balance. 1966. H. 8". Cast by the artist. Coll.: Colorado Springs Fine Arts Center.
Rearing Horse. 1970. H. 10¼". Cast by the artist.
South Wind. 1968. H. 8". Cast by the artist.
The Steer Wrestler. 1968. H. c. 8". Cast by the artist.

BARTLETT, PAUL WAYLAND

The Bohemian Bear Tamer. 1887. H. 68½", 27", 17". Gruet Fondeur, Paris. Coll.: Art Institute of Chicago; Corcoran Gallery of Art; Gilcrease Institute; George F. Harding Museum; The Metropolitan Museum of Art; Museum of Fine Arts, Boston; National Collection of Fine Arts, Smithsonian Institution. Exhibited: Paris Salon, 1887 (plaster); Paris Salon, 1888 (bronze).
Indian Dancer. Coll.: National Collection of Fine Arts, Smithsonian Institution. Exhibited: Pan-American Exposition, 1901, Buffalo (plaster).
Indian Ghost Dancer. Exhibited: Columbian Exposition, 1893, Chicago (plaster).
Preparedness (eagle). 1916. H. 12½". Grifoul, Newark, N.J. Coll.: The Metropolitan Museum of Art.
Sun Dance (Indian). Life-size. Coll.: National Collection of Fine Arts, Smithsonian Institution.

BAUR, THEODORE

The Buffalo Hunt. c. 1875. H. 22¾". The Meriden Britannia Co. (now International Silver Co.), Meriden, Conn. Coll.: Remington Art Memorial Museum.
Chief Crazy Horse. 1885. H. 29". Henry Bonnard Foundry, N.Y. Coll.: Denver Art Museum; Gilcrease Institute.

BEELER, JOE

The Apache. 1966. H. 13". Noggle Bronze Works, Prescott, Ariz.
The Buffalo Hunter. 1969. H. 14". Buffalo Bronze Works, Sedona, Ariz.
The Cheyenne. 1971. H. 12". Noggle Bronze Works, Prescott, Ariz.
Coffee Drinking Cowboy. 1966. H. 10¾". Classic Bronze, El Monte, Calif.
Medicine Man. 1968. H. 13½". Buffalo Bronze Works, Sedona, Ariz.
The Navaho. 1964. H. 14". Noggle Bronze Works, Prescott, Ariz. Coll.: National Cowboy Hall of Fame.
The Scout. 1971. H. 14". Buffalo Bronze Works, Sedona, Ariz.
The Sioux. 1967. H. 16". Noggle Bronze Works, Prescott, Ariz. Coll.: National Cowboy Hall of Fame.
Thanks for the Rain. 1970. H. 11". Buffalo Bronze Works, Sedona, Ariz.
Up the Trail. 1969. H. 17". Buffalo Bronze Works, Sedona, Ariz.

BEERY, NOAH

Buffalo Mother (buffalo with calf). 1959. H. 3½". Classic Bronze, El Monte, Calif.
Custer and the Washita. 1971. H. 14½". Rodriguez Bronze, El Monte, Calif.
Geronimo and Mexican Mule. 1967. H. 8". Classic Bronze, El Monte, Calif.

The Ghost Stage (Last Coach to Bodfish). 1967. H. 8". Classic Bronze, El Monte, Calif.
Gunfight on Front Street. 1964. H. 6". Classic Bronze, El Monte, Calif.
Jackson Sundown (Fourth of July at Lame Deer). 1958. H. 9". Classic Bronze, El Monte, Calif.
Mustangs. 1968. Classic Bronze, El Monte, Calif.
Running Free (five horses). 1957. H. 3½". Classic Bronze, El Monte, Calif.
Yellowstone Park Ballet (set of five bears). 1970. H. 1½ — 2½". Classic Bronze, El Monte, Calif.

BEIL, CHARLES A.

Bucking Horse and Rider. Coll.: C. M. Russell Gallery.
Buffalo Lying Down. Coll.: C. M. Russell Gallery.
Horse (ashtray). Coll.: C. M. Russell Gallery.
Long Horn Steer. Coll.: C. M. Russell Gallery.
Pack Horse. 1948. H. 12". Cast by the artist in Banff, Alberta. Coll.: C. M. Russell Gallery.
Saddle Horse Grazing. 1948. H. 11½". Cast by the artist in Banff, Alberta. Coll.: C. M. Russell Gallery.
Squaw with Baby on Back. Coll.: C. M. Russell Gallery.

SEVEN PIEGANS SERIES:

Calf Tail. 1968. H. 8⅛". Avnet Shaw Foundry, Plainview, N.Y.
Eagle Calf. 1968. H. 7½". Avnet Shaw Foundry, Plainview, N.Y.
Last Stone. 1968. H. 7¾". Avnet Shaw Foundry, Plainview, N.Y.
Medicine Bassribs. 1968. H. 7¾". Avnet Shaw Foundry, Plainview, N.Y.
Turtle. 1968. H. 7½". Avnet Shaw Foundry, Plainview, N.Y.
Two Guns White Calf. 1968. H. 8". Avnet Shaw Foundry, Plainview, N.Y.
Weasel Feather. 1968. H. 8½". Avnet Shaw Foundry, Plainview, N.Y.

BERKE, ERNEST

Apache Signal. 1966. H. 14½". Avnet Shaw Foundry, Plainview, N.Y. Coll.: Phoenix Art Museum.
Blackfoot Tracker. 1955. H. 16". Coll.: Texas Memorial Museum, University of Texas.
The Chieftain. 1967. H. 20½". Roman Bronze Works, N.Y., Avnet Shaw Foundry, Plainview, N.Y.
Crazy Horse. 1955. H. 17". Roman Bronze Works, N.Y.; Avnet Shaw Foundry, Plainview, N.Y.
The Death Song. 1968. H. 22". Avnet Shaw Foundry, Plainview, N.Y.
The Evening War Prayer. 1965. H. 17½". Roman Bronze Works, N.Y.; Avnet

Shaw Foundry, Plainview, N.Y.
Just Like a Lady (two Indian men holding a bucking horse). 1971. H. 20". Avnet Shaw Foundry, Plainview, N.Y.
Sitting Bull. 1965. H. 18⅞". Roman Bronze Works, N.Y.; Avnet Shaw Foundry, Plainview, N.Y.
The Tacticians (Indians setting up a dust diversion). Modeled 1968, cast 1969 and 1971. H. 22". Avnet Shaw Foundry, Plainview, N.Y.
The Washita (squaw fleeing in panic during Custer's raid). 1967. H. 14". Avnet Shaw Foundry, Plainview, N.Y.

BIGGS, ELECTRA WAGGONER

Riding Into the Sunset (Will Rogers on "Soapsuds"). Dedicated 1950. H. 9'5". Coll.: Texas Technical College; Will Rogers Auditorium; Will Rogers Memorial.
Will Rogers (head). Coll.: National Hall of Fame for Famous American Indians.

BLODGETT, GEORGE WINSLOW

Ascension Chama—Santo Domingo Pueblo. c. 1930s. H. 20". Coll.: Museum of New Mexico.
Clarence Rea—Acoma Pueblo. c. 1934. H. 18". Coll.: Museum of New Mexico.
Dee Bibb. c. 1943. H. 17½". Coll.: Museum of New Mexico.
Head of a Tewa Indian (Portrait of Albert Lujan of the Taos Pueblo). 1930. H. 10¼". Roman Bronze Works, N.Y. Coll.: Brookgreen Gardens; The Metropolitan Museum of Art; University Art Museum, University of New Mexico.
José Montoya—San Juan Pueblo. c. 1935. H. 17½". Coll.: Museum of New Mexico.
José Ray Cababasa—Santo Domingo Pueblo. c. 1930. H. 19". Coll.: Museum of New Mexico; Seattle Art Museum.
Marcial Quintana—Cochiti Pueblo. c. 1930s. H. 22". Coll.: Museum of New Mexico.
Ramon Tenorio. c. 1930. H. 20". Coll.: Museum of New Mexico.
Rose Chaves—Navaho Pueblo. c. 1930s.

BORGLUM, GUTZON

Apaches Pursued by U.S. Troops. Modeled 1901, cast 1946. H. 14". Roman Bronze Works, N.Y. Coll.: R. W. Norton Art Gallery; Witte Memorial Museum.
The Fallen Warrior (The Death of the Chief). c. 1891. H. 11". Coll.: Gilcrease Institute.
Harvey W. Scott. 1933. Life-size. Heroic size: Mt. Tabor Park, Oregon.
Henry Lawson Wyatt (boy with gun). 1911. Life-size.
Indian and Puritan. Unveiled 1916. Life-size. Coll.: Newark Public Library.
Indian Scouts. Exhibited: Columbian Exposition, 1893, Chicago.
The Man with the Upturned Face (John W.

MacKay). 1908. Coll.: MacKay School of Mines, University of Nevada.

Mares of Diomedes. 1903. H. 62″, 21″. Gorham and Co., N.Y. Coll.: Brookgreen Gardens; The Metropolitan Museum of Art; Musée Luxembourg, Paris (fragment); Newark Museum; R. W. Norton Art Gallery; Rhode Island School of Design. Exhibited: Louisiana Purchase Exposition, 1904, St. Louis.

Nation Moving Westward. Heroic size. Marietta, Ohio.

Texas Cowboys. Modeled 1927, cast 1942. H. 32′. San Antonio, Tex.

BORGLUM, SOLON H.

Aspiration. Installed 1920. Stone. H. c. 8′. St. Mark's-in-the-Bowery, N.Y.

Bear #1. H. 12″. *Bear #2.* H. 8¾″. Modeled c. 1900. Cast 1968. Renaissance Art Foundry, Norwalk, Conn. Coll.: New Britain Museum of American Art.

Bear Bookends. Modern casting from woodcarving. Renaissance Art Foundry, Norwalk, Conn.

Blizzard. 1900. H. 5¾″. Original and new castings: The American Art Foundry, N.Y.; Bejoit-Jabouf, Paris; Henry Bonnard Foundry, N.Y.; Sklaber and Co., N.Y.; Renaissance Art Foundry, Norwalk, Conn., Roman Bronze Works, N.Y. Coll.: Detroit Institute of Art; R.W. Norton Art Gallery; Texas Memorial Museum, University of Texas. Exhibited: Pan-American Exposition, 1901, Buffalo; Louisiana Purchase Exposition, 1904, St. Louis.

Broncos Frightened by Saddle. Original cast 1898. Pfeiffer-Theodore B. Starr. Cast 1971. H. 5″. Renaissance Art Foundry, Norwalk, Conn.

The Bucking Bronco. 1898. H. 15″. Bejoit-Jabouf, Paris; Henry Bonnard Foundry, N.Y.; Roman Bronze Works, N.Y. Coll.: Clayton Public Library, Clayton, Mo.; R. W. Norton Art Gallery.

Bucky O'Neill. Unveiled 1907. Heroic statue. Small model: 44″, 17″. Roman Bronze Works, N.Y. Coll.: R. W. Norton Art Gallery; Whitney Gallery of Western Art.

The Buffalo. c. 1896. H. 16″. (There is also a very small cast.) Pfeiffer Foundry, Paris. Exhibited: Pan-American Exposition, 1901, Buffalo.

Bulls Fighting. Cast c. 1906. H. c. 4″. B. Zoppo Foundry, N.Y.; Roman Bronze Works, N.Y. Coll.: Brookgreen Gardens; Detroit Institute of Art; The Metropolitan Museum of Art; National Arts Club. Exhibited: Pan-American Exposition, 1901, Buffalo; Louisiana Purchase Exposition, 1904, St. Louis.

Burial on the Plains (Desolation). Marble. 1900. H. 16″. Cast in bronze 1969. Original and modern castings: Renais-

sance Art Foundry, Norwalk, Conn. Exhibited: Pan-American Exposition, 1901, Buffalo (marble). Coll.: New Britain Museum of American Art.

Civil War Generals. Cemetery, Vicksburg, Miss.

Cowboy at Rest. Modeled 1904. Heroic size. Exhibited: Louisiana Purchase Exposition, 1904, St. Louis. Cast 1966: H. 36″; Roman Bronze Works, N.Y. Cast 1973: H. 36″; Renaissance Art Foundry; Norwalk, Conn. Coll.: New Britain Museum of American Art.

Dancing Horse. Modeled c. 1900. H. 17″. Cast in Paris. Exhibited: Pan-American Exposition, 1901, Buffalo; Louisiana Purchase Exposition, 1904, St. Louis.

Evening (cowboy standing beside his horse). c. 1905. H. 22″. Roman Bronze Works, N.Y. Only one cast was made.

Grizzly Bear Cub. H. 3¼″. Cast 1968. Renaissance Art Foundry, Norwalk, Conn. Coll.: New Britain Museum of American Art.

Horse Tamed. H. 7¾″. Roman Bronze Works, N.Y. Coll.: Detroit Institute of Art.

The Indian. Cast 1972. H. 19″. Renaissance Art Foundry, Norwalk, Conn. Coll.: New Britain Museum of American Art.

Indian Crouching. Modern castings.

Indian Love Chase. Plaster model 1905, cast 1970. H. 38″. Renaissance Art Foundry, Norwalk, Conn. Coll.: New Britain Museum of American Art.

Inspiration. Installed 1920. Stone. H. c. 8′. St. Mark's-in-the-Bowery, N.Y.

Intelligent Bronco. H. 20¾″. Roman Bronze Works, N.Y. Coll.: Detroit Institute of Art.

Lassoing Wild Horses. 1898. H. 33″. Roman Bronze Works, N.Y.; Susse Foundry, Paris. Coll.: Detroit Institute of Art; Gilcrease Institute; George F. Harding Museum; National Cowboy Hall of Fame; R. W. Norton Art Gallery. Exhibited: Pan-American Exposition, 1901, Buffalo.

Little Lame Horse. Exhibited: Paris Salon, 1899.

New Born. 1900. H. 4″. Roman Bronze Works, N.Y. Cast during artist's lifetime. Coll.: Joslyn Art Museum (original casting). Exhibited: Louisiana Purchase Exposition, 1904, St. Louis. Cast 1969: H. 4″; Renaissance Art Foundry, Norwalk, Conn. Coll.: New Britain Museum of American Art.

Night Hawking. 1898. H. 12½″. Henry Bonnard Foundry, N.Y.; Roman Bronze Works, N.Y. Coll.: R. W. Norton Gallery; Whitney Gallery of Western Art. Exhibited: Pan-American Exposition, 1901, Buffalo.

On the Border of the White Man's Land. Modeled 1899, cast 1906. H. 19″. Gorham and Co., N.Y.; Roman Bronze Works,

N.Y. Coll.: Brookgreen Gardens; The Metropolitan Museum of Art; Public Library, Westerly, R. I. Exhibited (entitled *The Scout*): Exposition Universelle, 1900, Paris (Silver Medal); Pan-American Exposition, 1901, Buffalo.

On the Trail (cowboy on a horse, frightened by a rattlesnake). 1900. H. 14½″. Roman Bronze Works, N.Y. Coll.: Joslyn Art Museum. Exhibited: Louisiana Purchase Exposition, 1904, St. Louis.

Our Slave (Captured Wild Horse) (horse lying down). Plaster c. 1898, marble 1901. H. c. 18″. Cast 1971: 7″. Renaissance Art Foundry, Norwalk, Conn. Exhibited: Pan-American Exposition, 1901, Buffalo (marble); Louisiana Purchase Exposition, 1904, St. Louis (marble). Coll.: New Britain Museum of American Art.

The Pioneer—A Reverie. Plaster. Visalia, Calif. Modeled for Panama-Pacific Exposition, 1915, San Francisco.

Pioneer in a Storm. Modeled c. 1904. H. 11″, 36″. Early Parisian casting. Cast 1969 Roman Bronze Works, N. Y. Coll: Gilcrease Institute; National Cowboy Hall of Fame. New Britain Museum of American Art.

Rough Rider. Modeled 1898. H. 19½″. Bejoit-Jabouf, Paris. Coll.: Detroit Institute of Art. Exhibited: Pan-American Exposition, 1901, Buffalo.

The Sioux Indian Buffalo Dance. Modeled in plaster 1904, cast 1967. H. 38″, 36″. Roman Bronze Works, N. Y. Coll.: New Britain Museum of American Art. Exhibited: Louisiana Purchase Exposition, 1904, St. Louis.

Snowdrift (mare and colt). Cast 1899 (also in marble; occasionally the mare was cast separately). H. 10¾″. Coll.: Detroit Institute of Art. Exhibited: Paris Exposition, 1901 (entitled *Sous l'Ouragan*); Pan-American Exposition, 1901, Buffalo; Louisiana Purchase Exposition, 1904, St. Louis (entitled *In the Wind*).

The Stampede of Wild Horses. Modeled in plaster 1899 (destroyed). Life-size. Exhibited: Paris Salon, 1899 (plaster); Exposition Universelle, 1900, Paris (Honorable Mention).

Steps Toward Civilization. Modeled in plaster 1904. Heroic size. Exhibited: Louisiana Purchase Exposition, 1904, St. Louis. Fragments of the head and torso of the Indian chief and grieving mother have been cast: *The Chief,* 1972, H. 18″; *Sorrow on the Plains,* 1973, H. 18″.

Winter. 1898. H. 10½″. Coll.: Cincinnati Art Museum.

BOYLE, JOHN

The Alarm (The Indian Family). 1884. Life-size. Lincoln Park, Chicago. Small version (entitled *Indian Mother and Child*): H. 29½″. Roman Bronze Works, N. Y.

Coll.: Gilcrease Institute.

Indian Hunter. Exhibited: Louisiana Purchase Exposition, 1904, St. Louis.

The Stone Age in America. Erected 1888. Life-size. Fairmount Park, Philadelphia.

The Struggle. 1905. H. c. 32″. Roman Bronze Works, N. Y.

Tired Out. Exhibited: Columbian Exposition, 1893, Chicago.

BROWN, HENRY KIRKE

The Choosing of the Arrow. 1849. Whereabouts unknown.

Comanche Indian Breaking a Wild Horse. Exhibited: Centennial Exposition of the National Academy of Design, 1925.

Dying Tecumsah. c. 1849.

The Eagle. 1867. H. 32″. Coll.: Gilcrease Institute.

Indian and Panther. 1849–50. H. 7′. Whereabouts unknown.

BUNN, KENNETH

Bounding Doe. 1969. H. 8″. Art Foundry, Loveland, Colo. Coll.: National Academy of Design, N. Y.

Elk. 1974. H. 16″. Art Foundry, Loveland, Colo.

Fox. 1970. H. 8″. Art Foundry, Loveland, Colo.

Indian and Goose. 1970. H. 12″. Art Foundry, Loveland, Colo.

Making Tracks (a cow moose). 1970. H. 12″. Art Foundry, Loveland, Colo.

Omaha Girl. 1972. H. 18″. Art Foundry, Loveland, Colo.

The Pause (mountain lion). 1973. H. 5″. Art Foundry, Loveland, Colo. Coll.: Columbus Gallery of Fine Arts, Columbus, Ohio.

Sniffing Cougar. 1972. H. 10″. Art Foundry, Loveland, Colo.

Snowshoe Rabbit. 1972. H. 3″. Art Foundry, Loveland, Colo.

Wolves. 1972. H. 9″. Art Foundry, Loveland, Colo. Coll.: George Amos Memorial Library, Gillette, Wyo.

BUSH-BROWN, HENRY KIRKE

The Buffalo Hunt. Exhibited: Columbian Exposition, 1893, Chicago.

Indian Buffalo Head. Exhibited: Columbian Exposition, 1893, Chicago.

Indian Mother and Child. H. 19″. Gorham and Co., N. Y. Coll.: Gilcrease Institute.

Mountaineer Soldier. Life-size. Charleston, W. Va.

CALDER, A. STERLING

A Dancing Sioux.

Indian Brave. c. 1910. H. 24″.

An Indian Dreamer.

Marcus Whitman, The Spirit of the Far West. Created for the Alaska-Yukon Pacific

Exposition, 1909, Seattle.

Pioneer Woman. 1927. H. 40″. Roman Bronze Works, N. Y. Coll.: Woolaroc Museum.

The Romance of New France. Exhibited: Louisiana Purchase Exposition, 1904, St. Louis.

CAMPBELL, KENNETH F.

Allen Wright (bust). 1¼ times life-size. Dedicated 1958. Coll.: National Hall of Fame for Famous American Indians.

Joseph—Nez-Percé Tribe (bust). Dedicated 1957. 1¼ times life-size. Coll.: National Hall of Fame for Famous American Indians.

Pocahontas (bust). 1¼ times life-size. Dedicated 1965. Coll.: National Hall of Fame for Famous American Indians.

CARLSON, GEORGE

Boy and the Eagle. First version: 1966; H. 12″; Noggle Bronze Works, Prescott, Ariz. Second version: 1970; H. 15″; Peterson Bronze Foundry, Venice, Calif.

Dance of the Mandan Buffalo Society. 1970. H. 15″. Peterson Bronze Foundry, Venice, Calif.

The Greeting. 1970. H. 17″. Bronze Images, Loveland, Colo. Coll.: Denver Public Library.

The Last Breath. 1968. H. 8″. Bronze Images, Loveland, Colo.

Lone Bear. 1967. H. 22″. Peterson Bronze Foundry, Venice, Calif.

Navaho Mountain Chant. 1970. H. 15″. Bronze Images, Loveland, Colo.

Navaho Woman. 1965. H. 18″. Peterson Bronze Foundry, Venice, Calif.

Pledge to the Sun. 1970. H. 17″. Bronze Images, Loveland, Colo.

The Vision. 1970. H. 19½″. Bronze Images, Loveland, Colo. Coll.: Denver Public Library.

Zuni Medicine Man. 1965. H. 9″. Peterson Bronze Foundry, Venice, Calif.

CARY, WILLIAM DE LA MONTAGNE

Going the White Man's Way. 1909. H. 12½″. Roman Bronze Works, N. Y. Coll.: Gilcrease Institute.

Pets of the Teepee. c. 1910. H. 11½″. Roman Bronze Works, N. Y. Coll.: Gilcrease Institute.

CHAPPELL, WILLIAM

Apache Warrior. 1968. H. 5¾″. Nambe Mills Foundry, Santa Fe, N. M.

Checkin' the Bronc. 1967. H. 11″. La Plata Bronze, Taos, N. M.

Chow Time (buffalo cow and calves). 1970. H. 7″. La Plata Bronze, Taos, N. M.

El Coyote. 1968. H. 5″. Nambe Mills Foundry, Santa Fe, N. M.

Mountain Sheep Family. 1971. H. 5″. La Plata Bronze, Taos, N. M.

Qualified (rider on bronc). 1970. H. 14″. La Plata Bronze, Taos, N. M.

Royal Elk. 1969. H. 28″. La Plata Bronze, Taos, N. M.

Southwest (road runner). 1970. H. 6″. La Plata Bronze, Taos, N. M.

West Bound Stage. 1972. H. 18″. La Plata Bronze, Taos, N. M.

The Winner (buffalo bull). 1970. H. 18″. La Plata Bronze, Taos, N. M.; Nambe Mills Foundry, Santa Fe, N. M.

CLARK, JAMES LIPPITT

Alaskan Kodiak Bear. 1904. H. 12″. Cast during the artist's lifetime. Coll.: Montclair Art Museum.

Alaskan White Sheep. 1939. H. 10″. Coll.: Explorers Club.

Bighorn Ram. H. 7½″.

Grizzly Bear. H. 24″. Original and recent castings: Montclair Art Museum; C. M. Russell Gallery.

Grizzly Bear Cubs at Play. 1920. H. 4″.

Osborn Caribou. 1930. H. 12″. Recent castings.

The Pronghorn. H. 9″.

Spotted Hyena. Modeled 1903. H. 6″. Gorham and Co., N. Y. Coll.: Brookgreen Gardens.

Standing Bear. H. 15″.

Wapiti Bull. H. 15″.

Wapiti Cow. 1950. H. 15″.

Wild Horses. c. 1930. H. 6½″.

CLARKE, JOHN L.

Glacier Park Bear. H. 10″.

Porcupine Quill. 1969. H. 10″. Ed Bohlin Founder, Los Angeles. Coll.: C. M. Russell Gallery.

CRISTADORO, CHARLES C.

A Range Rider of the Yellowstone. Heroic size: Billings, Montana, Airport; William S. Hart Museum.

Two Gun Bill. 1925. H. 37 ⅜″. Coll.: University of Delaware; William S. Hart Museum.

CURTIS, HUGHES

Buckboard Bounce. 1969. H. 13″. Cast by the artist.

Cowboy Serenade. 1948. H. 22″. Cast by the artist.

Death and the Drunkard. 1940. H. 27″. Cast by the artist.

The Herder. 1953. H. 20″. Cast by the artist.

Jemez Drummer. 1951. H. 23″. Cast by the artist.

Navaho Water Carrier. 1946. H. 16″. Cast by the artist.

Rim Rock. 1968. H. 16″. Cast by the artist. Coll.: Springville Art Gallery.

Saddling Up. 1947. H. 23″. Cast by the artist.

Spike. 1947. H. 15″. Cast by the artist.

Whittler. 1949. H. 21″. Cast by the artist.

DALLIN, CYRUS

Angel. 1924. Life-size. Temple Square, Salt Lake City, Ut.

Appeal to the Great Spirit. 1909. Life-size: in front of Museum of Fine Arts, Boston (dedicated 1913); U.S. State Department, Washington, D. C.; Walnut Street Bridge, Muncie, Ind., 1929. Small models 1913: H. c. 36″, 22″, c. 10″. Gorham and Co., N. Y. (cast many times). Coll.: Montclair Art Museum; Springville Museum of Art; Whitney Gallery of Western Art.

Archery Lesson. 1907. H. 17″. Also recent castings. Roman Bronze Works, N.Y.

Brigham Young Pioneer Monument (figures of Massasoit, Jim Bridger, Chief Washakie, and Brigham Young). Life-size. Dedicated 1897. Salt Lake City. Ut.

Cavalry Man. 1905. Heroic size. Hanover, Pa.

Emmeline B. Wells (a pioneer woman). Coll.: Springville Museum of Art.

Indian Chief (Mounted Warrior). 1884. H. 26″. Coll.: Gilcrease Institute.

Indian Chief (standing). Cast 1907. H. 26″. New-York Historical Society.

Indian Group. 1907.

Indian Hunter at the Spring. Dedicated 1913. Life-size. Robbins Memorial Park, Arlington, Mass.

The Last Arrow. 1923.

Massasoit. c. 1921. Life-size. Gorham and Co., N. Y.; Coles Hill, Plymouth, Mass. Life-size: in front of State Capitol, Salt Lake City, Ut., as part of the *Brigham Young Pioneer Monument*. Small version: Woolaroc Museum.

Medicine Man. Erected 1903. Life-size: Fairmount Park, Philadelphia. Small version: modeled 1899; H. 17″; Gruet Fondeur, Paris. Coll.: Gilcrease Institute; St. Louis Art Museum.

On the Trail (plaque with pioneers and covered wagons). H. 23″. Gorham and Co., N.Y.

On the Warpath. 1915. H. 33″, 23″. Gorham and Co., N.Y. Coll.: Brookgreen Gardens; R. W. Norton Art Gallery.

Pioneer Mother (A Memorial to the Pioneer Mothers of Springville, Utah). 1931. Life-size. Springville, Ut.

The Protest. 1904. Roman Bronze Works, N.Y.; Gorham and Co., N.Y. Exhibited: Louisiana Purchase Exposition, 1904, St. Louis. Small model: H. 18½″; Roman Bronze Works, N.Y. Some recent castings.

The Scout. Modeled 1914. Dedicated 1922. Heroic size. Penn Valley Park, Kansas City, Mo. Small models: H. 39″, cast 1902 by the artist; H. 36″, 22″, and 8″, Gorham and Co., N.Y. Exhibited:

Panama-Pacific Exposition, 1915, San Francisco.

Self-Portrait (bust). 1925. Coll.: Springville Museum of Art.

The Signal of Peace. Dedicated 1894. Life-size. Lincoln Park, Chicago. Exhibited: Columbian Exposition, 1893, Chicago.

Signing the Compact. H. 24″. Provincetown, Mass.

Two-Gun Cowboy (Cowboy Shooting 'Em Up). 1920. H. 24″. Gorham and Co., N.Y.

War or Peace. c. 1905. H. 33″. Roman Bronze Works, N. Y. Some modern castings.

DAVIDSON, JO

Pioneer Woman. 1927. H. 35″. Roman Bronze Works, N.Y. Coll.: Woolaroc Museum.

Will Rogers. 1938. H. 85″. National Statuary Hall, Washington, D.C.; Will Rogers Memorial. Small model: H. 20″. Cere Foundry. Coll.: Gilcrease Institute; Joslyn Art Museum.

DE GRAZIA, TED

Apache Hunter. 1960. H. 8″. Roman Bronze Works, N.Y. Noggle Bronze Works, Prescott, Ariz.

Desert Coyote. 1960. H. 5¼″. Noggle Bronze Works, Prescott, Ariz.

Indian Horse. 1960. H. 3″. Noggle Bronze Works, Prescott, Ariz.

Indian Mother. 1970. H. 10″. Nambe Mills Foundry, Santa Fe, N.M.

Junipero Serra. 1969. H. 12″. Classic Bronze, El Monte, Calif.

Navaho Family. c. 1960. H. 8″. Noggle Bronze Works, Prescott, Ariz.

Padre Kino. 1966. H. 7½″. Noggle Bronze Works, Prescott, Ariz.; Roman Bronze Works, N.Y.

Road Runner. c. 1960. H. 7″. Noggle Bronze Works, Prescott, Ariz.

Yaqui Deer Dancer. c. 1960. H. 10″. Noggle Bronze Works, Prescott, Ariz.

DEMING, EDWIN W.

Bear Bookends. c. 1905–10. H. 5⅜″. Coll.: R. W. Norton Art Gallery.

Bear Cubs Nursing. Coll.: Whitney Gallery of Western Art.

Bears Eating Honey. 1905. H. 4½″. Coll.: R. W. Norton Art Gallery.

Bears in Combat. 1916. H. 6½″. Roman Bronze Works, N.Y.

Buffalo. H. 14½″. Coll.: Brooklyn Museum.

The Fight. c. 1906. H. 7¾″. Roman Bronze Works, N.Y. Coll.: Brookgreen Gardens; Gibbs Memorial Art Gallery; The Metropolitan Museum of Art.

Indian and Deer. 1901. Coll.: Remington Art Memorial Museum.

The Mourning Brave. Coll.: National Gallery of Art.

Mutual Surprise. 1907. H. 9½″. Roman Bronze Works, N.Y. Coll.: The Metropolitan Museum of Art; R. W. Norton Art Gallery.

The Seer (old woman leaning on a spear). c. 1905. H. 10″. Roman Bronze Works, N.Y.

Two Wolves. 1910. Coll.: Remington Art Memorial Museum.

The Watering Place.

EGGENHOFER, NICK

Dog Soldier. 1967. H. 13″. Avnet Shaw Foundry, Plainview, N.Y.

Travois. 1967. H. 9½″. Avnet Shaw Foundry, Plainview, N.Y.

Trouble Underfoot. 1969. H. 9″. Avnet Shaw Foundry, Plainview, N.Y.

The Wagon Boss. 1969. H. 9″. Avnet Shaw Foundry, Plainview, N.Y.

ELWELL, R. FARRINGTON

Indian in a Canoe. Cast 1930s. H. 11″. Noggle Bronze Works, Prescott, Ariz. Coll.: Woolaroc Museum. Cast 1972. H. c. 8″. Art Bronze, London.

The Sun Fisher. Modeled 1930s. Cast 1972. H. c. 16″. Art Bronze, London.

FAIRBANKS, AVARD T.

Bronze Doors of Historic Oregon. Entrance of United States National Bank, Portland, Ore.

Buffalo. Coll.: Springville Museum of Art.

Dr. Marcus Whitman (pioneer to the Pacific Northwest). 1950–52. H. 8′. Roman Bronze Works, N.Y. Coll.: National Statuary Hall, Washington, D.C.

Esther Morris. c. 1961. In front of the State Capitol, Cheyenne, Wyo. Coll.: National Statuary Hall, Washington, D.C.

The Fighting Sioux. 1966. University of North Dakota.

John Burke. State Capitol grounds, Bismarck, N.D. Coll.: National Statuary Hall, Washington, D.C.

Lincoln the Frontiersman. 1939–40. H. 9′. Roman Bronze Works, N.Y. Ewa Plantation School, Hawaii.

Old Oregon Trail (medallion). 1924. Diam. 3′. Oregon Brass Works, Baker and Seaside, Ore.

Pioneer Family. Dedicated 1947. H. 9′. Garganni Foundry, N.Y. State Capitol grounds, Bismarck, N.D.

Pioneer Mothers Memorial (in honor of the Old Oregon Trail Pioneers). 1927–28. Dedicated 1929. H. 7′. Cast in Florence, Italy. Esther Short Park, Vancouver, Wash.

Pony Express (equestrian group). Utah Pioneer Centennial Celebration.

Pony Express Monument. Dedicated 1963. Stateline, Lake Tahoe, Nevada (near Friday's Station, a relay point on the cross-country road).

Ute Brave. Union Building, University of Utah, Salt Lake City.

Winter Quarters. Modeled 1935. H. 8′. Roman Bronze Works, N.Y. Mormon Pioneer Cemetery, Florence, Neb. Scale model: Joslyn Art Museum; Temple Square Museum.

FARNHAM, SALLY JAMES

The Cowboy. H. 9½″. Coll.: Remington Art Memorial Museum.

Horse and Rider. c. 1900. H. 9½″. Roman Bronze Works, N.Y. Coll.: Remington Art Memorial Museum.

Payday Going to Town. 1931. H. 18″. Roman Bronze Works, N.Y. Coll.: Woolaroc Museum.

Scratchin' 'Im. H. 12¾″. Roman Bronze Works, N.Y. Coll.: R. W. Norton Art Gallery.

The Sun Fisher. c. 1920. H. 14″. Roman Bronze Works, N.Y. Coll.: R. W. Norton Art Gallery.

Will Rogers. Modeled 1938. H. 21″, 8½″. Roman Bronze Works, N.Y. Coll.: R. W. Norton Art Gallery.

FRASER, JAMES EARLE

Bear. Copyright 1931. H. 6½″. Recent castings: Modern Art Foundry, Long Island City, N.Y.

Buffalo Herd. 1950. H. 13″. Unfinished at the artist's death. Recent castings: H. 30″; 6″. Modern Art Foundry, Long Island City, N.Y.

Buffalo Prayer. Modeled c. 1917, cast c. 1931. H. 44″. Second castings after the artist's death: Modern Art Foundry, Long Island City, N.Y. Coll.: Whitney Gallery of Western Art.

Discoverers and Indians. Michigan Boulevard Bridge, Chicago.

The End of the Trail (early version). Modeled c. 1894, cast 1971. H. 12″. Modern Art Foundry, Long Island City, N.Y. Coll.: George Arents Research Library, Syracuse University.

The End of the Trail (final version). Original plaster modeled 1915. H. 18′. National Cowboy Hall of Fame. Bronze: Mooney Grove, Visalia, Calif. 1971. H. 18′. Life-size: unveiled 1929, Waupon, Wis. Small models: H. 45″, 38″, 37″, 33″, 30⅜″, 18″, 12″. Cast 1918: Roman Bronze Works, N.Y; Gorham and Co., N.Y. Recent casting: Modern Art Foundry, Long Island City, N.Y. Coll.: Dallas Museum of Fine Arts; Detroit Institute of Art; Gilcrease Institute; Joslyn Art Museum; Nelson Gallery-Atkins Museum; R. W. Norton Art Gallery; Rockwell Foundation; St. Louis Art Museum; Whitney Gallery of Western Art. Exhibited: Panama-Pacific Exposition, 1915, San Francisco (Gold Medal).

Cheyenne Chief. 1904. Heroic size. Exhibited: Louisiana Purchase Exposition, 1904, St. Louis.

Indian Head: Two Moons. c. 1919. H. 13.″ Recent castings: Modern Art Foundry, Long Island City, N.Y.

Indian Head: White Eagle. 1919. H. 14″. Recent castings: Modern Art Foundry, Long Island City, N.Y.

Lewis and Clark. c. 1927. Heroic size. State Capitol, Jefferson City, Mo. Small model: H. 30″; recent casting: Modern Art Foundry, Long Island City, N.Y.

Pioneer Woman (study). H. 16″. Recent castings: Modern Art Foundry, Long Island City, N.Y.

Pioneer Woman. 1927. H. 36″. Cast for competition and recent castings: Modern Art Foundry, Long Island City, N.Y. Coll.: Woolaroc Museum.

Storm-Driven. c. 1918. H. 16″. Recent castings: Modern Art Foundry, Long Island City, N.Y.

Theodore Roosevelt as a Rough Rider. Modeled 1910, cast 1920. H. 22″, 8¼″. Recent castings (22″ version): Modern Art Foundry, Long Island City, N.Y. Coll.: American Museum of Natural History; New-York Historical Society; R. W. Norton Art Gallery.

Theodore Roosevelt with Gunbearers. c. 1939, H. c. 24½″, 12½″. Heroic size: American Museum of Natural History (cast by Gorham and Co., N.Y.). Small model, recent casting: Modern Art Foundry, Long Island City, N.Y.

Wind Swept (In the Wind). c. 1916. H. 5″. Recent castings: Modern Art Foundry, Long Island City, N.Y.

FRAUGHTON, EDWARD J.

Bog Rider. 1972. H. 19″. Young Fine Art Casting, Salt Lake City, Utah.

Brigham Young (portrait bust). 1970. H. 24″. Western Arts Studio, Salt Lake City, Utah. Brigham Young Cemetery, Salt Lake City, Utah.

Buffalo Hunter (portrait bust). 1971. H. 8″. Western Arts Studio, Salt Lake City, Utah.

Buffalo Scout. 1971. H. 17½″. Western Arts Studio, Salt Lake City, Utah; Ed Kearney Casting, Logan, Utah; Young Fine Art Casting, Salt Lake City, Utah.

A Draw. 1971. H. 5¾″. Western Arts Studio, Salt Lake City, Utah.

The Last Arrow. 1973. H. 16″. Young Fine Art Casting, Salt Lake City, Utah.

Mormon Battalion Monument. 1969. H. 9½′. Fonderia Ferdinando Marinelli, Florence, Italy. Presidio Park, San Diego, Calif. Small model: cast 1969. H. 24″. Art Bronzes, Richmond, Calif.

Partners (prospector). 1968. H. 9¼″. Cast by the artist; Western Arts Studio, Salt Lake City, Utah; Ed Kearney Casting, Logan, Utah; Young Fine Art Casting, Salt Lake City, Utah.

Pioneer Family Group. 1974. H. 8′. Western Arts Studio, Salt Lake City, Utah. Brigham Young Cemetery, Salt Lake City, Utah.

Sugar Leo (portrait of a champion quarter horse stallion). 1968. H. 17½″. Cast by the artist; Art Bronzes, Richmond, Calif.

Where the Trail Ends. 1973. H. 15½″. Young Fine Art Casting, Salt Lake City, Utah.

Winter Quarters Monument (relief plaque). 1971. H. 54″. Western Arts Studio, Salt Lake City, Utah. Mormon Pioneer Cemetery, Florence, Neb.

FREE, JOHN D.

Almost a Bad Day. 1965. H. 6¼″. Harrold Phippen Foundry, Topeka Kan.

Bluffin' She Ain't. 1969. H. 6″. Harrold Phippen Foundry, Topeka, Kan.

Cow Boss. 1966. H. 7½″. Harrold Phippen Foundry, Topeka, Kan. Coll.: National Cowboy Hall of Fame.

Cuttin' One Back. 1965. H. 6¾″. Harrold Phippen Foundry, Topeka, Kan.

The Last War Whoop. 1967. H. 8″. Harrold Phippen Foundry, Topeka, Kan.

Nothin' Like a Chaw. 1971. H. 4½″. Harrold Phippen Foundry, Topeka, Kan.

Range Pony. 1968. H. 5½″. Harrold Phippen Foundry, Topeka, Kan.

Signal to String 'Em. 1970. H. 8½″. Harrold Phippen Foundry, Topeka, Kan.

Two Party Line. 1968. H. 7¼″. Harrold Phippen Foundry, Topeka, Kan.

Where the Money Is Made. 1967. H. 6¾″. Harrold Phippen Foundry, Topeka, Kan.

GREEVES, RICHARD V.

AMERICAN WESTERN CHARACTERS SERIES:

Mr. Cavalryman. 1970. H. 19″. Bear Paw Bronze Works, Skull Valley, Ariz.

Mr. Cowboy. 1970. H. 18″. Bear Paw Bronze Works, Skull Valley, Ariz.

Mr. Gambler. 1970. H. 18″. Bear Paw Bronze Works, Skull Valley, Ariz.

Mr. Indian. 1970. H. 18¾″. Bear Paw Bronze Works, Skull Valley, Ariz.

Mr. Miner. 1970. H. 18″. Bear Paw Bronze Works, Skull Valley, Ariz.

Mr. Mountain Man. 1970. H. 18″. Bear Paw Bronze Works, Skull Valley, Ariz.

HAMILTON, JIM

The Contract (cowboys shaking hands). 1970. H. 13″. Turkey Track Foundry, Pawhuska, Okla.

Drummin' (cowboy meets girl). 1968. H. 10¼″. Harrold Phippen Foundry, Topeka, Kan.

The Four Horsemen (children on horse). 1971. H. 10½″. Turkey Track Foundry, Pawhuska, Okla.

Ground Tide (cow pony). 1969. H. 9″. Tur-

key Track Foundry, Pawhuska, Okla.

Learnin' How (roping a horse). 1972. H. 10″. Turkey Track Foundry, Pawhuska, Okla.

Siesta. 1971. H. 3¾″. Turkey Track Foundry, Pawhuska, Okla.

Sprout (boy and a dog). 1968. H. 11″. Turkey Track Foundry, Pawhuska, Okla.

Summertime (two horses). 1970. H. 8¼″. Turkey Track Foundry, Pawhuska, Okla.

Tall in the Saddle. 1971. H. 14¼″. Turkey Track Foundry, Pawhuska, Okla.

Thinking Big (boy, horse, and dog). 1968. H. 7″. Turkey Track Foundry, Pawhuska, Okla.

HANBURY, UNA

End of the Siesta (colt). 1971. H. 5″. Nambe Mills Foundry, Santa Fe, N.M.

Maid to Please. 1971. H. 9″. Nambe Mills Foundry, Santa Fe, N. M.

Moniet El Nefous (mare). 1970. H. 10″. Nambe Mills Foundry, Santa Fe, N.M.

Navaholand. 1973. H. 20″. Shidoni Founders, Santa Fe, N.M.

New Born Foal. 1971. H. 2″. Shidoni Founders, Santa Fe, N.M.

Sentinels (mountain goats). 1972. H. 14″ without base. Shidoni Founders, Santa Fe, N.M.

Tatumi (colt). 1970. H. 8″. Nambe Mills Foundry, Santa Fe, N.M.

Tonto Bars Hank. 1971. H. 9½″. Nambe Mills Foundry, Santa Fe, N.M.

Twilight Grazing. 1971. H. 6½″. Nambe Mills Foundry, Santa Fe, N.M.

HARVEY, ELI

American Bison. 1907. H. 9¾″. Coll.: Los Angeles County Museum of Art.

Brown Bear. Life-size. Providence, R.I.

Bull Elk (Elk's Club insignia). 1907. H. 34″. Gorham and Co., N.Y. Coll.: Denver, Colo.: Los Angeles County Museum of Art; Marshalltown, Iowa; Mohawk Trail, Mass.; Omaha, Neb.; Terre Haute, Ind.; Whitney Gallery of Western Art.

Longhorn. 1904. H. 18″. Roman Bronze Works, N.Y.

Panther. 1908. H. 11½″. Coll.: Newark Museum.

HEIKKA, EARLE

Big Horn Sheep. Recent casting. Coll.: C. M. Russell Gallery.

C. M. Russell (portrait from a plaster). Modeled 1930. Recent casting. H. 10¾″. Classic Bronze, El Monte, Calif.; Modern Art Foundry, Long Island City, N.Y. Coll.: R. W. Norton Art Gallery.

Day of the Slow Guns. Recent casting. H. 13½″. Classic Bronze, El Monte, Calif.

Fallen Prey. Cast 1962. H. 7″. Rodriguez Bronze, Los Angeles, Calif.

Hangover. Recent casting. H. 6½″. Classic Bronze, El Monte, Calif.

Miss Wild West. Recent casting. H. 13″. Classic Bronze, El Monte, Calif.

Montana Wolf. Cast 1961. H. 8″. Modern Art Foundry, Long Island City, N.Y. Coll.: C. M. Russell Gallery.

Overland Stage. Recent casting. H. 16½″. Classic Bronze, El Monte, Calif.

Pack Horse. Modeled 1940. H. 9½″. Recent casting. Avnet Shaw Foundry, Plainview, N.Y.; Roman Bronze Works, N.Y. Coll.: C. M. Russell Gallery.

Piegan Scout. Modeled 1931. H. 15″. Recent casting. Classic Bronze, El Monte, Calif.

Road Agent. Modeled 1930s, cast 1960s. H. 11½″. Classic Bronze, El Monte, Calif. Coll.: National Cowboy Hall of Fame.

Saddle Horse. Modeled 1930s. H. 11″. Recent casting. Avnet Shaw Foundry, Plainview, N.Y. Coll.: C. M. Russell Gallery.

Surprise. Recent casting. Classic Bronze, El Monte, Calif.

Three-Figure Pack Train. Modeled 1930s. H. 11½″. Recent casting. Roman Bronze Works, N.Y. Coll.: C. M. Russell Gallery.

Trophy Hunters (five-figure pack train). Modeled 1930. H. 14½″. Modern casting. Classic Bronze, El Monte, Calif.

HOFFMAN, FRANK

Buffalo (standing). H. 7″. Recent casting.

Lying Down Buffalo. Modeled 1920, cast c. 1971. H. 6″. Specialty Precision Casting, Tucson, Ariz.

HOFFMAN, MALVINA

Apache—Jicarilla (bust). 1934. Roman Bronze Works, N.Y. H. 20″. Coll.: Field Museum of Natural History.

Blackfoot Woman. c. 1923. H. c. 24″. Alexis Rudier, Paris. Coll.: Field Museum of Natural History.

Eskimo Man (bust). 1930. H. 18½″. Alexis Rudier, Paris. Coll.: Field Museum of Natural History.

Eskimo Woman (bust). 1930. H. 16″. Alexis Rudier, Paris. Coll.: Field Museum of Natural History.

Horse. Alexis Rudier, Paris. Coll.: Woolaroc Museum.

Navaho Man (bust). 1934. H. 68″. A. Valsuani, Paris. Coll.: Field Museum of Natural History.

Navaho Woman (standing). 1934. Alexis Rudier, Paris.

San Ildefonso (woman's head). 1934. H. 14″. Roman Bronze Works, N.Y. Coll.: Field Museum of Natural History.

Sign Talk (*Blackfoot Man*). 1930. H. 24″, 79″. Alexis Rudier, Paris. Coll.: Field Museum of Natural History; Gilcrease Institute.

Sioux Man. 1930. H. 17″. Alexis Rudier, Paris. Coll.: Field Museum of Natural History.

HOMER II, SAINT CLAIR

Apache Scout. 1962. H. 12½″. Cast by the artist. F. Bruni Fondeur, Rome; Precision Metal Smiths, Cleveland, Ohio. Coll.: George Gund Collection of Western Art; R. W. Norton Art Gallery.

Cheyenne Dog Soldier. 1965. H. 12″. F. Bruni Fondeur, Rome; Precision Metal Smiths, Cleveland, Ohio. Coll.: R. W. Norton Gallery.

He Found Apache Gold. 1958. H. 2¼″. Cast by the artist. Coll.: R. W. Norton Art Gallery.

One of Lee's Soldiers. 1964. H. 4″. F. Bruni Fondeur, Rome; Precision Metal Smiths, Cleveland, Ohio. Coll.: R. W. Norton Art Gallery.

One Too Many Irons in the Fire (One-Eyed Pete). 1965. H. 7″. Cast by the artist. Precision Metal Smiths, Cleveland, Ohio. Coll.: George Gund Collection of Western Art; R. W. Norton Art Gallery.

The Only Shield on the Staked Plain. 1964. H. 8″. Precision Metal Smiths, Cleveland, Ohio.

Red Man's Requiem. 1958. H. 2″. Cast by the artist. Coll.: R. W. Norton Art Gallery.

The Sheriff. 1962. H. 8″. Cast by the artist. F. Bruni Fondeur, Rome; Precision Metal Smiths, Cleveland, Ohio. Coll.: R. W. Norton Art Gallery.

Sioux. 1965. H. 3¾″. Cast by the artist. Coll.: R. W. Norton Art Gallery.

A Sioux Called Hump. 1958. H. 11″. Cast by the artist. Precision Metal Smiths, Cleveland, Ohio. Coll.: George Gund Collection of Western Art.

The Spirit Horse. 1973. H. 8¾″. Precision Metal Smiths, Cleveland, Ohio.

The Star Shooter. 1970. H. 29″. F. Bruni Fondeur, Rome.

HOUSER, ALLAN C.

Apache Devil Dancer. c. 1961. H. 15.″ Nambe Mills Foundry, Santa Fe, N. M. Coll.: Department of the Interior, Indian Office.

Buffalo Dancer. c. 1969. Metal, masonry nails, and welding rods. H. 15″. Nambe Mills Foundry, Santa Fe, N. M. Coll.: Heard Museum of Anthropology and Primitive Art (Indian Collection).

Flute Player. 1971. H. 8″. Nambe Mills Foundry, Santa Fe, N.M.

Herding Goats. 1971. H .16½″. Nambe Mills Foundry, Santa Fe, N. M. Coll.: Southern Plains Indian Museum and Craft Center.

Indian and Hawk. 1971. H. 18″. Nambe Mills Foundry, Santa Fe, N.M. Coll.:

Institute of American Indian Arts.

The Lead Singer. 1970. H. 10½″. Nambe Mills Foundry, Santa Fe, N.M.

Morning Song. 1971. H. 7″. Nambe Mills Foundry, Santa Fe, N.M. Coll.: Institute of American Indian Arts.

Navaho Sheep Herder. H. 6¾″. Nambe Mills Foundry, Santa Fe, N.M.

Rain Arrow. 1971. H. 12¼″. Nambe Mills Foundry, Santa Fe, N.M.

HUMPHRISS, CHARLES H.

Appeal to the Great Spirit. 1900. H. 30½″. Gorham and Co., N.Y.; Roman Bronze Works, N.Y. Coll.: Gilcrease Institute.

Cowboy on a Bucking Horse. c. 1910.

Dance Leader. H. 19″. Coll.: Montclair Art Museum.

Indian Chief (bust). H. 49″. Roman Bronze Works, N.Y. Coll.: Gilcrease Institute.

Indian Chief (sundial). H. 30½″. Roman Bronze Works, N.Y. Coll.: Gilcrease Institute. H..45″; Montclair Art Museum.

Indian on a Horse (Warrior).

Indian's Appeal to Manitou. 1906. H. 16½″. Coll.: Gilcrease Institute.

The Trumpeter. 1910. H. 20″.

Water for a Helpless Brother. H. 21½″.

HUNT, WAYNE C.

Bronco Buster. H. 9″.

Cochise. H. 15½″.

Cowboy Roping a Wild Horse. H. 9″.

Fighting Mustangs.

Hung Up. H. 8½″.

Mustanger.

The Sun Fisher. H. 13″.

Tom Jeffords. Cast 1969. H. 16″. Classic Bronze, El Monte, Calif.

HUNTINGTON, ANNA HYATT

Bear Playing with His Feet. Coll.: R. W. Norton Gallery (two).

Bears. 1960. H. 78″. Coll.: National Hall of Fame for Famous American Indians.

Bison or Buffalo. H. 12″.

Brown Bears. 1935. H. 45″. Gorham and Co., N.Y. Coll.: Brookgreen Gardens.

Burro Bucking Pack. 1936. H. c. 6″. Coll.: Museum of Northern Arizona.

Colts in a Snow Storm.

Fawn. Coll.: Corcoran Gallery of Art; Joslyn Art Museum.

Fighting Bulls. H. 8½″.

Fighting Stallions. 1950. H. 77″. Coll.: Brookgreen Gardens; Redding Public School, Redding, Conn.

Goats Butting. 1904. H. 10¼″. Roman Bronze Works, N.Y. Coll.: Detroit Institute of Art; The Metropolitan Museum of Art.

Horses. H. 8½″.

I Want All the Reins in My Hand. Coll.: R. W. Norton Art Gallery.

Jaguar (Panther). Modeled 1906, cast 1926. H. 28½″. Jno Williams Founder, N.Y. Coll.: The Metropolitan Museum of Art. Exhibited: Panama-Pacific Exposition, 1915, San Francisco (plaster).

Jaguar Eating. 1907. H. 17″. Kunst Foundry, N.Y. Coll.: Brookgreen Gardens.

Jaguar on a Ledge. H. 8″. Coll.: R. W. Norton Art Gallery.

Jaguars. 1935. H. 32″. Gorham and Co., N.Y. Coll.: Brookgreen Gardens.

Men and Bull.

Panther. (looking up). H. 8⅝″. Gorham and Co., N.Y. Coll.: Newark Museum.

Pony with Ears Laid Back. 1930. Coll.: Museum of New Mexico.

Reaching Jaguar (Reaching Panther). Modeled 1906, cast 1926. H. 45″. Jno Williams Founder, N.Y. Coll.: Bronx Zoo Park, N.Y.; Brookgreen Gardens; The Metropolitan Museum of Art; Newark Museum. Exhibited: Panama-Pacific Exposition, 1915, San Francisco (plaster). Early study: 1906. H. 6⅜″. Gorham and Co., N.Y. Coll.: Joslyn Art Museum.

Rolling Bear. Before 1914. H. 3¼″. Roman Bronze Works, N.Y. Coll.: Newark Museum.

Rolling Horse. H. 7″. Coll.: National Cowboy Hall of Fame.

Wild Boars. 1935. H. 43½″. Roman Bronze Works, N.Y. Coll.: Brookgreen Gardens; R. W. Norton Art Gallery.

Winter. c. 1902. H. 7½″. Roman Bronze Works, N.Y. Coll.: The Metropolitan Museum of Art. Exhibited: Louisiana Purchase Exposition, 1904, St. Louis.

Wolf and Its Prey. c. 1960. H. 6½″.

Wolves. 1960. H. 78″. Coll.: National Hall of Fame for Famous American Indians.

Work Horse. 1963.

Young Abe Lincoln. 1961. H. 39½″. Coll.: Public Library, Bethel, Conn.; Phoenix Art Museum.

JACKSON, HARRY

Algonquin Chief and Warrior. 1971. H. 30″. Wyoming Foundry Studios, Lucca, Italy. Coll.: Woolaroc Museum.

Bustin' One. 1959. H. 13″. Wyoming Foundry Studios, Lucca, Italy; Vignali-Tommasi, Pietrasanta Art Foundry, Pietrasanta, Italy. Coll.: Amon Carter Museum.

The Cowboy's Meditation. 1964. H. 23″. Wyoming Foundry Studios, Lucca, Italy; Vignali-Tommasi, Pietrasanta Art Foundry, Pietrasanta, Italy. Coll.: Woolaroc Museum.

Cowman's Salty Cuss. 1959. Wyoming Foundry Studios, Lucca, Italy; Vignali-Tommasi, Pietrasanta Art Foundry, Pietrasanta, Italy. Coll.: Texas Memorial Museum, University of Texas.

Lone Hand. 1961. H. 15″. Wyoming Found-

ry Studios, Lucca, Italy; Vignali-Tommasi, Pietrasanta Art Foundry, Pietrasanta, Italy. Coll.: Texas Memorial Museum, University of Texas.

The Pony Express. 1967. H. 19″. Polychrome bronze. Wyoming Foundry Studios, Lucca, Italy. Coll.: Wyoming State History and Archives Dept.

The Range Burial. 1958. H. 15¼″. Vignali-Tommasi, Pietrasanta Art Foundry, Pietrasanta, Italy. Coll.: Amon Carter Museum; R. W. Norton Art Gallery; Whitney Gallery of Western Art.

Running in the Remuda. 1961. Wyoming Foundry Studios, Lucca, Italy; Vignali-Tommasi, Pietrasanta Art Foundry, Pietrasanta, Italy. Coll.: Texas Memorial Museum, University of Texas.

Sittin' Purty. 1959. H. 16″. Wyoming Foundry Studios, Lucca, Italy; Vignali-Tommasi, Pietrasanta Art Foundry, Pietrasanta, Italy.

Stampede. 1958–59. H. 14½″. Vignali-Tommasi, Pietrasanta Art Foundry, Pietrasanta, Italy. Coll.: Amon Carter Museum; Whitney Gallery of Western Art.

The Steer Roper. 1959. H. 12″. Wyoming Foundry Studios, Lucca, Italy; Vignali-Tommasi, Pietrasanta Art Foundry, Pietrasanta, Italy. Coll.: Glenbow-Alberta Institute; Whitney Gallery of Western Art.

Trail Boss. 1958. H. 8½″. Wyoming Foundry Studios, Lucca, Italy; Vignali-Tommasi, Pietrasanta Art Foundry, Pietrasanta, Italy.

JENNEWEIN, C. PAUL

Eagle. Arlington Bridge, Washington, D.C.

Indian and Eagle. 1929. H. 58″. Roman Bronze Works, N.Y. Coll.: Ball State Teachers College, Muncie, Ind.; Brookgreen Gardens; Tours, France; National Collection of Fine Arts, Smithsonian Institution.

JONAS, LOUIS PAUL

Caribou. H. 9″. Coll.: Woolaroc Museum.

Chief Eagle Head. H. 14⅜″. Terra cotta with bronze finish. Coll.: Lauren Rogers Library and Museum of Art.

Deer. H. 11″. Coll.: Woolaroc Museum.

Grizzly's Last Stand. 1930. H. 12′ 6″. City Park, Denver.

Jaguar. H. 5″. Coll.: Brookgreen Gardens.

KAUBA, CARL

Bucky O'Neill. H. 14½″.

The Cavalryman. H. 28½″.

Charging Buffalo. H. 19½″, 9½″. Coll.: Rockwell Foundation.

Chief Wolfrobe. Polychrome bronze. H. 26½″. Coll.: Gilcrease Institute.

The Cowboy (on a bucking horse). Cast c.

1972. H. 7″. Karl Fuhrman and Co., Vienna.

Defiant Warrior. H. 10″.

Early Instruction. H. 15″.

A Friend in Need. H. 19″. Coll.: Gilcrease Institute.

How-Kola ("Remember me, I'm the one who once saved your life so don't shoot!"). H. 20″. Coll.: Gilcrease Institute.

In the Wickie—Up. H. 13½″.

Indian Attack. H. 9½″.

Indian Chief (bust). H. 19″. Coll.: Gilcrease Institute.

Indian Chief with War Bonnet. H. 12¾″.

Indian Horse Thief. Coll.: George F. Harding Museum.

Indian Hunter with Bow and Arrow (on one knee). Cast c. 1972. H. 2½″. Karl Fuhrman and Co., Vienna.

Indian on a Horse (with a raised tomahawk). H. 6″. Cast c. 1972. Karl Fuhrman and Co., Vienna.

Indian Sentry (standing with a rifle). H. 4″.

Indian Tracker with a Rifle (on one knee). H. 2½″. Cast c. 1972. Karl Fuhrman and Co., Vienna.

Indian Training Horse. H. 8″.

Indian Warrior. H. 22½″. Coll.: Gilcrease Institute.

Invocation. H. 11″.

Little Soldier (Indian). Cast c. 1972. H. c. 5″. Karl Fuhrman and Co., Vienna.

A Lost Race. H. 6″.

The Marksman. H. 16½″.

On the War Path. H. 18″.

Peace. H. 29¾″.

Ready for Action. H. 11″.

The Rifleman. H. 6½″.

Running Fire. H. 11½″.

Shot in the Eye (Indian). Cast c. 1972: H. c. 5″. Karl Fuhrman and Co., Vienna.

Smoke on Guard. H. 11½″.

Standing Bear (Indian). Cast c. 1972: H. c. 5″. Karl Fuhrman and Co., Vienna.

Swift Dog (Indian). Cast c. 1972: H. c. 5″. Karl Fuhrman and Co., Vienna.

The War Chant (Indian with canoe). 1920s. Polychrome bronze. H. 6⅜″.

The War Whoop. H. 10¼″. Coll.: Rockwell Foundation.

KEMEYS, EDWARD

After the Feast (wolf). Original plaster modeled 1878. Cast during the artist's lifetime. Coll.: The Field Museum of Natural History. Cast 1972: H. 7¼″.

After the Fight. 1878. Coll.: The Field Museum of Natural History.

Bear. Coll.: University of Michigan Museum of Art.

Bear Cub. 1886. Lakeview Center, Peoria, Ill.

Bears. State Building, Jefferson City, Mo.

Before the Feast (buffalo). 1887. Coll.: The Field Museum of Natural History.

Big Snake (relief). 1894. Entrance to the Marquette Building, Chicago.

Bison (Buffalo). 1887. Bridge to Union Pacific Railroad, Omaha, Neb.

Black Bear. H. 10½″.

Black Hawk (relief). 1894. Entrance to the Marquette Building, Chicago.

Bobcat. H. 22″.

Brown Moose (relief). 1894. Coll.: Chicago Historical Society; Entrance to the Marquette Building, Chicago.

Buffalo. H. 7½″.

Buffalo Hunt (relief). 1894.

Buffalo Reclining. 1895. H. 2¾″.

Chassogonac (relief). 1894. Coll.: Chicago Historical Society; Entrance to the Marquette Building, Chicago.

Chicagou (relief). 1894. Entrance to the Marquette Building, Chicago.

Child of the Plains (antelope).

Cinnamon Cub with Antelope Carcass. Original plaster modeled c. 1881. Cast during the artist's lifetime. Coll.: The Field Museum of Natural History. Cast 1972: H. 9¼″; Wyoming Foundry Studios, Lucca, Italy.

Climbing Panther. Coll.: University of Michigan Museum of Art.

Comrades (bears). Original plaster modeled 1875. H. 8½″. Cast 1972: Wyoming Foundry Studios, Lucca, Italy.

Coyote. H. 9¾″.

Crouching Snarling Panther. c. 1876. H. 5¼″. Coll.: University of Michigan Museum of Art.

Daniel de L'Hut (relief). 1894. Entrance to the Marquette Building, Chicago.

The Deer Stalker. Original plaster modeled before 1885. H. 7⅛″. Cast 1972: Wyoming Foundry Studios, Lucca, Italy.

De Menthet (relief). 1894. Coll.: Chicago Historical Society; Entrance to the Marquette Building, Chicago.

Disturbed at His Breakfast (wildcat and hare). Original plaster modeled 1877. H. 5½″.

Eagle. 1893–94. H. 5′. Coll.: The Field Museum of Natural History; Entrance to Hot Springs National Park, Ark.

Elk. Cast during the artist's lifetime. H. 5⅛″. Coll.: The Field Museum of Natural History.

Elk. Cast 1972. H. 22¼″.

Elk Bronze. H. 5⅛″. Coll.: The Field Museum of Natural History.

The End of the Wood-rat's Tail. Original plaster modeled before 1895. H. 6⅛″.

Fast as Fate (jaguar and snake). Original plaster modeled 1877. Cast during the artist's lifetime. Coll.: The Field Museum of Natural History. Cast 1972: 4″.

Fighting Panther and Deer.

Fox. H. 6⅜″. Coll.: The Field Museum of Natural History.

Frontenac (relief). 1894. Coll.: Chicago Historical Society; Entrance to the Marquette Building, Chicago.

A Grizzly Grave Digger. c. 1884. H. 16½″. Coll.: The Field Museum of Natural History.

Hairy Bear (relief). 1894. Entrance to the Marquette Building, Chicago.

Head of a Buffalo (colossal). St. Louis, Mo. Railroad Station.

Henry de Tonti (relief). 1894. Coll.: Chicago Historical Society; Entrance to the Marquette Building, Chicago.

Howling Coyote. H. 27″. Coll.: The Field Museum of Natural History.

Hudson Bay Wolves. Erected 1872. Life-size. The Philadelphia Zoo, Fairmount Park.

In the Presence of the Queen (panther and alligator). H. 7″. Coll.: The Field Museum of Natural History.

Jacques Marquette (relief). 1894. Entrance to the Marquette Building, Chicago.

Jaguar Lovers. H. 12½″. Coll.: Corcoran Gallery of Art.

Jean Baptiste Talon (relief). 1894. Coll.: Chicago Historical Society; Entrance to the Marquette Building, Chicago.

The John W. Noble Memorial Fountain. 1894. H. 5′. Hot Springs, Ark.

Keokuk (relief). 1894. Entrance to the Marquette Building, Chicago.

La Taupine (relief). 1894. Coll.: Chicago Historical Society; Entrance to the Marquette Building, Chicago.

The Little Brown Man of the Woods (bear). Original plaster modeled c. 1880s. Cast during the artist's lifetime. H. 8¼″. Coll.: The Field Museum of Natural History. Cast 1972: H. 7¾″.

Little Panther (relief). 1894. Entrance to the Marquette Building, Chicago.

Locked in Death. 1877. Coll.: The Field Museum of Natural History.

Louis Joliet (relief). 1894. Coll.: Chicago Historical Society; Entrance to the Marquette Building, Chicago.

Manifest Destiny (wolf). H. 9½″. Coll.: The Field Museum of Natural History.

A Midnight Rambler (bear). H. 9″. Cast during the artist's lifetime. Coll.: The Field Museum of Natural History. Cast 1972: H. 8¾″; Wyoming Foundry Studios, Lucca, Italy.

A Miss Is as Good as a Mile. H. 5″.

Mountain Lion and Elk. 1890. Lakeview Center, Peoria, Ill.

Nika (relief). 1894. Coll.: Chicago Historical Society; Entrance to the Marquette Building, Chicago.

Noon Day (relief). 1894. Coll.: Chicago Historical Society; Entrance to the Marquette Building, Chicago.

Ocelot and Turtle. H. 2½″. Cast 1972: Wyoming Foundry Studios, Lucca, Italy.

On the Verge (bighorn sheep). Original plaster modeled before 1883. H. 14⅛″.

On the War Path. H. 18″.

Panther and Cubs. 1907. H. 26½″. Jno Williams Founder, N.Y. Coll.: The Metropolitan Museum of Art.

Peacock and Sleeping Rabbit. Coll.: The Field Museum of Natural History.

Playing Possum. 1874. Coll.: The Field Museum of Natural History.

Possum Up De Gum Tree. H. 7″. Coll.: The Field Museum of Natural History.

Rangers of the Big Horn (mountain sheep). H. 8¾″. Cast 1972: Wyoming Foundry Studios, Lucca, Italy.

Resting Buffalo. H. 2¾″.

Robert de la Salle (relief). 1894. Coll.: Chicago Historical Society; Entrance to the Marquette Building, Chicago.

Shaubena (relief). 1894. Entrance to the Marquette Building, Chicago.

Sitting Bull (relief plaque). 1884. H. 33½″. Coll.: Chicago Historical Society.

Stag (standing). Coll.: University of Michigan Museum of Art.

Stag (reclining). H. 8⅝″. Coll.: University of Michigan Museum of Art.

Still Hunt. Modeled 1881–83. Erected 1885. 2′7″ × 5′. Central Park, New York City. Small model cast during the artist's lifetime: Coll.: The Field Museum of Natural History. The Sagamore Hill National Historic Site. Cast 1972: H. 6⅝″.

Striding Panther. Coll.: The Field Museum of Natural History.

Toilet in the Chaparral (lynx). Original plaster modeled 1898. H. 8⅛″.

Two Eagles. c. 1893–94. Life-size. Hot Springs National Park, Ark.

Two Panthers. Coll.: University of Michigan Museum of Art.

War Eagle (relief). 1894. Coll.: Chicago Historical Society; Entrance to the Marquette Building, Chicago.

Watching the Beaters. H. 11½″ Coll.: The Field Museum of Natural History.

Waubansie (relief). 1894. Entrance to the Marquette Building, Chicago.

While Mother Sleeps. 1875. H. 6⅜″. Coll.: The Field Museum of Natural History; National Collection of Fine Arts, Smithsonian Institution.

Wolf at Bay. 1870.

Wounded Wolf. 1870.

KITTLESON, JOHN

The Jack Thrasher Memorial (trophy). 1971. H. 18″. Bronze Images, Loveland, Colo.

Longhorn Steer Head. 1969. H. 5″. Bronze Images, Loveland, Colo.

My Meat. 1970. H. 13″. Bronze Images, Loveland, Colo.

Red Desert Water Hole. 1971. H. 3½″. Bronze Images, Loveland, Colo.

Sioux Buffalo Scout. 1972. H. 26″. Bronze Images, Loveland, Colo.

Standing Quarter Horse. 1972. H. 9½″. Bronze Images, Loveland, Colo.

Sundown Serenade (howling coyote). 1972. H. 10½″. Bronze Images, Loveland, Colo.

Survival (freezing man warmed by a buffalo carcass). 1970. H. 4½″. Bronze Images, Loveland, Colo.

KNIGHT, CHARLES R.

Bear. Coll.: American Museum of Natural History.

Bison and Wild Dog. Coll.: American Museum of Natural History.

Grizzlies. 1924. H. 21½″. Roman Bronze Works, N.Y. Coll.: American Museum of Natural History; Field Museum of Natural History; Los Angeles County Museum of Art.

Moose. H. 11½″.

Wildcat.

KOPTA, EMRY

Coyonyema (snake chief). 1914–23. H. 10″. Roman Bronze Works, N.Y.

Hopi Man. 1914–23. H. 30″. Cast by the artist. Roman Bronze Works, N.Y. Coll.: Heard Museum of Anthropology and Primitive Art (Indian Collection).

Meditation (figure). 1914–23. H. 10″. Roman Bronze Works, N.Y.

Nampeyo (Hopi potter). Modeled 1914–25, cast 1973. Roman Bronze Works, N.Y. Coll.: Museum of Northern Arizona.

Sacci—Antelope Chief. 1930. H. 10¼″. Roman Bronze Works, N.Y.

Saalako (snake mother). 1914–23. H. 10″. Roman Bronze Works, N.Y.

Shupela (sun chief). 1914. H. c. 9½″. Roman Bronze Works, N.Y.

Water Carrier. 1914–23.

LA PRADE, JOHN

Almost Up. 1972. H. 7″. Classic Bronze, El Monte, Calif.

Desert Sport. 1969. H. 16″. Noggle Bronze Works, Prescott, Ariz.

Dogie. 1972. H. 6″. Classic Bronze, El Monte, Calif.

Hell of a Way to Go. 1972. H. 24″. Classic Bronze, El Monte, Calif.

Orphan of the Hills. 1971. H. 13″. Classic Bronze, El Monte, Calif.

Think It Over (cowboy and horse with front feet tied). 1965. H. 10″. Noggle Bronze Works, Prescott, Ariz.

Tying Knots in the Devil's Tail. 1970. H. 17″. Classic Bronze, El Monte, Calif.

Where There's A Will, There's A Way. 1972. H. 12″. Classic Bronze Works, El Monte, Calif.

LEIGH, WILLIAM R.

Buffalo. 1911. H. 15″. Roman Bronze Works, N.Y. Coll.: Gilcrease Institute; National Cowboy Hall of Fame.

MacMONNIES, FREDERICK

Buffalo Bill. Roman Bronze Works, N.Y.

Coll.: Gilcrease Institute.

Pioneer Monument to Kit Carson. 1936. Heroic size: Denver. Models from the *Pioneer Monument to Kit Carson:*
a) *Kit Carson.* H. 24½″. Coll.: Birmingham Museum of Art.
b) *The Prospector.* H. 24½″.

Theodore Roosevelt and the Rough Riders. H. 25″, 16″. Coll.: American Museum of Natural History.

McMURRY, LEONARD

The Archer. c. 1952. H. c. 24″. Cast at Oklahoma University.

Cattle Trail. 1957. H. c. 36″. Cast at Lawton, Okla.

Chief Tishomingo—Chickasaw. Dedicated 1963. 1¼ times life-size. Coll.: National Hall of Fame for Famous American Indians.

The Eighty-Niners. c. 1958. 1½ times life-size. Cast in Mexico. Civic Center, Oklahoma City.

Jim Thorpe—Sac and Fox. Dedicated 1960. 1¼ times life-size. Coll.: National Hall of Fame for Famous American Indians.

Legend of the Westerner. 1974. H. 35′. Zuckerman Foundry, Italy. Coll.: National Cowboy Hall of Fame.

Sacajawea—Shoshoni. Dedicated 1959. 1¼ times life-size. Coll.: National Hall of Fame for Famous American Indians.

Sequoyah—Cherokee. Dedicated 1962. 1¼ times life-size. Coll.: National Hall of Fame for Famous American Indians.

MacNEIL, HERMON A.

The Adventurous Bowman. 1902. Dedicated 1907. Exhibited: atop pillar at the Panama-Pacific Exposition, 1915, San Francisco; Column of Progress Memorial, Columbus, Ohio.

A Chief of the Multinomah Tribe (chieftain from *The Coming of the White Man*). Cast 1905, 1907. H. 33⅜″. Roman Bronze Works, N.Y.; Jno Williams Founder, N.Y. Coll.: Gilcrease Institute (two); Lauren Rogers Library and Museum of Art; The Metropolitan Museum of Art; Montclair Art Museum.

The Coming of the White Man. Modeled 1902–3. Dedicated 1907. Washington Park, Portland, Ore.

Explorer and Indian Reliefs. 1894. Coll.: Chicago Historical Society.

Manuelito (old Navajo chief). Cement statue: Gallup, N.M. Bronze model: H. 15½″.

McKinley Memorial. Heroic size. Columbus, Ohio.

Navaho Orator. 1905. H. 17½″. Coll.: Gilcrease Institute.

Pioneer Mother, Pilgrims' Memorial. Waterbury, Conn. Exhibited: Exposition Universelle, 1900, Paris; Pan-American Exposition, 1901, Buffalo.

Pioneer Woman. 1926. H. 35″. Coll.: Woolaroc Museum.

Pony Express. Dedicated 1940. Civic Center Park, St. Joseph, Mo.

A Primitive Chant. 1909. H. 25″. Roman Bronze Works, N.Y. Coll.: Gilcrease Institute (two); The Metropolitan Museum of Art. Exhibited: Louisiana Purchase Exposition, 1904, St. Louis.

Return of the Snakes (Moqui Snake Dance). c. 1896. H. 23″. Coll.: American Museum of Natural History; Art Institute of Chicago; Gilcrease Institute; Mead Art Building, Amherst College. Exhibited: Exposition Universelle, 1900, Paris; Pan-American Exposition, 1901, Buffalo.

The Sun Vow. Modeled 1889. H. 69½″, 73″. Cast 1901, 1919: Roman Bronze Works, N.Y. Coll.: Albright-Knox Art Gallery; Art Institute of Chicago; Baltimore Museum of Art; Brookgreen Gardens; Carnegie Institute; Corcoran Gallery of Art; The Metropolitan Museum of Art; Montclair Art Museum; Museum of Arts and Sciences, Norfolk, Va.; Public Museum and Art Gallery, Reading, Pa.; St. Louis Art Museum.

The Young Warrior (plaque). H. 21″.

MANSHIP, PAUL

Abraham Lincoln, the Hoosier Youth. Dedicated 1932. H. 12′6″. Lincoln National Life Insurance Plaza, Fort Wayne, Ind. Small model: Modeled 1929, cast 1955. H. 18¼″. Bruno Bearzi Foundry, Florence, Italy.

Appeal to the Great Spirit. 1947. H. 12½″. Bruno Bearzi Foundry, Florence, Italy. Whereabouts unknown.

Colonial Settlers. 1962. H. c. 6″. Bruno Bearzi Foundry, Florence, Italy. Whereabouts unknown.

Indian and Boy (with dog). c. 1954. H. 5″. Bruno Bearzi Foundry, Florence, Italy.

Indian and Boy. c. 1954. H. 4½″. Bruno Bearzi Foundry, Florence, Italy.

Indian and Pronghorn Antelope. 1914. Indian: H. 13″; Antelope: H 12½″. Roman Bronze Works, N.Y. Coll.: Art Institute of Chicago; Detroit Institute of Art; Gilcrease Institute; Mead Art Building, Amherst College; The Metropolitan Museum of Art; Pratt Institute (heroic size 1917); St. Louis Art Museum; Smith College Art Museum.

Indian Archer (from *Indian and Pronghorn Antelope*). Roman Bronze Works, N.Y. Coll.: Los Angeles County Museum of Art; St. Louis Art Museum.

Indian Hunter. 1947. H. 11½″. Bruno Bearzi Foundry, Florence, Italy. Whereabouts unknown.

Indian Hunter and Bear. 1964. H. 5″. Bruno Bearzi Foundry, Florence, Italy.

Indian Hunter with Dog. 1926. H. 23¼″. Coll.: Addison Gallery; Art Institute of

Chicago; Corcoran Gallery of Art; John Herron Art Institute; The Metropolitan Museum of Art. Life-size: 1916. Cochran Memorial Park, St. Paul. Vaucresson, France.

Lesson in Archery. 1947. H. 11½″. Bruno Bearzi Foundry, Florence, Italy. Whereabouts unknown.

Pioneer Mother. c. 1920s. H. c. 5″.

Spirit of the Chase. 1915. Life-size. Coll.: Pratt Institute.

Theodore Roosevelt Memorial. 1965. H. 17′. Theodore Roosevelt Island in the Potomac, Washington, D.C.

Western Pioneers. 1962. H. c. 6″. Bruno Bearzi Foundry, Florence, Italy. Whereabouts unknown.

Young Lincoln (study for *Abraham Lincoln, the Hoosier Youth*). c. 1929. H. 18″. Coll.: St. Paul Art Center.

MARKS, GEORGE

The Get-A-Way. 1972. H. 11½″. Artists and Sculptors Foundry, Burbank, Calif.

The Night Horse. 1970. H. 10″. Artists and Sculptors Foundry, Burbank, Calif.

Piñon Packer. 1970. H. 5¾″. Artists and Sculptors Foundry, Burbank, Calif.

Walkin' the Night Guard. 1971. H. 10″. Artists and Sculptors Foundry, Burbank, Calif.

MORA, JOSEPH J. ("Jo")

Bronco Buster. 1930. H. 7½″. California Art Bronze Foundry, Los Angeles. Coll.: National Cowboy Hall of Fame.

The Cowboy. 1929. H. 88″. California Art Bronze Foundry, Los Angeles. Coll.: Woolaroc Museum.

Cowboy on Horseback. 1915. H. 9½″. Gorham and Co., N.Y.

The Indian Chief. 1928. H. 86″. California Art Bronze Foundry, Los Angeles. Coll.: Woolaroc Museum.

The Indian Squaw. 1928. H. 76″. California Art Bronze Foundry, Los Angeles, Calif. Coll.: Woolaroc Museum.

Joe Mora Trophy. Coll.: National Cowboy Hall of Fame.

The Outlaw (Belle Starr). 1929. H. 83″. California Art Bronze Foundry, Los Angeles. Coll.: Woolaroc Museum.

MOYERS, WILLIAM

The Bronco. 1969. H. 12″. Artists and Sculptors Foundry, Burbank, Calif.

Cold Weather Cowboy. 1968. H. 6¼″. Artists and Sculptors Foundry, Burbank, Calif.

How Riders are Made. 1972. H. 8½″. Artists and Sculptors Foundry, Burbank, Calif.

The Last Arrow. 1967. H. c. 8″. Artists and Sculptors Foundry, Burbank, Calif. Coll.: Gilcrease Institute.

Loser Buys the Drinks. 1971. H. 12″. Artists and Sculptors Foundry, Burbank, Calif.

The Price of a Herd. 1972. H. 11″. Artists and Sculptors Foundry, Burbank, Calif.

Range War. 1968. H. 11″. Artists and Sculptors Foundry, Burbank, Calif. Coll.: National Cowboy Hall of Fame.

The Strawberry Roan. 1966. H. 11¾″. Artists and Sculptors Foundry, Burbank, Calif.

The Warbonnet. 1969. H. 6¾″. Artists and Sculptors Foundry, Burbank, Calif.

Winter. 1970. H. 12 ⅜″. Artists and Sculptors Foundry, Burbank, Calif.

NARANHO, MICHAEL

Buffalo Dancer. 1971. H. c. 17″. Shidoni Founders, Santa Fe, N.M.

Dance of the Eagle. 1970. H. c. 16″. Shidoni Founders, Santa Fe, N.M.

Deer Spirit. 1970. H. 13¾″. Shidoni Founders, Santa Fe, N.M.

Generation Gap (bears). 1971. H. 4½″. Shidoni Founders, Santa Fe, N.M.

Kneeling Nude (Indian). 1970. H. 13″. Shidoni Founders, Santa Fe, N.M.

Wolf Scout. 1970. H. 13½″.

PARK, MADELEINE

Brahma Bull. H. 13″. Coll.: Whitney Gallery of Western Art.

Charles Curtis—Kaw. Dedicated 1959. 1¼ times life-size. Coll.: National Hall of Fame for Famous American Indians.

Indian Dancing Girl. Public Library, Katonah, N.Y.

Osceola—Seminole. Dedicated 1958. 1¼ times life-size. Coll.: National Hall of Fame for Famous American Indians.

PHILLIPS, GORDON

Coffee, Beans, and Broncs. 1970. H. 17″. Avnet Shaw Foundry, Plainview, N.Y.

Four A. M. (cowboy and horse). 1969. H. 10″. Avnet Shaw Foundry, Plainview, N.Y.

One from the Rough String. 1967. H. 10″. Avnet Shaw Foundry, Plainview, N.Y.

Skins or Scalp. 1972. H. 13½″. Avnet Shaw Foundry, Plainview, N.Y.

Speaks with Forked Tongue. 1972. H. 6″. Avnet Shaw Foundry, Plainview, N.Y.

Trouble with the Lead Rope. 1968. H. 14″. Avnet Shaw Foundry, Plainview, N.Y.

PHIPPEN, GEORGE

The Apache. 1965. H. 15″. Bear Paw Bronze Works, Skull Valley, Ariz.

Brahma Bull (lying down). Modeled 1929, cast 1959. H. 6½″. Bear Paw Bronze Works, Skull Valley, Ariz.; Noggle Bronze Works, Prescott, Ariz. Coll.: C. M. Russell Gallery.

Cowboy (standing). 1965–66. H. 12½″. Bear Paw Bronze Works, Skull Valley, Ariz.

Cowboy in a Storm. 1966. H. 17″. Bear Paw Bronze Works, Skull Valley, Ariz.

The Cowboy's Devil. 1966. H. 8½″. Bear Paw Bronze Works, Skull Valley, Ariz.

George Wayland. 1964. H. 36″. Noggle Bronze Works, Prescott, Ariz.

Kino Group. 1963. H. 14″. Bear Paw Bronze Works, Skull Valley, Ariz.

Mountain Man. 1965. H. 12½″. Bear Paw Bronze Works, Skull Valley, Ariz.

Mr. Quarter Horse. 1960–61. H. c. 11½″. Bear Paw Bronze Works, Skull Valley, Ariz.

The Rock Hopper. Modeled 1956, cast 1957. H. 17″. Bear Paw Bronze Works, Skull Valley, Ariz.; Noggle Bronze Works, Prescott, Ariz.

POGZEBA, WOLF

Brahma Bull Rider. 1965. H. 11½″. Cast by the artist.

Bronco Rider. 1965. H. 12″. Cast by the artist.

Bronco Buster. 1963. H. 16″. Cast by the artist.

Bronco Buster. 1965. H. 14″. Cast by the artist.

Buffalo. 1962. H. 11″. Cast by the artist.

The Bull Rider. 1965. H. 11½″. Cast by the artist.

Confronted Elks. 1967. H. 8″. Cast by the artist.

Elk. 1963. H. 11″. Cast by the artist.

Empty Saddle. 1963. H. 10½″. Cast by the artist. Coll.: Salt Lake Art Center.

Riderless Horse (Lone Horse). 1963. H. 10½″. Cast by the artist.

POLK, FRANK

Bad Time for the Clown. 1971. H. 17″. Classic Bronze, El Monte, Calif.

Bareback Rider. 1969. H. 16″. Classic Bronze, El Monte, Calif.

Bull Dogger. 1968. Classic Bronze, El Monte, Calif.

The Calf Roper. 1970. H. 14″. Classic Bronze, El Monte, Calif.

Cowboy Packing a Saddle. 1969. H. 11″. Classic Bronze, El Monte, Calif.

Cutting Horse. 1971. H. 14″. Classic Bronze, El Monte, Calif.

Saddle Bronc Rider. 1968. H. 17″. Classic Bronze, El Monte, Calif.

Team Roping. 1969. H. 16″. Classic Bronze, El Monte, Calif.

Texas Longhorn Steer. 1969. H. 8″. Classic Bronze, El Monte, Calif.

POTTER, LOUIS

The Alaskan. Coll.: George F. Harding Museum.

The Arrow Dancer.

Basket Weaver. Gorham and Co., N.Y. Coll.: Gilcrease Institute.

Medicine Man. Coll.: George F. Harding Museum.

The Wind (Spirit of the Wind). 1907. H.

39″. Coll.: Gilcrease Institute.

POWELL, ASA L. ("ACE")

Indian Bust. 1960; 1968. H. 8″. Classic Bronze, El Monte, Calif.; Noggle Bronze Works, Prescott, Ariz.

Indian Head. 1971. H. 7½″. Classic Bronze, El Monte, Calif.

Medicine Horse. 1968. H. 21½″. Classic Bronze, El Monte, Calif.

Napi. c. 1966. H. 9″. Vance Foundry, Los Angeles, Calif.

Napi and His Friends. 1961. H. 11″. Avnet Shaw Foundry, Plainview, N.Y. Coll.: C.M. Russell Gallery.

Napi and Mice. 1960. H. 6″. Avnet Shaw Foundry, Plainview, N.Y.; Classic Bronze, El Monte, Calif.; Noggle Bronze Works, Prescott, Ariz.

Saddle Horse. 1961. H. 5¼″. Classic Bronze, El Monte, Calif.; Modern Art Foundry, Long Island City, N.Y. Coll.: C. M. Russell Gallery.

Standing Grizzly. 1972. H. c. 16″. Classic Bronze, El Monte, Calif.

Two Trails to God. 1960. H. 10¼″. Modern Art Foundry, Long Island City, N.Y. Coll.: C. M. Russell Gallery. Second version cast c. 1972.

Western Horse. 1971. H. 7½″. Modern Art Foundry, Long Island City, N.Y.

PROCTOR, A. PHIMISTER

Bear Cub. c. 1885–88. Small.

Bear's Head (memorial for the Boone and Crockett Club). 1909.

Big Beaver (bust of the model who posed for *On the War Trail*). Cast 1973. H. 7½″. Classic Bronze, El Monte, Calif.

Blackfoot Maiden. Cast 1973. H. 12″. Classic Bronze, El Monte, Calif.

The Bronco Buster. 1918. H. 15′. Civic Center, Denver. Small model (known as *The Buckaroo*): 1915; H. 28½″; H. Gorham and Co., N.Y.; Roman Bronze Works, N.Y. Coll.: George Gund Collection of Western Art; Mead Art Building, Amherst College; The Metropolitan Museum of Art; R.W. Norton Art Gallery; Rockwell Foundation.

Buffalo. 1897. H. 12½″. Original and recent casts: Verbeyst Founders. Coll.: Gilcrease Institute; Paine Art Center; Walters Art Gallery.

Buffalo Head. 1917. Arlington Cemetery Bridge, Washington, D.C.

Buffalo Hunt. Cast 1973. H. 30″. Classic Bronze, El Monte, Calif.

Bull Moose. Cast 1903. H. 20″. R.W. Norton Art Gallery; Rockwell Foundation; Whitney Gallery of Western Art. Exhibited: World's Columbian Exposition, 1893, Chicago (original model). Cast 1973. H. 19½″. Classic Bronze, El Monte, Calif.

A Bull Startled by a Frog. 1922. H. 6¾″.

Coll.: R.W. Norton Art Gallery.

A Bull Startled by a Rabbit. 1894. H. 4½″. Coll.: R.W. Norton Art Gallery.

Charging Buffalo. Cast 1973. H. 12½″. Classic Bronze, El Monte, Calif.

Chief Weasel (plaque). H. 7¼″. Gorham and Co., N.Y. Coll.: Gilcrease Institute (two).

The Circuit Rider. 1922. Heroic size. State Capitol Grounds, Salem, Ore.

Cougar. H. 9½″. Roman Bronze Works, N.Y. Coll.: Gilcrease Institute.

Cub (grizzly) *and Rabbit.* Modeled 1885–88, copyright 1893. H. 4½″. Coll.: Birmingham Museum of Art. Cast 1973. H. 4½″. Classic Bronze, El Monte, Calif.

Dr. John McLoughlin. Heroic size. Salem, Ore.

Elk. Model exhibited: World's Columbian Exposition, 1893, Chicago. Cast 1973. H. 16½″. Classic Bronze, El Monte, Calif.

Elk (The Challenge). Exhibited: Exposition Universelle, 1900, Paris; Pan-American Exposition, 1901, Buffalo.

Fawn. Modeled 1885. H. 7″. Cast 1973. Classic Bronze, El Monte, Calif.

Indian and Buffalo Group (Death of the King of the Herd). 1916. H. 18⅛″. Gorham and Co., N.Y. Coll.: Corcoran Gallery of Art; George F. Harding Museum.

Indian and Trapper. c. 1929. Heroic size. Model for the McKnight Memorial Fountain, Wichita, Kans. Head of trapper: cast 1973; H. 11″. Classic Bronze, El Monte, Calif.

Indian Maiden and Fawn. Cast before 1925. Heroic size. Cast 1973. H. 20″. Classic Bronze, El Monte, Calif.

The Indian Warrior. 1898. H. 39″. Gorham and Co., N.Y. Coll.: Brooklyn Museum; Corcoran Gallery of Art; Gilcrease Institute; R.W. Norton Art Gallery; Portland Art Museum; St. Louis County Historical Society; Woolaroc Museum. Exhibited: Exposition Universelle, 1900, Paris (Gold Medal).

Irontail (plaque). H. 7″. Gorham and Co., N.Y. Coll.: Gilcrease Institute.

Jackson Sundown (bust). 1916. Heroic size. Coll.: Stanford University. Cast 1973. H. 11¼″. Classic Bronze, El Monte, Calif.

Kneeling Indian Fountain. Erected 1921. Lake George, N.Y.

Little Wolf (small bust). Originally cast during the artist's lifetime. Coll.: William S. Hart Museum. Cast 1973. H. 12″. Classic Bronze, El Monte, Calif.

Lobo. Coll.: Texas Memorial Museum, University of Texas.

Miniature Buffalo. Cast 1973. H. 1¼″. Classic Bronze, El Monte, Calif.

Morgan Stallion. 1913. H. 15½″. Gorham and Co., N.Y. Coll.: The Metropolitan Museum of Art.

Mounted Indian (plaque). Modeled 1949, cast 1973. D. 12″. Classic Bronze, El Monte, Calif.

Mule Deer (Fate). 1893. H. 7″. Gorham and Co., N.Y. Coll.: Mead Art Building, Amherst College; The Metropolitan Museum of Art; R.W. Norton Art Gallery. Exhibited: Exposition Universelle, 1900, Paris (Gold Medal); Pan-American Exposition, 1901, Buffalo. Cast 1973. H. 6½″. Classic Bronze, El Monte, Calif.

Mustangs. Unveiled 1948. H. 15″ from plinth to top of mustang's head. Coll.: Texas Memorial Museum, University of Texas. Small model of horse head (*Texas Memories*) cast 1973. H. 9½″. Classic Bronze, El Monte, Calif. Small model of mare's head cast 1973. H. 11″. Classic Bronze, El Monte, Calif.

On the War Trail. Dedicated 1920 (winner of the Paris Exposition). H. 15′. Civic Center, Denver. Small model: H. 5′. Gorham and Co., N.Y. Coll.: Gilcrease Institute; George Gund Collection of Western Art; Mead Art Building, Amherst College; The Metropolitan Museum of Art; R.W. Norton Art Gallery; Rockwell Foundation. Small model cast 1973. H. 40″ and 20″. Classic Bronze, El Monte, Calif.

Oxen Plowing (small bronze). Exhibited: Pan-American Exposition, 1901, Buffalo (Agricultural Building).

Panther with Kill. c. 1894–97.

Panthers or *Pumas.* c. 1896. Entrance to Prospect Park, Brooklyn, N.Y. Exhibited: Exposition Universelle, 1900, Paris. Small model cast 1973. H. 12″. Classic Bronze, El Monte, Calif.

The Pioneer. 1917–18. Presented 1919. Heroic size. Gorham and Co., N.Y. University of Oregon Campus, Eugene, Ore. Small model (bust) cast 1973. H. 13½″. Classic Bronze, El Monte, Calif.

The Pioneer Mother (equestrian group). Heroic size. 1923–27. Dedicated 1928. Penn Valley Park, Kansas City, Mo.

The Pioneer Mother. 1934. Heroic size. University of Oregon Campus, Eugene, Ore.

Pony Express Rider (Series of plaques along the original Pony Express route between St. Joseph, Mo., and San Francisco, Calif.). Small model cast 1973. Diam. 17″. Classic Bronze, El Monte, Calif.

Prowling Panther. c. 1894. H. 6½″. Jno Williams Founder, N.Y. Coll.: Corcoran Gallery of Art; R.W. Norton Art Gallery; Texas Memorial Museum, University of Texas. Exhibited: Exposition Universelle, 1900, Paris; Pan-American Exposition, 1901, Buffalo. Cast 1973. H. 10″ and 5″. Classic Bronze, El Monte, Calif.

Pursued. Copyright 1915 and 1928, cast 1916 and 1928. H. 16½″. Gorham and Co., N.Y.; Roman Bronze Works, N.Y.

Coll.: Brookgreen Gardens; Gilcrease Institute. Cast (with spear) 1973. H. 16½″. Classic Bronze, El Monte, Calif.

The "Q" Street Buffalo. 1911. Heroic size. "Q" Street Bridge, Washington, D.C. Small model: 1912–14; H. 13″. Gorham and Co., N.Y.; Tiffany and Co., N.Y. Coll.: Indianapolis Museum of Art; Mead Art Building, Amherst College; The Metropolitan Museum of Art; Toledo Art Museum. Cast 1973. H. 9″ and 19″. Classic Bronze, El Monte, Calif.

Slim. H. 12″. Roman Bronze Works, N.Y. Coll.: Gilcrease Institute.

Theodore Roosevelt as a Rough Rider (equestrian). c. 1920. Heroic size: Portland, Ore.; Minot, N.D. Small version: Mandau, N.D.

Til Taylor. c. 1926. Heroic size. Pendleton, Ore.

PUTNAM, ARTHUR

Bear. Coll.: Oakland Art Museum.

The Indian. 1931. H. 9″. Presidio Park, San Diego.

Puma and Deer. Modeled 1912. Coll.: Oakland Art Museum.

Resting. 1913. Exhibited: Armory Show, 1913, New York.

Snarling Jaguar. 1906. H. 2¾″. Putnam and Storey Foundry, San Francisco, Calif. Coll.: California Palace of the Legion of Honor; Fine Arts Gallery of San Diego; The Metropolitan Museum of Art.

The following, all cast in 1921 by Alexis Rudier of Paris, are in the collection of the California Palace of the Legion of Honor:

Bear Scratching Hind Paw. H. 7½″.

Coyote Frightened. H. 7½″.

Indian and Puma. H. 7½″.

Indian and Puma. H. 16½″.

Lynx Kitten. H. 4″.

Lynx Kitten Watching. H. 4″.

Puma and Footprints. H. 13¾″.

Puma on Lookout. H. 4½″.

Puma Resting. H. 2½″.

Puma Resting on His Paws. H. 6″.

Resting. H. 4″.

Wounded Buffalo and Young. H. 4″.

The following, all (except where noted) cast in 1921 by Alexis Rudier of Paris, are in the collection of the Fine Arts Gallery of San Diego:

Bear and Ox Skull. H. 6″.

Bear and Skull. H. 6″.

Bear Walking. H. 4½″.

Buffalo Head. H. 14″.

Buffalo, Indian, and Horse. First cast 1906–11. H. 14″.

Colt. H. 12½″.

Coyote. H. 7⅝″.

Double Puma. H. 6⅞″.

Eagle. H. 10″.

Head of a Female Puma. H. 11½".
Horse, Mexican, and Bear. H. 15½".
Indian and Puma. H. 8¾".
Indian Woman Grinding Corn. H. 11½".
Large Puma Smelling Ox Tracks. H. 13¾".
Lion on a Cliff. H. 13½".
Little Bear Standing. H. 6½".
Little Lynx Snarling. H. 3½".
Lynx Head. H. 5¼".
Lynx Head. H. 10¾".
Lynx Kitten. H. 4¼".
Lynx Resting. H. 3¾".
Puma Carrying Deer. H. 11½".
Puma Looking Out. H. 5¾".
Puma on Guard. H. 19¼".
Puma on Lookout. H. 4½".
Reclining Jaguar Licking Leg. H. 4¾".
Reclining Lynx. H. 4½".
Reclining Puma. H. 5½".
Reclining Puma Holding Head High. H. 5½".
Scratching Bear and Fragments. H. 5½".
Skunked Lynx. H. 3⅝".
Skunked Lynx. H. 5".
Two Buffaloes Fighting. H. 6¾".
Two Pioneers. H. 6½". Sketch for Haile Monument.

REISS, HANS E.

Bull Head. c. 1925–30. H. 13". Cast in Germany. Hans Reiss Memorial, Lake Tahoe, Calif.
Crow Indian in His Medicine Sleep. c. 1925–30. H. 13". Cast in Germany.
Falling-Over-the-Banks—Blackfoot Indian. c. 1925–30. H. 13". Cast in Germany.
Louis Straw Hat—Crow Indian. c. 1925–30. H. 13". Cast in Germany.
106-Year-Old-Indian (possibly the man known as Many Mules). c. 1925–30. H. 13". Covered with 24-karat gold. Cast in Germany.
Weasel Tail. c. 1925–30. H. 13". Cast in Germany.

REMINGTON, FREDERIC

The Bronco Buster. 1895. H. 24¼" including artist's base. Henry Bonnard Foundry, N.Y.; Roman Bronze Works, N.Y. Coll.: Amon Carter Museum; Art Institute of Chicago; Birmingham Museum of Art; Brookgreen Gardens; Butler Institute of American Art; Cincinnati Art Museum; Columbia Museum of Art; Currier Gallery of Art; Dartmouth College (Carpenter Art Gallery); Denver Public Library (Rockwell Collection); M. H. De Young Museum; Gilcrease Institute; George Gund Collection of Western Art; George F. Harding Museum; Homer Garrison Texas Ranger Museum; Indianapolis Museum of Art; Joslyn Art Museum; Los Angeles County Museum of Art (on loan to the White House, Washington, D.C.); Mead Art Building, Amherst College; The Metropolitan Museum of Art; Milwaukee Art Center;

Montclair Art Museum; Museum of Fine Arts, Houston; Museum of Fine Arts, Springfield, Mass.; National Cowboy Hall of Fame; New-York Historical Society; R. W. Norton Art Gallery; Paine Art Center; Philbrook Museum; Princeton University Art Museum (restrike); Remington Art Memorial Museum; Rockwell Foundation; St. Louis Art Museum; University of Utah, Museum of Fine Arts; Whitney Gallery of Western Art; Woolaroc Museum.
The Bronco Buster. 1905. H. 32½". Roman Bronze Works, N.Y. Coll.: Amon Carter Museum; Gilcrease Institute; Lyndon Baines Johnson Library; The Metropolitan Museum of Art; R. W. Norton Art Gallery; Philbrook Museum; Remington Art Memorial Museum.
The Buffalo Horse. 1907. H. 35". Roman Bronze Works, N.Y. Coll.: Gilcrease Institute.
The Buffalo Signal. 1902. H. 36". Roman Bronze Works, N.Y. Private collection.
The Cheyenne. 1901. H. 22½". Roman Bronze Works, N.Y.; Tiffany and Co., N.Y. Coll.: Amon Carter Museum (two); Birmingham Museum of Art; Denver Public Library (Rockwell Collection); Gilcrease Institute; George Gund Collection of Western Art; George F. Harding Museum; Los Angeles County Museum of Art; The Metropolitan Museum of Art; Milwaukee Art Center; R. W. Norton Art Gallery (two); Remington Art Memorial Museum.
Coming Through the Rye (Off the Range). 1902. H. 27". Roman Bronze Works, N.Y. Coll.: Amon Carter Museum; Birmingham Museum of Art; Corcoran Gallery of Art; Gilcrease Institute; George F. Harding Museum; Homer Garrison Texas Ranger Museum; Lovelace Foundation for Medical Education and Research—Albert K. Mitchell Collection; The Metropolitan Museum of Art; National Cowboy Hall of Fame; R. W. Norton Art Gallery; Remington Art Memorial Museum; The White House; Whitney Gallery of Western Art (two).
The Cowboy. Unveiled 1908. Life-size. Fairmount Park, Philadelphia.
Dragoons—1850. 1905. H. 28". Roman Bronze Works, N.Y. Coll.: Amon Carter Museum; George F. Harding Museum; The Metropolitan Museum of Art; National Cowboy Hall of Fame; R. W. Norton Art Gallery; Remington Art Memorial Museum.
The Horse Thief. 1907. H. 25¾". Roman Bronze Works, N.Y. Coll.: Gilcrease Institute; R. W. Norton Art Gallery.
The Mountain Man. 1903. H. c. 28⅛" including artist's base. Roman Bronze Works, N.Y. Coll.: Amon Carter Museum; Birmingham Museum of Art;

Corcoran Gallery of Art; Denver Public Library (Rockwell Collection); Detroit Institute of Art; Gilcrease Institute; George Gund Collection of Western Art; Los Angeles County Museum of Art; The Metropolitan Museum of Art; R. W. Norton Art Gallery (three); Remington Art Memorial Museum; Santa Barbara Museum of Art; Texas Memorial Museum, University of Texas; Woolaroc Museum.
The Norther. 1900. H. 22". Roman Bronze Works, N.Y. Coll.: Gilcrease Institute.
The Outlaw. 1906. H. 22½". Roman Bronze Works, N.Y. Coll.: Amon Carter Museum (two); Birmingham Museum of Art; Gilcrease Institute; George Gund Collection of Western Art; Los Angeles County Museum of Art; The Metropolitan Museum of Art; R.W. Norton Art Gallery; Remington Art Memorial Museum; Rockwell Foundation; St. Louis Art Museum.
The Rattlesnake (Snake in the Path). 1905. H. 22". Roman Bronze Works, N.Y. Coll.: Amon Carter Museum (three); Birmingham Museum of Art; Bradford Brinton Memorial Museum; Dartmouth College (Carpenter Art Gallery); Fine Arts Gallery of San Diego; Gilcrease Institute; George F. Harding Museum; Los Angeles County Museum of Art; Mead Art Building, Amherst College; The Metropolitan Museum of Art; R. W. Norton Art Gallery (two); Paine Art Center; Princeton University Art Museum; Remington Art Memorial Museum; Rockwell Foundation; Whitney Gallery of Western Art.
The Savage (The Indian Brave). 1908. H. 11". Roman Bronze Works, N.Y. Coll.: Amon Carter Museum; Birmingham Museum of Art; Denver Public Library (Rockwell Collection); Gilcrease Institute; George Gund Collection of Western Art; George F. Harding Museum; The Metropolitan Museum of Art; R. W. Norton Art Gallery; Remington Art Memorial Museum; Witte Memorial Museum.
The Scalp (The Triumph). 1898: H. 21½"; Henry Bonnard Foundry, N.Y. 1901: H. 23¾"; Roman Bronze Works, N.Y. Coll.: Amon Carter Museum (three); Birmingham Museum of Art; Corning Community College; Gilcrease Institute; George Gund Collection of Western Art; George F. Harding Museum; Lyndon Baines Johnson Library; Los Angeles County Museum of Art; The Metropolitan Museum of Art; R. W. Norton Art Gallery (two); Remington Art Memorial Museum.
The Sergeant. 1904. H. 10¼". Roman Bronze Works, N.Y. Coll.: Amon Carter Museum; Birmingham Museum of Art; Bradford Brinton Memorial Museum;

General Douglas MacArthur Memorial; Gilcrease Institute; George F. Harding Museum; The Metropolitan Museum of Art; Museum of the Southwest; R. W. Norton Art Gallery; Remington Art Memorial Museum; Rockwell Foundation.
The Stampede. 1909. H. 22". Roman Bronze Works, N.Y. Coll.: Amon Carter Museum; Gilcrease Institute; R. W. Norton Art Gallery; Remington Art Memorial Museum.
Trooper of the Plains—1868. 1909: H. 26½". Roman Bronze Works, N.Y. Coll.: Amon Carter Museum (two); Birmingham Museum of Art; Gilcrease Institute; George Gund Collection of Western Art; The Metropolitan Museum of Art; National Cowboy Hall of Fame; Newark Museum; R. W. Norton Art Gallery; Remington Art Memorial Museum.
The Wicked Pony (The Fallen Rider). 1898. H. c. 22". Henry Bonnard Foundry, N.Y. Coll.: Amon Carter Museum; Birmingham Museum of Art; Gilcrease Institute; George Gund Collection of Western Art; The Metropolitan Museum of Art; R.W. Norton Art Gallery.
The Wounded Bunkie. 1896. H. 20¼". Henry Bonnard Foundry, N. Y. Coll.: Amon Carter Museum; Birmingham Museum of Art; Clark Institute; Gilcrease Institute; The Metropolitan Museum of Art; R. W. Norton Art Gallery; Whitney Gallery of Western Art; Yale University Art Gallery.

RHIND, JOHN MASSEY

The Corning Fountain. Erected 1899. Heroic size. Bushnell Park, West Hartford, Conn.
Indian Massacre. Coll.: Chicago Historical Society.
Indian Scout. H. 72". Coll.: Butler Institute of American Art.
On the Lookout. 1919. H. 22½". Coll.: Newark Museum.
Waiting for the Peace Parley. 1919. H. 22½".

RICHTER, HANK

Arapaho. 1969. H. 8¾". Noggle Bronze Works, Prescott, Ariz.
Cibilo (buffalo hunter). 1972. H. 7½". Precision Specialty Casting, Tucson, Ariz.
Coyote. 1968. H. 4". Noggle Bronze Works, Prescott, Ariz.
Hokahay (Indian on horseback). 1972. H. 14". Noggle Bronze Works, Prescott, Ariz.
Hopi Snake Dancers. 1970. H. 14½". Noggle Bronze Works, Prescott, Ariz.
The Navaho (Longhair). 1971. H. 9". Noggle Bronze Works, Prescott, Ariz.
Pulling Hide. 1972. H. 11½". Noggle

Bronze Works, Prescott, Ariz.

Shearin' Time. 1972. H. 5¼″. Prescott Metal Casters, Prescott, Ariz.

Sioux Warrior. 1968. H. c. 7″. Noggle Bronze Works, Prescott, Ariz.

The Young Hunter. 1969. H. 13½″. Noggle Bronze Works, Prescott, Ariz.

ROCKWELL, ROBERT H.

Moose. H. 20″. Coll.: American Museum of Natural History.

Survival of the Fittest (two moose). 1970. H. 20½″. Garganni Foundry, N.Y.

ROGERS, RANDOLPH

The Dying Indian. H. 7′. Coll.: Brooklyn Museum.

Indians and Buffaloes. Exhibited: 1913.

The Last Arrow. 1880. H. 45″. Fonderia Nelli, Rome. Coll.: Cincinnati Art Museum; The Metropolitan Museum of Art; University of Michigan Museum of Art.

Meriwether Lewis of the *Washington Monument.* 1861. Richmond, Va.

ROSSI, PAUL

GREAT SADDLES OF THE WEST SERIES:

California Classic Stock Saddle—1895. 1972. H. c. 5½″. Graves Foundry, Tucson, Ariz.

California Mission Vaquero Saddle—1885. 1972. H. c. 5½″. Graves Foundry, Tucson, Ariz.

California Ranchero Saddle—1830. 1972. H. c. 5½″. Graves Foundry, Tucson, Ariz.

Cheyenne Indian Man's Saddle—1820. 1972. H. c. 5½″. Graves Foundry, Tucson, Ariz.

Great Plains Stock Saddle—1870. 1972. H. c. 5½″. Graves Foundry, Tucson, Ariz.

McClellan Cavalry Saddle—1875. 1972. H. c. 5½″. Graves Foundry, Tucson, Ariz.

Santa Fe (California) Saddle—1840. 1972. H. c. 5½″. Graves Foundry, Tucson, Ariz.

Spanish War Saddle—1840. 1971. H. 5½″. Graves Foundry, Tucson, Ariz.

Texas Stock Saddle—1855. 1972. H. c. 5½″. Graves Foundry, Tucson, Ariz.

Woman's Side Saddle—1895. 1972. H. c. 5½″. Graves Foundry, Tucson, Ariz.

RUNGIUS, CARL

Bighorn Sheep. c. 1915. H. 16¾″. Roman Bronze Works, N.Y.

Bull Moose. 1905. H. 17″. Roman Bronze Works, N.Y. Coll.: Rockwell Foundation.

RUSSELL, CHARLES M.

Ah-Wah-Cous (antelope). Cast 1968. H. 6¾″.

Alert (deer). Cast 1941. H. 7″. Nelli Art Bronze Foundry, Los Angeles. Coll.: R. W. Norton Art Gallery; Whitney Gallery of Western Art.

American Cattle (buffalo). Modeled 1925. H. 5¼″. Cast during the artist's lifetime. Roman Bronze Works, N.Y. Coll.: Amon Carter Museum; Montana Historical Society; National Cowboy Hall of Fame; R. W. Norton Art Gallery; Whitney Gallery of Western Art.

Antelope. Cast 1964. H. 5⅛″. Avnet Shaw Foundry, Plainview, N.Y.; Roman Bronze Works, N.Y.

Arabian Horse. Cast 1965. Noggle Bronze Works, Prescott, Ariz.

Assiniboine Warrior. Coll.: C. M. Russell Gallery.

An Awkward Situation (deer scratching ear). Cast 1941. Nelli Art Bronze Works, Los Angeles; Roman Bronze Works, N.Y. Coll.: National Cowboy Hall of Fame; R. W. Norton Art Gallery.

The Battle (two mountain goats). Modeled c. 1908. H. 6¾″. Cast during the artist's lifetime. Coll.: Amon Carter Museum; National Cowboy Hall of Fame; R. W. Norton Art Gallery; Whitney Gallery of Western Art.

Bear #1. H. 2¾″. Cast during the artist's lifetime and after his death. Nelli Art Bronze Works, Los Angeles; Roman Bronze Works, N.Y. Coll.: Amon Carter Museum.

Bear #2. Modeled c. 1925. H. 4½″. Cast during the artist's lifetime and after his death. Nelli Art Bronze Works, Los Angeles; Roman Bronze Works, N.Y. Coll.: Amon Carter Museum.

Bear and Jug. H. 5½″. Cast during the artist's lifetime. Roman Bronze Works, N.Y. Coll.: Amon Carter Museum; Birmingham Museum of Art.

Bear Cub.

Beil Steer Head. Modeled 1912. H. 4″. Coll.: R. W. Norton Art Gallery.

The Berry Eater. Cast c. 1939. H. 4¼″. Coll.: R. W. Norton Art Gallery.

Bessie B. Cast 1961. H. 6⅞″. Coll.: R. W. Norton Art Gallery.

Best of the String. Cast 1968. H. 5¾″. Roman Bronze Works, N.Y.

Big Horn Ram. Coll.: Whitney Gallery of Western Art.

Blackfoot War Chief. Modeled c. 1900. H. 10⅝″. Cast since the artist's death. Roman Bronze Works, N.Y. Coll.: Amon Carter Museum; Montana Historical Society; R. W. Norton Art Gallery.

The Bluffers (bear and buffalo). Modeled c. 1924. H. 7½″. Cast during the artist's lifetime and after his death. Roman Bronze Works, N.Y.; California Art Bronze Foundry, Los Angeles; Nelli Art Bronze Foundry, Los Angeles. Coll.: Amon Carter Museum; Colorado Springs Fine Arts Center; R. W. Norton Art Gallery; St. Louis Art Museum; Whitney Gallery of Western Art.

The Bronc Twister. Modeled c. 1920. H. 17⅛″. Cast during the artist's lifetime. Califor-

nia Art Bronze Foundry, Los Angeles; Roman Bronze Works, N.Y. Coll.: Amon Carter Museum; Bradford Brinton Memorial Museum; Lovelace Foundation for Medical Education and Research—Albert K. Mitchell Coll.; Montana Historical Society; National Cowboy Hall of Fame; R. W. Norton Art Gallery; Whitney Gallery of Western Art.

Buck Deer. Modeled c. 1900. H. 5¼″. Coll.: Montana Historical Society.

Bucking Bronco Bookends. Coll.: C.M. Russell Gallery.

Buffalo. Vance Foundry, Los Angeles. Coll.: Montana Historical Society; Whitney Gallery of Western Art.

Buffalo Bull. Modeled 1903. Cast c. 1963. H. 4″. Coll.: Montana Historical Society; R. W. Norton Art Gallery.

The Buffalo Family. Modeled c. 1925. H. 6½″. Cast during the artist's lifetime. Roman Bronze Works, N.Y. Coll.: Amon Carter Museum; Colorado Springs Fine Arts Center; Gilcrease Institute; R. W. Norton Art Gallery; Whitney Gallery of Western Art.

Buffalo Head. Coll.: R. W. Norton Art Gallery.

The Buffalo Hunt (The Buffalo Runner). Modeled c. 1904. H. 10″. Cast during the artist's lifetime. Roman Bronze Works, N.Y. Coll.: Amon Carter Museum; Bradford Brinton Memorial Museum; Gilcrease Institute; Lovelace Foundation for Medical Education and Research—Albert K. Mitchell Coll.; National Cowboy Hall of Fame; R.W. Norton Art Gallery; Whitney Gallery of American Art.

Buffalo Rubbing Rock. Modeled c. 1921. H. c. 5½″. Cast during the artist's lifetime. Roman Bronze Works, N.Y. Coll.: Amon Carter Museum; Gilcrease Institute; National Cowboy Hall of Fame; R. W. Norton Art Gallery; Whitney Gallery of Western Art.

Buffalo Skull Medallion. Diam. 1½″. Coll.: R.W. Norton Art Gallery.

The Bug Hunters. Modeled c. 1926. H. 6⅛″. Cast during the artist's lifetime. California Art Bronze Foundry, Los Angeles. Coll.: Amon Carter Museum; R.W. Norton Art Gallery; Whitney Gallery of Western Art.

Bull Head. (Fulkerson). Modeled 1902, cast c. 1966.

The Challenge (bull). Modeled 1916, cast 1941. H. 5″. Nelli Art Bronze Foundry, Los Angeles. Coll.: National Cowboy Hall of Fame; The R. W. Norton Art Gallery; Whitney Gallery of Western Art.

Changing Outfits. Cast 1951. H. 33⅛″. National Cowboy Hall of Fame; R.W. Norton Art Gallery; Whitney Gallery of Western Art.

A Cheyenne Chief (profile). Cast 1941. H.

5″. Nelli Art Bronze Works, Los Angeles.

Chief Joseph (plaque). Recent casting. H. 7½″. Roman Bronze Works, N.Y. Coll.: National Cowboy Hall of Fame; R. W. Norton Art Gallery; Whitney Gallery of Western Art.

The Combat. Modeled 1908. H. 9″. Coll.: R. W. Norton Art Gallery.

Counting Coup. Modeled 1904. H. 11¼″. Cast during the artist's lifetime. Roman Bronze Works, N.Y. Coll.: Amon Carter Museum; Gilcrease Institute; Lovelace Foundation for Medical Education and Research—Albert K. Mitchell Collection; National Cowboy Hall of Fame; R.W. Norton Art Gallery.

Coyote. H. 5¾″. Cast during the artist's lifetime and after his death. Roman Bronze Works, N.Y.; Nelli Art Bronze Works, Los Angeles. Coll.: Amon Carter Museum; National Cowboy Hall of Fame; R.W. Norton Art Gallery; Whitney Gallery of Western Art.

The Coyote Dance.

The Cryer. H. 11½″. Cast during the artist's lifetime, in 1941, and later. California Art Bronze Foundry, Los Angeles. Coll.: Amon Carter Museum; Gilcrease Institute; National Cowboy Hall of Fame; R. W. Norton Art Gallery.

A Disputed Trail (bear ashtray). Cast 1941. H. 4″. Nelli Art Bronze Works, Los Angeles. Coll.: National Cowboy Hall of Fame; R. W. Norton Art Gallery.

Dobe's Goat. Modeled 1926. H. 3⅜″. Montana Historical Society; Museum of New Mexico; R.W. Norton Art Gallery.

Double Buffalo. H. 4½″. Coll.: R.W. Norton Art Gallery.

An Enemy That Warns (wolf and its prey). Modeled c. 1921. H. 5″. Cast during the artist's lifetime and after his death. Roman Bronze Works, N.Y. Coll.: Amon Carter Museum; Gilcrease Institute; George Gund Collection of Western Art; Montana Historical Society; R. W. Norton Art Gallery; Whitney Gallery of Western Art.

The Enemy's Tracks. Modeled c. 1920. H. 12½″ (also in 9″ version). Cast during the artist's lifetime and after his death. Roman Bronze Works, N.Y. Coll.: Amon Carter Museum; Gilcrease Institute; Lovelace Foundation for Medical Education and Research—Albert K. Mitchell Collection; National Cowboy Hall of Fame; R. W. Norton Art Gallery; St. Louis Art Museum; Whitney Gallery of Western Art.

Fallen Monarch. Modeled c. 1909. H. 3⅜″. Roman Bronze Works, N.Y. Coll.: National Cowboy Hall of Fame; R. W. Norton Art Gallery.

Forest Mother. Cast 1950. H. 5⅛″. Roman Bronze Works, N.Y. Coll.: National Cowboy Hall of Fame; R. W. Norton

Art Gallery; Whitney Gallery of Western Art.

Glacier Park Grizzly (Grizzly on a Log). Modeled 1913. Cast 1958. H. 6″. Sculpture House, N.Y. Coll.: Amon Carter Museum; George Gund Collection of Western Art; Montana Historical Society; R. W. Norton Art Gallery; Whitney Gallery of Western Art.

Going Grizzly. Modeled 1922, cast c. 1963. H. 4″. Coll.: Montana Historical Society.

Grey Eagle (horse). Modeled 1892. H. 8¼″. Cast since the artist's death. Roman Bronze Works, N.Y.; Classic Bronze, El Monte, Calif. Coll.: National Cowboy Hall of Fame; R. W. Norton Art Gallery; Whitney Gallery of Western Art.

Grub Stake (bear). Modeled 1916. H. 4½″. Roman Bronze Works, N.Y. Coll.: Colorado Springs Fine Arts Center.

A Happy Find (bears). H. 4⅜″. Cast during the artist's lifetime. Roman Bronze Works, N.Y. Coll.: Amon Carter Museum; R. W. Norton Art Gallery; Whitney Gallery of Western Art.

His Winter Store (Hopi Indian seated). Modeled 1906, cast 1941. H. c. 4″. Nelli Art Bronze Works, Los Angeles. Coll.: National Cowboy Hall of Fame; R. W. Norton Art Gallery; Whitney Gallery of Western Art.

Hog on a Hill. Modeled 1924, cast 1962. H. 2¾″. Modern Art Foundry, Long Island City, N.Y. Coll.: Montana Historical Society; R. W. Norton Art Gallery.

Horse Head. Modeled 1918. H. c. 4⅜″. Cast after the artist's death. Coll.: Montana Historical Society; National Cowboy Hall of Fame; R. W. Norton Art Gallery; C. M. Russell Gallery; Whitney Gallery of Western Art.

Horse Head (cast from a model in the Jones Collection).

In the White Man's World. Cast 1947. H. 15¼″. California Art Bronze Foundry, Los Angeles; Roman Bronze Works, N.Y. Coll.: Colorado Springs Fine Arts Center; National Cowboy Hall of Fame; R. W. Norton Art Gallery; Whitney Gallery of Western Art.

Indian Family—Indian Man. Modeled c. 1914. H. 5⅜″. Cast during the artist's lifetime. B. Zoppo Foundry, N.Y. Coll.: Amon Carter Museum; Gilcrease Institute; National Cowboy Hall of Fame; R. W. Norton Art Gallery; William S. Hart Museum.

Indian Family—Indian Woman. Modeled c. 1914. H. 5⅛″. Cast during the artist's lifetime. California Art Bronze Foundry, Los Angeles. Coll.: Amon Carter Museum; Gilcrease Institute; National Cowboy Hall of Fame; R. W. Norton Art Gallery; William S. Hart Museum.

Indian Head (plaque). Modeled c. 1904.

Diam. 19″. Recent casting. Roman Bronze Works, N.Y.

It Ain't No Lady's Job. Modeled 1926, cast 1962. H. 8″. Roman Bronze Works, N.Y. Coll.: Akron Art Institute; Montana Historical Society; National Cowboy Hall of Fame; R. W. Norton Art Gallery; Whitney Gallery of Western Art.

Jim Bridger. Modeled c. 1925. H. 14⅜″. Cast during the artist's lifetime. California Art Bronze Foundry, Los Angeles; Roman Bronze Works, N.Y. Coll.: Amon Carter Museum; Gilcrease Institute; Montana Historical Society; National Cowboy Hall of Fame; R. W. Norton Art Gallery; Whitney Gallery of Western Art.

The Last Laugh (wolf and skull). Modeled c. 1916. H. 4½″. Cast during the artist's lifetime and after his death. Roman Bronze Works, N. Y.; B. Zoppo Foundry, N.Y. Coll.: Amon Carter Museum; Gilcrease Institute; George Gund Museum of Western Art; National Cowboy Hall of Fame; R. W. Norton Art Gallery; Whitney Gallery of Western Art.

Lone Buffalo. Modeled c. 1900. H. 4⅜″. Cast during the artist's lifetime. Roman Bronze Works, N. Y. Coll.: Amon Carter Museum; Montana Historical Society (plaster); National Cowboy Hall of Fame; R. W. Norton Art Gallery; Whitney Gallery of Western Art.

The Lone Warrior. Cast 1955. H. 7¼″. Montana Historical Society; National Cowboy Hall of Fame; The R. W. Norton Art Gallery.

Lunch Hour. Cast c. 1939. Nelli Art Bronze Works, Los Angeles. Coll.: Whitney Gallery of Western Art.

Malemute (wolf). Cast 1958. H. c. 4¾″. Sculpture House, N.Y. Coll.: Amon Carter Museum; Colorado Springs Fine Arts Center; The C. M. Russell Gallery; George Gund Collection of Western Art; Montana Historical Society; National Cowboy Hall of Fame; R. W. Norton Art Gallery.

Marauder (wolf). Cast 1968. Coll.: Montana Historical Society.

Me Happy. Cast after the artist's death. H. 15⅛″. Classic Bronze, El Monte, Calif. Coll.: Amon Carter Museum; George Gund Collection of Western Art.

Me Skookam. Cast after the artist's death.

Meat For Wild Men (buffalo hunt). Modeled c. 1920, cast 1924 and after the artist's death. H. 11½″. Nelli Art Bronze Foundry, Los Angeles; Roman Bronze Works, N.Y. Coll.: Amon Carter Museum; National Cowboy Hall of Fame; R. W. Norton Art Gallery; The White House.

The Medicine Man. Modeled c. 1920, cast during the artist's lifetime. H. 7″. Roman Bronze Works, N.Y. Coll.: Amon Carter Museum; Bradford Brinton Memorial Museum; Colorado Springs Fine Arts Center; Gilcrease Institute, National

Cowboy Hall of Fame; R. W. Norton Art Gallery; Whitney Gallery of Western Art.

Medicine Whip. Modeled 1911. H. 9½″. Cast during the artist's lifetime. California Art Bronze Foundry, Los Angeles. Coll.: Amon Carter Museum; Gilcrease Institute; George Gund Collection of Western Art; National Cowboy Hall of Fame.

Monarch of the Forest (elk). Modeled 1926. Cast 1941 and later. H. 9½″. Nelli Art Bronze Foundry, Los Angeles; Roman Bronze Works, N.Y. Coll.: National Cowboy Hall of Fame; R. W. Norton Art Gallery; Whitney Gallery of Western Art.

A Monarch of the Plains (buffalo). Modeled 1926, cast 1941. H. 2⅞″. Nelli Art Bronze Foundry, Los Angeles. Coll.: National Cowboy Hall of Fame. Coll.: R. W. Norton Art Gallery.

Monarch of the Rockies (curly-horned sheep). Modeled 1925, cast 1941. H. 4¾″. Nelli Art Bronze Foundry, Los Angeles.

Montana Mother. Modeled c. 1917. H. 4⅞″. Cast after the artist's death. Sculpture House, N.Y. Coll.: Amon Carter Museum; Colorado Springs Fine Arts Center; George Gund Collection of Western Art; Montana Historical Society.

Mountain Lion. Coll.: Whitney Gallery of Western Art.

Mountain Mother (bear and two cubs). Modeled c. 1924. H. 4⅞″. Cast during the artist's lifetime. California Art Bronze Foundry, Los Angeles; Nelli Art Bronze Foundry, Los Angeles. Coll.: Amon Carter Museum; Bradford Brinton Memorial Museum; Colorado Springs Fine Arts Center; Gilcrease Institute; National Cowboy Hall of Fame; C. M. Russell Gallery; Whitney Gallery of Western Art; William S. Hart Museum.

Mountain Sheep. Modeled c. 1911. H. 8½″. Cast during the artist's lifetime and in 1958. Roman Bronze Works, N.Y. Coll.: Amon Carter Museum; Colorado Springs Fine Arts Center; National Cowboy Hall of Fame; Whitney Gallery of Western Art.

Mountain Sheep. Modeled 1924. H. 3¾″. Recent casting. Roman Bronze Works, N.Y. George Gund Collection of Western Art; Montana Historical Society.

N. T. Sturr. Modeled 1970. Coll.: Museum of Northern Arizona.

Nature's Cattle (buffaloes). Modeled c. 1911. H. 7″. Cast during the artist's lifetime. California Art Bronze Foundry, Los Angeles. Coll.: Amon Carter Museum; National Cowboy Hall of Fame.

Nature's People (pronghorned deer). Modeled 1905, cast c. 1963. H. 5⅝″. Roman Bronze Works, N.Y. Coll.: Colorado Springs Fine Arts Center; Montana Historical Society; R. W. Norton Art Gallery.

Navaho. H. 5⅛″. Cast during the artist's lifetime and after his death. Nelli Art Bronze Foundry, Los Angeles; Roman Bronze Works, N.Y. Coll.: Amon Carter Museum; National Cowboy Hall of Fame.

Navaho Squaw (On the Trail). H. 6¾″. Roman Bronze Works, N.Y. Coll.: National Cowboy Hall of Fame; Whitney Gallery of Western Art.

Night Herder (Self-Portrait). Modeled 1925. H. 13¼″. Cast during the artist's lifetime and after his death. California Art Bronze Foundry, Los Angeles; Roman Bronze Works, N.Y. Coll.: Amon Carter Museum; Bradford Brinton Memorial Museum; Colorado Springs Fine Arts Center; Gilcrease Institute; George Gund Collection of Western Art; Montana Historical Society; National Cowboy Hall of Fame; R. W. Norton Art Gallery; Whitney Gallery of Western Art.

Nobleman of the Plains (Sioux). H. 5¾″. Roman Bronze Works, N.Y. Coll.: National Cowboy Hall of Fame; R. W. Norton Art Gallery.

Not a Chinaman's Chance. Modeled c. 1893. H. 10¾″. Recent casting. Coll.: Amon Carter Museum.

Offering to the Sun God. 1902. H. 13″. Early casts by Roman Bronze Works, N.Y.; cast 1941 by Nelli Art Bronze Foundry, Los Angeles. Coll.: Gilcrease Institute; National Cowboy Hall of Fame; R. W. Norton Art Gallery; Whitney Gallery of Western Art.

Oh! Mother, What Is It? (bear and cubs). Modeled c. 1914. H. 3¾″. Cast during the artist's lifetime. California Art Bronze Foundry, Los Angeles; B. Zoppo, N.Y. Coll.: Amon Carter Museum; Gilcrease Institute; National Cowboy Hall of Fame; R. W. Norton Art Gallery.

Old Man Indian (plaque). Modeled 1898, cast c. 1950. H. 4½″. Roman Bronze Works, N. Y. Coll.: National Cowboy Hall of Fame; R. W. Norton Art Gallery; Whitney Gallery of Western Art.

On Neenah (self-portrait). 1925. H. 10″. Coll.: National Cowboy Hall of Fame.

Owl on a Stick (Nancy Russell's hiking stick). Cast 1965. Coll.: C. M. Russell Gallery.

Packed and Ready. Cast c. 1968.

Paint Creek Grizzly. Modeled 1922. Coll.: C. M. Russell Gallery.

Painting the Town. Modeled c. 1920. H. 11⅞″. Cast during the artist's lifetime. Nelli Art Bronze Foundry, Los Angeles. Coll.: Amon Carter Museum; Colorado Springs Fine Arts Center; National Cowboy Hall of Fame; R. W. Norton Art Gallery; C. M. Russell Gallery.

Peace. Modeled 1889. Recent casting. H. 13″. Trigg—C. M. Russell Foundation Inc. Coll.: Gilcrease Institute; Montana Historical Society.

Piegan Brave. Modeled 1898. H. 5″. Cast 1963. Sculpture House, N.Y. Coll.: Amon Carter Museum; Montana Historical Society; R. W. Norton Art Gallery; C. M. Russell Gallery.

Piegan Girl. Modeled 1902, cast c. 1966. H. 10½″. Roman Bronze Works, N.Y.

Piegan Squaw (Piegan Maiden or Indian Maiden). Modeled c. 1902. Copyright 1928. H. 6½″. Cast during the artist's lifetime and after his death. California Art Bronze Foundry, Los Angeles; Roman Bronze Works, N.Y. Coll.: Amon Carter Museum; Colorado Springs Fine Arts Center; Gilcrease Institute; National Cowboy Hall of Fame; R. W. Norton Art Gallery; C.M. Russell Gallery; Whitney Gallery of Western Art.

Pig. Modeled 1886. H. 2¾″. Coll.: National Cowboy Hall of Fame; R. W. Norton Art Gallery.

The Poker Game. Modeled c. 1893 (modern casting). H. 7⅛″. Coll.: Amon Carter Museum.

Prairie Pals (horse and rabbit). Modeled c. 1917. H. 4½″. Cast after the artist's death. Sculpture House, N.Y. Coll.: Amon Carter Museum; Colorado Springs Fine Arts Center; George Gund Collection of Western Art; Montana Historical Society; R. W. Norton Art Gallery; Texas Memorial Museum, University of Texas.

Quarterhorse. H. 7″. Recent casting. Coll.: National Cowboy Hall of Fame; R. W. Norton Art Gallery.

The Range Father. Modeled c. 1926. H. 5⅛″. Cast during the artist's lifetime. California Art Bronze Foundry, Los Angeles. Coll.: Amon Carter Museum; Colorado Springs Fine Arts Center; Montana Historical Society; National Cowboy Hall of Fame; R. W. Norton Art Gallery; St. Louis Art Museum.

Ready for the Kill (mountain lion ashtray). Modeled 1909, cast c. 1941 and later. H. 3¾″. Roman Bronze Works, N.Y.; Nelli Art Bronze Works, Los Angeles. Coll.: National Cowboy Hall of Fame; R. W. Norton Art Gallery; Whitney Gallery of Western Art.

Red Bird. Modeled 1908. H. 11½″. Roman Bronze Works, N.Y. Coll.: R. W. Norton Art Gallery; Rockwell Foundation; C. M. Russell Gallery; Whitney Gallery of Western Art.

The Robe Flesher. Modeled c. 1925. H. 4⅞″. Cast during the artist's lifetime. Roman Bronze Works, N.Y. Coll.: Amon Carter Museum; National Cowboy Hall of Fame; R. W. Norton Art Gallery.

Royalty of the Rockies. Modeled 1925. H. 4⅞″. Nelli Art Bronze Works, Los Angeles. Coll.: Montana Historical Society; National Cowboy Hall of Fame; R. W. Norton Art Gallery; Whitney Gallery of Western Art.

Russell (set of bookends with sculptor's self-portrait—left and right). Modeled 1920. H. 5″, 5¼″. Roman Bronze Works, N.Y. Coll.: Colorado Springs Fine Arts Center; R. W. Norton Art Gallery.

Russell Profile (Kid Russell). Modeled 1898. Diam. 4¾″. Roman Bronze Works, N.Y. Coll.: National Cowboy Hall of Fame; R. W. Norton Art Gallery; Whitney Gallery of Western Art.

Scalp Dance. Modeled c. 1904. H. 14″. Cast during the artist's lifetime. California Art Bronze Foundry, Los Angeles; Roman Bronze Works, N.Y. Coll.: Amon Carter Museum; Gilcrease Institute; Henry H. Huntington Library and Art Gallery; National Cowboy Hall of Fame; R. W. Norton Art Gallery; Whitney Gallery of Western Art.

The Scalp Dancer. c. 1914. H. 5⅞″. Cast during the artist's lifetime. Roman Bronze Works, N.Y. Coll.: Amon Carter Museum; Gilcrease Institute; National Cowboy Hall of Fame; R. W. Norton Art Gallery.

Scouting the Enemy. H. 7¾″. Coll.: National Cowboy Hall of Fame; R. W. Norton Art Gallery; Whitney Gallery of Western Art.

Secrets of the Night. Modeled c. 1926. H. 11½″. Cast during the artist's lifetime and after his death in 1968. Roman Bronze Works, N.Y. Coll.: Amon Carter Museum; Gilcrease Institute; National Cowboy Hall of Fame; R. W. Norton Art Gallery; Texas Memorial Museum, University of Texas; Whitney Gallery of Western Art.

The Sentinel. 1968. H. 7¾″.

Shooting the Moon.

Sign Talk. Modeled c. 1900. H. 7″. Roman Bronze Works, N.Y. Coll.: George Gund Collection of Western Art; Montana Historical Society; R. W. Norton Art Gallery.

The Sioux. H. 3½″. Coll.: National Cowboy Hall of Fame; R. W. Norton Art Gallery; Whitney Gallery of Western Art.

Sitting Bear. H. 4¾″. Sculpture House, N.Y. Coll.: Amon Carter Museum; Colorado Springs Fine Arts Center; Montana Historical Society.

Sitting Bear (small). Cast after the artist's death. Roman Bronze Works, N.Y.

Six Reins from Kingdom Come. H. 4½″. Cast 1962. Sculpture House, N.Y. Coll.: Akron Art Institute; Colorado Springs Fine Arts Center; Montana Historical Society; Whitney Gallery of Western Art.

The Sled Man. H. 9½″. Cast 1958. Sculpture House, N.Y. Coll.: Amon Carter Museum; Colorado Springs Fine Arts Center; George Gund Collection of Western Art; R. W. Norton Art Gallery.

Sleeping Thunder. Modeled c. 1902. H. 6⅞″. Cast during the artist's lifetime.

California Art Bronze Foundry, Los Angeles; Roman Bronze Works, N.Y. Coll.: Amon Carter Museum; Colorado Springs Fine Arts Center; Lyndon Baines Johnson Library; National Cowboy Hall of Fame; R. W. Norton Art Gallery; Whitney Gallery of Western Art.

Smoke of the Medicine Man. Modeled 1923. H. 5⅜″. Roman Bronze Works, N.Y. Coll.: National Cowboy Hall of Fame; Whitney Gallery of Western Art.

Smoking Up. Modeled 1903. H. 11″. Cast during the artist's lifetime and after his death. Roman Bronze Works, N.Y. Coll.: Amon Carter Museum; Colorado Springs Fine Arts Center; Gilcrease Institute; Montana Historical Society; National Cowboy Hall of Fame; R. W. Norton Art Gallery; Rockwell Foundation; Woolaroc Museum.

Smoking with the Spirit of the Buffalo. Modeled 1914. H. 4½″. Cast during the artist's lifetime. Roman Bronze Works, N.Y.; B. Zoppo Foundry, N.Y. Coll.: Amon Carter Museum; Gilcrease Institute; National Cowboy Hall of Fame; R. W. Norton Art Gallery; Texas Memorial Museum, University of Texas.

The Snake Priest. Modeled c. 1914. H. 4″. Cast during the artist's lifetime. California Art Bronze Foundry, Los Angeles. Coll.: Amon Carter Museum; National Cowboy Hall of Fame; R. W. Norton Art Gallery.

The Spirit of Winter. Modeled c. 1926. H. 10″. Cast during the artist's lifetime; possible additional casts in the future. Roman Bronze Works, N.Y. Coll.: Amon Carter Museum; R. W. Norton Art Gallery; Texas Memorial Museum, University of Texas.

Steer Head. Modeled 1916. H. 3⅝″. Roman Bronze Works, N.Y.; Vance Foundry. Coll.: National Cowboy Hall of Fame; R. W. Norton Art Gallery; Texas Memorial Museum, University of Texas; Whitney Gallery of Western Art.

The Texas Steer. Modeled c. 1925. H. 4″. Cast during the artist's lifetime and after his death. Nelli Art Bronze Works, Los Angeles; Roman Bronze Works, N.Y. Coll.: Amon Carter Museum; Gilcrease Institute; National Cowboy Hall of Fame; R. W. Norton Art Gallery; Whitney Gallery of Western Art.

The Thoroughbred. Cast 1960. H. 9″. Sculpture House, N.Y. Coll.: Amon Carter Museum; Montana Historical Society; National Cowboy Hall of Fame; R. W. Norton Art Gallery; C. M. Russell Gallery.

To Noses That Read, A Smell That Spells Man. Modeled c. 1920. H. 4½″. Cast during the artist's lifetime and after his death. California Art Bronze Foundry, Los

Angeles; Roman Bronze Works, N.Y. Coll.: Amon Carter Museum; Bradford Brinton Memorial Museum; Joslyn Art Museum; National Cowboy Hall of Fame; R. W. Norton Art Gallery; Rockwell Foundation; Whitney Gallery of Western Art.

Treed. Modeled 1920, cast 1941. H. c. 5¾″. Nelli Art Bronze Works, Los Angeles. Coll.: National Cowboy Hall of Fame; R. W. Norton Art Gallery; Whitney Gallery of Western Art.

Turkey. H. 4⅝″. Recent casting. Coll.: Montana Historical Society.

Two Firehouse Horse Heads. Recent casting. Coll.: Montana Historical Society.

Walking Bear (Walking Grizzly). H. 2¼″. Recent casting. Coll.: Montana Historical Society; R. W. Norton Art Gallery.

Watcher of the Plains. Modeled c. 1902. H. 11″. Cast during the artist's lifetime and after his death. California Art Bronze Foundry, Los Angeles; Roman Bronze Works, N.Y. Coll.: Amon Carter Museum; Gilcrease Institute; National Cowboy Hall of Fame; R. W. Norton Art Gallery; Whitney Gallery of Western Art.

Weapons of the Weak. Modeled c. 1921. H. 6″. Cast during the artist's lifetime. Roman Bronze Works, N.Y. Coll.: Amon Carter Museum; National Cowboy Hall of Fame; R. W. Norton Art Gallery; Whitney Gallery of Western Art.

The Weaver (The Bucker and the Buckaroo). Modeled c. 1911. H. 15″. Cast during the artist's lifetime and after his death. Roman Bronze Works, N.Y. Coll.: Akron Art Institute; Amon Carter Museum; Bradford Brinton Memorial Museum; Gilcrease Institute; Lovelace Foundation—Albert K. Mitchell Collection; Montana Historical Society; National Cowboy Hall of Fame; R. W. Norton Art Gallery; Whitney Gallery of Western Art.

Where the Best Riders Quit. Modeled c. 1920. H. 14½″. Cast during the artist's lifetime and after his death. California Art Bronze Foundry, Los Angeles; Roman Bronze Works, N.Y. Coll.: Amon Carter Museum; Bradford Brinton Memorial Museum; Gilcrease Institute; George Gund Collection of Western Art; Lovelace Foundation—Albert K. Mitchell Collection; National Cowboy Hall of Fame; R.W. Norton Art Gallery; Santa Barbara Museum; Whitney Gallery of Western Art.

White Man's Burden. H. 6½″. Several casts made after the artist's death. Nelli Art Bronze Works, Los Angeles; Roman Bronze Works, N.Y. Coll.: National Cowboy Hall of Fame; R. W. Norton Art Gallery; Whitney Gallery of Western Art.

Wild Boar. Modeled 1913. H. 3⅝″. Nation-

al Cowboy Hall of Fame; R. W. Norton Art Gallery.

Wild Meat. Cast 1968. H. 5¾″.

Will Rogers. H. 11¼″. Cast during the artist's lifetime and after his death. Nelli Art Bronze Works, Los Angeles; Roman Bronze Works, N. Y. Coll.: Amon Carter Museum; Birmingham Museum of Art; California Palace of the Legion of Honor; Colorado Springs Fine Arts Center; Gilcrease Institute; National Cowboy Hall of Fame; R. W. Norton Art Gallery; Whitney Gallery of Western Art; William S. Hart Museum.

Wolf With Bone. H. 15¾″. Cast during the artist's lifetime. Roman Bronze Works, N.Y. Coll.: Amon Carter Museum; National Cowboy Hall of Fame.

X T Bar Longhorn. Modeled 1920, cast c. 1963. H. 3¾″. Roman Bronze Works, N. Y. Coll.: Colorado Springs Fine Arts Gallery; Montana Historical Society; National Cowboy Hall of Fame; R. W. Norton Art Gallery.

Young Man Indian (plaque). Modeled c. 1898, cast c. 1950. H. 4⅞″. Roman Bronze Works, N.Y. Coll.: National Cowboy Hall of Fame; R. W. Norton Art Gallery; Whitney Gallery of Western Art.

SAVILLE, BRUCE W.

Anthony Wayne and the Battle of Fallen Timber Monument. Dedicated 1928. Near Toledo, Ohio.

SIX INDIAN DANCE FIGURES:

Buffalo Dancer. c. 1937. H. 20¼″. Coll.: Museum of New Mexico.

Deer Dancers. c. 1937. H. 22″. Coll.: Museum of New Mexico.

Eagle Dancer. c. 1937. H. 14½″. Coll.: Museum of New Mexico.

Koshare. c. 1937. H. 18½″. Coll.: Museum of New Mexico.

Rainbow Dancer. c. 1937. H. 22½″. Coll.: Museum of New Mexico.

Snake Dancers. c. 1937. H. 24¼″. Coll.: Museum of New Mexico.

SCHILDT, GARY

Brahma Bull Rider. c. 1968. H. 6½″. Avnet Shaw Foundry, Plainview, N.Y.

Bucking the Wind. c. 1966. H. 8″. Avnet Shaw Foundry, Plainview, N.Y.

Flea-Bitten Dog. c. 1966. H. 4″. Avnet Shaw Foundry, Plainview, N.Y.

Hoop Dancer. 1972. H. 18″. Avnet Shaw Foundry, Plainview, N.Y.

Morning Lullaby. c. 1968. H. 7⅛″. Avnet Shaw Foundry, Plainview, N.Y.

Mountie. c. 1966. H. 4″. Avnet Shaw Foundry, Plainview, N.Y.

Old Dan. c. 1966. H. 6″. Ka-eyta Foundry, Harlem, Mont.

Old Man Winter. c. 1966. H. 12″. Ka-eyta Foundry, Harlem, Mont.

Out for Blood. 1967. H. 12″. Ka-eyta Foundry, Harlem, Mont.

Rabbit Hunters. 1972. H. 18″. Avnet Shaw Foundry, Plainview, N.Y.

SCHREYVOGEL, CHARLES

The Last Drop. Copyright 1900, cast 1903. H. 12″. Hoboken Foundry, Hoboken, N.J. (green cast); Roman Bronze Works, N.Y. (1904). Coll.: Birmingham Museum of Art; Gilcrease Institute; George Gund Collection of Western Art; George F. Harding Museum; National Cowboy Hall of Fame; Newark Museum; R. W. Norton Art Gallery; Paine Art Center; Rockwell Foundation; Whitney Gallery of Western Art.

White Eagle. c. 1899. H. 20¾″. Roman Bronze Works, N.Y. Cast during the artist's lifetime (also recent castings). Coll.: Birmingham Museum of Art; Gilcrease Institute; National Cowboy Hall of Fame.

SCHULTZ, HART MERRIAM ("LONE WOLF")

Buffalo Hunt. 1939. H. 18″. Gorham and Co., N.Y. Coll.: Phoenix Art Museum.

Camouflage. Cast 1929. H. 12¼″. Gorham and Co., N.Y. Coll.: Brookgreen Gardens.

Keeper of the Moon. Cast 1967. H. 3½″. Roman Bronze Works, N.Y.

Red Warriors. Modeled 1930. Cast 1967. H. 15″. Roman Bronze Works, N.Y. Coll.: Montana Historical Society.

Riding High. Modeled 1930, cast 1967. H. 10½″. Roman Bronze Works, N.Y. Coll.: Montana Historical Society.

SCRIVER, BOB

Bill Linderman. 1968. Cast by the artist. Life-size. Coll.: National Cowboy Hall of Fame.

The Buffalo Runner. 1964. H. 11½″. Cast by the artist.

Enemy Tracks. 1963. H. 13″. Cast by the artist.

Headin' for a Wreck. 1968. H. 19″. Cast by the artist.

Heading for Home (barrel races). 1968. H. 15″. Cast by the artist.

An Honest Try. 1968. H. 28″. Cast by the artist. Coll.: National Cowboy Hall of Fame.

Mountain Sentinels. 1968. H. 13″. Cast by the artist.

Pay Window. 1968. H. 28″. Cast by the artist. Coll.: National Cowboy Hall of Fame.

Reride. 1968. H. 19″. Cast by the artist.

Whitetail Buck. 1953. H. 16″. Cast by the artist.

SHAFER, L. E. ("GUS")

Born to Buck. 1971. H. 18″. Avnet Shaw

Foundry, Plainview, N. Y.

Country Doctor. 1971. H. 11½″. Harrold Phippen Foundry, Topeka, Kan.

Headin' Them Off. 1962. H. 11¼″. Avnet Shaw Foundry, Plainview, N.Y.

Me Friend (Indian). 1967. H. 16″. Harrold Phippen Foundry, Topeka, Kan.

Rough-Necks (from the series of four, including *Cook Russler, Sheriff,* and *Wrangler*). 1969. H. 10″. Harrold Phippen Foundry, Topeka, Kan.

Saturday Nite. 1969. H. 11¼″. Avnet Shaw Foundry, Plainview, N.Y.

Top Hand. 1967. H. 15″. Harrold Phippen Foundry, Topeka, Kan.

Tuckered Out (cowboy carrying a calf on saddle, with cow following). 1969. H. 13″. Harrold Phippen Foundry, Topeka, Kan.

Twilight (Indian giving thanks). 1971. H. 12¼″. Liera Foundry, Carrara, Italy.

The Wagon Master (Erected in celebration of the fiftieth anniversary of Country Club Plaza). 1972. H. 10′. Country Club Plaza, Kansas City, Mo.

SHEPHERD, J. CLINTON

The Bronc Twister. 1922. H. 20″. Coll.: R. W. Norton Art Gallery.

The Cayuse.

Cowboy Roping a Calf. 1923. H. 21″. Roman Bronze Works, N.Y. Coll.: Woolaroc Museum.

The Desert Rat (miner and his mine-burro). 1928. H. 16¼″. Gorham and Co., N.Y. Coll.: Birmingham Museum of Art.

The Herder. 1922. H. 16½″. Roman Bronze Works, N.Y. Coll.: Gilcrease Institute.

The Horse Wrangler. 1928. Coll.: Birmingham Museum of Art; R. W. Norton Art Gallery.

Indian Scout. 1929. Coll.: R. W. Norton Art Gallery.

Maverick. 1923. H. 21″. Roman Bronze Works, N. Y. Coll.: Gilcrease Institute; R. W. Norton Art Gallery.

The Night Hero. 1932. Coll.: R. W. Norton Art Gallery.

Pony Tracks. 1929. H. 8½″. Coll.: Glenbow-Alberta Institute.

SHRADY, HENRY MERWIN

Buffalo Fight. 1903. H. 22¼″. Coll.: Gilcrease Institute; R. W. Norton Art Gallery.

Bull Moose. 1900. H. 20¾″. Roman Bronze Works, N.Y. Coll.: Gilcrease Institute; The Metropolitan Museum of Art; R. W. Norton Art Gallery; Rockwell Foundation.

Cavalry Charge. 1924. H. 53½″. Coll.: The Metropolitan Museum of Art.

Elk Buffalo (*Monarch of the Plains*). 1901. H. 33″; 23″. Roman Bronze Works, N.Y. Coll.: Gilcrease Institute; Remington

Art Memorial Museum; Rockwell Foundation.

The Empty Saddle. Copyright 1900. H. 19″, 11″. Roman Bronze Works, N.Y. Coll.: National Gallery of Art.

Horse. 1903. H. 22¼″. Coll.: R.W. Norton Art Gallery.

SNIDOW, GORDON

Bad News. 1972. H. 9½″. Buffalo Bronze Works, Sedona, Ariz.

The Cattle Buyer. 1969. H. 6½″. Cast by the artist.

Dustin' Off. 1969. H. 4″. Cast by the artist.

The Roper. 1969. H. 12½″. Cast by the artist.

Springtime. 1967. H. 3½″. Cast by the artist.

SPAMPINATO, CLEMENTE

Bucked Loose. 1953. H. 24½″. Alberati Foundry, Rome, Italy; Modern Art Foundry, Long Island City, N.Y.

Buffalo Hunt. 1954. H. 18½″. Alberati Foundry, Rome, Italy; Modern Art Foundry, Long Island City, N.Y.

Bulldogging Contest. 1955. H. 14″. Alberati Foundry, Rome, Italy; Modern Art Foundry, Long Island City, N.Y.

Cowboy Embrace. 1967. H. 16½″. Alberati Foundry, Rome, Italy; Modern Art Foundry, Long Island City, N.Y.

Double Crossing Horse. 1953. H. 23½″. Alberati Foundry, Rome, Italy; Modern Art Foundry, Long Island City, N.Y.

Forced Landing. 1972. H. 29″. Alberati Foundry, Rome, Italy; Modern Art Foundry, Long Island City, N.Y.

Headed for a Fall. 1954. H. 15″. Alberati Foundry, Rome, Italy; Modern Art Foundry, Long Island City, N.Y.

Indian War Group. 1955. H. 18¼″. Alberati Foundry, Rome, Italy; Modern Art Foundry, Long Island City, N.Y.

Man Killer. 1956. H. 24″. Alberati Foundry, Rome, Italy; Modern Art Foundry, Long Island City, N.Y.

Saddle Bronc Rider. 1953. H. 23¼″. Alberati Foundry, Rome, Italy; Modern Art Foundry, Long Island City, N.Y. Coll.: Oklahoma Art Center.

SPEED, GRANT

Earnin' His Dollar a Day. 1971. H. 17½″. Cast by the artist.

End of a Short Acquaintance. 1966. H. 8¾″. Classic Bronze, El Monte, Calif.

The Fast Gitaway. 1969. H. 9″. Cast by the artist.

The Free Spirit. 1971. H. 14″. Classic Bronze, El Monte, Calif.

On to a Better Range. 1968. H. 11½″. Classic Bronze, El Monte, Calif. Cast by the artist.

Openin' Up New Country. 1971. H. 14½″.

Classic Bronze, El Monte, Calif.

Ridin' Point. 1970. H. 14″. Cast by the artist. Coll.: Homer Garrison Texas Ranger Museum.

Scoutin' the War Party. 1967. H. 4½″. Cast by the artist.

Stampedin' Over a Cutbank. 1972. H. 24″. Cast by the artist.

Watchin' the Posse Close In. 1970. H. 12″. Classic Bronze, El Monte, Calif.

STEVENS, LAWRENCE TENNEY

Bear. Coll.: Newark Museum.

RODEO SERIES:
Bareback Rider. 1964. H. 33″.
Barrel Racer. 1969. H. 22½″.
Brahma Bull Riding. 1962. H. 34″.
The Bull-Dogger. 1964. H. 21″.
Calf Roping. 1965. H. 18″.
The Cutting Horse. 1960. H. 20″.
Saddle Bronc Riding. 1970. H. 37″.
Team Tying. 1963. H. 22″.
Trick Riding. 1968. H. 35″.

STONE, WILLARD

Alice Brown Davis (Seminole). Erected 1964. Roman Bronze Works, N.Y. 1¼ times life-size. Coll.: National Hall of Fame for Famous American Indians.

General Stand Waite's Cherokee Warrior. c. 1971. Roman Bronze Works, N.Y. H. c. 7″. Coll.: Fidelity Bank, Oklahoma City, Okla.

Push-Ma-Ta-Ha (Choctaw). c. 1970. Roman Bronze Works, N.Y. Coll.: Five Civilized Tribes Museum.

Something in Common. 1969. H. 14″. Roman Bronze Works, N.Y. Coll.: National Cowboy Hall of Fame.

Tah'chee (Cherokee war chief). 1969. Roman Bronze Works, N.Y. H. 12″. Coll.: Five Civilized Tribes Museum.

SWANSON, J. N.

The Cougar.
Her First Look. 1969. H. 6¾″. Franco Vianello Foundry, Richmond, Calif.

TIGER, JEROME

The Stickball Player. 1967. H. 64″, 15¾″. Coll.: Five Civilized Tribes Museum.
Resting. 1967. H. 12″.

TROUBETZKOY, PAUL

Bronco Buster.
Cattle Roping (The Wrangler). 1927. H. 10¾″. A. Valsuani Foundry, Paris. Coll.: Glenbow-Alberta Institute; R.W. Norton Art Gallery.

The Indian Scout. 1893. H. c. 22″. Roman Bronze Works, N.Y. Coll.: Henry E. Huntington Library and Art Gallery.

Two Cowboys. 1916. H. c. 19″. Roman Bronze Works, N.Y. Coll.: Henry E. Huntington Library and Art Gallery.

War Chief (equestrian). H. 21½″.
Working Cowboy. 1911. H. 21″.

WARD, JOHN QUINCY ADAMS

The Indian Hunter. 1860. H. 10′. Central Park, N.Y.; Delaware Park Golf Course, Buffalo, N.Y.; Oakview Cemetery, Urbana, Ohio. Small model: H. 16″; Garganni Founders, N.Y. Coll.: American Academy of Arts and Letters; Brookgreen Gardens; The Metropolitan Museum of Art; New-York Historical Society; Sheldon Art Gallery.

Simon Kenton, the Indian Fighter. c. 1860. H. 26½″. Coll.: Cincinnati Art Museum (plaster); Public Library, Urbana, Ohio.

WARNER, OLIN LEVI

Joseph, the Noble and Heroic Chief of the Nez-Percé Indians. 1889. Diam. 17½″. Jno Williams Founder, N.Y. Coll.: Denver Museum of Natural History; The Metropolitan Museum of Art; Oregon Historical Society.

Lot, Chief of the Spokane Indians. 1891. Diam. 8″. Coll.: The Metropolitan Museum of Art; Walters Art Gallery.

Moses, Chief of the Okinokan Indians. 1891. Diam. 8¼″. Coll: The Metropolitan Museum of Art; Oregon Historical Society; Walters Art Gallery.

N-Che-Askwe, Chief of the Coeur D'Alene Indians. 1891. Diam. 7¼″. Coll.: The Metropolitan Museum of Art; Walters Art Gallery.

Sabina, Daughter of Kash-Kash, a Cayuse Indian. 1891. Diam. 5¾″. Coll.: The Metropolitan Museum of Art; Portland Art Museum; Walters Art Gallery.

Seltice, Chief of the Coeur D'Alene Indians. 1891. Diam. 7¼″. Coll.: Metropolitan Museum of Art; Oregon Historical Society; Walters Art Gallery.

Ya-Tin-Ee-Ah-Witz, Chief of the Cayuse Indians. 1891. Diam. 10¾″. Coll.: Denver Museum of Natural History; The Metropolitan Museum of Art; Oregon Historical Society; Walters Art Gallery.

Young Chief, Chief of the Cayuse Indians. 1891. Diam. 8″. Coll.: The Metropolitan Museum of Art; Walters Art Gallery.

WARREN, CONSTANCE WHITNEY

Cowboy. Coll.: Princeton University Art Museum.

Cowboy. Dedicated 1957. In front of the State Capitol, Oklahoma City, Okla.

Cowboy Number Three. Coll.: Woolaroc Museum.

Cowboy Number Four. 1921. A. Valsuani Founder, Paris. Coll.: Columbia Museum of Art.

Lariat Cowboy.

Old Chisholm Trail Cowboy. Coll.: Texas Memorial Museum, University of Texas.

Rider (W.J. Hart). H. 18½″.

WARREN, MELVIN C.

Angry West. 1971. H. 21″. Amel Bronze, Clifton, Tex.

The Drifter. 1967. H. 10″. Harrold Phippen Foundry, Topeka, Kan. Coll.: Lyndon Baines Johnson Library.

Making the Decision. 1969. H. 13″. Amel Bronze, Clifton, Tex. Coll.: Lyndon Baines Johnson Library.

Rangers on Patrol. 1973. H. 12″. Amel Bronze, Clifton, Tex.

Run for the Rio Grande. 1967. H. 19¾″. Harrold Phippen Foundry, Topeka, Kan. Coll.: Homer Garrison Texas Ranger Museum; Lyndon Baines Johnson Library; National Cowboy Hall of Fame.

Texas Ranger. 1972. H. 13″. Amel Bronze, Clifton, Tex. Coll.: Lyndon Baines Johnson Library.

Viva Zapata. 1970. H. 15½″. Amel Bronze, Clifton, Tex. Coll.: Lyndon Baines Johnson Library.

WEINMAN, ADOLPH A.

Bison. c. 1922. H. 12″. Coll.: R. W. Norton Art Gallery.

Chief Blackbird (bust). Modeled 1903, cast 1907. H. 16½″. Roman Bronze Works, N.Y. Coll.: Birmingham Museum of Art; Brooklyn Museum; Denver Museum of Natural History; Gilcrease Institute (two); Indianapolis Museum of Art; R.W. Norton Art Gallery.

Chief Flatiron (bust). Modeled c. 1903. H. 12″. Roman Bronze Works, N.Y. Coll.: Gilcrease Institute; R.W. Norton Art Gallery.

Destiny of the Red Man. Modeled 1903, cast 1947. H. 55″. Roman Bronze Works, N.Y. Coll.: R.W. Norton Art Gallery.

Indian Hunting Dog. 1945. Coll.: R.W. Norton Art Gallery.

The Rising Sun.

Womboli. Modeled 1902. H. 8½″. Roman Bronze Works, N.Y. Coll.: Brookgreen Gardens; Gilcrease Institute.

WHITEHORSE, ROLAND N.

Apache Fire Dancers. 1969. H. 9½″. Southwestern Bronze Foundry, Fletcher, Okla. Coll.: Southern Plains Indian Museum and Craft Center.

Blackfoot Warrior. 1969. H. 7″. Coll.: Southern Plains Indian Museum and Craft Center.

Counting Coup. 1969. H. 9″. Southwestern Bronze Foundry, Fletcher, Okla.

Crow War Dance. 1970. H. 7″. Learned Foundry, Oklahoma City, Okla.

Flute Maker. 1972. H. 5″. Artistic Ornamental Foundry, El Paso, Tex.

Hoop Dancer. 1972. H. 6″. Artistic Ornamental Foundry, El Paso, Tex.

Kiowa War Dancer. 1971. H. 7″. Nambe Mills Foundry, Santa Fe, N.M.

Mountain Spirit Dancer. 1971. H. 8″. Nambe Mills Foundry, Santa Fe, N.M.

Rescue. 1971. H. 10″. Nambe Mills Foundry, Santa Fe, N.M.

Tokoko Warrior. 1970. H. 7″. Learned Foundry, Oklahoma City, Okla.

WHITNEY, GERTRUDE VANDERBILT

Aztec Fountain. Life-size. Pan-American Building, Washington, D.C.

Buffalo Bill Cody—The Scout. 1923. H. 12′ 5″. Roman Bronze Works, N.Y. Coll.: Buffalo Bill Historical Center.

WIEGHORST, OLAF

Bucking Horse. Modeled 1930s, cast 1930s and recently. H. 8″. Classic Bronze, El Monte, Calif.

Indian by the Campfire. c. 1964. H. 3½″. Roman Bronze Works, N.Y.

Restin' and Reminiscin'. c. 1965. H. 7⅞″. Roman Bronze Works, N.Y.

Western Cowboy. Modeled c. 1930s. H. 11″. Original foundry not known. Recent casting: Classic Bronze, El Monte, Calif.

WINGATE, CURTIS

The Bronc Buster. 1970. H. 14″. Bear Paw Bronze Works, Skull Valley, Ariz.

Buffalo Skull. 1970. H. 3″. Prescott Metal Casters, Prescott, Ariz.

California. c. 1970. H. 13″. Bear Paw Bronze Works, Skull Valley, Ariz.

Cowboy 1900. 1972. H. 11″. Prescott Metal Casters, Prescott, Ariz.

Fra Marcos de Niza and Esteban. 1969. H. 9¾″. Prescott Metal Casters, Prescott, Ariz.

The Trapper. c. 1967. H. 4¾″. Bear Paw Bronze Works, Skull Valley, Ariz.

Vacquero. 1970. H. 9″. Prescott Metal Casters, Prescott, Ariz.

YOUNG, MAHONRI MACINTOSH

Frontiersman and Indian Scout. c. 1932. H. 16″. Roman Bronze Works, N.Y. Coll.: Art Gallery of Brigham Young University (plaster).

Indian Scout. H. 16″. Coll.: Art Gallery of Brigham Young University.

Joseph and Hyrum Smith. 1908. Life-size. Roman Bronze Works, N.Y. Temple Square, Salt Lake City, Ut.

Kneeling Indian (Navaho). Roman Bronze Works, N.Y.

Laborer. c. 1907. H. 16″. Roman Bronze Works, N.Y. Coll.: Cranbrook Art Gallery; Newark Museum.

Lunch in the Desert. c. 1930. H. 8″. Roman Bronze Works, N.Y. Coll.: Brigham

Young University.

Navaho Pony. 1907. Statuette. Roman Bronze Works, N.Y. Temple Square, Salt Lake City, Ut.

Pioneer Woman. 1927. H. 36″. Roman Bronze Works, N.Y. Coll.: Woolaroc Museum.

Pony Express Rider. c. 1932. H. 15″. Roman Bronze Works, N.Y. Coll.: Art Gallery of Brigham Young University.

Prospector. 1907. Statuette. Roman Bronze Works, N.Y. Temple Square, Salt Lake City, Ut.

Rolling His Own. c. 1928. H. 13¼″. Roman Bronze Works, N.Y. Coll.: Art Gallery of Brigham Young University (plaster); Philip Ashton Rollins Collection of Western Americana, Princeton University.

Sea Gulls. 1913. Life-size. Roman Bronze Works, N.Y. Temple Square, Salt Lake City, Utah.

The Stone Cart. H. 5″. Roman Bronze Works, N.Y. A. Valsuani Founder, Paris. Coll.: Art Gallery of Brigham Young University.

A Texas Longhorn. H. 8¾″. Roman Bronze Works, N.Y. A. Valsuani Founder, Paris.

This is the Place Monument. 1947. Heroic size. Rochette and Parzini Corp. Emigration Canyon State Park, Salt Lake City, Utah.

Three Buffalo. H. 6″. Roman Bronze Works, N.Y. Coll.: Art Gallery of Brigham Young University.

Two Fighting Bulls. H. 6″. Roman Bronze Works, N.Y. Coll.: Art Gallery of Brigham Young University.

INDEX OF MONUMENTAL AMERICAN WESTERN BRONZES

a rock. Wo Peen, a Pueblo artist from San Ildefonso, was the model. Philip S. Sears. Fruitland Museum grounds, Harvard University.

CHARLAMONTE
Hail to the Sunrise. In memory of the Mohawk Indians. Joseph P. Pollia. Erected 1932 by the Tribes and Councils of the Improved Order of Red Men. Mohawk Trail, Route 2, west of the Shunpike Bridge.

PLYMOUTH
Massasoit. Cyrus Dallin. Dedicated 1921. Coles Hill, overlooking Plymouth Harbor.

PROVINCETOWN
Signing the Compact. Cyrus Dallin.

MICHIGAN
DETROIT
The Spirit of Transportation. Indian carrying a canoe on his shoulders. Carl Milles. Dedicated 1960. Civic Center.

ISHPEMING
Chief Hopocan.

MONROE
General Custer. Equestrian statue. Edward Clark Potter. Presentation 1910.

PONTIAC
Chief Pontiac. Jerry Farnsworth. Lobby of the City Hall.

MINNESOTA
DULUTH
Daniel Graysolon Sieur duLuth. Jacques Lipchitz. Dedicated 1965. University of Michigan, Duluth Campus.

MINNEAPOLIS
Hiawatha and Minnehaha. Jakob Henrik and Gerhard Fjelde. Island in Minnehaha Creek, above Minnehaha Falls.
Old Crossing Treaty Monument. A Chippewa is holding a peace pipe, with his hand offered in friendship. Carl C. Mose. Eight miles west of Red Lake Falls.

ST. PAUL
Indian Hunter with Dog. Paul Manship. 1926. Cochran Memorial Park.

WINONA
Wenonah. Isabel Kimball. Erected 1902. Main and Lake Streets.

MISSISSIPPI
VICKSBURG
Civil War Generals. Solon H. Borglum. Vicksburg Cemetery.

MISSOURI
JEFFERSON CITY
Bears. Edward Kemeys. State Building.

Lewis and Clark. James Earle Fraser. State Capitol.

KANSAS CITY
The Pioneer Mother. Equestrian group. A. Phimister Proctor. 1923–27. Dedicated 1928. Penn Valley Park.
The Scout. Cyrus Dallin. 1914–15. Dedicated 1922. Penn Valley Park.

ST. JOSEPH
Pony Express. Hermon A. MacNeil. Dedicated 1940. Civic Center Park.

ST. LOUIS
Zuni Bird Charmer. Walter Hancock. Dedicated 1932. Forest Park.

MONTANA
BILLINGS
A Range Rider of the Yellowstone. William S. Hart and his horse. Charles C. Cristadoro. Logan Field Airport.

FORT BENTON
Lewis and Clark and Sacajawea. Bob Scriver. 1974.

NEBRASKA
FLORENCE
Winter Quarters. Avard T. Fairbanks. Dedicated 1936. Mormon Pioneer Cemetery (west of the city).

LINCOLN
Buffalo or *American Bison.* George Gaudet. Dedicated 1930. Pioneers' Park.
The Sower. Lee Lawrie. Nebraska State Capitol.
The Smoke Signal. Bronzed cast stone. Ellis Louis Burman. Dedicated 1935. Pioneers' Park.
Walking Bear Cub. Ralph Humes. Dedicated 1930. Children's Zoo.

OMAHA
Bison. Edward Kemeys. 1887. Bridge of the Union Pacific Railroad.
Elk. Eli Harvey. 1907.

NEVADA
RENO
The Man with the Upturned Face (John W. McKay). Gutzon Borglum. McKay School of Mines, University of Nevada.

STATELINE—LAKE TAHOE
The Pony Express. Avard T. Fairbanks. Dedicated 1963.

NEW JERSEY
MONTCLAIR
The Sun Vow. Hermon A. MacNeil. 1901. In front of the Montclair Museum.

NEWARK
Indian and Puritan. Gutzon Borglum. Un-

veiled 1916. Entrance to the Newark Public Library.
Indian Group. A mother recognizes her daughter, who clings to her Indian husband. Chauncey Ives. Dedicated 1895. Lincoln Park.

NEW YORK
BUFFALO
Red Jacket (Portrait of Sa-Co-Ye-Wat-Ha, meaning "Keeps Them Awake"). Memorial to a distinguished Seneca warrior and orator. Dedicated 1891. Inscription: "When I am gone and my warnings are no longer heeded the craft and the avarice of the white man will prevail. My heart fails me when I think of my people so soon to be scattered and forgotten." Forest Lawn Cemetery.

KATONAH
Indian Dancing Girl. Madeleine Park. New York Public Library.

LAKE GEORGE
Kneeling Indian Fountain. A. Phimister Proctor. Erected 1921.

NEW YORK CITY
Aspiration. Solon H. Borglum. Installed 1920. St. Mark's-in-the-Bowery.
Dying Indian. Charles C. Rumsey. Entrance to The Brooklyn Museum.
The Indian Hunter. John Quincy Adams Ward. 1860. Central Park.
Inspiration. Solon H. Borglum. Installed 1920. St. Mark's-in-the-Bowery.
Panthers (Pumas). A. Phimister Proctor. c. 1896. Entrance to Prospect Park, Brooklyn.
Reaching Jaguar. Anna Hyatt Huntington. 1906. Central Park Zoo.
Still Hunt. Edward Kemeys. Erected 1885. Central Park.
Theodore Roosevelt with Gunbearers. James Earle Fraser. Erected c. 1939. In front of the American Museum of Natural History.

PAINTED POST
Chief Montour. Norman Phelps. Dedicated May 1950. Monument Square.

SCHENECTADY
Chief Hopocan. Old Fort.

WINONA
Wenonah. Isabel Kimball. c. 1900.

NORTH DAKOTA
BISMARCK
Pioneer Family. Avard T. Fairbanks. Dedicated 1947. State Capitol grounds.
Sacajawea. Leonard Crunelle. Dedicated 1910. East side of Capitol grounds.

MANDAN
Theodore Roosevelt as a Rough Rider. Eques-

trian statue. A. Phimister Proctor. c. 1920.

MINOT
Theodore Roosevelt as a Rough Rider. Equestrian statue. A. Phimister Proctor. Dedicated 1924. Roosevelt Park.

NEWTOWN
Four Bears Monument. Dedicated 1932. East side of the Missouri River, overlooking the Four Bears Bridge.

OHIO
AKRON
Chief Hopocan.

BARBERTON
Chief Hopocan.

CINCINNATI
Chief Hopocan.

COLUMBUS
McKinley Memorial. Hermon A. MacNeil.

LODI
Chief Hopocan.

MARIETTA
A Nation Moving Westward. Gutzon Borglum.

TIFFIN
Indian Maiden. Leonard Crunelle and Lorado Taft. Frost Parkway, near Monument Square.

TOLEDO
Fallen Timber Monument. Bruce W. Saville. Dedicated 1928. Route 577. Site of Battle, Lucas County.
Elk. Eli Harvey. 1907.

URBANA
Indian Hunter. John Quincy Adams Ward. Oakview Cemetery.

OKLAHOMA
ANADARKO
The National Hall of Fame For Famous American Indians:

1. *Black Beaver.* Delaware Indian. Keating Donahue. Dedicated and erected 1954.
2. *Chief Joseph.* Leader of the Nez-Percé of southwestern Oregon during the mid-nineteenth century. Kenneth F. Campbell. Dedicated and erected 1957.
3. *Allen Wright.* Principal Chief of the Choctaw nation, 1866–70. Kenneth F. Campbell. Dedicated and erected 1958.
4. *Osceola.* Seminole war leader during the early nineteenth century. Madeleine Park. Dedicated and erected 1958.
5. *Charles Curtis.* Member of the Kaw or Kansas tribe, leader in nine-

teenth-century Indian affairs. First man of Indian descent to be elected as Vice-President of the United States, serving with President Herbert Hoover. Madeleine Park. Dedicated and erected 1959.

6. *Quanah Parker*. Comanche leader. Jack Hill. Dedicated and erected 1959.

7. *Sacajawea*. Shoshoni woman who acted as guide and interpreter for the Lewis and Clark Expedition of 1805–6. Leonard McMurry. Dedicated and erected 1959.

8. *Jim Thorpe*. Famous athlete of the Sac and Fox tribe. Leonard McMurry. Dedicated and erected 1960.

9. *Pontiac*. Chief of the Ottawa tribe during the mid-eighteenth century. Pietro Montana. Dedicated and erected 1961.

10. *Little Raven*. Southern Arapaho Indian of the mid-nineteenth century. John Learned. Dedicated and erected 1962.

11. *Sequoyah*. Inventor of the Cherokee alphabet. Leonard McMurry. Dedicated and erected 1962.

12. *Tishomingo*. Chickasaw leader. Leonard McMurry. Dedicated and erected 1963.

13. *Alice Brown Davis*. Appointed Chief of the Seminole tribe in Oklahoma in 1922. Willard Stone. Dedicated and erected 1964.

14. *Pocahontas*. The daughter of Powhatan, she rescued Captain John Smith of Jamestown. Kenneth F. Campbell. Dedicated and erected 1965.

15. *Will Rogers*. Famous humorist of Cherokee descent. Electra Waggoner Biggs. Dedicated and erected 1965.

16. *Major General Clarence L. Tinker*. General Tinker was of Osage descent. In perishing in the battle for Midway in 1942, he became the first American general to lose his life in World War II. Leonard McMurry. Dedicated and erected 1966.

17. *José Maria*. Chief of the Anadarkos and leader of the Caddos. Leonard McMurry. Dedicated and erected 1969.

18. *Roberta Campbell Lawson*. The first woman in America of Indian descent (Delaware tribe) to become national President (1935–38) of the National Federation of Women's Clubs. Leonard McMurry. Dedicated and erected 1969.

Bronze portrait busts to be erected at The National Hall of Fame for Famous American Indians when and as funds are available:

19. *Hiawatha*. Mohawk.
20. *John Ross*. Cherokee.
21. *Keokuk*. Sac and Fox.
22. *Massasoit*. Wampanoag.
23. *Pushmataha*. Choctaw.
24. *Stand Watie*. Cherokee.
25. *Tecumseh*. Shawnee.

Bears. Anna Hyatt Huntington. 1960. Grounds of The National Hall of Fame for Famous American Indians.

Wolves. Anna Hyatt Huntington. 1960. Grounds of The National Hall of Fame for Famous American Indians.

CLAREMORE

Riding Into the Sunset (Will Rogers on "Soapsuds"). Equestrian statue. Electra Waggoner Biggs. Dedicated 1950. Entrance to the Will Rogers Memorial.
Will Rogers. Standing figure. Jo Davidson. 1938. In entrance lobby of the Will Rogers Memorial.

OKLAHOMA CITY

Cowboy. Constance Whitney Warren. In front of the State Capitol.
The Eighty-Niners. Leonard McMurry. c. 1958. Civic Center.
Indian Boy. Jo Taylor. O'Neil Park.
Legend of the Westerner. Photographs of Joel McCrea as Buffalo Bill served as a model. Leonard McMurry. 1974. Entrance to National Cowboy Hall of Fame.
Pioneer Preacher. The preacher is Reverend Price Beauregard Hicks, pioneer Methodist minister, evangelist, and elder in Indian Territory. Voncille Deering. Oklahoma City University Campus.

PONCA CITY

Pioneer Woman. Bryant Baker. c. 1927.

OREGON

EUGENE

The Pioneer Mother. A. Phimister Proctor. 1934. University of Oregon Campus.
The Pioneer. The model for this work was J. C. Craven, a trapper. A. Phimister Proctor. 1917–18. University of Oregon Campus.

PENDLETON

Til Taylor. A. Phimister Proctor. c. 1926.

PORTLAND

Colonel Roosevelt as a Rough Rider. A. Phimister Proctor. 1920. South Park Block.
The Coming of the White Man. Hermon A. MacNeil. Dedicated 1907. Washington Park.

Fountain and Elk. Roland Hinton Perry. 1900. Fourth and Main Streets.
Harvey W. Scott. Gutzon Borglum. 1933. Mount Tabor Park.
Indian Group. Hermon A. MacNeil. Washington Park.
Pioneer Woman or *Joy*. Frederic Littman. 1955–56. Council Crest Park.
Sacajawea. Alice Cooper. Dedicated 1905. Washington Park.
Skidmore Fountain. Olin Levi Warner. 1888. Front Street.

SALEM

The Circuit Rider. A. Phimister Proctor. 1922. East side of the State Capitol grounds.
Dr. John McCoughlin. A. Phimister Proctor.
The Pioneer. Covered with gold leaf. Ilrich Ellerhusen. State Capitol.

PENNSYLVANIA

HANOVER

The Cavalry Man. Cyrus Dallin. 1905.

PHILADELPHIA

The Cowboy. Frederic Remington. Unveiled 1908. Fairmount Park.
Hudson Bay Wolves. Edward Kemeys. Erected 1872. Fairmount Park (The Philadelphia Zoo).
The Medicine Man. Cyrus Dallin. Erected 1903. Fairmount Park.
The Stone Age in America. John Boyle. Erected 1888. Fairmount Park.

WOMELDORFS

Chief Shikellamy. Joseph P. Pollia. Erected 1930. Conrad Weiser Memorial Park, Berks County.

RHODE ISLAND

PROVIDENCE

Brown Bear. Eli Harvey.
Henry Young. A scout under General Sheridan. Opposite the Biltmore Hotel.

WATCH HILL

Ninigret—Indian with a Fish. Enid Yandell. Memorial Building.

TENNESSEE

CHATTANOOGA

Chief John Ross. Chief of the Cherokee nation for forty-one years. Belle Kinney. Hamilton County Court House.

TEXAS

AUSTIN

Mustangs. A. Phimister Proctor. Unveiled 1948. Texas Memorial Museum, University of Texas.
Old Chisholm Trail Cowboy. Constance Whitney Warren. The Texas Memorial Museum, University of Texas.

DALLAS

Archer—Tejas Warrior. Allie Victoria Tennant. Erected 1936. Entrance to the Texas Exposition's Hall of State.
Seven Texas Heroes. Pompeo Coppini. State Fair grounds.
The Texas Ranger. Waldine Tauch. Dedicated 1961. Love Field Administration Building.

FORT WORTH

Riding Into the Sunset (Will Rogers on "Soapsuds"). Equestrian statue. Electra Waggoner Biggs. Entrance to the Will Rogers Auditorium.

LUBBOCK

Riding Into the Sunset (Will Rogers on "Soapsuds"). Equestrian statue. Electra Waggoner Biggs. Texas Technical College.
West Texas Pioneer Family. Granville W. Carter. 1968. American State Bank.

SAN ANTONIO

Texas Cowboys. Monument to the old trail drivers. Gutzon Borglum. Modeled 1927, cast 1942.

UTAH

OGDEN

Wonders of the Great Outdoors. James Fitzgerald. 25th Street and Kiesel Avenue.

SALT LAKE CITY

Angel. Cyrus Dallin. Temple Square.
Brigham Young. Portrait bust. Edward Fraughton. 1970. Brigham Young Cemetery.
Brigham Young Pioneer Monument. The figures represent Brigham Young, Jim Bridger, and Chief Washakie. Cyrus Dallin. Dedicated 1897. South Temple and Main Street intersection.
Handcart Pioneer Monument. Thorlief S. Knaphus. 1947. Temple Square.
Massasoit. Cyrus Dallin. c. 1921. Entrance to the State Capitol.
Pioneer Family Group. Edward Fraughton. 1974. Brigham Young Cemetery.
Sea Gulls. Mahonri MacIntosh Young. 1913. Temple Square.
This is the Place Monument. Mahonri MacIntosh Young. 1947. Emigration Canyon State Park.
Ute Brave. Avard T. Fairbanks. Union Building, University of Utah.

SPRINGVILLE

Pioneer Mother (A Memorial to the Pioneer Mothers of Springville, Utah). The sculptor's mother was the model. Cyrus Dallin. 1931.

VIRGINIA

CHARLOTTESVILLE

George Roger Clark Memorial. Robert Aiker.

Lewis and Clark. Charles Keck.

Pocahontas. William Partridge. Churchyard.

RICHMOND
Meriwether Lewis. Randolph Rogers. 1861. The Washington Monument.

WASHINGTON
SEATTLE
Chief Seattle. Heroic bust. James Wehn. c. 1912. Pioneer Square.
Chief Seattle. James Wehn. Dedicated 1912. Tilicum Square.

VANCOUVER
Pioneer Mother. Avard T. Fairbanks. 1929. Esther Short Park.

WASHINGTON, D.C.
Aztec Fountain. Gertrude Vanderbilt Whitney. Pan American Building.
Buffalo Head. A. Phimister Proctor. Installed 1917. On the cornerstone of the Arlington Cemetery Bridge.

WEST VIRGINIA
CHARLESTON
Mountaineer Soldier. Henry Kirke Bush-Brown.

MORGANTOWN
Mountaineer. Donald De Lue. Dedicated 1971. Student Center Building, West Virginia University.

WHEELING
The Mingo. In memory of the first inhabitants of the Ohio Valley. Henry Ben. Dedicated 1928. Memorial Boulevard and National Road.

WISCONSIN
OSHKOSH
Chief Oshkosh. G. Trentanova. Unveiled 1911. Menominee Park.
Winnebago Lady. Donald Hord. Garden of Paine Art Center.

SHERWOOD
Red Bird. Adolph E. Seebach. High Cliff State Park, Lake Winnebago.

WAUPIN
Dawn of Day. Indian Woman. Clarence Addison Shaler. Shaler Park.
Red Bird. Adolph E. Seebach. Near Sherwood, Lake Winnebago.
The End of the Trail. James Earle Fraser. Unveiled 1929.

WYOMING
CHEYENNE
American Family. Robert Russin. 1966. Federal Court Building.

Esther Morris. Avard T. Fairbanks. Entrance to the State Street Capitol.
Honorable Justice John Burke. Avard T. Fairbanks. State Capitol.
Pony Express. Harry Jackson. State Capitol.

CODY
Buffalo Bill Cody—The Scout. Gertrude Vanderbilt Whitney. 1923. Buffalo Bill Historical Center, Whitney Gallery of Western Art.